D1242847

Piero della Francesca and His Legacy

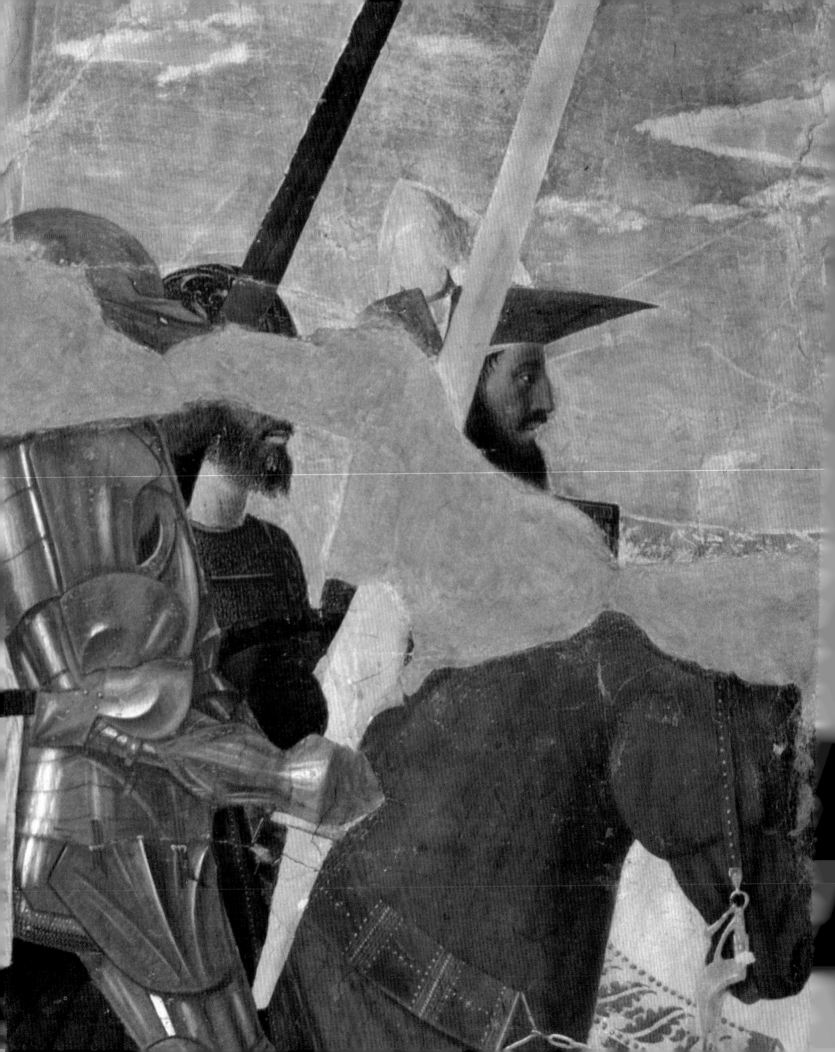

STUDIES IN THE HISTORY OF ART · 48 ·

Center for Advanced Study in the Visual Arts

Symposium Papers XXVIII

Piero della Francesca and His Legacy

Edited by Marilyn Aronberg Lavin

National Gallery of Art, Washington

Distributed by the University Press of New England

Hanover and London

Copyright © 1995 Trustees of the National
Gallery of Art, Washington

All rights reserved. No part of this book may
be reproduced without the written permission
of the National Gallery of Art, Washington,
D.C. 20565

This publication was produced by the Editors
Office, National Gallery of Art, Washington
Editor-in-Chief, Frances P. Smyth

The type is Trump Medieval, set by Artech
Graphics II, Inc., Baltimore, Maryland

The text paper is 80 pound LOE Dull

Printed by Princeton Polychrome Press,
Princeton, New Jersey

Distributed by the University Press of
New England, 23 South Main Street,
Hanover, New Hampshire 03755

Abstracted and indexed in BHA
(Bibliography of the History of Art)
and Art Index

Proceedings of the symposium *"Monarca
della Pittura:* Piero and His Legacy," sponsored
by the Center for Advanced Study in the Visual
Arts, National Gallery of Art, the J. Paul Getty
Museum, and the Getty Center for the History
of Art and the Humanities, Washington,
4–5 December 1992

ISSN 0091-7338
ISBN 0-89468-203-2

Frontispiece: Piero della Francesca, *Battle
of Constantine* (detail), 1452–1466, fresco
San Francesco, Arezzo; photograph: Alinari

Contents

Preface

In December of 1992, the five-hundredth anniversary year of Piero della Francesca's death, the Center for Advanced Study in the Visual Arts, National Gallery of Art, the J. Paul Getty Museum, and the Getty Center for the History of Art and the Humanities jointly sponsored a two-day symposium, *"Monarca della Pittura:* Piero and His Legacy," held in Washington. In addition to eighteen scholarly papers, the gathering included an interactive computer imaging demonstration that explored in three-dimensional movement Piero's fresco cycle in the church of San Francesco in Arezzo.

This volume reconsiders Piero's chronology, style and expression, iconography, and subsequent attention as painter and mathematician. Included here are the papers delivered at the symposium as well as an essay by James R. Banker. Colin Eisler and Serafin Moralejo were not able to prepare their papers for publication. An appendix to this volume describes the imaging project undertaken by Princeton University.

The symposium was planned in consultation with Marilyn Aronberg Lavin who, in addition to contributing an essay and moderating a session, generously agreed to edit the volume and write the introduction. Martin Kemp, Daniel Arasse, and Bert W. Meijer also served as moderators at the symposium. Additional support from the Arthur Vining Davis Foundations and the Istituto Italiano per gli Studi Filosofici helped to make the symposium possible.

The Center for Advanced Study in the Visual Arts was founded in 1979, as part of the National Gallery of Art, to foster study of the history, theory, and criticism of art, architecture, and urbanism through programs of meetings, research, publication, and fellowships. This is the forty-eighth volume of Studies in the History of Art and the twenty-eighth in the symposium series. The series is designed to document scholarly meetings, sponsored singly or jointly, under the auspices of the Center and is also intended to stimulate further research and scholarly debate. A summary of published and forthcoming titles may be found at the end of this volume. Many of the publications result from collaboration between the Center for Advanced Study and sister institutions, including universities, museums, and research institutions.

HENRY A. MILLON
Dean, Center for Advanced Study in the Visual Arts

MARILYN ARONBERG LAVIN
Princeton University

Introduction
Monarca della Pittura: *Piero and His Legacy*

The phrase "monarch of painting" was applied to Piero soon after his death by the mathematician Fra Luca Pacioli, Piero's compatriot from Borgo Sansepolcro.[1] Until well into the eighteenth century, however, Piero was remembered more for his science than for his painting.[2] Only after two of his works were bought for the National Gallery in London in the early 1850s did his reinstatement as a creative artist begin. The transition was fairly rapid. By 1875 full-scale copies of two of his frescoes were put on display in Paris. Twenty years later his *Madonna del Parto* was discovered in Monterchi, and by 1911 it was considered important enough to be stripped off the wall and taken to Florence for restoration. In 1912 the English wife of one of Piero's last relatives published the first book on his career, including many documents.[3] As his fame began to grow, painters of the 1920s, ravished by the portentous blend of restrained ardor and formal purity, claimed him as the one Renaissance master to give their abstract work legitimacy. Even though very few of his works were outside Italy, Piero della Francesca soon became a universal aesthetic idol. Knowing little of his scientific writings, the public now meets him in college courses, on trips to Tuscany, or through contemporary artists who echo his style and refer to him as their favorite of favorites. Today we honor Piero as one of the most highly regarded painters of the early Renaissance, and one of the most respected artists of all time.[4]

The goal of this study has been to define the context in which Piero worked, as well as to investigate the legacy he left to the centuries that followed. To range over the broad spectrum of his contributions, five topics were chosen for analysis: the chronology in his personal oeuvre; his contributions to art as religious and political expression; stylistic and iconographic relationships of his work to the art of his contemporaries in Italy and northern Europe; the interrelation between his paintings and painted architecture and his mathematics; and last, the reasons for his great appeal in the twentieth century.

Piero's Chronology

Owing to the consistency in the character of Piero's style and the paucity of documentation concerning his career, fixing a chronology of his works has resisted general agreement. The problem is of considerable importance in understanding the historical implications of his artistic contributions, as well as the meaning and function of his works in the context in which they were produced. Yet no clear consensus on the progress of his career has emerged, and opinions continue to diverge widely. Among the scholars who have occupied themselves with this problem, Creighton Gilbert is unique in having focused on the sequence of Piero's career in a concentrated and comprehensive way. In a 1968 publication,[5] he offered a sur-

vey of Piero's career, calling attention to the issues of stylistic development within the historical context of the commissions. In the years following Gilbert's book, authors have continued to direct their attention to problems of chronology but without offering a complete system that satisfies all the questions involved. A small database of chronologies drawn from the major twentieth-century monographs emphasizes these variations in opinion. The comparative chart generated from this database is reproduced in Appendix 1.

James Banker addressed problems of Piero's chronology in a roundtable discussion, and presents here a series of new documents concerning Piero's *Misericordia Altarpiece*. Serving to ground the commission in a network of the confraternity members, the documents also bring fresh challenges in terms of relating payments to the actual time of production. Frank Dabell, who has provided fundamental evidence concerning Piero's early artistic training and other activities, made an eloquent plea for cooperation and coordination among archival scholars, and for interaction and communication between them and other types of historians. It is generally agreed that a public database of documents, into which new material could be entered coherently and consistently, and from which information could be drawn according to set standards, is highly desirable.

Piero and the Theme of Constantine

In Piero's cycle of frescoes in Arezzo, scenes of Constantine's vision and victory were joined to the legend of the True Cross for the first time on a monumental scale, and they were given a dignity and grandeur that had never been seen before. By this token, the Arezzo cycle became the universal joint, so to speak, that holds the medieval and the modern aspects of the tradition together. Here scholars of medieval, Renaissance, and baroque art and literature were asked to lay out the threads of the Constantinian myth as it developed in various national traditions, with the aim of placing Piero's Constantinian scenes in their larger historical context. Part of the goal was to demonstrate, at least by implication, what aspects of the tradition were available to Piero, which he used, and

how he adapted them. The other task was to define how his innovations in turn affected the theme of Constantine as it was employed in later centuries.

In recent decades, the production of commentaries on the Arezzo paintings has expanded conspicuously. Along with art historians, theoreticians, critics, and artists in increasing numbers have expressed their thoughts on the cycle. Within the diversity of viewpoints that have been championed, one topic has proved constant: the association of the frescoes with what became known as the "Turkish question," the threat of imminent invasion of the Italian mainland by the Turkish Muslims who had already conquered Constantinople (1453). Jean Babelon was the first to recognize the headgear (the high-crowned hat with long pointed visor), of Constantine in Arezzo, as well as Pilate in Piero's *Flagellation*, as being that of the Byzantine emperor John VIII Palaeologus, known from Pisanello's medal.[6] This observation was of fundamental importance in that, in spite of the anomalous equating of an evil figure (Pilate) with a hero (the emperor), it laid the foundation for much of the speculation that was to follow. At first the association of the frescoes with politics was put forth as an allegory.[7] But as time went on, hypothesis hardened in fact, until each new interpretation began to take a connection with the contemporary political situation as a starting point. Furthermore, what began as a sartorial parallel between the monumental Aretine figure of Constantine and the costume of an ancillary figure in the small-scale, obviously private panel of the *Flagellation*, now is often regarded as a sign of their iconographic identity. In the final phases of this development, a veritable competition has developed as to which specific events in the contemporary international conflict between East and West are referred to in both the paintings.[8]

There can be no doubt that, by its very nature, the story of the True Cross carries undertones of propaganda for crusades in defense of the faith. In fact, it served precisely this purpose for centuries before Piero's time. A political undertone, however, is one thing, while the religious purpose of a work of art in a particular place of worship is quite another. It should be clearly stated

here that, up to this point, no evidence has been cited to relate the commissions for the *Flagellation*, a painting discovered in Urbino in the eighteenth century, and the Arezzo cycle; nor is there evidence that the people of Arezzo or the friars of San Francesco were in any way involved in the planning of military action against the Turks. On the other hand, the local Franciscans, and Arezzo as a community, had ideological ties with the historical Constantine. And while allusions to current political circumstances lie beneath the surface of all True Cross iconography, including Piero's, his version of the legend raises the subject from the level of romantic adventure to local patriotism and beyond, to epic narrative in a way that prepared it for use in proving the hegemony of popes and, ultimately, of kings.[9]

The papers on this theme follow a roughly chronological and geographical arrangement. Stephen G. Nichols begins the discussion by setting the late medieval controversies about Constantine into their intellectual framework. His analysis defines the uniquely visual aspects of the Constantinian myth that established the possibilities for its universal understanding. Michael Curschmann discusses German vernacular poetry and the transferral of Constantinian elements to the Byzantine emperor Heraclius (610–641), who in turn was taken over as a late medieval German hero-king, represented in texts and pictorial cycles. Curschmann analyzes the significance of several German mural cycles and an important two-day feast that celebrated Constantine together with Heraclius in the form of dramatic representations.

Jack Freiberg follows the Constantinian theme into the Vatican, focusing specifically on the Constantinian impact in papal politics in the period of the sixteenth-century reforms. He brings together a number of Constantinian cycles in locations so familiar and along paths so well trodden, that they have become all but invisible. Freiberg brings these cycles back to center stage where, as they were conceived, they played significant and powerful roles.

Marc Fumaroli's paper carries our theme into the baroque period where he finds certain reposts in the court of Louis XIV to some of the questions challenging Constan-

tinian authority as defined by earlier generations and discussed by Stephen Nichols.

These scholars amply demonstrate the importance of this theme in Western political thought. It is to be hoped that further studies following the subject in still greater topographical and chronological detail, in the literature and the visual arts, will follow in short order.

Piero's Style and Content

Much has been said about the sources of Piero's style under the inspiration of Siena and Florence. Piero's connections with certain aspects of painting in France and the Netherlands also have been seen as crucial to his development. For the most part, these relationships have been discussed generically, in terms of individual motifs or the use of the oil technique. The challenge here was to analyze the way in which Piero used and adapted the work of his predecessors to achieve the cool passivity and idealized forms that are the fundamental qualities of his personal style. These very qualities contributed to the "rediscovery" of Piero during the early stages of the modernist movement, and were taken in the first half of the twentieth century as indicating that his work was purely abstract, devoid of meaning in the traditional sense. Now, increasingly it is understood that he was a deep thinker, particularly concerning matters of theology and history. Looking at both aspects of his career—what he had to say and how he said it—focuses the discussion of how his serene style and structural finesse relate to the cerebral complexity of his message.

The variety of responses to these questions indicates the richness of Piero's life-long professional preoccupations. Daniel Arasse concentrates on a few images from the Arezzo cycle to locate Piero's measured *disegno* and geometric mode as part of his own visual culture. He observes that Piero's narrative method does not reflect contemporary discussions of *istoria*, but has a dimension of its own. Maurizio Calvesi gives a new reading to Piero's *Flagellation* and reaffirms the belief that Piero uses visual language to chronicle history. In doing so, Calvesi adds a new international dimension to the interpretation of this famous painting.

(See, below, a database mapping the many contending opinions on this topic, Appendix 2). In my paper on Piero's *Adoration* in London, I take the position that Piero was a brilliant art historian who investigated tradition, in both Italy and the Netherlands, honored it, and magnified it to express universal themes. This tendency rose to an apogee at the end of his career, when he turned away from complex "scientific" spatial structures to express the splendors of creation in a way at once simpler than in his early career and yet more mysterious.

Finally, Bert Meijer importunes readers to observe a greater role than is usually recognized for Rogier van der Weyden in Piero's receptive thinking. Presenting a dramatic confrontation of important works by the two masters, Meijer calls attention to an altarpiece Rogier created for an Italian patron, yet never before discussed in relation to Piero.

Piero's Mathematics and Architecture

Piero's prowess as a mathematician is by now manifest.[10] Equally demonstrable is the fact that some of Piero's two-dimensional representations of architecture can be reconstructed in three-dimensional space.[11] Not thoroughly analyzed is the relation between these phenomena in terms of iconographical and religious meaning in his paintings. The question is not simply how his investigations of plane and solid geometry guided the structure of his composition, but how the actual thought processes—knowledge, logic, skill—in both fields contributed to the results we see.

The task of answering these questions would include a look into Piero's education (which has never been done systematically), his social status, and his professional position. It would include his literary production, both in the context of Renaissance science and in practical applications to the representation of architecture and spatial ambients. It would involve his response to contemporary architectural theory and his contributions to contemporary architectural style. These correlations, in turn, should be related to his depictions in the categories of urban space, built structures, interiors, and landscapes.

It was not possible here to cover all these subjects, but the process was undertaken.[12]

Paul Grendler took up the question of Piero's education. While we may never know what triggered the perception of form that is so inimitable in Piero's work, with the application of Grendler's work to the little we do know of Piero's particular situation, our view of his intellectual milieu is moved onto firm footing for the first time.

That milieu, in the field of mathematics, is discussed by J. V. Field. Her analysis underlines the effects of differences in intellectual classifications between the Renaissance and our own time, in relation to the way Piero would have considered pictorial structure. Her observations on the fifteenth-century preoccupation with the creation of three-dimensional objects rather than three-dimensional space is of signal importance in considering Piero's plasticity of form. Martin Kemp discusses the legacy of Piero's work in the field of mathematics. The questions posed in this case grapple with the unspoken implications of Piero's articulation of universal truths as the reason so many people took his ideas as their own. John Shearman reviews scientific information specific to the concepts of reflection and refraction available to Piero and indicates how he used it in his painting of the *Baptism of Christ*. Shearman's close analysis forms a platform for understanding how Piero manipulates the composition (the placement of the figure of Christ) so that the naturalistic effects (reflection/refraction) serve to underscore the miraculous nature of the subject.

Christine Smith discusses the morphology of Piero's painted architecture. Using only documented and sure chronological factors, Smith enters almost completely uncharted territory where she contributes to the definition of the resources—ancient, medieval, and contemporary—Piero used to shape his painted architectural forms. Smith builds a cogent body of evidence for Piero's geographic movements, the observations he made in various towns, and the results of his deliberations over what he saw. With these fundamental contributions to our understanding of his architectural vocabulary, we are better prepared to consider questions of how Piero used architectural settings to communicate particular as well as universal ideas.

Piero and Twentieth-Century Sensibility

Within a few years of his death, two sets of Piero's frescoes had been covered over (in the Vatican) or destroyed (in Ferrara); by 1585, if not before, his *Baptism of Christ* was languishing under a sheet in the back room of a small church in Sansepolcro. His name does not appear in the literature of art until well into the nineteenth century, and then at first his paintings were deemed mediocre (Jacob Burckhardt called his work "naive").[13] But as the aesthetics of modern abstraction and formalism developed, his artistic status shot upward. Aldous Huxley called his paintings "strange and startlingly successful . . . experiments in composition"; Roberto Longhi eulogized his spatial intervals, poetic tonal organization, lack of emotion, and the archaic quality of his classicism. Edging close to the language of modernism, in 1929 the painter and critic André Lhote called him "the first cubist."[14] Piero's star rose thereafter to ever new heights, and by now he is the favorite painter, not only of artists, art historians, and amateurs, but also of literary theorists.

In 1967 Albert Boime was among the first to document with archival material the evidence for "Piero watching" that began in the 1870s, oddly enough within the very walls of the French Academy.[15] Boime asks what it is about Piero's art that still seems to promise sustenance to our fragile position in the world of today. In answer, he reviews early twentieth-century definitions of secular anxiety and suggests that Piero's qualities of calm dispassion underlie our admiration with promises of salvation. The novelty of Boime's definition is that it moves political and psychological philosophy to a visual plane, one that must be dealt with in a creative fashion if we are to survive the irresistible power of mass media we now endure.

Michael Zimmermann traces the "critical reception" of Piero in the voices of critics, art historians, and artists: the cubists, the "purists"—Amédée Ozenfant and Édouard Jeanneret (Le Corbusier) and Gino Severini. Differing with Boime, Zimmermann sees the accomplishments of both Seurat and Piero grow in stature at the same time (the 1920s), and for many of the same reasons. His collage of written criticism creates a picture not only of attitudes toward Picro during the first quarter of the twentieth century, but also of the self-definition of modernism at the same time.

The persistence of interest in Piero into our own day is broached, finally, by Rosalind Krauss. She sees as the basis for true abstract structure the "quintessential grid," and the web of surface construction used by many contemporary artists as the link between Piero and current trends. Piero's tightly woven surfaces, of course, underlie representations of deep iconographical value, whereas what Krauss calls the "grid as such," a central figure in her definition of modernist painting, is paradigmatic of a determination to produce abstract, nonobjective works of art. This paradox of meaning versus no meaning leaves open still the issue of why so many people, and artists in particular, find Piero's work so compelling.

Five hundred years after Piero's death, we cannot pretend to have solved the many conundrums that surround his life and works. At the same time, as we continue to respond to the challenges they present, we arrive at a new beginning in which we may consider ourselves deeply rewarded for having asked some of the right questions.

Comparative Chronology of Piero della Francesca's Works

MADONNA, CONTINI-BONACOSSI
Documented: No

Longhi (1927)	c. 1440
(1942)	——
(1962)	——
Clark (1951)	——
(1969)	——
Hendy (1968)	immature
Gilbert (1968)	——
Battisti (1971)	fake or 19th century
Salmi (1979)	1438
Paolucci (1989)	——
Lightbown (1992)	c. 1448
Bertelli (1992)	——

MISERICORDIA ALTARPIECE
Documented: Yes
dates: 1445–1462

Longhi (1927)	1445
(1942)	1445–1462
(1962)	——
Clark (1951)	1445–1462
(1969)	1445–1462
Hendy (1968)	1445–1462
Gilbert (1968)	1445–1464
Battisti (1971)	1445–1462
Salmi (1979)	1445–1462
Paolucci (1989)	c. 1445–1460
Lavin (1992)	c. 1445–1460
Lightbown (1992)	c. 1445–1454–1460
Bertelli (1992)	1445–1462?

BAPTISM OF CHRIST
Documented: No

Longhi (1927)	1440–1445
(1942)	c. 1445–1450
(1962)	——
Clark (1951)	1450–1455
(1969)	1450–1455
Hendy (1968)	1440–1445?
Gilbert (1968)	1460–1464
Battisti (1971)	1460–1462
Salmi (1979)	c. 1447
Lavin (1981)	1455–1460
Paolucci (1989)	c. 1445
Lightbown (1992)	1452–1453
Bertelli (1992)	1451

FLAGELLATION
Documented: No

Longhi (1927)	1444
(1942)	——
(1962)	1448–1452
Clark (1951)	1456–1457
(1969)	1456–1457
Hendy (1968)	1459?
Gilbert (1968)	1463–1464
Lavin (1968)	1458–1460
Battisti (1971)	1463/1465–1469?
Salmi (1979)	c. 1453
Paolucci (1989)	c. 1460

Lightbown (1992)	c. 1448–1449
Bertelli (1992)	1455

SAINT GEROME, BERLIN
Documented: No
date: signed and dated, 1450

Longhi (1927)	——
(1942)	——
(1962)	1440–1445
Clark (1951)	——
(1969)	1450; overpainted
Hendy (1968)	——
Gilbert (1968)	shop 1450
Battisti (1971)	1450
Salmi (1979)	1450
Paolucci (1989)	1450
Lightbown (1992)	1450
Bertelli (1992)	1450

SAINT GEROME, VENICE
Documented: No

Longhi (1927)	1440–1450
(1942)	——
(1962)	——
Clark (1951)	1450–1455
(1969)	1450–1455
Hendy (1968)	c. 1450
Gilbert (1968)	1470–1473
Battisti (1971)	1470–1475
Salmi (1979)	c. 1453
Paolucci (1989)	c. 1450
Lightbown (1992)	c. 1452
Bertelli (1992)	1450

SIGISMONDO MALATESTA BEFORE SAINT SIGISMUND, RIMINI
Documented: Yes
date: 1451

Longhi (1927)	1451
(1942)	——
(1962)	1451
Clark (1951)	1451
(1969)	1451
Hendy (1968)	1451
Gilbert (1968)	1451
Battisti (1971)	1451
Lavin (1974)	1451
Salmi (1979)	1451
Paolucci (1989)	1451
Lightbown (1992)	1451
Bertelli (1992)	1451

SIGISMONDO, PORTRAIT, LOUVRE
Documented: No

Longhi (1927)	1451
(1942)	1451
(1962)	——
Clark (1951)	——
(1969)	——
Hendy (1968)	1451
Gilbert (1968)	1451
Battisti (1971)	1451
Salmi (1979)	1451+
Paolucci (1989)	c. 1451
Lavin (1992)	c. 1450

Lightbown (1992) c. 1451
Bertelli (1992) c. 1460

SAINT AUGUSTINE ALTARPIECE
Documented: Yes
dates: 1454-1469
Longhi (1927) ———
 (1942) ———
 (1962) 1460-1475
Clark (1951) 1454-1469
 (1969) 1454-1469
Hendy (1968) 1454-1469
Gilbert (1968) 1454-1469
Battisti (1971) 1454-1469
Salmi (1979) 1454-1469
Paolucci (1989) 1460-1469
Lavin (1992) 1454-1469
Lightbown (1992) 1460-1469
Bertelli (1992) 1454-1469

CYCLE OF THE TRUE CROSS, AREZZO
Documented: No
Longhi (1927) 1452-1465?
 (1942) ———
 (1962) ———
Clark (1951) 1452-1466; Annunciation
 (1969) 1452-1466
Hendy (1968) 1452-1466
Gilbert (1968) 1451-1466
Battisti (1971) 1459-1466
Salmi (1979) c. 1454-1464
Paolucci (1989) 1452-1458
Lavin (1992) 1452-1466
Lightbown (1992) 1454-1458
Bertelli (1992) 1448, 1452-1455

SANTA MARIA MAGGIORE FRESCOES
Documented: No
Longhi (1927) 1458-1459; Saint Luke
 (1942) ———
 (1962) ———
Clark (1951) 1458-1459; pupil
 (1969) 1458-1459; assistant
Hendy (1968) 1458-1459
Gilbert (1968) 1458-1459; school
Battisti (1971) 1458-1459
Salmi (1979) 1458-1459
Paolucci (1989) ———
Lavin (1992) 1458-1459
Lightbown (1992) c. 1459
Bertelli (1992) 1458-1459

VATICAN FRESCOES (lost)
Documented: Yes
dates: 1458-1459

MAGDALENE, AREZZO, DUOMO
Documented: No
Longhi (1927) 1450-1460s
 (1942) ———
 (1962) ———
Clark (1951) c. 1466
 (1969) c. 1466
Hendy (1968) 1466?
Gilbert (1968) 1460-1464

Battisti (1971) 1473-1486?
Salmi (1979) c. 1464
Paolucci (1989) c. 1460
Lavin (1992) c. 1460
Lightbown (1992) 1468
Bertelli (1992) c. 1460

SAN GIULIANO, SANSEPOLCRO
Documented: No
Longhi (1927) ———
 (1942) ———
 (1962) 1460s (fragment)
Clark (1951) ———
 (1969) c. 1460
Hendy (1968) not after 1469
Gilbert (1968) shop
Battisti (1971) 1454?
Salmi (1979) 1454? attributed
Paolucci (1989) 1455-1458
Lightbown (1992) 1454-1458
Bertelli (1992) 1458-1459

HERCULES, BOSTON, GARDNER
MUSEUM OF ART
Documented: No
Longhi (1927) c. 1460
 (1942) ———
 (1962) ———
Clark (1951) 1460-1466
 (1969) 1460-1466
Hendy (1968) 1470s
Gilbert (1968) 1460-1464 (Fortezza)
Battisti (1971) 1470s
Salmi (1979) c. 1467
Paolucci (1989) c. 1465
Lightbown (1992) 1470-1475
Bertelli (1992) before 1459

MADONNA DEL PARTO
Documented: No
Longhi (1927) 1450-1455
 (1942) ———
 (1962) ———
Clark (1951) 1460+
 (1969) 1460+
Hendy (1968) c. 1459
Gilbert (1968) shop
Battisti (1971) 1476-1482/1483
Salmi (1979) c. 1461
Paolucci (1989) 1455
Lavin (1992) 1460-1465
Lightbown (1992) c. 1455
Bertelli (1992) before 1467

RESURRECTION
Documented: No
Longhi (1927) 1450-1460s
 (1942) 1450-1460
 (1962) ———
Clark (1951) c. 1463
 (1969) c. 1463
Hendy (1968) 1460
Gilbert (1968) 1442-1447
Battisti (1971) 1474 (wall)
Salmi (1979) c. 1458

Paolucci (1989) c. 1458
Lavin (1992) 1463–1465
Lightbown (1992) c. 1458
Bertelli (1992) after 1459–before 1474

SAINT ANTHONY ALTARPIECE, PERUGIA
Documented: Yes
dates: 1456–1464
Longhi (1927) 1460–1475
 (1942) ———
 (1962) ———
Clark (1951) 1469+
 (1969) 1469+
Hendy (1968) ———
Gilbert (1968) 1442–1458; 1463–1464
Battisti (1971) 1478–1484
Salmi (1979) c. 1470–1480
Paolucci (1989) 1460–1470
Lavin (1992) 1460–1470
Lightbown (1992) c. 1469
Bertelli (1992) c. 1475

MONTEFELTRO PORTRAITS, FLORENCE
Documented: No
Longhi (1927) 1465–1466
 (1942) ———
 (1962) ———
Clark (1951) 1465
 (1969) not after 1472
Hendy (1968) 1466 (Federico), after 1472 (Battista)
Gilbert (1968) c. 1472–1473
Battisti (1971) after 1472
Salmi (1979) c. 1468–1472
Paolucci (1989) 1465–1472
Lavin (1992) 1472–1474
Lightbown (1992) 1472–1473
Bertelli (1992) 1473

MONTEFELTRO ALTARPIECE, BRERA
Documented: No
Longhi (1927) 1470–1475
 (1942) ———
 (1962) 1472–1474
Clark (1951) 1472–
 (1969) 1472–1475
Hendy (1968) after 1480?
Gilbert (1968) 1472–1475
Battisti (1971) 1472–1474
Salmi (1979) 1472–1474
Paolucci (1989) 1472–1474
Lavin (1992) 1472–1474
Lightbown (1992) c. 1475
Bertelli (1992) 1469–1472

MADONNA AND CHILD WITH ANGELS, WILLIAMSTOWN, MASS., CLARK ART INSTITUTE
Documented: No
Longhi (1927) ———
 (1942) 1466–1472; not seen
 (1962) ———
Clark (1951) ———
 (1969) after 1470; not seen
Hendy (1968) 1445–1451
Gilbert (1968) shop

Battisti (1971) 1474–1478
Salmi (1979) 1480–1482
Paolucci (1989) c. 1470
Lightbown (1992) c. 1480–1482
Bertelli (1992) not by Piero; after 1476

SENIGALLIA MADONNA
Documented: No
Longhi (1927) 1470–1485
 (1942) ———
 (1962) ———
Clark (1951) ———
 (1969) 1472–1475
Hendy (1968) 1469+
Gilbert (1968) 1472–1475
Battisti (1971) 1478+
Salmi (1979) c. 1478
Paolucci (1989) c. 1470
Lavin (1992) 1478–1480
Lightbown (1992) 1478–1480
Bertelli (1992) 1475–1476

ADORATION OF THE CHILD, LONDON
Documented: No
Longhi (1927) 1470–1485
 (1942) ———
 (1962) ———
Clark (1951) 1472–1475
 (1969) c. 1472–1475
Hendy (1968) after 1480
Gilbert (1968) after 1475
Battisti (1971) 1480s
Salmi (1979) 1483–1485
Paolucci (1989) 1472–1474
Lavin (1992) c. 1478–1480
Lightbown (1992) 1483–1484
Bertelli (1992) c. 1472

APPENDIX 2:

Identification of Figures in Piero della Francesca's Flagellation

Source	Date	Commissioner/Owner	Seated	Turbaned	Bearded	Youth	Bald
Inventory	1744				Guidantonio	Oddantonio	Federico
Dennistoun	1851				Manfredo dei Pio	Oddantonio	Tommaso dell'Agnello
Witting	1890				Caterino Zeno		
Pichi	1892				Serafini	Oddantonio	Ricciarelli
Babelon	1930		John VIII Palaeologus				
Clark	1951				Thomas Palaeologus	allegory	Guidantonio
Gilbert	1952				Anonymous bystanders		
Running	1953			Herod	Gentile	soldier	Joseph of Arimathea
Siebenhüner	1954				John VIII Palaeologus	Oddantonio	Guidantonic
Gombrich	1959				Judas	Christ	Sanhedrin
Tolnay	1963				Jew	pagan	Aryan
Murray	1968				Jew	angel	western layman
Lavin	1968	Ottaviano Ubaldini			Ottaviano Ubaldini	allegory	Ludovigo Gonzaga
Hartt	1970				Palaeologus	David	judge
Gilbert	1971				Gentile	soldier	Joseph of Arimathea
Battisti	1971				Byzantine	Oddantonio	Visconti
Gouma-Peterson	1976	Bessarion-Federico	John VIII Palaeologus	Herod	Greek Ambassador	allegory	western prince
Borgo	1979				Sanhedrin	gardener	Sanhedrin
Salmi	1979				Bacci, Agnolo	Bacci, Andrea	Bacci, Francesco
Ginzburg	1981	Bacci, Giovanni-Federico	John VIII Palaeologus		Bessarion	Buonconte	Bacci, Giovanni
Hoffman	1981			Herod	Jew	youth	Christianized Jew
Turchini	1982	Ottaviano-Federico			Bessarion	Buonconte	Ottaviano Ubaldini
Pope-Hennessy	1986	*Flagellation of Saint Jerome*				literary critics	
Lollini	1991			Herod	rabbi	young Jew	Jew
Calvesi	this volume			Herod	Thomas Palaeologus	Matthias Corvinus	Italian prince

GLOSSARY

Agnolo Bacci: nephew of Francesco Bacci

Andrea Bacci: nephew of Francesco Bacci

Bald: figure on right of foreground group

Bearded: figure on left of foreground group

Bessarion: Orthodox priest made cardinal of western church

Buonconte: son of Federico da Montefeltro

Caterino Zeno: Italian ambassador to Constantinople

Matthias Corvinus: king of Hungary

Federico: Federico da Montefeltro, after 1472 duke of Urbino

Francesco Bacci: oldest son of Baccio di Magio Bacci, owner of burial property in the "Cappella Maggiore" in San Francesco, Arezzo

Guidantonio: Guidantonio da Montefeltro, father of Federico

Ludovico Gonzaga: marquis of Mantua

Manfredo dei Pio: counselor of Oddantonio da Montefeltro

Oddantonio: Oddantonio da Montefeltro (d. 1444); half brother of Federico

Ottaviano Ubaldini della Carda: nephew of Federico da Montefeltro

John VIII Palaeologus: emperor of Byzantium (d. 1448)

Ricciarelli: assassin of Oddantonio da Montefeltro

Seated: figure seated under portico

Serafini: assassin of Oddantonio da Montefeltro

Source: bibliographical source

Tommaso dell'Agnello: counselor of Oddantonio da Montefeltro

Thomas Palaeologus: brother of John VIII

Turbaned: figure with back turned

Visconti: Filippo Maria Visconti (or Francesco Sforza)

Youth: young man in center of foreground group

BIBLIOGRAPHY

Babelon, Jean. "Jean Paleologus et Ponce Pilate." *Gazette des Beaux-Arts*, series 6, 4 (1930), 365–375.

Battisti, Eugenio. *Piero della Francesca.* 1st ed. 1971, 2d ed. Milan, 1992.

Bertelli, Carlo. *Piero della Francesca.* Milan, 1991; London, 1992.

Borgo, Vico. "New Questions for Piero's 'Flagellation.'" *Burlington Magazine* 121 (1979), 547–553.

Calvesi, Maurizio. "La *Flagellazione* nel quadro storico del Convegno di Mantova e dei progetti di Mattia Corvino," in this volume.

Clark, Kenneth. *Piero della Francesca.* 1st ed. 1951, 2d ed. London, 1969.

Dennistoun, James. *Memoirs of the Dukes of Urbino.* London, 1851.

Gilbert, Creighton. "On Subject and Not-Subject in Italian Renaissance Pictures." *Art Bulletin* 34 (1952), 202–216.

Gilbert, Creighton. *Change in Piero della Francesca.* Locust Valley, N.Y., 1968.

Gilbert, Creighton. "Piero della Francesca's *Flagellation*: The Figures in the Foreground." *Art Bulletin* 53 (1971), 41–51.

Ginzburg, Carlo. *Indagini su Piero.* Turin, 1981; *The Enigma of Piero.* Thetford, Norfolk, 1985.

Gombrich, Ernst. "The Repentance of Judas in Piero della Francesca's Flagellation of Christ." *Journal of the Warburg and Courtauld Institutes* 22 (1959), 172.

Gouma Peterson, Thalia. "Piero della Francesca's Flagellation: An Historical Interpretation." *Storia dell'arte* 28 (1976), 217–233.

Hartt, Frederick. *Italian Renaissance Art.* New York, 1970.

Hendy, Philip. *Piero della Francesca.* London, 1968.

Hoffmann, John. "Piero della Francesca's 'Flagellation': A Reading from Jewish History." *Zeitschrift für Kunstgeschichte* 44 (1981), 340–357.

Inventory of 1744, unpublished ms. BUU [Urbino], *Fondo del Comune,* ms. 93 (miscell.) c. 224r; rediscovered by Ginzburg 1981, 50.

Lavin, Marilyn Aronberg. "Piero della Francesca's *Flagellation.* The Triumph of Christian Glory." *Art Bulletin* 50 (1968), 321–342.

Lavin, Marilyn Aronberg. *Piero della Francesca.* New York, 1992.

Lightbown, Ronald. *Piero della Francesca.* Oxford, 1992.

Lollini, Fabrizio. "Una possibile connotazione antiebraica della 'Flagellazione' di Piero della Francesca." *Bollettino d'arte* 65 (1991), 1–28.

Longhi, Roberto. *Piero della Francesca.* 1927, 2d ed. 1945; 3d ed. Milan, 1963.

Murray, Peter. "A Note on the Iconography of Piero della Francesca." *Festschrift Ulrich Middeldorf,* ed. Antje Kosegarten and Peter Tigler. Berlin, 1968, 178.

Paolucci, Antonio. *Piero della Francesca: Catalogo completo.* Florence, 1989.

Pichi, Giovanni Felice. *La vita e le opere di Piero della Francesca.* Sansepolcro, 1892.

Pope-Hennessy, John. "Whose Flagellation." *Apollo* 124 (1986), 162–165.

Running, Paul D. "Letter to the Editor." *Art Bulletin* 35 (1953), 85–86.

Salmi, Mario. *La pittura di Piero della Francesca.* Novara, 1979.

Siebenhüner, Herbert, "Die Bedeutung des Rimini-Freskos und der Geisselung Christi des Piero della Francesca." *Kunstchronik* 8 (1954), 124–126.

Tolnay, Charles de. "Conceptions religieuses dans la peinture de Piero della Francesca." *Arte antiche e moderna* 23 (1963), 205–241.

Turchini, Angelo. "Un'ipotesi per la 'Flagellazione' di Piero della Francesca. *Quaderni medievali* 14 (1982), 61–93.

Witting, Felix. *Piero della Francesca.* Strasbourg, 1890.

NOTES

1. "La perspectiva, se ben si guarda, senza dubio nulla sarebe se questa [geometry] non si acomodasse. Come al pieno dimostra el monarca ali dì nostri de la pictura e architectura Pietro di Franceschi nostro teraneo . . . per un suo compendioso tractato"; *Luca Pacioli; Divina Proportione* (1497), ed. 1509, in *Quellenschrift für Kunstgeschichte, Neue Folge*, ed. Constantin Winterberg, vol. 20 (Vienna, 1889), 40.

2. In our own day he has been called "one of the greatest" mathematicians of the fifteenth century, on a par with Toscanelli, whom he probably knew; see Marshall Clagett, *Archimedes in the Middle Ages*, 3 vols. (Philadelphia, 1978), 3:pt. 3 (The Medieval Archimedes in the Renaissance 1450–1565), 399–400, 415–416.

3. *Piero della Francesca* (Città di Castello, 1912) by Evelyn Marini-Franceschi.

4. The five-hundredth anniversary of Piero's death was marked by a number of colloquia and exhibitions on both sides of the Atlantic, each concentrating on varying aspects of the artist:

Giuseppe Centauro, *Dipinti murali di Piero della Francesca. La basilica di S. Francesco ad Arezzo: Indagini su sette secoli* (Milan, 1990); *The Angelic Space: A Celebration of Piero della Francesca* (Monash University Gallery, 15 October to 28 November 1992) (Clayton Victoria [Australia], 1992), ed. Harriet Edquist and Juliana Engberg; *Piero della Francesca ad Arezzo: Atti del Convegno Internazionale di Studi, Arezzo, 7–10 Marzo 1990*, ed. Giuseppe Centauro and Margherita Moriondo Lenzini (Venice, 1992); Pier Giorgio Pasini, *Piero e I Malatesti: L'attività di Piero della Francesca per le corti romagnole* (Milan, 1992); *Con gli occhi di Piero: Abiti e gioielli nelle opere di Piero della Francesca*, ed. Maria Grazia Ciardi Dupre and Giuliana Chesne Dauphine Griffo (Venice, 1992); *Piero della Francesca e il Novecento: Prospettiva, spazio, luce, geometria, pittura murale, tonalism, 1920–1938*, ed. Maria Mimita Lamberti and Maurizio Fagiolo dell'Arco (Venice, 1991); *Piero e Urbino, Piero e le Corti rinascimentale*, ed. Paolo Dal Poggetto (Venice, 1992); *Una scuola per Piero: Luce, colore e prospettiva nella formazione fiorentina di Piero della Francesca*, ed. Luciano Bellosi (Venice, 1992); *Nel raggio di Piero: La pittura nell'Italia centrale nell'eta di Piero della Francesca*, ed. Luciano Berti (Venice, 1992); Francesca Chielli, *La grecità antica e bizantina nell'opera di Piero della Francesca* (Florence, 1993); Antonio Paolucci et al., *Piero della Francesca: La Madonna del Parto: Restauro e iconografia* (Venice, 1993); *Piero della Francesca: Il polittico di Sant'Antonio*, ed. Vittoria Garibaldi (Milan, 1993); *Piero 500 Anni*, ed. Claudia Cieri Via and Marisa Emiliani Dalai (Venice, 1995). Colloquium, *Facets of Piero della Francesca* (Renaissance Studies Certificate Program, the Graduate School and University Center of the City University of New York), 26–27 February 1993. Two major television programs were produced: "The Piero Trail," BBC, Anna Benson-Gyles, producer, September 1992; and "Piero della Francesca," RAI, Anna Zanoli, producer, October 1992.

5. Creighton Gilbert, *Change in Piero della Francesca* (Locust Valley, N.Y., 1968).

6. Done when the emperor was in Italy for the Council of Union, 1438–1439; Jean Babelon, "Jean Paleologus et Ponce Pilate," *Gazette des Beaux-Arts* 4, ser. 6 (1930), 365–375.

7. Kenneth Clark, *Piero della Francesca* (London, 1951), 22–26. The East-West association had already been made in a preliminary way by Aby Warburg, "Piero della Francescas Constantinschlacht in der aquarell Kopie des Johann Anton Ramboux," in his *Gesammelte Schriften* (Leipzig, 1932), 1:251–254, 389–391.

8. Among the authors who have promulgated interpretations of the greatest historical specificity are: Carlo Ginzburg, *Indagine su Piero* (Turin, 1981); English edition, *The Enigma of Piero: Piero della Francesca: The Baptism, The Arezzo Cycle, The Flagellation* (London, 1985); Frank Büttner, "Das Thema der Konstantinschlacht Piero della Francescas," *Mitteilungen des Kunsthistorischen Instituts in Florenz* 1–2 (1992), 23–40; Maurizio Calvesi, "La leggenda della vera croce di Piero della Francesca: I due Giovanni all'ultima crociata," *Art e Dossier* 75 (1993), 40–41, and his article in this volume. The issue of whether the victory is shown at the Milvian bridge or on the banks of the Danube (two different versions of the legend) forms part of these arguments, thereby missing the unique, Tuscan quality of Piero's landscape.

9. See Marilyn Aronberg Lavin, *The Place of Narrative: Mural Painting in Italian Churches (431–1600)* (Chicago, 1990), chaps. 4 and 6; "Piero della Francesca's Iconographic Innovations at Arezzo," in *Iconography at the Crossroads*, ed. Brendan Cassidy (Princeton, 1993), 139–149; and *Piero della Francesca: San Francesco, Arezzo* (New York, 1994).

10. Besides demonstrating this fact, Marshall Clagett has shown that his skill included the invention of two Euclidian theorems not rediscovered until many decades after Piero's death; see above, note 2.

11. The first to do so were Rudolf Wittkower and B.A.R. Carter, "The Perspective of Piero della Francesca's 'Flagellation,'" *Journal of the Warburg and Courtauld Institutes* 16 (1953), 292–302.

12. Three sessions were dedicated to Piero's scientific work in *Piero 500 Anni* (Urbino, Arezzo, Sansepolcro, 4–12 October 1992): "Ottica, proporzioni, prospettiva nell'opera dipinta di Piero;" "Per l'edizione critica dei trattati di Piero della Francesca;" and "Piero teorico nella storia della matematica rinascimentale."

13. *Der Cicerone*, 1855.

14. See summary of this material in Pierluigi De Vecchi, *L'opera di Piero della Francesca*, Classici dell'arte (Milan, 1967), 10–14.

15. "Seurat and Piero della Francesca," *Art Bulletin* 47 (1965), 265–271. The subject was discussed also by Roberto Longhi and above all, by André Chastel.

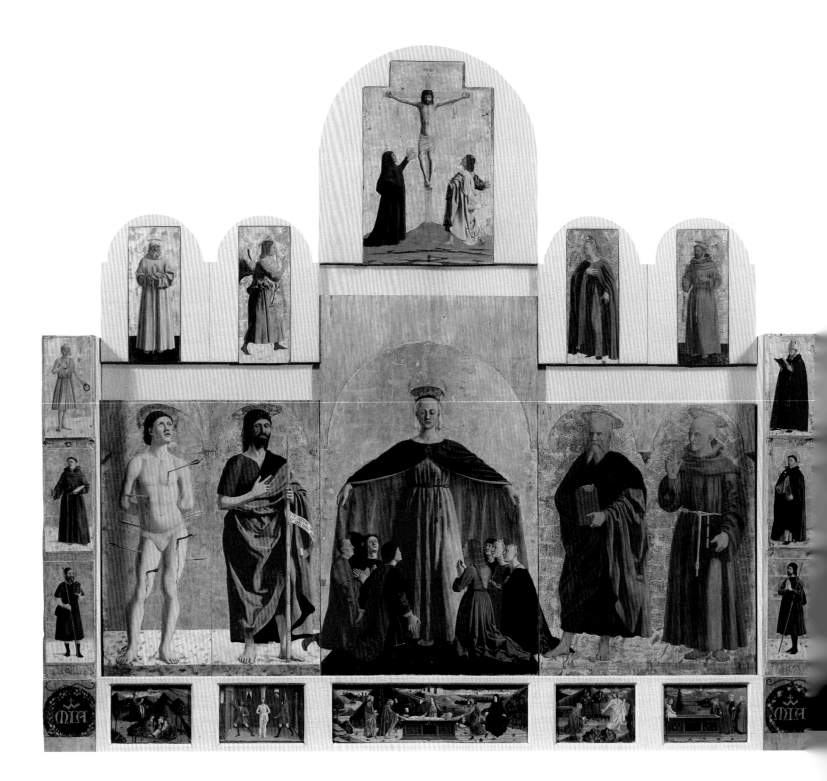

JAMES R. BANKER
North Carolina State University

The Altarpiece of the Confraternity of Santa Maria della Misericordia in Borgo Sansepolcro

O n 11 June 1445, Piero della Francesca con-
tracted to paint an altarpiece for the confra-
ternity of Santa Maria della Misericordia in
Borgo Sansepolcro for the price of 150 gold
florins.[1] I have discovered several previously
unpublished documents concerning the altar-
piece, as well as other documents on the
family of Piero della Francesca, that taken
together suggest the following points: (1) The
della Francesca family had been associated
with the confraternity of the Misericordia
for at least a half century prior to the com-
mission to Piero in 1445. (2) The commission
derived from the same social groups and in-
dividuals for whom Piero had worked and
painted in the 1430s.[2] (3) The altarpiece as
originally planned and executed was large and
required buttressing vertical columns, thus
conforming to a type seen in many monu-
mental trecento altarpieces. (4) Most of the
payments to Piero came late in the period
spanned by the documents; these and other
documents suggest that he did relatively
little actual painting until 1449/1450 to the
mid-1450s with a greater portion executed be-
tween 1459 and 1461–1462. (5) Mario Salmi's
hypothesis that the Camaldolese monk
Giuliano Amidei painted the Misericordia
predella is virtually proved. (6) The confra-
ternity constructed a chapel for a proces-
sional banner (gonfalone) executed by Matteo
di Giovanni within a decade of the comple-
tion of Piero's altarpiece.

Piero's ancestors were associated with the
confraternity of the Misericordia from at
least the late fourteenth century. "Monna
Cecha de Benedecto dela Francescha nel suo
testamento facta a dei XX de dicembre
MCCCLXXXVIIII, lasciò ala dicta Companie
[della Misericordia] uno broccolo d'oglio.
Pietro suo figliuolo [era] erede." This Monna
Cecha or Francesca was Piero's great grand-
mother and came to maturity in the middle
of the fourteenth century.[3] We may now
consider this Francesca to be the most likely
source for the family's name, "della Fran-
cesca," which I note is a name of the four-
teenth century, proving that the name was
used by the family long before the time of
the painter and his mother. Vasari held that
Piero's mother was also named Francesca
and was the source of the family name.[4]

The painter's grandfather, "Pietro de
Benedetto dela Francesca," on 6 December
1390 bequeathed 5 lire to the church of the
Misericordia. Pietro made his children his
heirs, and one of these children, Benedetto,
paid the substantial sum of 20 florins for him
to the confraternity in 1404.[5] This Benedetto,
father of Piero, had even closer ties with the
brotherhood. In an undated note of the early
fifteenth century, Benedetto is listed as ca-
marlingho, or treasurer, of the confraternity.[6]
Benedetto's participation can be documented
until 1426, when he appears among the mem-
bership of the confraternity.[7] In the 1440s
three of Benedetto's four sons played signifi-
cant roles in the life of the confraternity.

The brotherhood of the Misericordia reflected upon and executed its intention of placing an altarpiece in its oratory for nearly forty years. The confraternal leaders represented a group of approximately thirty brothers who desired an image that would serve several functions: appeal to the Madonna's will to represent the brothers as individuals and as a corporation to her Son, increase the intensity of the members' devotion, and, at least eventually through an indulgence, stir the interest of the people of Borgo Sansepolcro to attend their services and donate money. Most important of all, the painting was to be placed on the high altar where mass was celebrated frequently.

The lengthy negotiations on the Misericordia chapel, later called "la Cappella di S. Maria," indicate the assertive role of tradition on the altarpiece that Piero eventually painted. The moment when the brothers began to consider the construction of the altarpiece cannot be fixed, but it occurred more than two decades before the commission of 1445. On 4 September 1422 Urbano di Bartolomeo dei Pichi bequeathed 60 florins to the Misericordia confraternity for making and painting "an ornamented altarpiece before the major altar of the church or oratory of the confraternity of flagellation of Santa Maria della Misericordia of said Borgo for which there are to be expended 60 gold florins in making and painting."[8]

It is impossible to know whether the bequest of Urbano began the process of conceiving of a new altarpiece for the church or whether Urbano simply seized on the brothers' desire for a replacement for their already existing altarpiece. It may have been that the brothers did not have a proper altarpiece and simply placed their *gonfalone* on its altar to have an image there when masses were said. The altarpiece in conception from at least 1422 would be more substantial and permanent than a processional banner.

One important provision in Urbano dei Pichi's testament has heretofore gone unnoticed, and this lapsus has led to a fundamental misunderstanding of the history of the altarpiece. Urbano also bequeathed 20 florins for the construction of four beds for the use of the poor in the hospital of the Misericordia. He provided that his stemma be painted on these beds. Urbano did not so provide for the altarpiece;[9] he apparently understood that the con-

fraternal members would not permit him the privilege of placing his family coat of arms on the altarpiece and did not ask his heirs to bind the confraternity. Consequently the altarpiece was not the altarpiece of the Pichi family, and the family did not have patronage over the oratory, the chapel, or the altarpiece of the Misericordia and did not choose its imagery.[10] It should be noted that the 60 florins bequeathed by Urbano dei Pichi and the 50 florins bequeathed subsequently by Luca di Guido di Neri dei Pichi on 8 February 1435 did not pay all the contracted salary of the carpenter and the painter.[11] Thus both the Pichi family and the confraternity were responsible for the altarpiece and its cost.

The confraternal leaders initiated the construction of the altarpiece in 1428, when they contracted with the carpenter Bartolomeo di Giovannini d'Agnolo to build a wooden frame. The carpenter or the notary already possessed "the form of the design of said altarpiece" from Maestro Ottaviano Nelli, painter of Gubbio, which he was to follow. The confraternity was to pay Bartolomeo 25 florins for his construction of wood and iron.[12]

Inasmuch as Piero was to make his wooden structure identical to this earlier one, every indication of this contract and the payment contract of 1430 to the same carpenter is important.[13] The document of 1428 adds at least one important feature to our relatively limited knowledge of Piero's altarpiece. Aside from indicating its eventual destination, that it required iron supports, and that the carpenter received the substantial sum of 25 florins, it states that Bartolomeo was "to fabricate an altarpiece from wood for the altar of the said confraternity so that it [the wooden structure] holds the altar with the feet of said altarpiece, which feet will come outside the altar so that it [the altar] ought to be included within said feet."[14] The carpenter was to build a wooden altarpiece with legs or vertical buttresses, and these legs were to be outside the altar table and extend to the floor.

It is probable that the confraternal officials had a particular model of an altarpiece in mind: the altarpiece on the high altar in the abbey of San Giovanni Evangelista in Borgo Sansepolcro, which had been commissioned in the 1360s by the Camaldolesi monks there and painted by a follower of Pietro Lorenzetti. As Christa Gardner von Teuffel has argued, the abbey

altarpiece once was enclosed within buttresses of a typical trecento design. These vertical buttresses, or side columns, strengthened the altarpiece, provided ample space for the display of saints, and enclosed the altar table with feet.[15] In the period around 1430, the carpenter Bartolomeo constructed a similar altarpiece for the church of San Francesco in Borgo Sansepolcro derived from the same trecento model with vertical buttresses. Piero della Francesca worked on this altar of San Francesco in 1432, in all probability gessoing it.[16]

The existence of the 1428 document and the description of the earlier altarpiece exclude at least one proposed reconstruction of Piero's painting. It has been proposed that originally the altarpiece represented the Virgin and two saints and subsequently, when Bernardino was made a saint, the confraternity enlarged the altarpiece to include panels for four saints and the Madonna. The original carpentered buttresses suggest a larger structure than two panels with saints and one with the Madonna.[17]

A second document of 1430 records the consigning of the completed unpainted altarpiece to the confraternity by the carpenter and the payment of the salary of 25 florins by Angelo dei Pichi, one of the heirs of Urbano.[18] The buttresses are not mentioned, but the later contract reaffirms all the requirements of 1428. Between 1430 and 1445 the documentary record is silent concerning an altarpiece for the confraternity except for a large but conditional bequest from another Pichi. In 1435 Luca di Guido di Neri dei Pichi, heir of Urbano, granted the confraternity 50 florins "for making and painting an altarpiece for the major altar of the oratory of the confraternity of flagellation of Santa Maria della Misericordia." However, that provision became operative only under certain conditions and only after the death of Guido's wife, Panta.[19] In fact, Luca's first choice was to have a chapel in the abbey of Borgo Sansepolcro; the 50 florins would be available to the Misericordia confraternity only if the Camaldolese abbot rejected Luca's conditions for a chapel in the abbey. Most researchers have assumed that the abbot rejected the bequest of Luca dei Pichi, thereby passing the 50 florins to the confraternity. However, the abbot Paschasio did not, at least at first. On 15 February 1436, Paschasio accepted the bequest and the conditions set forth by Luca, within a year of Luca's death as his

testament required. Moreover, later when the Pichi family made payments to the painter, they state that they are acting as heirs of Urbano and never of Luca. However, nothing involving Piero is simple or straightforward. On two occasions, in 1461 and 1464, the officials of the Misericordia designated a procurator to seek money from the heirs of Luca, on the latter occasion stating that Luca's bequest was for an altarpiece. Therefore, it is not certain that the bequest by Luca dei Pichi was ever passed to the confraternity, and if it was, as the 1464 procuration suggests, that the Pichi ever conveyed the 50 florins to the confraternity.[20]

These documents raise another question that I shall simply mention. The 1445 contract from the confraternity required Piero della Francesca to follow the existing altarpiece in "width, height, and in its shape (foggia) as is now there out of wood." The phrase "de ligno" creates problems. Should it be read to state that the altarpiece is only of wood and thus lacks paint, even though we know that it had been sitting on the altar since 1430? It is doubtful that the contract was simply making specific that Piero's altarpiece should be made of wood as was the earlier model completed in 1430. The fact that Piero received the iconographic program from the confraternal officers ("for images and figures and ornaments as to him will be expressed by the aforementioned prior and councillors or their successors in office"), rather than from the earlier altarpiece, suggests that the altarpiece commissioned from the carpenter in 1428 had not in 1445 received paint.[21] In any event, the contract of 1445 required Piero to build a new wooden structure for the altarpiece.

Why was Piero chosen to paint the Misericordia altarpiece? Why not either Maestro Antonio d'Anghiari or Ottaviano Nelli, who were both Piero's senior and had experience in the area? Or why not bring in a Sienese painter as the operari of San Francesco had with Sassetta and as the confraternity of Santa Caterina did in 1445? That flagellant confraternity had commissioned the Sienese painter Pietro di Giovanni d'Ambrogio da Siena to paint a Mary with cherubim, which was installed on the confraternal altar on 22 March 1445.[22] Perhaps the Misericordia confraternity had waited for Ottaviano to be available, but he had often been occupied in his native Gubbio in the late

1430s and was approaching seventy years of age in 1445.

Despite having lost the commission to paint the large altarpiece in San Francesco to Sassetta, Master Antonio, Piero's former employer and probable master, often received a small and at least one moderately important commission in Borgo Sansepolcro in 1445. Communal officials paid Master Antonio 50 lire for a Madonna in the New Auditorium of the Council of the People in 1444. Why then did the confraternal officials bypass Master Antonio, even though Antonio's probable former partner Ottaviano Nelli had designed the earlier carpentry of the altarpiece? In fact, in the early 1440s the confraternity of the Misericordia on at least two occasions called on Antonio for small contracts of repair (that had no connection to artistic production).[23]

That Piero was commissioned, and at a considerable salary, presumes that he had already received recognition both in and outside his native town. Piero certainly had begun to paint by 1431 (and more likely earlier) and had worked with Master Antonio on at least five sites in the middle of the 1430s. This makes it likely that Piero had executed commissions prior to the 1445 Misericordia commission, perhaps in Borgo Sansepolcro. Among such commissions, I suggest the Chapel of Don. Rigo in the Pieve in the late 1430s or the "Baptism" in the church of San Giovanni d'Afra in the late 1430s or early 1440s.[24] It is clear from confraternal documents of Borgo Sansepolcro that after the mid-1430s Piero did not accept small commissions or repair "jobs," in the manner of the local painters Simone di Domenico d'Arezzo, Master Antonio, and Benedetto de Cera, for whom they were sources of income. Piero either had a sufficient number of large commissions or a more elevated idea of the role of the painter. More likely, he had both plentiful commissions and an evolving conception of himself as an artist.

The role of Piero's family in securing the commission for him should not be ignored. His father, Benedetto, had been a *camarlingho* earlier in the century, and two sons in addition to Piero held positions in the confraternity. Marco was selected *spedaliere* of the confraternity in 1442, and in this office he supervised the confraternal hospital. I can now confirm that Don. Francesco di Benedetto di Pietro, monk in the Camaldolese abbey in Borgo Sansepolcro from 1428 to 1448, was Piero's brother. He served as chaplain of the confraternity of the Misericordia in 1443, saying mass at the Marian festivals and hearing the confessions of the members. More generally, but no less important, Piero's father served as one of the four heads of government in Borgo Sansepolcro in 1444, when he was selected as a conservator. Though out of office by 1445, he, like other former conservators, retained great honor and influence.[25]

Now to examine more closely the contract of commission: the committee contracting with Piero sought a traditional altarpiece with a gold background and ultramarine blues. Kenneth Clark defined the conception of the altarpiece in the contract as "completely medieval in spirit."[26] As discussed above, the measurements and conception of the altarpiece were derived from the already existing altarpiece in the oratory of the confraternity.[27] The men of the confraternity bound Piero to use the earlier altar frame in the oratory as a model. Also, as Carlo Bertelli has noted, Piero was to employ the earlier exemplar for the construction and deployment of the new altarpiece in the oratory through to its completion and placement on the altar.[28]

Esteem for Piero was expressed by the salary of 150 florins and by the requirement that no other person could apply brush to the altarpiece. Perhaps in the knowledge that Piero possessed or would gain other commissions, the confraternal committeemen required that he complete the altarpiece within three years. The frequently noted condition that Piero remained responsible for ten years for any defect of the wood or "himself" requires special attention. This requirement is not customary in contracts to painters, though the carpenter Bartolomeo agreed to give similar assurances in 1430.[29] The provision has usually been dismissed as owing to Piero's youth and inexperience. Because we now know that he was approximately thirty-three years of age and had fourteen years of experience prior to 1445, such an explanation is no longer persuasive.[30] Perhaps, as Bertelli has suggested, the wood of the structure built by the carpenter Bartolomeo already showed some defect. Or perhaps the structure also carpentered by Bartolomeo for the high altar of San Francesco upon which Piero had labored, and which structure had been replaced by another from the hand or bot-

tega of Sassetta, had shown a defect in the wood or from the gessoing. These conjectures aside, Piero was to be held responsible for any defects arising from the wood or from any other flaws of his own making.

The schedule of payments in the contract has customary features. Piero was to receive an initial payment of 50 florins (one-third of the total price) and the remainder when he completed the altarpiece. He was not necessarily to receive an initial payment immediately, as has been stated or assumed by most researchers. Instead, Piero was to receive 50 florins "immediately at his petition" and therefore not necessarily in the summer of 1445. If he had received the money immediately, the contract of commission would have included the transaction—this procedure can be seen in the commission of 1430 of Master Antonio to paint the San Francesco altarpiece—or the act following the commission would have been a *quietatio*, the customary notarial act recording a payment.[31] Yet no record of immediate payment exists. Moreover, the total of newly discovered payments to Piero does not permit an initial payment of 50 florins to him in 1445.

The newly discovered documents provide the basis for the reconstruction of nearly all the payments to Piero. Said payments may not necessarily follow or be concurrent with or precede the pace of painting, but they provide hints for the periods of the artist's labor. As there are few such chronological signposts for Piero, these payments are important; integrated with published documents, they provide a basis for reconstructing the progress of work on the Misericordia altarpiece.

Payments to Piero extend over the two decades after the contract was drawn, with nearly two-thirds of the altarpiece's price paid only after 1460. The most important conclusions derived from the documents are (1) that Piero did not take his earnest money immediately; (2) that he started painting later than previously thought; and (3) that, as is generally believed, he substantially completed the task in 1461 or 1462. It is generally assumed that Piero received his 50 florins earnest payment and began working more or less immediately.[32] There exists no documentary evidence to substantiate the two assumptions of immediate payment and immediate painting. The documentary evidence all points to a delay in the beginning, with an interval as long as five or more years before any significant amount of painting was done.

From a lengthy study of notarial documents, I have made the judgment that when Piero remained in Borgo Sansepolcro for an extended period of time, his presence would be manifest in the notarial acts: receiving payments, participating in his family's business transactions, or simply witnessing contracts. Between 9 May 1438 and 1449, only two documents have been found that locate Piero in Sansepolcro. One is well known, from 11 June 1445, when he accepted the Misericordia commission. The second is from two months earlier, 12 April 1445, and is published here for the first time; lending considerable weight to my claim, it notes Piero as a witness to a land purchase on that date. Thus, while he was in Borgo Sansepolcro for several months in the spring of 1445, he seems not to have been there for any other extended period from the summer of 1438 to 1449.[33]

Meanwhile, money for the altarpiece did start to change hands. But as nothing concerning Piero's life is ever clear-cut, the sequence of events must be reconstructed from fragments and hints in the documents. On 10 January 1446, the prior of the Misericordia, Goro Procaccio, conveyed 100 lire to Piero's father in the abbey of Borgo Sansepolcro as "part payment for the tavola."[34] Computed at 5 lire 5 soldi to the florin as stipulated in the commission of 1445, the earnest of 50 florins promised to Piero would have been worth 262½ lire. While this initial payment to Piero in 1446 of the small sum of 100 lire matches nothing in the written agreement, it does suggest Piero's absence at the time and sets up a series of possibilities which, through various deductions, I believe leads to several plausible conclusions.

First, because from the previously unedited payment record to be presented shortly, we now know that 643 lire of the 787 lire payment promised to Piero can be linked to specific moments, there remain 144 lire (c. 27 florins) to account for.[35] I do not believe that Piero received the 144 lire or 27 florins in June 1445 with the commission. In addition to the other reasons discussed above, had he received 27 florins with the commission, the payment of January 1446 would have been an additional 23 florins to complete the 50 florins earnest

money required in the contract. Instead, as we know, the payment was for 100 lire (19 florins). Moreover, had Piero received all 50 florins by January 1446, it is doubtful that the Pichi family would have paid an additional 53½ lire beyond the earnest money in 1450 or would have waited until 1454 to demand that Piero get on with the altarpiece.

The payment to Piero of 53½ lire from the Pichi was conveyed to the painter through his brother Marco. On 29 April 1450, an agent of the Pichi family, Leonardo di Pietro Vecchi, acknowledged the sale of Pichi *guado* for a total of 386 florins. Of this sum, he conveyed only 53½ lire to "Marcho di Benedetto di Pietro for Pietro his brother for part of the payment for the labor of constructing the *tavola* in the oratory of S. Maria della Misericordia." This amount is obtusely precise, given that over 2,000 lire were available from the sale of *guado*, and suggests that the two Pichi men, Nardo d'Angelo dei Pichi and Teodosio di Domino Cristofano dei Pichi (heirs of Urbano di Meo dei Pichi) were completing the payment of a previously agreed upon amount. Perhaps this was their portion of the initial 50 florins earnest money, or they were responsible only for the carpentry of the altarpiece.

Further in this line of arguing, I propose that there was another yet-to-be-discovered payment between 1445 and 1454, from the Pichi and/or the confraternity, that would account for the remainder of the 50 florin advance. The hypothetical payment would have added up to 109 lire, or the difference between the full amount (262½ lire [50 florins]) and 100 lire plus 53½. It would have been to this payment that a document of January 1454, discovered by Eugenio Battisti, refers. There Nardo and Teodosio dei Pichi encouraged Piero's father to cajole Piero to return to Borgo Sansepolcro by the end of the Lenten season of 1454 "for making and building the altarpiece of the Misericordia." If Piero did not return by early spring, then Benedetto would be compelled to return the amount paid to him. This document also refers to an agreement held by Nardo dei Pichi and signed by Piero and his father; therefore, it is clear it does not refer to the 1450 payment to Piero's brother Marco.[36]

Thus, perhaps with the 1450 payment or as late as 1454, Piero had received his earnest money, only after which he was obligated to begin making the altarpiece. It is significant

that the verbs used in the documents of 1450 and 1454 specifically denote the activity of *building, making,* or *constructing*: "construenda" (1450) and "pro faciendi et edificandi tabula" (1454). It is significant that the verbs employed are not past participles that would denote or imply completed activity. More important, not one word denotes painting. Because of formal and stylistic characteristics, scholars have traditionally regarded the Misericordia altarpiece as among Piero's first paintings, dating some of the panels to the late 1440s. On the basis of the documents, however, I propose that this judgment is incorrect. The fact is that payments, paintings (some signed and dated), and other references attest to his absence from Borgo Sansepolcro and his presence in Rimini, Rome, and, most researchers hypothesize, Arezzo between 1450 and 1460. As we have seen, the document of 1454, referring to Piero, demands his return to his native city. In the years 1446–1449 and 1451–1460, Piero is securely documented in Borgo Sansepolcro on only two occasions: 4 October 1454 and 22 September 1458.[37] I grant that Piero probably returned to his native town after the Pichi demanded his return, and that he probably painted parts of the Misericordia altarpiece and thus was present in October 1454 to receive the commission for the San Agostino altarpiece. Thereafter he is documented only once in Borgo Sansepolcro before his mother's death in late 1459.[38]

In the years 1460–1462, there are numerous indications that Piero remained in Borgo Sansepolcro for an extended period of time.[39] This is the moment when Piero would have devoted days and months to painting the Misericordia altarpiece. In this period there is a second phase of payments to Piero suggesting that the altarpiece was completed. On 5 June 1461 the confraternity of the Misericordia initiated the paying of Piero by shifting a credit of 285 lire owed to them by Nardo di Benvenuto. Piero received this sum on 5 September 1461.

One day before arranging this transfer, on 4 June 1461, the confraternity congregated and appointed a procurator to act for them "especially in the case with the heirs of Luca dei Pichi and the heirs of Urbano dei Pichi."[40] The confraternity doubtless sought payment of the bequests of the Pichi of 1422 and 1435 for their altarpiece. This act of 4 June 1461 and the aforementioned land sale and assignment of

credit the following day appear to be an attempt by the confraternity to gain the resources to complete payments to Piero. In a well-known document of January 1462, the confraternity conveyed *guado* worth 15 lire to Piero's brother Marco "for part of the payment of the altarpiece which his brother Piero has painted."[41]

Mario Salmi long ago asserted, on the basis of stylistic analysis, that a monk named Don. Giuliano Amidei da Firenze, who is known to have been a miniaturist, painted the scenes on the predella of the Misericordia altarpiece. In fact, in this very period of the late 1450s and early 1460s, Don. Giuliano's name appears in the chapter of the Camaldolesi monks in the abbey of Borgo Sansepolcro. He was in the abbey on 8 November 1458 and is often found in the notarial acts of Borgo Sansepolcro into the early 1460s.[42] More important, there is a document placing him in the Oratory of the Misericordia. For 9 September 1460, one finds the short note: "Don. Giugliano for part payment for painting the shields, five lire."[43] It would complete our thinking if we could say that the shields painted were those for the altarpiece, but the context suggests that Giuliano painted the arms of the Misericordia on a stone that recounted an indulgence granted by Pope Pius II in 1460.[44] But it is clear that Don. Giuliano worked in Borgo Sansepolcro in the years that Piero was present for an extended period of time to complete the Misericordia altarpiece and that the miniaturist was employed by the confraternity.

By the summer of 1461 or early 1462, Piero had completed the Misericordia altarpiece, although he continued to pursue his just compensation for several years.[45] Relevant to this point are documents concerning a sale of land by the confraternity. On 4 May 1462 the officials of the confraternity sold land to the brothers Sante and Andrea, sons of Giovanni, and arranged for the payment of the debt for the land. This act was recorded in the "Communal Palace and residence of the Florentine Captain of Borgo S. Sepolcro in the place where justice is rendered and before the judicial bench." Moreover, as Piero and his brother Marco were present as witnesses, it appears that Piero was applying pressure on the confraternity to complete payment for the altarpiece. This hypothesis is confirmed by a subsequent act of 20 February 1467, which recounts the dribbling in of payments from the purchasers to the confra-

ternity and to Piero. Between 4 May 1462 and 20 February 1467, Piero received 183 lire, 7 soldi, and 3 denari by this route—from the brothers Sante and Andrea by way of a Pichi family member—"for part of the altarpiece" and another nearly 16 lire from another representative of the confraternity.[46] While the exact dates Piero received these approximately 200 lire are not known, it is clear that these two payments represent most, if not all, of his remaining compensation for the Misericordia altarpiece.[47]

To conclude: Piero's altarpiece in the "Chapel of Saint Mary," in the oratory of the Misericordia, from its earliest conception was large, with vertical columns or buttresses and predella. With the documentation of payments to Piero nearly complete, it is clear that there were two phases: 1446–1450 or 1446–1454 for the earnest money, and 1461–1462 and a little beyond for the remaining 100 florins owed at the completion of the painting. Inasmuch as he did not receive his earnest money until the 1450s, and much of that would have been expended in the materials for the carpentry of the altarpiece and "fine gold" leaf for its background, Piero in all probability delayed much of his painting of the Misericordia altarpiece until c. 1460. Knowledge of this delay resolves apparent inconsistencies between the 1445 contract and Piero's fulfillment of it. Only when Piero received his 50 florins in the early 1450s was it possible for the Pichi to demand Piero's return to construct the altarpiece in 1454; this delayed most of the painting until c. 1460. Because Piero received his earnest money so late, the provision to finish the altarpiece within three years, as the contract provided, lost all meaning. Finally, all the evidence substantiates the suggestion of Charles Hope that since the contract did not specify a storiated predella, Piero was not obligated to paint it. Hence Giuliano Amidei was paid after a late decision to add narratives to the predella.[48]

Epilogue: Further Information on Paintings in the Oratory of the Confraternity of the Misericordia

In 1469–1470, the confraternity made substantial payments, whether from the Pichi or from other sources, for construction in their church. To their high altar, called "la capella di S. Maria,"[49] which housed Piero's

altarpiece, the brothers added a second space called "the Chapel of the Gonfalone."[50]

Men who worked with Piero at various phases in his career made contributions to this chapel. Pelegrino di Benedetto d'Anthonio de Cera, brother of the papal official and Roman architect Francesco dal Borgo, sold blue paint for the *gonfalone*. Giovanni del Bigio, who built the choir in the tribune in the church of San Agostino where Piero's altarpiece stood, constructed the predella of the *gonfalone*. Finally, and most important, the confraternity commissioned the Sienese artist Matteo di Giovanni to make a new *gonfalone* and paint a new image of Mary on it. On 29 June 1470, the prior of the confraternity sent nearly 77 lire in the hands of his representative, who "paid Matteo di Giovanni, painter, in Siena for part of the payment for the *gonfalone*."[51] This document of 1470 is the latest notice thus far to come to light concerning the fifteenth-century decorations of the two altars in the oratory of the confraternity of the Misericordia in Piero's native town of Borgo Sansepolcro.

APPENDIX

Document 1
ASF, NA 14042, fols. 21v–22v
28 July 1426
The Confraternity of Santa Maria della Misericordia designates a procurator in its "vestitario societatis fustigatorum S. Marie dela Misericordia." The group is stated to be in sufficient number to appoint Marius olim ser Mathei de Fedelis as syndic and procurator.

Iohannes Alberti, Prior
Bartolomeus Bartolomei de Gratianis
Francischus Nichole
Iohanguido Docti de Doctis
Lucas Guidonis de Pichis
Bartolomeus Iohachini Ducii
Benedictus Petri Benedicti
Petrus Luce Benedicti
Christoforus Antonii Donibuosi
Iulianus Mathei Ciacii
Andreas Pauli Contenti
Michelangelus Massi Vanni
Ludovichus Mei Primini
Francischus Iohannis Pauli magistri
Tomassus Baptiste Martini
Magister Angelus Guiglelmi
Michelangelus Chechi
Andreas Iohannis Tani
Bencivenne Andre
Antonius Marci Cime
Antonius Saracini
Iohachinus Guidonis de Pichis
Iulianus Nolfi Docti
Dompnus Matheus Christofori
Francischus ser Iohannis Marci
Francischus ser Iohannis Ciucii
Gorus Prochaccii
Iacobus Stefani spetarius
Franceschus Antonii Gliesis
Nannes Nerii texitor
Criachus Antonii Marci
Paulus Tarducci
Nannes Ciucholi

Document 2
ASF, NA 7017, unfol.
28 June 1428
Title in margin: "Pro tabula Sancte Marie de Misericordia."

Priors of the confraternity contract with the carpenter Bartolomeo di Giovannini d'Agnolo to build the wooden frame of its proposed altarpiece.

Die XXVIII iunii. Actum in appoteca predicta, presentibus ser Michelangelo, Christoforo Francisci ser Fei et Iohanne Andre Donati testibus rogatis.

Antonius magistri Ionte prior societatis Sancte Marie de Misericordia et providi viri Francischus ser Iohannis Marci, Lucas Francisci Fei et Andreas Iohannis Tani, electi in dicta societate ad instantiam habentis plenum mandatum ab hominibus dicte societatis et ex reformatione inter homines facta pro ut apparet et dicit in libro reformationum dicte societatis. Ipsi prior et superstites prefati via et nomine dicte societatis et hominum dederunt et convenerunt Bartolomeo Iohanini Angeli carpentario presenti et recipienti ad fabricandum unam tabulam de ligno pro altare dicte societatis quantum tenet altare cum pedibus dicte tabule qui veniunt extra altare quod includi debet inter dictos pedes, ad lignaminum dicti Bartolomei et omnibus aliis expensis mercantibus in dicto laborerio fiendo et fabricando de lignamine et feramento, salvo quod de feris cortinarum, quam tabu-

Iam dictus Bartolomeus promiserit fabricari secundum formam designi dicte tabule quod dimiserunt penes me asserentes habuisse a Magistro Optaviano pictore de Eugubio et eam polire de retro et ingessare, non tamen ante ingessare, salvo quod non teneatur facere nisi unum scabellum in imo tabule, pro mercede et salario fiorini vigintiquinque valoris et modo et forma et relectis in testamento Urbani de Pichis, solvendis hic modo vide-licet ad petitionem dictis Bartolomeis lib. XXV de dicta summa et residuum post fulcitum tabulam quam explere promisit per totum mensim Octobri proxime futuris. Que omnia sibi ibi iurari observari et fabricari et solvere promiserunt hinc inde ut supradicto sub pena dupli et obligando bonis dicte societatis et dictis Bartolomeis etc., quarantigia precipi etc.

Document 3
ASF, NA 7020, unfol.
15 February 1436 (N.B., second series of acts of 1436)
Title in margin: "Concessio capelle Iohachino et aliis de domo de Pichis."

Luca Guido dei Pichis makes a bequest of 50 florins to the Badia of Borgo Sansepolcro for a chapel. Here the abbot Paschasius accepts the bequest. At some later time the abbot apparently changed his mind because we know that the confraternity of Santa Maria della Misericordia eventually attempted to secure Luca's bequest. Benedetto di Piero de Benedetto was one of the witnesses.

In a meeting of the chapter of the monks of the Badia, including the abbot Paschasius, Piero's brother and monk Francischus Benedicti de Burgo and the other monks deliberated upon the bequest of Luca Guidi Nerii dei Pichis of 8 February 1435: "Item reliquit pro anima sua capelle site in Abbatia predicte iuxte capellam Crucifixi et sepulcrum suum fiorini quinquaginta." The abbot and monks were to decide if they wished to accept the bequest within one year from the testator's death. If the abbot did not want the bequest and its obligations, then "dictam quantitatem quinquaginta fiorini Societate disciplinatorum Sancte Marie de Misericordia convertendo pro tabula fienda et pingenda ad altare mauis oratorii societatis predicte." Having joined with Iohachinus Guidi Neri dei Pichis, Andreas and Marcolinus, sons of the deceased Petri Guidi Neri dei Pichis, the abbot and chapter decided to accept the bequest:

Et attenta utilitate que ex acceptatione dicti legati provenerit et in future provenire potest dicto monasterio et omnibus consideratis quam considerari potest super inde sponte deliberate et consulte et omnium meliori modo, via, iura, causa, forma et ordine quibus fieri potest dictum legatum acceptando et pro ipso consequendo et habendo dictam capellam sitam in Abbatia dict Burgi iuxtam Capellam Crucifixi et sepulcrum dicti olim Luce concesserunt et approverunt in perpetuum dictis Iohachino et Andree et Marcolino de Pichis heridibus dicte Luce et ididem presentibus et etiam una cum eis meo notario infrascripto persone publice presenti stipulanti et recipienti pro aliis et vice et nomine Angeli Nardi de

Pichis, Lodovici Lodovici de Pichis, Mathei et aliis filiis domini Christofori Nardi de Pichis et Mei, Gnoli et Francisci Martini de Pichis et aliis hominibus de domo predicta de Pichis pro eis et eorum in perpetuum de dicta domo descendentibus et domui predicte secundum formam dicti legati. . . .

Then Iohachinus, Andreas, and Marcolinus promised to pay the 50 florins after the death of Luca's wife, Panta, and at the petition of the abbot.

Document 4
ASF, NA 7026, fol. 51v
12 April 1445
Note in margin: "Emptio Francisci Geronimi Angeli."

Piero della Francesca is recorded as a witness to a land sale.

Die suprascripta. Actum in Burgo in domo et sala domus Fei Francisci ser Fei sitam in Asgio Burgi Novi, presentibus Nicolai Iohannes Andree Bonasegneri, Andrea Palmieri, Petro Benedicti Petri Benedicti Francisci. . . .

Document 5
ASF, NA 7027, fol. 9r
10 January 1446
The father of Piero della Francesca accepts a payment from the confraternity of the Misericordia.

Die suprascripti et loco [die decima mensis Ianuarii. Actum in appoteca Abbatie et residentie mei notaii], presentibis ser Antonio Baptiste et Baptista Marci Boddi et ser Michelangelo Iuliani testibus et rogatis.

Benedictus Petri Benedeicti in suo nomine et vice et nomina Petri pictoris sui filii pro quo de rato habuit, promisit et fuit confessus et contentus et habuisse a Goro Procaccii, priore Fraternitatis Sancte Marie de Misericordia et Guido Antonii consiliario per manum Laurentii Casucci depositorio dicte societate, lib. centum den. cort. pro parte solutionis tabule vigoris instrumentum manum mei notai, a quibus centum lib. ipsius dicte nomine de dicte societate absoluit etc. que omnia et predictis obligationibus etc. Renunptantes precipi.

Document 6
ASF, NA 7031, unfol.
29 April 1450
Title in margin: "Quietatio Leonardi Petri."

Marco, brother of Piero della Francesca, accepts 53½ lire from members of the Pichi family for constructing the altarpiece of the Misericordia.

Die dicta et loco, presentibus Iohanne Nicolai Busichio et Luca Mei dela Ciuccia de Burgo, testibus rogatis.

Nardus Angeli de Pichis et Theodosius Domini Christofori de Pichis presentes asserentes se fore et esse constitutos a se ipsi et ab aliis ad quos spectat hereditas Urbani Mei de Pichis ac etiam ipse Nardus suo nomine sponte et vice et nomine suorum fratrum et coheredii Angeli de Pichis ad quos hereditas dicti Urbani spectium(?) dicatur pro dimidia et ipse

Theodosius suo nomine et fratrum suorum ac filiorum Mathei sui etiam quodam fratris coheredum dicte domini Cristofori mediante persona domina Christopina ad quos hereditas predictam dicti Urbani spectium dicatur pro altera dimidia, pro quibus fratribus suis dictus Nardus et pro quibus etiam fratribus et nepotibus suis Dominus Theodosius de rata habituris promiserunt infrascripto Leonardo etc. fuerunt confessi et confessi habuisse et recepisse et pro eis dictis nominibus solutis fuisse et esse Marcho Benedicti Petri pro Petro eius fratre pro parte solutionis mercedis tabule construende in oratorio Sancte Marie de Misericordia a Leonardo Petri Vechi lib. LIII et sol. X cort. pro resta quantitatum guadorum in pluribus vicibus habitorum et emptorum per dictum Leonardum de guado dicte hereditatis dicti Urbani et pretiorum dictorum guadorum . . . summam fiorini trecentorm octuagintasex et ultra a quo pretio toto dicti emptoque guadi per dictum Leonardum et pretii habituri de bonis dicte hereditatis dicti Urbani prefati Nardi et Theodosius dictis nominibus absolverunt dictum Leonardum. . . .

Document 7
BSS, AC, Fondo della Misericordia, reg. 8, fol. 98v
4 September 1460

In the payments made by the prior of the confraternity of Santa Maria della Misericordia, there appears a payment to "Dompnus Giugliano" for painting the "armi":

"Don. Giugliano per parte paghamento del'armi depinse, lire 5."

Document 8
ASF, NA 6998, filza 1460–1469, no. 11. Also noted in marginal title in ASF, NA 6956, unfol., but the act is not written: "Sindicatio sotietatis S. Marie de Misericordia in ser Uguccium Nofrii in heredibus Luce de Pichis et in heredibus Urbani de Pichis."
4 June 1461

The men of the confraternity of Santa Maria della Misericordia create a procurator to act against the Pichi family.

Beo de Gora di Piochaccia—Prior
Giovanni d'Antonio de Stracinno—consigliare
Meo del Bagina—consigliare

Bartolomeo di Coluccio	Guido d'Antonio
Francesco di Giovanni di Paolo	Ruberto di Lorenzo di Nanni
Francesco di Luchino	Nicholo di Dombonsi
Vicho di ser Francesco	Vicho di Guardi
Chescho di Pannilonghi	Filippo di Benvenuto
Nicholo di Nicholo de Bazzo	Marcho di Palogio del Assalino
Lucha di Francesco mareschalcho	Giovanni Matteo del Bageana
Antonio Solderini da Firenze	Benedetto d'Angelo d'Umbertino
Francesco di Pechi	Masso di Nicholo di Condeo
Giovanni Paolo di Pietro di Goro	Cristofano di Beo di Procaccia
Manuello di Giovanni del Taragle	Gelle di Meo
Pisanello	Stefano di Iachomo

" . . . pro ut et de dictis pactis apparere dicitur manu Stefani Iacobi Bartolomei syndici dicte societatis etc., specialiter in casu cum heredibus Luce de Pichis et heredibus Urbane de Pichis et qualibet etc."

Document 9
ASF, NA 7040, fol. 41v
5 June 1461
Title in the margin: "Residium Sotietatis Sancte Marie."

A debtor of the confraternity of the Misericordia conveys 275 lire to Piero della Francesca. It should be noted that the "residium" in the title of the act refers to the remainder of a payment from Nardus Benvenutis to the confraternity for a land sale on the same day and not the remainder of Piero's payment for the altarpiece of the Misericordia.

Dictis die loco et testatibus.

Suprascriptus Nardus Benvenutis dicto nomine recognoscens se et dictum eius patrem debitorem suprascripto sotietatis Sancte Marie et dictorum prioris et sindicorum pro ea a quantitate lib. CCLXXXVIII et sol. quinque solutis per eum et satisfactis pro dicte sotietate ut asseravit dicti contrahactis videlicet magistro Petro pictori lib. CCLXXV et Iohanne Nicolai Dombosi pro sigello lib. XIII et sol. V ab inde supra pretium dicti rei promisit eis dictis nominibus et residium ab inde supra in quantitate lib. XXII sol. XIII et den. VIII cort. solvente sibi ad vigorum petitionem reservate pretio dicta petia terre. Ex pacto ubique etc. Observando etc. et obligando se etc. Renunptiantes etc. et guarentigia precipi etc.

Document 10
ASF, NA 7040, fol. 41r
5 September [1461]
The confraternity of the Misericordia agrees that the debtor in document 9 has completed payment of his debt.

Die V septembri presentibus Ceccho Nannis Massi et Luca Bacelli testibus. Cassum de licentia Guidetti Prioris et Andree Nannis Tani et Francisci Iohannis Pauli et Mathei Palamides et Roberti Laurentii sindicorum confitentium satisfactam esse domini [?] et predicta societate solutis a magistro Petro pictori presenti et confitenti habuisse etc.

Document 11
ASF, NA 7040, fols. 128v–129r
4 May 1462
Title in margin: "Emptio Santis [et] Andree Iohannis."

With Piero and Marco della Francesca as witnesses, the officials of the confraternity of the Misericordia sell land with a part of the sales price eventually to go to Piero.

Die suprascripta. Actum in residentia inferiori palatii comunis Burgi ubi ius redditur et ante bancum iuris, presentibus Luchino Leonis de Gratianis, Andrea Angeli Artini, magistro Petro et Marcho Benedicti Petri et aliis pluribus testibus adhibitis et rogatis.

Egregii viri ser Ugucius Nofrii de Burgo prior socie-
tatis hominum fustigatorum Sancte Marie de Miseri-
cordia et Andreas Iohannis Tani et Francischus
Iohannis Pauli magistri et Matheus Antonii Pala-
midis sindici dicte societatis et hominum, asserentes
ad hec habere plenum arbitrum et mandatum, sponte
et ex certe scientia vice et nominibus societatis pre-
dicte et hominum et personarum eiusdem iura qui-
dem proprio et per allodem in perpetuum dederunt
vendiderunt et tradiderunt Santi olim Iohannis Petri
Archi de dicto Burgo ibidem presenti ementi et reci-
pienti pro se et Andrea eius fratris carnali et pro
ambobi eorum et eorum heredibus et subcessoribus
et iura sua habituris unam petiam terre laboratorie
de bonis societatis predicte sitam in districtis Burgi
in contrata Sagnovis iuxta rem (notary left confines
of land blank).

Document 12
ASF, NA 19250, filza 1459–1520, no. 1, fol. 9r
28 February 1464

The confraternity of the Misericordia selects two
procurators to act for them against the Pichi family.

Rubertus Laurentii Nannis prior Sotietatis Sancte
Marie de Misericordie et spectabiles viri Bartolo-
meus Antonii Gucciarelli, Meus Luchini, Iohannes
Antonii Saracini, Antonius Gualterii sindici dicte
sotietatis prout dixerunt apparere mandetur manu
ser Ugutii Honofrei sponte et certa scientia omnes
simul omni meliori modo, via, iura et forma quibus
magis et melius potuerunt, fecerunt, constituerunt,
creaverunt et ordinaverunt procuratores et sindico
dicte sotietatis spectabiles viros dominum Galeot-
tum Francisci et ser Ugutium Honofrei ibidem pre-
sentes et acceptantes ad omnem et quamcumque
litem et causam seu cum aliqua et quacumque per-
sona collegio vel universitate et specialiter et nomi-
natum in causa quam habere intendunt cum here-
dibus Luce Guidonis de Pichis de quodam legato
facto dicte sotietatis pro tabula pingenda per dictum
Lucam.

Document 13
ASF, NA 7044, fol. 6r–v
20 February 1467
Title in margin: "Emptio Sanctis et Andree Iohannis
Petri."

Iohannes Antonii Saracini de Burgo, prior societatis
S. Marie de Misericordia and other officials, had sold
to the brothers Santes and Andrea Iohannes Petri
land in the district of Borgo S. Sepolcro for a price
of lib. 548 sol. 13 and den. 8. This act records the
payments by the brothers, including the sums of
lire 183 sol. 6 and den. 8 and lire 15, sol. 17 and den.
3 for Piero for part of the payment for the tavola.

Dictis anno et indictione et pontificatu, die XX
mensis Februarii. Actum in Burgo predicto in studio
domum mei notai infrascripti, presentibus Mario
Antonii Ionte et Gello Mei Rizzi et Iacobo Iohannis
Gualdi omnibus de dicto Burgo testibus ad hec
habitis vocatis et rogatis.

Egregii viri Iohannes Antonii Saracini de Burgo Prior
Sotietatis S. Marie de Misericordia de dicto terre
Burgo et ut et tamquam unus ex sindicis dicte Socie-
tatis et una cum eo Bartolomeus Antonio Uguciarelli
de Burgo predicto et Meus olim Luchini ser Mei Dori
etiam sindici dicte societatis, eorum nominabus et
vice et nomine Antonii Gualteris Luce eorum quarti
collegi et sindici societatis predicte, pro ut de eorum
mandato publice apparere dixerunt in mano ser Man-
fredi Francisci notarii de dicto Burgo et habere suffi-
ciens mandatum ad huiusmodum actus casus simule
invicem sibi auctoritas dictis nominabus et vice et
nomine dicte societatis et hominum sponte et ex
certa scientia ex causa et titulo vere venditionis iure
quidem proprio et in perpetuum per allodem deder-
unt, vendiderunt et tradiderunt Santi olim Iohannis
Petri orchi de dicto Burgo ibidem presenti ementi et
recipienti pro se et Andrea eius fratris et pro ambo-
bus eorum et eorum heredibus et successores propria
in iura sua habituris unam petiam terre laboratem
in districto Burgi in contrata Sagnovis iuxtam rem
filiorum Bartolomei de Gratianis et rem filiorum
Pieri Fci et rem heredum Leonardi Petri et viam vel
altrem finem siqui sunt sibi dudum venditam iam
sunt anni plures videlicet a anno domini millesimo
CCCCLX, die XIII mensis Augusti ad talem ante
platea comunis qui plus dederunt et seu obtulerunt
se debitores quam aliquis alius et de cuius vendintur
asseverunt fuisse solutum gabellorum ad habendum,
tenendum, possidundum et quicquid dictis fratribus
emptoribus placerunt faciendum cum omnibus et
singulis que infra predictis continentis. . . . Et hoc
pro pretio et nomine vera et iusta pretii ad rationem
XXVII bol. pro qualibet tabula dicte rei quam esse
dixerit tabulas CLXVIII et pedes X alteros etc. quod
pretium [*pretium* repeated] in summa lib. quingen-
tarum quadragintaocto et sol. XIIII et den. II cort.
fuerunt confessi dictis operarii solutum fuisse et esse
his personis videlicet Matheo Palamides tunc priori
dicte societatis lib. LXVI et sol. V in una manu et
alia manu lib. XXXIIII, sol. VII et den. III eidem
Matheo et in tertia manu eidem Matheo lib. XXIIII,
sol. VII et den. [o]. Item per Marcholinum de Pichis
solutis prout apparit in bastardello dicte societatis
lib. LXXV cort. Item Guido Neri Capasini solutis
per Bartolomeum Bartolomolei pro dicte societate
et ——— ab eius appoteca lib. XXVIIII. Item lib.
CLXXXIII sol. VI et den. VIII solutis per Urbanum
Marcolini [de Pichis] Magistro Petro Benedicti pictori
pro parte tabule dicte societatis in una manu et in
alia manu solutis dicto Magistro Petro per Bartolo-
meum Bartolomei lib. XV et sol. XVII et den. III.
Item lib. XL solutis Marcholino de Pichis per dictum
Bartolomeum Bartolomei. Item lib. L. solutis Iuliano
Mei Petri Bartoli per dictum Bartolomeum Bartolo-
mei. Item lib. XIIII et sol. V solutis Nicolao de
Uguciis aurifici pro sigello de argento dicto societa-
tis. Item lib. XV sol. XVII et den. VI solutis Guidetto
Antonii depositario dicte societatis hac presenti die
pro restu dicti totum pretii. [The remainder of the
document records other payments by the purchasers
and the statement that the purchase price had been
paid. No other comment on Piero or the altarpiece.]

Document 14
BSS, AC, AM, reg. 8, fol. 142r
29 June 1470
The confraternity of the Misericordia records the payment to Matteo di Giovanni for painting a banner.

Feci una buletta a Ghuydetto d'Antonio nostro depositaro che desse paghasse a Matteo de Giuvanni depentore in Siena per parte de paghamento del ghonfalone che à tolto a fare a detta chasa. Lire sesantuna [e] soldi nove valgliano di cortonesi lire settantasei, soldi sedici [e] denari tre. . . .

NOTES

1. A shorter form of this paper was delivered at the conference, "Facets of Piero della Francesca," organized by Cynthia Pyle, director of the Renaissance Studies Certificate Program, at the Graduate School and University Center of the City University of New York, 26–27 February 1993. I wish to thank Marilyn Aronberg Lavin, Maureen Banker, Charles Hope, and Clare Robertson for their suggestions on the form of this paper.

2. Compare the names in documents 1, 2, and 8 in the Appendix with documents 2, 3, and 8 in James Banker, "The Program of the Sassetta Altarpiece in the Church of S. Francesco in Borgo S. Sepolcro," *I Tatti Studies* 4 (1991), 48–53, 57–58.

3. Borgo Sansepolcro (BSS), Archivio Comunale (AC), Archivio della Misericordia (AM), reg. 236, fol. 47v. Inasmuch as the son of this Francesca wrote his testament in the following year and her grandson Benedetto, Piero's father, was between fourteen and eighteen years of age, we may judge that she was of an advanced age in 1389. Benedetto's age is in part derived from the fact that in Borgo Sansepolcro one had to be twenty years of age to participate in the communal council. Petrus Benedicto Francesce, Benedetto's father, is listed among the councillors for 1391 in BSS, AC, series II, reg. 1, fol. 9v, but the name is crossed out and the word *mortus* added. The name Benedictus Petri is added at the bottom of the list in another hand. Therefore, the name Benedictus was added after the death of his father. The addition must have been made between 1391 and 1396 because that list was not used after 1396, and his name doubtless appeared in the early 1397 list of the Consiglio del Comune. The folio with his name is now lost, as is about one-third of the names of the councillors for that year. Two documents of 1400 record that Benedetto was between twenty and twenty-five years of age in that year: see Archivio di Stato, Firenze (ASF), Notarile Antecosimiano (NA), 7121, fols. 4005v–4006r. The construction "Monna Ceccha de Benedetto" usually implies "Ceccha, daughter of Benedetto," but I have rejected that Ceccha was a daughter because the document twice states that Pietro, son of Benedetto, was also her son.

4. See BSS, AC, AM, reg. 236, fol. 47v for another hand recording that her son Pietro conveyed the oil to the brotherhood; this hand appears often in dated entries for the 1390s, so we may assume that Monna Francescha died soon after having written her testament, perhaps from the plague of 1389.
 Giorgio Vasari, *Le vite de' più eccelenti pittori, scultori ed architettori italiani*, ed. Gaetano Milanesi, 9 vols. (Florence, 1878–1885), 2:489–490. As is well documented, Piero's mother was named Romana.

5. BSS, AC, AM, reg. 236, fol. 49v. Ronald Lightbown, *Piero della Francesca* (Oxford-Milan, 1992), 11, 285, note 2.

6. Benedetto and his siblings are listed in these records in a bequest as the heirs of their uncle Giovanni de Simone in 1409. Lightbown (1992, 285,

note 5) misread part of this document as saying the painter Piero della Francesca was an heir of Giovanni de Simone. In fact, the document reads: "Benedecto et fratelli de Pietro de Benedicto herede." The bequest is repeated at the bottom of the page: "Giovanni de Simone de Benedecto calzolaio lasciò al compagnia lire 10. Herede Benedecto dela Franchescha." BSS, AC, AM, reg. 236, fol. 51v. Lightbown mistakenly identifies the folio as 41v.

7. ASF, NA 14042, fol. 21v. See Appendix, document 1. Eugenio Battisti, *Piero della Francesca*, 2 vols. (Milan, 1971), 2:218, document 4, lists Benedetto as the prior of the confraternity, but in this document of 28 July 1426 Iohannes Alberti is clearly listed as prior.

8. ASF, NA 19282, fol. 54v; for an excerpt of the testament, see Battisti 1971, 2:10.

9. See Battisti 1971, 2:10 for the assumption that the Pichi were patrons of the altar. For the bequest of the beds, see ASF, NA 19282, fol. 54v.

10. It was part of the trecento tradition of the confraternity that individual contributions of money or discipline would redound to the corporate good. In flagellation confraternities, traditionally, property bequeathed would be sold immediately so that the group would not have material interests and the demands of the donor would not be elevated above the needs of other members. It may be accurate to say that this corporate element suffered diminution throughout the fifteenth century. The Misericordia in Borgo Sansepolcro did accumulate and hold property in the quattrocento. The Pichi family increasingly attempted to gain control over the altarpiece, and this led to conflict between the family and the confraternity. Bountiful evidence exists to indicate that the Pichi tried to deal directly from the beginning with the artisans who would construct and paint the altarpiece. The officers of the confraternity retained explicit control over the iconography of the altarpiece; see the 1445 document of commission in Battisti 1971, 2:220, document 20.

11. ASF, NA 19282, fols. 136r–138r; Battisti, 2:10, and see the comments of Frank Dabell in his review article of Lightbown 1992 and Carlo Bertelli, *Piero della Francesca* (New Haven, Conn., 1992), in *Burlington Magazine* 135 (1993), 41.

12. For my discussion of the contract of 1428, see the Appendix, document 2. On Ottaviano di Martino di Nello da Gubbio, see Umberto Gnoli, *Pittore e miniatori nell'Umbria* (Spoleto, 1923), 1:227–230. Nelli was born c. 1375 and thus was somewhat aged by 1445. In the late 1430s he received several commissions in Gubbio. If alive or available to paint in Borgo Sansepolcro in 1445, he may have been surpassed by the talent of the local Piero della Francesca.

13. The bequest of Urbano dei Pichi in 1422 and the bequest of Luca dei Pichi in 1435 specified that the altarpiece was intended for the high altar; see Battisti 1971, 2:10. The 1445 commission does not state that Piero's altarpiece was to be on the high altar, but it was to be placed where the former altarpiece was

located; Battisti 1971, 2:220. An altarpiece of the dimensions constructed by Piero must have been intended for the high altar.

14. See document 2 in the Appendix. The salary of the carpenter Bartolomeo for the work done for the Misericordia confraternity can be compared with his salary for a large double-faced altarpiece that he contracted to construct for the church of San Francesco in 1426, for which he received approximately 50 florins (250 lire); see Banker 1991, 47–48, document 1. There is striking similarity between the two contracts. In 1426 Bartolomeo di Giovannino d'Angelo was explicitly instructed to build a structure modeled on the Gothic altarpiece of the Abbey, and, as I have demonstrated in the 1991 article, the eventual result of the 1426 contract was that the front of the Sassetta altarpiece placed in San Francesco in 1444 included a central panel, four lateral saints, predella, and buttresses with saints.

15. Christa Gardner von Teuffel, "Masaccio and the Pisa Altarpiece: A New Approach," *Jahrbuch der Berliner Museen* 19 (1977), 34–36, note 40, and Gardner von Teuffel, "The Buttressed Altarpiece: A Forgotten Aspect of Tuscan Fourteenth-Century Altarpiece Design," *Jahrbuch der Berliner Museen* 21 (1979), 34–35, notes 21–22.

16. Banker 1991, 11–58.

17. Piero Scapecchi, following several ideas of Battisti (1971, 1:92), holds that the altarpiece was originally a triptych and only later became a polyptych with a Madonna and four saints; "'Tu celebras burgi iam cuncta per oppida nomen': Appunti per Piero della Francesca," *Arte cristiana*, new series, 7–8 (1984), 209–213.

In Charles Hope's review of Lightbown 1992, Bertelli 1992, and John Pope-Hennessy, *The Piero della Francesca Trail* (London, 1991), in the *Times Literary Supplement*, no. 4667 (11 September 1992), 16, Hope asserts that because the 1445 commission to Piero does not mention *storie*, the Misericordia in its original construction did not include a predella with narrative paintings. He holds that the predella as originally conceived presented figures of saints, and, since the predella was not mentioned in Piero's contract, he was not responsible for painting it; private communication, 2 May 1993.

18. See document 2 in Frank Dabell, "Antonio d'Anghiari e gli inizi di Piero della Francesca," *Paragone* 417 (1984a), 81–82.

19. ASF, NA 19282, fol. 136r–v for Luca's testament; see also Battisti 1971, 2:10.

20. For the foregoing, see the Appendix, documents 8 and 12.

21. For the commission of 1445, see Battisti 1971, 2:220, document 20. I believe Carlo Bertelli (1992, 192) was the first to note the importance of the phrase "de ligno."

22. For Sassetta, see Banker 1991; for Pietro di Giovanni d'Ambrogio, see Frank Dabell, "Un Senese a Sansepolcro: Documenti per Pietro de Giovanni

d'Ambrogio," *Rivista d'arte*, new series, 1, 37 (1984b), 361–371. For the general artistic traditions of the upper Tiber valley and Aretine territory, see Vera Chiasserini, *La pittura a Sansepolcro nella alta valle Tiberine prima di Piero della Francesca* (Florence, 1951) and, more recently, the comments of Stefano Casciu, "Antecedenti a Piero nell'Ariento," in *Nel raggio di Piero: La pittura nell'Italia centrale nell'età di Piero della Francesca*, ed. Luciano Berti (Venice, 1992), 33–45.

23. On 20 August 1442, Marcho di Benedetto, Piero's brother, as an official of the confraternity, purchased two tiles for the roof of the church of the Misericordia that he then conveyed to Master Antonio, who was paid a little over a lire to repair the roof. On 7 June 1443 Antonio was paid 2½ lire to paint the confraternity's sign on a confraternal property, presumably the same MIA that appears on the altarpiece painted by Piero. Antonio also received several other small commissions and repair work from other confraternities in the 1440s; he apparently was available. BSS, AC, AM, reg. 24, fols. 89r, 99v. There are also payments to a Maestro Antonio d'Arezzo in 1450 (BSS, AC, AM, reg. 24, fol. 159v). There is a note of Master Antonio d'Arezzo in 1460, but this artisan is listed as a "scharpelatore." Antonio d'Anghiari was given citizenship in Arezzo in 1447; see Dabell 1984a, 91, document 21.

24. For Piero's and Antonio's activity in the 1430s, see James Banker, "Piero della Francesca as Assistant to Antonio d'Anghiari in the 1430s: Some Unpublished Documents," *Burlington Magazine* 135 (1993), 16–21.

25. For Marco, see BSS, AC , AM, reg. 24, fol. 89r; for the monk Francesco, see fol. 97v and James Banker, "Piero della Francesca, il fratello Don. Francesco di Benedetto e Francesco del Borgo," *Prospectiva* 68 (1992), 54–56; for Benedetto as a conservator, see BSS, AC, series II, reg. 2, unfol., 25 April 1444 and ASF, NA 19303, unfol., 14 June 1444.

26. Kenneth Clark, *Piero della Francesca* (London, 1951), 8, note 2.

27. Some writers have suggested that Piero journeyed to Pisa to see the form of Masaccio's altarpiece in the church of the Carmine there for a solution of how to construct the form of the Misericordia polyptych; see the discussion in Bertelli 1992, 172. Since Piero followed the structure on the altar of the Misericordia oratory from 1430, he would not have used Masaccio's altarpiece as a model for the form. Whether Piero saw Masaccio's altarpiece for other reasons, and borrowed from Masaccio's images, is another question and will not be addressed here.

28. Bertelli 1992, 172.

29. See Dabell 1984a, document 2, 81–82.

30. Banker 1993, 16–21. I shall discuss the year of Piero's birth in a chapter on his family in my forthcoming book tentatively entitled "The Culture of Borgo S. Sepolcro in the Time of Piero della Francesca."

31. For the 1445 commission to Piero from the Misericordia confraternity, see Battisti 1971, 2:220, document 20. The document states that Piero would receive his earnest money "nunc ad eius petitionem." It is redundant and confusing to read this phrase as "now at his request"; "nunc" can also be translated "immediately," and the phrase so translated ("immediately at his request") conveys exact meaning. For the 1430 commission to Antonio, see Banker 1991, 48–50, document 2.

32. Lightbown (1992, 31) states that the construction of the wooden structure and its priming probably delayed painting until spring 1446.

33. For Piero's presence in Borgo Sansepolcro on 9 May 1438, see Dabell 1984a, 89, document 14. For 12 April 1445, see the Appendix, document 4. Lightbown (1992, 37) has also judged that Piero was seldom in Borgo Sansepolcro from 1446 to 1454, though, in an apparent contradiction, he also holds that Piero began painting in 1446.

34. For this and other payments to Piero by the officials of the confraternity and the Pichi family, see the Appendix, documents 5–6, 9–11, and 13.

35. These figures are rounded off to the nearest lire. I am aware that painters often asked for, and patrons often paid, additional sums beyond those found in the original contract. However, in order not to multiply concepts unnecessarily and thereby create more confusion, I am assuming that Piero did not receive additional payments beyond the contracted 150 florins (equaling 787 lire and 10 soldi). One would need some additional evidence to prove that Piero sought an additional payment before dealing with that possibility. I know of no occasion in Piero's career when he asked for or received any money beyond that stipulated in the original contract.

36. For the document of 1454, see Battisti 1971, 2:221, document 34. The agreement would customarily have a provision requiring the recipient of the money to pay a penalty for nonfulfillment of the contract. The penalty usually was double the stated amount of the contract. Battisti has hypothesized that Benedetto had to sign this private agreement between Piero and Nardo dei Pichi because Piero was under twenty-five years of age. It should be clear that Piero was in his early thirties in 1445. His father still represented Piero often, because Benedetto had not emancipated any of his sons. Piero, Marco, Antonio, and their father held their property in common until Benedetto's death in 1464 (Battisti 1971, 2:225, document 78), and the sons held their property in common until just before Piero's death before dividing their common property on 4 February 1492; see Battisti 1971, 2:239–240, document 204. Thus Benedetto could represent Piero's interests because they were the family's common interest. Second, Battisti read this document to say that Piero had to return to Borgo Sansepolcro and also finish the altarpiece in forty days. Given that reality, Battisti asserted that the altarpiece was near completion in 1454. But that reading certainly is faulty; most subsequent scholars have read this not as the "next forty" but to return by the end of Lent. See the comments of Dabell 1993, 40–41.

37. See Battisti 1971, 2:222, document 39 and 2:223, document 52. Battisti concludes that Piero was present when arms were said to be assigned to him in March 1453 (2:221, documents 33 and 34). Piero may have been present or his *balestra* assigned by the family to someone else.

38. See Battisti 1971, 2:224, document 60.

39. Battisti 1971, 2:224–225, documents 62, 67, 70, 71.

40. See Appendix, document 8.

41. Battisti 1971, 2:224–225, document 67.

42. For examples, see ASF, NA 6954, unfol., 8 November 1458; ASF, NA 9817, unfol., 12 December 1458; and ASF, NA 9817, unfol., 29 September 1460. See Mario Salmi, "Piero della Francesca e Giuliano Amidei," *Rivista d'arte* 24, 1–2 (1942), 26–44 and the comments of Giovanna Damiani, "Intorno a Piero," in Berti 1992, 68–71, 84–89.

43. See Appendix, document 7.

44. BSS, AC, AM, reg. 8, fol. 98v, in which a stone worker is paid for making the shields.

45. This date conforms with the traditional date of the completion of the altarpiece; for example, see Battisti 1971, 2:11. This date has been repeated in part because Lorentino d'Andrea d'Arezzo, Piero's sometime assistant, completed the painting of a chapel in San Francesco in Arezzo, dated 1463, that has been judged to be modeled on Piero's Misericordia altarpiece. It should be noted, however, that Lorentino drew from Piero only in his representation of the Madonna and Crucifixion. In itself, this demonstrates that Piero had completed those two parts of the Misericordia altarpiece. On Lorentino, see the comments of Damiani, in Berti 1992, 75–81.

46. For these two acts see the Appendix, documents 11 and 13.

47. Donna Cristopina, wife of Nardi Nerii dei Pichis, had donated a piece of land in 1431 to the Misericordia, and she is alluded to in the act of 1450 (Appendix, document 6). See her testament, ASF, NA 19282, fols. 74v–76r.
 The land sold by the confraternity in documents 11 and 13 (see Appendix) may have been bequeathed to the confraternity by the Pichi or it may have been owned by the confraternity. In any event, the confraternity still believed that the Pichi family had not completely paid the value of the earlier bequests. On 28 February 1464 the confraternal officials appointed a procurator "in the cause which they maintain they have with the heirs of Luca di Guido dei Pichi from a bequest made by said Luca to said confraternity for painting an altarpiece." Thus, by the 1460s, Luca's 1435 bequest to the abbey had been rejected by the Camaldolese abbot and the Pichi obligation to pay 50 florins transferred to the Misericordia. If the confraternity received this bequest, it probably went toward a new chapel and a new image of Mary. See Appendix, document 12. Again around March 1465, the confraternity took up its case against the Pichi family, when they sent someone to Florence to get a judgment against Marcolino dei Pichi for an unstated cause; see BSS, AC, AM, reg. 8, fol. 114v.

48. Hope 1992, 16.

49. The most important part of this construction was carried out by Master Giuliano "che fa la capella di S. Maria" and received payments in 1465; BSS, AC, AM, reg. 8, fol. 114v; on fol. 115r this Master Giuliano received at least one subsequent payment. Though the construction of 1465 may have been in a chapel for the existing *gonfalone*, I believe that this "chapel of S. Maria" was the principal altar and housed Piero's Mary of the Misericordia. In 1475 an account specified "the roof of the church above the major altar": BSS, AC, AM, "Libro grosso," fol. 50r. Another chapel was named the "chapel of the *gonfalone*."

50. Certainly there was an earlier *gonfalone* that would have been used for the members' processions. A document of 1 March 1465 relates that the prior of the confraternity, Matteo de Palamidessi, sent 3 florins with a confraternal employee "which he carried to Florence in order to have the curtain before the *gonfalone*" painted; BSS, AC, AM, reg. 8, fol. 114r. There is no indication of the name of the person who painted this curtain for the Misericordia.
 For the construction in the confraternal oratory, see BSS, AC, AM, reg. 8, fols 131v–132v, May–June 1469.

51. See Appendix, document 14.

STEPHEN G. NICHOLS

Johns Hopkins University

In Hoc Signo Vincis:
Constantine, Mother of Harm

The public establishment of Christianity may be considered as one of those important and domestic revolutions which excite the most lively curiosity, and afford the most valuable instruction. The victories and the civil policy of Constantine no longer influence the state of Europe; but a considerable portion of the globe still retains the impression which it received from the conversion of that monarch; and the ecclesiastical institutions of his reign are still connected, by an indissoluble chain, with the opinions, the passions, and the interests of the present generation.[1]

One could not imagine a more cogent rationale for this study of Piero than the sentiments just quoted from Edward Gibbon's *The History of the Decline and Fall of the Roman Empire*, written over two centuries ago. When Piero della Francesca painted his fresco cycle of the True Cross in Arezzo from 1452 to 1466, the "victories and the civil policy of Constantine," insistently portrayed throughout the preceding millennium, still mattered very much, as Marilyn Aronberg Lavin and others who have discussed Piero's frescoes have shown.

Barely two decades before Piero set to work, the fourteenth session of the Council of Basel ("probably on 7 November 1433") heard Nicholas of Cusa (1401–1461) attack the validity of one of the putative political consequences of Constantine's conversion and baptism by Pope Sylvester, the document called the *Constitutum Constantini*, or *Donation of Constantine*, whereby the emperor purportedly placed political control of the western empire in the hands of the pope.[2] A decade later, Lorenzo Valla drew upon Cusanus for his violently polemical denunciation of this same document in his tract *De Falso Credita et Ementita Constantini Donatione* (c. 1439–1442).[3] Nor were matters related to Constantine's victories and civil policies limited to Italy or continental Europe in the fifteenth century. In 1449, just three years before Piero began work at Arezzo, Reginald Pecock, bishop of Saint Asaph (England), discussed the same issues in a well-known work, *The Repressor of over much Blaming of the Clergy*.[4]

A century and a half earlier, Dante Alighieri interwove the leitmotif of Constantine's conversion, victories, and civil policy through key passages of all three cantiche of his *La Divina Commedia*, while devoting a chapter of his treatise on government to the question.[5] It was Dante, in his very first reference to Constantine in *Inferno* 19, who so brilliantly expresses the paradox that Constantine's conversion to Christianity had bequeathed to the West.

"Ahi, Costantin, di quanto mal fu matre,
non la tua conversion, ma quella dote
che da te prese il primo ricco patre!"
(*Inferno* 19:115–117)

[Ah, Constantine, of how much ill was mother,

not your conversion, but that dowry
which the first rich father took from you.][6]

Toward the end of *Purgatorio*, Dante will evoke both sides of the Constantinian legacy: the good one, when Beatrice says to him that he will be with her forever a citizen of Rome whereof Christ is Roman (*Purgatorio* 32:101–102), and the evil one when he describes an apocalyptic vision of the papal chariot attacked by an eagle from above and by a fox and a dragon from below (*Purgatorio* 32:109–160).

"Qui sarai tu poco tempo silvano;
e sarai meco sanza fine cive
di quella Roma onde Cristo è romano.
Però, in pro del mondo che mal vive,
al carro tieni or li occhi, e quel che vedi,
ritornato di là, fa che tu scrive."
(*Purgatorio* 32:100–105)

Non scese mai con sì veloce moto
foco di spessa nube, quando piove
da quel confine che più va remoto,
com' io vidi calar l'uccel di Giove
per l'alber giù, rompendo de la scorza,
non che d'i fiori e de le foglie nove;
e ferì 'l carro di tutta sua forza;
ond' el piegò come nave in fortuna,
vinta da l'onda, or da poggia, or da orza.
(*Purgatorio* 32:109–117)

Poi parve a me che la terra s'aprisse
tr'ambo le ruote, e vidi uscirne un drago
che per lo carro sù la coda fisse;
e come vespa che ritragge l'ago,
a sé traendo la coda maligna,
trasse del fondo, e gissen vago vago.
Quel che rimase, come da gramigna
vivace terra, da la piuma, offerta
forse con intenzion sana e benigna,
si ricoperse, e funne ricoperta
e l'una e l'altra rota e l'temo, in tanto
che più tiene un sospir la bocca aperta.
(*Purgatorio* 32:130–141)

[*"Here shall you be short time a forester, and you shall be with me forever a citizen of that Rome whereof Christ is Roman. Therefore for profit of the world that lives ill, hold your eyes now on the chariot, and what you see, mind that you write it when you have returned yonder"*. . . . *Never with so swift a motion did fire descend from dense cloud, when it falls from the confine that stretches most remote, as I saw the bird of Jove swoop downward through the tree, rending the bark as well as the flowers and the new leaves, and it struck the chariot with all its force, so that it reeled like a*

ship in a tempest, driven by the waves, now to starboard, now to larboard. . . . *Then it seemed to me that the earth opened between the two wheels, and I saw a dragon issue therefrom, which drove its tail upward through the chariot, and, like a wasp that retracts its sting, drawing to itself its malignant tail, tore out part of the bottom and made off, all content. What was left was covered again, as live soil with grass, with the plumage, offered perhaps with sincere and kind intent, and both one and the other wheel were covered with it in less time than a sigh keeps open the mouth.]*

Commentators have long recognized that the apocalyptic vision represents persecutions or calamities that befell the Christian church. As Edward Moore noted in his 1903 commentary: "The third great calamity is the acquisition of temporal passions through the 'Donation of Constantine.' The eagle descends once more and leaves the Car covered with *its own feathers.* . . . This exactly describes the position maintained by Dante in the *De Monarchia*. It is of the very form or essence of the church that she should have no such possessions. They are of the plumage of the eagle. They belong of right to the emperor alone; he had no power or right to alienate them; nor had the church any power or right to receive them."[7]

Dante was clearly appalled by the concept of an association of church and state, a concept whose legality he challenged, as Moore noted, in Book 3, chapter 10, of his treatise *De Monarchia*. Unlike the fifteenth-century polemicists, he did not question the authenticity of the Donation of Constantine, but rather rejected its basic principle, that imperial authority could be alienated by the emperor. In Dante's eyes, as even so truncated a quotation from *Purgatorio* 32 demonstrates, the *Constitutum Constantini* was less a fraud than a failed or sick image. The sight of the papal chariot trying to fly, not on its own sufficient spiritual power, but with the pitiful aid of the displaced pinions of the imperial eagle, exudes pathology. Could one indeed find a more graphic image of metaplasm, the medieval rhetorical term for a barbarism or figure gone awry?

Lorenzo Valla, writing over a century later, deployed a precocious historical criticism in dismantling the very fabric of the

Donation to prove its status as a forgery. But Valla and the Donation of Constantine came from different worlds. His disconfirmation, while perfectly appropriate for the climate of the fifteenth century, totally missed the point of the Donation of Constantine and the climate from which it emerged.

The fact is that the Donation of Constantine cannot be addressed as an isolate. It emerged from two successive and, in some senses, contradictory historical movements: first, from Constantine's own time when Eusebius was largely responsible for articulating and legitimating the earliest legends of the emperor's conversion and historical baptism at Nicomedia at the end of his life. These documents demonstrate the crucial role played by theories of visual imagery and symbolic representation in establishing a basis for the Constantine mythos.

If the first campaign established Constantine's authority as a rationale for the primacy of the eastern church, inevitably a second movement emerged in the late seventh and early eighth centuries to appropriate the prestige of Constantine's baptism and its consequences for the western church. A second set of accretions to the Constantine legend evolved in Britain, France, and Italy wherein Constantine's baptism was made to take place not long after his conversion and to have been presided over not by the Greek prelate, Eusebius of Caesarea, but rather by Sylvester, bishop of Rome.

The Sylvester legend spread rapidly in the East and in the West from the sixth and seventh centuries, assuring that Rome became not only the site of the conversionary vision prior to the battle of the Milvian bridge, but also the site of Constantine's baptism, now seen to have been performed by Sylvester.[8] This second phase, however, had less to do with Sylvester's role in Constantine's spiritual development than with positioning Sylvester to become the emperor's successor as temporal overlord of the West. In a very real sense, it is this phase of the legend that paves the way for Piero, for it initiates a persistent appropriation of the spiritual aura of Constantine for western purposes.

Using the same formula of visual imagery, dream vision, and interpretation established by Eusebius in the fourth century for the initial mythologization of Constantine's conversion, the western material stressed a different chronology for his baptism and the founding of Constantinople through a different set of legends in which Sylvester played a central role.[9] Well before the mid-eighth century, the generally accepted date for the forged *Constitutum Constantini*, the western church, and more particularly, the bishop of Rome, were implicated in a movement to assert ecclesiastical authority over temporal affairs, a key element in the complaints leveled against the Donation by Dante, Cusanus, Valla, and others.

The occidental movement coincided more or less with the de facto division of the Roman and Orthodox churches and was actively evolving in the climate of the Carolingian reinforcement of the autonomy of the Roman church. Both movements used similar procedures in developing divergent myths of Constantine's conversion and baptism, or rather one should say that the western evolution of the Constantine myth followed very closely the pattern of visual image theory used during the first phase.

That pattern was set in the fourth century by Eusebius, who invoked a three-stage sequence for the visual image theory by which the miraculous conversion of Constantine was narrativized and authenticated. The sequence began with a supernatural visual sign, the cross appearing in the heavens at noon accompanied by the written legend: *In hoc signo vincis*. The following night, Christ appears to Constantine in a dream to instruct him on the use of the sign he had seen during the impending battle with Maxentius. Finally, holy men explain the meaning of the apparitions to Constantine who has material representations constructed of the visionary cross, and these in turn gave rise to other kinds of commemorative representations, both verbal and visual. This is Eusebius' account in the *De Vita Constantini* of the translation by Constantine of his vision into material artifacts:[10]

The following day, Constantine calling together the workers in gold and precious stones, he sat in the midst of them and described to them the figure of the sign he had seen, bidding them represent it in gold and precious stones. And this representation I myself have had the opportunity of seeing. . . . *But at the time above specified, being struck with amazement*

at the extraordinary vision and resolving to worship no other God save him who had appeared to him, he sent for those who were acquainted with the mysteries of His doctrine, and enquired who that God was, and what was intended by the sign of the vision he had seen.[11]

Within the economy of the original myth-story, we find a rapid succession from supernatural visions to material production of signs representing that vision. This was in accord with what we might call the politics of witness evolved by Christianity to legitimize the material manifestations of the supernatural on which so much of its theology rested. Since the elect who perceive visions are unlike other mortals, it was argued, there must be associates to record the account from the chosen ones, thereby transforming the supernatural interventions into exemplary stories.

Underlying the concept of an intermediary like Eusebius lay the understanding that the intensely personal nature of the vision required translation to be rendered in a manner that not only could offer credibility to the event and its consequences, but also interpret it in terms of institutional history, in this case the institution of Christianity itself. The account of the reception of such a supernatural vision had, in short, to be the matter of its own *historia*.

Eusebius demonstrates his intuitive grasp of these principles when, at an earlier date, he publicly calls attention to the emperor's oneiric intimacy with Christ, and asks Constantine to furnish his future biographer with some details.

. . . you have frequently received perception of the Savior's divinity through actual experience and have become not by words but by events themselves a herald of the truth to all. You yourself, my Emperor, should leisure permit, could tell us if you wished of the countless manifestations of your savior and his countless personal visits during sleep. (2) I do not mean those suggestions of His that are forbidden to us, but those implanted by reason in your own self, conveying what is publicly beneficial and useful for the care of all. (3) You might, for instance, fittingly tell us about the manifest support by your Champion and Guardian God in battles, the destruction of enemies and conspirators, protection from dangers, solutions of the insoluble . . . about your fore-

thought for the general good . . . about your undertaking of enormous projects.[12]

The Tricennial Orations, *De Laudibus Constantini* (*LC*), in 336, celebrating the thirtieth year of Constantine's accession, show how, long before the *De Vita Constantini*, Eusebius had already cast himself as "translator" of Constantine's special relationship with the divinity. Here Eusebius seeks not only to document and portray Constantine's visions, but also to link them explicitly to a Christian political agenda.

As Harold Allen Drake tells us, these encomia stated for the first time "the political philosophy of the Christian Empire, that philosophy of the State which was consistently maintained throughout the millennium of Byzantine absolutism." It was a philosophy based on the idea that "the existence of One True God must mean that there is only one true rule . . . that rule is the Roman Empire, governed by an Emperor chosen by God through his Logos, Christ."[13]

Eusebius freely admits the private nature of Constantine's vision, a sign of the emperor's status as a chosen vessel:

No human eye has seen this, nor any ear discerned it, for it is not possible for the mind encased in flesh to discern what things are prepared for those graced with piety, such as yourself, most God-fearing sovereign, to whom alone . . . has the Universal All-ruling God Himself given power to purify human life, to whom he has revealed even his own Saving Sign, by which he prevailed over death and fashioned a triumph over His enemies. Setting this victorious trophy, apotropaic of demons, against the idols of error, he has won victories over all his godless foes and barbarians, and now over the demons themselves, which are but another type of barbarians (*LC* 6:21).

As witness for the vision and its consequences, Eusebius must transform private vision into historical event replete with material consequences and accounts of the representations of the visionary images produced. He does so a little later in the *De Laudibus* in a manner that leaves little doubt as to the political thrust of the act of witness so far as bridging any remaining gap between the secular and religious tenor of imperial power.

Those who waged war against the Universal Sovereign, encouraged by the numbers of their gods, attacked with great strength in military

forces, advancing behind phantoms of the strengthless dead. But he, fortified with the armor of piety, arrayed against the multitude of his foes the Saving and Life-Giving Sign like some safeguard and shield against evils, and gained a victory over his enemies and the spirits alike. Then with a well-founded conclusion rendering a thanksgiving prayer to the cause of victory, by loud voice and by commemorative inscriptions he proclaimed to all men the Victory-bringing Sign and erected in the midst of the ruling city this great trophy against all enemies, this explicit and indestructible salutary Sign of the Roman Empire and safeguard of the Universal Kingdom. *This he taught all men to acknowledge, above all the military, who surely most of all need to know not to pin one's hopes on spears and panoplies, nor on strength of body, but to recognize the God over all, the Giver of every good, and of victory itself* (LC 9:8–9, emphasis added).

While Eusebius' oft-deplored rhetorical excess may seem tiresome to the modern reader, we cannot afford to ignore the extraordinary visual dimension it imparts to his account. It is this same visuality that Jacobus de Voragine captures in the thirteenth century in the *Golden Legend* (*Legenda Aurea*), the same pictorial flair that inspired monumental frescoes from Agnolo Gaddi's cycle of the True Cross at Santa Croce in Florence beginning in the early fourteenth century.[14]

Let us also note Eusebius' insistent references to the production and use of material images commemorating Constantine's vision, victories, and civil acts. The visual image plays a crucial role in establishing the chain of representations that ultimately creates the historical record precisely because of their symbolic power in Christian culture. As Eusebius demonstrates, visions mediate between historical figures and God in the Bible. They provide evidence for the ongoing interaction between history and divinity. Indeed, this nexus offered the ultimate rationale for the role played by pictures in Christianity, beginning with the logic for the portrayal of Christ himself. John of Damascus, in his eighth-century response to the iconoclasts who ruled Byzantium in the first part of that century, asserts that, for Christians, picture and history naturally implicate each other, Christ being the undisputed figuration of God in history.[15]

The visions associated with the Constantine legend from the beginning use word and image in a highly iconographic manner. Indeed, the early interpreters seem to have been consummate art critics, understanding the power of juxtaposing image and logos in an original miraculous event, and then of reproducing that visual and verbal conjunction in written accounts and visual replicas of the signs figuring in the visions.

They understood, as we do, the reciprocal interaction of source and reception in authenticating a legend: the image provides the source for the reception of the myth; the reception then produces legitimating confirmations of the original image in terms of corroborating witnesses—"the whole army saw the cross in the sky," "Constantine told this to me years later," are two examples provided by Eusebius—and finally the reception histories themselves become the sources for subsequent receptions of the legend. So even within Eusebius' own oeuvre, the *De Laudibus* synthesizes the state of Constantine's mythos in the years immediately preceding his death while providing accounts that will reappear, narrativized, in the *De Vita Constantini*.

We find this pattern repeated in one form or another throughout the elaboration of the Constantine-True Cross material, including the vernacular treatment of the Heraclius accretion to the legend of the True Cross by Gautier d'Arras in France in the early thirteenth century. Accretions to the mythos at each stage increase the specificity of the historical account, extending it through time. Thus the story of how Emperor Heraclius recovers the True Cross stolen by infidels from Jerusalem, four centuries after Helena had rediscovered it and Constantine housed it fittingly in the holy city, both reaffirms the historicity of the original myth and demonstrates its continuing relevance and generative power through time. The secret of its strength as a cultural force lies in its ongoing contemporaneity.[16]

The manifestations of figural vision in each phase occur in a verbal context, that is, as *historia* as in the *De Vita Constantini*, or in some other kind of written treatise. This means that the visual image and the dream vision—always described as presenting an intense visual experience—are initially for-

mulated by ekphrasis, that is, as verbal descriptions of visual events and artifacts.

In this capacity, they may be said to function not unlike the rationale adduced for icons, verbal icons, given in the seventh ecumenical council of Nicaea (787). Many of the statements about icons from the proceedings of that council could apply to the visualization of Constantine's conversion.[17]

Icons remind us of Christ's life among men. That which the narrative declares in writing is the same as that which the icon does in colors (232 c, Sahas, 69).

. . . the painting of icons is something that has been handed down to the church before the holy councils, as well as after them, like the tradition of the gospel. Thus, as when we receive the sound of the reading with our ears, we transmit it to our mind, so by looking with our eyes at the painted icons, we are enlightened in our mind. Through two things following each other, that is by reading and also seeing the reproduction of the painting, we learn the same thing, that is, how to recall what has taken place. The operation of these two most basic senses is also found conjoined in the Song of Songs, where it says: Show me thy face, and cause me to hear thy voice; for thy voice is sweet, and thy countenance is beautiful (220E–221A, Sahas, 61).

The defense of the icon in these passages relies very much on the politics of witness. So long as the subject matter of the icon conforms to the religious, it is inconceivable, seemingly, that the representation could be false. Indeed, given the operative theory of representation, it could not be. For the icon depends on resemblance; likeness connects image to prototype in so tight a nexus of referentiality that iconophiles could argue, as did Saint Basil in a formula echoed by John of Damascus and reaffirmed by the Council of Nicaea, that "the honor given to the image is transferred to the prototype."[18]

This does not mean that no distinction is made between image and prototype. On the contrary, they are careful to spell out the difference in formulas that reaffirm the concepts of resemblance and referentiality. "What the icon has in common with the archetype is only the name, not the essence" (252D, Sahas, 84); or again, "it is quite clear to everyone that 'icon' is one thing and 'pro-

totype' another; the one is inanimate, the other animate" (261A, Sahas, 91).

Christ serves well as an example for specifying the nature of the relationship between representation and prototype. For the resemblance between icon and original comes from two sources: the name "Christ" by which the icon is identified and the Gospel texts that describe him. Since the essence of Christ, his divinity, cannot be captured pictorially, the likeness conveyed must then come from traditional social myths about the appearance of Christ—the expectations handed down from generation to generation—and from descriptions, however incomplete, in scripture.[19]

In other words, "likeness" does not mean exact resemblance to a model available for comparison. Likeness may also take the form of idea, concept, or analogy gleaned not from ocular evidence but from textual sources. In short, we are dealing with a theory of bimodal representation, one that permits verbal texts to be represented graphically and icons to represent the Logos and its history. Anthropologically, the visual system reinforces the oral and written narratives in the circularity of sources that we saw Eusebius refine and propagate for the early Constantine mythos.

The seventh ecumenical council of Nicaea outlines how such bimodal representation works in practice:

The representation of scenes in colours follows the narrative of the gospel; and the narrative of the gospel follows the narrative of the paintings. Both are good and honourable. Things which are indicative of each other undoubtedly speak for each other. If we say 'the sun is over the earth,' it is certainly daytime. And if we say 'it is daytime,' the sun is certainly over the earth. So it is in this case. When we see on an icon the angel bringing the good news to the Virgin, we must certainly bring to mind that the angel Gabriel was sent from God to the virgin. And he came to her and said: 'Hail, O favored one, the Lord is with you. Blessed are you among women' (Luke 1:26–28). *Thus from the gospel we have heard of the mystery communicated to the Virgin through the angel, and this way we are reminded of it. Now when we see the same thing on an icon we perceive the event with greater emphasis* (269B–C, Sahas, 98).

Thinking back to the first phase of the

Constantine legend, we can see now how expertly Eusebius exploits this bimodal circularity, only, in Constantine's case, it begins with the visual set of images. Eusebius tells us in *De Laudibus* that to the emperor "alone of those who have yet been here since the start of time has the Universal All-Ruling God Himself given power to purify human life, to whom He has revealed even His own Saving Sign, by which He prevailed over death and fashioned a triumph over His enemies" (*LC* 6:21).

Then after Constantine's death, in *De Vita Constantini*, he again recounts the visions to show how the emperor brought spiritual power to imperial rule by imposing the sign of the cross upon his army and the empire. But note how insistently Constantine and the cross become entwined. Through the circularity of vision and *vita*, the cross has become invested in him and his legend. The cross has become Constantine's sign as well as Christ's. But there are nuances: Christ possessed an unchanging spiritual value, Constantine a variable, political valence. As such he had become a mythical signifier ready to be appropriated by a Sylvester, a Heraclius, a Charlemagne, or, as Dante would complain, by the unknown forger of the Donation of Constantine. If the first phase of the Constantine legend tells us nothing else, we learn that control of images and of their interpretation is crucial for a successful politics of witness.

If Constantine's conversion changed the social, political, and religious contours of a significant portion of the then-known world, the Donation of Constantine, for the roughly seven hundred years that it was believed to be authentic, allowed one-half of the imperial mantle of temporal rule to be vested in the western church. The Donation proposed a vision of western unity with church and state closely interlinked to provide, theoretically, a shield against pagan foe and internal heretic alike. Little wonder that it has been called that "most stupendous of all the medieval forgeries which . . . commanded for seven centuries the almost unquestioning belief of mankind."[20]

Dante might view this conflation of spiritual and temporal power with apocalyptic horror, and Walter von der Vogelweide vigorously vent Ghibelline hatred of the document. The fact remains that the Con-

stantine legend had, from the beginning, provided a powerful thematic of Christian unity against pagan invasion, signified in Piero della Francesca's time by western fears of the Turks. The Donation simply gave putative legal status to a powerful cultural current. While it is undoubtedly ironic that the Donation should have been definitively exposed as a forgery when the Turkish threat was so strong, Piero's frescoes at Arezzo provide vivid proof that the politics of witness that made the Donation possible and plausible in the first place remained fully operable.

Finally, I would like to deal briefly, not with the context of the undoing of the Donation, but with its beginning in the eighth century. Valla and the other humanist voices raised against the authenticity of the Donation say nothing about the role that image theory plays in the document. Yet the framing story told by the Donation as motivation for the act—taken more or less directly from the Life of Sylvester, bishop of Rome[21]—and the details of the transfer of power invoke the politics of witness in a way at once familiar and very strange. The same pieces that we found in *De Vita Constantini* have been deployed, but they have been boldly transposed. If, as has been argued, the *Constitutum Constantini* proved the most successful forgery ever perpetrated, its success may in no small measure be ascribed to its brilliant use of images, both verbal and visual, a fact not lost on the seventh ecumenical council of Nicaea.

Early in the text of the Donation, speaking in the first person, Constantine recounts the story of the leprosy that disfigured his body. Pagan seers advised him to bathe his entire body in the blood of newborn infants. Yielding at the last moment to the entreaties of the infants' mothers, Constantine spares the babies. On the following night, the apostles Peter and Paul appear to him in a dream advising him to seek out Sylvester, bishop of Rome, who will immerse him in holy water, curing his illness entirely. Constantine will then convert, forbid the persecution of Christians, and order that all the churches be restored throughout the world.

Constantine awakens and goes to Mount Soracte where the apostles have told him Sylvester and his flock were hiding. Finding Sylvester, Constantine interrogates him as

to the identity of his oneiric visitors. In answer, Sylvester produces icons of Peter and Paul; Constantine recognizes in the icons the same faces as those he had seen in his dream. The rest of the story confirms the vision: Constantine's baptism becomes a literal as well as a symbolic cleansing of the emperor's body.

Much could be said about the symmetrical exchange of symbols in the Donation as Constantine divests himself of imperial insignia such as the crown, the neckband, the purple mantle, the scarlet tunic, the Lateran Palace itself, all henceforth invested in the Roman pontiff. While they were indeed the trappings the pope had assumed by the ninth century, in the text of the Donation they function as material details corroborating the historicity of the account. They are like the crosses and churches mentioned by Eusebius: markers in the real world of the impression left by an extraordinary event. The minuteness of the details lends verisimilitude, reinforcing the overall *effet de réel*.

The pivotal point in the account, and the one that seems exciting even at this distance, comes in a paragraph taken practically without variant from the *Vita Silvestri*: the account of Sylvester's exhibiting the icons of Peter and Paul in which Constantine instantly recognizes the faces of his nocturnal apparitions. For this section to have been redeployed as it is within the general strategy of the Donation suggests a sophisticated level of art criticism, or at least an intuitive understanding of image theory.

To appreciate the sophistication of the Donation account, we need to recall the cognate scene in *De Vita Constantini*. There, the day following the emperor's vision, workmen produce a real cross from his description: "he sat in the midst of them and described to them the figure of the sign he had seen, bidding them represent it in gold and precious stones." Eusebius leaves no doubt of the emperor's central role in both having the vision and supervising its material realization.

The Donation significantly reverses the scenario. Constantine still has the vision, but Sylvester possesses the signs, the images of the apostles, who function in this account as the cross figured in *De Vita Constantini*.

Furthermore, it is Constantine who must seek out Sylvester, bringing to him a description whose significance he personally does not understand. In this case Sylvester not only explains the vision but produces confirming images of it, which, unlike the cross in the first account, *exist prior to the vision*. In short, the church already possesses what Constantine must find. Constantine does not bring the cross to the world in the Donation narrative, but simply confirms the veracity of its sign systems with his vision, and honors the power of its moral stature by his donation. The narrative frames the vision in such a way as to teach what Saints Basil and John of Damascus claimed: that Christian icons exactly resemble the holy men and objects they claim to, and that they do have spiritual power, here the power of religious conversion.[22]

Who could doubt this when we read Constantine's "own" words, saying in the imperial first person plural:

frygium vero candido nitore splendidam resurrectionem dominicam designans eius sacratissimo vertici manibus nostris posuimus, et tenentes frenum equi ipsius pro reverentia beati Petri stratoris officium exhibuimus; statuentes, eundem frygium omnes eius successores pontifices singulariter uti in processionibus.[23]

we placed upon [the pope's] most holy head, with our own hands, a glittering tiara of dazzling white representing the Lord's resurrection, and holding the bridle of his horse, out of reverence for the Blessed Peter, we performed for him the duty of groom, decreeing that all his successors, and they alone, use this same tiara in procession in imitation of our power.

One is tempted to call the Donation a kind of *miracle* or morality play *avant la lettre*. That is not how Lorenzo Valla perceived it, though, when he termed it unmotivated as well as illegal. Within the context of the seventh and eighth centuries, however, Constantine's extraordinary gesture of divestiture may be seen to have important analogues. I will conclude by mentioning one of them.

In Bishop Aldhelm's (d. 710) *De Laudibus Virginitatis*, composed in England in the late seventh century, we find the first mention of a legend in which Sylvester again interprets a dream of Constantine, this one concerning

the founding of Constantinople. This dream takes place during a visit by Constantine to Byzantium while Sylvester remains in Rome. In the vision, Constantine sees an old woman, very decrepit and near death. Sylvester appears before the emperor and commands him to pray for the woman; as the emperor prays, the woman transforms herself into a young and beautiful maiden. In a gesture one might take as a forerunner of Rodolphus Glaber's eleventh-century image of Europe's being adorned with a white mantle of churches, Constantine covers the woman with his cloak and places a diadem of burnished gold and shining gems on her head.[24]

Bewildered as to the meaning of the dream, when he awakens, Constantine fasts for a week. On the seventh day, Sylvester again visits him in a dream explaining that the decrepit old woman represents the then ancient city of Byzantium whose walls are wasted because of their age, while the beautiful young woman is the future city of Constantinople that Constantine must found according to Sylvester's instructions.[25]

Leaving aside the startling image of the bishop of Rome's masterminding the founding of Constantinople, let us keep in mind the image of the woman draped with the emperor's cloak. Iconographically, she reminds one of images of the Virgin-with-a-mantle protecting humankind, where the Virgin symbolizes the church and her mantle, the church's realm. Constantine, of course, was known for his ecclesiastical benefactions in Constantinople, but also for having constructed the Anastasis or church of the Holy Sepulcher in Jerusalem after Helena's finding of the True Cross. If we accept the current ninth-century dating of the forging of the *Constitutum Constantini*, Aldhelm's image of Constantine placing his cloak and diadem on the beautiful young maiden anticipates—and may even have suggested—the similar scene in the Donation. For the Donation specifically enumerates the imperial diadem and scarlet and purple robes as the symbolic vestments of political authority with which Constantine invests the western church.

The emperor portrayed in the *Constitutum Constantini* represents a ninth-century western perception, in a form favorable to the papacy, for a state in which, for better or for worse, religion and political power closely correlate. The *Constitutum*, in short, provided a powerful religio-political myth for the Latin West, virtually a new "Roman Constantine" whom the civically involved artists and poets of the day could celebrate in all the innovative ways we have seen. By assuring the continued relevance to the Latin West of the emperor's mythos, the Donation fueled artistic restatements as well as political controversy, both crucial for the High Middle Ages.

Gibbon's sweeping assessment of the continuing political relevance of Constantine with which we began could surely not have been made had the Donation never been formulated. Bishop Aldhelm, Agnolo Gaddi, Jacobus de Voragine, Piero, and Dante understood the historic importance of the Donation. Lorenzo Valla certainly showed great skill as a philologist in challenging the document's authenticity, but he missed the point. Piero got it right.

I would like to express my thanks to Tracy Adams, whose ingenuity and interest in assisting with this project have materially aided its progress.

1. Edward Gibbon, *The History of the Decline and Fall of the Roman Empire*, 6 vols. (Boston, 1850), 2:248.

2. Nicholas of Cusa, *De Concordantia Catholica: The Catholic Concordance*, ed. and trans. Paul E. Sigmund (Cambridge, 1991), Book 3, chap. 2. See also Morimichi Watanabe, *The Political Ideas of Nicholas of Cusa, with Special Reference to His* De Concordantia Catholica (Geneva, 1963), particularly chap. 5.1, 145–156.

3. Lorenzo Valla, *De Falso Credita et Ementita Constantini Donatione*, ed. W. Setz, in Monumenta Germaniae Historica 10 (Weimar, 1976).

4. Reginald Pecock, *The Repressor of over much Blaming of the Clergy*, Rolls Series, *Rerum Britannicarum Medii Aevi Scriptores* 19 (London, 1860), xix, xx, 350–366.

5. The passages in question are: *Inferno* 19:115–117; *Purgatorio* 32:124–129; *Paradiso* 20:58–60; *De Monarchia* 2:12.15–18, 2:13.66–69, 3:10.1–6, 105–107, 3:13.6–4.

6. Dante Alighieri, *The Divine Comedy*, trans. Charles S. Singleton, 6 vols., Bollingen series 80 (Princeton, 1977).

7. Quoted by Singleton, *Purgatorio, 2: Commentary*, 800–801.

8. Christopher Bush Coleman, *Constantine the Great and Christianity* (New York, 1914), 164–172.

. . . there must have been in existence at Rome by the beginning of the sixth century, a book containing the legend of Constantine's leprosy and baptism by Sylvester . . . It is probable that toward the end of the sixth century this anonymous Vita Silvestri *was touched up by an enthusiast for the primacy of Rome who saw the opportunity it afforded. [. . . A subsequent, more complete] version had apparently become known in the east before the end of the sixth century, where in fact the* Vita Silvestri *generally became popular, and seems even to have displaced the original eastern form of the legend of Constantine's conversion.* (Coleman 1914, 166–167)

9. See note 8 above. Coleman (1914, 164) also observes: "The Latin versions of the legend [of Constantine's conversion] end with two episodes, the miraculous founding of Constantinople, and the finding of the true cross, which are not found in the Greek versions." Coleman himself tries to negotiate the different versions by arguing the need "to distinguish between the legend itself (that is, the bare story that Constantine was a persecutor afflicted with leprosy, and was converted, baptized, and cured through the agency of Sylvester at Rome) and differences of detail or variations in the different written versions." It is precisely in the skein of tangled details and conflicting versions, rather than in some

artificially extracted legend, that we may discover the workings of the visual and verbal theories, that is, the mythological anthropology that produced the legend. Indeed, without the disparate webs of imagery, there is no legend.

10. The principal edition of *De Vita Constantini* is Friedhelm Winkelmann, *Über das Leben des Kaisers Konstantin*, in *Eusebius Werke* 1.1 (Berlin, 1975). Recent articles of interest for the historical and rhetorical basis of *De Vita Constantini* are Harold Allen Drake, "What Eusebius Knew: The Genesis of the *Vita Constantini*," *Classical Philology* 83 (1988), 20–38, and Michael J. Hollerich, "Myth and History in Eusebius's *De Vita Constantini: Vit. Const.* 1.12 in Its Contemporary Setting," *Harvard Theological Review* 82.4 (1989), 421–445.

11. *De Vita Constantini* 1, trans. E. C. Richardson, *Eusebius: Church History, Life of Constantine the Great, and Oration in Praise of Constantine*, vol. 1 of *A Select Library of Nicene and Post-Nicene Fathers of the Christian Church* (Grand Rapids, Mich., 1982).

12. *De Laudibus Constantini* 18.1–3. Harold Allen Drake, *In Praise of Constantine: A Historical Study and New Translation of Eusebius' Tricennial Orations* (Berkeley, Calif., 1976), 126–127.

13. Drake 1976, 11.

14. *The first time that all parts of the [Constantine] story were brought together in literary form was in* The Golden Legend, *a prose compendium of saints' lives and religious events written by the Dominican Bishop Jacobus de Voragine about 1261–1262 Under the feast of 3 May are found several versions of Constantine's vision, battle, and victory and Helena's finding and proofing of the cross. Under 14 September the historical story of the theft and retrieval of the cross is embellished with many fabulous details from apocryphal sources. It is generally agreed that the texts of the* Golden Legend *provided the main literary source for the subject matter of Agnolo Gaddi's frescoes.* (Marilyn Aronberg Lavin, *The Place of Narrative: Mural Decoration in Italian Churches, 431–1600* [Chicago, 1990], 103.)

15. "Shall we not record with images the saving passion and miracles of Christ our God, so that when my son asks me, 'what is this?' I may say that God the Word became man, and that through him not only Israel passed through the Jordan, but the whole human race regained its original happiness?" Saint John of Damascus, "First Apology of Saint John of Damascus against Those Who Attack the Divine Images," §18, in *On the Divine Images*, trans. David Anderson (Crestwood, N.Y., 1980), 26.

16. The continuing power of foundational myths in western culture, particularly their implication in conceptions of history, forms the basis of a work relevant to the material discussed in this paper: Hans Blumenberg, *Work on Myth (Arbeit am Mythos)*, trans. Robert M. Wallace (Cambridge, Mass., 1985).

17. The following quotations are taken from Daniel J. Sahas, *Icon and Logos: Sources in Eighth-Century*

Iconoclasm, An Annotated Translation of the Sixth Session of the Seventh Ecumenical Council (Nicaea, 787) (Toronto, 1988).

18. Basil of Caesarea, *On the Holy Spirit*, chap. 29, in Jacques Paul Migne, ed., *Patrologia Graeca* (Paris, 1857–1903), 32:204D–205A; John of Damascus, ed. Anderson 1980, 1.21 (29); Sahas 1988, 252C–E (84–85), 273A–B (101).

19. *As to the name 'Christ,' this is indicative of divinity and of humanity as well, the two perfect natures of the Savior. Christians have been taught to depict the icon of that nature of his according to which He has been seen, not of that according to which He is invisible; the latter is uncircumscribable. For we have heard from the gospel that* No one has ever seen God *(John 1.18). Therefore since Christ is depicted according to his human nature, it is obvious, as the truth has shown, that Christians confess that what the icon has in common with the archetype is only the name, not the essence.* (Sahas, 1988, 252C–D, 84)

20. James Bryce, *The Holy Roman Empire*, new ed. (New York, 1905), 99.

21. Watanabe 1963, 145–146; Coleman 1914,

175–176. Coleman appends to his book the relevant passages from the conversion of Constantine in the *Vita Sylvestri* (Appendix 1, 217–227); the text of the *Constitutum Constantini* (Appendix 2, 228–237); and Cusanus' attack on the Donation from *De Concordantia Catholica*, Book 3, chap. 2 (Appendix 3, 238–242).

22. One may usefully recall in this context the eleventh-century Old French *Vie de Saint Alexis*, in which an icon of the Virgin in a church in Edessa speaks in order to point out the saintly Alexis, who has sat unrecognized for seventeen years next to the church door. The speaking icon lies at the basis of the saintly status of Alexis and of the hagiographical account that becomes the verbal equivalent of the icon.

23. *Constitutum*, §16, text from Coleman 1914, 236.

24. *De Laudibus Virginitatis*, ed. Rudolf Ehwald, in *Aldhelmi Opera Omnia*, Monumenta Germaniae Historica, *Auctores Antiquissimi* 15 (Berlin, 1919), 259. See also *Aldhelm: The Prose Works*, trans. Michael Lapidge and Michael Herren (Cambridge, 1979), 83.

25. Ehwald 1919, 259; Lapidge and Herren 1979, 84.

MICHAEL CURSCHMANN
Princeton University

Constantine—Heraclius: German Texts and Picture Cycles

In Germany, as elsewhere, the hagiographic trilogy of the Holy Cross—its prehistory in the Old Testament, its discovery by Helena under the aegis of her son, Emperor Constantine, and its recovery by Emperor Heraclius three hundred years later—occasioned a number of (mostly partial) recreations in poetic and pictorial narrative between the twelfth century and the fifteenth.[1] The corpus of texts in question has never been surveyed, let alone analyzed, and the latter is true also of the corpus of pictorial representations that have survived. However, to attempt seriously to reduce that deficit in the present context would take up too much space and generate more tedium than light. Mindful of Piero della Francesca's role as the foremost creative transformer of the legend in his time, I shall instead concentrate on the process of transmission and on two representative German examples of such transformation. From my particular vernacular vantage point, it appears that the two basic forms of (written) textual transmission of all or parts of this hagiographic material were verse chronicles and prose legendaries. I will use this vantage point to discuss how such relatively amorphous traditions transport such material to those points where, for whatever reason, representation then shifts to more specialized and selective modes, be they verbal or visual. Because, in Germany, Heraclius offers such an instructive example of one kind, he will be the subject of the first of my two case studies.

I

We begin with the church of Our Lady in the village of Fraurombach, near the town of Schlitz in the state of Hesse. Probably in the second quarter of the fourteenth century, when it was basically still in its original romanesque state, a cycle of wall paintings was executed here, in mixed fresco/secco technique, at the east end of the nave (fig. 1).[2] The murals depict, in highly unorthodox fashion, the story of Heraclius and the cross, the story associated with the feast of *elevatio crucis* (14 September). The dimensions are very much smaller, but in other respects the composition is superficially similar to the one in Arezzo: three tiers of pictures on both the north and the south walls face each other across the single nave and are connected through a triumphal arch that in this instance separates the nave from the choir beyond. In its current form and dimension this arch is (later) gothic, but even its higher and wider romanesque predecessor, still visible above (figs. 2, 3), left enough room for pictures to be placed on either side, in single vertical file, again arranged in three tiers and reaching into the spandrels at the top. Time and man have not been kind to what must have been monumental narrative art of some distinction. Architectural alterations,

notably the creation of a (gothic) north win-dow and of a gallery over the nave, have destroyed considerable parts, mostly where the narrative must have begun, on the north wall (fig. 4). The walls were completely painted over at some point, and what could still be salvaged from under a thick layer of plaster after the rediscovery of the paintings in 1901 may have suffered almost as much from repeated and inept attempts at conser-vation as from renewed exposure.

Even so, fragmented and faded as it is today, this sequence of pictures is still recog-nizable as unique among Heraclius cycles in that it narrates mostly events from the emperor's childhood and adolescence. This in turn means that it must be descended from a literary, poetic tradition that began in the 1180s with an Old French verse romance, *Eracle*, by Gautier d'Arras. This poem was then adapted, most probably around 1220, by a German whom we know only as Otte and who retained the outline of the story.[3] It is an amalgam of hagiographic, romance, and folktale elements that divides along generic lines into three main parts.

First, Heraclius is a divinely gifted child clairvoyant whom his mother sells into slav-ery to Emperor Focas (Phokas). He proceeds to demonstrate his special talent by discov-ering a stone that renders its bearer invulner-able, a yearling that, if allowed to mature, will outrun all other horses, and a virgin of pure heart by the name of Athanais who will make the emperor an exemplary wife. In

every case Heraclius himself proves the value of his judgment, albeit in a pattern of diminishing returns: stone in hand, he has himself tied to a rock and submerged in deep water for a long time without drowning. His prematurely challenged horse beats three champion racers, but subsequently has to be killed because it has spilled all of its bone marrow in the process. The third case in effect develops into the second major part of the story. Focas tries his wife's virtue too severely: she is kept a virtual prisoner in his absence, falls in love with a young knight, Parides, and conspires with a wily old woman named Morfea to effect a rendezvous. Upon his and the emperor's return, Heraclius with the magic eye realizes of course what has happened, but he persuades his master to forgive, divorce his wife, and let the young people marry and live happily ever after. Part three, the legend proper, begins eight years later, when Heraclius is elected emperor after Focas and follows the traditional Byzantine chronicle account: the Persian idolater Cosdras (Chosroes) abducts Christ's cross from Jerusalem and creates for himself an artificial heaven where the cross stands behind his throne. Heraclius meets the younger Cosdras and his army at the Danube and eventually kills him in single combat. He invades the tower of the elder Cosdras, and confronts and decapitates the unrepen-tant old man. In returning the cross to Jerusalem, Heraclius makes the mistake of approaching the gate on horseback in imperi-

al regalia. The gates close and, admonished by an angel of the Lord, he carries the cross into the city in penitent's garb and on foot.

Rudolf Kautzsch's estimate that close to half of the painted surface had been irretrievably lost even by his time (note 2 above) may be a little too high, but it is clear that any new attempt at detailed analysis of the composition at Fraurombach and its relation to its poetic source will have to be preceded by the kind of close inspection that cannot be undertaken without special technical assistance. It is hoped that the new photographs will serve as encouragement in that direction. Equally clear, however, is the overall result of the reliance of the painter's patrons on some version of Otte's poem as, to put it conservatively, their chief source of inspiration and iconography. In terms of narrative chronology, the sequence began on the north wall, moving from west to east and top to bottom, with an extensive account of the hero's childhood, purchase by the emperor's steward, and first appearance before the emperor (fig. 5). This emphasis on the extra-

canonical part of his biography then continued across the arch and into the top register on the south wall. An important key is the scene in the spandrel to the right of the arch (figs. 6, 7): this must be the young Heraclius, underwater and weighted down by a stone tied around his neck.[4] This in turn virtually guarantees that the badly faded scenes from there to the right depicted salient moments from what I have called the second part of the story: Athanais letting herself fall from her horse to be received into Morfea's house, where Parides is waiting; and on the south wall: the lovers in bed[5] and Heraclius' plea before Phokas (fig. 8). That the legend proper is represented by only five scenes in the two registers below is not surprising in itself, for *exaltatio* cycles are not only rare but invariably short. In this case, what appears to have been included is the battle on the Danube(?) in the middle register to the right of the arch; the confrontation with the elder Chosroes, who sits on his throne with the cross behind him(!) and no other visible attribute,[6] followed in the same frame by his

2. Fraurombach, Heraclius murals, second quarter fourteenth century, the triumphal arch, top
Bildarchiv Foto Marburg

3. Fraurombach, Heraclius murals, second quarter fourteenth century, the triumphal arch, top left: Heraclius and the steward leave Emperor Phokas
Bildarchiv Foto Marburg

decapitation, while (perhaps) his younger son is trying to escape to the right;[7] and, in the bottom register, the two scenes outside Jerusalem.[8] The context and overall proportions are surprising, and that brings us back to Otte and the main question: how do we get from there to here, from Otte's poem to this particular visualization?

The first and decisive step was taken by Otte himself. While he did retain the outline and much of the substance of Gautier's story, he dramatically changed its general character and import by adding a number of comments throughout and a lengthy historical appendix at the end that systematically relate these events to the course of world history. For example, the narrator uses the occasion of Heraclius' birth to point out that, while this child is destined to recover the True Cross, Jerusalem itself will be lost after that until Godfrey of Bouillon comes along, who lies buried there "to this day."[9] Thus the battle between Good and Evil never really ends, except that it is now carried on by the West—the *translatio* theory, which parallels the occasional transfer of literary motifs from the legend of Constantine to that of Charlemagne. In what serves in effect as a prologue to the third part, Otte takes Heraclius' election as Phokas' successor as an opportunity to correct Gautier's apolitically Byzantine point of view: Constantine has indeed moved the capital of the Roman Empire east, but Charlemagne has long restored it to its rightful home. Hence, whereas Heraclius is quite properly called "emperor," it is brazen presumption for the latter-day "kings" of Constantinople to claim that title.[10] Finally, as the poem moves on beyond Gautier's conclusion into a series of historical anecdotes,[11] not all of them favorable to the hero, attention gradually shifts to king *tagebreht*, that is, Dagobert I of the Merovingian Franks. In such ways Otte firmly situates Gautier's fanciful story in the grand design of salvation history, down to some quite specific geopolitical implications, as described by his countryman, Otto of Freising, in his seminal *Chronica sive Historia de duabus civitatibus* of 1146.[12]

This rehistoricization in turn propelled the poem into an unusual trajectory of transmission. The gradual vernacularization of universal historiography brought forth a type of text that flourishes from the middle of the twelfth century well into the fourteenth and is even more characteristically German: the vernacular world chronicle in verse. That is the context in which Otte's composition of over five thousand lines is predominantly transmitted and read. Two of the three surviving copies are actually insertions into individual manuscripts of two of these monumental verse histories. The third (incomplete one) is almost as clearly marked as *historia* by being copied together with Heinrich von Veldeke's *Eneit*: together they form an early history of the Roman Empire in East and West in one volume (c. 1300).[13] In a fourth case that is always overlooked in this connection, because it has no direct bearing on the constitution of the critical text, yet another one of the great historiographical compilers has adopted the tale by fashioning his very own version of what is obviously Otte's poem.

The original *Kaiserchronik* that ushered in this new age of vernacular historiography around 1140 contained a conventional account of the Heraclius legend in just over two hundred lines.[14] This account was basically retained in the first of two redactions made in the course of the thirteenth century, but in one of the three surviving full-length copies of this redaction, written close to 1300, it was replaced by a copy of Otte's *Eraclius*.[15] This insertion serves as an early indicator of a tendency that ultimately accounts for much of the text as well as the general open-endedness of the last, largest, and most diversely disseminated of these verse chronicles. Its original compiler was one Heinrich von München, in the first half of the fourteenth century.[16] In 1398 Johann Albrant von Suntra, a copyist within one of the two main branches of this textual tradition who hailed from Hesse but appears to have worked in Vienna, once again inserted Otte's text. In this case, however, the association as such may go back quite a bit further. A number of Heinrich von München manuscripts show distinctive, if minor, traces of Otte's text in this particular section of the compilation, and from what we know

so far about the filiation of the work as a whole, it seems quite possible that the original design contained at least substantial *Eraclius* extracts.[17] It would have been one of several preexisting poetic texts that Heinrich wove into his "world history," as long as they were generically "appropriate," but this is the only one of them that seems to have lived in almost exclusive association with this particular brand of the *genus historicum* for the whole length of its documented shelf life. That point is, if anything, underscored by the additional example of Jans Enikel, who composed his own world chronicle around 1280. Enikel leans even more heavily than the others toward the anecdotal, and under Phokas he includes what are in effect the first and second parts of Otte's story, ostensibly because he finds nothing else to tell about this particular emperor.[18] He claims to be working from oral accounts, and there is of course the possibility that some form of secondary orality had been generated by then, but Enikel's own version is the product of a deliberately literary effort. While the story of Heraclius' youth is considerably shortened, the romance between Athanais and Parides is recast and refocused almost like an independent novella in the manner of the thirteenth-century *fabliau* or *Schwank*. This development calls for examination in its own right.[19] Its contribution to this discussion is that it makes us realize how firmly the subject of Heraclius, as framed by Gautier and Otte, had become established in this late medieval German historiography—so firmly that it could even be restricted to the nonlegendary episodes and still qualify as an integral part of the general historiographic enterprise that translates the concept of salvation history into vernacular, human proportions.

That undoubtedly is the context and the spirit in which the Fraurombach project was conceived, in all likelihood by the collegiate canons of Hünfeld nearby. They had recently assumed the patronage over the little church of Our Lady and, since their own community and church were dedicated to the Holy Cross (*ad sanctam crucem*), this may have been their way of marking that occasion. Such a community of secular canons was also a very likely owner of the kind of book we have been considering, and they might

have chosen the subject of Heraclius over that of Constantine precisely because of its special narrative appeal.

The precise nature of the text-picture relationship created in this case awaits further study, but a brief warning may be in order. Rudolf Kautzsch, who first considered the possibility of a connection specifically with Heinrich von München's chronicle, noted at the same time that there were discrepancies in content as well as narrative chronology. The crowned figure enthroned directly to the right of the river scene (fig. 6), for example, does not seem to fit into the "normal" sequence of events, and the river scene itself, following on the one that shows Heraclius and the steward riding out to test the young horse (fig. 5), is, textually speaking, out of order. Kautzsch himself went from there into speculation concerning an alternative, perhaps shorter version as the actual source,[20] but, as a matter of methodology, we no longer expect the kind of direct correspondence implied by this argument. For one thing, even where the immediate source was indeed a written text (as distinct from a more loosely structured oral tradition), there remains an unknowable multitude of possibilities as to the exact composition of that text—all we can do is describe the type of tradition to which it most probably belonged. More important, when it comes to secular or semisecular literary topics, the pictorial medium very rarely attempts to replicate a text; it tells its own story, in its own language, in its own space, and for its own varying purposes.[21] There is no indication that the designers of this particular picture story had political intentions, be they the general kind to be encountered in the textual tradition on which they drew or the more specific kind attributed recently to Duke Otto ("The Child") of Brunswick in explanation of his patronage of the Holy Cross cycle in Brunswick cathedral.[22] Their goals were religious, but not to the exclusion of a certain worldliness: a worldliness, however, that was spiritually and historically sanctioned by this particular historiographic background and allowed them to portray a divinely gifted child as an instrument of salvation history. It works to this day. When Fraurombach celebrated its 1,250th anniversary, in

the summer of 1992, the children of the village performed a play derived from the pictures on the walls of their church.

II

My second example is a late medieval play of the Holy Cross. It combines the legends of Constantine and Heraclius and is dubbed the *Augsburger Heiligkreuzspiel* by modern scholars, because the only surviving copy is in Augsburg.[23] There the local merchant Claus Spaun, attested between 1494 and c. 1520, assembled a two-volume collection mainly of religious and secular plays, of which the other half is now in Wolfenbüttel. The play in question is actually South Tyrolian in origin and belongs to a group of

4. Fraurombach, Heraclius murals, second quarter fourteenth century, north wall
Bildarchiv Foto Marburg

texts that Spaun did not copy himself but took from an earlier collection that he divided between these two volumes. Since he dated the Wolfenbüttel codex 1494, this older collection must have been written by that time. Its paper marks indicate a date not long before that, and its language is Tyrolian. The Augsburg volume, the one that incorporated the *Heiligkreuzspiel*, was not complete until much later, probably around 1520. In its present state it exhibits two fairly large lacunae for this text: one, toward the end, where Heraclius tries to enter Jerusalem on horseback, is obviously due to the subsequent loss of one leaf; the other, several scenes at the very beginning, may have occurred when the earlier manuscript was divided up[24] or even at some earlier stage in

5. Fraurombach, Heraclius murals, second quarter fourteenth century, north wall. Middle tier: Heraclius and the steward show the magic stone to the emperor; top tier: Heraclius on the auction block between his mother and the steward
Bildarchiv Foto Marburg

the transmission of this particular text. For there is little doubt that the scribe who wrote the copy owned by Spaun did not have the original before him. The stage directions were originally written in Latin, and their subsequent (occasionally faulty) conversion into the vernacular, as well as numerous indicators of simply negligent transmission,[25] reveal that the play itself is quite a bit older, possibly decades, composed and performed while Piero was painting in Arezzo, some 250 road miles to the south. It fits comfortably—in language, style, and theme—into a well-documented custom of fifteenth-century religious pageantry in South Tyrol, from Sterzing (Vipeteno) at the foot of the Alps to Brixen (Bressanone) and Bozen (Bolzano) further south.[26] Near Brixen, the Augustinian Canons of the Holy Sepulcher had founded the Abbey of Neustift, which soon included what may be the oldest Tyrolian Holy Cross church, the chapel of Saint Michael, designed in the 1190s as an architectural replica of Constantine's church of the Holy Sepulcher in Jerusalem, and fortified especially against the much-feared Turkish invasion before the end of the fifteenth century.[27] At Brixen, two of the three synods held there in the 1450s stressed particularly this great threat posed by the Ottoman Turks in those years after the fall of Constantinople. The bishop of Brixen, who convened these diocesan synods, was no other than Nicholas of Cusa (1450–1458). As part of his campaign against superstitious ignorance among his flock, he undertook to classify all church feasts according to their relative authenticity and importance. In the resulting lists, the liturgical feasts of *inventio* (3 May) and *elevatio* (14 September) appear among those that *praecipiantur servari*, either *ex iure scripto* (*inventio*) or *ex generali consuetudine cleri et populi* (*elevatio*, here referred to as *exaltatio*).[28] Generally speaking, this was a good time and a good place for a play of the Holy Cross, and its planners made a systematic effort to combine the two legends associated with those two liturgical feasts. The resulting spectacle lasted two days, based on about 2,300 lines of dialogue in verse. They were divided evenly between these two days and required the participation of about forty-five actors on each.

In the *Legenda Aurea* and its vernacular descendants, the tale of the *inventio* begins

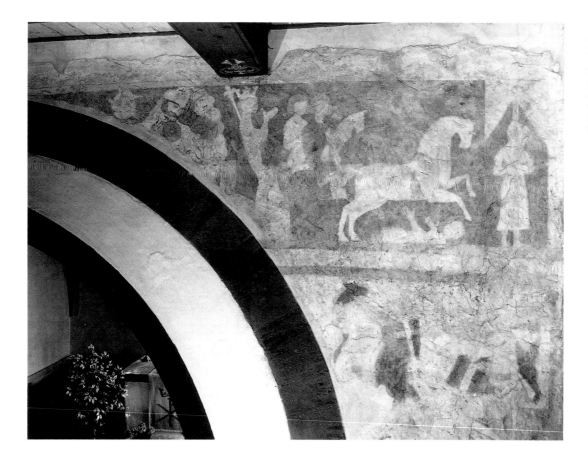

6. Fraurombach, Heraclius murals, second quarter fourteenth century, the triumphal arch, top right: Heraclius submerged in the river; the empress falls off her horse, while the old woman waits in the door of her house
Bildarchiv Foto Marburg

with Adam and recounts the Old Testament prehistory of the wood that was eventually used for Christ's cross.[29] Several of the scenes that Piero painted in Arezzo evoke and visualize that prehistory. In contrast to that, the Tyrolian play is strictly and programmatically dipartite: its planners and/or author completely ignored the Old Testament part and thus cleared the stage for an enactment of the legend that parallels and juxtaposes Constantine and Heraclius as Roman emperors in the service of that cross. They act within a structure that defines this service as crucial episodes in the perennial war against the infidel. Each day, after the initial procession of the actors "mit pfeyffen vnd mit trummetten," we witness a scene in which Lucifer and his hellish crew threaten mischief,[30] and consequently, we next see pagan potentates summoning their troops to battle—against Rome on the first and against Jerusalem on the second day. The whole play ends with the disgruntled departure of the devils. There is no historical connection between the two parts or any sense

of progression at the end: the organizational framework of this Thespian diptych is liturgical and its textual background legendary.

As for what actually happens, the opening series of scenes, showing Maxentius in preparation to invade the empire, must have followed basically the same pattern that is used on the second day to establish Costras as yet another heathen aggressor. The beginning of the text as we have it, with a speech by the second of five pagan knights ("haydnisch ritter") come to join Maxentius' army (lines 1–3), corresponds exactly to the speech by the second of five pagan knights who arrive before Costras in response to his summons (lines 1162–1165).

Costras' own extensive preparations, initiating a major campaign against Jerusalem, for a total of 378 lines of text, offer a good example of the great lengths to which our playwright went to emphasize or, as in this instance, create parallels between Constantine's struggle against his rival Maxentius and Heraclius' campaign against the outsider Chosroes. That this principle is in fact the

overriding one of his composition has been demonstrated in considerable detail by Heinrich Biermann;[31] my own observations concern the effect it has on the figure and legend of Constantine. For instance, in analogy to Heraclius, Constantine is portrayed as a regular defender of the faith from the beginning. Thus Maxentius positions himself not at the Milvian bridge, near Rome, but at the Danube, "bey dem wasser Danubio" (line 70), like a true barbarian, while his people speak specifically of invading Christian territory, "das lant der kristen lewte" (line 14). Furthermore, Maxentius does not simply fall victim to his own clever schemes and conveniently disappear into the river with his men: Constantine has to vanquish him personally, just as Heraclius vanquishes the younger Chosroes. Thus the stage direction after line 257 reads: "Do streyttent Constantinus mit Maxencio vnd Constantinus gewint den syg." But most important of all, there is no conversion and no baptism as the result of this victory. Constantine's Christianity is a *fait accompli* that enables him to interpret without delay and fail his nocturnal vision as a sign from God, Christ's cross which he orders his troops to paint on their shields (lines 221–235). With that, he also loses his main reason for dispatching his mother, Helena, to Jerusalem. In fact, she sets out on her own volition—to make her own contribution to the war effort, as it were (lines 294–297)—and the text even hints that she takes the new cross banner (*panier*) with her (line 278). Clearly, liturgically inspired dramatic celebration—the new medium—takes precedence over the textual past as we know it, or think we know it.

I will go a little further and define that relationship, if not more precisely, at least in more meaningful terms—again with respect to Constantine whom, incidentally, the chronicles I have discussed present in an entirely different role. The tradition upon which the author of a liturgical play would naturally draw is the one generated and backed by the *Legenda Aurea*,[32] but that is not to say that the *Legenda Aurea* is "the source" of the play or that the relationship should even be considered in those terms. The notion of a single, specific source loses its critical and explanatory power when it forces the critic to explain at every turn[33] that the presumed adaptor has altered, ignored, or expanded upon it. Ukena's (earlier) conclusion, that the sometimes substantial discrepancies reflect a version of the legend other than, but related to, the *Legenda Aurea*,[34] only avoids the underlying methodological issue in a slightly more self-conscious way.

The first thing to remember is that Jacobus was not so much a storyteller as a critical compiler who sought to establish what was historically, dogmatically, and liturgically "correct"; to strip it down to its essentials; and to correlate it with the higher chronological order of the liturgical year. The *inventio* story, controversial in many respects almost since its inception and especially in the thirteenth century,[35] is (along with that of the *elevatio*!) perhaps the most obvious example of this basically nonnarrative approach. These two chapters "regorgent de variantes."[36] When, for example, Jacobus presents the events of Constantine's vision, conversion, and baptism, he paraphrases and critiques no fewer than six named sources in addition to certain ostensibly misinformed *ultramarinae historiae* and an indeterminate number of *chronicae*, adduced to support his own stated preference for some form of the Eusebian version.[37] According to him, this version is preferable in fact to what is contemporaneously preached in church: "videtur esse magis authentica quam illa, quae per ecclesias recitatur."[38] Ironically, had Jacobus been able to attend the second of Nicholas of Cusa's synods at Brixen, in 1455, he would have heard some of the texts in the collection begun by him referred to as *superstitiosa* unfit for popular preaching: "Item ne populo praedicentur superstitiosa, quae in legenda lombardica habentur de S. Blasio, Barbara, Catharina, Dorothea, Margarita, etc."[39] This list, besides including several of the numerous accretions that occurred over time, reflects of course quite different reservations, reservations that, as Sherry Reames points out, Jacobus might even have shared.[40] The more important point, however, is that, in the intervening two hundred years, circumstances have changed dramatically. Precisely because of this steady expansion of the corpus, the frequent title, *Legenda Lombardica*, has taken on almost generic connotations, and there

can be little doubt that the preaching referred to here was done in the vernacular (German), where the tradition had long gone beyond mere expansion.

Jacobus' work had once served as a catalyst that almost immediately began to produce a multitude of vernacular adaptations, and these adaptations naturally tend to abandon his critical and expostulatory stance in favor of straight and therefore selective narrative. We know of no fewer than twenty subsequent German legendaries that carry the *inventio*, and for nine of these the *Legenda Aurea* is the immediate and only source.[41] Since all but a few of these collections remain unpublished, I shall confine myself to a few examples and a few specific points, which should, however, demonstrate with sufficient clarity what principles are at work in this transition into vernacular narrative.

The most widely known direct descendant of the *Legenda Aurea* in the Low Countries was the *Südmittelniederländische Legenda Aurea* (108 extant manuscripts), completed in early 1358 by the so-called "Bijbelvertaler." He believed in literalness and the sanctity of his sources; hence his rendering of the *inventio* shows no major deviations.[42] This kind of orthodoxy is in dramatic contrast to the recently edited *Elsässische Legenda Aurea* (36 extant manuscripts), which was written in the first half of the fourteenth century and became the major vernacular authority in the German southwest for the next 150 years. It, too, is meant to be a translation, but that obviously left room for what turns out to be a consistent attempt at achieving continuous and coherent narration wherever that element was lacking in the original.[43] The second (and larger) of the two late medieval German legendaries that enjoyed anything like mass distribution (197 extant manuscripts), *Der Heiligen Leben*,[44] was composed around 1400, probably in Nuremberg, and became the most widely read vernacular legendary first in the German south and finally in all parts of the German-speaking world. In its basic organization, it emulates the example of the *Legenda Aurea*, but for its individual chapters it relies on a great variety of Latin and German sources, including poetic ones, and it takes considerable liberties with them. In the case of the *inventio*, the author hap-

pens to have gone back to the late thirteenth-century verse legendary known as *Das Passional*, which in turn hews closely to Jacobus' text,[45] and yet his rendering of the legend displays the same tendencies as those in the *Elsässische Legenda Aurea*, albeit in slightly different fashion.

The desire to condense and streamline is evident from the beginning in both narratives, for example, when Seth's encounter with the archangel Michael is reduced to one, the first, of three variants given by Jacobus. Both texts also omit every bit of editorial comment and ignore several sub-variants. The *Elsässische Legenda Aurea* leaves out the appearance of Christ meant to reinforce the vision associated with the war against Maxentius; *Der Heiligen Leben* does the same with Constantine's subsequent prayer for a bloodless resolution of the battle; and the appearance of Peter and Paul, who point the emperor in the direction of Pope Sylvester, is missing in both. Most revealing, however, is their (individually different) handling of the conjunction of the two major rivaling accounts of the circumstances surrounding Constantine's vision as given by Jacobus. Unlike some independent (and apparently singular) collections such as the *Mittelfränkische Heiligenpredigt/Legendar* or the *Wolfenbüttler Legendar*, which simply drop the whole Maxentius episode (along with all the historical and theological criticism),[46] both the *Elsässische Legenda Aurea* and *Der Heiligen Leben* incorporate it

7. Fraurombach, Heraclius murals, second quarter fourteenth century, the triumphal arch, top right (detail): Heraclius submerged in the river
Bildarchiv Foto Marburg

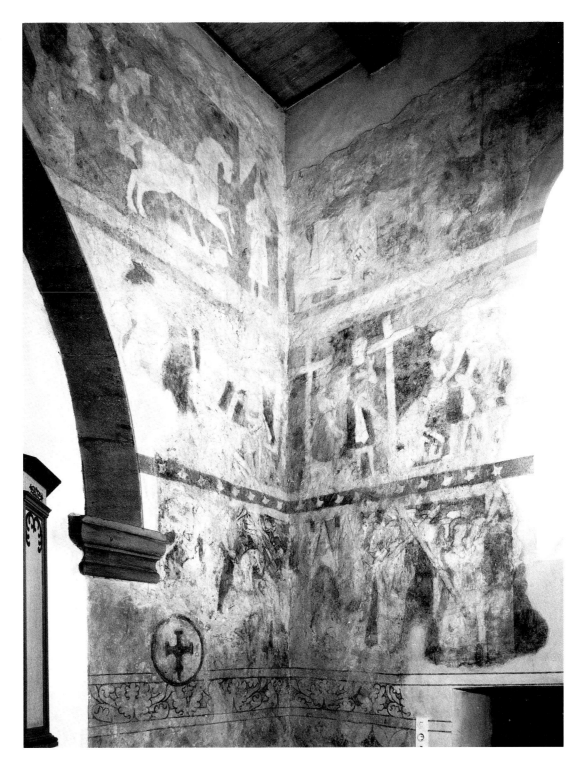

8. Fraurombach, Heraclius
murals, second quarter four-
teenth century, south wall,
from top to bottom: the
empress and her lover in
bed(?)—Heraclius counsels
mercy(?); Heraclius before
Chosroes—Heraclius slays
Chosroes; Heraclius returns
the cross, on horseback and
on foot
Bildarchiv Foto Marburg

into novel narrative arrangements. The for-
mer simply reapportions these two episodes
between father and son: after Constantine's
battle against the barbarians, his conversion,
and baptism, the narrator states, "dirre Con-
stantinus lies noch ime einen sun, ŏch Con-
stantinus genant, der wart ŏch keyser. Der
solte wider Maxencium striten" (315, lines
33–34). In other words, it is the *younger*
Constantine who, in exact parallel to what
happened to his father, fights the battle
against Maxentius; has the vision; adopts the

cross without further ado, since the confirming appearance of Christ has been omitted; and prays that no blood be shed on this occasion. Maxentius obliges, but Constantine the younger is not converted fully until he is baptized by Pope Sylvester: "Noch hette dirre Constantinus ganzen globen nút so lange vncz daz er von sant Siluester getöffet wart" (316, lines 8–10). In that he reacts exactly like his father, who is not converted fully until Eusebius confirms him in his new faith and baptizes him: "doch englöbte er nút genczlich dise wort. Do kam zu ime Eusebius der bobest vnd festente in in dem glöben vnd döfte in" (315, lines 31–33). Such reconfigurations and adjustments signal a new understanding of the legend with regard to its narrative potential, but there are of course different ways of realizing that potential, and the author of *Der Heiligen Leben* found another one. He follows his source (and Jacobus) in associating both episodes with the same Constantine, but instead of treating them as alternative variants he links them by redefining the second as reinforcement of the first and as the ultimate cause of the emperor's conversion. To this end, Constantine's first search for the meaning of the strange sign that enables him to defeat the barbarians is made to end in failure. When later, after the victory over Maxentius, he realizes that the same symbol has aided him once again (*aber*),[47] he renews his inquiries. This time a Christian arrives to enlighten him, and he is baptized by Pope Eusebius. This latter detail is the final indicator of successful transformation: the second episode has been pulled into the confines of the first to help create a new narrative whole. On the surface, some of these omissions and realignments may not seem of great importance, but taken together they mean that a whole new dimension of broadly based popular narrative has been created where there simply is no longer the one stable and authoritative text as the primary point of reference. The new diversity extends even to such details as the Temple of Venus, which, according to Jacobus' recollection of the *Historia Ecclesiastica*, Emperor Hadrian had built to keep Christian worshipers away from Mount Calvary.[48] The *Passional*, the Bijbelvertaler's Dutch legendary, and the *Elsässische Legenda Aurea*

retain this motif, whereas the others have Helena's workmen dig directly into the plot of land identified by Judas, as they do in the *Augsburger Heiligkreuzspiel* (lines 740–755).

What happens when this process of vernacularization reaches beyond the legendaries proper can be seen early in a singular *Kreuzholzlegende* that was composed some time in the fourteenth century and survives as an extra-legendary reading for the feast of *inventio* in a Swabian manuscript of 1412.[49] This almost quirky reworking of the tradition does not seem bound by any authority and fills the established framework with all kinds of alien elements. Hadrian's abovementioned temple is there, for example, but when the workmen break it down they find inside none other than Joseph of Arimathea, alive and well and ready to talk! Of the two competing versions of Constantine's vision, only the first survives in this context, but of particular interest with regard to the Augsburg play is the way in which it is related to the preceding biblical part: the Jews bury the cross, because Joseph of Arimathea preaches too much about the meaning of the crucifixion and because the cross works too many miracles; when, many years later, Emperor Constantine is threatened by pagan forces, he remembers those miracles ("die zaichen des crutzes Christi Jesu, die es getan het": 127–128), and that in effect triggers the vision. It is not surprising then that there is not even talk about a conversion after that; Constantine's habitual association with the Holy Cross is represented as such, and accordingly his son, the younger Constantine, sends his mother to Jerusalem to procure similar powers for him.

As I have already indicated, none of these observations is meant to suggest any direct relationship between the *Augsburger Heiligkreuzspiel* and any particular other written manifestation of this varied vernacular tradition. On the contrary, that a *Kreuzholzlegende* could be offered as reading for the day of *inventio crucis* that clearly subordinates the subject of Constantine's conversion to the celebration of his valiant service to Christianity, and that two widely used legendaries rearrange the Constantine story in a manner very similar, in principle, to what the author of the *Heiligkreuzspiel* does on a larger scale in combining the same story

with that of Heraclius are strategems indicative of a movement toward multiple, polygenetic, and sometimes freewheeling adaptation. The fact that the stage directions for the play were originally given in Latin does make it highly likely that the local clergy had a strong hand in planning and supervision, but that by itself says little about the status of the Latin *Legenda Aurea* in this undertaking. In the new environment that I have sketched out, vernacular remakes abound, word of mouth may have played as important a role as communication in writing, and the producers of new texts will have relied as much on popular belief and literary convention as they did on legendary authority. They also relied on images. Our playwright is quite capable of creating visually effective incidents of his own. For example, Helena has Judas locked up to starve him into compliance, and then she stages a banquet within his view to "tickle his stomach" ("küczlen in dem magen": line 673), as she archly puts it. To this end, a tower from which Judas can watch the proceedings replaces the usual dry well, a special stage direction describes the scene, and the dialogue reflects the ensuing battle of wills. In contrast, but not coincidentally, some of the traditional key scenes completely lack stage directions or other indicators of their iconography in this play: What exactly is it that Constantine sees in his sleep? What are we to imagine as the "trinity" that Chosroes "erects" in his palace ("vnd richtet auff dy dryualtigkait": page 525)? We are not told, one must assume, because everybody knew, and those particulars would be supplied, arranged, or pointed to ad hoc as part of an established visual repertoire.

The existence of such a repertoire in the everyday public experience of the laity belongs in yet another dimension of popular interaction with the tenets and contents of church lore. This dimension has received a good deal of attention in recent years, but mostly in connection with certain forms of private devotion and the kinds of images most conducive to that.[50] To explore it further in our context would, in practical terms, lead us back to Fraurombach or forward to one or the other of several fifteenth-century Holy Cross cycles preserved in the north, of which by far the most extensive is the mural decoration of the choir in the erstwhile church of the Holy Cross in Wiesendangen, Switzerland.[51] However, this would at the same time take me well beyond my present, limited purpose. That purpose has been to introduce at least some of the northern material into the discussion of Piero's work and its background in medieval literature, mentality, and convention, and to do this by building two models designed to show how tradition in the broad sense relates to those isolated acts of individualization that tend to monopolize our attention as literary or art historians. In the process, something else has become apparent that should at least be mentioned in conclusion. If only for political reasons, as demonstrated almost incidentally by the poet Otte, the matter of Constantine clearly was a concern of the "high culture" during the High Middle Ages. By the time Piero painted in Arezzo, it had obviously become in Germany the subject of a predominantly popular culture.

1. For some of the texts, see the following entries in *Die deutsche Literatur des Mittelalters. Verfasserlexikon*, 2d ed. (Berlin, 1978–): "Augsburger (südbairisches) Heiligkreuzspiel," 1:528–530; "Hans Folz," 2:769–793, especially 780; "Heinrich von Freiberg," 3:723–730; "Helwig von Waldirstet," 3:987–989; "Von dem Holz des Heiligen Kreuzes," 4:117–119; "Kreuzesholzlegende," 5:371–372; "Lutwin," 5:1087–1089; "Sündenfall und Erlösung," forthcoming. For picture cycles see Stefan Brenske, *Der III. Kreuz Zyklus in der ehemaligen Braunschweiger Stiftskirche St. Blasius (Dom)* (Brunswick, 1988) (my thanks to Horst Bredekamp for making this publication available to me) and K. A. Wiegel, *Die Darstellungen der Kreuzauffindung bis zu Piero della Francesca* (diss., Cologne, 1973).

2. It is indicative of the "state of the art" in this case that the only general review of the paintings themselves, their date, and the (hypothetical) circumstances of their creation is a popular introduction by a local historian, Heinrich Sippel, *Die gotischen Wandmalereien in der Dorfkirche von Fraurombach im Schlitzerland*, 2d ed. (Schlitz, 1989). This brochure also contains an incomplete but useful set of photographs taken of life-size copies made in the 1920s that apparently have since disappeared (Sippel 1989, 15). The only professional art historian to have conducted a thorough study of the paintings and their historical ambience, including the relationship to their textual source, was Rudolf Kautzsch. His two papers were written in the years immediately following their rediscovery but can still serve as a solid basis for further discussion: "Die Herakliusbilder zu Frau-Rombach in Oberhessen," in *Studien aus Kunst und Geschichte: Friedrich Schneider zum Siebzigsten Geburtstage*, ed. Josef Sauer (Freiburg, 1906), 507–530 (this paper contains the fold-out chart that is reproduced here as fig. 1); and "Ein Beitrag zur Geschichte der deutschen Malerei in der ersten Hälfte des XIV. Jahrhunderts," in *Kunstwissenschaftliche Beiträge: August Schmarsow gewidmet*, ed. Rudolf Kautzsch et al. (Leipzig, 1907), 73–94 (narrowing the date to between 1300 and 1340 through a comparative stylistic survey).

3. Gautier d'Arras, *Éracle*, ed. Guy Raynaud de Lage (Paris, 1976); Otte, *Eraclius*, ed. Winfried Frey (Göppingen, 1983). For a brief introduction see Wolfgang Wallizeck, "Otte I," in *Die deutsche Literatur* 7 (1989), 199–203. Recent comparative studies are by Karen Pratt, *Meister Otte's Eraclius as an Adaptation of Eracle by Gautier d'Arras* (Göppingen, 1987); Edith Feistner, *Otte's* Eraclius *vor dem Hintergrund der französischen Quelle* (Göppingen, 1987); and Silvia Schmitz, "'Der vil wol erchennen chan.' Zu Gautiers und Ottes *Eraclius*," *Germanisch-romanische Monatsschrift* 42 (1992), 129–150. Along with a few general remarks concerning Fraurombach and other Heraclius cycles, Feistner (1987, 38–40) has included three pictures derived from Sippel's photographs and a copy of Kautzsch's chart.

4. *Eraclius*, ed. Frey 1983, lines 1196–1248. In the painting, the youthful figure, clad in a dark cloak, lies on its back, in approximate parallel to the curve of the arch, with its legs dangling down and its arms tied together at the wrists and raised toward the ceiling. The stone is a millstone (with a hole in the middle) and appears below the figure's head and shoulders, tied to its neck with a rope; see also the reproduction of this detail in Sippel 1989, fig. 6.

5. My own observations agree here with those of Kautzsch and traditional bed-scene iconography. Sippel (1989, 20) has an entirely different interpretation that combines this scene with the standing figure in the corner to the left; see Sippel 1989, fig. 7.

6. This accords particularly with the description by Otte, who adds that the result of this arrangement is that even Christian travelers kneel before him in prayer: *Eraclius*, ed. Frey 1983, lines 4655–4675.

7. In Otte's account, Chosroes' second son, who is still very young, is taken to Judea where he later dies unceremoniously (*Eraclius*, ed. Frey 1983, lines 5345–5349). In contrast, the story later promulgated by Jacobus de Voragine (*Jacobi a Voragine Legenda Aurea*, ed. Theodor Graesse, 3d ed. [Breslau, 1890; repr. Osnabrück, 1965], 606), and first recorded in any vernacular in the *Kaiserchronik* (*Kaiserchronik eines Regensburger Geistlichen*, ed. Edward Schröder [Berlin, 1895; repr. Berlin, 1964], lines 11302–11309), says that he was baptized and grew to be a famous leader.

8. Sippel 1989 reproduces this sequence as figs. 9–13. The only extant example of a mural Heraclius sequence in Germany that predates Fraurombach, the relevant portion of the Holy Cross cycle in Brunswick (Brenske 1988, probably 1240–1250), is only slightly more elaborate: abduction of the cross (Brenske 1988, fig. 38); Chosroes enthroned (fig. 40); single combat between Heraclius and the older son (fig. 43); decapitation of Chosroes (fig. 47); baptism of the younger son (fig. 50); the two scenes outside Jerusalem (figs. 52 and 54).

9. *Eraclius*, ed. Frey 1983, lines 374–382.

10. *Eraclius*, ed. Frey 1983, lines 4535–4556, 4557–4621. Actually Otte (line 4596) uses the politically correct term *Romanie* for Byzantium.

11. *Eraclius*, ed. Frey 1983, lines 5444–5647.

12. Otto von Freising, *Chronica sive Historia de duabus civitatibus*, ed. Walther Lammers (Darmstadt, 1980). There has always been general agreement that Otto's chronicle was the direct source at least for Otte's long appendix, corresponding to pages 394–398 in the edition cited. From Feistner's careful analysis of all historical references and allusions in Otte's work (Feistner 1987, 62–82), it is clear that they also come together in the spirit of Otto's "Tale of Two Cities," as the story of humanity's salvation in the struggle between Good and Evil, which places the work "in ein geschichts-'metaphysisches' Kontinuum" (Feistner 1987, 81).

13. This reading perspective changed somewhat when a sixteenth-century owner of the manuscript

had it bound together with a copy of the romance *Mai und Beaflor*. The codex is now Munich, Bayerische Staatsbibliothek, cgm. 57.

14. *Kaiserchronik*, ed. Schröder 1964, lines 11138–11351.

15. Vienna, Österreichische Nationalbibliothek, codex Vindobonensis 2693.

16. This monumental work is still unpublished, and the substantive diversity of its manuscripts (they range in length from c. 56,000 to 100,000 lines) has so far defied conclusive stemmatological analysis. For an introduction see Norbert Ott, "Heinrich von München," in *Die deutsche Literatur* 3 (1981), 827–837. The manuscript in question is Gotha, Forschungsbibliothek, codex Gothanus Chart. A3.

17. Thanks go to Gisela Kornrumpf, of the Bavarian Academy of Science, for expert advice on this matter.

18. *Jansen Enikels Werke*, ed. Philip Strauch (Hannover-Leipzig, 1900), 1–596, lines 20411–20942, especially 20411–20422. Later (lines 21950–22182), Enikel shifts even more abruptly to Chosroes and a particularly fanciful account of his throne and the subsequent confrontation with Heraclius that have nothing to do with Otte.

19. This examination would also have to include the fifteenth-century prose version that seems somehow to be connected to Jans Enikel or his source: Vienna, Österreichische Nationalbibliothek, codex Vindobonensis 2861, in *Eraclius: Deutsches und französisches Gedicht des zwölften Jahrhunderts*, ed. Hans Ferdinand Massmann (Quedlinburg-Leipzig, 1842), 371–373.

20. Kautzsch 1906, 525 f.

21. See my articles, "Images of Tristan," in *Gottfried von Strassburg and the Medieval Tristan Legend*, ed. Adrian Stevens and Roy Wisbey (Cambridge, 1990), 1–17, and "*Der aventiure bilde nemen*: The Intellectual and Social Environment of the Iwein Murals at Rodenegg Castle," in *Chrétien de Troyes and the German Middle Ages*, ed. Martin Jones and Roy Wisbey (Cambridge, 1993), 219–227. In a newly discovered cycle of wall paintings (second quarter of the sixteenth century) that features the legendary Germanic heroes Dietrich von Bern and Hildebrand in confrontation with the giant Sigenot, we have the rare example of a monumental sequence that, instead of putting its own stamp of interpretation on the story, essentially uses a picture program that preexisted in the form of illustrations in an early printed edition of the relevant text; see Michael Curschmann and Burghart Wachinger, "Der Berner und der Riese Sigenot auf Wildenstein," *Beiträge zur Geschichte der deutschen Sprache und Literatur* 116 (1994), 360–389.

22. See Brenske 1988, especially 101–117.

23. Augsburg, Staats- und Stadtbibliothek, 4° codex H 27, 47r–89v. For a description of the whole manuscript, see Elke Ukena, *Die deutschen Mirakelspiele des Spätmittelalters. Studien und Texte. 2. Teil: Texte* (Bern-Frankfurt, 1975), 363–376, and 467–559,

which contain a new edition of the play with a brief commentary. Ukena's discussion of literary aspects (in vol. 1) does not yield much; more important in this regard is the study by Heinrich Biermann, *Die deutschsprachigen Legendenspiele des späten Mittelalters und der frühen Neuzeit* (diss., Cologne, 1977), especially 187–218.

24. According to Ukena 1975, 545–546.

25. See Ukena 1975, 546.

26. Ukena (1975, 466) assigns the particular dialect features of the text to a geographic triangle formed by the towns of Meran, Bozen, and Brixen.

27. See Anton Dörrer, "Kult und Spiel in Fluß und Stauung: Drei Beispiele aus Tirol," *Zeitschrift für Volkskunde* 58 (1956–1957), 91–117, especially 91–97. The same abbey is known to have owned, in 1445, at least one major manuscript of German religious plays: see "Innsbrucker (thüringisches) Fronleichnamsspiel," in *Die deutsche Literatur* 4 (1983), 398–400.

28. The texts of the synods as well as Nicholas' reform proposals are printed in *Synodi Brixinenses saeculi XV*, ed. Gustav Bickell (Innsbruck, 1880), 31–57; quotations from pages 40 and 45 respectively.

29. *Legenda Aurea*, ed. Graesse 1890, chap. LXVIII: *De inventione sanctae crucis* (303–311); chap. CXXXVII: *De exaltatione sanctae crucis* (605–611). Piero's unique interpretation of the Genesis scene is discussed in Marilyn Aronberg Lavin, *The Place of Narrative: Mural Decoration in Italian Churches, 431–1600 A.D.* (Chicago, 1990), 99–118.

30. For the first day, this introductory part can be reconstructed easily from the first stage direction for the second part (*Actum an dem andern tag*). It calls explicitly for a repetition of the procession that had opened the previous day and repeats only the opening lines of Lucifer's initial speech, referring the performers to the text recorded earlier (*als oben stet*: page 510). The precursor of Costras (*der vorlauffer Costre*), who then initiates the proceedings on earth with a prologue addressed to the audience (lines 1022–1037), undoubtedly mirrors the appearance of a precursor of Maxentius in the same function on the day before.

31. Biermann 1977, 188–202. His general conclusions (page 190) are worth quoting:

Der Sieg des Kaisers Constantin über das heidnische Heer des Maxentius steht in deutlicher Parallele zum Sieg des Eraclius über den ältesten Sohn des Costras; der Auffindung des Kreuzes durch Helena entspricht der Raub des Kreuzes durch Costras. Diese klare Gruppierung von vier Handlungskomplexen um eine Mittelachse ergibt sich durchaus nicht selbstverständlich aus dem vorgegebenen Legendenstoff. Sie ist vielmehr das Ergebnis einer geschickten Erweiterung sowie eines gezielten Selektionsverfahrens.

32. See note 29 above. The *Legenda* is one of those medieval texts that tend to be taken for granted and has therefore not received too much critical attention for its own sake. This is beginning to change,

though, even to the point where diametrically opposed approaches and points of view are emerging. See Alain Boureau, *La Légende Dorée: Le système narratif de Jacques de Voragine* (Paris, 1984) and Sherry L. Reames, *The* Legenda Aurea*: A Reexamination of Its Paradoxical History* (Madison, Wisc., 1985). Most of the papers at a colloquium on the *Legend* held in 1983 were devoted to its vernacularization: Legenda Aurea*: Sept siècles de diffusion*, ed. Brenda Dunn-Lardeau (Montreal, 1986). As far as the German branch of this process is concerned, the fundamental new editions and studies are *Die elsässische Legenda Aurea* 1, *Das Normalcorpus*, ed. Ulla Williams and Werner Williams-Krapp (Tübingen, 1980), 2, *Das Sondergut*, ed. Konrad Kunze (Tübingen, 1983), and 3, *Die lexikalische Überlieferungsvarianz: Register, Indices*, ed. Ulla Williams (Tübingen, 1990); Konrad Kunze, "Jacobus a (de) Voragine (Varagine)," in *Die deutsche Literatur* 4 (1983), 448–466; Werner Williams-Krapp, *Die deutschen und niederländischen Legendare des Mittelalters: Studien zu ihrer Überlieferungs-, Text- und Wirkungsgeschichte* (Tübingen, 1986).

33. As does Biermann 1977, 203–210.

34. Ukena 1975, 1:280.

35. See Johannes Straubinger, *Die Kreuzauffindungslegende: Untersuchungen über ihre altchristlichen Fassungen mit besonderer Berücksichtigung der syrischen Texte* (Paderborn, 1912) and Klaus Schreiner, "'Discrimen veri ac falsi'. Ansätze und Formen der Kritik in der Heiligen- und Reliquienverehrung des Mittelalters," *Archiv für Kulturgeschichte* 48 (1966), 1–53, especially 17–20 and following.

36. Boureau 1984, 97.

37. *Legenda Aurea*, ed. Graesse 1890, 307. Boureau (1984, 98) identifies these "chronicles" as "les tables chronologiques detaillés qui indiquent les dates des règnes et des pontificats."

38. *Legenda Aurea*, ed. Graesse 1890, 307.

39. *Synodi Brixinenses*, ed. Bickell 1880, 41. See Schreiner 1966, 41, and Reames 1985, 50. Needless to say, Nicholas also lists the feasts of these saints ("et his similia") among those that "nec mandentur nec ad observandum exhortentur" (*Synodi*, 45).

40. Reames 1985, 160–161. It is worth adding that Martin Luther singled out exactly the same four female lives as theologically flawed, and for the same reason that presumably guided Nicholas of Cusa: these martyrs "arrogantly" promise their followers redemption without works (Schreiner 1966, 46).

41. See the "Legendenregister" in Williams-Krapp 1986, 429.

42. See Williams-Krapp 1986, 53–56. Werner Williams-Krapp has kindly supplied me with a copy of this chapter in manuscript: Amsterdam, University Library, codex VI B 14, fol. 233v–237v.

43. The *Kreuzauffindung* is chapter 65 in Williams and Williams-Krapp 1980, 314–319.

44. There is no modern critical edition; the text generally cited is that of a highly suspect modernization by Severin Rüttgers, *Der Heiligen Leben und Leiden*, 2 vols. (Leipzig, 1913). The *inventio* appears in 2:48–53.

45. *Das Passional*, ed. Friedrich Karl Köpke (Quedlinburg-Leipzig, 1852), 265–290.

46. Again Werner Williams-Krapp has kindly lent me his copies; respectively, Strasbourg, Bibliothèque Nationale et Universitaire, codex 2931, fols. 001-0jv, and Wolfenbüttel, Herzog August Bibliothek, codex 316, fol. nov., fols. 120v–128v.

47. "Da ward er froh und erkennet wohl, daß ihm das Zeichen des Heiligen Kreuzes aber geholfen hätt": *Der Heiligen Leben*, in Rüttgers 1913, 51. The *Passional* (ed. Köpke 1852) had paved the way for this explicit coupling of the two events with verses 271, 13–15: "Ein ander buch saget also/ von disme Constantino,/ wie im zweimal wart ein sic."

48. *Legenda Aurea*, ed. Graesse 1890, 308.

49. Augsburg, Staats- und Stadtbibliothek, 2° codex 438, fols. 261v–264v. *Fastnachtspiele aus dem fünfzehnten Jahrhundert, Nachlese*, ed. Adelbert von Keller (Stuttgart, 1858; repr. Darmstadt, 1966), 122–129. See Werner Williams-Krapp, "Kreuzesholz-legende," in *Die deutsche Literatur* 5 (1985), 371–372.

50. The chapter "Realismus und Bildrhetorik," in Hans Belting, *Das Bild und sein Publikum im Mittelalter: Form und Funktion früher Bildtafeln der Passion* (Berlin, 1981), 105–141, does make a connection between devotional and dramatic representation, but that discussion would have to be extended beyond the imagery associated with the Passion.

51. It was commissioned in the 1490s by the brothers Ulrich and Hugo von Hohenlandenberg (the latter became bishop of Constance in 1496); painted by Hans Haggenberg of Winterthur between 1496 and 1498; and restored in 1964–1967. See Hans Bachmann, "Die Kirche in Wiesendangen und ihre Wandgemälde," *Anzeiger für Schweizerische Altertumskunde*, new series, 18 (1916), 118–134, 186–203, 290–300 (the basic study); Walter Hugelshofer, *Die Kirche von Wiesendangen und ihre Wandbilder* (Bern, 1970); Jürgen Michler, *Gotische Wandmalerei am Bodensee* (Friedrichshafen, 1992), 134–135, 138–139, 204 (with diagram). This cycle of about thirty individual scenes also includes what is, along with Piero's, the most interesting depiction of Chosroes' throne in the fifteenth century. See Hermann Koller, "Der Thron Khosraus II: Zu den Chorgemälden in der Kirche von Wiesendangen," *Zeitschrift für Schweizerische Archäologie und Kunstgeschichte* 27 (1970), 93–100.

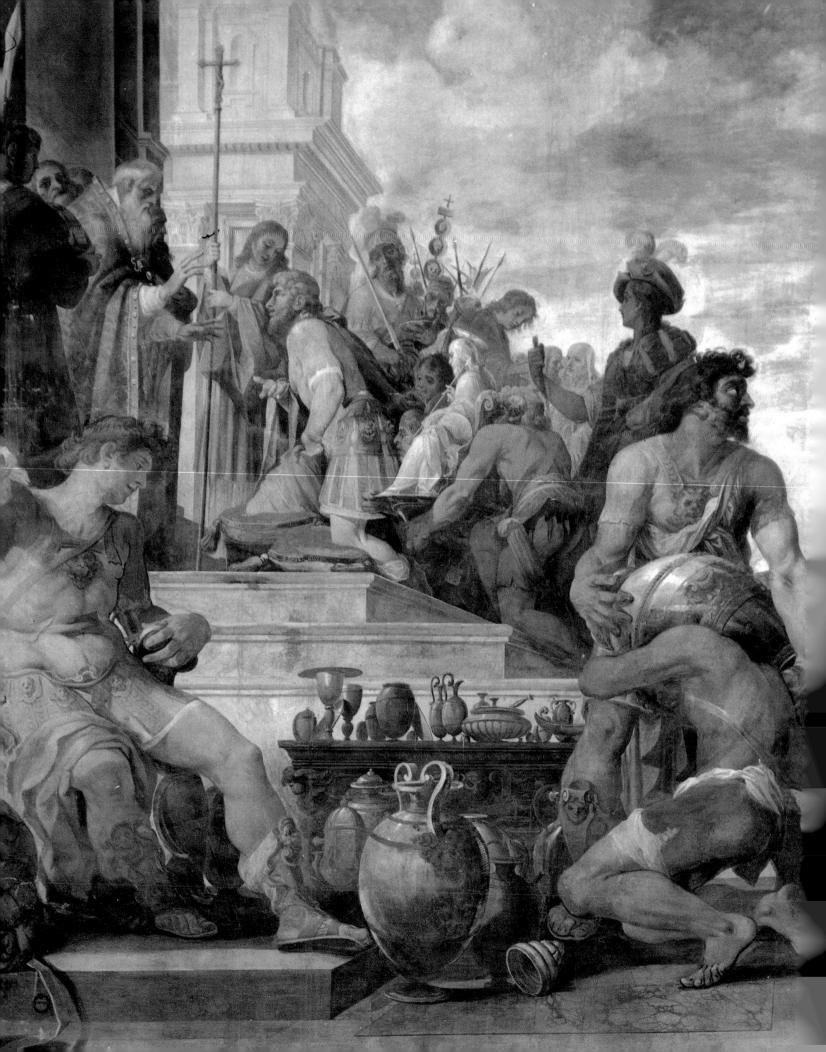

JACK FREIBERG

Florida State University

In the Sign of the Cross:
The Image of Constantine in the Art
of Counter-Reformation Rome

The orchestration of Constantine's image was a matter of great concern in sixteenth-century Italy, principally in Rome, ancient imperial capital and papal seat. The emperor's revolutionary role in Christian history was often addressed in the polemics of the Reformation, with particular focus placed on his legendary grant of temporal power to the papacy. The veracity of the text on which this claim rested had been discredited in the fifteenth century, and Protestant critics during the Reformation attacked Constantine's legendary donation with renewed vigor.[1] In response to these attacks, a florescence of Constantine imagery occurred in the monumental visual arts, including fresco cycles and other art forms, constituting an important, if little known, chapter in this history. While the full extent of this rich visual tradition remains to be uncovered, in Rome alone six cycles of the life of Constantine were created.[2]

I begin early in the century with the most familiar series commissioned by the two Medici popes, Leo X (1513–1521) and Clement VII (1523–1534), for the main ceremonial hall in the Vatican palace (1519–1524).[3] Developed in part by Raphael and executed following the master's death by his shop, led by Giulio Romano, the cycle gained enormous prestige and influenced the subsequent history of Constantine imagery. Four large scenes, painted to simulate woven tapestries suspended upon the walls, celebrate Constantine's *res gestae* (figs. 1–3). The story begins with the emperor's divine mandate to conquer, his Vision of the Cross on the eve of battle, succeeded by the mighty confrontation in which Constantine, aided by heavenly beings, vanquishes Maxentius at the Milvian bridge. The emperor then receives the regenerative waters of baptism from Pope Sylvester I, signifying both his personal salvation and the sacralization of his powers. The legendary Roman baptism was said to have occurred at the Lateran baptistery, here identified by the characteristic features of its architecture, a central pergola encircled by an ambulatory. In the last of the principal scenes, Constantine demonstrates his superior faith by ceding to the papacy certain rights, dignities, and honors of his imperial office. This pivotal, albeit legendary, event in the history of the church is depicted as it might have taken place within Saint Peter's with the emperor kneeling before the enthroned Pope Sylvester to offer a statuette of the goddess Roma as symbol of the bequest.[4] Along the lower walls, additional details of the story are painted in monochrome to simulate gilded bronze reliefs. The ideal audience for this splendid decoration is found in the corners of the room where eight popes of the early church, enthroned and sheltered by imperial baldachins, witness the conversion of the Roman world to Christianity.

Of considerable interest is the hybrid

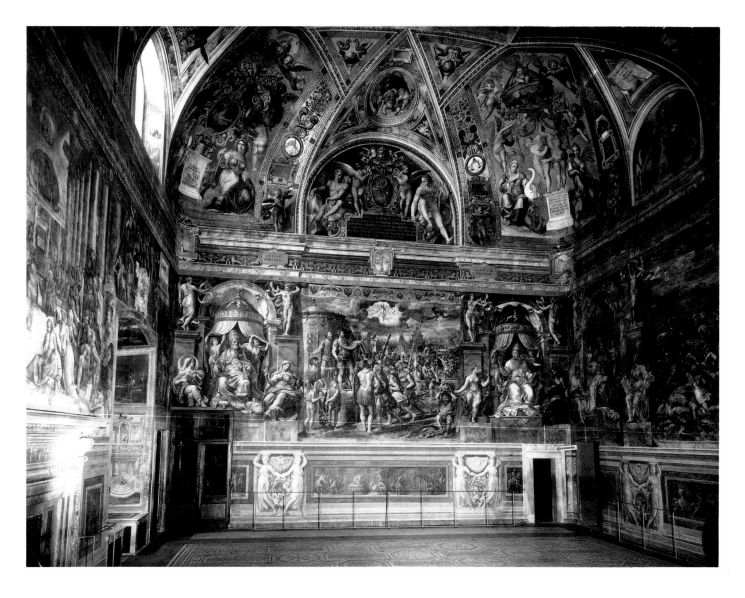

nature of the cycle. Constantine's Vision and Battle are recorded in the authentic historical sources, but the Lateran Baptism originates in the legendary *Vita Silvestri* of the fifth century.[5] The Donation scene refers to the famous medieval forgery that purports to record Constantine's grant to the papacy. Diverse visual traditions have also been brought together: the emperor's conversion to Christianity and his patronage of the church were often treated during the later Middle Ages in Italy, but the battle with Maxentius was never included.[6] At the Vatican, this martial episode was interpolated from the True Cross legend. Piero della Francesca must be credited with having depicted for the first time on a large scale Constantine's divinely willed victory over

the enemy of the church. Piero amplified the emperor's role in the True Cross story by inserting the scene of his miraculous revelation. Nevertheless, it was the Holy Cross, not Constantine's personal biography, that remained Piero's focus.[7]

The comprehensive nature of the Vatican cycle, in its diverse literary and visual sources, suggests the epic sweep of the Constantine tradition, celebrated at the hub of the papal palace. It is not sufficiently appreciated that this painted cycle represents a revival of the theme after a lapse of almost two centuries.[8] Equally innovative is its palace setting, for all previous treatments of Constantine's biography appear in churches or chapels dedicated to Pope Sylvester.[9] The unprecedented shift from a sacred to a resi-

1. Giulio Romano and others, *Constantine's Deeds*, 1519–1524, frescoes, Sala di Costantino, Vatican palace
Archivio Fotografico Musei Vaticani

2. Giulio Romano and others, *Baptism of Constantine*, 1519–1524, fresco, Sala di Costantino, Vatican palace
Archivio Fotografico Musei Vaticani

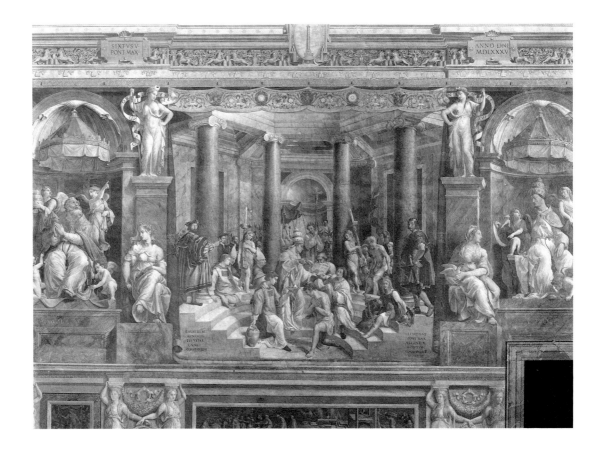

3. Giulio Romano and others, *Donation of Constantine*, 1519–1524, fresco, Sala di Costantino, Vatican palace
Archivio Fotografico Musei Vaticani

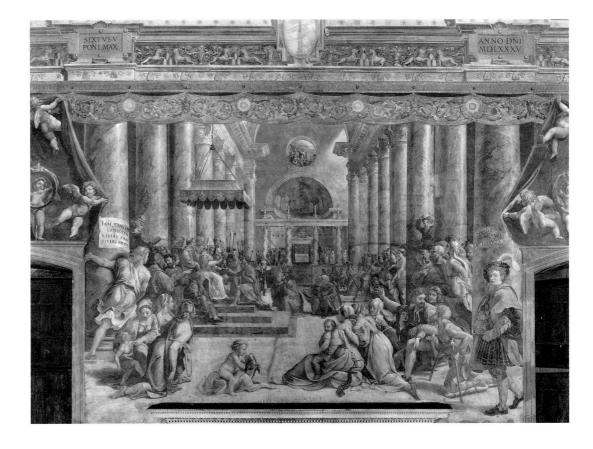

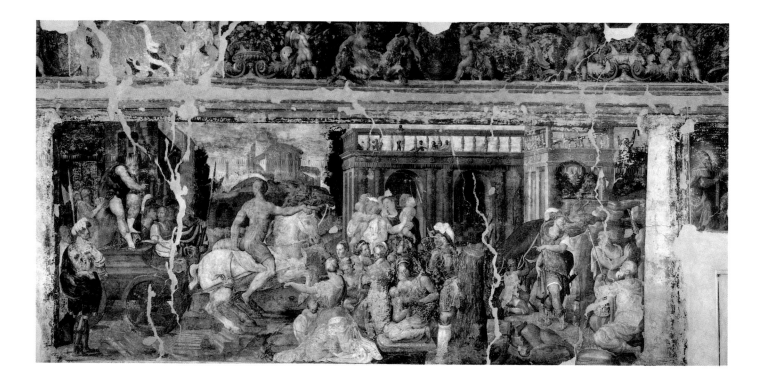

dential context was occasioned by the special nature of the Vatican, a residence to be sure, but one that carries august associations, bound as it is to the person and functions of Christ's vicar. By virtue of its location, the Vatican cycle acclaims the authority of the pope against the backdrop of his temporal, not his spiritual, powers.[10]

It has sometimes been said that the Sala di Costantino frescoes represent the final attempt on the part of the papacy to defend its claims to temporal power on the threshold of the Reformation. In truth, the Constantine theme does drop out of sight in Rome in the middle decades of the century, but during this same period the story was treated twice in the Emilia. These examples are significant for indicating attitudes toward the Constantine mythos then prevalent at the highest ecclesiastical levels. The first non-Roman cycle, dating from the early 1550s, was painted by Prospero Fontana, again in a nonecclesiastical setting, the main *salone* of the residence of the papal legate to Bologna, the most important city of the papal states outside Rome.[11] Conquered by Julius II in 1506, and site of the coronation of the Holy Roman Emperor Charles V by Clement VII in 1530, Bologna was a showcase of papal claims to temporal dominion. In fact, Con-

stantine imagery had been employed in Bologna as part of the ephemeral decorations that accompanied the imperial coronation. One of the triumphal arches erected at that time was decorated with the same principal scenes that appear in the Vatican palace.[12]

The original extent of Fontana's cycle is uncertain owing to the state of its preservation, but the surviving portions all derive from the Sylvester legend. One entire wall of the *salone* is devoted to three scenes in continuous narration, beginning with the emperor's renouncement of the cure that had been prescribed for his leprosy by the pagan priests, to bathe in the blood of three thousand infants (fig. 4).[13] Constantine accompanied his extraordinary demonstration of virtue with an impassioned discourse in praise of *pietas*, the quintessential Roman virtue that was the source of Rome's dominion: "romani imperii dignitas de fonte nascitur pietatis," as the emperor states in the text. This very scene was originally considered for inclusion in the Vatican cycle, and it is possible that Fontana's fresco reflects that earlier project.[14]

The second non-Roman cycle was commissioned in 1568 from the sculptor Silla da Viggiù for the illustrious Abbey church dedicated to Saint Sylvester at Nonantola

4. Prospero Fontana, *Constantine Renounces the Pagan Cure; Discovery of Pope Sylvester; Constantine's Dream of Saints Peter and Paul*, c. 1550, fresco, Palazzina della Viola, Bologna
Gabinetto Fotografico Soprintendenza alle Gallerie, Bologna

(Modena).[15] Silla's eight marble reliefs, completed in 1572, decorate a new repository for the relics of Pope Sylvester that was set up in conjunction with the church's high altar.[16] Among the noteworthy features of this project is the extent of the narrative series, again closely following the Sylvester legend, which traces the pope's life from his early education to the translation of his relics from Rome to Nonantola in 756, eighteen scenes in all. Six of the panels incorporate multiple episodes in the tale, but in two cases events concerning Constantine are isolated and afforded grander treatment.[17] One shows the emperor renouncing the bloodbath, the other, the baptism where attention is focused on the climax of the scene when Constantine saw Christ in a heavenly effulgence (fig. 5). In the final relief the emperor appears before the seated pope and proffers his grant, now depicted as the actual document of donation whose binding nature is communicated by the imperial *bullae* that dangle from its lower edge (fig. 6).[18]

The Constantine theme was revived in Rome during the reign of the Bolognese Pope Gregory XIII (1572–1585), who was surely familiar with the frescoes in Bologna as well as the reliefs in Nonantola. One of the towering figures of the Counter-Reformation period, Gregory initiated a comprehensive program of reform based on the ideals of the early church, specifically the great age of Christian triumph under Constantine.[19]

Gregory's program was expressed visually in the Sala di Costantino of the Vatican palace, where the original gilded wooden ceiling bearing Medici emblems was replaced with a high vault, lavishly decorated by Tommaso Laureti (1582–1586).[20] In the lunettes and angles of the vault, personifications of the eight provinces of Italy (along with the islands of Corsica and Sicily) and others representing Asia, Africa, and Europe proclaim the territorial hegemony of the popes as a result of Constantine's conversion to Christianity and his donation (see fig. 1).[21] These continents, as well as Italy and "various islands," are named in the Donation document.[22] Even the extensive texts used to

5. Silla da Viggiù, *Baptism of Constantine*, c. 1572, marble, Abbazia di San Silvestro, Nonantola
Soprintendenza per i beni artistici e storici di Modena e Reggio Emilia

6. Silla da Viggiù, *Donation of Constantine; Funeral of Sylvester; Translation of Sylvester's Relics to Nonantola*, c. 1572, marble, Abbazia di San Silvestro, Nonantola
Soprintendenza per i beni artistici e storici di Modena e Reggio Emilia

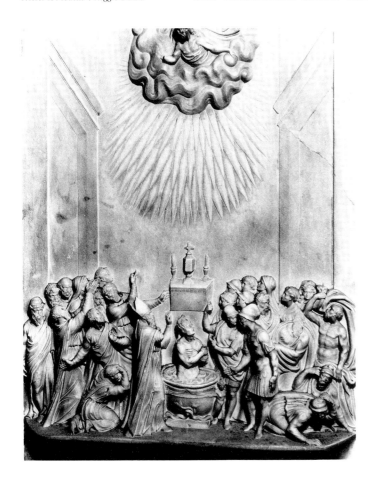

7. Tommaso Laureti,
*Triumph of Christianity
over Paganism*, 1585–1586,
fresco, Sala di Costantino,
Vatican palace
Archivio Fotografico Musei Vaticani

8. Girolamo Muziano,
Cesare Nebbia, and others,
*Constantine's Vision of
the Cross*, c. 1580–1583,
fresco, Galleria delle Carte
Geografiche, Vatican palace
Archivio Fotografico Musei Vaticani

explicate these figures evoke the codified form of Constantine's grant in a written instrument. The center of the vault (completed during the pontificate of Sixtus V) is defined as the underside of an honorific canopy framed by tasseled lambrequins that honors the pope within the actual room in the way he is distinguished in the donation scene on the lower wall. The central image, whose bold illusionism carries enormous visual power, celebrates Constantine's revolutionary achievement as an emblem of salvation: a gleaming bronze statue of the crucified Christ stands upon an altar, supplanting a pagan idol that lies shattered on the pavement (fig. 7).[23]

Gregory's ambitious building program involved augmenting Bramante's Cortile del Belvedere, the grand architectural statement that was an essential element in transforming the Vatican residence into a royal palace. Gregory constructed along the western corridor a level above the third story, at the height of the Stanze and the Sala di Costantino.[24] The decoration of this new space was executed between 1580 and 1583, at the same time the program for the vault of the Sala di Costantino was developed. Egnazio Danti, esteemed mathematician and geographer, was called to Rome to design the detailed topographical maps of Italy that decorate the lower walls and give the space its name, Galleria delle Carte Geografiche. Along the

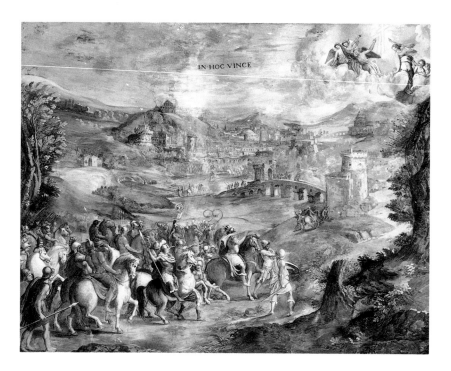

vault, Girolamo Muziano, Cesare Nebbia, and numerous assistants painted miraculous events that had occurred in the regions represented below.[25] In tandem, these frescoes constitute a visual inventory of the original lands of the church and extol the exemplary religiosity of its people, recipients of divine grace.

The series of eighty scenes in the vault begins at the south end of the gallery with

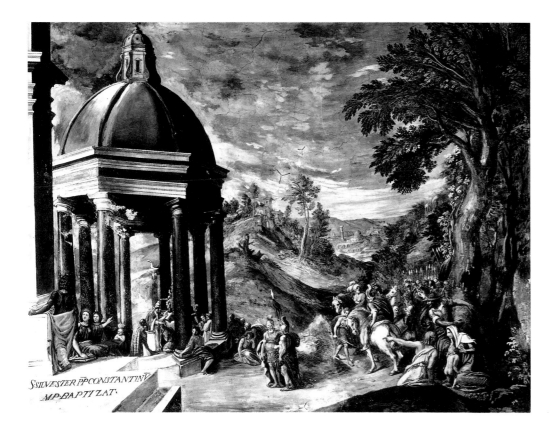

9. Girolamo Muziano,
Cesare Nebbia, and others,
Baptism of Constantine,
c. 1580–1583, fresco, Galleria
delle Carte Geografiche,
Vatican palace
Archivio Fotografico Musei Vaticani

10. Girolamo Muziano,
Cesare Nebbia, and others,
*Constantine Acts as Papal
Groom*, c. 1580–1583,
fresco, Galleria delle Carte
Geografiche, Vatican palace
Archivio Fotografico Musei Vaticani

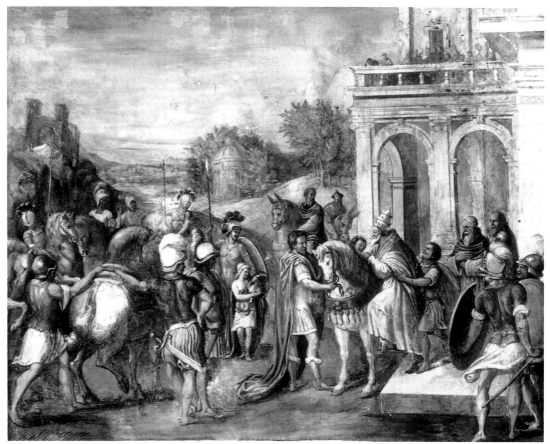

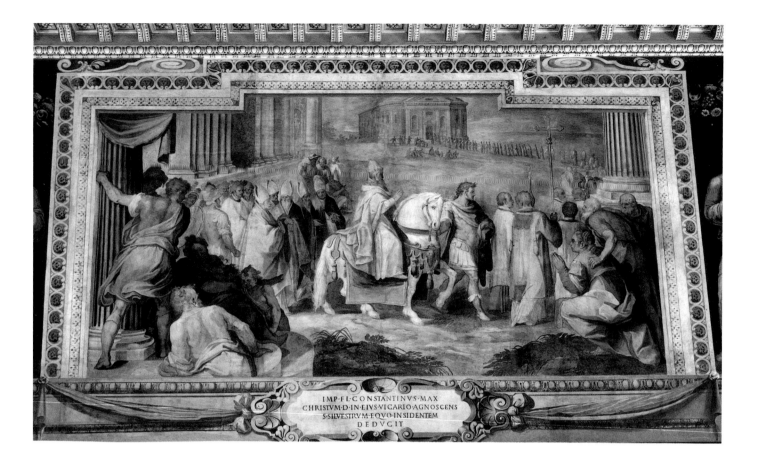

IMP·FL·CONSTANTINVS·MAX
CHRISTVM·D·IN·EIVS·VICARIO·AGNOSCENS
S·SILVESTRVM·EQVO·INSIDENTEM
DEDVCIT

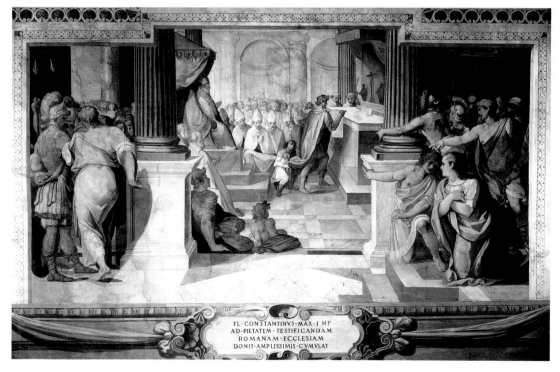

FL·CONSTANTINVS·MAX·I·MP
AD·PIETATEM·TESTIFICANDAM
ROMANAM·ECCLESIAM
DONIS·AMPLISSIMIS·CVMVLAT

11. Cesare Nebbia,
Giovanni Guerra, and
others, *Constantine Leads
Sylvester's Horse*, c. 1590,
fresco, Sala di Costantino,
Lateran palace
Archivio Fotografico Musei
Vaticani

12. Cesare Nebbia,
Giovanni Guerra, and
others, *Donation of
Constantine*, c. 1590,
fresco, Sala di Costantino,
Lateran palace
Archivio Fotografico Musei
Vaticani

five episodes drawn from Constantine's life, the only frescoes in the cycle that form a cohesive narrative. In the privileged position along the vault's main axis are the Vision of the Cross, here seen just before the climactic battle at the Milvian bridge, the Baptism, and Constantine acting as papal groom by holding the reigns of Sylvester's horse as the pope mounts his steed (figs. 8–10).[26] The story is expanded by two additional episodes placed at the sides that depict the emperor's participation in the construction of Saint Peter's and Saint Paul's.[27] Although Constantine's Donation is not included in the series, the subjects of the frescoes recall the text, while its tangible results are played out in the territorial images that line the walls of the Galleria.

Gregory's prominent treatment of Constantine in the Vatican palace decoration set the stage for the extraordinary expansion of the theme during the reign of his successor, Sixtus V (1585–1590). Unlike the Vatican-centered developments we have been tracing in Rome, the Sistine images were focused at the Lateran. The church of San Giovanni in Laterano, honored as *Mater et Caput Omnium Ecclesiarum Urbis et Orbis*, was the first church built by Constantine and Rome's cathedral. For a thousand years the Lateran palace, said to have been ceded to the popes by Constantine with the Donation, was the principal papal residence. During the Middle Ages its honorific titles, *patriarchium* and *sacrum palatium*, communicated the supreme authority exercised from within its walls.[28] But with the transfer of the papacy to the Vatican in the mid-fifteenth century, the Lateran fell into a decline that reached its nadir during the first half of the sixteenth century.

Around 1560 Pope Pius IV (1559–1565) launched a comprehensive restoration of the complex, and each of his successors contributed to the rehabilitation of this most venerable relic of the Constantinian Golden Age. It was Sixtus V, however, who put his stamp on the site. Little more than a month after assuming office, he began to reorganize the Lateran, excavating from its ruins a majestic vision of the papacy in its ancestral seat. Sixtus' idea was to provide an exalted context for the ceremonial functions of the pope, ones that had not been celebrated there for some time, but which he intended to be revived: church councils, consistories, stational Masses.

The commemoration of Constantine was a significant element of Sixtus' new Lateran.[29] Two cycles dealing with the emperor's life were developed at that time by Cesare Nebbia and Giovanni Guerra who, along with a phalanx of assistants, were responsible for embellishing the Sistine buildings throughout the city with narrative images celebrating all phases of sacred history. The decoration of one of the principal meeting halls in the newly constructed papal palace was devoted to Constantine's deeds, including the canonical Vision of the Cross and Baptism, both modeled on the scenes in the Vatican Sala di Costantino.[30] The political message is amplified by Constantine leading the pope's horse, the *officium stratoris*, the reverential act recorded in the text of the Donation (fig. 11).[31] The scene itself was understood to signify the first *possesso*, that majestic ceremony in which the pope takes possession of the Lateran and with it assumes his temporal power.[32] The cycle concludes with Constantine's Donation, which here received prominent treatment for the first time in Rome since the Vatican Sala di Costantino (fig. 12).[33] The event is cast as recorded in the text of the Donation, the document placed by the emperor "above the venerable body of the blessed Peter," that is, upon the high altar of Saint Peter's.[34] Constantine's pious bequest is no longer cast in symbolic terms as it had been at the Vatican; rather, it is depicted as a binding instrument of law.[35]

The second cycle painted at the Lateran during Sixtus' reign expands that of the palace, projecting its message from the private domain of the residence to a public, celebratory context. This cycle decorates the new loggia Sixtus constructed against the north transept façade of the church, facing the streets that lead visitors to the basilica from the direction of downtown Rome.[36] It replaced the loggia built around 1300 by Pope Boniface VIII. Both the Sistine loggia and its predecessor provided a noble backdrop for the appearance of the pope, in particular for the special blessing offered at exceptional times of the year *urbi et orbi*, to the city of Rome and to the world.[37]

In Boniface's loggia, the imperial flavor of the papal benediction at the Lateran was

made explicit by images of Constantine's baptism, the construction of the basilica, and, between them, Boniface himself blessing the people.[38] In the Sistine loggia, the cycle was expanded to seven scenes beginning with Constantine's Vision of the Cross and Battle with Maxentius (combined in one field) and ending with the deferential *officium stratoris*. Strategically flanking the center, where the pope would appear, are placed the two essential statements of papal power, Constantine's Donation to the Church and the Baptism by Pope Sylvester, both following the format of the frescoes in the nearby palace (figs. 13, 14).[39]

Constantine's prominence in the Sistine rehabilitation of the Lateran should be viewed as more than simply the reiteration of traditional claims to papal temporal authority. The profound associations of the Lateran itself with the first Christian emperor require emphasis here: it was his own palace, the legendary place of his baptism, and the first church he built. The commemoration thus carries the flavor of a site-specific statement in which the imperial Lateran plays a major role. When seen alongside the works of Gregory XIII at the Vatican, it is clear that a full-scale revival of Constantine imagery was effected at this time in Rome, almost sixty years after the execution of the Vatican Sala di Costantino.

This revitalization of the visual tradition that celebrates the triumph of Christianity and the powers of the papacy signals a new phase in the Catholic response to the religious controversies that defined the century. As in the later Middle Ages, Constantine is projected as a primary focus for the advancement of papal temporal claims, but these claims now carry a new emphasis centered on the millennial dream of Christian unity. In the later sixteenth century this goal was fueled by the necessity of recapturing the eastern lands of the church that had been lost to the Turk. The victory of Catholic forces at Lepanto in 1571, acclaimed as the "greatest victory ever won by Christian arms" and the turning point in the struggle against Islam, made this goal an immediate possibility.[40] In both geographical and political terms, Lepanto was identified as the gateway to the east: with the straits of the Dardanelles in Christian hands, the way was

now open to reconquer Constantine's city, Constantinople, and ultimately to repossess Jerusalem.[41]

The heroic confrontation at Lepanto was brought into the closest possible association with Constantine in the Lateran palace where the battle appears between the Vision of the Cross and the Donation, projected with the dramatic immediacy of a report from the front (fig. 15).[42] The city seen in the far distance, bathed in heavenly glory, clarifies the underlying meaning of the victory. The high dome and obelisk evoke Constanti-

13. Cesare Nebbia, Giovanni Guerra, and others, *Donation of Constantine*, c. 1590, fresco, San Giovanni in Laterano, Benediction loggia
Archivio Fotografico Musei Vaticani

14. Cesare Nebbia, Giovanni Guerra, and others, *Baptism of Constantine*, c. 1590, fresco, San Giovanni in Laterano, Benediction loggia
Archivio Fotografico Musei Vaticani

nople's characteristic features, Hagia Sofia and the obelisk that was raised in the hippodrome by Emperor Theodosius I.[43] Lepanto is thus identified as the necessary step toward the ultimate Christian goal, conquest of the eastern lands of the church, signifying full restoration of the unity of the Christian world that was traditionally acclaimed as Constantine's great achievement.[44]

Drawing out the significance of this objective, and casting it in terms that transcend contemporary politics, are the exalted personages flanking the principal scenes, Aaron and Solomon at the sides of the *strator* episode, David and Moses framing the Donation. These Hebrew worthies—priests and kings of Jerusalem—are conceived as existing in a realm contiguous with our own; they collapse historical time in a single instant of mystical revelation, signaling the fulfillment of God's salvific plan: Constantine's conversion of the empire to Christianity, and Sixtus' hoped-for

reconquest of the east and reunification of the Christian empire.[45]

With Sixtus V the Constantinian theme of Christian unity assumed a personal dimension that clarifies the central role the emperor came to occupy in Counter-Reformation thought. During the late 1570s, before his elevation to the papacy, Cardinal Felice Peretti Montalto began construction of a villa on the Esquiline Hill, close to his beloved church of Santa Maria Maggiore.[46] By 1581, approximately the same time the Vatican Map Gallery was being decorated, he took up residence in the casino known as the Palazzetto Felice. Demolished in the last century to make way for Rome's rail station, the extensive fresco decoration is known only from literary description. The frieze decoration of one room was entirely devoted to Constantine, with many of the same scenes that would later appear at the Lateran.[47]

Whatever these lost frescoes might sug-

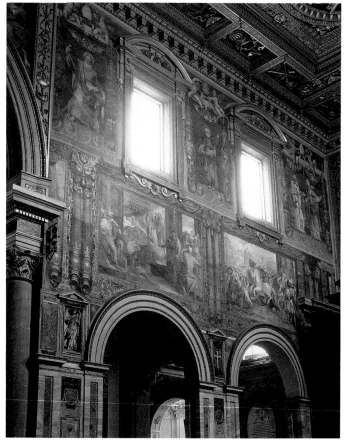

gest about the cardinal's career aspirations, their ultimate significance lies in Sixtus' lifelong affiliation with the Franciscans, taking vows at age thirteen and rising to the rank of vicar general of the order. Sixtus' Franciscan association became a central element of his papal persona, announced at the outset of his reign when he commemorated his accession to the Petrine dignity by issuing a medal depicting Saint Francis physically preventing the collapse of the Lateran basilica.[48] This image, one of the central themes in Franciscan iconography, had been divinely revealed to Pope Innocent III (1198–1216) in a dream. It was understood to signify the Franciscans' divine mandate to reform the church, with the Lateran symbolizing universal Christianity.[49]

Sixtus' Franciscan identity is especially relevant to the Constantine theme, for it was within the Franciscan context that major developments in the iconography of the True Cross, with its emphasis on Constantine, Helena, and the East, had occurred in the prior two centuries, the fore-

most Renaissance example being Piero's Arezzo cycle. Constantine and Francis had been paired by Saint Bonaventure—who, incidentally, was raised to the rank of doctor of the church by Sixtus—as dual agents of God's will whose mission it was to reform the world, the one bringing temporal peace through the Cross, the other bearing the imprint of the Cross upon his body as a sign of spiritual renewal.[50] The link between Constantine and Francis through the True Cross on the one hand, and that between Francis and the Lateran on the other, were essential factors in the Sistine revival of Constantine iconography at the Lateran.

The final cycle of the century addressed the emperor's crucial role in the history of Christian salvation, drawing out the idea of Constantine as an agent of reform that was expressed in Sixtus' grand statement at the Lateran. In advance of the tercentennial Holy Year of 1600—that exceptional time of grace when pilgrims would undertake a penitential journey to Rome—Pope Clement VIII (1592–1605) initiated a vast campaign to

16. *Altar of the Sacrament and Deeds of Constantine*, 1599–1600, San Giovanni in Laterano
Photograph: Alinari

17. From right: Bernardino Cesari, *Constantine's Triumphal Entry into Rome*; and Cesare Nebbia, *Constantine's Dream of Saints Peter and Paul*, 1599–1600, frescoes, San Giovanni in Laterano
Photograph: Bibliotheca Hertziana

18. From right: Paris Nogari, *Apparition of Christ at the Lateran*; and Giovanni Baglione, *Constantine's Donation to the Lateran*, 1599–1600, frescoes, San Giovanni in Laterano
Photograph: Bibliotheca Hertziana

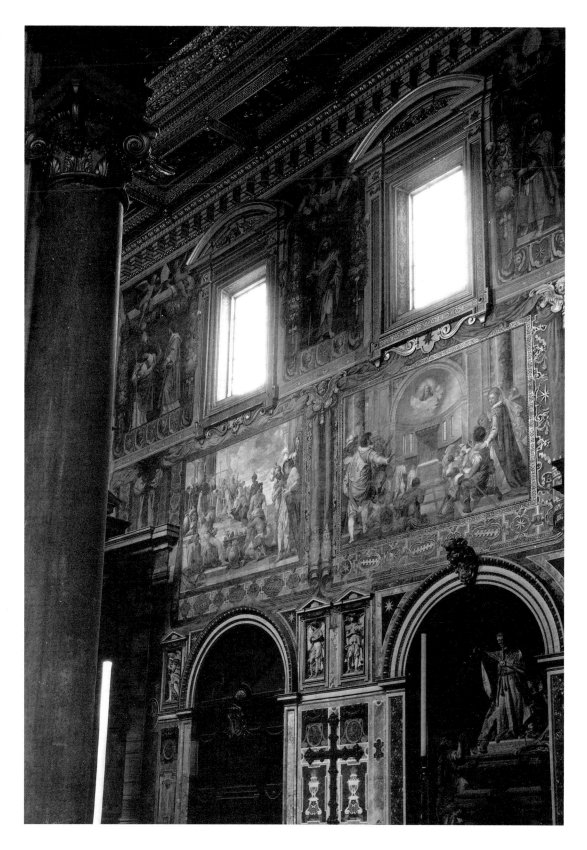

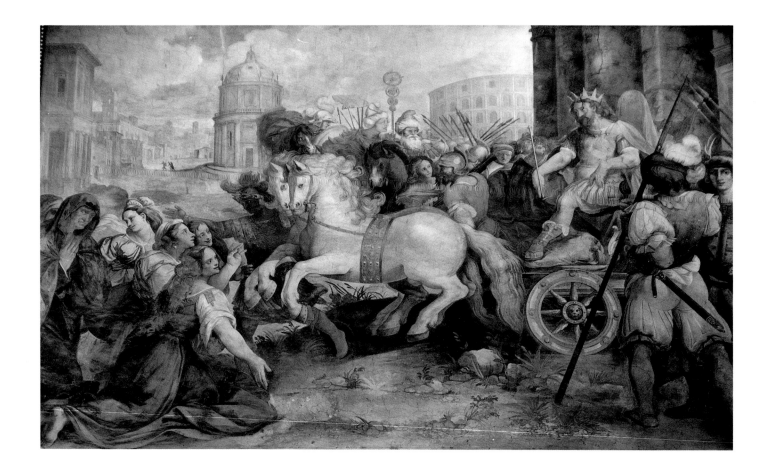

19. Bernardino Cesari,
*Constantine's Triumphal
Entry into Rome*, 1599–
1600, fresco, San Giovanni
in Laterano
Photograph: Bibliotheca Hertziana

restore the entire Lateran basilica.[51] Ultimately the project centered on the transept of the church, which was restructured as an independent liturgical space replete with its own entrance (the Sistine benediction loggia) and its own main altar dedicated to the Eucharist. The decoration celebrates the unity of the church by extolling the special history of the Lateran and its imperial patron (figs. 16–18).[52]

Eight large scenes framed by voluminous tapestrylike borders, recalling the fictive tapestries of the Sala di Costantino and evoking a state of perpetual celebration, are disposed equally between the two lateral walls. Although executed by five artists, Giuseppe Cesari d'Arpino was responsible for conceiving the cycle and coordinating its formal and iconographic features.[53] The first four episodes recount the essential elements of Constantine's biography: his triumphal entry into Rome following the victory over Maxentius; dream of Peter and Paul; discovery of Sylvester on Mount Soratte; and baptism by Sylvester at the Lateran. On the opposite wall, the focus of the cycle shifts to the Lateran where the emperor appears as patron, witnessing the rituals of foundation, consecration, Christ's miraculous appearance on the dedication day, and, in the last image, he endows the Lateran with vessels employed in the Christian liturgy. Here, for the first time since the fourteenth century, a cycle centered on Constantine's life and deeds in support of the church appears within the sacred space where the liturgy is celebrated.[54]

The physical context of the cycle within the church influenced the decoration in several essential ways. The particular scenes chosen for representation are derived from the Breviary lessons read to the faithful on the principal feasts in the church calendar that concern Constantine and the Lateran. The first four scenes derive from the texts associated with the feast commemorating Pope Sylvester on 31 December, and the last four from the celebration honoring the Lateran's dedication observed throughout the universal church on 9 November.[55]

The grounding of the frescoes in the spiri-

tual life of the Church also governed the way the scenes are disposed within the space. In keeping with the centrality of the altar, they proceed in a counterclockwise direction, beginning to the left of the transept altar and swinging around to culminate at its right. Generally, when a cycle unfolds around an altar, the sequence moves in a clockwise fashion, from the right side to the left.[56] The reversal of this usual order at the Lateran was likely occasioned by the practice of determining the privileged direction within churches not from the position of the laity or the officiating priest but from the altar itself.[57] In other words, the right or favored side of the altar is to our left where the cycle begins. Thus the frescoes are arranged with a particular relationship to the altar and to the Eucharist; they commence at the right hand of Christ.

Complementing the straightforward temporal narrative of the cycle, when each scene is read in sequence beginning at the altar, a second possibility emerges when the frescoes are considered as pairs set opposite one another across the transept. In this case they assert a meaningful correspondence based on the idea of promise and fulfillment: Constantine's personal salvation on the one side foreshadows the promulgation of Christianity at the Lateran on the other. The first two scenes we see upon entering the transept, *Sylvester Baptizes Constantine* and the *Foundation of the Lateran*, proclaim that the basilica was established on this spot as the direct consequence of Constantine's conversion. The spiritual benefits received personally by the emperor were to be made available to everyone at the Lateran. *Sylvester Discovered on Mount Soratte* and the *Consecration of the Lateran's High Altar* contrast the peripatetic early church with the first permanent, legally constituted church at the Lateran. In the next pair, *Constantine's Dream* and the *Apparition of Christ at the Lateran*, Christian truth is communicated through the appearance of divine personages. While Constantine's vision was private and involved his personal redemption, Christ's apparition was public and consecrated the Lateran as the font of salvation for all. The last two frescoes form visual parentheses around the cycle: *Constantine's Triumphal Entry into Rome* and his *Donation to the Lateran* link the emperor's demonstration of *pietas romana* in the first instance with his expression of *fides christiana* in the second (figs. 19–20).[58]

This typological ordering recalls a widespread convention of church decoration in which events from the Old Testament were juxtaposed with others from the New Testament across the space of the nave in precisely the way we see in the Lateran transept. This mode of relating narrative scenes according to their underlying, symbolic meaning is known from medieval as well as Renaissance art, and it is worth emphasizing that Piero applied it in the Arezzo cycle. It is of considerable interest that not only was Constantine credited with having originated this typological system, but its first application was said to have been at the Lateran, a claim advanced in the eighth century and often repeated.[59] This characteristic of the transept cycle thus recalls what was presumed to be the earliest official church decoration. At the same time it elevates Constantine's biography and the Lateran's history to the status of scriptural revelation.

The fundamental spiritual emphasis of the Lateran transept frescoes, derived from their literary sources and mode of disposition, illuminates one of the cycle's most puzzling elements when viewed against the prior sixteenth-century tradition: the exclusion of those episodes that in the past carried the most emphatic political meaning, Constantine's Vision of the Cross, Battle with Maxentius, and Donation. The omission of these episodes is all the more trenchant since the Vision is recalled by the two representations of the cross that appear along the left transept wall, worked in relief, while the other two episodes are evoked by the scenes that introduce and conclude the series.[60] *Constantine's Triumphal Entry into Rome* refers to the state of resolved conflict following military engagement, while the *Donation to the Lateran* casts the emperor as humble supplicant who, in a gesture of religious veneration, offers liturgical vessels for use in the Christian liturgy. These scenes celebrate the exceptional virtue and faith of the emperor, no longer adversary or opponent, but ally and colleague.[61]

It would be incorrect to see the substitution of these episodes for the more tradi-

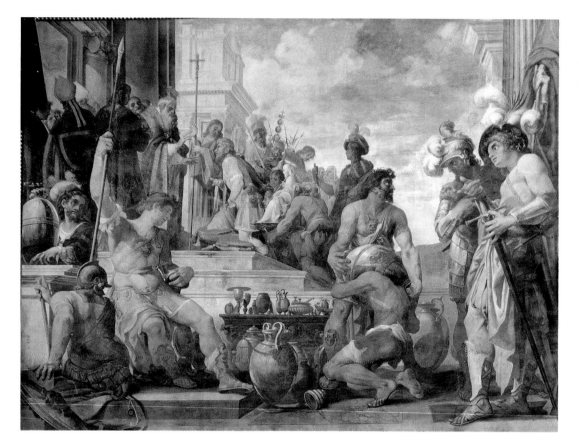

20. Giovanni Baglione,
*Constantine's Donation
to the Lateran*, 1599–1600,
fresco, San Giovanni in
Laterano
Photograph: Bibliotheca Hertziana

tional ones as a retreat from papal claims to temporal power. Rather, they respond to the liturgical context with particular emphasis drawn from the focus of the entire ensemble, the majestic altar dedicated to the Eucharist. The central event celebrated here is the spiritual triumph of the church, achieved through the conversion of Constantine and the official promulgation of the sacraments from Rome's cathedral.

The renewed concern for Constantine's temporal role in church history that was a major feature of the sixteenth-century cycles in residential contexts is assimilated in the Lateran transept to the model provided by the medieval and Renaissance tradition of ecclesiastical cycles. Underlying the synthesis of the temporal and spiritual facets of the Constantine myth, as expressed in the Lateran transept through the choice of scenes as well as the context itself, was the vision of Christian unity, a profound theological and political ideal, and one that possessed special resonance on the eve of the new century.

NOTES

1. For the Donation, see Horst Fuhrmann, ed., *Das Constitutum Constantini (Konstantinische Schenkung), Text* (Hannover, 1968). Concerning its critical fortunes, see Giovanni Antonazzi, *Lorenzo Valla e la polemica sulla donazione di Costantino, con testi inediti dei secoli XV–XVII* (Rome, 1985); and Pontien Polman, *L'élément historique dans la controverse religieuse du XVIe siècle*, Universitas Catholica Lovaniensis, Dissertationes theologicae, series 2, 23 (Gembloux, 1932), 171–173, 469–470, 535–536, 595–596.

2. Only cycles are under discussion here, but numerous single images involving Constantine are also to be found in the period. Portions of the following material were first presented in my "The Lateran and Clement VIII" (Ph.D. diss., New York University, 1988), 103–194, 595–624. See also Sigrid Epp, *Konstantinzyklen in Rom: Die päpstliche Interpretation der Geschichte Konstantins des Großen bis zur Gegenreformation* (Master's thesis, University of Munich, 1988), Schriften aus dem Institut für Kunstgeschichte der Universität München 36 (Munich, 1988).

3. The Sala di Costantino has been exhaustively studied by Rolf Quednau, *Die Sala di Costantino im vatikanischen Palast: Zur Dekoration der beiden Medici-Päpste Leo X. und Clemens VII.* (Hildesheim, 1979).

4. Inscriptions underscore the meaning of the scenes: Vision (ADLOCVTIO QVA DIVINITVS IMPVLSI CONSTANTINIANI VICTORIAM REPERERE); Battle (C. VAL. AVREL. CONSTANTINI IMP. VICTORIA. QVA. SVBMERSO MAXENTIO. CHRISTIANORVM OPES. FIRMATAE. SUNT); Baptism (LAVACRVM RENASCENTIS VITAE C. VAL. CONSTANTINI and HODIE SALVS VRBI E[T] IMPERIO FACTA EST); Donation (IAM TANDEM CHRISTVM LIBERE PROFITERI LICET and ECCLESIAE DOS A CONSTANTINO TRIBVTA). Quednau 1979, 852–853, doc. no. 51a–d.

5. For a review of the literary sources, see Christopher Bush Coleman, *Constantine the Great and Christianity* (New York, 1914). The Sylvester legend is best known in the text published by Boninus Mombritius, *Sanctuarium seu vitae sanctorum* (Milan, 1480), new ed., 2 vols. (Paris, 1910), 2:508–531. It was adopted as the official account of Constantine's conversion, appearing in the *Liber pontificalis*, and the Donation of Constantine (see following note). A compressed version of the tale was popularized in the thirteenth century by Jacobus de Voragine's *Legenda Aurea*.

6. For a survey of the iconographic tradition, see *Lexikon der christlichen Ikonographie*, 8 vols. (Rome, 1968–1976), 2:546–551, "Konstantin," 8:553–558, "Silvester I" (entries by Jörg Traeger).

7. On Piero's cycle, see most recently Marilyn Aronberg Lavin, *The Place of Narrative: Mural Decoration in Italian Churches, 431–1600* (Chicago, 1990), 167–194.

8. The last such cycle was painted by Maso di Banco in Santa Croce, Florence, in the 1330s. See Eve Borsook, *The Mural Painters of Tuscany: From Cimabue to Andrea del Sarto*, 2d ed. (Oxford, 1980), 38–42; David G. Wilkins, *Maso di Banco: A Florentine Artist of the Early Trecento* (New York, 1985), 19–59, 140–161, 169–176, figs. 1–57; and Lavin 1990, 68–69, figs. 47, 48.

9. The most prominent examples are in Tivoli, San Silvestro (early thirteenth century), and Rome, Santi Quattro Coronati, Oratory of San Silvestro (1246); Hanspeter Lanz, *Die romanischen Wandmalereien von San Silvestro in Tivoli: Ein römisches Apsisprogramm der Zeit Innocenz III.*, Europäische Hochschulschriften, series 28, Kunstgeschichte 22 (Bern, 1983); John Mitchell, "St. Silvester and Constantine at the SS. Quattro Coronati," in *Federico II e l'arte del Duecento italiano*, Atti della III Settimana di Studi di Storia dell'Arte Medievale dell'Università di Roma, ed. Angiola Maria Romanini, 2 vols. (Galatina, 1980), 2:15–32; and Guglielmo Matthiae, *Pittura politica del medioevo romano* (Rome, 1964), 73–91.

10. Paolo Cortesi (d. 1510) recommended that Constantine's Donation be represented in the courtyard of a cardinal's palace; Kathleen Weil-Garris and John D'Amico, "The Renaissance Cardinal's Ideal Palace: A Chapter from Cortesi's *De Cardinalatu*," in *Studies in Italian Art and Architecture 15th through 18th Centuries*, Memoirs of the American Academy in Rome 35, ed. Henry A. Millon (Rome, 1980), 91, 114, note 99.

11. See *La Palazzina della Viola in Bologna* (Bologna, 1935). In 1540 the property, formerly the villa of the Bentivoglio family, was purchased by the papal legate, Cardinal Bonifacio Ferrerio (d. 1543). The frescoes have been dated 1551–1553 by Vera Fortunati Pietrantonio, "L'immaginario degli artisti bolognesi tra maniera e controriforma: Prospero Fontana (1512–1597)," in *Le arti a Bologna e in Emilia dal XVI al XVII secolo*, Atti del XXIV Congresso Internazionale di Storia dell'Arte 4, ed. Andrea Emiliani (Bologna, 1982), 97–111.

12. Gaetano Giordani, *Della venuta e dimora in Bologna del sommo pontefice Clemente VII. per la coronazione di Carlo V. Imperatore celebrata l'anno MDXXX . . .* (Bologna, 1842), 15.

13. Alongside the renunciation scene, located on the western wall, are Constantine's dream of Peter and Paul, and Pope Sylvester as a penitent on Mount Soratte. Above the two doors piercing this wall are scenes of Constantine counseled by the Capitoline priests (left) and Constantine receiving Sylvester (right), both painted to simulate gilded bronze reliefs. The short north wall may have contained the Baptism of Constantine, but only fragments survive. Sylvester resurrecting the bull is depicted on the south wall.

14. A letter from Sebastiano del Piombo to Michelangelo, dated 6 September 1520, records that in addition to the Vision and Battle, the presentation of prisoners to Constantine and the preparation for the bloodbath were projected at that time; Quednau 1979, 845. A Raphael shop drawing shows the presentation of prisoners; Rolf Quednau, "Aspects of

Raphael's 'Ultima Maniera' in the Light of the Sala di Costantino," in *Raffaello a Roma: Il convegno del 1983* (Rome, 1986), 247–248, note 5, pl. XCII, fig. 1. No such drawing has yet been identified for the bloodbath episode, yet Fontana was in a position to know of such a project through his close association with Perino del Vaga, a member of Raphael's shop; Bernice Davidson, "Perino del Vaga e la sua cerchia: Addenda and corrigenda," *Master Drawings* 7 (1969), 404–409.

15. The commission belatedly fulfilled the testamentary bequest of Count Guido Pepoli, whose will of 1500 had provided for a new *arca*. See Girolamo Tiraboschi, *Storia dell'augusta badia di S. Silvestro di Nonantola*, 2 vols. (Modena, 1784–1785), 1:177–179; Gaetano Montagnani, *Storia dell'augusta badia di S. Silvestro di Nonantola . . .* (Modena, 1838), 65–68; Carlo Cesari, *Nonantola: Saggio storico-artistico* (Modena, 1901), 58; and Giuseppe Moreali, *Nonantola: Cenni storici e guida storico-artistica* (Rocca San Casciano, 1956), 79–82. A copy of the contract (dated 19 June 1568), payments, and other relevant documents are preserved in the Archivio Abbaziale di Nonantola, vol. 115 ("Documenti, scritture istrumenti, ed altre Memorie, e Carte interressanti"). The contract was drawn up among the Abbate Commendatario Gianfrancesco Bonomo, four of Pepoli's descendants, and the artist. (I am grateful to Gail Feigenbaum for signaling the existence of the *arca* and to Don Barbati who facilitated my examination of the documents.)

16. Each relief measures 75 x 56.5 cm. The following inscription reported by Tiraboschi 1784–1785, 1:179, once adorned the *arca*: "Monumentum hoc, in quo B. Silvestri Corpus quiescit, Guido Pepulus Comes testamento faciendum mandavit anno MD. Johannes & Cornelius ex Philippo, Sicinius & Fabius ex Hieronymo, & Romeus ex Alexandro piam avi paterni voluntatem aplian. sunt exequuti Anno Sal. MDLXXII. Abb. Guidone Ferrerio S.R.E. Cardin. Vercell. Pontefice Maximo Gregorio XIII." In 1572 Cardinal Guido Ferrerio replaced Bonomo as abbot, and it is his name that appears in the inscription. He was the grandnephew of Cardinal Bonifacio Ferrerio, who originally purchased the Palazzina della Viola at Bologna where the first Emilian Constantine cycle is located. See Pompeo Litta, *Famiglie celebri italiani*, 10 vols. (Milan, 1819–1903), vol. 3, s.v. "Ferrero di Biella;" and Lorenzo Cardella, *Memorie storiche de' cardinali della santa romana chiesa . . .* , 9 vols. in 10 (Rome, 1792–1797), 4:21–23, 5:84–86.

17. An eleventh-century copy of the *Vita Silvestri* is preserved in the Archive of the Abbazia and includes marginal notations in a sixteenth-century hand. Among the other texts bound in the same volume is a copy of the Donation of Constantine dated c. 1000. See Giuseppe Gullotta, *Gli antichi cataloghi e i codici della Abbazia di Nonantola*, Studi e testi 182 (Vatican City, 1955), 179–186.

18. Other scenes in the cycle that involve Constantine are: his dream of Peter and Paul; the imperial messengers lead Sylvester and his clerics to Rome; and Sylvester shows Constantine the image of Peter and Paul.

19. This idea has been discussed by Nicola Courtright, "Gregory XIII's Tower of the Winds in the Vatican" (Ph.D. diss., New York University, 1990). See also Jack Freiberg, "The Lateran Patronage of Gregory XIII and the Holy Year 1575," *Zeitschrift für Kunstgeschichte* 57 (1991), 66–87.

20. Quednau 1979, 31–34, 912–930, docs. 152–173; Maria Luisa Madonna, ed., *Roma di Sisto V: Le arti e la cultura* (Rome, 1993), 91–92 (entry by Flaminia Giorgi Rossi). A source of c. 1580 records the form of the original ceiling: "Ecci scrittura depinta che dice qualmente Clemente. VII. tini, cominciata a lion. x. di cui si scorgono l'imprese del suave (?), nel suffitto d'oro tutto." Ridolfo Lanciani, "Il codice barberiniano XXX, 89 contenente frammenti di una descrizione di Roma del secolo XVI," *Archivio della Società Romana di Storia Patria* 6 (1883), 459; also in Quednau 1979, 910, doc. 150. The divisions of the vault were reflected in the original pavement of the room; Giovanni Paolo Maffei, *Degli annali di Gregorio XIII . . .* , 2 vols. (Rome, 1742), 2:457: "Nel Palazzo Vaticano oltre ad aver fatto ristorare tutte le Pitture, i Soffitti, ed i stucchi, alzare la volta della gran Sala detta di Costantino, tirare il pavimento di pietre fine intagliate a proporzione della stessa volta. . . ."

21. An anonymous chronicle reports that Laureti had first thought to paint this subject as a narrative scene with Constantine ordering the destruction of pagan idols, but was prevented from doing so by Sixtus V (Ludwig von Pastor, *The History of the Popes from the Close of the Middle Ages*, 5th ed., 34 vols. [Saint Louis, Mo., 1923–1941], 20:613–614, 650–653; Quednau 1979, 915–916, doc. 157). Further on the decoration of the vault, see Helmut Wohl, "New Light on the Artistic Patronage of Sixtus V," *Arte cristiana* (1992), 123–134.

22. The accompanying inscriptions, for which see Quednau 1979, 918, doc. 159a, refer to the spread of Christianity throughout the empire. That the decoration was intended to make explicit Constantine's patronage of the church is stated in an anonymous chronicle which reports that Laureti "li venne in animo di far attioni del medesimo imperatore et in particulare quelle che fece in honore e beneficio di s. chiesa, et havendo esso Tommaso vista in una delli parieti della medesima sala la donatione d'Italia fatta da Costantino a S. Silvestro e suoi successori rappresentata per una figuretta non molto intelligibile, pensò di fare l'istessa Italia distinta in 8 provincie secondo l'ordine de Strabone per più intelligenza di tal donatione." Pastor 20:650–653; Quednau 1979, 915–916, doc. 157.

23. Fuhrmann 1968, 85–86: "et per nostras imperialium iussionum sacras tam in oriente quam in occidente vel etiam septentrionali et meridiana plaga, videlicet in Iudea, Graecia, Asia, Thracia, Africa et Italia vel diversis insulis nostram largitatem eis concessimus, ea prorsus ratione, ut per manus beatissimi patris nostris Silvestrii pontificis successorumque eius omnia disponatur."

24. For this addition to the palace, see James Ackerman, *The Cortile del Belvedere*, Studi e documenti

per la storia del palazzo apostolico vaticano 3 (Vatican City, 1954), 102–109; Diocletio Redig de Campos, *I palazzi vaticani* (Bologna, 1967), 174–178; and Pastor 20:616–621. See now Courtright 1990, 589–593; and Madonna 1993, 93 (entry by Maria Barbara Guerrieri Borsoi).

25. The maps are discussed by Roberto Almagià, *Le pitture murali della Galleria delle Carte Geografiche*, Monumenta Cartographica Vaticana 3 (Vatican City, 1952). For the frescoes in the vault, see Iris Cheney, "The Galleria delle Carte Geografiche at the Vatican and the Roman Church's View of the History of Christianity," *Renaissance Papers: 1989*, the Southeastern Renaissance Conference, ed. Dale B. J. Randall and Joseph A. Porter (Durham, N.C., 1989), 21–37; and Claudio Strinati, "Roma nell'anno 1600: Studio di pittura," *Ricerche di storia dell'arte* 10 (1980), 17–20.

26. The temporal sequence of these narratives is inverted so that the Baptism leads the series, with the Vision appearing after Constantine fulfills the role as groom for the pope. For the tradition of Constantine as papal groom, see Jörg Traeger, *Der reitende Papst: Ein Beitrag zur Ikonographie des Papsttums* (Munich, 1968), especially 56–57.

27. The Vision episode includes the words IN HOC VINCE; all the others have explanatory legends: Baptism (S. SILVESTER PP CONSTANTINV [I]MP. BAPTIZAT); Sylvester mounts his horse (CONSTANTINVS IMP S. SILVESTRI EQVI FRENVM TENET); Construction of Saint Peter's (CONSTANTINVS. IMP S. PETRO. APOSTOLO BASILICAM ERIGIT.); Construction of Saint Paul's (CONSTANTINVS. IMP S. PAVLO. APOSTOLO BASILICAM ERIGIT).

28. For the Lateran's honorific titles, see Reinhard Elze, "Das 'Sacrum Palatium Lateranense,' im 10. und 11. Jahrhundert," *Studi gregoriani* 4 (1952), 27–52. Constantine was said to have granted the Lateran palace to the popes with the Donation: "contradimus palatium imperii nostri Lateranense, quod omnibus in toto orbe terrarum praefertur atque praecellet palatiis. . . ." (Fuhrmann 1968, 87).

29. Gregory XIII introduced the idea of commemorating Constantine at the Lateran in a special way, but this remembrance did not involve the use of narrative cycles; Freiberg 1991, 80–84. A survey of Sixtus' interventions at the Lateran is now available in Madonna 1993, 94–135.

30. On the fresco decoration, see Domenico Fontana, *Della trasportatione dell'obelisco vaticano et delle fabriche di Nostro Signore Papa Sisto V*, 2 vols., 2d ed. (Naples, 1603–1604), 1:52r–52v; Liliana Barroero, "Il Palazzo Lateranense: Il ciclo pittorico sistino," in *San Giovanni in Laterano*, ed. Carlo Pietrangeli (Rome, 1990), 217–221; and Madonna 1993, 116. The building is discussed by Bettina Burkart, *Der Lateran Sixtus V. und sein Architekt Domenico Fontana* (diss., Rheinische Friedrich-Wilhelms-Universität, 1987) (Bonn, 1989).

31. Fuhrmann 1968, 92: "et tenentes frenum equi ipsius pro reverentia beati Petri stratoris officium illi exhibuimus. . . ."

32. The fresco was identified as such by Fontana 1603–1604, 1:52v: "quando egli [Constantine] conoscendo il Vicario di Christo per honorarlo maggiormente à piedi, con la mano al freno del cauallo conduce l'istesso san Siluestro à san Giouanni Laterano. . . ." Further on the *possesso*, see Francesco Cancellieri, *Storia de' solenni possessi de' sommi pontefice detti anticamente processi o processioni, dopo la loro coronazione dalla basilica vaticana alla lateranense . . .* (Rome, 1802).

33. Legends below each scene read: Vision (CONSTANTINVS. IMP VELLVM. CONTRA. MAXENTIVM. PARANS. VICTRICIS. CRVCIS. SIGNVM IN. CAELO. VIDET); Baptism (FL. CONSTANTINVS. PRIMVS. ROM. IMP CHRISTIANA. FIDE. PVBLICE. SUSCEPIA A. S. SILVESTRO. PAPA BAPTIZATVR); Donation (FL. CONSTANTINVS. MAX. IMP AD PIETATEM. TESTIFICANDAM ROMANAM. ECCLESIAM DONIS. AMPLISSIMIS. CVMVLAT); Strator (IMP. FL. CONSTANTINVS. MAX CHRISTVM. D. IN. EIVS. VICARIO. AGNOSCENS S. SILVESTRVM. EQVO. INSIDENTEM DEDVCIT).

34. Fuhrmann 1968, 97: "Huius vero imperialis decreti nostri paginam propriis manibus roborantes super venerandum corpus beati Petri, principis apostolorum, posuimus. . . ."

35. The first known representation of the Donation, the mosaic image that decorated the medieval east portico of the Lateran, which was still extant in the late sixteenth century, also depicted the emperor holding the document. See Ingo Herklotz, "Der mittelalterliche Fassadenportikus der Lateranbasilika und seine Mosaiken: Kunst und Propaganda am Ende des 12. Jahrhunderts," *Römisches Jahrbuch für Kunstgeschichte* 25 (1989), 25–95.

36. The frescoes are discussed in Madonna 1993, 122–125 (entry by Rita Torchetti). For the street system and Sixtus' contribution to its development, see René Schiffmann, *Roma felix: Aspekte der städtebaulichen Gestaltung Roms unter Papst Sixtus V.*, Europäische Hochschulschriften, series 28, vol. 36 (Bern, 1985).

37. This benediction, which carried a plenary indulgence, was delivered from the Lateran at the conclusion of the papal *possesso*. Its most significant enactment was on Easter Sunday when it coincided with Christ's Resurrection. Sixtus added Easter to the stational Masses traditionally celebrated at the Lateran, and it was from the new loggia that the *urbi et orbi* benediction was delivered by the pope.

38. Onofrio Panvinio, in Philippe Lauer, *Le palais de Latran: Étude historique et archéologique* (Paris, 1911), 483, described the decoration in the following way: "in his pictus est Bonifacius VIII populo ex eo moeniano benedicens, Constantini baptismus et Basilicae Lateranensis aedificatio." For the extant fragment of Boniface blessing, see Charles Mitchell, "The Lateran Fresco of Boniface VIII," *Journal of the Warburg and Courtauld Institutes* 14 (1951), 1–6; and Silvia Maddalo, "Bonifacio VIII e Jacopo Stefaneschi: Ipotesi di lettura dell'affresco della loggia lateranense," *Studi romani* 31 (1983), 129–150. For a possible reflection of what the other two scenes may have looked like, see Giovanna Curcio, "Giuliano

Dati: 'Comincia el tractato di Santo Ioanni Laterano,'" in *Scrittura biblioteche e stampa a Roma nel Quattrocento*, Atti del 2° seminario, 6–8 maggio 1982, ed. Massimo Miglio (Vatican City, 1983), 271–304, especially 294–297.

39. The loggia series also includes Constantine's dream of Peter and Paul combined in a single field with Sylvester exhibiting to Constantine the image of the two saints. The placement of the Donation before the Baptism, reversing the usual chronological sequence of these events, follows the order of the scenes that once existed in the east portico as they are recorded in the surviving visual records. See Herklotz 1989, 48–53; and Traeger 1968, 57–59. Additional scenes in the Sistine loggia assert Peter's primacy among the Apostles and the superiority of Old Testament priestly power over temporal might.

40. For this characterization of Lepanto, see Pastor 18:444. The Constantinian resonance of the battle was present from the start, for the standard Pius V gave to Marcantonio Colonna to carry into battle bore an image of the Crucified Christ with the inscription IN HOC SIGNO VINCES; Pastor 18:381.

41. The territorial significance of the victory was made explicit during the celebrations honoring Marcantonio Colonna, commander of the papal fleet. See especially the inscriptions mounted on the arches of Constantine (COGITA. ADITVM. IAM. PATEFIERI. AD. COSTANTINI. VRBEM. IVVANTE. DEO. RECVPERANDVM.) and Titus (LAETARE. HIERVSALEM. QVAM. OLIM TITVS. VESPASIANVS. CAPTIVAM DVXIT. PIVS. V. LIBERARE. CONTENDIT) for Colonna's triumphal entry into Rome; Girolamo Catena, *Vita del gloriosissimo Papa Pio Quinto* . . . (Rome, 1586), 204–205. The theme of reconquering Jerusalem was also proclaimed in an oration by Marcantonio Mureto honoring Colonna that was commissioned by the Roman Senate; Paolo Alessandro Maffei, *Vita di S. Pio Quinto sommo pontefice, dell'Ordine de' Predicatori* . . . (Rome, 1712), 360–363. See also Pastor 18:433–435.

42. One of the ships bears banners with Turkish emblems, and on the shore bound prisoners who wear turbans are led away. The atmospheric turbulence so clearly depicted in the fresco may allude to the eruption of a violent storm at the conclusion of the battle; Pastor 18:421.

43. For the monuments in question, see Wolfgang Müller-Wiener, *Bildlexikon zur Topographie Istanbuls* (Tübingen, 1977), 64–71, 84–96.

44. The Lepanto scene is one of four *vedute* that complement the Constantine histories. The other three depict rustic landscapes in which a variety of mundane activities are represented; in each case there is a simple building surmounted by a cross. These scenes may refer to the universal spread of Christianity under Constantine; see Eusebius, *Tricennial Oration*, 17.4: "In cities and villages, in all regions and the barbarian wastes He [Constantine] dedicated temples and precincts to the One God the Ruler of All, surely the Master of the Universe." H. A. Drake, *In Praise of Constantine: A Historical Study and New Translation of Eusebius' Tricennial Orations* (Berkeley, Calif., 1976), 124.

45. Sixtus' desire to transfer the Holy Sepulcher from Jerusalem to Rome partook of the same evangelical zeal; Pastor 22:160–161.

46. See Guglielmo Matthiae, "La villa Montalto alle Terme," *Capitolium* 14 (1939), 139–147; Matthias Quast, "Villa Montalto: Genesi del sistema assiale," in *L'architettura a Roma e in Italia (1580–1621)*, Atti del XXIII Congresso di Storia dell'Architettura, Roma, 24–26 marzo 1988, ed. Gianfranco Spagnesi, 2 vols. (Rome, 1989), 1:211–217; and Matthias Quast, *Die Villa Montalto in Rom: Entstehung und Gestaltung im Cinquecento* (Munich, 1991), especially 41–59, 139–162.

47. The fresco decoration of the villa was described in detail by Vittorio Massimo, *Notizie istoriche della Villa Massimo alle Terme Diocleziane con un'appendice di documenti* (Rome, 1836), 47–48. Massimo recorded ten scenes drawn from Constantine's life: Constantine embarks with his armada for Rome; vision of the Cross; battle with Maxentius; triumphal entry into Rome; dream of Peter and Paul; Constantine kneels before Pope Sylvester; Sylvester baptizes Constantine; the foundation of the first basilicas; the demolition of pagan temples and the destruction of idols; Constantine gives rich gifts (*ricchi donativi*) to Sylvester and to the church. Concerning the frescoes, see now Madonna 1993, 152–155 (entries by Sigrid Epp and Rita Torchetti).

48. Filippo Buonanni, *Numismata pontificum romanorum quae a tempore Martini V usque ad annum MDCXCIX*, 2 vols. (Rome, 1706), 1:381, no. 2; Madonna 1993, 450, no. 1 (entry by Giancarlo Alteri). For other depictions of this scene and for the use of Franciscan iconography during Sixtus' reign, see Corrine Mandel, "Golden Age and the Good Works of Sixtus V: Classical and Christian Typology in the Art of a Counter-Reformation Pope," *Storia dell'arte* 62 (1988), 51, note 106.

49. On the dream of Innocent III, see Jürgen Werinhard Einhorn, "Das Stützen von Stürzendem: Der Traum des Papstes Innocenz III. von der stürzenden Lateranbasilika bei Bonaventura. Vorgeschichte und Fortwirken in literatur- und kunstgeschichtlicher Sicht," in *Bonaventura: Studien zu seiner Wirkungsgeschichte*, Franziskanische Forschungen 28, ed. Ildefans Vanderheyden (Werl, Westfalen, 1976), 170–193; Maria Andaloro, "Il sogno di Innocenzo III all'Aracoeli: Niccolò IV e la basilica di S. Giovanni in Laterano," in *Studi in onore di Giulio Carlo Argan*, ed. Silvana Macchioni and Bianca Tavassi La Greca, 2 vols. (Rome, 1984), 1:29–37; and Julian Gardner, "Päpstliche Träume und Palastmalereien: Ein Essay über mittelalterliche Traumikonographie . . . ," in *Träume im Mittelalter: Ikonologische Studien*, ed. Agostino Paravicini Bagliani and Giorgio Stabile (Stuttgart-Zurich, 1989), 113–124.

The Franciscan pope Nicholas IV (1288–1292) alluded to the vision in inscriptions commemorating his renovations at the Lateran; Lauer 1911, 192–193.

50. In a sermon preached in Paris in 1262, Bonaventure said: "It was the Lord's good pleasure at the time

of Constantine that he willed to put an end to wars and tribulations through the sign of victory, that is, the sign of the cross, which appeared to Constantine. As he willed to imprint the sign of victory on Constantine, so he chose to imprint the sign of penance on Saint Francis." *The Disciple and the Master: St. Bonaventure's Sermons on St. Francis of Assisi*, ed. and trans. Eric Doyle (Chicago, 1983), 84; quoted by Lavin 1990, 193–194, 349, note 147. Bonaventure, *Opera Omnia*, vol. 9 (Quaracchi, 1901), 586–587. See also Einhorn 1976, 185–187 ("Konstantin und Franziskus"). For the elevation of Bonaventure to the rank of doctor, see Pastor 21:138. Sixtus also initiated the first comprehensive publication of Bonaventure's writings, which were issued by the Vatican press in eight volumes between 1588 and 1596.

51. Clement's initial steps were taken at the pastoral Visitation he conducted of the Lateran on 14 June 1592; Diego Beggiao, *La visita pastorale di Clemente VIII (1592–1605): Aspetti di riforma post-tridentina a Roma* (Rome, 1978), 112–119.

52. On the meaning of the altar that forms the fulcrum of the space, see Jack Freiberg, "Clement VIII, the Lateran, and Christian Concord," in *IL60: Essays Honoring Irving Lavin on His Sixtieth Birthday*, ed. Marilyn Aronberg Lavin (New York, 1990), 167–190. The program as a whole is analyzed in my forthcoming monograph, *The Lateran in 1600: Christian Concord in Counter-Reformation Rome* (Cambridge, 1995).

53. Giovanni Baglione, *Le vite de' pittori scultori et architetti dal pontificato di Gregorio XIII, del 1572 in fino a' tempi di Papa Urbano Ottavo nel 1642*, Rome, 1642, ed. Valerio Mariani (Rome, 1935), 89, 117, 147, 149, 190, 401, named the artists who were involved and identified Giuseppe Cesari d'Arpino as superintendent of the painted decoration of the transept. In general on Arpino, see Herwarth Röttgen, *Il Cavalier d'Arpino* [exh. cat., Palazzo Venezia] (Rome, 1973). A greater degree of independence among the artists than I believe was the case has been assumed by Herwarth Röttgen, "Repräsentationsstil und Historienbild in der römischen Malerei um 1600," in *Beiträge für Gerhard Evers anläßlich der Emeritierung im Jahre 1968*, Darmstädter Schriften 22 (Darmstadt, 1968), 71–82; and Strinati 1980, 26–33.

54. The only exception is the special case of the *arca* of Saint Sylvester at Nonantola discussed above. The author of that work, Silla da Viggiù, contributed to the sculptural decoration of the Lateran transept; Anna Maria Corbo, *Fonti per la storia artistica al tempo di Clemente VIII*, Ministero per i Beni Culturali e Ambientali, Archivio di Stato di Roma 85 (Rome, 1975), 134, 165–166, 186, 200, 214, 223, 241.

55. *Breviarium romanum ex decreto sacrosancti concilij tridentini restitutum, Pii Quinti Pont. Max. iussu editum, ex Clementis viii auctoritate recogni-* *tum* (Rome, 1606), 185–186, 974–976. From at least the twelfth century, portions of the *Vita Silvestri* were read on 31 December; Prior Bernhard, *Ordo officiorum ecclesiae lateranensis*, Historische Forschungen und Quellen 2–3, ed. Ludwig Fischer (Munich, 1916), 16: "in festiuitate sancti Siluestri pape VIIII lectiones leguntur de vita eius." The liturgical basis of the scenes follows a long tradition; further on the "Festival Mode," see Lavin 1990, 107–110, 137–138, 167, 169, 251.

56. Concerning the counterclockwise disposition of narrative cycles, see Lavin 1990, 255–260.

57. See Otto Nussbaum, "Die Bewertung von Rechts und Links in der römischen Liturgie," *Jahrbuch für Antike und Christentum* 5 (1962), 158–171; and in general on this issue, *Lexikon der christlichen Ikonographie* 3:511–515, s.v. "Rechts und Links" (entry by Erika Dinkler-von Schubert).

Lavin (1990, 259) suggested that the counterclockwise disposition was applied at the Lateran in order to frame the high altar (when viewed from the nave) with the two scenes that pertain to its special history—the consecration and the apparition of Christ—and to incorporate into the painted cycle the actual miraculous image of Christ located in the apse.

58. In the *Triumphal Entry* there is a reminiscence of the *Vita Silvestri* episode in which Constantine delivers his oration in praise of Roman virtue before the mothers; compare figs. 4, 19.

59. At the second council of Nicaea (787), the legates of Pope Hadrian I asserted that "Tale quid et divae memoriae Constantinus Magnus imperator olim fecit: aedificato enim templo Salvatoris Romae, in duobus parietibus templi historias veteres et novas designavit, hinc Adam de paradiso exeuntem, et inde latronem in paradisum intrantem figurans: et reliqua." See Jacques Paul Migne, ed., *Patrologia Latina* 221 vols. (Paris, 1844–1855), 129:289. The idea received wide attention in the sixteenth century; see, for example, Gabriele Paleotti, *Discorso intorno alle immagini sacre et profane . . .* [2.13] (Bologna, 1582), in *Trattati d'arte del Cinquecento fra manierismo e controriforma*, ed. Paola Barocchi, 3 vols. (Bari, 1960–1962), 2:303.

60. The crosses appear between the *Triumph* and *Dream*, and between the *Soratte* and *Baptism* episodes. In both cases they are formed with *giallo antico* marble, and are decorated with bronze elements: rays at the center of the cross, a seraph below it, and the dove of the Holy Spirit above.

61. The pairing of these scenes evokes the ancient triumphal ceremony that concluded at the Temple of Jupiter Optimus Maximus, where the triumphator offered sacrifice in thanksgiving for the victory. Here the Lateran supplants the pagan temple, and the sacrifice is that of the Eucharist.

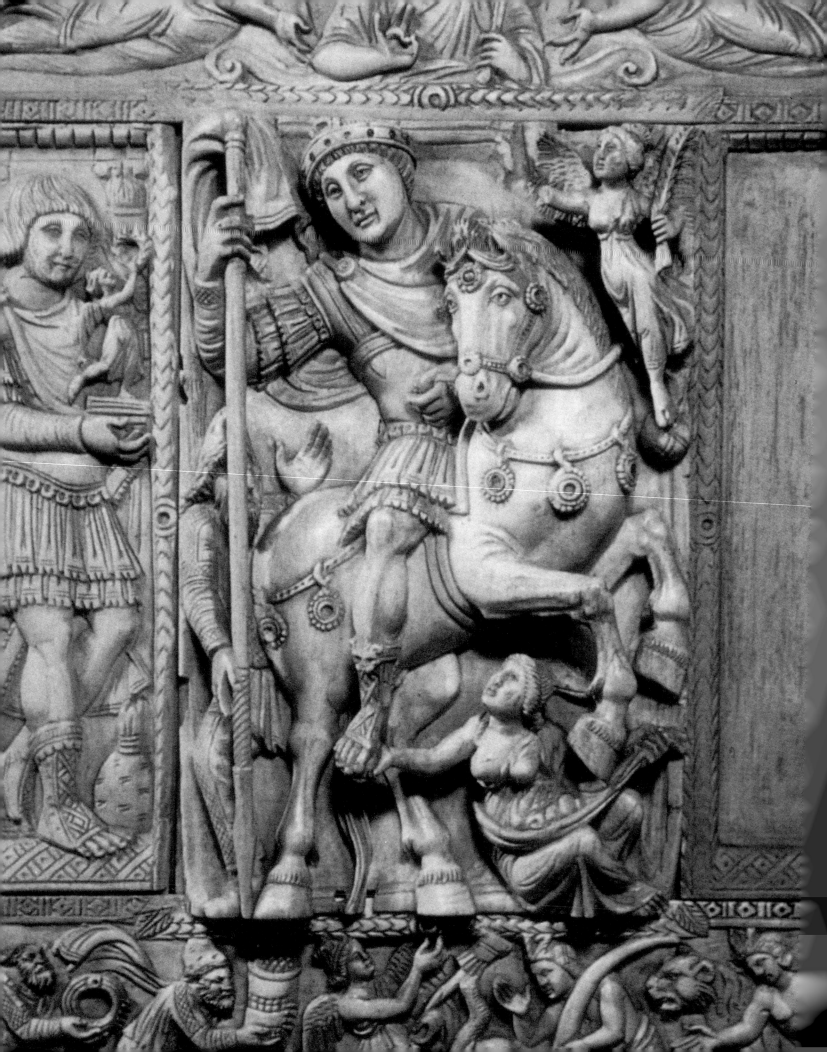

MARC FUMAROLI
Collège de France

Cross, Crown, and Tiara: The Constantine Myth between Paris and Rome (1590–1690)

In the seventeenth century, two powerful French patrons refused masterworks related to the Constantine myth which they had commissioned from the greatest artists of their time, Rubens and Bernini. This study explores the reasons why by focusing on the meanings of these works of art in their proper context. During that century, works of art, as well as *objets de vertu*, poetic pieces and literary works, played an important role in diplomatic maneuverings between the courts of Europe. They became a means of persuasion or seduction, eventually of challenge, in any case a symbolic gauge of the actual state of diplomatic relations. Art, and the symbols it conveyed, became political markers, far removed from the contemplative fervor embodied in Piero della Francesca's *Legend of the True Cross* in Arezzo. Between 1590 and 1690, major works of art on the theme of Constantine the Great became an important aspect of the intricate diplomatic chess game and ideological controversy between the French Catholic crown and the Roman Catholic tiara. Throughout that century, the gaze of Europe was focused upon these two political champions and the sort of signals they exchanged.

Relations between the French kings and the popes took an entirely new turn at the end of the sixteenth century. The last Valois

monarchs had refused to allow the Tridentine Canon, promulgated in 1563 by the Medici pope Pius IV, to become legally valid within the territory of France.[1] Furthermore, the legitimate heir to the French throne, Henry of Navarre, was an adherent of the Calvinist creed and in fact the head of the Calvinist party in French politics.[2] In 1585 Pope Sixtus V had excommunicated him, encouraging civil war between the Calvinist party and the Roman Catholic forces in France. The pope ostensibly ignored the presence in Henry's ranks of those who supported an increasing number of moderate, peace-loving Catholics called *politiques* or Gallicans. But Rome did not content itself with the medieval thunderbolt of excommunication. Counter-Reformation rhetoric was also directed toward France, first in order to inflame the zeal of the faithful against Henry's life and then, when that failed, to persuade him solemnly to abjure his heretical creed. For these purposes, old arguments and ancient symbols were revived and reused in new guises. At the height of the drama, two leading figures of Roman Catholicism, Baronius in Rome and Justus Lipsius in Antwerp, proferred solemn statements. Lipsius, himself a convert, published his *De Cruce libri tres*[3] in 1594, the very year of Henry IV's conversion, followed by his coronation and anointing (*sacre*) in Chartres cathedral. But Rome feared deception, and Pope Gregory XIII renewed the king's

For Irving Lavin

1. Peter Raul Rubens,
Triumph of Rome,
1622, oil sketch
Mauritshuis, The Hague;
photograph: Collège
de France, Paris

excommunication. It was withdrawn only in
1595, after a long and difficult series of nego-
tiations and compromises involving the
strongest minds at both courts: the cardinals
du Perron and d'Ossat in Paris and cardinals
Aldobrandini and Barberini in Rome. In order
to foster the reconciliation between the
newly legitimized king of France and the
papacy, Baronius in 1600 published the
ninth volume of his *Annales Ecclesiastici,*
with a magnificent Latin dedicatory epistle
addressed to Henry IV,[4] in which the Roman
cardinal celebrated the glory of the French
crown, linking it inseparably to the devotion
of the French kings toward the papal see.
The official historian of the church de-
scribed with enthusiasm the marriage of the
king to Maria de' Medici as a solemn re-
newal of the alliance between the spiritual
power of the popes and the temporal power
of the French kingdom. The ninth book of
the *Annales,* with its narration of the bap-
tism of Clovis and the loyalty of the Mero-
vingians toward Rome, was presented to the
new French royal couple as an erudite epi-

thalamium. The past mirrored the present,
and the early medieval army of the Frankish
Christian kings supporting the popes with
weapons ("arma signo Sanctae Crucis im-
pressa") offered a role model for Henry IV
and his own military power. An implicit
parallel with the Constantinian labarum
lurks here, but it was difficult for Baronius
to stress the point. He had told the full story
of Constantine in the third volume of his
Annales, which had appeared four years ear-
lier in 1596 with a dedicatory epistle ad-
dressed to Philip II, the worst enemy of
Henry of Navarre during the French civil
wars! In that volume the Oratorian scholar
had developed, along with the history of
Constantine's reign, his doctrine of the
cross: "signum Crucis, symbolum unionis,
symbolum catholicae unionis," as a symbol
of the obedience that temporal kings owed
to their common spiritual superior and
father, the pope. The same lesson, in differ-
ent terms according to circumstances, was
valuable for both the Spanish and the French
kings, delivered through the sign of the cross

2. Peter Paul Rubens,
Death of Constantine,
1622, oil sketch
Collection of René Küss, Paris;
photograph: Collège de France,
Paris

3. Justus Lipsius,
De Cruce libri tres
(Antwerp, 1594), 91
Bibliothèque nationale, Paris

and the myth of Constantine. In this third volume of the *Annales* dedicated to Philip II, the church historian, with powerful literary skills, quoting at length the authoritative Eusebius, gave full breadth to the papal version of Constantine's reign, refuting Calvinist and Lutheran objections. Under the renewed *integumentum* of the historical narration, the Roman theology of the double power of the papacy, cornerstone of the unity of the Constantinian church and of its Tridentine reassertion, was confirmed: as Constantine did "in illo tempore," temporal kings must now be subservient to the christological and universal power of the Roman tiara. But this underlying theological meaning was associated with and shielded by the most sublime rhetorical effect: Baronius' narration enshrined an apology of early Christian images and examples against pagan idols and modern heretical iconoclasm. He gave special significance to the three miraculous apparitions of the cross to Constantine and to the finding of the True Cross by Saint Helena. He insisted upon the martyrs of the great persecution and above all on the virgins:

Catherine of Alexandria, Pelagia, and Theodora of Antioch. The monumental narration of Constantine's epic was therefore built as a baroque altar, with its retable of the Holy Cross surrounded by the holy virgins, and with his reliquary containing the relics of the True Cross rescued by Saint Helena. Before this metaphoric altar, Constantine found the spiritual inspiration for his deeds on behalf of the true faith and the papal see.

Two years later in 1598, the Jesuit Jakob Gretser, a disciple of Ballarmine, published in Ingoldstadt a doctrinal treatise entitled *De Cruce Christi*,[5] in which he developed not Baronius' historical narration, but the same papal interpretation of the central symbolism of the cross. These works conveyed not so much historical conviction but rather the kind of assent that implied admiration, adoration, piety, and faith in and toward sacred truths and objects of worship. The intertwining of myth, doctrine, authority, visual symbol, and relics was viewed, at least by the Roman side, as in itself miraculously effective.

Relieved of his excommunication by Pope Clement VIII in 1595, Henry IV married the devout Catholic princess Maria de' Medici in 1600. Hymns of praise for the new French Constantine poured from Italian pens in addition to the magnificent epithalamium of Cardinal Baronius. In 1605 Francesco Bracciolini, secretary to Maffeo Barberini, who was soon to become the papal nuncio in

Paris, published there the first cantos of his allegorical epic, *La Croce racquistata.*[6] This Constantinian allegory of Henry IV's conversion would reappear in the funeral orations delivered after Henry IV's assassination in 1610.[7] Maria de' Medici, as regent, was incapable of imposing the Canon of Trent in the Estates General of 1614, but both she and her government were in agreement with Rome's wishes. She favored an alliance with Catholic Spain. This relatively successful honeymoon between crown and tiara began to darken around 1617, when Louis XIII broke free of his mother and took over the government of France.[8] Between mother and son, the real issue at stake in the long run was the political freedom of the French crown within Catholic Europe.

The evolution of the young Louis XIII, married by his mother to a Spanish princess and privately a devout man, toward a "politique" or "Gallican" position, was difficult and slow. As long as he had to contend with his still powerful mother, he was eager to assert his own power in ostensibly irenic terms toward the Holy See. In 1621 the royal commission for a series of tapestries representing the *Life of Constantine* may well have expressed the young king's overt Catholic fidelity to his father's pious legend. In this, moreover, he complied with the wishes of Maria de' Medici, since the tapestries were intended to decorate her own palace of Luxembourg. The role of the famous antiquarian Nicolas de Peiresc, adviser to the king's *garde des sceaux,* Guillaume Du Vair, close friend and correspondent of Rubens, was certainly decisive in the choice of the artist and perhaps of the program.[9] A moderate Gallican, Peiresc was nevertheless on excellent terms with the Roman curia, and his relations with the Italian virtuosi of the "République des Lettres" were the closest maintained by anyone in Paris.[10] Though it is not yet clear to what extent the Provençal scholar was responsible for his friend Rubens' receiving the commission, his personal involvement in the iconographical conception of the Constantine tapestries is proven by his correspondence with the Flemish artist.[11] In November 1622, on the arrival of the first four full cartoons, Peiresc accompanied the court officials who entrusted them to the

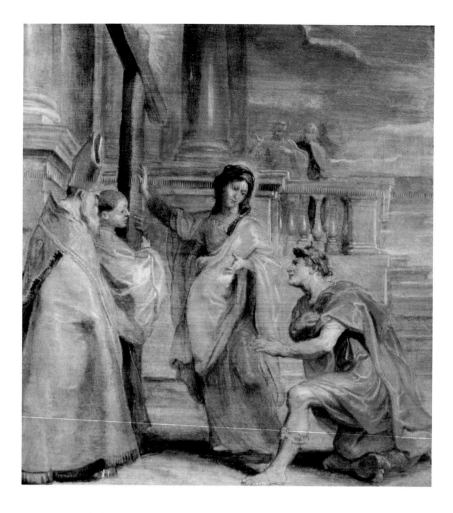

4. Peter Paul Rubens, *Saint Helena and the True Cross,* 1622, oil sketch
Collection of N.A. Coulouthros Embiricos, London; photograph: Collège de France, Paris

tapestry workshop of Saint-Marcel where they were to be woven. On that occasion, with complete knowledge of the erudite program devised mainly by Rubens, Peiresc explained the iconography of each scene to the experts of both the king and the queen mother.[12]

This special viewing of the cartoons and Peiresc's learned description of each subject were occasioned by an accident that occurred some months before. Between the winter of 1621 and the summer of 1622, when the preparatory oil bozzetti painted by Rubens had been sent to Paris to be approved by the king, the whole meaning of the series had changed drastically. Louis XIII bluntly refused Rubens' theme for the last episode of the series, which illustrated an allegory of the *Triumph of Rome* (figs. 1–2).[13] The king ordered Rubens to transform the Roman-centered last image of the series into the representation of the *Death of Constantine* (fig. 2).[14] Peiresc's subsequent and clever presentation of the reordered series was a

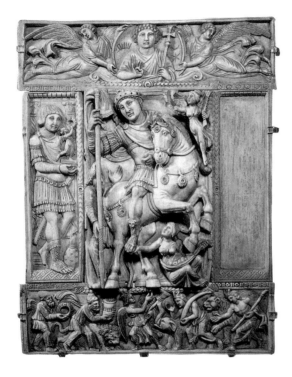

success, and soon after the visit to the work-
shop, the weaving started.

In its allegorical and mystical intentions,
Rubens' "idea" for the series was from the
start inspired by Justus Lipsius' *De Cruce*
(fig. 3) and Baronius' *Annales.* In this ico-
nographical program, the papacy and the
cross appear as the leading forces, and a par-
ticularly heroic Saint Helena is their devout
ally (fig. 4). The artist's visual sources are to
be sought not only in the well-known exam-
ples of antique sculpture that he had studied
in Rome (such as Trajan's Column and the
reliefs of the Arch of Constantine), but also
in the frescoes of Giulio Romano and
Raphael in the Vatican, which are amply
cited. For the design of the thirteen panels,
in fact, Rubens also turned to the less usual
historie carved in gems or sculpted in
cameos. Organized in collaboration with
Peiresc, from the latter years of the second
decade of the century, the project of publish-
ing his own collection of ancient intaglios
and cameos involved Rubens in the thor-

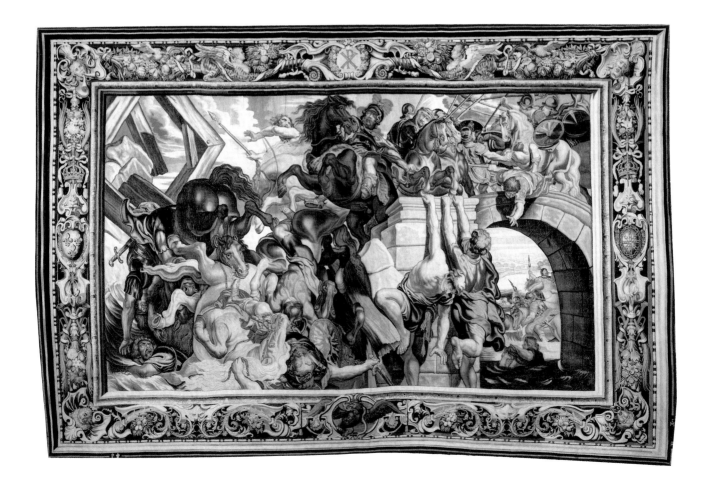

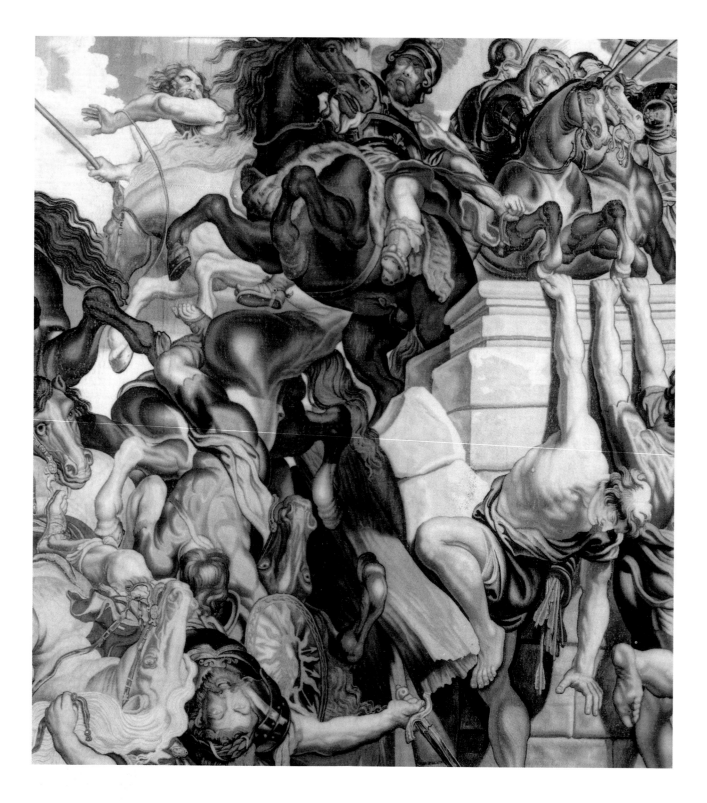

ough study of ancient history and iconography.[15] For this research, Byzantine miniatures as well as ivory reliefs had also been important references.[16]

The most striking example of this kind of derivation can be traced in a Byzantine relief

carved in Constantinople around the first half of the sixth century on a piece of elephant ivory. The relief represents an equestrian figure, surmounted by the figure of Christ holding the cross, which, at the beginning of the seventeenth century (and

until the first years of this century) bore the following inscription: CONSTANT. IMP. CONST. Both this early sixteenth-century addition and the iconography of the ivory plaque contributed, in Rubens' time, to the current interpretation of the relief as the *Triumph of Constantine* (fig. 5).[17] Besides the inscription, it may indeed be noted why the ivory iconography by itself inclined the ingenuous observer to think of Constantine: the equestrian figure appears as if suddenly stopped or struck by the vision of Christ appearing before the battle, not above but in front of him, at the Milvian bridge. Could this precious relief, in Peiresc's own collection until 1625 and now in the Louvre, have been the prototype for the figure of Constantine in Rubens' *Battle of the Milvian Bridge* tapestry (figs. 6–7)?[18] The posture of the horse is reversed, but the startled emperor looks in the direction of the spectator where the miraculous vision of the cross is supposed to be appearing. What model could be more appropriate, to the learned and philologically conscious artist, than his friend's ivory which was thought to have been carved not long after the sacred vision itself?

The royal censure of the *Triumph of Rome* disclosed uneasiness among the king's advisers concerning the entire series. Its symbolic meaning was certainly accepted or refused according to the party these political minds favored: the queen's compliance to papal views or the king's growing tendency toward stern national independence. This second trend is developed and theorized in a learned book written by the French Oratorian father Jean Morin and published in Paris only in 1630. The *Histoire de la délivrance de l'Église Chrestienne par l'empereur Constantin* is dedicated to Louis XIII,[19] then freed from his mother (exiled in Spanish Brussels) and leaning entirely upon the nationalist iron will of Cardinal Richelieu. Morin's book reflects vigorous historical scholarship and presents a thoroughly Gallican interpretation of the Constantine myth, tactfully in complete disagreement with Baronius' authoritative views. For Morin, Constantine's conversion occurred in France and through French bishops. The emperor, and therefore the miraculous cross, as well as the True Cross, had general Christian significance which was

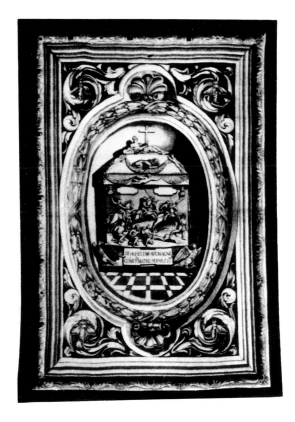

not particularly involved with the papacy. According to Morin, it was not through Constantine, but only much later and thanks to the French crown, from Pepin and Charlemagne on, that the pope obtained his temporal seat. The emperor's so-called *Donation* of Rome and Latium to Pope Damasus (Lorenzo Valla's name is never mentioned) is a belated fake and the third crown added by the popes to their tiara is therefore a medieval French gift.[20]

Morin's thesis bluntly affirms the temporal dependency of the popes on the French kings, who for centuries and until the reign of Louis XIII, according to these jealously Gallican views, had been the true secular arm of Christendom. In this light, the dissatisfaction of the royal advisers and of the sovereign himself is easily understood: Rubens' narrative sequence was not so much an apologetic historical allegory of the Most Christian of Kings as it was a celebration of Constantine's foundation of the sacred papal *imperium,* at once temporal and spiritual. It suppressed the national French significance of Henry IV's conversion and triumph and aligned them with the needs and universal vision of the papacy.

Subsequent events contributed to the French refusal of the cycle. Peiresc had to leave Paris in 1623, and in 1624 Richelieu, formerly councillor of the queen mother and now the proponent of a fiercely assertive and national foreign policy, entered the *conseil du roy*.[21] When, in 1625, Cardinal Francesco Barberini, accompanied by Cassiano dal Pozzo and a suite of learned *curiali*, arrived in Paris as papal legate, it was to attempt to halt the French military action in northern Italy, which involved war with Catholic Spain. The papal mission was a complete failure.[22] Before Cardinal Barberini's departure from France, Louis XIII offered him a magnificent gift. After a few decent refusals, the pope's nephew accepted as a personal gift the first eight completed tapestries of the *Constantine* series. On his way to Rome the cardinal met Peiresc in Aix-en-Provence. There Peiresc offered the prelate the Byzantine ivory that is now known as the *Barberini Ivory*.[23] This extraordinary second gift received by Francesco in France finds its true meaning if one assumes that the private donor, Peiresc, knew exactly what role this antique object had played as the prototype of the major figure in the central tapestry of the eight given to the cardinal: the equestrian emperor in the *Vision of the Cross during the Battle of the Milvian Bridge*. While comforting Roman hearts, this sensible gift restored to the tapestries, dismissed by the French king, their full original, Rubensian meaning. It did more: it linked the theological significance of the contemporary masterwork to its antique prototype believed to be a relic of Constantinian history and miracles. Peiresc knew how to please and pamper the tastes of his various guests.[24] As a private patron of the "République des Lettres," he needed badly, moreover, the favor and help of the powerful Roman cardinal for his own undertakings, in Rome and in the Catholic world, both erudite and scientific.

The reception of the tapestries in Rome confirms Peiresc's perspicacity. Some years later, as if the Rubens cycle, restored to its original meaning, was to be charged with a supplement of divine power, Francesco Barberini commissioned from the young Pietro da Cortona the cartoons for six new *historie*. These had to be woven in the newly founded Barberini workshop, in addi-

9. After Pietro da Cortona, *Constantine Ordering the Destruction of the Idols*, tapestry woven in Rome, May 1637
Philadelphia Museum of Art, given by the Samuel H. Kress Foundation

tion to the panel of the controversial *Triumph of Rome*, which at last was going to be executed according to Rubens' design.[25] The main *salone* of the Barberini palace, under the triumphant fresco painted by the same Pietro da Cortona, thus became an expiatory chapel, whose walls were, as in a church, completely covered with the relevant iconography for a festive liturgy dedicated to Constantine and Saint Helena. Along with the fourteen large tapestries, the Barberini workshop produced numerous additional

10. Early Christian lamp,
Francesco Angeloni,
Historia Augusta
(Rome, 1641), 369
Bibliothèque nationale, Paris

11. Constantinian coins,
Francesco Angeloni,
Historia Augusta (Rome,
1641), 377
Bibliothèque nationale, Paris

quasi-liturgical elements on overdoor panels and *portiere*, for example, the tapestries illustrating *Saint Helena's Sarcophagus* (fig. 8), *Constantine Ordering the Destruction of the Idols* (fig. 9), or the *portiere* with Prince Taddeo Barberini's coat of arms surmounted by the labarum.[26]

In this new setting and with this remarkable amplification, the intrinsic meaning of the Rubens cartoons had considerably matured. Freed from any French political allegorism, in Rome the Rubens tapestries were restored and enhanced as the kernel of a sacred story confirming the legitimacy of the Constantinian church and as the devotion of the reigning papal family to this archetypal history. It stood publicly as a silent challenge to the obdurate French Gallicanism.

Nevertheless, in spite of the constant political tension between Rome and Paris, the flow of polite and learned exchanges between the two courts eased the dialogue. In 1640, when Poussin went to Paris (and his trip is to be considered in itself as a Roman gift to the French court), he convinced the ministers of Louis XIII to subsidize the publication of the expensive volume of the *Historia Augusta* written by the Roman antiquarian Francesco Angeloni (figs. 10–11).[27] Published in 1641 in Rome with French subventions, this "histoire métallique" of Roman emperors mirrored, in its dedication to the

king, the facets of Louis XIII's virtues as a ruler. Through the analysis of Roman medals and coins, the last chapter of the treatise is devoted to the historical explanation of the reign of Constantine as the first model of the Christian ruler.[28]

Louis XIV carried the Paris-Rome drama to unprecedented heights. The bloody accident of the Corsican guard, which occurred in Rome in the vicinity of the French embassy at the Palazzo Farnese, the evening of 20 August 1662, offered the Sun King the occasion, before the European public, to curb the medieval and Tridentine pretensions of the papacy.[29] After the Treaty of Pisa of 1664, which ended the Corsican affair with the total humiliation of Rome, diplomacy and art could recover their habitual bittersweet functions. The pope's nephew went to Paris in a legation charged with officially presenting Pope Alexander VII's excuses to Louis XIV: Cardinal Flavio Chigi was intentionally received as a distant and obtrusive provincial cousin.[30] As a matter of fact, in the same year, even Bernini was allowed by the reigning Pope Alexander to leave Rome and serve, for a time, the French king—an excruci-

12. Gian Lorenzo Bernini,
Constantine the Great,
marble, 1622–1668/1670
Vatican Palace; photograph:
Art Resource

ating sacrifice! The artist was more honored in the Louvre than Cardinal Chigi![31]

During this artistic embassy, the Constantine myth played an indirect but major role. The Sun King did not ignore the particulars of an important commission received by Bernini from the *"papa-architetto"* in 1662, nor its theological-political meaning. An equestrian monument of Constantine was to be erected at the landing of the *Scala Regia*, opposite that of Charlemagne. The statue was finished between 1668 and 1670 after Bernini returned to Rome (fig. 12).[32] It may be suggested that this superb artistic achievement, irreducible to a single source, may be said nevertheless to be the second masterwork produced, after the Rubens *Milvian Bridge* tapestry, from the Byzantine ivory prototype donated by Peiresc in 1625 to Cardinal Barberini.[33]

But now the icon was placed in a most dramatic setting, in the august precincts of

the Sistine Chapel and no longer in a private palace. The weight of the sacred could not be heavier, in direct challenge to the French ambassador then entrenched in the Palazzo Farnese with an armed guard.[34] The diplomatic and symbolic war between Paris and Rome became even more bitter during the papacy of Innocent XI Odescalchi (1676–1689), who condemned all the decrees regarding the royal rights claimed by Louis XIV over the Gallican church and refused the royal appointments of French bishops.[35]

When at last, in 1685, during the most difficult period between the two courts, the Sun King was able to behold his own Bernini equestrian monument, commissioned back in 1665, he dismissed it on the spot. The comparison with the Vatican Constantine was unbearable.[36] The same highly rhetorical style, the same formal choice inspired by the *Barberini Ivory* more than half a century before, modeled the royal hero as represented by Bernini: like the obedient Roman emperor, he looked as if struck and stopped by a transcendent, invisible vision. Bernini's equestrian figure received its heroic authority from above, not from within. Therefore, in French eyes, it did not have a self-sufficient power but a derivative one. The same Roman spirit, shared by Rubens and Bernini, had inspired such symbolic ideas, offensive to the type of divine rights the French king claimed for himself: "L'État c'est moi." The doctrinal opposition between the Gallican crown and the Roman tiara had never been so tacitly evident and clear-cut then, in such expressions of taste.

This dramatic dialogue between Rome and Paris is certainly one of the most civilized cases of power struggle between two states in the entire course of history. I have presented here only a few glimpses of its extraordinary symbolic fertility. Let me insist upon what, from one point of view here, is by far its central issue. Between the Roman tiara and the Gallican crown, one can observe a fascinating war of images, involving in the long run the fate of European art. Rome, in spite of changing styles and fashions, is faithful to the tradition of early Christian devotion to images. Between relics and cult symbols, Roman works of art are links in the great chain of signs which attempt to relate the earthly and historic truth to the invisible and divine one. They are immersed in faith and in religious practices. Roman antiquarianism is a humanist version of the cult of relics. The *Roma Sotterranea* of Antonio Bosio belongs to the same theological world frequented by Rubens and Bernini in relation to the *Barberini Ivory*: an icon sacred by time, as a prototype for new representations, in a world open to visions and miracles, the world of the True Cross and of the legend of the Milvian bridge, a battle led and won by the apparition of the cross. Since the restoration of the national state by Henry IV, the French ideology of kingship, although immersed in sacred reverence, had to fight willy-nilly this syncretistic and transcendental concept. French official and historical images from then on could only be allegorical representations of the living king, the main source and depository of self-centered Gallican political power. The French concept of artistic images was therefore an exception in Roman Catholic Europe, and this most particular singularity deserves scholarly research. A distant source for modern developments, this striving for lay independence implied nevertheless at the beginning an intense feeling of artistic rivalry toward Rome, the motherland of antique and Renaissance art.

But the heartland of *modern* art, especially after the execution of Louis XVI, could not be other than Paris, the only iconophile and Catholic capital in a position since 1594 to cultivate images according to its own semantic definition and, at the same time, to remain free of the theological-rhetorical syncretism that had brought to a close the most creative moment of Tridentine art, in the Rome of Caravaggio and Annibale Carracci.

NOTES

1. Victor Martin, *Le gallicanisme et la Réforme catholique: Essai historique sur l'introduction en France des décrets du Concile de Trente* (Paris, 1919).

2. On the various aspects of Henry IV's life mentioned in this article, see Roland Mousnier, *L'assassinat d'Henri IV: Le problème du tyrannicide et l'affermissement de la monarchie absolue*, 2d ed. (Paris, 1992).

3. On Justus Lipsius, see José Ruysschaert, *Juste Lipse et les* Annales *de Tacite* (Turnhout, 1949). The *De Cruce* (Antwerp, Plantin, 1594) attests solemnly, before the European Republic of Letters, Lipsius' conversion to Catholicism. This work is a very learned treatise concerning the etymology, history, and semantics of Catholicism's central symbol of unity, the cross. See chapter 15:89 for the devotion of Constantine toward the cross, illustrated by engravings of the labarum (91 and 93). Lipsius insists that Constantine's miraculous visions were the model (the *idea*) for the magnificent *hasta* he ordered made "juxta speciem quae apparuisset" and for the *vexilla* his armies carried in the battle of the Milvian bridge.

4. On the dedication of the ninth volume of the *Annales* to Henry IV (1600), see Hubert Jedin, *Il cardinale Cesare Baronio: L'inizio della storiografia ecclesiastica cattolica nel sedicesimo secolo* (Brescia, 1982), 51. The third volume of the *Annales* (1594), dedicated to Philip II, king of Spain, is devoted to Constantine; for the events mentioned here, see, respectively, pages 400, 353, 23–24, 37–39.

5. On Jakob Gretser (1562–1626) and his *De Cruce Christi* (two other volumes were published in 1600–1605), see *Dictionnaire de théologie catholique, ad vocem*. See (1:57) the doctrinal development concerning the nature of the worship due to the cross, as *imago* of a divine *res significata*, as the ἔκτυπος of Christ's πρωτότυπος. The cult of the cross is not that of *doulia* but of *latria*. An Italian and vulgarized counterpart of Gretser's treatise appeared soon after, composed by Jacomo Bosio: *La trionfante e gloriosa Croce, lettione varia et divota ad ogni buon christiano utile e gioconda* (Rome, 1610). See page 738 for the reference to the recently assassinated Henry IV of France: "quasi un nuovo Paolo, di Persecutore diventato principalissimo difentore della Santa Fede cattolica."

6. Francesco Bracciolini (1566–1645), Tuscan poet and writer, was appointed secretary to Cardinal Federico Borromeo (1595–1600) in Milan. He subsequently was called to the service of Maffeo Barberini, the future Pope Urban VIII, whom he followed in his frequent missions and *nunziature* to the French court. With *La Croce racquistata*, Bracciolini attempted to present sacred history and legends of devotion in the form of an epic poem clearly inspired by Tasso's *Gerusalemme Liberata* (1580).

7. See Jacques Hennequin, *Les oraisons funèbres d'Henri IV: Les thèmes et la rhétorique* (Lille, 1978).

8. Roland Mousnier, *L'homme rouge ou la vie du cardinal de Richelieu (1585–1642)* (Paris, 1922), 2d part, chaps. 4 and 5.

9. On the series of tapestries, see David Dubon, *The History of Constantine the Great Designed by Peter Paul Rubens and Pietro da Cortona* (London, 1964) and, by the same author, *Constantine the Great: The Tapestries* [exh. cat., Philadelphia Museum of Art] (Philadelphia, 1964); see also John Coolidge, "Louis XIII and Rubens, the Story of the Constantine Tapestries," *Gazette des Beaux-Arts* (May–June 1966), 261–272. On the role of Peiresc, see especially his letters to Rubens only partially published by Max Rooses and Charles Ruelens, *Correspondance de Rubens et documents épistolaires concernant sa vie et ses oeuvres* (Anvers, 1887–1909); more than twenty important, unpublished contemporary letters written between Rubens and Peiresc have been found and will soon be published in a critical edition by David Jaffé. The work of Julius S. Held, *The Oil Sketches of Peter Paul Rubens: A Critical Catalogue*, 2 vols. (Princeton, 1980), 1:65, contains important comments about the oil bozzetto the *Triumph of Rome*, now in The Hague. The original concept of Rubens (twelve sketches) was part of the Orléans collection in the eighteenth century, engraved for the devout son of the regent by Nicolas Henri Tardieu in 1742–1746. The larger size of the *Triumph of Rome* may suggest, according to Held, that it was the first to be printed. This emphasis shows, above all, the central importance Rubens gave this allegorical idea within the overall concept of the series.

10. On Peiresc's close acquaintance with the erudite circles of the Roman curia, and on their correspondences and close collaboration, see the first published letters by Alexandre-Jules-Antoine Tauris de Saint-Vincens, *Correspondance inédite de Peiresc avec Jérôme Aleandre* (Paris, 1819); Cecilia Rizza, *Peiresc e l'Italia* (Turin, 1967); Nicolas-Claude Fabri de Peiresc, *Lettres à Cassiano dal Pozzo (1626–1637)*, ed. Jean-François Lhote and Daniel Joyal (Clermont-Ferrand, 1989); Francesco Solinas, "Percorsi puteani: Note naturalistiche ed inediti appunti antiquari," *Cassiano dal Pozzo*, Atti del Seminario Internazionale di Studi (Rome, 1989); on the relations between Peiresc, the Roman scholars, and Rubens in later years, see David Jaffé, *Rubens' Self-Portrait in Focus* (Brisbane, 1988) and, by the same author, "The Barberini Circle: Some Exchanges between Peiresc, Rubens and Their Contemporaries," *Journal of the History of Collections* 1 (1989), 119–147.

11. On Peiresc's exchange with Rubens on the subject of the *Life of Maria de' Medici* and on the cycle itself, see Jacques Thuillier and Jacques Fourcart, *Rubens: La Galérie des Médicis au Palais du Luxembourg* (Milan-Paris, 1969) and Silvia Manone, *Firenze e Parigi: Due capitali della spettacolo per una regina, Maria de' Medici* (Milan, 1987).

12. On this see Dubon 1964, 5–11, with accurate transcriptions of the documents.

13. The extensive bibliography of the oil bozzetti executed by Rubens and by his atelier is fully illustrated in Michael Jaffé, *Rubens* (Milan, 1989); see

also Dubon 1964, 10–11. See Held (1980, 67) on the role of Louis XIII in the commission of the tapestries. It is possible that the young king was not personally involved, as was his mother, in artistic patronage, but it is at least probable that his main advisers, notably Peiresc, were. Peiresc at that time was in charge of a pre-Colbertian duty in the royal government, as the right hand of Guillaume Du Vair, *garde des sceaux*. He may have both informed and consulted Du Vair, and through him the king, about the whole matter.

14. It is worthwhile to remark here that, according to Pierre Rosenberg (*La "Mort de Germanicus" de Poussin du Musée de Minneapolis* [Paris, Dossier du Département des peintures, Éditions des Musées Nationaux, 1973], 7–10), Poussin saw, if not the Rubens sketch in Paris, before his departure for Rome, at least the *Death of Constantine* tapestry when the series arrived in Rome. In any case, Rubens' composition inspired his own for the *Death of Germanicus*, ordered from the French painter by Cardinal Francesco Barberini, then the proud owner of the tapestry series. The *Death of Germanicus* entered the Barberini collection in January 1628 and therefore represents the first form of "reception" of Louis XIII's gift in Rome; it attests the extraordinary significance that this set of symbolic images had in the minds of the Barberini family. One must recall that the *Death of Constantine* was the "lay" subject chosen by the French king and his advisers to replace the *Triumph of Rome*, dismissed in Paris as much too partial to the papacy.

15. On the enterprise, see Nancy Thomson de Grummond, "Rubens and Antique Coins and Gems" (Ph.D. diss., University of North Carolina at Chapel Hill, 1968); on Peiresc's iconographical and antiquarian connoisseurship, see David Jaffé, "Aspects of Gem Collecting in the Early Seventeenth Century, Nicolas de Peiresc and Lelio Pasqualini," *Burlington Magazine* 135 (1993), 103–120.

16. For a thorough analysis of Rubens' application of the antiquarian iconographical interests shared with Peiresc, see Jaffé 1988.

17. Besides the catalogue entry (no. 20, pages 63–66) signed by Danielle Gaborit-Chopin, in the volume dedicated to the exhibition, *Byzance: L'art byzantin dans les collections publiques en France* (Paris, 1992), the latest scholarly contribution on the ivory plaque (now Louvre, Objets d'Art, no. 9063) is that of Anthony Cutler, "Barberiniana," in *Tesserae: Festschrift für Josef Engemann*, special issue of the *Jahrbuch für Antike und Christentum*, Ergänzungsband 18 (1991), 329–339 and plates. In both contributions the story of the ivory is reconstructed, and the interpretations of its iconography and the sixteenth-century inscription originally placed on the supporting panel are also stated.

18. Cutler (1991, 338) cites the letter written by Peiresc to his brother Palamède de Valavez on 29 October 1625, in which he describes a more subtle and detailed interpretation of the iconography of the ivory: "Un bas relief d'ivoire antique lequel j'avois recouvré depuis peu, où estoit représenté l'empereur Heraclius à cheval avec des contours où il estoit portant une croix et son filz Constantin portant une victoire et plusieurs provinces captives au dessus." In citing the subsequent mention of the ivory, which in the meantime had passed into Cardinal Francesco Barberini's collection, Cutler informs us of the most current and generalized identification of the relief as a representation of Constantine: one of the learned *antiquari* working for the cardinal described the relief in the inventory as "Un quadro antico d'avorio con Constantino Imperadore, con altre figure di basso rilievo con sue cornici di legno" (as cited in Marilyn Aronberg Lavin, *Seventeenth Century Barberini Documents and Inventories of Art* [New York, 1975], 82).

19. The full title of the book reveals perfectly well Father Jean Morin's intentions: *Histoire de la délivrance de l'Église chrestienne par l'empereur Constantin et de la grandeur et souveraineté temporelle donné à l'Église romaine par les roys de France.* On the title page there is a vignette depicting Charlemagne showing Pope Leo III a map of Italy with the caption "Italos parere jubeo," and Leo's answer: "Tu mihi quocumque hoc regni." In his dedicatory epistle to Louis XIII, the Oratorian Morin depicts the king (who, by his military intervention, had reestablished the Catholic ecclesiastical properties in Calvinist Béarn, demolished in Guyenne the Calvinist fortresses, and was currently besieging the Protestant La Rochelle) as the major hero of the Catholic war against heresy and the major tutor of *La grandeur et la majesté de l'Église romaine.* If Constantine may be considered as a precursor of the French king, it is with the distinct reservation that Louis XIII's ancestors were the true founders of the temporal papal state, and not the Roman emperor.

20. For a useful synthesis and a survey of the huge bibliography on this topic, see *Enciclopedia cattolica, ad vocem* "Constantino il Grande."

21. Mousnier 1992, 215–217. See W. F. Church, *Richelieu and Reason of State* (Princeton, 1972).

22. On the political effects of the Barberini legation to France, see Antonio Bazzoni, "Un nunzio straodinario alla Corte di Francia," *Gazzetta d'Italia* (Florence, 1880); Ludwig von Pastor, *Storia dei papi* (Rome, 1961), vol. 13; a complete edition of Cassiano dal Pozzo's diary of the trip to France is to be published by Carlo Bartoli, Giovanni Morello, and Francesco Solinas in the series *Quaderni Puteani* (Milan).

23. On the visit of Cardinal Barberini to Peiresc in Aix, see Solinas 1989; on the gift of the ivory, see Cutler 1991 and Gaborit-Chopin 1992.

24. On Peiresc's diplomatic ability and his international relations, see Agnès Bresson, *Peiresc: Lettres à Claude Saumaise (1620–1637)* (Florence, 1992).

25. On the founding of the Barberini workshop, see Urbano Barberini, "Pietro da Cortona e l'arazzerie Barberini," *Bollettino d'arte* (1950) 1:43–51; 2:145–152. On the tapestries themselves, see Dubon 1964, 13–22.

26. Dubon 1964, 17–18.

27. On this famous savant and historian, teacher of Giovanni Pietro Bellori, see *Dizionario biografico degli Italiani, ad vocem,* on Poussin's negotiations in Paris; see Francesco Solinas, "'Portare Roma a Parigi': Mecenati artisti ed eruditi nella migrazione culturale," in *Documentary Culture: Florence and Rome, from Grand Duke Ferdinand I to Pope Alexander VII,* Villa Spelman Colloquia 3 (Bologna, 1992), 227–261.

28. Angeloni, *Historia Augusta* (Rome, 1641).

29. On the "affair" and on the political tension between Rome and Paris at the time, see Bruno Neveu, "Des Farnèse aux Bourbons de Naples," in *Le Palais Farnèse* (Rome, 1981), especially 445–507, and Pierre Blet, "Louis XIV et le Saint-Siège," *XVIIe siècle* 23 (1979), 137.

30. On the diplomatic relations between Rome and Paris that followed the Treaty of Pisa, see Neveu 1981; during his trip to France, the complaints of Cardinal Chigi are described in the important and still unpublished manuscript diary by Monsignore Ravizzi, "Relazione della legazione in Francia del Signor Cardinal Flavio Chigi l'anno 1664," of which a copy (MS Corsiniano 38.A.18) is in the Biblioteca Corsiniana, Rome.

31. See Paul Fréart de Chantelou, *Diary of the Cavaliere Bernini's Visit to France,* critical edition by Anthony Blunt and George C. Bauer (Princeton, 1985).

32. On the commission and reception of Bernini's equestrian monument of Louis XIV, see Irving Lavin, "Le Bernin et son image du Roi-soleil," in *"Il se rendit en Italie": Études offertes à André Chastel,* ed. Jean-Pierre Babelon et al. (Paris-Rome, 1987), 441–478 (reprinted with additions in *Past-Present: Essays on Historicism in Art from Donatello to Picasso* [Berkeley, 1993], 138–200), and Simone Hoog, *Le Bernin. Louis XIV: Une statue déplacée* (Paris, 1989); on the Roman Constantine, see the well-documented essay by Tod Marder, "Bernini's Commission for the Equestrian Statue of Constantine in St. Peter's: A Preliminary Reading," in *An Architectural Progress in the Renaissance and Baroque Sojourns in and out of Italy,* Papers in Art History from the Pennsylvania State University 8, *Essays in Architectural History Presented to Hellmut Hager* (University Park, Pa., 1992), 281–294, where Bernini's possible reference to another Byzantine work (codex Parisinus graecus 510) is discussed. Madeleine Laurain-Portemer argued ("Mazarin, Benedetti et l'escalier de la Trinité des Monts," *Gazette des Beaux-Arts* 71 [1968], 178) that a first project of an equestrian statue of Louis XIV, to be erected in Rome on the Trinité staircase, existed earlier.

33. Until the nineteenth century the ivory relief was kept and admired in the Barberini collection in Rome; as is known, Fabio Chigi, later Pope Alexander VII, had been a protégé of the Barberini family, a personal friend of Cardinal Francesco, and a frequent visitor of his "Museo" from the sixteenth century. Also, in the years immediately after Francesco Barberini's return from France, Gian Lorenzo Bernini had contributed to the architectural planning of the family palace on the Quirinal; the sculptor must have been quite familiar with the precious ivory relief, which he would certainly have had the occasion to examine.

34. See Neveu 1981.

35. Pastor 1961, vol. 14.

36. See Hoog 1989.

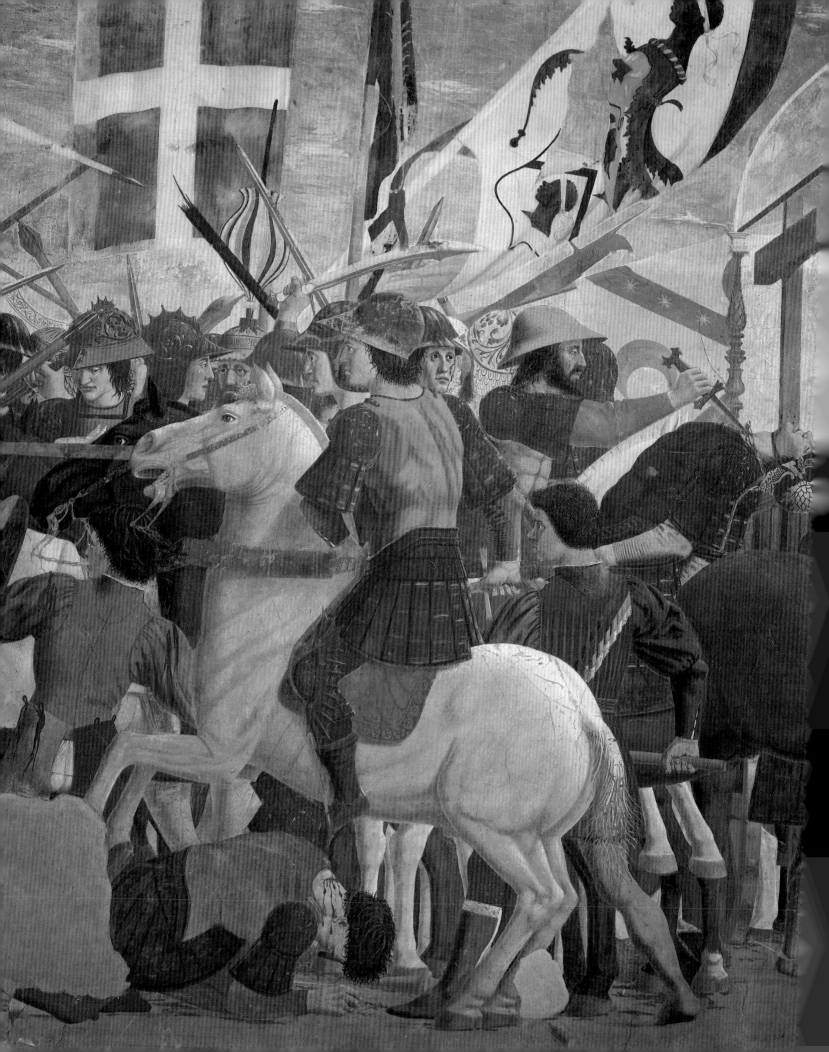

DANIEL ARASSE
École des Hautes Études en Sciences Sociales, Paris

"*Oltre le scienze dette di sopra*": Piero della Francesca et la vision de l'histoire

Oltre le scienze dette di sopra, fu eccellente nella pittura." C'est par cette formule, un peu lapidaire, que Vasari articule, d'entrée de jeu, le double versant, théorique et artistique, de l'activité de Piero della Francesca.[1] Je prendrai ici prétexte de ce raccourci vasarien pour aborder une question aussi rebattue que délicate: comment peut-on penser la relation entre la *science* de Piero della Francesca en matière de perspective (telle qu'il la formule dans le *De prospectiva pingendi*) et son *art* de peindre les *prospettive*? Vaste question, trop vaste même peut-être, et imprécise. Mais je ne l'envisagerai que sur un point particulier (la relation entre construction de la perspective et composition de la *storia*) et dans le but de définir la position de Piero par rapport à la culture humaniste de l'époque sur un thème alors central: la conception de l'Histoire et de la dignité de l'homme en son sein.

Au Quattrocento, l'Histoire est, on le sait, une discipline majeure des *studia humanitatis*. Dans sa version rhétorique et humaniste, elle devient un des domaines privilégiés où s'affirme, au service du Prince ou de la Cité, l'émergence d'un pouvoir nouveau: celui de la culture.[2] Conjointement, dans le domaine de la théorie artistique, d'Alberti à Gauricus en passant par Léonard, la peinture *di storia* est, quant à elle, la "grande oeuvre" du peintre et son prestige est indissociable du recours à une perspective régulière et à un mode de composition inspiré presque expli-

citement par la rhétorique antique. La perspective est l'assise de la composition peinte et cette dernière acquiert toute sa "dignité" quand, tel le discours éloquent, l'oeuvre du peintre assure l'intelligibilité persuasive et pathétique de ce qu'elle représente.[3]

Or, comme on le sait, dans son *De prospectiva pingendi*, Piero della Francesca ne dit rien sur la *storia* et sa composition. Certes, ce silence n'a rien à première vue de surprenant. Il répond à un choix énoncé dès le début du texte: la peinture est composée de trois parties—*disegno*, *commensuratio* et *colorare*—et Piero déclare intentionnellement n'aborder que la *commensuratio*, "quale diciamo prospectiva."[4] Ce choix fonde la cohérence du traité, son efficacité démonstrative et sa modernité, intellectuelle et scientifique. Comme le souligne Hubert Damisch, le *De prospectiva pingendi* constitue la premier traité de perspective "développé *more geometrico*, sur le mode strictement déductif.[5]

Tout cela est incontestable. Mais la force et la cohérence même de la position de Piero n'en ont pas moins fait quelque peu oublier qu'à lui seul, ce choix marquait une différence radicale et révélatrice par rapport à la conception humaniste du traité de peinture. Quand Piero della Francesca ne dit rien sur la *storia*, "grande oeuvre du peintre" humaniste, son silence découle bien sûr de son choix méthodologique; mais ce choix lui-même suggère que sa conception de la

Piero della Francesca,
Battle of Heraclius,
1452–1466, fresco (detail)
San Francesco, Arezzo;
photograph: Alinari

storia peinte et, donc, de l'histoire n'est pas celle d'Alberti, Léonard ou Gauricus, en un mot de l'humanisme.

De fait, chez Piero, l'intelligence de la perspective et celle de l'histoire entretiennent une relation complexe. À la différence de la conception humaniste, qui exige clarté spatiale et narrative, Piero manipule paradoxalement (en peinture) sa maîtrise (scientifique) de la perspective. Au début du livre 3 du *De prospectiva pingendi*, Piero déclare que la perspective est nécessaire car elle "discerne tucte le quantità proportionalmente commo vera scientia, dimostrando il degradare e accrescere di onni quantità per forza di linee." Cette formule n'est originale que par le commentaire qui l'accompagne: la perspective supplée en effet à l'incapacité où est l'intellect de juger par lui-même la mesure des choses, "cioè quanto sia la più propinqua e quanto sia la più remota."[6] Or, dans sa pratique artistique, Piero se distingue par la manière dont il utilise au contraire, très ponctuellement et très scientifiquement, la perspective pour brouiller les distinctions et empêcher de distinguer le plus lointain du plus proche. Qu'il s'agisse, par exemple, de la pala de Brera ou de *La Flagellation* d'Urbino, de *L'Annonciation* de Perugia, de la *Madonna del Parto*, de la *Madonna di Senigallia* ou de *L'Invention de la Croix*, il choisit un point de vue et un cadrage qui troublent la perception des emplacements dans la profondeur.[7] Piero fait ainsi "jouer" la perspective, mais il ne se livre certainement pas à un *ludus geometricus* arbitraire ou gratuit. En faisant revenir l'arrière-plan dans le premier plan, son paradoxe suscite des effets locaux de surface et, comme l'a également souligné Hubert Damisch, cette pratique montre qu'en étant "sensible à ce que les mathématiciens nomment aujourd'hui la *contrainte du plan*," le peintre fait, du même coup, "concourir la *perspectiva artificialis* à l'expression des valeurs de surface, proprement picturales."[8]

Ce paradoxe et la "double négation" qu'il implique[9] n'expriment pas cependant un souci exclusivement pictural de la surface. Comme on le verra pour *L'Annonciation* du polyptyque de Perugia, cet emploi de la perspective artificielle peut donner figure à ce qui est irreprésentable dans la représentation. Par ailleurs, si on le considère dans le contexte plus large de la composition de la *storia*, on ne peut guère le dissocier du contraste (bien connu) entre les espaces de Piero ("modernes" par leur constructibilité, leur immensité et leur caractère parcourable) et les figures qu'il y installe, "archaïques" à force de statisme et d'inexpressivité.[10] C'est une donnée essentielle de son style. Or, dans cette immobilité grandiose de ses figures, Piero fait, à nouveau, un choix radicalement opposé à celui de la peinture humaniste pour laquelle la rhétorique figurée des mouvements du corps permet de traduire les mouvements de l'âme, de constituer le discours de l'image, de persuader et d'émouvoir celui qui regarde. Immédiatement après le passage où il pose que la *dignitas* de la *storia* est corrélative d'une composition impliquant un nombre limité de figures, séparées par des intervalles judicieux, Alberti fait l'éloge de la *varietas* dans les mouvements.[11]

Alberti et Piero sont aussi "modernes" l'un que l'autre. Mais leurs modernités ne coïncident pas et cette simple constatation fait question. De quel ordre peut être la *dignitas* de la *storia* et de ses figures chez Piero? Cette "dignité" est incontestable, imposante et même majestueuse; mais sa définition ne saurait être celle de la *dignitas* humaniste. Elle ne s'articule pas à la conception rhétorique de l'Histoire et, plus fondamentalement, elle est certainement très différente de la *dignitas hominis* telle que va bientôt la définir Pic de la Mirandole: cette capacité unique de la créature humaine à se déplacer à travers les degrés de l'être, à être l'artiste de sa propre destinée spirituelle.[12] De quel ordre est donc la *dignitas hominis* pour Piero della Francesca, si elle n'est pas d'inspiration humaniste? Quelle est sa vision de l'histoire?

Le cycle d'Arezzo, le seul cycle historique de Piero qui nous soit parvenu, permet d'engager la réflexion. Sa conception de la *storia* peinte s'y articule avec une relative clarté.

Quelles que soient les élaborations dont l'interprétation du cycle a pu être l'objet, la disposition très complexe et calculée des épisodes successifs à travers les trois murs de la chapelle révèle que le *sens de l'histoire* (sa signification et sa finalité, sa "cause finale") est à la fois obscur dans le temps de

la successivité humaine et manifeste *sub specie aeternitatis*, du point de vue de la Providence. L'idée n'est ni neuve ni originale. Mais il vaut la peine de voir comment Piero la met en oeuvre; sa propre position s'y déclare.[13]

À travers le "désordre" irréductible de la succession narrative et malgré les entrecroisements et échos multiples de scènes en scènes et de registres en registres,[14] les deux murs latéraux présentent une progression claire, continue et irrésistible, du *sens de l'histoire*, qui traverse les hésitations et les incohérences apparentes de la pure succession événementielle. Sur le mur de droite et selon le sens général du récit, de haut en bas, la Croix apparaît progressivement dans l'histoire *comme signe*; sur le mur de gauche, de bas en haut, la Croix (qui existe désormais dans l'histoire) réapparaît triomphalement *comme chose*.[15]

De ce point de vue, qui est celui de la Providence et de l'"oeil moral,"[16] le *sens de l'histoire* est manifeste, alors qu'il est enchevêtré, invisible, au registre de la temporalité humaine des événements. Une comparaison rapide entre les deux batailles du registre inférieur confirme cette dualité.

La disposition de *La Victoire de Constantin sur Maxence* fait percevoir immédiatement le sens de l'épisode, le camp des vainqueurs et celui des vaincus, et l'intervalle central assure la complète intelligibilité de la *storia*. Mais, précisément, il n'y a aucune "bataille;" c'est un miracle qui assure la victoire. Jacques de Voragine proposait deux versions de l'événement tel que le rapportent les divers récits (miracle sans combat ou grand massacre); c'est la version miraculeuse qui a été choisie et, pour ainsi dire, renforcée dans sa représentation.[17] Au contraire *La Victoire d'Héraclius sur Chosroès* présente une bataille pleinement humaine, sans miracle, dont le sens, les camps et l'issue sont apparemment indiscernables. Jacques de Voragine ne donnait pourtant qu'une seule version de l'événement, un combat singulier sur un pont entre Héraclius et le fils de Chosroès, et c'est cet épisode qui était traditionnellement représenté dans le cycle de la Croix;[18] au contraire, Piero donne à voir une mêlée inextricable. Si, donc, l'introduction des deux scènes de bataille dans le cycle de la Croix est sans précédent,[19]

il faut ajouter que cette innovation a été l'occasion d'une élaboration précise. La mêlée furieuse entre les armées d'Héraclius et de Chosroès est une invention par rapport au texte de référence et tout se passe comme si Piero y transférait le massacre qu'il n'a pas retenu pour *La Victoire de Constantin*. De la sorte, le mur de droite met en évidence l'apparition miraculeuse de la Croix *comme signe*—tandis que s'amorce, sur le mur de gauche, le processus ascendant de sa réapparition triomphale *comme chose*.

Il y a plus car, dans la mise en oeuvre picturale de ce qui a pu être un programme fixé par le commanditaire, Piero laisse voir qu'il assume, comme peintre, le contenu de ce programme. Sur le mur de gauche, la mêlée donne l'occasion à Piero de peindre ce "tumulte" rejeté par Alberti: la *storia* semble bien en effet ici, au coeur de la bataille humaine, "non rem agere sed tumultuare."[20] Or, un double détail confirme que cette idée est bien celle de Piero en personne (autant, en tout cas, que celle de son commanditaire). Du sein de la bataille, deux figures seulement ont le regard tourné vers le spectateur, évoquant cet "admoniteur" albertien qui indique aux spectateurs ce qui se passe et leur suggère le sentiment à éprouver.[21] Située exactement sur l'axe central de la fresque, la première de ces figures est, avec le "fils de Chosroès," la seule à être clairement présentée sur le point de mourir, un poignard planté dans le cou d'où jaillit le sang. C'est donc une figure dont le regard s'aveugle. La seconde figure n'a, elle, à proprement parler, plus de regard: à l'extrême gauche du champ, en bas, c'est la tête coupée, replacée dans le champ, dont les paupières entrouvertes laissent entrevoir les yeux morts qui nous fixent, presque secrètement. Ainsi, depuis ce champ où "non rem agere sed tumultuare historia videtur," le double regard qui nous avertit est un regard qui s'aveugle et un regard mort. Ces deux détails ne peuvent pas être dus à l'intervention d'un quelconque conseiller; ils sont nécessairement une *invention* du peintre et ils confirment qu'à Arezzo, pour Piero, dans un cycle où la Providence intervient à plusieurs reprises pour "faire signe," la vision humaine de l'Histoire dans l'histoire se présente comme une incapacité à voir le sens sans l'intervention de la Providence.[22]

Il n'est pas possible, cependant, d'en rester là. Après tout, Piero illustre ici un récit qui implique l'aveuglement des hommes dans l'Histoire. Non seulement le Christ le dit lui-même sur la Croix ("Père, pardonne-leur, car ils ne savent pas ce qu'ils font," Luc, 23:34), mais Jacques de Voragine souligne à plusieurs reprises que le récit qu'il rapporte n'est pas clair, que ses diverses sources sont souvent ambiguës et même contradictoires.[23] Dans une certaine mesure, l'élaboration générale et particulière du cycle donne figure à cette double articulation du récit légendaire: providentiellement clair, obscur dans sa temporalité humaine.

Par ailleurs, la modernité "scientifique" des espaces de Piero, son intérêt pour l'Antiquité[24] comme pour la lumière et ses reflets dans le monde des apparences suffisent à montrer que, si sa position n'est pas celle de l'"humanisme rhétorique," elle ne saurait être non plus comprise comme une attitude simplement traditionnelle. Dans son ensemble, l'oeuvre de Piero confirme à quel point il convient de dépasser toute opposition simpliste et réductrice entre une "tradition" et une "modernité" qui serait exclusivement humaniste et rhétorique.

Pour tenter de cerner et de définir positivement ce qui est original dans cette modernité de Piero, il faut donc, sans doute, revenir à Ernst Cassirer et à ce "milieu intellectuel" dont il identifie l'existence dans l'Italie du Quattrocento et qui, "à côté de la culture scolastique déclinante et de la culture humaniste ascendante, représente une troisième forme, spécifiquement moderne, du savoir et de la volonté de connaître." Les termes qu'emploie Cassirer pour décrire l'attitude et les pratiques intellectuelles de ce milieu sont très remarquables car ils correspondent étrangement à qu'on pressent de l'activité réflexive et artistique de Piero:

Il ne s'agit pas, dans cette troisième direction, de fixer et de saisir scientifiquement un contenu religieux déterminé, de revenir à la grande tradition antique et d'y rechercher le renouvellement de l'humanité, mais de s'attacher à des tâches de techniques artistiques concrètes pour lesquelles on cherche une "théorie." Du sein de l'activité artistique créatrice surgit l'exigence d'une réflexion plus profonde de cette activité sur elle-même qui ne peut s'accomplir sans revenir aux fondements derniers du savoir, en particulier du savoir mathématique.[25]

Cassirer n'évoque pas Piero; significativement, il ne pense qu'à Alberti et Léonard. Mais, en voyant en Nicolas de Cues "l'exposant algébrique" de ce milieu intellectuel, il n'en invite pas moins à s'interroger sur la parenté intellectuelle qui a pu exister entre la philosophie du Cusain et l'art de Piero della Francesca.

Le rapprochement entre Nicolas de Cues et Piero della Francesca n'est pas neuf. Il a été opéré dès 1942 par Gina Nicco Fasola dans son introduction au De prospectiva pingendi.[26] Mais elle ne l'envisageait alors qu'en termes généraux. On peut tenter d'en préciser la portée car les écrits du Cusain éclairent d'un jour nouveau certains des aspects les plus originaux de l'art du peintre toscan.

Historiquement, le rapprochement entre Nicolas de Cues et Piero della Francesca est fondé: ils sont présents à Rome au même moment et ils y sont vraisemblablement en contact.[27] Il est, surtout, intellectuellement légitime. Sans doute, Piero n'est pas un letterato; mais, de son côté, Nicolas de Cues est indifférent au souci humaniste de l'élégance rhétorique: à ses yeux, le langage le plus humble peut exprimer le sens le plus pur.[28] De même, il n'est pas indifférent que, dans le dialogue De Idiota, écrit en 1450, le porte-parole de l'auteur face au philosophe et à l'orateur, le Profane, soit présenté en train de fabriquer une cuillère en bois et que, tout en considérant la peinture comme un modèle pour la pensée, il définisse cette dernière (mens) comme l'activité de mensurare, autrement dit comme une commensuratio, le terme même que Piero emploie pour désigner la prospectiva.[29]

Ces rapprochements sont significatifs puisqu'ils portent sur le mode d'expression d'une pensée. C'est cependant à un registre plus profond que la philosophie proprement dite de Nicolas de Cues, ce que Cassirer appelle son "intuition fondamentale," aide à situer certains des aspects les plus personnels de l'art de Piero. Je ne retiendrai ici que deux points—dont je demande qu'on les considère, à ce stade, comme des propositions de réflexion et de recherche plus que comme des conclusions abouties.

Comme on le sait, la *docta ignorantia* repose sur le principe que l'univers visible est le développement (*explicatio*) imparfait de Dieu, le déploiement dans la multiplicité de ce qui, en Dieu, est présent dans une indissoluble et étroite unité (*complicatio*)—chaque être individuel étant une contraction (*contractio*), conforme à sa propre nature, de la plénitude de l'Univers.[30] Sur cette base, Nicolas de Cues articule très décidément l'impossibilité où est l'intelligence de connaître Dieu (incommensurable à toute *commensuratio*) et la légitimité de la connaissance humaine (relative). La *docta ignorantia* est à la fois une ignorance savante et une science ignorante—la géométrie y offrant la voie la plus sûre vers une appréhension de l'infini, tout en ne permettant pas de franchir le seuil de l'incommensurable.

L'opposition, cependant, n'est nullement statique. Comme l'a mis en valeur Agnès Minazzoli, ce "seuil d'incommensurabilité" peut être franchi au terme d'une véritable conversion de la vision. Au registre de "la démonstration rationnelle . . . , voir, c'est avoir prise sur le monde, c'est le capter pour le mesurer," et "'Voir' équivaut ici à 'comprendre;'" au registre de la foi, qui ne se mesure "qu'à l'incommensurable," la révélation de la "coïncidence des contraires" annonce la "coïncidence du visible et de l'invisible, de la limite et de l'illimité;" "'Voir' équivaut ici à 'croire.'"[31]

Cette "intuition fondamentale" du Cusain permet de comprendre de façon renouvelée le jeu paradoxal qu'opère Piero entre la profondeur et la surface—et peut-être d'en dégager un enjeu latent.

En construisant ses espaces de façon à faire revenir la planarité dans la profondeur, en faisant ainsi "coïncider les opposés," Piero opère la *complicatio* de la profondeur et du plan. Il "complique" l'un dans l'autre d'une façon analogue à celle dont Nicolas de Cues dit qu'il faut "compliquer les pôles avec le centre."[32] En "enveloppant" ainsi la profondeur dans le plan et le plan dans la profondeur, la géométrie rend intellectuellement incompréhensible la représentation du visible. Il s'agit bien d'un paradoxe puisque, comme le déclare le *De prospectiva pingendi*, la perspective est nécessaire au peintre précisément pour démontrer l'accroissement ou la diminution des quantités "per forza di li-

nee."[33] Mais ce paradoxe s'explique peut-être par la fonction religieuse de l'image peinte: faire croire le fidèle. Mis dans l'impossibilité de discerner et de comprendre, le "voir" est appelé effectivement à croire. Dans le contexte de la peinture religieuse où ils s'exercent, les paradoxes de Piero pourraient viser à donner une figure intellectuellement incompréhensible à ce qui est incommensurable à tout visible: la Transcendance divine intervenant dans l'altérité du monde.[34]

Une oeuvre, au moins, me semble donner tout son sens *théologique* à cette pratique: *L'Annonciation* du polyptyque de Perugia. Le type de construction architecturale, le cadrage choisi et le point de vue adopté ont pour conséquence de faire surgir vers l'avant, entre Gabriel et Marie, en surface, le panneau de marbre(?) situé fictivement au fond du portique. De loin, c'est-à-dire à la distance d'où était vue l'oeuvre, ce panneau fait retour vers le premier plan et cet effet ponctuel de surface annule la profondeur apparente de l'architecture.[35] Que ce panneau puisse être considérée comme une "figure dissemblable" de la Divinité,[36] c'est, me semble-t-il, ce que confirme la seconde conséquence du dispositif élaboré par Piero. Le point de vue adopté fait en effet disparaître ici le volume et la saillie vers l'avant de l'édicule sous lequel est située la Vierge. Piero dissimule ainsi, entre les deux personnages, un massif de colonnes exactement placé sur l'axe reliant visuellement Gabriel à Marie. Ce n'est certainement ni un hasard ni un simple jeu, car la colonne est, elle, une "figure christique" bien connue et abondamment utilisée comme telle au Quattrocento.[37] Dans *L'Annonciation* de Perugia, la perspective géométrique et sa mise en place font affleurer au regard la transcendance dans l'altérité du visible—tout en en dissimulant la figure la plus aisément reconnaissable. En "enveloppant" ainsi la profondeur dans le plan, la construction perspective donne à (ne pas) voir la mystérieuse "coïncidence des opposés" qui constitue le coeur théologique de la représentation: cette coïncidence de l'Éternité et du Temps, de l'Infini et du fini, de l'Infigurable et de la figure, de l'Incommensurable et de la mesure qui s'accomplit avec l'Annonciation, et qui n'est autre que le mystère de l'Incarnation de Dieu en l'homme.[38]

L'interprétation peut encore avancer d'un pas. Pour obtenir un tel effet de sens, Piero della Francesca a évidemment construit avec soin le point de vue qui détermine l'aspect de son oeuvre. Il n'est pas indifférent que ce point de vue corresponde très précisément à ce que les théoriciens actuels de la géométrie appellent un point de vue "instable ou non générique."[39] Ce dernier constitue en effet la matrice et la synthèse virtuelle des multiples "points de vue génériques" possibles. Ainsi, pour le dire en termes contemporains de Piero (ceux de Nicolas de Cues), le point de vue "non générique" enveloppe (complicatio) tous les points de vue particuliers qui le développent (explicatio); il les contient tous "dans une indissoluble et étroite unité," tel l'univers en Dieu[40]—ou plutôt, tel le point de vue de Dieu sur cet univers que les hommes ne peuvent percevoir que dans son imparfaite explicatio. Il serait bien possible que le Monarca della pittura ait confié à la géométrie et à sa perspective la mission de construire une figure méconnaissable de la Transcendance dans l'altérité du visible. Ce ne serait après tout qu'une version mathématique de cette pratique de l'"oeil moral" au terme duquel le regard doit chercher moins à comprendre qu'à croire.

On pourrait, à ce point, pousser plus systématiquement l'interprétation. On le pourrait à la fois en ce qui concerne l'immobilité grandiose des figures de Piero ou son indifférence à la particularisation physionomique des personnages les plus importants de ses storie.[41] Les limites de cette communication engagent cependant à retourner à la question initiale, celle de la "vision de l'histoire."

Je noterai seulement que, si la "coïncidence des opposés" rend nécessaire l'aveuglement relatif des hommes dans l'histoire (à moins que la Providence ne s'y manifeste miraculeusement), l'idée selon laquelle chaque créature est une contractio, conforme à sa propre nature, de la plénitude de l'univers peut contribuer à préciser la nature de l'incontestable dignitas qui investit toutes les figures de Piero. Selon Nicolas de Cues en effet et pour citer à nouveau Cassirer, "à travers le cours des événements contingents et sous la contrainte des conditions extérieures, [l'homme] n'en reste pas moins le 'dieu créé.' Enfermé dans le temps, voire

dans la particularité de tel ou tel moment, pris au piège des déterminations de l'instant, il se manifeste cependant, envers et contre tout, comme le dieu occasionné."[42] Que leur rôle dans l'histoire soit positif ou négatif, qu'elles refusent aveuglément les signes de Dieu ou qu'elles en acceptent la révélation, les figures de Piero possèdent une puissance et une dignitas qui pourraient marquer leur participation à l'unité de la divinité et manifester l'immanence de l'Infini dans ses aspects finis.[43]

Il ne s'agit, dans ce qui précède, ni d'expliquer Piero della Francesca par Nicolas de Cues, ni de suggérer que Piero della Francesca illustrerait les idées du philosophe, réduites à quelques formules bien choisies. Il s'agit plutôt de considérer la pensée de Nicolas de Cues comme un horizon ou un cadre théorique, philosophique et intellectuel, permettant de préciser et d'enrichir notre compréhension de ce qui a inspiré la pratique artistique de Piero. Avec ce qu'elle implique de convergences d'intérêts et de différences individuelles d'approches, la notion de ce "milieu intellectuel" dont Nicolas de Cues serait "l'exposant algébrique" me paraît en particulier opératoire pour cerner la parenté qui, à travers leurs manifestes différences, a rapproché les oeuvres d'Alberti et de Piero.

Comme je l'ai indiqué plus haut, je ne fais ici que proposer une hypothèse de recherches. Celles-ci me semblent devoir être continuées pour éviter, par exemple, la tautologie qui rend compte de l'originalité artistique de Piero par son "génie" propre. Elles me semblent devoir être continuées aussi car elles peuvent jeter quelque lumière sur la fortune critique et historique de Piero et sur le destin singulier de ses cycles de fresques. Si, à Ferrare et à Rome, la grande peinture narrative du Monarca della pittura est très vite jugée archaïque, et détruite—au point qu'il n'en reste plus comme témoignage que le décor d'une église franciscaine, dans une ville qui ne saurait passer pour un centre important dans l'histoire de la culture—c'est sans doute parce que la vision de l'histoire mise en oeuvre dans ces fresques n'était ni celle de la culture princière ni, surtout, celle de l'humanisme rhétorique. La modernité de Piero deviendra décidément un archaïsme quand l'emportera la concep-

tion "classique" de la peinture, d'origine humaniste; et ce n'est pas un hasard si son art non rhétorique redeviendra moderne quand la modernité consistera précisément à rejeter la rhétorique en peinture et à y exalter la composition de surface. Interpréter cependant les surfaces peintes de Piero en fonction de ces considérations exclusivement picturales serait en réduire les enjeux théoriques, philosophiques et religieux. L'idée qu'il a pu exister une parenté entre sa pratique "scientifico-artistique" et le mode de pensée "mystico-spéculatif"[44] de Nicolas de Cues est une proposition qu'il convient de préciser et d'approfondir.

NOTES

1. Giorgio Vasari, *Le vite de' più eccellenti pittori, scultori ed architettori*, ed. Gaetano Milanesi, 9 vols. (Florence, 1906), 2:488.

2. Voir Donald J. Wilcox, *The Development of Florentine Humanist Historiography in the Fifteenth Century* (Cambridge, Mass., 1969); Nancy S. Struever, *The Language of History in the Renaissance: Rhetoric and Historical Consciousness in Florentine Humanism* (Princeton, 1970); Berthold L. Ullman, *Studies in the Italian Renaissance* (Rome, 1973), 321–343; Eric Cochrane, *Historians and Historiography in the Italian Renaissance* (Chicago, 1981), 3–86; Robert Black, "Rhetoric and History in Accolti's *Dialogue on the Preeminence of Men of His Own Time*," *Journal of the History of Ideas* 43 (janvier–mars 1982), 3–32.

3. Voir John R. Spencer, "Ut Rhetorica Pictura: A Study in Quattrocento Theory of Painting," *Journal of the Warburg and Courtauld Institutes* 20 (1957), 26–44; Michael Baxandall, *Giotto and the Orators: Humanist Observers of Painting and the Discovery of Pictorial Composition* (Oxford, 1971), 121–139. Robert Klein a bien montré comment, chez Pomponius Gauricus, la "perspective de composition" ou *perspectiva superior* reprend la notion de *perspicuitas* telle qu'elle est élaborée par Quintilien, dans Pomponius Gauricus, *De Sculptura (1504)* (Genève-Paris, 1969), 177–181.

4. Piero della Francesca, *De prospectiva pingendi*, ed. Gina Nicco Fasola (Florence, 1984 [1942]), 63.

5. Hubert Damisch, "La perspective au sens strict du terme," dans *Piero teorico dell'arte*, ed. Omar Calabrese (Rome, 1985), 17. Voir aussi Piero della Francesca 1984, 29–33; Carlo Bertelli, *Piero della Francesca* (New Haven, Conn., 1992), 153.

6. Piero della Francesca 1984, 129. Telle qu'en écrit Piero della Francesca, la perspective aide à la lucidité de la représentation bidimensionnelle des corps, mais elle n'a pas à faire avec la lucidité de la composition—à la différence de Gauricus, qui associe immédiatement perspective de disposition et clarté de la narration (Gauricus 1969, 188).

7. Sur le retour du plan dans la profondeur, voir Marilyn Aronberg Lavin, *Piero della Francesca: The Flagellation* (New York, 1972), 72; Thomas Martone, "L'affresco di Piero della Francesca in Monterchi: una pietra miliare della pittura rinascimentale," dans *Convegno Internazionale sulla "Madonna del Parto" di Piero della Francesca*, ed. Biblioteca Comunale di Monterchi (Monterchi, 1982), 19–99, et "Piero della Francesca e la prospettiva dell'intelletto," dans Calabrese 1985, 173–186; Bertelli 1992, 164. Sur les réserves qu'inspire cependant l'interprétation de cette pratique par Thomas Martone comme "trompe l'intelligence," voir plus loin, note 34.

8. Damisch 1985, 17 et 29.

9. Jean Petitot, "Osservazioni in margine alle relazioni di Thomas Martone e Louis Marin," dans Calabrese 1985, 208.

10. Sur l'"archaïsme" de Piero della Francesca, voir entre autres Bertelli 1992, 84–85, qui invente le terme de "néo-archaïsme" pour qualifier les choix artistiques de Piero par rapport à l'Antiquité.

11. Leon Battista Alberti, *De la Peinture. De Pictura, 1435*, ed. et trad. Jean-Louis Schefer (Paris, 1992), 170–172.

12. Voir Ernst Cassirer, *Individu et cosmos dans la philosophie de la Renaissance*, trad. Pierre Quillet (Paris, 1983), 112–113.

13. Je résume ici différents passages de mon intervention "Piero peintre d'histoire?" dans Calabrese 1985, 85–114.

14. Sur ce point, voir Louis Marin, "La théorie narrative et Piero peintre d'histoire," dans Calabrese 1985, 55–84 et, dans un esprit différent, Marilyn Aronberg Lavin, *The Place of Narrative: Mural Decoration in Italian Churches, 431–1600* (Chicago, 1990), 167–194, en particulier 188–194.

15. Le caractère intentionnel de ce dispositif est confirmé par l'écart iconographique qui consiste à faire revenir la Croix entière à Jérusalem; voir Arasse 1985, 98–99.

16. Voir Michael Baxandall, *Painting and Experience in Fifteenth Century Italy* (Oxford, 1972), 103–109.

17. En ne représentant aucun pont qui expliquerait matériellement la défaite de Maxence, Piero renforce le caractère miraculeux de sa fuite, provoquée par la minuscule croix tenue à bout de bras par Constantin.

18. On peut en reconnaître le souvenir dans le duel des deux cavaliers qui ferme la séquence sur la droite. Ce ne sont pas les armures ou les physionomies qui permettent cette identification mais le fait qu'en surface, comme exorcisée, la Croix surgit, *comme chose*, de la bouche du cavalier tué; voir Arasse 1985, 105–106.

19. Lavin 1990, 191.

20. Alberti 1992, 170.

21. Alberti 1992, 178–179.

22. Cet aveuglement causé par les passions humaines est évoqué, dans la partie supérieure gauche de l'arc d'entrée, par la figure du Cupidon aux yeux bandés. Je nuancerais à ce propos l'opinion de Carlo Bertelli (1992, 87) selon lequel "we do not know what Piero had painted on the other pilaster, as an anti-eros in opposition to this irresponsible love." En face de ce Cupidon en effet, au registre inférieur du pilier, Piero a peint un ange dont il ne reste plus que le visage, aux yeux bien ouverts—le contraste entre ces deux figures oppose manifestement l'aveuglement des passions humaines et la clairvoyance de l'amour et du regard spirituels.

23. Voir Arasse 1985, 100–101.

24. Voir entre autres Bertelli 1992, 89.

25. Cassirer 1983, 68.

26. Piero della Francesca 1984, 1–59.

27. Bertelli 1992, 153. Voir aussi Maurizio Calvesi, "Systema degli equivalenti ed equivalenze del Sistema in Piero della Francesca," *Storia dell'arte* 24–25 (1975), 88, qui reprend Eugenio Battisti, *Piero della Francesca*, 2 vols. (Milan, 1971–1972), 1:107.

28. Cassirer 1983, 28. Sur le style littéraire de Nicolas de Cues, voir l'introduction d'Agnès Minazzoli à sa traduction de Nicolas de Cues, *La Tableau ou la vision de Dieu* (Paris, 1986), 25–28.

29. Voir Minazzoli 1986, 17; Cassirer 1983, avec la traduction du *De Idiota* (246–247): "C'est de la pensée que toutes choses reçoivent limite et mesure. Je conjecture que *mens* vient de *mensurare*."

30. Sur Nicolas de Cues, outre Maurice de Gandillac, *La Philosophie de Nicolas de Cues* (Paris, 1941), voir aussi Cassirer 1983, 13–95; Alexandre Koyré, *Du monde clos à l'univers infini*, trad. Raissa Tarr (Paris, 1962), 17–36.

31. Minazzoli 1986, 18–20.

32. Voir Koyré 1962, 28, qui cite le *De docta ignorantia*, II, 12: "Ainsi donc, si . . . tu veux comprendre quelque chose au mouvement de l'Univers, tu dois 'compliquer' le centre avec les pôles, en t'aidant, autant que tu le peux, de ton imagination."

33. Piero della Francesca 1984, 129.

34. En interprétant cette pratique (dont il met remarquablement en valeur l'originalité et la rigueur) comme un "trompe l'intelligence," Thomas Martone (1985) en réduit la portée. La limite de son interprétation se marque au fait que, dans son hypothèse, l'observateur doit se transformer en "agent investigateur, s'approchant de la peinture pour faire des observations perspicaces" (179). Ce n'était évidemment pas de la sorte qu'étaient pratiquées (ni donc conçues) les oeuvres de Piero. Voir en revanche, ses remarques intéressantes (1982) sur la façon dont, chez Piero, la perspective vise à construire un espace clos, "distinct et fini." Voir aussi les brèves remarques d'Eugenio Battisti, "Teoria Vs arte," dans Calabrese 1985, 187–204, en particulier 200–204.

35. Le caractère intentionnel de cette disposition est confirmé par le fait que la coloration du marbre(?) continue *en surface* l'orientation des lignes de fuite de droite du portique; elle rabat ainsi la profondeur illusoire sur la réalité du plan et "complique" l'une dans l'autre.

36. Voir Georges Didi-Huberman, *Fra Angelico. Dissemblance et figuration* (Paris, 1990), 66–81, qui qualifie joliment de "pan de fuite" ce lieu du panneau (72).

37. Je prépare une étude sur ce thème et l'emploi de la perspective dans les *Annonciations* du Quattrocento pour figurer le mystère irreprésentable de l'Incarnation. Voir Daniel Arasse, "Annonciation/ Énonciation. Remarques sur un énoncé pictural au Quattrocento," *Versus. Quaderni di studi semiotici* 37 (janvier–avril 1984), 6–9.

38. Voir Arasse 1984, 4–5; Louis Marin, "Énoncer une mystérieuse figure," *La Part de l'oeil* 3 (1987), 123–129.

39. Voir Petitot 1985, 208. Une situation est dite "générique" quand elle reste stable à travers des transformations minimes (le figure d'un cube en perspective ne change pas de nature quand on déplace légèrement le point de vue de l'observateur). Il faut une situation exceptionnelle ("non générique") pour que la perception de la tridimensionnalité "dégénère" et qu'on voie coïncider la perception d'un cube et celle d'un hexagone. Dans cette situation "non générique" (et instable), la perception de la profondeur se perd et il y a retour de la représentation à la bidimensionnalité. Je remercie chaleureusement Jean Petitot pour la patience avec laquelle il m'a fait comprendre ce point délicat.

40. Koyré 1962, 21.

41. Calvesi 1975, 87, qui cite Nicolas de Cues ("la quiete è unità che complica il moto, essendo questo una quiete serialmente ordinata, se sottilmente consideri la cosa," *De docta ignorantia*, II, 3); à rapprocher de Nicco Fasola (1984, 26) qui décrit le mouvement des figures de Piero comme une "successione di stati." De même, Maurizio Calvesi (1975, 90) se fonde sur Nicolas de Cues pour interpréter les reprises de visages types dans les figures de Piero et y voir une négation de l'altérité au nom de l'identité première et éternelle. Pour ma part, je verrais plutôt dans cette pratique la marque de la conception particulière que Piero se fait de la *dignitas* humaine, en écho au concept cusain de *contractio* (voir ci-dessous, note 43).

42. Cassirer 1983, 58–59.

43. Voir Cassirer 1983, 44, qui cite Nicolas de Cues (*De Visione Dei*, chap. 6) sur la visage de Dieu: "Votre visage précède toute face qui peut estre figurée, et [il] est le véritable exemplaire de toutes, et . . . toutes les faces sont les images de la vostre, qui ne participe de nulle autre."

44. L'expression est de Max Jammer, *Concepts of Space: The History of Theories of Space in Physics* (Cambridge, Mass., 1954), ed. consultée *Storia del Concetto di Spazio* (Milan, 1979), 78.

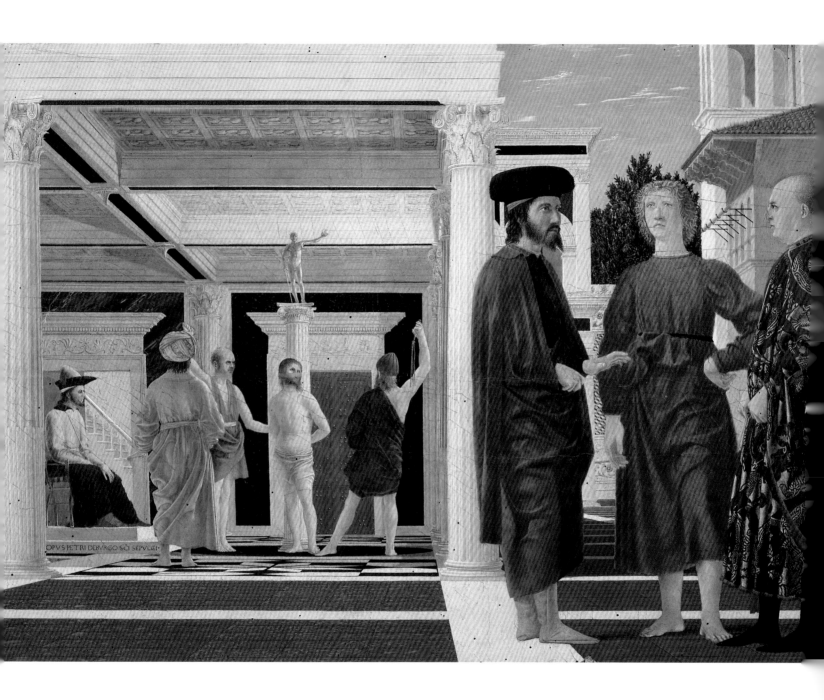

MAURIZIO CALVESI
Università degli Studi di Roma "La Sapienza"

La Flagellazione *nel quadro storico del convegno di Mantova e dei progetti di Mattia Corvino*

Nella *Flagellazione* di Piero della Francesca, uno stesso gesto accomuna la figura con turbante, che si mostra di spalle, e il primo personaggio del gruppo di destra. Entrambi portano avanti una mano tesa, all'altezza della vita. Percorrendo la rimanente produzione del pittore, riconosciamo altre due volte questo medesimo gesto: in uno degli angeli del *Battesimo*, e nel Profeta o Santo che è affiancato ad altra figura di Profeta nella parete di fondo di San Francesco ad Arezzo. È possibile dare un significato comune a questi gesti tra loro uguali?

La ben nota scritta un tempo leggibile sulla cornice della *Flagellazione*, "Convenerunt in unum," rinvia a un versetto del secondo Salmo, ripreso dagli Atti degli Apostoli (4, 26–27) con riferimento alla Passione di Cristo: "Adstiterunt reges terrae, et principes *convenerunt in unum* adversus Dominum, et adversus Christum ejus. *Convenerunt* enim vere in civitate ista adversus sanctum puerum tuum Jesum, quem unxisti, Herodes, et Pontius Pilatus, cum gentibus, et populis Israel." (Si sono sollevati i re della terra e i principi si sono radunati contro il Signore e contro l'Unto suo. In questa città, infatti, contro il tuo santo figlio Gesù, Erode e Ponzio Pilato si sono messi d'accordo con le nazioni e il popolo d'Israele.)

Il latino *convenire* significa tanto radunarsi, quanto accordarsi. "Convenerunt in unum" è frase fatta che vuol dire "si radunarono, si riunirono nello stesso luogo."

Il secondo *convenerunt* sembra piuttosto doversi tradurre, come infatti viene tradotto, "si accordarono, si misero d'accordo": contro il tuo santo figlio, Erode e Ponzio Pilato si sono messi d'accordo con le nazioni e il popolo d'Israele.

Alla luce di questo passo cui il dipinto si rifaceva, l'uomo di spalle con turbante dovrebbe essere Erode, rivolto verso Pilato, e il suo gesto potrebbe ben significare l'accordo. In questo malvagio patto i due flagellatori starebbero poi a rappresentare "le nazioni e il popolo d'Israele." Che la mano portata avanti, come a giurare, possa indicare un patto, un accordo, è in realtà più che verosimile. A loro volta, i tre personaggi di destra sarebbero raffigurati nell'atto di prendere un accordo, di fare un patto: un patto uguale e contrario, come vedremo, in difesa del Cristo.

Anche se tre secoli dopo, *Il giuramento dei tre Orazi* di David può costituire un suggestivo termine di confronto: il giuramento (come anche nel disegno dello stesso David illustrante *Il giuramento di Bruto*) vi è raffigurato nel suo antico codice gestuale, con la mano, appunto, portata in avanti. I patti e le alleanze a tre sono del resto un classico, un topos, dalla leggenda greca dell'accordo tra i tre fratelli di Feneo contro quelli di Tegea, ai tre Orazi e Curiazi, al giuramento dei tre eroi dei tre regni nell'antica Cina, o ai tre confederati svizzeri che J. H. Füssli, in un dipinto conservato nel Rathaus di Zurigo,

Piero della Francesca,
Flagellation of Christ,
c. 1458–1460, tempera
Galleria Nazionale delle Marche,
Palazzo Ducale, Urbino;
photograph: Alinari

ritrasse nell'atto di giurare.

Un altro dipinto di Jacques-Louis David, l'incompiuto *Giuramento del Jeu de Pomme*, può suggerire per coincidenza non casuale un confronto sia con i tre personaggi della *Flagellazione*, sia con i tre angeli del *Battesimo*. Abbiamo infatti, come nella *Flagellazione*, una figura centrale fiancheggiata da due astanti visti di profilo, il primo dei quali, a sinistra, porta avanti la mano in segno di giuramento. Inoltre, come nel *Battesimo*, i tre personaggi si abbracciano e due di essi si stringono la mano, la sinistra con la sinistra. È improbabile che David conoscesse l'opera di Piero, ma entrambi hanno tenuto presente l'iconografia delle tre Grazie, tema del resto diffuso anche nella cultura neo-classica.

Secondo il Ripa, le tre Grazie sono un simbolo di "vera amicitia" e come noto, il De Tolnay ha confrontato i tre angeli di Piero con una medaglia di Niccolò Fiorentino, dove sono riprodotte le tre Grazie con la scritta: "Concordia."[1] Altri ha pensato a un simbolo di concordia religiosa, cioè all'accordo o riconciliazione delle Chiese d'Oriente e d'Occidente.[2] Il Battisti, sempre rifacendosi all'iconografia delle tre Grazie, ha suggerito il significato di "dare, ricevere, restituire," secondo la lettura delle tre Grazie come liberalità, presente in Strabone, Seneca, Fulgenzio, Boccaccio, Alberti, Alciati, Ripa.[3] Personalmente ritengo che vi sia una connessione con il passo dell'evangelista Giovanni (1, 15–16) che precede immediatamente la testimonianza del Battista sul Battesimo di Gesù (1, 29–34). È detto infatti in questo passo, per bocca dello stesso Battista: "E dalla sua pienezza (*plenitudine*) tutti ricevemmo, e grazia per grazia" (*gratiam pro gratia*). Per Agostino, che mette in relazione la *plenitudo* con la liberalità, queste due "grazie" sono la fede e l'immortalità; l'immortalità o vita eterna, seconda grazia, non è che la ricompensa della prima ovvero della fede: "ipsa fides gratia est; et vita aeterna, gratia pro gratia."[4] Offrendo la fede, che è di per sè una grazia, ed è dunque qualcosa che già si riceve in dono (con il battesimo, appunto), si ottiene in cambio un'altra grazia, quella della vita eterna. Gregorio Nazianzeno definisce poi così il battesimo: "Lo chiamano dono, grazia, battesimo. . . . Si dice dono perchè è dato a co-

loro che nulla prima hanno dato, grazia perchè concesso a chi anzi è debitore."[5] *Gratiam pro gratia*, di nuovo. I due angeli di destra si scambierebbero *gratiam pro gratia*, e l'accordo è siglato dal gesto del terzo angelo che porta avanti la mano in segno di patto. Questo gesto sembra quindi riconfermarsi, comunque, in quel significato di patto, concordia o accordo che abbiamo individuato anche nei due analoghi gesti della *Flagellazione*.

E veniamo all'ultima immagine da esaminare, cioè il Profeta o Santo che, negli affreschi di Arezzo, porta avanti la mano in direzione di un secondo Profeta. Non conosciamo l'identità di queste due figure, ma si è pensato a Geremia, o Daniele, o Giona, o all'evangelista Giovanni, che nei loro scritti alludono tutti all'albero della Croce. Quindi due profetiche testimonianze, o per così dire due fonti, due fonti tra loro concordanti: ed ecco che il gesto potrebbe di nuovo alludere alla concordanza ovvero all'accordo. Come mi propongo di dimostrare in uno scritto di prossima pubblicazione, i due personaggi sono, con buone probabilità, San Giovanni e il profeta Ezechiele: il primo concorda con il secondo nel parlare della Nuova Gerusalemme e degli alberi di vita.[6]

Possiamo così tornare alla *Flagellazione*, confermati nell'ipotesi che il gesto di Erode e quello corrispondente del primo personaggio del gruppo di destra, alludano entrambi a un accordo, a un patto, a un'alleanza. Ai danni di Gesù, il primo ("Convenerunt . . . adversus Jesum"); in sua difesa il secondo. E in effetti ciò è ben indicato anche dall'inversione del triangolo compositivo, che a sinistra si presenta con la figura-perno (Erode) in avanti e girata di schiena; mentre a destra la figura-perno (il giovane biondo) è arretrata rispetto alle altre due e mostrata frontalmente. Questa inversione, unita alla ripetizione del gesto laconico ed essenziale, suggerisce con meravigliosa e geometrica semplicità la contrapposizione delle due alleanze: quella dei reprobi e quella dei giusti, quella dei nemici di Cristo e quella dei suoi difensori.

Siamo, come si vede, nell'ambito dell'ipotesi avanzata per primo da Kenneth Clark nel 1951,[7] secondo cui il dipinto risalirebbe agli anni intorno al 1460 (ciò che è anche

stilisticamente calzante) e il Cristo flagellato alla presenza di un personaggio con turbante, starebbe a significare le tribolazioni della Chiesa a opera dei turchi, che nel 1453 avevano conquistato la gloriosa sede cristiana di Costantinopoli. Da allora la principale preoccupazione dei pontefici fu, a lungo, di organizzare una crociata contro i maomettani, la cui espansione minacciava lo stesso Occidente. Pio II (Enea Silvio Piccolomini) fu il più attivo promotore di questa impresa, mai realizzata, ma da lui strenuamente voluta. Nel 1459 egli convocò a Mantova, a questo scopo, regnanti e principi cristiani e ancora nel 1464, anno della sua morte, fece l'ultimo tentativo, recandosi benché malato ad Ancona—dove si spense—per raccogliere le forze alleate da imbarcare alla volta dell'Oriente.

Nel dipinto di Piero, i tre personaggi di destra sarebbero appunto dei contemporanei, interessati a organizzare la riscossa cristiana. L'uomo barbuto, aggiungeva il Clark, potrebbe essere Tommaso Paleologo, fratello dell'ex imperatore d'Oriente.

Questa ipotesi di base si è rivelata la più attendibile nell'opinione della maggioranza degli studiosi e costituisce a mio avviso un binario affidabile, da cui non è produttivo allontanarsi.

L'idea, invece, che i tre personaggi sulla destra possano essere dei contemporanei di Gesù (un pagano, un soldato e Giuseppe d'Arimatea secondo il Gilbert;[8] i membri del Sinedrio secondo il Borgo;[9] tre ebrei secondo il Lollini[10]) stride con la positiva evidenza dei personnagi stessi, ben in avanti, rispetto alla cui "attualità"—sottolineata dal fatto che si tratta evidentemente di ritratti—la scena della flagellazione si pone con chiarezza, nella sua distanza prospettica, come "antefatto": antefatto sia pure recente, con riferimento agli eventi del 1453 nel turbante del turco e nel copricapo di Pilato. Se qualche credito ha ora incontrato lo scritto del Lollini, ciò è dovuto all'ammirevole bagaglio di erudizione che lo correda, senza tuttavia che gli argomenti-chiave risultino convincenti. Sarebbe una stranezza, ad esempio, un ebreo biondo. Non è poi possibile considerare un connotato di inferiorità sociale—quale sarebbe quella degli ebrei sia pure ricchi—il capo nudo, dato che in presenza della divinità i personaggi di Piero sono quasi sempre

senza cappello (si veda ad esempio la *Madonna della Misericordia*).

La pista del Clark, invece di essere abbandonata, va piuttosto vagliata in tutte le direzioni, tenendo ferma la trasparente allusione ai fatti del 1453 e proseguendo nei tentativi, fin qui poco convincenti, di identificare i tre ritratti di destra. A rinforzo dell'ipotesi del Clark, può ora valere la nostra lettura dei due gesti di Erode e dell'altro personaggio, come gesti giurati di due accordi uguali e contrari. Il *convenerunt* della scritta e del passo degli Atti degli Apostoli (si radunarono e si misero d'accordo) alluderebbe appunto all'intesa tra Erode, Pilato e gli ebrei (metafora storica del complotto turco), ma anche, nell'attualizzazione della scena, alla convergenza di sforzi intesi a operare in senso contrario, cioè in favore della cristianità, a cominciare da quel convegno di principi e regnanti che in Mantova aveva indetto Pio II. In proposito, vorrei chiamare l'attenzione su un fatto che non è stato ancora notato. "Conventus" (convegno) è il nome che il pontefice dava alla dieta di Mantova, e *convenire* è il verbo che ricorre nelle sue numerose e pressanti lettere d'invito rivolte a *reges* e *principes* perché si recassero all'appuntamento o vi mandassero loro ambasciatori.

Il passo degli Atti degli Apostoli dice: "Adstiterunt reges terrae et principes convenerunt in unum." Parole molto simili troviamo nelle suddette lettere d'invito del pontefice, come: "ad *conveniendum*"; "*convenire* cura . . . erit"; "in *conventu* tot *principum*"; "credidimus honori tuo plurimum *convenire*"; "ut cum aliis Christi fidelibus *principibus convenient*"; "si *principes* et prelati *conveniant*"; "ad *conventum* hunc Mantuanum"; Expectamus *principes* huc *conventuros* vel si id non poterunt oratores eorum quorum neminem *convenisse* hucusque satis miramur"; "optamus velis celeriter *convenire*.[11] Ecco infine una frase particolarmente congeniale al dipinto, anche per il riferimento al dispiacere che la manovre di Maometto II (o le sporche pratiche maomettane) arrecano a Gesù Cristo. Mattia Corvino—dice Pio II—è pronto ad intervenire: "*Convenient* ut speramus et reliqui potentatus Italie, nec *reges* Occidentis auxilia negabunt, ostendetque pius Jesus Mahometheas sporcitias sibi odiosas esse.[12] (Ve-

ranno a convegno, come speriamo, anche gli altri potentati d'Italia, né i re occidentali negheranno il loro aiuto, e il pio Gesù mostrerà come gli siano odiose le nefandezze di Maometto.)

È questa una buona conferma del fatto che la scritta "Convenerunt in unum" conteneva un'allusione—facilmente percepibile all'epoca—al convegno di Mantova. Non dobbiamo però pensare che i tre dibattuti personaggi vogliano rappresentare il convegno stesso. Se questa fosse stata intenzione di Piero, la figurazione sarebbe più complessa. In realtà, la dieta di Mantova fu l'evento fondante, il costante punto di riferimento di una politica di Pio II che si protrasse nel tempo.

Un altro elemento che ribadisce l'orientamento del Clark è la colonna cui il Cristo è legato, sormontata da una statua pervasa di luce che sorregge un globo. Gli studiosi concordano sul significato solare di questo simulacro, ma hanno proposto le più varie supposizioni sul luogo che esso designerebbe: si è pensato al Laterano, o a Gerusalemme. Altri, più giustamente, hanno pensato a Costantinopoli. Quando Costantino trasferì la propria sede a Bisanzio, fu eretta nel centro del foro una statua bronzea dell'imperatore, issata su una colonna. Costantino vi era raffigurato come Helios (Sole), nell'atto di tenere in mano un globo. È ben probabilmente a questo leggendario monumento (sulla cui storia e sulle cui testimonianze non possiamo qui intrattenerci) che Piero intese alludere. Se la flagellazione del Cristo alla presenza del turco è una metafora del triste destino di Costantinopoli espugnata da Maometto II, appare logico e conseguente l'identificazione simbolica della colonna con quella di Costantino, emblema della città "martire." Dopo quella storica, la flagellazione immaginata da Piero rappresenta una "seconda" Passione del Cristo, che ha luogo non più a Gerusalemme ma, appunto, a Costantinopoli. La statua del Sole è comunque un'allusione all'Oriente, dove appunto il sole sorge, e quindi all'Impero di Oriente. Essa conferisce, per altro, un attributo solare alla figura divina del Cristo, "Sol invictus" e "Sol justitiae."

Nei suoi tenaci tentativi di organizzare la riscossa contro il turco, Pio II tenne sempre presenti le profferte di collaborazione e le invocazioni di aiuto che provenivano dal già citato Mattia Corvino, il giovanissimo re d'Ungheria, salito al trono nel 1458, preoccupato per le minacce d'invasione turca del suo regno—che si estendeva fino all'Adriatico—e disposto a capeggiare una spedizione di forze alleate che muovessero al contrattacco, puntando alla riconquista di Costantinopoli. L'ulteriore argomento che qui propongo, consiste nell'identificazione del giovane con il re Mattia.

Il riscontro con alcuni dei ritratti del sovrano risulta incoraggiante. Mattia, nato verso il 1440, non era ancora ventenne alla data del convegno di Mantova: l'età si addice al personaggio effigiato da Piero, ma risulta calzante anche il modo con cui è rappresentato. I ritratti di Mattia lo mostrano quasi invariabilmente a capo nudo, cinto come un imperatore romano da una corona d'alloro, sulle chiome bionde e arricciate che con i loro caratteristici serpentelli ne incorniciano il volto. Nel dipinto di Piero, la testa bionda del giovane si staglia appunto contro un alto albero di alloro: è un espediente per conciliare il convenzionale riferimento iconografico dei ritratti di Mattia con l'esigenza devozionale di mostrarlo a capo del tutto scoperto in presenza del Cristo. Ma è un espediente che ricorda singolarmente quello adottato da Benozzo Gozzoli per ritrarre un idealizzato Lorenzo de' Medici come re mago, nella celeberrima cavalcata fiorentina (1459–1463): anche qui l'adolescenziale volto del biondo e incoronato "Laurentius" si staglia contro un alberello di alloro ("laurus").

La coincidenza, più o meno alla stessa data, è difficilmente casuale. Essa sembra confermare che anche nel dipinto di Piero si tratta di una personalità regale;[13] e infine è rafforzata dal fatto che il secondo re mago (in cui si vuol riconoscere il defunto Giovanni VIII Paleologo, come simbolo dell'Impero d'Oriente) non solo ha qualche somiglianza con l'uomo barbuto e vestito all'orientale della *Flagellazione* (in cui il Clark ravvisava Tommaso Paleologo, fratello di Giovanni), ma ha un'identica impostazione di tre quarti, con lo sguardo analogamente affisato. Quasi che Piero si sia ricordato anche di questa figura, nell'assonanza, come vedremo, del significato. Ma non solo l'analogia con il Lorenzo de' Medici di Benozzo può concorrere a suggerire che il giovane biondo

della *Flagellazione* sia anch'egli una figura regale. Gioca anche, all'interno del dipinto di Piero, la sua corrispondenza con Erode, come figura-fulcro del contrapposto e rovesciato triangolo compositivo. Erode Antipa era il re di Giudea, nemico di Cristo; è logico che il suo equivalente in senso rovesciato o contrario, ovvero l'anti-Erode, sia un re difensore del Cristo, come Mattia Corvino.

Ma venendo alle immagini di Mattia, il suo più antico ritratto con la classica corona d'alloro è un rilievo del 1465, dovuto a un maestro lombardo e conservato nel Civico museo di Milano. È trascorso forse qualche tempo dal dipinto di Piero e vi ritroviamo, appena più pingue, la stessa fisionomia di giovane sovrano. Tutti gli altri ritratti (della serie con corona d'alloro sul capo biondo) sono posteriori anche di molti anni e mostrano un volto decisamente ingrassato, ormai diverso da quello che Piero effigiò.[14] Caratteristico è il naso piuttosto grosso e pronunciato: e a ben guardare è grosso e pronunciato anche il naso del giovane della *Flagellazione*, benché il pittore ne abbia attenuato l'evidenza, grazie allo scorcio frontale.

Tra i ritratti che presentano Mattia senza l'alloro in capo, bensì con la corona regale, uno lo mostra ricoperto da una veste rossa, ovvero del colore scelto da Piero;[15] altri tre lo raffigurano giovane e magro, come nell'immagine pierfrancescana. Il primo è una xilografia; il secondo è una miniatura di Boccardino Vecchio, che raffigura il trionfo del re, dal volto idealizzato di adolescente.[16] Il terzo, miniato nel 1469 in un *Missale* della Biblioteca Vaticana che in origine Mattia donò a un frate francescano, è particolarmente interessante perché il re è collocato sotto alla colonna della flagellazione, nell'atto di adorare il Cristo contornato dai simboli e dai personaggi della Passione, tra cui Pilato, Erode e Giuda. Il volto, negli occhi ben distanziati e nel rapporto naso-bocca, attesta una somiglianza con il nostro personaggio.

Mattia amava di farsi ritrarre a cospetto del Cristo dei dolori. A testa scoperta in segno di reverenza (come nella *Flagellazione*) egli appare ad esempio in una miniatura del *Missale Romanum* della Bibliothèque Royale di Bruxelles, senza il ramo di alloro ma con la corona regale deposta ai suoi piedi, mentre, vestito di una tunica (come nel dipinto di Piero: anche se blu invece che rossa) adora il Crocefisso; sulla destra, scene della Passione del Cristo tra cui la flagellazione.[17]

Il Cristo alla colonna è poi raffigurato sotto al Crocefisso nel cosiddetto Calvario di Mattia Corvino. Si tratta di una delle più belle e ricche opere d'oreficeria del Quattrocento. Il Calvario propriamente detto, formato appunto dal Cristo alla colonna che sorregge il monte su cui posa la croce, è opera probabilmente francese dei primi anni del secolo. Mattia ne venne in possesso e lo corredò di un'elegante base che è stata attribuita al Pollaiolo.[18] Il piedistallo, concepito ed eseguito tra il 1465 e il 1472, presenta due sfingi e figurazioni del trionfo del Sole, della Luna e di Giove. Il trionfo del Sole (Helios) orna la parte centrale e frontale, ricollegandosi alle figure del Cristo alla colonna e del Cristo crocefisso, mentre la Luna si riferisce alla Vergine e Giove, con l'aquila, a San Giovanni. Dietro la testa del Crocefisso campeggia una grande aureola con i raggi solari, a conferma della sua identificazione con il Sole. Mattia dunque contemplava e prediligeva l'iconografia del Cristo-Sole, quale ricorre anche nella *Flagellazione* di Piero. Qui infatti la colonna cui è legato Gesù, è sormontata analogamente, come abbiamo visto, da una statua raffigurante Helios, il Sole divinizzato, e il volto del Cristo appare aureolato da raggi solari.[19]

L'identificazione di Cristo con il Sole si fonda sul Vangelo di Giovanni (*lux hominum*) e sulle parole stesse di Gesù ("Ego sum lux mundi"), nonché su passi di Agostino, Ambrogio e Bernardo di Clairvaux.[20] Il monogramma di San Bernardino è composto, come noto, da tre lettere del nome di Gesù entro un tondo che evoca il sole, circondato da dodici raggi. Il minorita Giovanni da Capestrano, grande predicatore della crociata contro i turchi, aveva un particolare culto per San Bernardino, suo maestro, con il quale aveva promosso la riforma dei francescani. Nel 1455 egli si era unito con l'esercito di Giovanni Hunyadi, padre di Mattia, e nel luglio dell'anno successivo aveva preso parte alla battaglia contro i turchi presso Belgrado, guidando l'ala sinistra dei crociati alla vittoria. Come scrive Iris Origo, il culto di Bernardino si era diffuso in tutta Italia mentre il santo era ancora in vita e "subito dopo la sua morte in Ungheria, attraverso Giovanni Capistrano."[21]

Mattia era poi stato educato da Giovanni Vitéz, appassionato di astronomia, e proteggeva l'umanista ungherese Giano Pannonio, nipote del Vitéz, che nel 1452–1453 scrisse un inno al Sole, definito "deus summus," "astrorum dominus," "mens mundi," "lucis origo."[22] Secondo Zoltan Nagy, un'ampia serie di espressioni poetiche e figurazioni artistiche ungheresi del Quattro e del Cinquecento testimonia "che l'idea di Gesù-Sole, già molto conosciuta e coltivata in Ungheria alla metà del sec. XV, si diffuse ulteriormente nei decenni seguenti."[23]

Si va così delineando la possibilità che la *Flagellazione* sia stata commissionata dallo stesso Mattia, il cui regno confinava con la repubblica di Venezia, si estendeva alle coste dell'Adriatico e si affacciava di fronte alle Marche, suscitando l'interesse di città come Ancona, che chiese di far parte del dominio ungherese, e trovando agganci in città come Pesaro (dove Piero lavorò), retta da Alessandro Sforza, fratello del duca di Milano. Questi, ottimo amico di Mattia, modellò su quella del re ungherese la propria organizzazione militare e verso la metà degli anni Sessanta promise in sposa al Corvino la figlia Ippolita, cugina di Battista, consorte del duca di Urbino. Mattia del resto fu in rapporti diplomatici, ed anche artistici e culturali con la stessa corte di Urbino. Tra i numerosi umanisti italiani che furono in contatto con il re ungherese e ne tessero l'elogio, non mancarono i marchigiani, come Costantino da Fano e Antonio Bonfini de Ascoli.

Nel dipinto, Mattia si sarebbe fatto raffigurare come "atleta della virtù" votato alla lotta, secondo una felice immagine della Gouma-Peterson: il suo atteggiamento richiama, come è stato osservato,[24] l'*Ercole* del Pollaiolo (si veda l'atteggiarsi della mano sul fianco) o soprattutto i *David* di Donatello, con lo stesso atteggiarsi della mano in uno di essi[25] e con la caratteristica posizione delle braccia che sarà ripresa anche nel *David* del Verrocchio.

La sua sofferenza, in quanto minacciato e insidiato da Maometto II-Erode (il personaggio con turbante che assilla il Cristo), è assimilabile a quella stessa di Gesù. "Quasi Messiam Mathiam," dirà Marsilio Ficino, lodando il re ungherese come "salvatore" di antichi testi e considerandolo un nuovo

Ercole, vincente contro i turchi.[26] Mattia amava poi paragonarsi agli antichi imperatori, ai cui medaglioni (di Adriano, di Nerone, di Druso) mescolava il proprio.

La tunica del giovane biondo evoca un'eroica idea "romana" e antica, quale era cara appunto al Corvino. I piedi scalzi sono un simbolo di obbedienza e fede, quell'obbedienza assoluta che Mattia offriva alla Chiesa di Roma. Sembrano al tempo stesso designarlo come un pellegrino, "pellegrino di Terra Santa," disposto al supremo e coraggioso pellegrinaggio verso i sacri luoghi occupati dagli infedeli. Ma il particolare dei piedi scalzi richiama poi, nella produzione di Piero, un'altra figura regale, quella di Eraclio, ritratto negli affreschi di Arezzo mentre entra a piedi nudi in Gerusalemme per riportarvi la reliquia della Croce. Un angelo infatti, come narra la *Leggenda Aurea*, gli impose di togliersi i calzari, per essere degno del modo umile con cui Cristo era entrato in Gerusalemme. Mattia, candidato alla guida dei crociati, voleva in sostanza imitare Eraclio, che sconfisse Cosroe nella ben nota battaglia, rappresentata ad Arezzo come metafora dell'auspicata crociata cristiana.

C'è di più. Negli affreschi di Arezzo, la scena della battaglia di Eraclio contro Cosroe, come anche la vittoria di Costantino, rievocano in realtà il duplice e vittorioso scontro dell'esercito cristiano contro Maometto II, avvenuto nell'estate del 1456. Le due battaglie ebbero luogo intorno a Belgrado sulle rive del Danubio e la loro eco fu enorme. L'esercito cristiano era capeggiato, come già ricordavo, da Giovanni Hunyadi padre di Mattia Corvino, e dal frate francescano Giovanni da Capestrano, il quale mise in fuga il nemice mostrando la Croce e invocando il nome di Gesù. Quest'ultimo episodio è celebrato con enfasi in una lettera di Mattia Corvino del marzo 1460, finalizzata alla canonizzazione del Capestrano.[27] Giovanni da Capestrano, alla vigilia della seconda battaglia, aveva poi avuto l'apparizione di una scritta mandata dal cielo, nella quale si leggeva: "Esto constans, Joannes" (O Giovanni, sii costante: con chiaro riferimento a Costantino).[28] Appare dunque abbastanza evidente che la visione e la vittoria di Costantino intendono rievocare, ad Arezzo, quelle del Capestrano. Per altro, la vittoria di Costantino, preceduta dall'apparizione dell'angelo

con la Croce, è descritta dalla *Leggenda Aurea* in due versioni: la prima ambienta la battaglia contro "una moltitudine di barbari" sulle rive del Danubio, ed è senz'altro questa (e non la seconda, cioè lo scontro con Massenzio) che Piero intese rappresentare, come dimostrano alcuni particolari.[29] Anche la battaglia di Eraclio si svolse, secondo la testimonianza della *Leggenda Aurea*, sulle rive del Danubio, ovvero intorno allo stesso fiume che fu teatro delle due vittorie cristiane del 1456, gloria dell'Ordine francescano.

L'auspicata vittoria di Mattia era considerata, in Italia, come il trionfo stesso della cristianità. Intorno al 1465 fu eseguito in Roma un affresco con il trionfo del giovane re ungherese, sul prospetto di una casa in via del Pellegrino. Come sappiamo da una copia settecentesca ad acquarello, Mattia era rappresentato a cavallo, e insignito del titolo di difensore della Religione in un cartiglio sorretto da un angelo.[30]

Come scrive Tibor Klaniczay, "il bastione più forte della crociata contro i turchi non poteva essere che l'Ungheria, il cui eccellentissimo re era la personalità più adeguata per coprire il ruolo di supremo comandante di essa."[31]

E in effetti Pio II, dopo aver nominato generale delle forze pontificie Federico da Montefeltro, nella dieta di Mantova aveva designato proprio il re Mattia come duce della grande crociata. Questi aveva eletto a scopo della sua vita la riscossa contro il turco, e si dichiarò pronto a ogni sacrificio, disposto anche a rinunciare al comando che, in caso di un efficace concorso dell'impero germanico, avrebbe devoluto a un generale tedesco. Offrì come base delle operazioni militari le più importanti fortezze lungo il confine meridionale dell'Ungheria, compresa quella di Belgrado, principale baluardo della cristianità.

Il progetto fallì, ma fu coltivato a lungo da Mattia e da Pio II. Nel 1462 il re allarmò il pontefice, prospettando che Maometto II aveva intenzione di conquistare l'Occidente e la stessa Roma. Dopo di che strinse una lega con Venezia, lega cui aderì Pio II nel 1463, annunciando il progetto di recarsi personalmente ad Ancona ad attendervi la flotta veneta.

Penso che proprio dopo questa data,

quando il pericolo turco si fece più acuto, Piero eseguì il suo dipinto, e probabilmente su committenza dello stesso Mattia. Questi si fece raffigurare tra un rappresentante dell'Impero d'Oriente (forse proprio Tommaso Paleologo, come torneremo a dire) e un principe occidentale, italiano, come a testimoniare il proprio eroico impegno per la riunificazione dei territori della cristianità, dell'Oriente con l'Occidente.

E qui si avverte una qualche interferenza di significati con la *Cavalcata* di Benozzo, che Piero, come abbiamo visto, sembra aver tenuto presente, *Cavalcata* dove i tre re magi sono impersonati da Lorenzo de' Medici, dall'ex imperatore di Oriente e, come ha dimostrato Marco Bussagli,[32] da Sigismondo, che era stato sovrano del Sacro Romano Impero e aveva ricostituito l'unità della Chiesa sanando lo scisma.

Nella *Flagellazione* avremmo Mattia al posto di Sigismondo; Tommaso Paleologo, legittimo aspirante al trono di Oriente, al posto del fratello già imperatore; e al posto di Lorenzo de' Medici un altro principe italiano più interessato al progetto della crociata (o un suo rappresentante).

Anche l'opera di Benozzo, per altro, era nata dal convegno di Mantova, o meglio dal passaggio di Pio II in Firenze, mentre al convegno si recava, passaggio che aveva richiamato nella città dei Medici alcuni potenti del tempo, rinnovando la memoria del soggiorno di Eugenio IV e del risolutivo concilio di Firenze del 1439, cui aveva partecipato, appunto, Giovanni VIII Paleologo. Ma ora la potestà del Paleologo era stata usurpata da Maometto II e il pontefice chiedeva aiuti per la crociata. In qualche modo, pertanto, l'affresco di Benozzo non poteva non alludere anche a questo programma, oltre a rievocare il concilio fiorentino del 1439. Ma forse i Medici, con tale rievocazione, intendevano dire: "abbiamo già dato." Cosimo, in realtà, aveva ricevuto con una certa freddezza il pontefice in viaggio per Mantova, e quando questi, nell'agosto del 1463, indisse un nuovo convegno a Roma, Firenze rifiutò il tributo, mossa anche da gelosia nei confronti di Venezia, che ormai era divenuta la principale alleata di Pio II e di Mattia.

L'opera di Piero potrebbe risalire al 1463–1464, dopo l'esecuzione dell'affresco di Benozzo, quando Pio II "eroicamente" morì

in Ancona, dove si era recato per organizzare la crociata. Alla firma dell'affresco fiorentino (OPUS BENOTII, in caratteri maiuscoli), quella di Piero nella *Flagellazione*, dagli stessi caratteri, poteva forse essere considerata come una risposta, allusiva all'impegno per la difesa della cristianità: OPUS PETRI S(ANCTI) SEPULCRI. Secondo Marilyn Lavin, l'indicazione del luogo di nascita di Piero—in questa come in altre sue firme—alluderebbe al culto del Santo Sepolcro.[33]

Per quanto riguarda l'identificazione dei due personaggi che affiancano Mattia, abbiamo già visto che il primo a sinistra, vestito all'orientale, può essere con buone probabilità Tommaso Paleologo: Piero sembra tenere presente, nel ritrarlo, il volto del defunto fratello Giovanni quale è raffigurato nella *Cavalcata* di Benozzo, e la sua presenza risulterebbe logica, trattandosi della persona più direttamente interessata alla riconquista di Costantinopoli. Nel 1459 egli aveva inviato al convegno di Mantova messaggeri con richieste di aiuto; nel 1460 i turchi lo avevano costretto a fuggire dalla Morea ed egli si era rifugiato in Italia, portando con sé la testa dell'apostolo Andrea, crocefisso a Patrasso, reliquia accolta con grandi festeggiamenti a Roma.

Nel personaggio di destra si potrebbe riconoscere un alto rappresentante della repubblica di Venezia, con cui Mattia aveva stretto lega nel 1463.[34] Ma anche l'ipotesi in favore di Ludovico Gonzaga, che ospitò il convegno di Mantova, potrebbe risultare valida.[35]

Resta infine il problema di chi sia ritratto sotto le vesti di Pilato. È stato fatto un confronto apparentemente convincente con una medaglia del Pisanello raffigurante Giovanni Paleologo. Ma sembrerebbe da escludere che Piero attribuisse il ruolo negativo di Pilato all'ex imperatore di Bisanzio. Lo stesso Piero, ad Arezzo, ritrasse Costantino con il copricapo e il volto barbuto dei Paleologi (forse per alludere all'eroico Costantino XII, morto durante la presa di Costantinopoli); ma attribuì lo stesso copricapo e il volto barbuto anche ad uno dei capitani dell'esercito sconfitto da Costantino, come si vede dalla copia ottocentesca della scena di battaglia.

Esiste per altro un ritratto dello stesso Maometto II con la medesima barba e il medesimo copricapo, mentre il Lollini ha recentemente pubblicato un Teseo dalle *Vite* di Plutarco della Malatestiana di Cesena, sempre con quella barba e quel copricapo, osservando che nello stesso manoscritto è raffigurato in modo uguale anche un altro personaggio greco, Lisandro.[36] Dobbiamo quindi concludere che quel particolare copricapo non può guidarci utilmente nella ricerca dell'identificazione.

Resta il fatto, tuttavia, che nella presa di Costantinopoli ci fu chi svolse proprio la parte di Pilato: vale a dire i genovesi della colonia di Pera (Galata), che durante l'assedio della città, prevedendo la vittoria dei turchi, si mantennero neutrali, sperando così di poter conservare la loro potestà sul sobborgo. È anche possibile quindi che con la figura di Pilato, Piero intendesse alludere a questa defezione, anche se l'ipotesi resta vaga. O forse con Pilato egli voleva indicare tutti coloro che (come i Medici) si rifiutavano di partecipare alla lotta contro il turco.

Alla figura di Pilato che (possibile metafora, dunque, dei genovesi o di altri principi italiani) non interviene ed è anzi sostanzialmente "d'accordo" con Erode-Maometto II, si contrapporrebbe nel rovesciamento del triangolo compositivo l'alleato di Mattia, pronto invece alla lotta.

Sull'originaria destinazione del dipinto, non si possono avanzare che vaghe ipotesi. Recenti ricerche indicano che, forse, la tavola si trovava un tempo nella chiesa di San Francesco ad Urbino.[37]

Se la commissione fu di Mattia, il re potrebbe aver destinato l'opera a un ordine francescano delle Marche (i francescani davano un forte supporto ideologico alla crociata, mentre il padre di Mattia aveva combattuto a fianco del minorita Giovanni da Capestrano; e a un francescano Mattia donerà nel 1469, come abbiamo visto, la propria effigie a cospetto del Cristo dei dolori); oppure il dipinto potè essere indirizzato a un principe italiano, magari a quello che è ritratto all'estrema destra.

O ancora, allo stesso Federico da Montefeltro, che Pio II aveva nominato generale delle forze pontificie. La consorte di Federico, Battista Sforza, apparteneva per altro all'ordine francescano.

NOTE

1. Charles De Tolnay, "Conceptions religieuses dans la peinture de Piero della Francesca," *Quaderni d'arte antica e moderna* 3 (1963), 10–11. La più completa trattazione del *Battesimo* è in Marilyn Aronberg Lavin, *Piero della Francesca's Baptism of Christ* (New Haven, Conn., 1981).

2. Marie Tanner, "Concordia in Piero della Francesca's *Baptism of Christ*," *Art Quarterly* 1 (1972), 1–20.

3. Eugenio Battisti, *Piero della Francesca*, 2 vols. (Milano, 1971), 1:116–117. Si veda anche Maurizio Calvesi, "Sistema degli equivalenti ed equivalenze del Sistema in Piero della Francesca," *Storia dell'arte* 24–25 (1975), 106–108.

4. *Aurelii Augustini In Joannis Evangelium tractatus* 5, 9, in Jacques Paul Migne, ed., *Patrologia Latina* (Paris, 1845), vol. 35. Si veda, per questa lettura del *Battesimo* di Piero, Maurizio Calvesi, "Le Grazie di Piero," *Alfabeta* 31 (dicembre 1981).

5. *Gregorii Theologi Oratio XL. In Sanctum Baptisma*, in Jacques Paul Migne, ed., *Patrologia Graeca* (Turnhout, 1862), 36:362.

6. Secondo questa interpretazione, la città di Gerusalemme nella quale Eraclio fa il suo ingresso, allude alla Città Celeste, come meta dell'umanità redenta e che ha ben meritato. Nello sfondo gli alberi di vita, in rapporto di concordanza con la scena dirimpettaia della morte di Adamo (l'umanità che potrà accedere alla vita eterna quando l'albero del peccato "farà i suoi frutti," divenendo albero della vita). La concordanza simbolica tra le due scene rimanda appunto a Giovanni (*Apocalisse*) ed Ezechiele, raffigurati nel mezzo.

7. Kenneth Clark, *Piero della Francesca* (London, 1951), 20.

8. Creighton Gilbert, "On Subject and Not-Subject in Italian Renaissance Pictures," *Art Bulletin* 34 (1952), 208–209.

9. Ludovico Borgo, "New Questions for Piero's *Flagellation*," *Burlington Magazine* 918 (1979), 547–553.

10. Fabrizio Lollini, "Una possibile connotazione antiebraica della *Flagellazione* di Piero della Francesca," *Bollettino d'arte* 65 (1991), 1–28.

11. Ludwig von Pastor, *Storia dei Papi dalla fine del medioevo*, 17 vols. (Roma, 1925), 2:684–694.

12. Pastor 1925, 2:690.

13. Naturalmente potrebbe sorgere l'ipotesi che anche il personaggio della *Flagellazione* sia Lorenzo de' Medici. Ma questi era nato nel 1449 (nel ritratto di Benozzo è idealizzato anche nell'età) e non poteva rappresentare, in questo contesto, la casata dei Medici, che per altro non mostrò particolare e attivo interesse per il progetto di crociata di Pio II.

14. Mi riferisco ai ritratti del sovrano reperibili nel *Missale Romanum* della Bibliothèque Royale di Bruxelles (miniatura di Attavante, 1487); nel *Marlianus* della Biblioteca Granacci di Volterra (miniatura di Ambrogio de Predis, 1488); nel *Cortesius* della Herzog August Bibliothek di Wolfenbüttel (miniatura di artista romano del 1478); e nello *Hieronimus* della Österreichische Nationalbibliothek di Wien (1488). Una prima identificazione del giovane della *Flagellazione* con Mattia Corvino, sulla base di questi ritratti, è in Maurizio Calvesi, "La *Flagellazione* di Piero della Francesca. Identikit di un enigma," *Art e Dossier* 70 (luglio–agosto 1992), 22–27.

15. Nel *Didymus* della Pierpont Morgan Library di New York (miniatura del 1488).

16. Nel *Philostratus* della National Széchényi Library di Budapest.

17. Il *Missale* risale al 1487; la miniatura è di Attavante.

18. Si veda Zoltan Nagy, "Antonio del Pollaiolo: Il piedistallo del Calvario di Mattia Corvino," *Acta Historiae Artium Academiae Scientiarum Hungaricae* 1–2 (1987–1988), 3–104.

19. Per una buona osservazione di questo particolare, attualmente non leggibile nell'originale, rinvio alla tavola riprodotta in Carlo Bertelli, *Piero della Francesca* (Milano, 1991), 129.

20. Riportati in Nagy 1987–1988, 18–19.

21. Iris Origo, *San Bernardino e il suo tempo* (Milano, 1982), 142.

22. Si veda Nagy 1987–1988, 29.

23. Nagy 1987–1988, 23.

24. Thalia Gouma-Peterson, "Piero della Francesca's *Flagellation:* An Historical Interpretation," *Storia dell'arte* 28 (settembre–dicembre 1976), 227–228:

His heroic nature and divine associations—scrive la Gouma-Peterson a proposito del giovane della *Flagellazione*—*are emphasized by his parallelism with the figure of Christ in the Flagellation scene, and is brought out through the stance and general posture of the two figures as well as through their appearance. Both figures are extremely beautiful and athletic, and stand out as the most handsome and most idealized figures in the painting. These qualities of physical beauty and strength are related to the Christian concept of the athlete of virtue, which became popular in northern Italy at the end of the fourteenth and the beginning of the fifteenth century. . . . Both figures express the concept of the Christian athlete of virtue and the theme of Christ's and the Church's victory.*

In proposito va rilevato che il principe di Albania Giorgio Castriota detto Skanderbeg, valoroso nemico di Maometto II, interessato da Pio II al suo progetto di crociata, fu chiamato dal precedente papa Callistro III "atleta di Cristo."

25. La posizione del braccio sinistro del giovane della *Flagellazione*, ripiegato sul fianco su cui poggia il dorso e non la palma della mano, sembra in effetti ripresa dal *David* di Donatello del Bargello (1440), cui si ispirerà anche l'*Ercole* del Pollaiolo dello Staatliche Museen di Berlino.

26. Si veda il testo di Marsilio Ficino (*Exhortatio ad bellum contra Barbaros*, 1480), nel catalogo della mostra *Matthias Corvinus und die Renaissance in Ungarn* (Wien, 1982), 344.

27. La lettera è riportata in appendice a Giovan Battista Barberio, *Compendio dell'heroiche virtù e miracolose attioni del Beato Giovanni da Capestrano* (Roma, 1661) ed è trascritta in Maurizio Calvesi, "La leggenda della vera croce di Piero della Francesca: I due Giovanni all'ultima crociata," *Art e Dossier* 75 (gennaio 1993), 40–41. Questo articolo (uscito nel dicembre 1992: si veda la nota che segue) approfondisce indicazioni sul significato delle due battaglie, già anticipate dallo scrivente nella presente comunicazione e in quella letta al precedente convegno pierfrancescano di Urbino.

28. L'episodio è narrato da Barberio (1661, 117–123). Giovanni da Capestrano, incoraggiato dal segnale celeste, aveva intrapreso la battaglia, capeggiando una "fortissima e scielta soldatesca d'Italiani, Spagnuoli, e Germani"; attraversato il Danubio, aveva affrontato e sgominato il nemico essendo armato soltanto di un "bastoncello sopra del quale haveva posto il segno del Thau" (cioè della croce). "Et cum vixillo sanctissimae Crucis Turcorum potentia fuit contrita a potenti dextera Dei," scriveva frà Giovanni da Tagliacozzo a frà Giacomo delle Marche il 10 febbraio 1461, rievocando la battaglia (Aniceto Chiappini, *Reliquie letterarie Capestranesi* [Aquila, 1927], 277). In una illustrazione del libro del Barberio, il Capestrano è rappresentato alla testa dell'esercito cristiano mentre avanza tenendo in mano la croce protesa in avanti e mettendo così in fuga i soldati turchi. La stessa iconografia è già presente nel dipinto di Sebastiano di Cola da Casentino del Museo de L'Aquila, dove Giovanni da Capestrano è ritratto con episodi della sua vita ai lati, tra cui la battaglia di Belgrado: il frate avanza con calma, seguito dai suoi, protendendo uno stendardo con la croce che mette in fuga i nemici. È proprio lo stesso atteggiamento in cui Piero ritrae Costantino che, con qual semplice gesto, riporta la vittoria. Così dunque si svolse, alla fine del mese di luglio del 1456 la seconda, trionfale battaglia dell'esercito cristiano; la prima aveva avuto luogo il 3 giugno, quando Giovanni Hunyadi, affiancato dal Capestrano, aveva riconquistato la città di Belgrado, insidiata dalle truppe di Maometto II che avevano risalito il Danubio. La vittoria di Costantino dipinta da Piero ad Arezzo è stata collegata alla battaglia di Belgrado del luglio 1456 anche da Frank Büttner, "Das Thema der Konstantinschlacht Piero della Francescas," *Mitteilungen des Kunsthistorischen Instituts in Florenz* 1–2 (1992), 23–40. Questa rivista quadrimestrale, consta di tre numeri annui: la data di pubblicazione del n. 1–2, non precisata, dovrebbe risalire all'ultimo quadrimestre del 1992. L'ingresso del fascicolo nella Biblioteca Hertziana di Roma è registrato in dicembre e ne ho potuto prendere conoscenza solo nei mesi seguenti. La mia tesi, già avanzata nel convegno pierfrancescano di Urbino (4 ottobre 1992), è stata espressa in contemporaneità con quella del Büttner, con la quale collima. Il Büttner osserva per altro che Pio II, nel suo appello per la crociata nella dieta di Mantova, citò proprio la battaglia del luglio 1456 paragonandola alla vittoria di Costantino. Diversamente da me, il Büttner non collega, nel ciclo di Arezzo, la sconfitta di Cosroe con la precedente battaglia del 3 giugno.

29. Il racconto illustrato da Piero (anche a parere del Büttner, si veda la nota che precede) è il seguente:

In quel tempo si era radunata sul Danubio una immensa moltitudine di barbari che avevano l'intenzione di oltrepassarlo e di sottomettere al loro potere tutte le regioni fino all'occidente. Quando Costantino ebbe tale notizia mosse gli accampamenti e si schierò col suo esercito sulle rive opposte del Danubio: ma il numero dei barbari cresceva sempre più e già comincia vano ad attraversare il fiume cosicché Costantino era atterrito al pensiero di dovere, il giorno dopo, attaccare battaglia. Durante la notte fu svegliato da un angelo che lo esortò a guardare in alto. Costantino alzò gli occhi al cielo e vide il segno della croce tutto di splendida luce e al di sopra queste parole: "in questo segno vincerai." Confortato dalla celeste visione l'imperatore fece fare una croce da portare alla testa dell'esercito: poi piombò sui nemici mettendoli in fuga e uccidendone un gran numero. (Jacopo da Varagine, Leggenda Aurea, edizione italiana a cura di Cecilia Lisi [Roma, 1952], 308–309.)

Ma secondo altri autori, dice la stessa *Leggenda Aurea*, la battaglia vinta da Costantino nel segno della croce fu invece quella contro Massenzio, che ebbe luogo non sulle rive del Danubio, bensì del Tevere:

Quando Massenzio invase l'impero romano, l'imperatore si scontrò con lui vicino al ponte Albino: essendo in grande ansietà per le sorti del combattimento più volte alzò gli occhi al cielo facendo voti per la sua vittoria; ed ecco nella parte orientale del cielo apparve una croce di fuoco circondata da angeli che gli dissero: "Costantino, in questo segno vincerai!" Secondo la storia tripartita Costantino molto si meravigliò di questa visione non comprendendo cosa significasse: ma la notte seguente Cristo gli apparve col medesimo segno e gli ordinò di farne eseguire uno simile chè molto gli sarebbe stato di aiuto nel prossimo combattimento. Allora Costantino baldanzoso e sicuro della vittoria, si fece sulla fronte il segno della croce e prese in mano una croce d'oro; dopodichè pregò il Signore perché non permettesse che la sua destra si macchiasse di sangue romano. Infatti Massenzio, vedendo Costantino che si avvicinava al fiume, dimenticò di aver fatto minare il ponte dalla base; si slanciò all'assalto e la trappola preparata per l'avversario fece precipitare nel profondo del fiume l'autore stesso dell'inganno. Costantino, per volere unanime, divenne unico imperatore.

La critica ha sempre ritenuto, a cominciare dal Vasari, che Piero intendesse raffigurare questo secondo episodio, suggestionata anche dal particolare del cavallo che, fuggendo con il suo cavaliere davanti all'imperatore, si trova con le zampe posteriori nell'acqua. Si è pensato quindi a Massenzio che in quella battaglia, secondo la *Leggenda Aurea*, perse la vita sprofondando nel Tevere mentre "si slanciava

all'assalto" contro Costantino. Ma la figura dipinta da Piero non va all'assalto, bensì volge in fuga; e in realtà non precipita nel fiume, bensì lo sta guadando. L'esercito che fugge, per altro, è menzionato solo nella prima narrazione della *Leggenda Aurea*, mentre nella seconda la vicenda si conclude non con la fuga ma, appunto, con l'annegamento di Massenzio e il crollo del ponte. Inoltre la scena del *Sogno di Costantino*, quale raffigurata ad Arezzo, corrisponde al contesto della prima narrazione meglio che non a quello della seconda. L'apparizione della croce nella seconda versione è diurna e non notturna, alla presenza di più angeli e non di uno solo; è poi seguita da un'apparizione notturna, però con il Cristo e non con l'angelo. Invece nella prima versione è un solo angelo che appare di notte con la croce, come nell'affresco di Piero. Costantino, che ancora dorme, sta per essere da lui svegliato.

30. Si veda Nagy, 1987–1988, 33, 50. La copia settecentesca si trova nella Biblioteca Vaticana (codex Barberinianus latinus 4423, fol. 73). La scritta sottostante recita: "Matthia Corvino dipinto in una casa a mano manca all'entrata della strada del Pellegrino, della qual pittura ne fa menzione il Giovio."

31. Il brano (da Tibor Klaniczay, "A hereszteshad eszméje és a Mátyás mitosz," *Jrodalomtörténeti*

Közlemények 1 [1975]) è riportato in traduzione italiana da Nagy 1987–1988, 49.

32. Marco Bussagli, "Identificazione di un imperatore," *Art e Dossier* 67 (aprile 1992), 13–14.

33. Marilyn Aronberg Lavin, "Piero della Francesca's *Flagellation*: The Triumph of Christian Glory," *Art Bulletin* 50 (1968), 321–342.

34. La stola sulla spalla, portata da questo personaggio, ricorre in diversi dipinti veneziani di area belliniana e carpaccesca, raffiguranti senatori o procuratori della Repubblica.

35. Sia pure nel contesto di un'interpretazione diversa, Lavin (1968) riconosceva in questo personaggio Ludovico Gonzaga, sulla base dell'innegabile somiglianza con il ritratto in bronzo dello Staatliche Museen di Berlino.

36. Lollini 1991, 9–10.

37. Enrico Ferdinando Londei, "La scena della *Flagellazione* di Piero della Francesca: La sua identificazione con un luogo di Urbino nel Quattrocento," *Bollettino d'arte* 65 (gennaio–febbraio 1991), 48, 64–65. Londei, "Ipotesi sulla collocazione originaria della *Flagellazione* di Piero della Francesca: Indizi di percorso," *Art e Dossier* 71 (settembre 1992), 31–32.

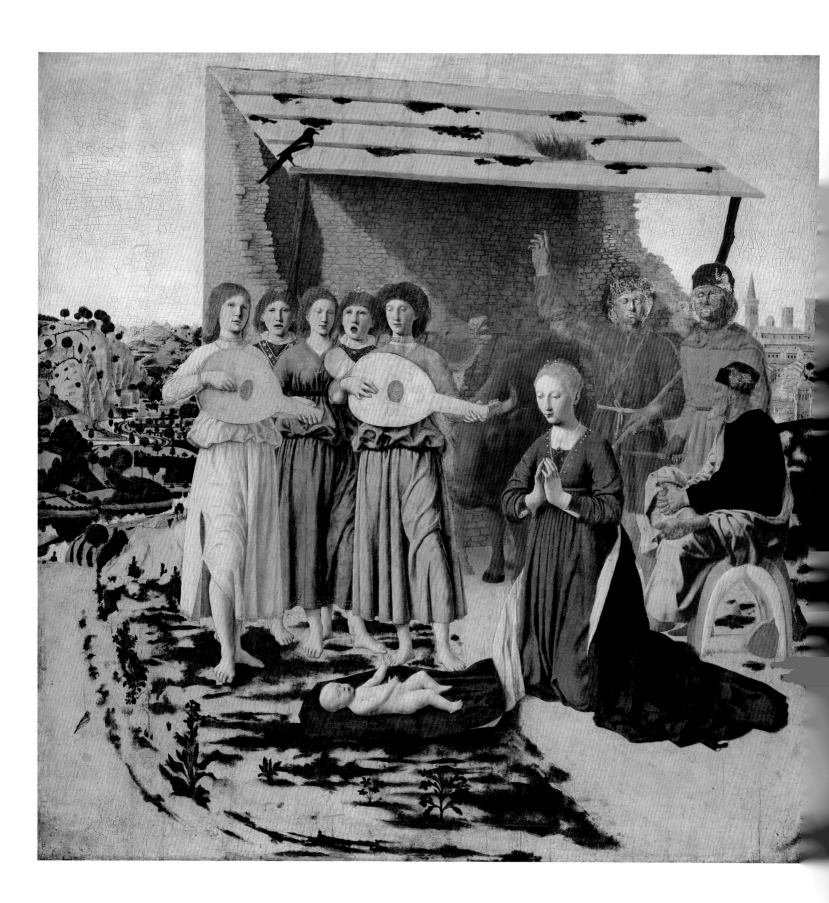

MARILYN ARONBERG LAVIN
Princeton University

Piero's Meditation on the Nativity

Most of Piero della Francesca's works make him seem, as a man, quite somber and aloof.[1] In fact, we know nothing of Piero's private personality. His voluminous writings yield only his intellectual activities, no personal remarks. The contracts he signed are for the most part standard, and although his name appears often in the rosters of elected officials in Sansepolcro, there are no clues to his political position or indications as to how he participated in town government. When he died, his property, except for some charitable donations, went to the family of his brother Marco, meaning that he himself had no direct heirs.[2] Even in death, then, Piero's personality remained opaque.

The panel of the *Adoration of the Child* (fig. 1) was painted some time in the 1480s among Piero's last works.[3] After his death, it was listed in two inventories, one of 1500 and another of 1515, as still in family hands (where it remained until the nineteenth century).[4] Although it comes down to us in a partially ruined state, according to the reports of the museum conservators, Piero had completed the painting: where the shepherds' heads and bodies are scraped down to original priming and drawing, there are small fragments of pigment showing the original finish. Joseph's head is abraded, but his feet and hands are perfectly intact. However, what is not scraped down to the outline has been severely cleaned, and most of the heads and draperies have lost a glaze.[5]

Nevertheless, in spite of all this damage, conceptually nothing is missing. The *Adoration* remains a paradigm of Piero's work done not for a commission but for himself, most probably for his own tomb.[6] Perhaps a unique prototype for the *Baptism of Christ*, which we know Mantegna made for his own funerary chapel two decades later,[7] this painting by Piero reflects his own volition and is therefore free of the restraints of patronage, whether private or public. I believe, in fact, that when Piero painted the *Tabula cum Nativitate Domini*,[8] he not only confirmed his belief in the reality of the mystical world, but also demonstrated a facet of his personality that until then had remained all but invisible.

Within an almost square composition (126 x 123 cm), a group of twelve relatively independent figures are held together by a single mission: each in his own way confirms the divinity of Christ. We shall see that the general conception of the subject depends, as so many of Piero's paintings do, primarily on the text of the *Golden Legend*.[9] Within this context, the central motif of Mary kneeling before the Christ Child lying on the ground identifies the scene as an *Adoration*, the first moment in which the world celebrates the birth of the Savior. Quite a standard part of Nativity iconography by the mid-fifteenth century,[10] the motif follows a widely read account of Christ's birth by Saint Bridget of Sweden, one of the

1. Piero della Francesca,
Adoration of the Child,
c. 1480–1485, tempera
and oil on panel
National Gallery, London

most important late medieval visionaries. Bridget reports that she saw a lovely, young, light-haired woman who, after a painless delivery, knelt to adore her child lying naked on the ground. Shivering with cold, the baby lifted his arms to his mother. "I heard the singing of the angels," says Bridget, "which was of miraculous sweetness and great beauty."[11] Piero represents these details, showing the Madonna with light red hair, kneeling in prayer before the earthbound newborn. He reaches toward her with outstretched arms, protected only by a portion of her robe. Reports of Bridget's vision were recorded in the Process of her canonization in 1391,[12] and quite soon after, the motif of Mary kneeling in adoration of the Infant was introduced into panel painting. We see it, for example, in a painting by a Pisan Master from about 1400 (fig. 2).[13] In Piero's time the Bridgetine motif was still very much in use in Italy as well as in northern Europe, and in fact his configuration shares a number of characteristics with works by other fifteenth-century painters. Alesso Baldovinetti's earlier large-scale fresco in the atrium of Santissima Annunciata in Florence, dated 1461–1463, shows Mary on her knees in the foreground of an arrangement that places the reclining Child quite close to the picture plane. The deep landscape vista on the left side of the composition anticipates Piero's distant vistas.[14] The *Portinari Altarpiece*, by Hugo van der Goes, painted in the Netherlands but shipped to Florence in 1483,[15] parallels Piero's naked Child and lower-class ethos. Domenico Ghirlandaio's *Nativity* (fig. 3), with kneeling Madonna and the Child on her robe, is dated 1485 and was similarly installed in a funerary chapel.[16] What distinguishes Piero's image from those of his contemporaries, however, is his rejection of their visual rhetoric. Without forfeiting the monumental timelessness of his earlier style, he eliminates any reference to an elaborate architectural setting, and to the retinue of the Magi, and returns his scene to the simplicity of the vision itself. In fact, he very pointedly presents all the traditional elements of the story in their most mundane guise, exalting, thereby, the humility of the theme. My purpose here is to define this paradoxical approach, characteristic of Piero's late paintings, in which he makes the high

spiritual value of nature's lowliest forms into his overt subject.[17]

He begins by transporting the manger of the inn on a snowy night outside Bethlehem, to a beautiful day in Tuscany in the outskirts of Sansepolcro.[18] He places the *Adoration* on a kind of natural podium, high above the level of a valley. We are shown a rural landscape on the left, and an urban vista on the right. In the distant landscape, lofty palisades tower over a winding river, as they do to the north of Sansepolcro. Dark green trees reflected in the water are clipped to perfect bulb-shaped roundness, with sunlight dancing on their surfaces. The urban view is equally clear, with tranquil, well-organized streets and towers kept in good repair. Once more, as in his painting of the *Baptism of Christ*, Piero shows the sanctity of his native land, both countryside and city, securing the terrain of Sansepolcro and its people as worthy of a saintly visit.[19] As in that earlier painting, his purpose on this occasion is to define, with great precision, the scene's locale. However, in contrast to the *Baptism*, where the spatial recession sweeps into the depth without obstruction (next to Christ's right hip), here the action is concentrated on the apron stagelike area that remains quite close to the picture plane. Such an arrangement, which has often been

2. Pisan Master, *Bridgetine Nativity*, c. 1400, tempera on panel
Galleria Nazionale di Capodimonte, Naples; photograph: Alinari

compared to northern designs,[20] is an utterly new departure for Piero. Like the equally late *Senigallia Madonna*,[21] this painting lacks all mathematical indications as to how to read the space. Rejecting the clear and rational structure of his earlier works, the composition resists all orthogonal indications. Even the shed, which might have had geometric edges, is instead quite uneven; moreover, it is the one architectural element in his entire oeuvre that is set askew to the picture plane.[22] These facts are all the more intriguing when we note that this shift to nonrational construction corresponds to the very period of Piero's most intense mathematical speculation.[23]

The character of the locale, on the other hand, is simple and straightforward. Every Italian farm has a high-placed promontory open to the sun called the *aiuola* (or *aia* in Tuscan dialect). This area is regularly used for threshing wheat. Piero had constructed such an *aiuola* close to the picture plane to give an unobstructed view of the infant who is often called the "Bread of Angels."[24]

No longer the amazonian matriarch of Piero's earlier paintings, Mary here is more lyrical and conventionally beautiful than any of Piero's other women (fig. 4). Her loveliness is enhanced by her braided hairdo and jewels at head and breast. She is the fairest among women (*pulcherrima inter mulieres*), the beloved wife of the Canticle. At the same time, she is humble as she kneels directly on the earth.

The baby lying on her robe is a real newborn, his snowy body dramatically silhouetted against the royal blue. Although he is so

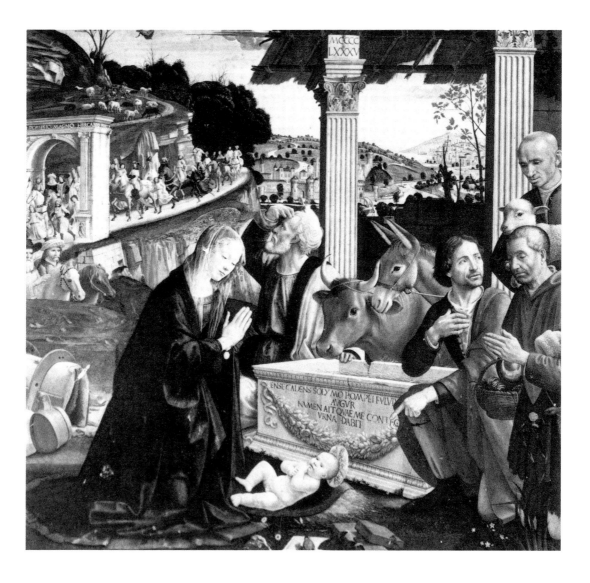

3. Domenico Ghirlandaio, *Nativity*, 1485, tempera (and oil?) on panel

Santa Trinita, Sassetti Chapel, Florence; after Eve Borsook and Johannes Offerhaus, *Francesco Sassetti and Ghirlandaio at Santa Trinita, Florence: History and Legend in a Renaissance Chapel* (Doornspijk, 1981), fig. 24

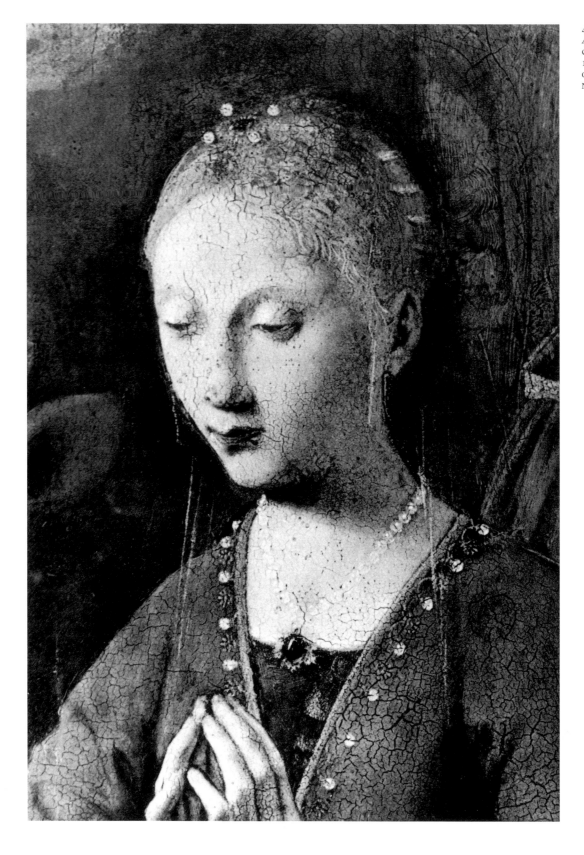

young he is still without hair, his are the only eyes in the composition that are truly focused. As he lifts his arms with outstretched hands, he gazes directly at his mother with respect and gratitude. But it is his nakedness that is the crux of the revelation: his unadorned, well-formed body, as described in Bridget's vision, proves that the Word has indeed become flesh.

Five angels worship him with music, three playing stringed instruments and two singing. With skilled fingers, the forward figures fret and pluck their lutes and bow the viol.[25] Their pastel dresses hang in columnar folds that mold their legs and leave their feet and ankles bare. In contrast to their simple garments, the two singers in the back are more ornately dressed. They intone the *Gloria* with open mouths, wearing the crossed "dalmatic" of deacons.[26] The richness of this liturgical garb, encrusted with pearls and other gems, proves that their song, and the action of the painting, has the value of a heavenly ritual. Yet Piero has made the "miraculous sweetness" of the angelic concert visible in the guise of peasant boys. Whether arrayed in finery or simply dressed, they stand in the grass and have no wings.[27]

The presence of the ox and the ass depends on ancient tradition. Even before the concept of the Virgin Birth was established, before the iconography of the Nativity had a narrative form, Christ's birth was represented on early Christian sarcophagi simply by a feeding crib or manger (*tegurium*) and two lowly animals, an ox and an ass. The scene thus represented nothing more than the fulfillment of Isaiah's prophecy: "The ox knoweth his owner, and the ass his master's crib" (Isaiah 1:3).[28] In later centuries, when the narrative was fully developed, the animals remained. So they do here, but with novel meaning. The ox who "knows his owner" looks at the infant and lowers its head in a kind of prayer. No one before Piero had depicted this animal expressing such heartfelt understanding. But the ass, which in both life and art is often conceived of as the epitome of contrariness,[29] paradoxically carries the devotional conceit to an even higher level of participation. This coarse animal (thinly painted *alla prima* and now quite transparent) lifts his head with open muzzle and brays with all his heart. According to its judicious placement, the beast joins in singing the liturgy:

6. Augustan coin, reverse
After Harold Mattingly, *The Roman Coins in the British Muesum* (London, 1923), I, pl. 15, no. 4

Benedicite, omnes bestiae et pecora, Domino; laudate et superexaltate eum in saecula.

O all ye beasts and cattle, bless the lord: praise and exalt him above all forever.[30]

Piero was not the first to employ the motif of the singing donkey. From the mid-fourteenth century on, *Nativity* scenes with the ass' open-mouthed head raised in song appear throughout Europe (fig. 5).[31] But Piero reinforced the point in a particular manner. By juxtaposing the animal head directly with that of an angel, he shows the angels and ass as part of the same liturgical choir.[32] It has not been pointed out before that Piero often used this kind of visual joining to make similar points. In the corner of the lower right tier in Arezzo, for example, we find the head of a soldier and the head of a soldier's horse mysteriously fused.[33] In Arezzo this optical linking serves to strengthen a sense of equality between the animal and the human being as two members of the same Christian army. The juxtaposition, in the case of the *Adoration*, implies that, in spite of the patent difference in the quality of their song, the angelic boys have been joined by the four-footed vocalist to verify the advent of the Savior.[34]

In Ghirlandaio's *Adoration*, the stable symbolizing King David's collapsed tabernacle was given the elegant form of a Roman building in tatters, the crumbling roof and chipped sarcophagus referring also to paganism's fall.[35] Piero, by contrast, recreates the broken structure in lowly fieldstone, a farm shed with lean-to roof that was never supported with anything more elevated than two unworked staves.[36] In this form, the structure resembles most the flimsy *tegurium* of early Christian art, often said to have been used to hide the truth of the Savior's royal status from his unbelieving foes.[37] As he so often did, Piero turned for the simple truth to the pristine early church.

Two shepherds are positioned in front of the shed, having come from the fields still carrying their working staffs. In spite of their simple clothes, and their damaged faces, they express great solemnity. One raises his right arm to point heavenward; the other follows this gesture with his glance. In the long history of shepherds attending Nativity scenes, depending on their gestures, these rural characters express a variety of responses to the angelic message they have just received: awe, fear, surprise, and acclamation (as we see here).[38] Years before, Piero had given a similar gesture to one of the Elders in his painting of the *Baptism of Christ*, where, without doubt, it indicates a miraculous source of knowledge.[39] The motif in this case partakes something of all these aspects. But this rustic visitor has another trait that is unique: the staff he carries is cylindrical, and he holds it like a scepter. With one arm raised and a baton in the other, the figure refers to a famous statue-type of the Roman emperor Augustus. Although the most famous version of the statue (known as the *Augustus of the Prima Porta*) was not known in the Renaissance, the motif was familiar from coins (fig. 6)[40] and other representations. It is appropriate here because, according to medieval legend, Augustus had mystic connections to the story of Christ's birth. On the day of the winter solstice, the birthday of the sun and the original date given to Christmas, Augustus celebrated a great victory and closed the gates of peace. Then, alone with the Tiburtine Sibyl, in a room on the Capitoline Hill, he asked the soothsayer if the world would someday see the birth of a greater man than he. Her answer was to show him a wondrous vision of the Madonna and Child seen as the *Ara Coeli*, the Altar of Heaven. This is the scene Ghirlandaio represented over the entrance arch of the Sassetti Chapel (fig. 7).[41] I

propose that with these gestures Piero raised the status of the lowly fieldhand to imperial dignity in order to allude to that same vision. With such an interpretation, we come to realize why he placed his scene on a promontory high above the valley's floor. It was to suggest the heavenly vision of the Ara Coeli, but to show it in its earthly form, divinely illuminated by the naturalistic splendor of the cloudless sky.

The same paradoxical combination of high and low is found in the figure of Saint Joseph. In apocryphal stories about the Holy Family's journey, Mary rides to Bethlehem on a donkey (some say the very donkey of the Nativity scene). The donkey's saddle here serves as the old man's chair, and the water bottle that leans against it is part of the gear from the same trip (fig. 8).[42] The figure of Joseph, however, is anything but narrative. No longer the despondent husband of tradition, as in the Uccellesque predella of Quarata (fig. 9, c. 1435),[43] Joseph is ennobled by his pose. With his legs crossed and his hands with interlaced fingers in his lap, he is lost in thought. This meditative pose casts him in the role of judge, enthroned on the saddle as though it were the curule chair.[44] Even more specifically, Piero gives Joseph the "heel-on-knee" position of the antique statue called the *Spinario* (in reverse), which at this very period had just been mounted on

7. Domenico Ghirlandaio, *Augustus and Tiburtine Sibyl*, 1485, fresco
Entrance arch of the Sassetti Chapel, Santa Trinita, Florence; photograph: Alinari

8. *Meditationes de Vita Christi*, manuscript illumination, fourteenth century
Bibliothèque Nationale, Ms. It. 115; after *Meditations on the Life of Christ*, trans. and ed. Isa Ragusa and Rosalie B. Green (Princeton, 1961), fig. 29

9. Uccellesque predella,
Adoration of the Magi,
c. 1435, tempera on panel,
from a lost altarpiece, San
Bartolomeo a Quarata
(Antella) (detail)
Museo diocesano, Florence; after
Stefano Borsi, *Art e Dossier* 69,
supplement (1992), 26–27
(centerfold)

the Capitoline Hill where the Ara Coeli vision took place.[45] Characterized with these details, the Jewish Joseph joins the pagans in universalizing the recognition of the Messiah.

During his career, Piero had often expressed divinity in simple worldly things, finding lofty theological significance in humble forms. Two scenes from the altar wall in Arezzo floridly make this point. In the *Burial of the Wood* (fig. 10), one of the earliest monumental representations of low-life in Italian art, he showed ruffians, one biting his lip, one exposing his genitals, one drunk, pushing the magic wood into a pool.[46] He emphasized their coarseness by juxtaposing the backside of the man in the corner with the rear end of a horse (as another nearby horse gives a "horse laugh"; fig. 11)! Yet their labor to up-end the plank, as has often been pointed out,[47] is in the manner of *Christ Carrying the Cross*. On the other side of the window, on the second tier left of the altar wall, he depicted *Judas Raised from the Well* (fig. 12) in an equally new way. Unlike compositions of this scene in other cycles of the Cross,[48] it is reminiscent of illustrations to, of all things, Boccaccio's *Decamerone* (fig. 13).[49] The story tells of Andreuccio da Perugia who, having fallen into a dung heap, goes into a well to wash. When soldiers come for water, they run in fright when they see a man instead of

10. Piero della Francesca,
Burial of the Wood,
1452–1466, fresco
San Francesco, Arezzo;
photograph: Alinari

a bucket.[50] Anyone in the fifteenth century seeing dandies at a well where a man tied to a rope is emerging would have gotten the joke. But the way in which Judas is extracted carries another level of meaning. He is pulled up by the hair in the same manner as Habakkuk was carried off by an angel. When he was in Rome in 1458–1459, Piero could have seen the well-known example of this motif on the wooden doors of Santa Sabina (fig. 14). Like Habakkuk, Judas is being carried off for a higher good he does not yet understand.[51]

As the purveyor of his final expression of universal understanding, Piero chose a very lowly and quite unlikely subject: a monumental magpie (*gazza*), perching here on the roof of the shed. To understand the magpie's meaning, we must remember that throughout history birds have been taken as symbols of the soul, free to soar far and wide and finally ascend to heaven. Their entrails were read for auguries, and their endless circling carried the notion of immortality. The small birds in the grass around the Christ Child here have this significance.[52] The magpie, on the other hand, is usually considered a bothersome pest. A large and bony bird, it is known as easily domesticated but a robber that hides the shiny things it steals. Most of all, the magpie is annoying because of its continual and senseless chatter. The ancients said the magpie was the very opposite of Calliope, the Muse of Music, and a Tuscan

proverb transfers the slander to a woman's scolding tongue ("Le donne son sante in chiesa, angele in istrade . . . e gazze alla porta": Women are saints in church, angels in the street . . . and magpies at the doorway).[53]

Piero again reverses the tradition. His magpie is silenced. Perching on the corner of the shed, the long black tail extends to its full length. The massive head and black beak are seen in dignified isolation. It stands above the scene, noble in its perfect profile, elegant but monastic in abstract black and white. In Piero's hands, the magpie is not a shrill babbler of nonsense, but a silent witness to the truth. Piero's magpie possesses the same divine knowledge to which the august shepherd alludes. The magpie's unaccustomed and paradoxical silence stifles the false words of the Old Law, just as the donkey's cacophonic braying sings the praise of the New. Both animals, linked by a descending diagonal that seems to separate light from darkness, verify the arrival of the "true" Word.[54]

The painting of the *Adoration of the Child* is the third in a remarkable series in which Piero affirms the sanctity of Borgo Sansepolcro, his homeland: in the *Baptism of Christ*, which glorifies the feast of first appearances, a distant vista of the town reminds the viewer of the city's founding in the name of a sacred relic of Christ's tomb, brought from the Holy Land by two pious travelers.[55] In the *Resurrection of Christ*, where he represents the actual relic (fig. 15), he reminds the viewer that "Christ the Judge" dwells in Sansepolcro and keeps its government strong.[56] Here he shows the city's special calling as a replica of Christ's tomb, to tell the future in the beginning. Sansepolcro, in the background of the Nativity, proleptically completes the cycle of salvation.

In representing the Nativity of Christ as a revelation, Piero seems to have had a very specific text of the *Golden Legend* in mind. In the passage that follows the scene of Augustus and the Sibyl, Jacobus de Voragine gives the following outline of the revelation's recipients: (1) "The Nativity was revealed to the creatures which possessed existence and life, such as the plants and trees;" examples

13. Illustration to Boccaccio's *Decamerone*, Story of Andreuccio da Perugia, woodcut (ed. Venice, 1494)
After Marilyn Aronberg Lavin, *The Place of Narrative* (Chicago, 1990), fig. 155

14. Early Christian sculptor, "Habakkuk Taken by an Angel," fourth–sixth century, carved wooden relief, doors of Santa Sabina, Rome
After Gisela Jeremias, *Die Holztür der Basilika S. Sabina in Rom* (Tübingen, 1980), pl. 38

The text then goes on to tell how the Nativity functions in the world: (1) It came to pass for "confusion of the demons." (2) It took place to "enable men to obtain pardon for their sins;" the example is a prostitute. (3) It took place to "cure our weakness," for "as Saint Bernard says: 'Humankind suffers from a three fold malady—birth, life, and death . . . Christ brought a three fold remedy: His birth purified ours, His life corrected ours, and His death destroyed ours.'" Finally (4) the Nativity came to pass "to humble our pride. For as Saint Augustine says: 'The humility which the Son of God showed in His Incarnation is to our benefit as an example, as a consecration, and as a medicine: as an example, to teach us to be humble ourselves; as a consecration, because it delivers us from the bonds of sin; and as a medicine, because it heals the tumour of our vain pride.'"[57]

Throughout his career, Piero had used his mathematical prowess to bring depicted forms to the ideal perfection we find so modern. The cool passivity and mathematical underpinning of most of his compositions make the construction so impressive that it often seems to be the main issue. In the fifteenth century, the same qualities of structural rationality, clarity of form, and emotional reserve struck an equally new but different note. The medieval paradigms of the religious hierarchy had been forbidding and distant. Piero gave them humanity in a new, perfected form. His figures were lofty and charismatic, affective and potent, worthy of their eschatological responsibilities. But they were also familiar and accessible. In this, his final painting, he loses none of his underlying structure, but he denies his former elegance. He strips his figures of their exotic garb and classical settings. He simplifies and, although it does not seem possible, he purifies his subject, recharging each detail into a kind of a *summa* of his personal philosophy of the high in the low. He does all this to convey but one, essential message: "Dominus natus est." I like to think that by expressing the fundamental dogma of the church with lowly creatures, the aged Piero revealed not only his profound respect for all of God's creation, but finally his own good humor and sense of divine joy.

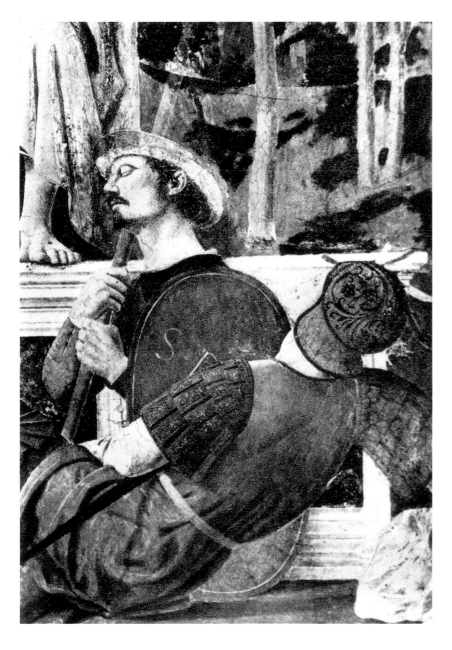

15. Piero della Francesca, *Resurrection of Christ*, detail of soldiers and the relic, c. 1463–1465, fresco
Palazzo dei Priori, Sansepolcro; photograph: Alinari

are the vines of Engedi that bloomed. (2) "The Nativity was revealed to the creatures possessed of existence, life, and sensation, that is, to the animals;" examples are the ox and ass that "miraculously recognizing the Lord, knelt before Him and adored Him." (3) "The Nativity was revealed to creatures possessed of existence, life, sensation, and reason, that is, to men;" examples were the shepherds who spent two nights a year with their flocks, one of which was the winter solstice. And (4), "The Nativity was revealed to the creatures who possessed existence, life, sensation, reason, and knowledge, namely the angels."

NOTES

1. This text has been published in Italian in *Piero 500 Anni*, ed. Claudia Cieri Via and Marisa Emiliani Dalai (Venice, 1994), 122–129.

2. The fullest publication of documents to date is that in Eugenio Battisti, *Piero della Francesca*, 2 vols. (Milan, 1971), 2:213–246.

3. All major monographs and catalogues discuss the *Adoration* and its dating; Roberto Longhi, *Piero della Francesca*, 2d ed. (Milan, 1948), 28; 3d ed. (Milan, 1963), 70 [1470–1485]; Kenneth Clark, *Piero della Francesca* (London, 1951), 44 [1472–1475]; Philip Hendy, *Piero della Francesca and the Early Renaissance* (London, 1968), 10–12 [after 1480]; Creighton Gilbert, *Change in Piero della Francesca* (Locust Valley, N.Y., 1968), 115–116 [after 1475]; Battisti 1971, 1:436–451; 2:76–79, 87–88, 244 [1482–1485]; Mario Salmi, *La Pittura di Piero della Francesca* (Novara, 1979), 138 [1483–1485]; Antonio Paolucci, *Piero della Francesca* (Florence, 1989), 63, 73–74 [1472–1475]; Ronald Lightbown, *Piero della Francesca* (Oxford, 1992), 273–278 [1482–1484]; Carlo Bertelli, *Piero della Francesca* (London, 1992), 218 [1473–1474].

4. Battisti 1971, 2:76–79, 244, 246.

5. Martin Davies, *The Earlier Italian Schools* [cat., National Gallery], 2d ed. (London, 1961), 433–434; Kenneth Clark, *Piero della Francesca*, 2d ed. (London, 1969), 230.

6. The area of the family tomb still exists in a chapel off the cloister of the cathedral of Sansepolcro. It will be recalled that before 1518 this building was the abbey church of the Camaldolites; Piero's brother Francesco (d. 1458) had been a friar here, and the burial site had been in the family for at least two generations; confer Attilio Brilli, *Borgo Sansepolcro* (Sansepolcro, 1972), 20.

7. Planned for Sant'Andrea in Mantua; see *Andrea Mantegna*, ed. Jane Martineau et al. [exh. cat., Royal Academy of the Arts and Metropolitan Museum of Art] (London, 1992), 253–254, no. 64, fig. 84a.

8. As it is called in the inventory; see above, references in note 4.

9. *Jacobi a Voragine Legenda Aurea vulgo Historia Lombardica dicta*, ed. Johannes George Theodore Graesse (Breslau, 1890), part 6, 43–46; the original Latin text was written c. 1262–1264 and almost immediately translated into many languages. By the mid-fourteenth century, the *Legenda* was used as a textbook in vernacular schools in Italy; see Paul Grendler, *Schooling in Renaissance Italy: Literacy and Learning, 1300–1600* (Baltimore, 1989), 285 and his article in this volume. A modern English adaptation is *The Golden Legend of Jacobus de Voragine*, trans. Granger Ryan and Helmut Ripperger, 2d ed. (New York, 1969), 46–51.

10. This variation on the Nativity subject was first defined by Rosalind Schaff, "The Iconography of the Nativity in Florentine Painting of the Third Quarter of the Quattrocento with Particular Reference to the Madonna and Child" (Masters thesis, Institute of Fine Arts, New York University, 1942); see also Henrik Cornell, *The Iconography of the Nativity of Christ*, Uppsala Universitets Arsskrift, 1924, 1 (Uppsala, 1924); and Gertrude Schiller, *Ikonographie der christlichen Kunst*, 6 vols. (Kassel, 1966), 1:88–90.

11. Saint Bridget described her vision, which occurred in Rome in 1370, in her *Revelations* (ed. Rome, 1628), 2:Book 7, chap. 21, 230–231.

12. *Bibliotheca Sanctorum*, 14 vols. (Vatican City, 1963), 3:439–533.

13. Maestro Pisano, *Nativity*, Naples, Gallerie Nazionali di Capodimonte; see also Schiller 1966, 1:88–90.

14. Compare Ruth Wedgewood Kennedy, *Alesso Baldovinetti* (New Haven, Conn., 1938), 101–103, 218–219 (with discussion of Piero's possible influence on the younger artist); Baldovinetti, incidentally, is documented in Arezzo in 1482 (Kennedy 1938, 218–219, note 234); the fresco is reproduced in color (but reversed) in Lightbown 1992, fig. 116.

15. Confer Bianca Hatfield Strens, "L'arrivo del trittico Portinari a Firenze," *Commentari* 19 (1968), 315–319.

16. Namely the Sassetti Chapel; see Eve Borsook and Johannes Offerhaus, *Francesco Sassetti and Ghirlandaio at Santa Trinita, Florence: History and Legend in a Renaissance Chapel* (Doornspijk, 1981), discuss the altarpiece in its context. By the 1460s the motif of Christ lying on his mother's robe was a commonplace: for example, Fra Filippo Lippi, *Nativity*, Uffizi, Florence; see Jeffrey Ruda, *Fra Filippo Lippi Studies* (New York, 1993), cat. no. 48. Like many of Fra Filippo's Infants, Ghirlandaio's Christ Child also points to his own mouth, in clear reference to the passage "Ego sum via, veritas, et vita" (John 14:6).

17. The concept of Piero's exaltation of lowly forms of nature is developed more fully in my monograph *Piero della Francesca* (New York, 1992).

18. See reference in note 57 below for the *Golden Legend's* description of darkness banished at the Nativity.

19. See Marilyn Aronberg Lavin, *Piero della Francesca's "Baptism of Christ"* (New Haven, Conn., 1981), chap. 2, for descriptions of the topography around Sansepolcro, discussions of the history of the city, and analysis of its self-conception as a "New Jerusalem." See also Franco Polcri who calls it "una città teologica," in his essay in *Piero 500 Anni*.

20. The various discussions on this point are reviewed by Battisti 1971, 2:76–79.

21. Battisti 1971, 1:376–384, 2:62–64; Lavin 1992, 120 and pl. 38.

22. See the analysis by Angeli Janhsen, *Perspektivregeln und Bildgestaltung bei Piero della Francesca* (Munich, 1990), 96–103.

23. For a summary of Piero's writings, the manuscript copies, and the published editions, see Lightbown 1992, 291–292, 297.

24. The expression "bread of angels" is from the Bible: Psalm 77 [78]:25, "panem angelorum manducavit homo" ("the bread of angels was eaten by men"), and Wisdom 16:20, "proquibus angelorum esca nutrivisti populum tuum" ("as against this, you nourished your people with food of angels"); the phrase is quoted in the liturgy: "Ecce Panis Angelorum, factus cibus viatorum" (in *Festa Santissimi Corporis Christi: Sequentia*) *Liturgicae Orationis Concordantia Veralia. Prima Pars: Missale Romanum* (Rome, 1964), 455. Dante refers to this phrase in the *Purgatorio*, Canto 2, line 11 ("Voi altri pochi che drizzaste il collo/ per tempo al pan de li angeli"); he recalls it in a line in the *Convivio* (1, i, 6–7), and *Paradiso*, Canto 12, lines 151–154, and 22 at the end; see *The Divine Comedy*, trans. Charles S. Singleton (Princeton, 1977), 254–255, 369–370. For the Latin *area* (the word from which *aiuola* derives) in the sense of "threshing floor," see Vergil, *Georgics* I, 187–191. I thank Kim Veltman for calling my attention to Dante's allusion, and Robert Hollander for help with the references. Clark 1951, 75, in speaking poetically and in general of the sacrificial nature of Piero's types, mentions the threshing floor: "No painter has shown more clearly the common foundations in Mediterranean culture, of Christianity and Paganism. His Madonna is the great mother, his risen Christ the slain god; his altar is set up on the *threshing floor*, and his saints have trodden the wine press." The Eucharistic allusion is more overt in Van der Goes' *Nativity*, where a sheaf of wheat lies on the ground next to the infant. See Barbara G. Lane, " 'Ecce Panis Angelorum,' The Manger as Altar in Hugo's Berlin *Nativity*," *Art Bulletin* 58 (1975), 476–486, for further references.

25. The musical activities of these angels have been discussed at length; see Battisti 1971, 439–440; also Marco Bussagli, *Storia degli Angeli: Racconto di immagini e di idee* (Milan, 1991), 272–285.

26. W. B. McNamee, "The Origin of the Vested Angel as a Eucharistic Symbol in Flemish Painting," *Art Bulletin* 54 (1972), 263–278.

27. In this element, these angels differ from the winged boys in the *Brera Madonna* and the *Senigallia Madonna*.

28. Schiller 1966, 1:70; for example, fig. 143 (sarcophagus lid, end of the fourth century, San Ambrogio, Milan).

29. See next note.

30. *The Hours of the Divine Office in English and Latin*, Liturgical Press ed., 3 vols. (Collegeville, Minn., 1963), 1:198, from Sunday at Lauds I (from the Canticle of the three young men). This observation was first made by Sidney Don in a graduate seminar paper entitled "Piero and the Franciscans" (Yale University, 1977); Paul Barolsky made a similar point in "Piero's Native Wit," *Source: Notes in the History of Art* 1.2 (1982), 21–22. Like many animals

given symbolic meaning during the Middle Ages, the ass had both bad and good connotations. Erwin Panofsky wrote a lengthy footnote about the ox and the ass in Nativity scenes, in his *Early Netherlandish Painting*, 2 vols. (Cambridge, Mass., 1953), 1:470, note 1, demonstrating that, along with many representations in which both animals show their affection for the Christ Child, there are those in which the ass, identified with the Old Testament, exhibits ignorance or lack of piety. See also Schiller 1966, 2:158, 160. Battisti 1971, 1:440 and 537, note 604, develops this idea to the extreme, saying that the donkey's braying indicates (in) "connessione col gesto del pastore, verso il cielo . . . la disperazione per l'impossibilità della grazia" and "un segno apocalittico." However, there is also a continuous tradition in medieval art in which this animal represents a deep sense of religious understanding. As early as the ninth century, illustrations to Psalm 103 (104), in the Utrecht Psalter (fol. 59v), for example, in which all the beasts praise the Lord, include two braying/ singing asses (*Latin Psalter in the University Library of Utrecht, formerly Cotton MS Claudius.vii*), facsimile (London, 1920), pl. 119. The story of Balaam's ass with its typological symbolism is an instance in which the animal's rapport with divinity is even greater than that of the human being who owns him; see Elene H. Forsyth, "L'ane parlante: The Ass of Balaam in Burgundian Romanesque Sculpture," *Gesta* 20.1 (1981) (Essays in Honor of Harry Bober), 59–66; and Gregory Penco, "Il simbolismo animale nella letteratura monastica," *Studi monastica* 6 (1964), 7–38, especially 13–14. One of the legends of Saint Anthony of Padua (before 1231) concerned the ass at Rimini that knelt before a transubstantiated host, recognizing, it was said, "the host in Christ and Christ in the Host." From the same period, and demonstrating a positive attitude toward the ass, is the liturgical drama by Pierre Corbeil, archbishop of Sens (d. 1222); see below, note 34. In the Florentine *Fior di Virtù*, another late medieval text (1300–1323) commonly read in Renaissance vernacular schools (see Grendler reference, note 9), the virtue of abstinence is compared to the thirsty wild ass who will wait for two or three days for the water to clear before drinking; *The Florentine Fior di Virtù* of 1491, trans. Nicholas Fersin (Washington, D.C., 1953), chap. 27, 98; Carlo Frati, "Richerche sul 'Fiore di virtù,'" *Studi di filologia romanza* 6 (1893), 247–447 (reference from Paul Grendler). Of course, the figure of the ass can also refer to obstinacy and buffoonery. See Helen Adolf, "The Ass and the Harp," *Speculum* 25 (1950), 49–57; and Francis Klingender, *Animals in Art and Thought to the End of the Middle Ages*, ed. Edward Antal and John Harthan (London, 1971), 289, 298.

31. The earliest example known to me (called to my attention by Marci Freedman) is that by Biagio di Goro Ghezzi in the apse frescoes (left wall), in San Michele, Paganico, c. 1375 (fig. 5); Gaudenz Freuler, *Biagio di Goro Ghezzi a Paganico: L'affresco nell'abside della chiesa di S. Michele* (Milan, 1986), 50, 53, pl. III, fig. 42. The figure of the ass here is perhaps the most prominent of the composition, placed in the

geometric center behind the crib and under the peak of the double-sloping roof. The animal is only one of many music makers in this composition: on the second tier on either side of the shed is a choir and orchestra of angels; to the left behind Mary is a bagpiping shepherd, and to the right, behind Joseph, is a sheep that raises its muzzle in the air to add its voice. See further the small *Nativity* by Simone dei Crocifissi, c. 1380, reproduced in *Gli Uffizi, Catalogo Generale*, 2d ed. (Florence, 1980), 519, no. 3475, where Joseph's crosslegged pose seated on a saddle also forecasts Piero's. Not all donkeys with heads raised, however, are braying; some are eating hay from a wall-crib; for example, the *Nativity* by Petrus Christus, c. 1445, in the National Gallery of Art, Washington, D.C.; *Preliminary Catalogue of Paintings and Sculpture, National Gallery of Art* (Washington, D.C., 1941), 39–40, no. 40, and in the *Adoration of the Magi* by Joos van Gent, c. 1467, the Metropolitan Museum of Art, New York (Leo van Puyvelde, *The Flemish Primitives*, trans. D. I. Wilton [Brussels, 1948], 76). This motif, in fact, constitutes a second stream of meaning for the motif: Eucharistic, in the sense that the hay again refers to the sacrament. Another example of the eating motif, coupled now with a magpie on the roof of the shed, is the much-disputed *Adoration of the Child* in the Glasgow Art and Museum Gallery, Kelvingrove, no. 158, wood, 50 x 40 cm. This peculiar painting, whose relationship to Piero has yet to be worked out, is variously attributed to Antonello da Messina, Valenzano Jacomart Baço, a Burgundian Master, and Colantonio, and dated by all to about 1475 (Greta Ring, *A Century of French Painting, 1400–1500* [London, 1949], 225, no. 212), except for Albert Chatelet, *French Painting from Fouquet to Poussin* (Geneva, 1963), 24 (color photo), who oddly calls it "The Nativity of Saint Sixtus," by a painter from the "entourage of the Limbourg Brothers," and dates it c. 1410–1416. The braying donkey in Michelangelo's *Sacrifice of Noah* on the Sistine Chapel ceiling, and Juseppe Ribera's *Drunkenness of Silenus*, painting and engraving, are both related to the derision of pre-Christian religions, Judaism in the first case and paganism in the second; for the Sistine version, see Edgar Wind, "The Ark of Noah, a Study in the Symbolism of Michelangelo," *Measure* 1 (1950), 411–429.

32. Barolsky (1982) suggested that the donkey, in fact, completes the symmetry of the choir, made up of three singers and three musicians.

33. Marilyn Aronberg Lavin, *The Place of Narrative: Mural Painting in Italian Churches 431–1600 A.D.* (Chicago, 1990), fig. 147.

34. This interpretation of the voice of the ass parallels precisely that expressed in the early fourteenth-century liturgical drama by Pierre Corbeil, known as the *Prose de l'ane*. In the performance, an ass carries on its back a young woman who represents the Virgin. The verse text describing the action says that the donkey is "strong and fair" ("pulcher et fortissimus") and that his repeated braying signifies Amen ("Amen dicas, asine"), in praise of the Lord; see Félix Clément, "Drame liturgique: L'ane au Moyen Age,"

Annales archéologiques 16 (1856), 26–38, especially 34, and Louis Charbonneau-Lassay, *La mystérieuse emblématique de Jésus-Christ: Le Bestiaire du Christ* (Bruges, 1940), 228–229; Karl M. Young, *Drama of the Medieval Church*, 2 vols., 3d ed. (Oxford, 1967), 2:169–170. I am indebted for all references to the play to my husband, Irving Lavin, who will develop the theme of the virtuous donkey in a forthcoming essay.

35. The building in a state of dilapidation had a long tradition. See the passage in the *Golden Legend*, 48, concerning the night of Christ's birth when the "Eternal Temple of Peace" crumbled to the ground. For Ghirlandaio's architecture, see Borsook and Offerhaus, 1981.

36. Paolo Bensi has recently shown that Piero produced the surface texture of this shed with his fingertips; prints are visible behind and around the Virgin's head in some photographs (for example, Battisti 1971, 1: fig. 230). Bensi observed that this technique was often used by Jan van Eyck; see his contribution to *Piero 500 Anni*.

37. For example, Schiller 1966, 1:70, fig. 147, Museo Lateratense (Vatican), 190, fourth century. Jacobus de Voragine quotes Peter Comestor's *Scholastic History*, where the place is described simply "as a shelter against the uncertainties of the weather" (*Golden Legend*, 47).

38. See Ernst Kitzinger, with Slobodan Ćurčić, *The Mosaics of Santa Maria dell'Ammiraglio at Palermo* (Washington, D.C., 1990), 175–182, figs. 108–112; and Schiller, 1966, 1: figs. 213, 214, and 276; also in the *Meditations on the Life of Christ*, trans. and ed. Isa Ragusa and Rosalie B. Green (Princeton, 1961), fig. 32. It has been suggested more than once that there was an actual representation of the dove of the Holy Ghost or of God the Father in the original frame made for this painting, to which the shepherd would be pointing; see Marco Bussagli's forthcoming contribution to *Piero 500 Anni*.

39. Lavin 1981, 61–62. Piero used the same gesture for the imperial figure of Heraclius in the battle scene on the lowest tier of the left wall in the cycle of the *True Cross* in Arezzo, basing himself on a drawing after a lost equestrian statue thought to be Heraclius himself. See Michael Vickers, "Theodosius, Justinian, or Heraclius?" *Art Bulletin* 58 (1976), 281–282; also reproduced in Lavin 1992, 98, fig. 51, and pl. 27.

40. See Richard Brilliant, *Gesture and Rank in Roman Art*, Memoirs of the Connecticut Academy of Arts and Sciences, 14 (New Haven, Conn., 1963), 59–68, especially figs. 2.34 and 2.42, "adlocutio." The motif is most clearly seen in the statue of Augustus of the Prima Porta, not discovered until the nineteenth century; see Erika Simon, *Augustus Kunst und Leben in Rom um die Zeitenwende* (Munich, 1986), pl. opp. 52 (Prima Porta); but see also Harold Mattingly, *The Roman Coins in the British Museum*, 12 vols. (London, 1923–1966), 1: pl. 7, nos. 16–20, pl. 15, reverse no. 4.

41. Borsook and Offerhaus 1981, fig. 19; see discussion in note 100. Accounts of the legend appear in the *Mirabilia urbis Romae*, the *Speculum humanae salvationis*, and in *La leggenda aurea*; see Antonio Monteverdi, "La leggenda d'Augusto e dell'Ara Celeste," *Atti del V Congresso Nazionale di Studi Romani* (Rome, 1940), 2:463–467; Philippe Verdier, "A Medallion of the 'Ara Coeli' and the Netherlandish Enamels of the Fifteenth Century," *Journal of the Walters Art Gallery* 24 (1961), 9–37, especially notes 2, 47. The medieval history apparently stems from the inscription on one of the columns in the left nave colonnade in the church of Ara Coeli in Rome, which reads in part: *cubiculum augustae*, meaning that it was part of the entrance to the office of a functionary of the emperor. The Latin was misread in the Middle Ages to mean the "bedroom of Augustus," and hence the connection with his home. The full iconography was represented by Rogier van der Weyden in the early 1460s in his *Middelburger Altarpiece* painted for Peter Bladelin (Berlin, Staatliche Museen, Gemäldegalerie), where the vision scene is on the wing to the left of the central *Nativity* scene. Although there is no way to prove that Piero somehow gained knowledge of this altarpiece, his work shows many similarities to it: Rogier had also included the Bridgetine motif, the oblique shed, a landscape vista on the left and townscape on the right, along with the scene of Augustus and the Sibyl; see Panofsky 1953, 276–278, 469–471; Shirley N. Blum, *Early Netherlandish Triptychs: A Study in Patronage* (Berkeley, Calif., 1969), 17–28, 121–126; Martin Davies, *Rogier van der Weyden* (London, 1972), 10–11, 22, 201–203; Odile Delenda, *Rogier van der Weyden* (Zurich, 1987), 48–52. For further connections between Piero and Rogier, in this case the *Pesaro Altarpiece*, see Bert Meijer's paper in this volume.

42. *Meditations* 1962, figs. 25–31; the saddle is seen again in figs. 34–35, 37–38, 42–44.

43. Color reproduction in Stefano Borsi, *Art e Dossier* 69, supplement (1992), 26–27; predella di Quarata, Museo diocesano, Florence; from a lost altarpiece that was in San Bartolomeo a Quarata (Antella). In the *Adoration of the Magi*, which was the central section of three, Saint Joseph is seated to the left on the saddle, with his left foot over his right knee and his head supported by his left hand, in the typical gesture of worried concern.

44. J. J. Tikkanen, *Die Beinstellungen in der Kunstgeschichte*, Acta Societatis scientiarum fennicae 42.1 (Helsingfors, 1912), 150–186, especially 163, 168; see also Brilliant 1963, 108–109, 125, 133, 149, 151, 153.

45. William S. Heckscher, *Sixtus IIII Aeneas insignes statuas romano populo restituendas censuit* (The Hague, 1955), 20–21, 43.

46. See Lavin 1992, pl. 18.

47. See the collection of references, starting with Roberto Longhi, *Piero della Francesca* (Milan, 1927), in Bertelli 1992, 114, note 44.

48. In such scenes Judas is usually shown *in the*

well; compare the Wessobrunner Betebuch manuscript, ninth century: Andreas and Judith Stylianou, *In Hoc Vinces . . . , By This Conquer* (Nicosia, Cyprus, 1971), 179, and a predella on the *Saint Helen Altarpiece* by Michele di Matteo, 1427: *Catalogo dell'Accademia di Venezia*, ed. Sandra Moschini Marconi (Venice, 1955), 172, no. 195.

49. Reproduced in Lavin 1992, pl. 17 and fig. 52.

50. Vittore Branca, *Boccaccio medievale* (Florence, 1981), 402–403; reproduced in Lavin 1990, fig. 155; also *Giovanni Boccaccio*, 3 vols., intro. Vittore Branca (Florence, 1966), 1:118, 124 and 3:966–968.

51. In the story of the True Cross, after Judas reveals to Saint Helena where the cross is hidden, he is appointed the bishop of Jerusalem and helps to restore the cross relic to the people. Ernst H. Kantorowicz, "The 'King's Advent' and the Enigmatic Panels in the Doors of Santa Sabina," *Art Bulletin* 26 (1944), 207–231; Gisela Jeremias, *Die Holztür der Basilika S. Sabina in Rom* (Tübingen, 1980), pl. 38 (see also pl. 23 for a representation of the crosslegged motif on the doors); see also Lavin 1990, 181–183.

52. Herbert Friedmann, *The Symbolic Goldfinch* (New York, 1946), 88, discusses this tradition and comments on Piero's finch.

53. Salvatore Battaglia, *Grande dizionario della lingua italiana* (Turin, 1972), 4, 622 (col. 2), *gazza*, no. 5 (Proverbi Toscani, 103); also 1986, 13, 331, *pica*. Compare Dante's *Convivio*, 3, vii, 9: "Se alcuno volesse dire contra, dicendo che alcuno uccella partì . . . massimamente de la gazza e del pappagallo, . . . rispondo che non è vero che parlino." In mythology, the nine Pierides, daughters of a king of Macedonia, were transformed into magpies for having dared to challenge the Muses to a singing contest; Ovid, *Metamorphoses* V, 294–678; also Dante, *Purgatorio*, Canto 1, 11; Singleton, 6. It will be recalled that one of Piero's early patrons (sponsors of the *Madonna della Misericordia Altarpiece*) were members of the prominent Sansepolcro family of the Pichi, another Italian word for magpie; see the article by James Banker in this volume.

54. Continuing the thought of Battisti (see above, note 30), Marco Bussagli discusses the combination of donkey and magpie briefly in his survey of Piero's career, "Piero della Francesca," *Art e Dossier* 71, supplement (1992), 47; and more fully in *Piero 500 Anni*, claiming that the noisy intrusion of both animals carries allusions to apocalyptic dissonance, in marked contrast to the angels' celestial harmony. Unfortunately, Bussagli's observations do not take into account Piero's very pointed variations on the themes: the chattering magpie is silent, and the braying donkey sings with the angels. It is precisely the inversion of tradition that Piero uses to make his point.

55. Lavin 1981, 23–25.

56. Lavin 1992, 37–39, 108–110.

57. *Golden Legend*, 49–51; the Nativity's banishment of darkness is described in this passage.

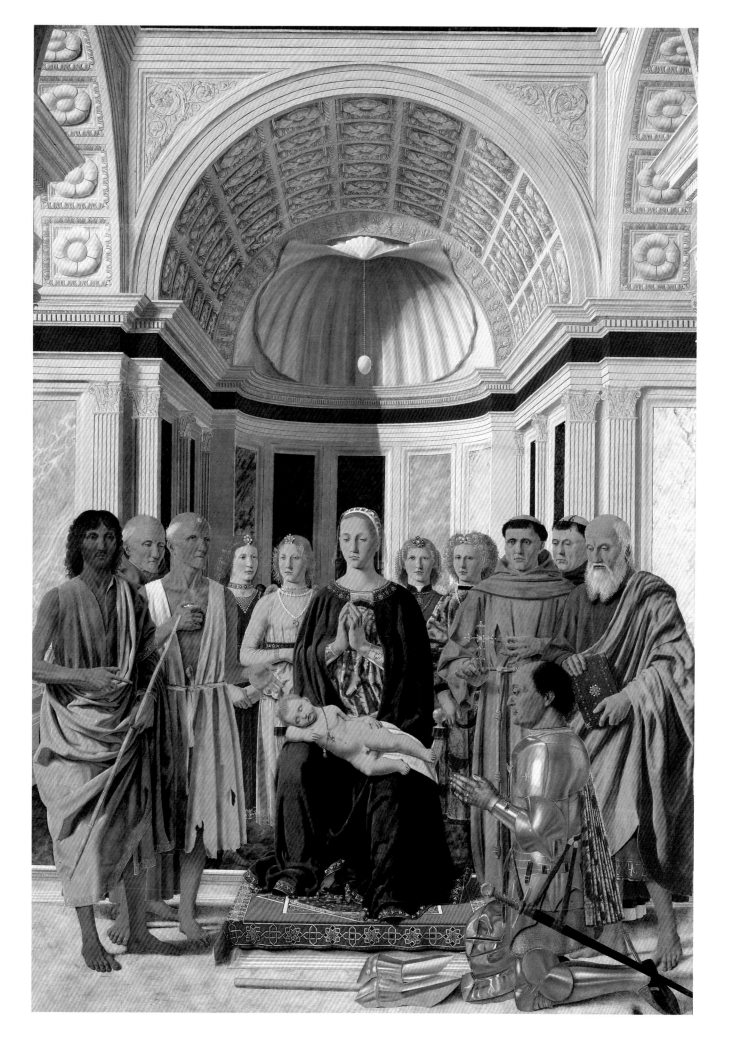

BERT W. MEIJER
Nederlands Interuniversitair Kunsthistorisch Instituut, Florence
Universiteit Utrecht

Piero and the North

Like many other topics in Italian art history, the relationship between the painting of Piero della Francesca and that of the Netherlands was formulated for the first time in an illuminating way by Roberto Longhi.[1] In his discussion of previous literature on Piero, Longhi cites Johann David Passavant's monograph on Raphael, in which the German scholar observed that the rich costume in which the man on the right in Piero's *Flagellation* is clothed is treated in the Netherlandish way (fig. 1).[2] Elaborating on this observation, Longhi stated that the gold brocade cloak has only one parallel in European painting: that of chancellor Nicolas Rolin in Jan van Eyck's *Madonna of Chancellor Nicolas Rolin* in the Louvre, painted twenty years or more before Piero's work (fig. 2).[3]

The similarities are striking indeed, and need to be understood in their historical framework. The velvet textile decorated with silk gold brocade, worn by both Piero's and Van Eyck's figures, was among the best-known Italian luxury products imported into the north by Italian middlemen in the fifteenth century.[4] Both painters render a pattern called *griccia*, or the "pineapple pattern," in which the stem and leaves are the central decorative motif. Piero and Jan use this fabric on other figures as well. In its initial state it was particularly connected with Florence.[5] Not only do both artists depict velvet garments of Italian origin, but both render them in a similar manner, with relatively broad

forms and using saturated color with a little white pigment added, an approach first used by Van Eyck. Moreover, in both cases the gilding is done without the use of metallic paint, which permitted a free and naturalistic handling.[6] That a painting by the older Flemish artist inspired Piero to include similar fabrics and to render them in this manner is quite possible. After all, in Piero's time Jan van Eyck's work was represented in Italy by quite a number of his paintings, in Milan, Venice, Padua, Genoa, Florence, Urbino, and Naples.[7] To understand better the presence of these textiles in Piero's work, one should know more than I about their use in Italian daily life. In any event, Piero seems to have painted gold brocade velvet in a more naturalistic, Eyckian manner than his Italian contemporaries. There are also similarities between Piero's and Jan's way of rendering other materials. Compare, for example, the substance and texture of garments in Van Eyck's version of the *Stigmatization of Saint Francis* in Turin (fig. 3) with those in Piero's *Saint Jerome and Girolamo Amadi* in Venice (fig. 4). In the latter painting, Piero seems to surpass Van Eyck in natural representation of drapery folds and texture.[8]

Since Longhi's juxtaposition of the *Rolin Madonna* and Piero's *Flagellation*, other similarities to Jan's painting have been mentioned. According to Millard Meiss, and followed by others, the relationship between the profile portrait and landscape background in the

Montefeltro Diptych (fig. 5) recalls a similar relationship in the Van Eyck painting (fig. 2). He also calls attention to the similarly superimposed planes in which the higher level in a two-dimensional sense represents the lower one in space, a compositional type Piero had used earlier in his *Saint Jerome and Girolamo Amadi* (Venice, c. 1450, fig. 4).[9] Others have observed that the diptych can be related to the representation of religious figures at bust height against a landscape background, encountered first in Rogier van der Weyden's *Braque Triptych*.[10] But the earliest isolated bust-length portrait set before a landscape seen in bird's-eye view, or before a blue sky, seems to have been done by Hans Memling, who became a master in Bruges in 1466,[11] and it is generally agreed that the idea was Netherlandish in origin.[12] The panoramic view and landscape structure in Piero's diptych likewise recalls that of the *Madonna of Chancellor Nicolas Rolin* (fig. 6), as does a new awareness of aerial perspective, lacking, for instance, in Piero's *Saint Jerome* in Berlin.[13] Both may reflect the landscape background of Jan's lost *Women's Bath*, owned by Ottaviano Ubaldini della Carda, Federico da Montefeltro's nephew and principal counselor at his court in Urbino.[14] Although this painting is lost, it is known from Bartolommeo Fazio's detailed description, which evokes an image similar to the landscape of the *Rolin Madonna*.[15] Probably Piero admired Van Eyck's analytic manner of rendering reality in his works, some of which he must have seen.[16] The asymmetric composition with the donor in profile on one side and a three-quarter biblical or saintly figure on the other, as in the *Madonna of Chancellor Nicolas Rolin*, was, according to Otto Pächt, an Eyckian innovation.[17] Piero adopted a comparable spatial relationship between the figures in his fresco in Rimini with *Sigismondo Malatesta before Saint Sigismund* (1451) (fig. 7), as well as in the *Saint Jerome and Girolamo Amadi* in Venice.[18]

As we know, Bartolommeo Fazio, the Genoese historian and secretary of King Alfonso in Naples, in his *De viris illustribus* of 1456, attributed to Van Eyck new discoveries about the properties of colors that Vasari, a century later, called the invention of *colorire a olio*.[19] More recent research has pointed out that the innovation resulted, in particular, in the increased range of color values, their luster, vividness, and unification. These results were achieved with oil glazes in more or less transparent layers, and a more sparing use of white pigment.

Piero's encounter with oil is thought to have taken place in 1439 in Sant'Egidio, the church of the hospital of Santa Maria Nuova in Florence, when he collaborated with Domenico Veneziano. According to Vasari, Domenico's almost completely lost murals in the Cappella Maggiore, or Portinari Chapel, in Sant'Egidio were painted with the use of oil.[20] What this means for the technique of Piero's panels is not clear. After all, Italian mural painting, even when it is a mixture of fresco and oil, requires a technical procedure that is quite different from painting on panels. The new Flemish technique for glazing with oil, which put Netherlandish painting in a leading position, was invented for painting on panels, not for painting on walls.[21] In Piero's panel paintings, oil as the only binding agent is documented at least from the later 1460s on,[22] in works such as the *Archangel Michael* completed in or before 1469 (fig. 8).[23] Some authors put the date of the transition to a predominantly oil medium in Italy precisely during Piero's career, in the late 1450s or 1460s.[24] Piero's experimentation with oil, however, must have started even earlier. In the view of Michel Laclotte the naturalism with which Piero renders the skin and flesh tones in his portrait of *Sigismondo Malatesta* (Louvre, c. 1450, fig. 9)—elements still lacking in Pisanello's portrait of *Leonello d'Este* (Bergamo, Accademia Carrara)—puts Piero on the same level as Rogier van der Weyden, Jan van Eyck's successor as the champion of the Flemish tradition, whose working manner he reflects. This opinion should be tempered by the fact that, in this particular painting, oil as binding agent was used along with tempera.[25] It has also been claimed that, except for Colantonio, around 1450 Piero was the only artist to have understood the importance of the Flemish model. However, at that date painters all over Italy were already using or experimenting with the Flemish oil technique. More technical research must be done on the work of these and other Italian painters before we can define Piero's exact role in the development of the new technique in Italy.[26] That Piero's

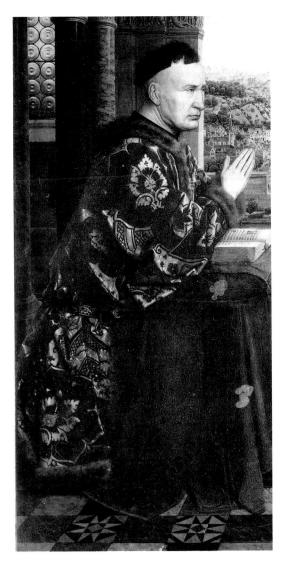

1. Piero della Francesca, *Flagellation of Christ*, c. 1458, tempera (detail)
Galleria Nazionale delle Marche, Palazzo Ducale, Urbino; photograph: Alinari

2. Jan van Eyck, *Madonna of Chancellor Nicolas Rolin* (detail)
Musée du Louvre, Paris; photograph: Alinari

contact with the works of Rogier precedes his acquaintance with paintings by Van Eyck is likewise an idea that requires further documentation.[27] In all probability, this idea is based on the notion that, among the Flemish paintings present at the court of Ferrara around 1450, there were works by Van der Weyden and anonymous masters but nothing identifiable by Jan.[28]

Amazingly, in his studies of Piero, Longhi completely disregarded Rogier van der Weyden.[29] Yet Rogier is discussed by Bartolommeo Fazio as being among the four major artists of his time.[30] Both Jan and Rogier were also mentioned by Filarete in Milan as masters who worked very well with oil.[31] In the fifteenth century, Rogier and his workshop were represented by paintings in many Italian regions and cities, for example,

Chieri, Genoa, Ferrara, Florence, Urbino, Pesaro, and Naples. A strikingly large number of these paintings were carried out in Flanders on the orders of wealthy Italian merchants, for themselves or for their princely or bourgeois patrons in Italy. Other works were possibly executed by Rogier during his presence in the peninsula.[32] Such examples provided instruction in the use of oil for leading painters in Ferrara, among them the Sienese Angelo Maccagnino, as we know from remarks by Ciriaco d'Ancona, and as is shown by some works of Ferrarese provenance attributed to him.[33] As early as 1446, Leonello d'Este bought Van der Weyden's paintings.[34] Angelo Decembrio, in his dialogue on art set at the court of Leonello and in the voice of the duke himself, relates a tapestry depicting the *Justice of Trajan* and *Saint Gregory and the Skull of Trajan* to Rogier's lost scenes of those subjects painted for the town hall of Brussels (fig. 10).[35] In this well-known passage, Leonello warns against transalpine tapestry designers and weavers who are more concerned with opulence, rich colors, and frivolous charm than with true representation of the nude figure and ancient literary sources. These remarks were but a prelude to what, in the next century, would become open disdain in Italy for Netherlandish *disegno* and for the rendering of anatomy and figures in space by northern artists. From Piero's time, however, this opinion is otherwise conspicuously absent from Italian written sources.[36] Decembrio's passage has been thought to reflect the ideas of Leonello concerning works of art present at his court.[37] On the other hand, it has also recently been argued that the criticism of the Trajan tapestry is that of Decembrio himself, and that Leonello not only did not own such a tapestry but was not even acquainted with it.[38] The matter has some bearing on Piero, who, it has been said, would have seen the tapestry based on Van der Weyden's design in the ducal palace in Ferrara when he painted there for Borso d'Este,[39] and who might have remembered the grouping of figures in the tapestry when he was working on the frescoes in Arezzo.[40]

Neither the tapestry mentioned by Decembrio nor the paintings by or associated with Rogier that are known to have been in Ferrara during the lifetime of Leonello and his successor, Borso d'Este, can be related at this

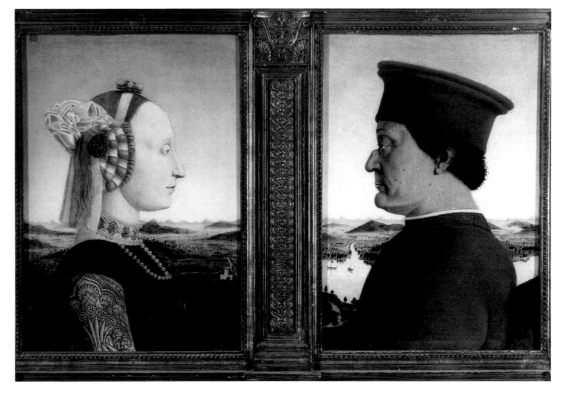

3. Jan van Eyck, *Stigma-*
tization of Saint Francis
Galleria Sabauda, Turin;
photograph: Alinari

4. Piero della Francesca,
Saint Jerome and Girolamo
Amadi in a Landscape,
1450, tempera
Gallerie dell' Accademia, Venice;
photograph: Alinari

5. Piero della Francesca,
Montefeltro Diptych:
Federico da Montefeltro,
Battista Sforza, 1472–1474,
oil and tempera
Galleria degli Uffizi, Florence;
photograph: Alinari

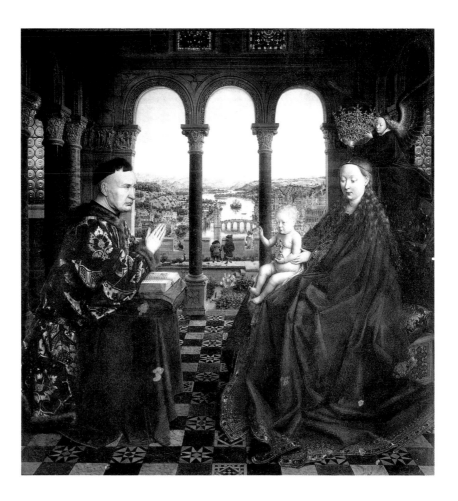

6. Jan van Eyck, *Madonna of Chancellor Nicolas Rolin*
Musée du Louvre, Paris;
photograph: Alinari

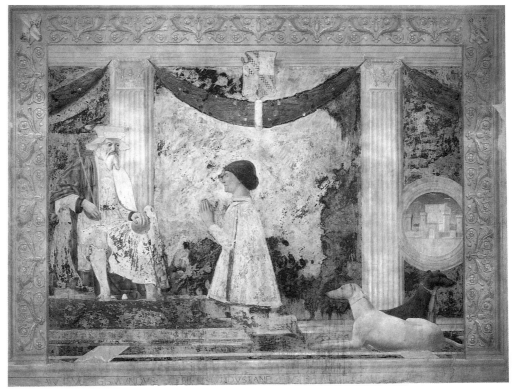

7. Piero della Francesca,
Sigismondo Malatesta before Saint Sigismund,
1451, fresco
Tempio Malatestiano, Rimini;
photograph: Alinari

moment to Piero.[41] As has been observed by Federico Cavalieri, however, it is possible that Piero knew the small Sforza triptych now in Brussels, which is generally thought to have been executed by Rogier's workshop, perhaps with the collaboration of the master himself (fig. 11).[42] The triptych is one of the most interesting northern paintings in the context of Piero della Francesca. It was painted for Alessandro Sforza, ruler of Pesaro and brother of Francesco, duke of Milan. It includes portraits of Alessandro himself, his daughter Battista, and his son Costanzo.[43] Its execution must predate the marriage, in February 1460, of Battista (1446–1472) to Federico da Montefeltro, already Alessandro's brother-in-law and close ally.[44] In all probability the triptych was commissioned during Alessandro's eight months' stay in Burgundy, Flanders, and Bruges, ending in March 1458, from which he returned to Pesaro in May. A *terminus post quem* for the painting is also the retirement to a convent in 1457 of Alessandro's wife, Sveva, Federico da Montefeltro's half-sister,

who is not included among the three portrait figures.[45] Until late in the fifteenth century the painting was in the Sforza library in Pesaro. According to an inventory, the "tavoletta di Cristo in croce cum li paesi di man de Ruggeri" was transported to Urbino in or before 1500 by a certain Aloisio de Mateo.[46]

As Cavalieri has pointed out, there are obvious similarities between the portrait of Alessandro in the Sforza triptych (fig. 12) and Piero's portrait of Federico in the Montefeltro altarpiece (fig. 13), a painting, which in its general iconographical aspect of a Madonna in a church, in the identification of the Virgin as Mater Ecclesiae, and in its bright lighting on the wall, has also been considered to derive from prototypes by Van Eyck or Van der Weyden.[47] Both figures are kneeling with folded hands; both figures are in armor with their swords at the left side and legpieces laid before them on the ground. Even the luster on the armor and the highlighted white areas and spots are rendered with similar intensity and in more or less the same locations on the armor (although one spot is the reflection of a window, a device known from paintings by Jan van Eyck). Behind both kneeling portrait figures is a standing figure with a red mantle.

The principal biographical reason to repre-

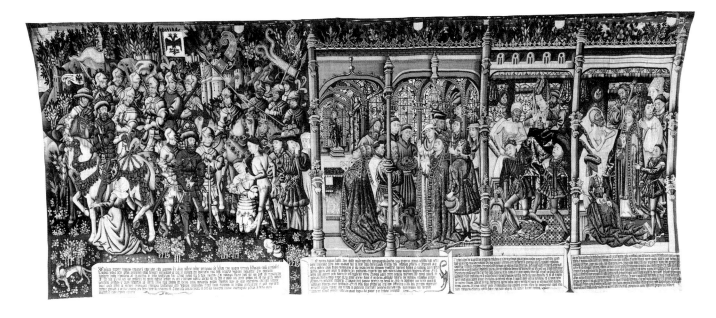

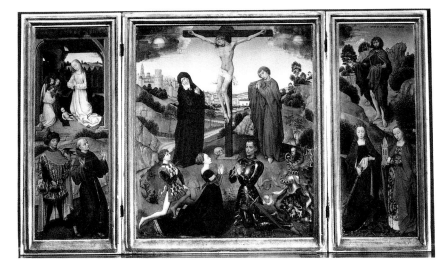

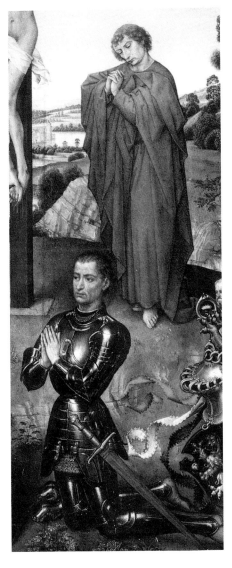

10. After Rogier van der Weyden, *Episodes of the Life of Trajan and That of Herkenbald*
Bernisches Historisches Museum, Bern

11. Rogier van der Weyden (and/or workshop), *Triptych of Alessandro Sforza*
Musées Royaux des Beaux-Arts, Brussels

12. Rogier van der Weyden (and/or workshop), *Triptych of Alessandro Sforza* (detail)
Musées Royaux des Beaux-Arts, Brussels

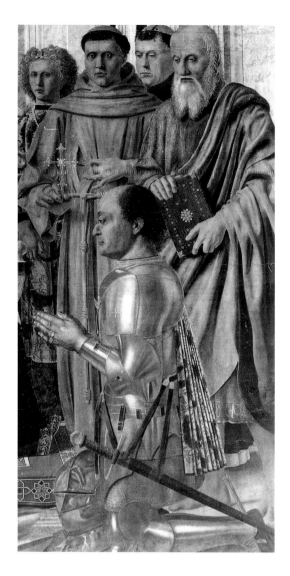

in the choice of the Sforza triptych as a starting point for Piero's altarpiece. However, to explain the similarities between the two figures it may be sufficient to suppose that Piero actually saw the triptych during a stay in Pesaro.[51]

The profile portrait of Battista in the Sforza triptych is clearly based on a model other than that by Piero, now in the Uffizi (fig. 5). It is hard to say whether this fact may be an indication that the latter portrait was painted before Piero saw the Sforza triptych (fig. 14).[52] However, perhaps the painting in Brussels may have had some importance for Piero's *Adoration of the Child* in London (fig. 15). This work is painted in oil. It has been thought to epitomize Piero's interest in Flemish painting. As in other instances, the traces of this interest are amalgamated by Piero into a new, highly original composition. It has been suggested by some,[53] and denied by others on chronological grounds,[54] that the newborn Christ Child lying on his back may

sent the two dukes in military outfit is that they were both important military commanders. According to Vespasiano da Bisticci, Alessandro was "il secondo capitano de' tempi sua che congiungse la disciplina militare colle lettere; che il primo fu il duca d'Urbino."[48] Marilyn Aronberg Lavin has observed that after Altichiero's fresco for the Cavalli family in the church of Santa Anastasia at Verona and other north Italian frescoes of the later fourteenth century for more than fifty years there are no examples of armored donor portraits in Italian art.[49] Van der Weyden's Sforza altarpiece is the first and only chronologically close precedent for Piero's kneeling donor in armor with his hands folded.[50] Given the close relations between the courts of Pesaro and Urbino and between their two rulers, Federico may have been personally involved

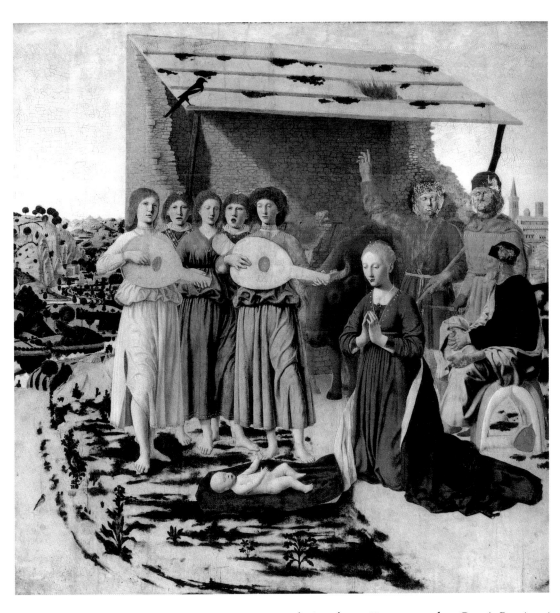

15. Piero della Francesca,
Adoration of the Child,
1480–1485, oil and tempera
National Gallery, London

16. Hugo van der Goes,
Portinari Triptych (detail)
Galleria degli Uffizi, Florence;
photograph: Alinari

derive from Hugo van der Goes' *Portinari Triptych*, in Florence since 1483 (fig. 16).[55] In that painting, and in other Flemish works, the Virgin wears a darker robe than in Piero's painting but in both the latter work and in Van der Goes' triptych she is placed in an off-center position. At the same time, nearly all the elements in Piero's painting are found, surprisingly enough, in the central panel of Rogier van der Weyden's triptych painted for Pieter Bladelin in Middelburg, now in Berlin (fig. 17); a ruinous, slightly diagonally placed barn with a bird on the roof, a kneeling Virgin on the opposite diagonal, the Christ child lying on an edge of his mother's dark blue mantle, of which the underside has northernlike, angular folds.[56] Since the Van

der Goes Christ Child is not lying on a slip of mantle but, more crudely, immediately on the ground, Piero's Flemish source or sources may well have been other than the *Portinari Triptych*. Moreover, it should be observed that already in Filippo Lippi's *Adoration of the Child*, in the Uffizi and datable c. 1455, the Christ Child is depicted on a slip of the cloak of the Virgin, who holds her hands in an upward position (fig. 10).[57] These elements also have a parallel in the *Nativity* in the right wing of the *Triptych of Alessandro Sforza* (fig. 19) as well as in some other early Flemish paintings of the subject.[58]

Although we need more extensive technical and documentary study, the affirmation that, except for Colantonio, around 1450 Piero was the only Italian artist with a real awareness of the importance of northern painting is probably an overstatement.[59] Nonetheless, his interest in Flemish art was particularly intense and more profound than in many of his colleagues. This interest is reflected in the references to Netherlandish imagery and painting technique that appear relatively early in the literature on Piero. Our present perception of artistic innovations of centuries ago, because of our way of ordering them as a series of events that seem to follow one after another, hardly conveys the original, revolutionary impact they had and the sometimes highly charged emotions they must have aroused. The powerful force

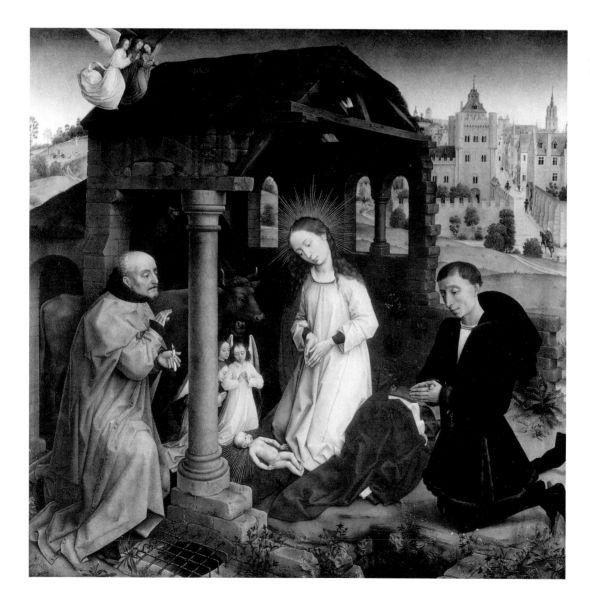

17. Rogier van der Weyden, *Bladelin Altarpiece*, central panel
Staatliche Museen, Berlin

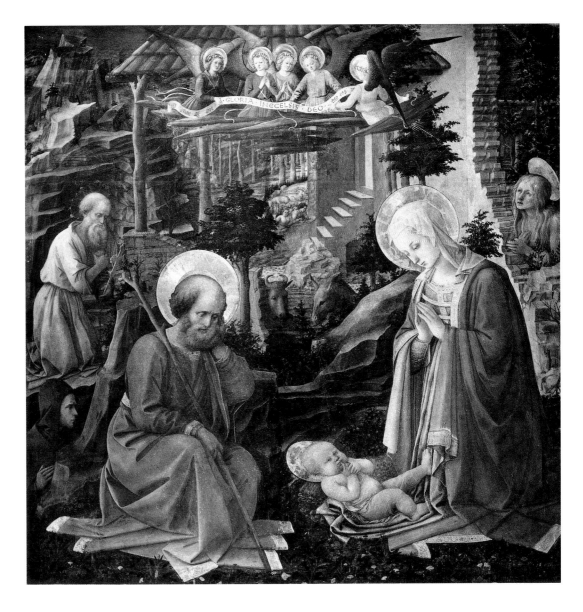

of Jan van Eyck's discoveries with regard to glazing in oil, as well as the physical appearance of his works, must have come to Piero and other Italian painters as something of a surprise or a shock. Jan's stature in Italy was such that fifteen years after his death he was still considered the leading painter of the century, "nostri saeculi pictorum princeps."[60] For the engraved series *Nova Reperta* published in the 1580s or 1590s, Giovanni Stradano, Vasari's former assistant, included among his designs the invention of oil painting with the inscription "the famous master Jan van Eyck invented oil painting handy for the painters."[61] All these indications in some way confirm Vasari's statement that, even after Jan's technical invention, and

despite the importation of many Netherlandish paintings, for years the Italians themselves did not discover the secret.[62] In this perspective we may perhaps also understand Vespasiano da Bisticci's often quoted statement that when in the early seventies Federico da Montefeltro wanted an artist able to paint in oil on panel, he was still forced to search for a *Fiammingo*.[63] Apart from Piero, there were nonetheless other Italians who experimented with the oil technique and assimilated it. However, for numerous reasons, among which were different indigenous traditions, the results remained quite different from those reached by the highly estimated Flemings.

In more recent times, Netherlandish panel

paintings and tapestries have been fairly often studied in the context of Italian art. Nevertheless, their fundamental role, and particularly the pioneering one of Jan van Eyck, in the evolution of painting in Italy in the fifteenth century is still underestimated. The point has been stressed, but by surprisingly few authors.[64] A relatively large number of Jan's and Rogier's clients were Italians; their works were studied by many of their fifteenth-century Italian colleagues; and the earliest known literary sources on these Flemish painters are Italian. Even so, the chauvinism of Vasari and later writers, as well as the self-proclaimed primacy of the more classical-intellectual approach of Italian artists, have for too long been an obstacle in recognizing the extent and depth of the northern European contribution to Italian art and the importance of northern art and artists in Italy.

Piero's great interest in northern painting was not reciprocated by an interest of similar intensity on the part of artists in the north. Piero does not figure among the forty Italian artists whose *Vite* by Vasari were translated by Karel van Mander and included in his *Schilder-boeck* of 1604. For the sake of curiosity in this realm, it should perhaps be mentioned that the motif of the man who pulls his shirt off over his head in Piero's *Baptism* in London[65] has its counterparts in paintings of the same subject by two Italianizing Dutch artists, the *Baptism of Christ* by Jan van Scorel in Haarlem executed around 1530, and another by his pupil Lambert Sustris done in the 1540s in Padua.[66]

A possibly more significant example of Piero's *Nachleben* in the Netherlands is of more recent date. During two sojourns in Italy in 1938 and 1939, Pyke Koch, one of the so-called Dutch magic realists, discovered Piero della Francesca. His interest in Piero parallels that of De Chirico and the artists of the *Pittura metafisica*. The Dutch artist admired particularly the clarity of conception, the hieratic attitudes, and the serene expression of many of Piero's figures (fig. 20). In Koch's view, but certainly not only in his view, Piero was "the greatest of all painters."[67]

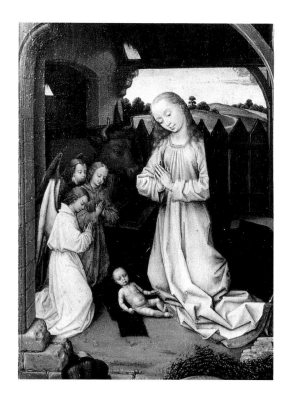

19. Rogier van der Weyden (and/or workshop), *Triptych of Alessandro Sforza* (detail) Musées Royaux des Beaux-Arts, Brussels

20. Pyke Koch, *Mrs. van Boetzelaer* Private collection

NOTES

1. For comments on Roberto Longhi, *Piero della Francesca* (Milan, 1927), see, among others, Liana Castelfranchi Vegas, "Piero della Francesca e l'apice del gusto fiammingo a Urbino nel decennio 1465–1475," in her *Italia e Fiandra nella pittura del Quattrocento* (Milan, 1983), 147, note 2.

2. Johann David Passavant, *Rafael von Urbino und sein Vater Giovanni Santi*, 2 vols. (Leipzig, 1839), 1:432, French ed. (Paris, 1860), 1:393. For interpretations of the subject and for ideas on the identification of the figures, see Maria Grazia Ciardi Dupré Dal Poggetto and Maria Cristina Castelli in *Piero e Urbino, Piero e le corti rinascimentali*, ed. Paolo Dal Poggetto [exh. cat., Palazzo Ducale and Oratorio di San Giovanni, Urbino] (Venice, 1992), 115–121: and Appendix 2 of the introduction to the present volume.

3. Roberto Longhi, *Piero della Francesca con aggiunte fino al 1962* (edizione delle opere complete di Roberto Longhi, vol. 3), (Florence, 1963), 27.

4. Mark Lewis Evans, "Northern Painters and Italian Art, 15th and 16th centuries," 2 vols. (Ph.D. diss., University of East Anglia, 1983), 1:12–13.

5. See Paolo Peri, "Velluti auro-serici nelle opere di Piero," in *Con gli occhi di Piero: Abiti e gioielli nelle opere di Piero della Francesca* [exh. cat., Basilica inferiore di San Francesco, Arezzo] (Venice, 1992), 69–72, for Piero's use of this motif. Jan van Eyck used gold brocade velvet for the first time in the figure of Saint Donatianus in his *Virgin and Child with George van der Paele* in Bruges; this figure was compared with that of Saint Zanobio in Domenico Veneziano's Saint Lucy Altarpiece (Uffizi) by Ernst Gombrich, "Light, Form and Texture in XVth Century Painting" (1964), reprinted in *The Heritage of Apelles* (Oxford, 1976), 31–32; Castelfranchi Vegas 1983, 38–39, figs. 12, 13. According to Ronald Lightbown, *Piero della Francesca* (Milan, 1992), 75, 100, 213, Piero studied works of Van der Weyden to learn the technique of imitating gold brocade, embroidery, and the play of light on fabrics.

6. For Van Eyck's color, see Marcia B. Hall, *Color and Meaning: Practise and Theory in Renaissance Painting* (Cambridge, 1992), 69, 70.

7. Roberto Weiss, "Jan van Eyck and the Italians," *Italian Studies* 9 (1956), 1–15; Emil Reznicek, "Le Fiandre e Firenze: Opere d'arte fiamminghe nelle collezioni fiorentine del Quattrocento," *Incontri*, new series 2 (1986–1987), 167–181. For a panorama of Flemish paintings and artists in Italy, see Enrico Castelnuovo, "Presenze straniere: Viaggi di opere, itinerari di artisti," in *La pittura in Italia, Il Quattrocento* (Milan, 1987), 1:514–523.

8. For Van Eyck's *Stigmatization of Saint Francis* in Turin see Elisabeth Dhanens, *Hubert and Jan van Eyck* (New York, 1980), 363; for Piero's *Saint Jerome* in Venice, see the following note.

9. Millard Meiss, "Highlands in the Lowlands of Jan van Eyck, the Master of Flemalle and the Franco-Italian Tradition," *Gazette des Beaux-Arts* 57 (1961), 305, reprinted in *The Painter's Choice: Problems in the Interpretation of Renaissance Art* (New York, 1976), 58. For Piero's *Saint Jerome*, see also Dal Poggetto 1992, 107–109; Castelli 1992, 110–112. For the portraits of Federico and Battista, see Castelli 1992, 154–158.

10. Painted shortly after the painter's probable trip to Italy in 1450, which inspired him to create monumental figures. See Lorne Campbell, *Renaissance Portraits: European Portrait-painting in the 14th, 15th, and 16th Centuries* (New Haven, Conn., 1990), 120; Carlo Bertelli, *Piero della Francesca* (New Haven, Conn., 1992), 224. Rogier's stay in Rome, controversial in more recent literature, is mentioned by Fazio; see note 30 below.

11. Campbell 1990, 120–121. See also Lightbown 1992, 231.

12. See, for instance, Charles Sterling, "Fouquet en Italie," *L'oeuil* (1988), 24, 26.

13. According to Bertelli (1992, 161), in Piero's diptych, there is none of the aerial perspective of Jan's *Crucifixion* in New York: "It is more a reasoned and thoughtful viewing than a reaction to reality."

14. Richard Cocke, "Piero della Francesca and the Development of Italian Landscape Painting," *Burlington Magazine* 122 (1980), 631.

15. ". . . horses, minute figures of men, mountains, groves, hamlets and castles carried out with such skill you would believe one was fifty miles distant from another." See Michael Baxandall, "Bartolomaeus Facius on Painting: A Fifteenth-century Manuscript of the *De Viris Illustribus*," *Journal of the Warburg and Courtauld Institutes* 27 (1964), 102 and note 27, for the description and the ownership of Van Eyck's painting.

16. According to some scholars, one extant painting Piero might have seen in Florence is the *Saint Jerome* today in Detroit. This tiny painting is dated 1441, a year after Jan's death, and some scholars believe it was finished or executed by Petrus Christus. It may well be a replica of the Van Eyck workshop. The *Saint Jerome* was the property of Niccolò Albergati (d. 1443) before it became part of the collection of Lorenzo de' Medici, where Ghirlandaio saw it and used it as source for his fresco with Saint Jerome in the Church of the Ognissanti in Florence. The identification of the Detroit painting with the one owned by Lorenzo de' Medici was made by Erwin Panofsky, *Early Netherlandish Painting* (Cambridge, Mass., 1953), 189 and note 4. The books on a shelf in the Berlin *Saint Jerome* and the finger between the pages of the Bible that Piero uses in his *Saint Jerome* in Venice of c. 1450 have been connected with those in the painting in Detroit by Bertelli (1992, 16), who also indicates a possible relation with Van Eyck's lost *Saint Jerome* in Naples, recorded by Fazio and reflected in the paintings of the subject by Colantonio and Antonello da Messina. It should be pointed out, however, that the motif of a finger between the pages of a book was fairly common in Flemish painting in general.

17. Otto Pächt, *Van Eyck: Die Begründer der altniederländischen Malerei*, ed. Maria Schmidt-Dengler (Munich, 1989), 84–85.

18. Bertelli 1992, 180. For the fresco, see Marilyn Aronberg Lavin, "Piero della Francesca's Fresco of Sigismondo Pandolfo Malatesta before St. Sigismund," *Art Bulletin* 56 (1974), 345–374.

19. Baxandall 1964, 102; Giorgio Vasari, *Le vite de' più eccellenti pittori, scultori ed architettori* (1568), ed. Gaetano Milanesi (Florence, 1878–1885), 2:565–567.

20. Vasari's chronology of the introduction of oil painting into Italy is universally considered as unacceptable (Vasari 1878–1885, 1:185); the frescoes in Sant' Egidio are nearly completely lost; see Giulietta Chelazzi Dini, in *Una scuola per Piero: Luce, colore e prospettiva nella formazione fiorentina di Piero della Francesca*, ed. Luciano Bellosi [exh. cat., Galleria degli Uffizi] (Venice, 1992), 77–80, no. 6, illustration. However, the argument for following Vasari in his statement on their technique is in the documents for the wall paintings in Sant'Egidio: several payments are for linseed oil, as Gaetano Milanesi has observed (Vasari 1878–1885, 2:685). For Piero's participation in the work done in Santa Maria Nuova, see Helmut Wohl, *The Paintings of Domenico Veneziano* (New York, 1980), 2, 202: Hall 1992, 62.

21. Vasari 1878–1885, 2:564: "mancava loro [i pittori in Italia] il modo di fare che le figure in tavola posassino come quelle che si fanno in muro."

22. In 1466 the Compagnia della Nunziata at Arezzo ordered a banner from Piero, with the Virgin and the Angel of the Annunciation to be painted in oil ("lavorato a oglio"). It was finished in 1467 but is now lost; see Gaetano Milanesi, "Le vite di alcuni artefici fiorentini scritte da Giorgio Vasari. Corrette ed accresciute coll'aiuto de' documenti da . . . ," *Giornale storico degli archivi toscani* 4 (1862), 10–13.

23. Hall 1992, 72, 80, with earlier bibliography.

24. Hall 1992, 71–72; see also 56, 79–85.

25. Michel Laclotte, "Il ritratto di Sigismondo Malatesta di Piero della Francesca," in *Piero della Francesca a Rimini: L'affresco nel Tempio Malatestiano* (Bologna, 1984), 95. See also Mauro Natale, "Lo studiolo di Belfiore: Un cantiere ancora aperto," in *Le Muse e il principe: Arte di corte nel rinascimento padano. Catalogo* [exh. cat., Museo Poldi Pezzoli] (Modena, 1991), 29.

26. See, for instance, Jill Dinkerton, "La *Musa* di Londra: Analisi delle techniche pittoriche delle due stesure," in Modena 1991, 251–262, particularly 251, 260, 262, on Cosimo Tura's *Muse* in the National Gallery in London.

27. Laclotte 1984, 102.

28. Compare Laclotte 1984, 96–98. The following payments for Flemish paintings, partially known before, are presented by Massimo Medica, *Catalogo*, in Modena 1991, 314, 315, and by Grazia Biondi, *Saggi*, in Modena 1991, 294, 295: (1) 10 August 1446, payment of 100 golden ducats "per un bellissimo dipinto raffigurante San Giorgio fatto fare a Bruges" (Computisteria Camera Ducale, mandati vol. 7, fol. 317); (2) 31 March 1447, payment of 120 golden ducats for the "imagine seu pictura nobilissima quam idem Paulus Poggus (Paolo Poggi) deduci fecit ex Bruges ad prefatum dominum nostrum (Leonello d'Este)" (Computisteria Camera Ducale, vol. 8, fol. 40v). This payment may refer to the triptych with a *Deposition* in the central panel, shown by Leonello d'Este to Ciriaco d'Ancona on 8 July 1449, as we know from the latter's description (see Giuseppe Colucci, *Delle Antichità picene* [Fermo, 1792], 15, fols. cxliii–cxliv). See also the slightly later description by Fazio (Baxandall 1964, 105). (3) 15 August 1450: "vos factores generales ipsius dari faciatis Paulo de Podio et pro eo Filippo Ambrosio sociis mercatoribus in Ferraria ducatos viginti aurii quos dictus Paulus solvit nomine prefati illustri domini nostri in Bruges excellenti et claro pictori magistro Rogerio pars et pro parte solutionis nonnullarum picturarum quas ipse fatori habet prefato domino nostro" (Computisteria Camera Ducale, vol. 10, fol. 127v). Ernst Kantorowicz, "The Este Portrait by Roger van der Weyden," *Journal of the Warburg and Courtauld Institutes* 3 (1939–1940), 179, gave a slightly different reading. (4) 31 december 1450: "E a di XXXI de dicembre ducati vinte d'oro per lei a Filippo deli Ambruoxi et compagni per nome de Paulo de Pozio da Bruza per altritanti che el dito Paulo pago a magistro Ruziero depintore in Bruza per parte de certe depinture delo illustrissimo olim nostro signore, che lui faceva fare al dio magistro Roziero come per mandato dela soa olim registrato al registro dela Camera del anno presente a carte 129 al zornale N de usita a carte 33 vaglino a soldi 48 per ducato" (first published by Adolfo Venturi, "I primordi del Rinascimento artistico a Ferrara," *Rivista storica italiana* 1 [1884], 608). See also Friedrich Winkler, *Der Meister von Flémalle und Rogier van der Weyden: Studien zu ihren Werken und zur Kunst ihrer Zeit mit mehreren Katalogen zu Rogier* (Strassburg, 1913), 182–183; Kantorowicz 1939–1940, 179. (5) 21 June 1451: "E adì deto ducati vinte d'oro de Venezia per lui a Filippo deli Ambruoxi per altritanti che lui fiece pagare ad uno depintore in abruzo per le mane de Paulo de Poxo de Bruza per due figure che detto Paolo fiece fare in Abruza per uxo del studio dicto come per mandato delo ilustre nostro signore appare registrato al registro dela camera carte 203, al zornale n de uscita a carte 103, vaglino a soldi 49 per ducato." According to H. Stein, "Un diplomate bourguignon au XVe siècle, Antoine Haneron," *Bibliothèque de l'École des Chartres* 98 (1937), 15, this is a payment concerning two panels painted by Rogier in Brussels in 1451. The payment is mentioned by Kantorowicz 1939–1940, 179.

Whether the portrait of Francesco d'Este, natural son of Leonello, in the Metropolitan Museum of Art, New York, painted by Van der Weyden during Francesco's long years in Flanders, ever returned to Ferrara is unknown. See Kantorowicz 1939–1940, 165.

29. Apart from Van Eyck, Longhi considered some other fifteenth-century northern artists in relation with Piero. In associating Fouquet and Piero, he was

probably inspired by Filarete's praise of the French painter as a portrait specialist, mentioned in the same breath as Van Eyck and Rogier van der Weyden, see *Treatise on Architecture, being the Treatise by Antonio di Piero Averlino Known as Filarete*, ed. John. R. Spencer, 2 vols. (New Haven, Conn., 1965), 1:120, 311; 2, book 9, fol. 69r; book 24, fol. 182r. Bertelli followed this lead by trying to associate copies of Fouquet portraits done in Rome with such works by Piero as the Rimini fresco and the lost wall paintings in the Vatican; Bertelli 1992, 21–22, 35, 40, 63. See also Sterling 1988, 23–31.

30. The others are Jan van Eyck, Gentile da Fabriano, and Pisanello. Fazio is also the source for Rogier's visit to Rome in the Holy Year 1450 when Piero may also have been there. See Baxandall 1964, 100 and elsewhere.

31. See note 29 above.

32. Maurice Vaes, "Oeuvre de Rogier van der Weyden en Italie, Asti, Ferrare, Naples," *Bulletin de l'Institut Historique belge de Rome* 14 (1934), 260–263; Baxandall 1964, 104–107; Evans 1983, 29; Castelfranchi Vegas 1983; Anna Garzelli, "Rogier van der Weyden, Ugo van der Goes, Filippo Lippi nelle pagine di Monte," in *Studi di storia dell'arte in memoria di Mario Rotili* (Naples, 1984), 321–330, pls. CLII–CLIX, figs. 1–14; Riccardo Passoni, *Opere fiamminghe a Chieri*, in *Arte del Quattrocento a Chieri* (Torino, 1988), 71–80; Reznicek 1986–1987, 167–181; Castelnuovo 1987, 514–523.

33. Colucci 1792, fol. cxliv; Natale, 1:40, 399; Medica, 315; Daniele Benati, 388, fig. 493, all in Modena 1991.

34. See note 28 above.

35. Michael Baxandall, "A Dialogue on Art from the Court of Leonello d'Este: Angelo Decembrio's *De Politia litteraria pars LXVIII*," *Journal of the Warburg and Courtauld Institutes* 26 (1963), 304–326, in particular 316, fig. 36c. Decembrio's dialogue was completed in Naples, Spain, and/or Milan. Compare Nello Forti Grazzini, "Leonello d'Este nell'autunno del Medioevo: Gli arazzi delle 'Storie di Ercole,'" in Modena 1991, 61.
A tapestry, already in Lausanne some time before 1461, and now in Bern, shows not only the two episodes mentioned by Decembrio but all four episodes painted by Rogier. Giorgio di Saluzzo, bishop of Lausanne, owned the tapestry and exhibited it in the *Aula episcopalis* in the castle of Ouchy. At his death in 1461, it passed to the chapter of Lausanne cathedral as a legacy; Anna Maria Cetto, *Der Berner Traian- und Herkinbald-Teppich* (Bern, 1966), 40–42. According to Forti Grazzini (1991, 61–62), it should not be excluded that Decembrio saw it there.

36. In the next century it was an argument used in Italy as a weapon in the competition for primacy between the two major European schools of painting, and which has had a steady afterlife up to some art-historical literature of the present day.

37. The passage is part of additions made by the Milanese humanist to the first redaction of his dialogue some time after 1447 and before its publication in 1462, twelve years after Leonello's death; Baxandall 1963, 306; Caterina Badini, "Angelo Decembrio, De Politia Litteraria," in Modena 1991, 162–165, note 38; Forti Grazzini 1991, 61.

38. Forti Grazzini 1991, 61. The author observes that in Ferrara there is no documentation of the presence or acquisition of the tapestry mentioned by Decembrio, and that all known versions are datable only after Leonello's death. Nevertheless, Decembrio does mention works of art (and their stylistic differences) that are immediately related to Leonello: his portrait by Pisanello (Accademia Carrara, Bergamo) and another portrait, now lost, by Jacopo Bellini (Badini 1991, 165; Natale 1991, 18). Moreover, it should be noted that Decembrio mentions only the Trajan episodes of the tapestry and not the two others that regard Herkenbald. In fact, there were many more copies of the Trajanic scenes than of the episode with Herkenbald; for example, the now lost tapestries in the palace in Evora in 1483, and those of Don Carlos de Viana in 1483; Cetto 1966, 40; Jan G. van Gelder, "Enige kanttekeningen bij de Gerechtigheidstaferelen van Rogier van der Weyden," in *Rogier van der Weyden en zijn tijd, Internationaal Colloquium* (1964), (Brussels, 1974), 119–164, especially 142. The tapestry described by Decembrio as in Ferrara might have consisted of only the two scenes of Trajan. If this were the case, it indeed was not the version documented with Bishop Saluzzo (see note 35 above).

39. On Piero in Ferrara, see Modena 1991; Giordana Mariani Canova, "Piero e il libro miniato nelle corti Padane," in Dal Poggetto 1992, 253–257.

40. Bertelli 1992, 86, fig. 70, 114, note 49; some of the women's headdresses in the Arezzo frescoes may have been modeled on examples of Northern origin. Lightbown (1992, 75) observes that Flemish prototypes might have inspired the reflections in the water of the river in the *Battle of Maxentius*.

41. For these paintings, see note 28 above.

42. Federico Cavalieri, "Echi fiamminghi in Italia: Una tavola del '400," *Osservatorio delle arti* 4 (1990), 42–49. The painting's central panel measures 54 x 46 cm; its wings 54 x 19.5 cm. Anomalies in the placement of the three donor portraits may well have to do with the fact that at least two of them were not done from life.

43. Identified by Jacques Mesnil, *L'art au nord et au sud des Alpes à l'époque de la Renaissance* (Paris-Brussels, 1911), 32–39.

44. For Battista's life, see Marinella Bonvini Mazzanti, "Per una storia di Battista Sforza," in Dal Poggetto 1992, 142–147.

45. For the trip of Alessandro and for Sveva, see Germano Mulazzani, "Observations on the Sforza Triptych in the Brussels Museum," *Burlington Magazine* 113 (1971), 252.

46. The same inventory of the Sforza library mentions two other works by Van der Weyden, a portrait

of Alessandro Sforza and one of the duke of Burgundy, both "in due occhij," that is, in three-quarter or frontal view, the northern invention complementary to the profile portrait that flourished in Italy. (For the Italian profile portrait, see Laclotte 1984, 87–95). An early echo of the Flemish half-figure portrait in three-quarter view is Domenico Veneziano's *Portrait of a Young Florentine*, 1440–1445, formerly in the Alte Pinakothek, Munich; see Sterling 1988, 24, fig. 4. The portrait of Philip the Good may be one of a number of versions of two portraits by Rogier, none of them accepted as original. For the inventory of the Sforza library in Pesaro, see Mulazzani 1971, 253, note 17; Martin Davies, *Rogier van der Weyden: An Essay, with a Critical Catalogue of Paintings Assigned to Him and Robert Campin* (London, 1972), 207. For Rogierian portraits of Philip the Good, see Max J. Friedländer, *Early Netherlandish Painting*, 2 vols. (Leiden-Brussels, 1967), 2:88, nos. 125a–g, pl. 127; Davies 1972, 239–240.

47. Cavalieri 1990, 49. For the Pala di Montefeltro, see Marilyn Aronberg Lavin, "Piero della Francesca's Montefeltro Altarpiece; a Pledge of Fidelity," *Art Bulletin* 51 (1969), 367–371, also Carlo Bertelli, "Lo spazio nella pala del Montefeltro," in Dal Poggetto 1992, 169–172; Castelli 1992, 174–175.

48. Vespasiano da Bisticci, *Virorum illustrium CIII qui saeculo XV extiterunt vitae* (1480–c. 1498), *Vite di uomini illustri del secolo XV*, ed. Paolo D'Ancona and Erhard Aeschlimann (Milan, 1951), 231. In nearly all extant portraits, Federico da Montefeltro is represented in armor and in profile; see Mario Scalini, "Armature ad Urbino: L'opera di Paolo Uccello e Piero," in Dal Poggetto 1992, 179–185.

49. Lavin 1969, 368.

50. Cavalieri 1990, 49.

51. Cavalieri 1990, note 17. Cavalieri's still unpublished larger study on the Sforza triptych, mentioned in his note 8, has been kindly sent to this author. It contains interesting observations that are awaiting publication. For Piero in Pesaro, see Maria Rosaria Valazzi, "Piero scomparso a Pesaro e Ancona," in Dal Poggetto 1992, 427–433; Lightbown 1992, 71.

52. Eugenio Battisti, *Piero della Francesca*, 2 vols. (Milan, 1971), 1:519, note 486, 2: fig. 190, emphasizes "la mancanza di rassomiglianza, certamente non dovuta solo ad invecchiamento e a malattia," between the two profile portraits of Battista. The author supposes that when doing the portrait in the Uffizi, Piero had neither the live model nor a painted one before him, but a death mask. While this supposition is unproven, it is certain that the painter of the Sforza triptych in Flanders had to do without the live model. What the starting point was for this portrait of Battista, shown somewhat younger than in Piero's painting, is not known. For other portraits of Battista, see Francesca Laurana in Dal Poggetto 1992, 160–161, no. 128.

53. See, for example, Kenneth Clark, *Piero della Francesca* (London, 1969), 61. See also Lightbown 1992, 274.

54. According to Bertelli 1991, 218, Piero's painting is cited in two angels of the *Madonna and Saints* (Arezzo, Museo Statale d'Arte Medievale), painted by the Aretine artist Lorentino d'Andrea and dated 1482. The dependence on Piero's music-making angels is neither to be excluded nor certain. For Lorentino's painting, see also Giovanna Damiani, in *Nel raggio di Piero: La pittura nell'Italia centrale nell'età di Piero della Francesca*, ed. Luciano Berti [exh. cat., Sansepolcro, Casa di Piero] (Venice, 1992), 94–96, no. 15. For Flemish influences on the *Nativity*, see also Castelfranchi Vegas 1983, 134. Longhi (1963, 67) sees more relations with the Master of the Annunciation of Aix, Fouquet, and Charenton.

55. The painting by Van der Goes arrived in Florence in 1483. Bianca Hatfield Strens, "L'arrivo del trittico Portinari a Firenze," *Commentari* 19 (1968), 315–319.

56. For this work, see Davies 1972, 201–203, pl. 121; Odile Delenda, *Rogier van der Weyden: Das Gesamtwerk des Malers* (Stuttgart-Zurich, 1988), 82–85.

57. Giuseppe Marchini, *Filippo Lippi* (Milan, 1975), 211, no. 48, fig. 144; see also the discussion by Marilyn Aronberg Lavin in this volume.

58. For example, the *Adoration of the Shephards* by the Master of Flémalle in Dijon, Musée des Beaux-Arts; Davies 1972, 247–248, pl. 155.

59. Laclotte 1984, 97.

60. Fazio (1456) in Baxandall 1964, 103.

61. Alice Bonner McGinty, "Stradanus (Jan van der Straet): His Role in the Visual Communication of Renaissance Discoveries, Technologies, and Values," (Ph.D. diss., Tufts University, 1974; University Microfilms, Ann Arbor, Mich.), 141–144. For a good illustration, see Dhanens 1980, 69, fig. 40.

62. Vasari (1568), ed. Milanesi, 1878–1885, 2:567: "Ma contuttociò sebbene; mercanti ne facevano incetto e ne mandavano [painting done in oil] per tutto il mondo a principi e gran personaggi, a loro molto utile, la cosa non usciva di Fiandra. . . . non si trovó mai nello spazio di molti anni."

63. Vespasiano da Bisticci 1951, 209: "per non trovare maestri a suo modo in Italia che sapessino colorire in tavole a olio, mandò infino in Fiandra per trovare uno maestro solenne, et fello venire a Urbino, dove fece fare molte pitture di sua mano solennissime et maxime in uno suo istudio, dove fece dipingere e' filosofi e poeti e tutti e' dottori della Chiesa." According to the same source, Federico also wanted Flemish tapestry weavers at his court. See for these masters Benedetta Montevecchi, "Giusto, Berruguete e i Fiamminghi a Palazzo," in Dal Poggetto 1992, 338.

In 1492 Giovanni Santi did not include Justus van Gent in his *Cronaca Rimata*, but he does mention his Flemish predecessors of a half century and more earlier, Jan van Eyck and Rogier van der Weyden: "Di colorir son stati excellenti/Che han superati molte volte el vero;" Renée Dubos, *Giovanni Santi peintre et chroniqueur à Urbin, au XV^e siècle* (Bordeaux, 1971), 73–74.

64. Meiss 1961, 304: "(Van Eyck) is not only the most acute and passionate analyst of visual appearances in his century but more than anyone else he found symbols for this intense visual activity, alluding to it, in other words, by iconographic equivalents." See also Reznicek 1986–1987, 168.

65. A motif used before Piero by Masolino in Castiglione d'Olona and by Domenico di Bartolo in Siena; see Luciano Berti, *Nel raggio di Piero* (Venice, 1992), 17, fig. 23. Gentile da Fabriano's version in San Giovanni Laterano in Rome, copied in a drawing by Pisanello, is quite different. See Bertelli 1992, 58, fig. 48.

66. For these paintings, see Bert W. Meijer, "Over Jan van Scorel en het vroege werk van Lambert Sustris," *Oud Holland* 106 (1992), 10, figs. 14, 15.

67. Carel Blotkamp in *Pyke Koch* [exh. cat., Institut Néerlandais, Paris, Gemeentemuseum, Arnhem, Musée d'Art moderne] (Liège, 1982–1983), introduction, under fig. 1, and throughout. See also Carel Blotkamp, *Pyke Koch* (Amsterdam, 1972), 96–98, 102, 137, note 43 (also on Piero and Co Westerik), 142, note 9; D. Kraaijpoel, "Piero als voorbeeld," *Kunstschrift* 5 (1992), 41–46 (also on Westerik and others).

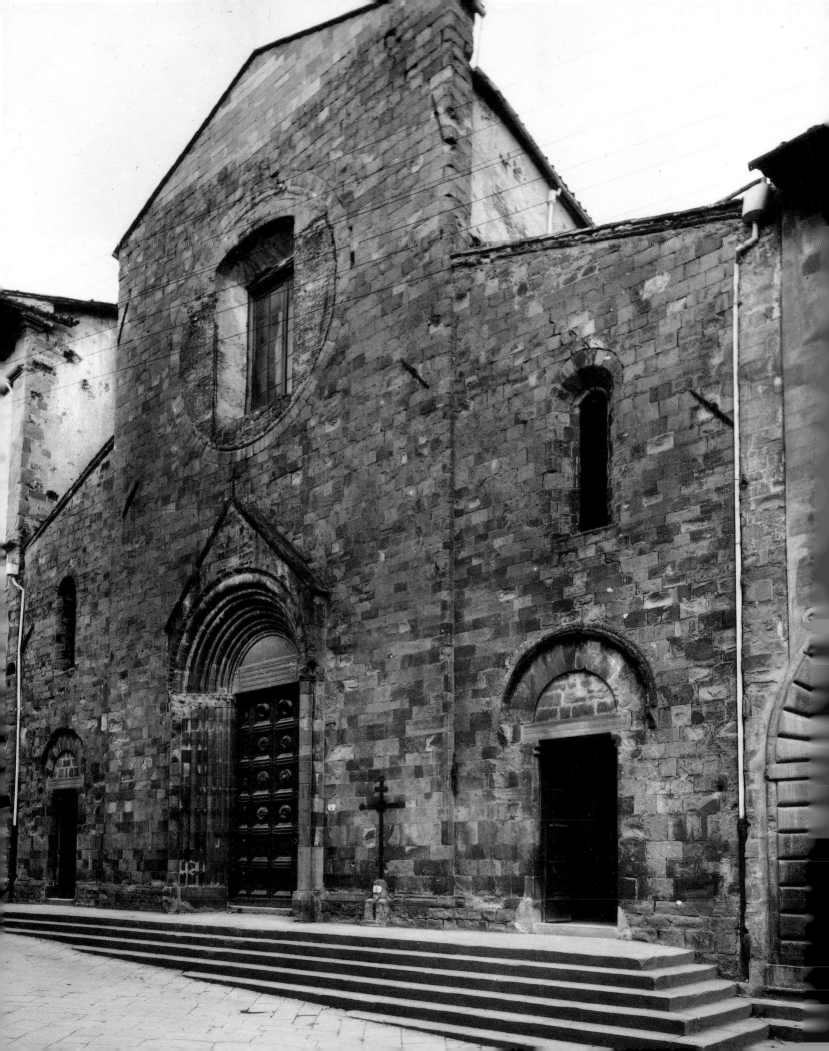

PAUL F. GRENDLER
University of Toronto

What Piero Learned in School: Fifteenth-Century Vernacular Education

We know nothing about Piero della Francesca's education. The lack of information on his schooling is particularly unfortunate because, by the time of his death, he clearly was an extraordinarily learned man in some fields. By contrast, a certain amount is known about primary and secondary education in the Italian Renaissance. By the early fifteenth century, Italian schools had developed fairly standard school structures and curricula. Further, the organization and curricula of elementary and secondary schools demonstrated much similarity from town to town and region to region. Relying on what is known about pre-university schools, Piero's father's occupation, the education of contemporary artists, and Piero's mathematical works, I will speculate on the schooling that Piero may have received.

Father, Family, and Town

Piero della Francesca was born, probably between 1410 and 1415, in the town of Sansepolcro on the border between Tuscany and Umbria.[1] Indeed, Piero lived in Sansepolcro with the exception of time spent as an assistant painter in Florence, and extended trips to Arezzo, Rome, and Urbino to execute painting commissions. Sansepolcro was a town of about 4,000 to 4,400 souls in the decade of Piero's birth. Plague in 1425 reduced its population, but recovery raised it again to about 4,400 by mid-century.[2]

Sansepolcro was a regional commercial center whose major trade was the buying and selling of agricultural products and tools. The town also boasted merchants who sold cloth to nearby villages. These same cloth merchants gathered and sold an herb called woad to cloth manufacturers in northern and central Italy, who turned it into a blue dye.[3]

Piero's father, Benedetto, earned his living as a merchant who bought and sold wool and woad. He does not seem to have been a merchant prince such as the powerful heads of Florentine commercial enterprises or Francesco di Marco Datini (c. 1335–1410), the merchant of Prato.[4] Such men bought and sold merchandise, engaged in banking activities on an international scale, and became very wealthy. Benedetto della Francesca did not reach these heights; no merchant residing in a regional center such as Sansepolcro could hope to attain such a peak of commerce and wealth. Nor could Benedetto's family boast of noble status or claim to be one of the most important in the town. Still, Benedetto was well off by contemporary standards. Like other Renaissance merchants, he invested in land when he could, and became embroiled in a number of commercial disputes.[5] He was wealthy and important enough in Sansepolcro that his sons would be among the minority of the male population privileged to attend school.

Only a minority of the male children of a

Renaissance city or town, usually the upper one-fourth to one-third of the sons of the town, attended school. The earliest Italian schooling and literacy statistics came from late sixteenth-century Venice, where 25 to 33 percent of the male population of school age (six through fifteen) attended school. The schooling rate for girls was considerably lower, certainly less than 10 percent.[6] Since schools were probably more available in large cities such as Venice, the modest commercial center of Sansepolcro may have had a slightly lower schooling and literacy rate.

A Choice of Schools: Latin or Vernacular Abbaco?

When Piero reached the age of six or seven, his parents had to decide what kind of school he should attend. Italy in the late Middle Ages and the Renaissance had two school systems, Latin and vernacular.

By the middle of the fourteenth century, Italians had established a large educational structure of primary and secondary schools. Probably every city or town and some rural villages in northern and north central Italy had schools. Major urban centers such as Venice, Genoa, and Florence had numerous schools and enrolled many pupils. Smaller centers such as Sansepolcro followed in their wake, but obviously had fewer schools.

Schools and their teachers can be classified according to their sponsors and financial support as communal, church, and independent.[7] The town government, called the "commune," sponsored and controlled communal schools. The commune appointed the teacher, fixed the terms of his contract, paid his salary (which was often supplemented by student fees), and might exercise limited curriculum control. Communal schools embodied the government's ideological and financial commitment to educating some of the boys of the town, often the sons of the leading citizens. But communal schools were not numerous; a town might have only a single communally supported teacher who taught twenty to thirty boys.

Church schools, that is, schools organized and sponsored by an ecclesiastical person or institution, such as a bishop acting through the cathedral chapter, a monastery, or a parish priest, were even fewer in number.

The textbook cliché states that the church was the most important educator in medieval and Renaissance Europe. This is simply not true for Italy. For several reasons, Italian ecclesiastical schools underwent such drastic decline between 1000 and 1300 that almost all pre-university ecclesiastical schools disappeared.[8] After 1300 the church educated only a few of the Italian boys destined for the religious life; indeed, many future priests, monks, and friars attended secular schools. Convents for religious women also educated some girls. The close association between church and school typical of fourteenth- and fifteenth-century England,[9] and possibly elsewhere, did not prevail in the Italian peninsula in the fourteenth, fifteenth, and first half of the sixteenth centuries.[10]

Independent schools educated the vast majority of children fortunate enough to attend school. A freelance master and the parents created an independent school. Some independent masters taught in wealthy households, either living there or visiting daily to teach the children of the household. Many more independent masters simply opened schools in their homes or in rented premises and taught all those children in the neighborhood whose parents were willing to pay the modest fees demanded. An independent master normally taught as many boys as could fit into a single room, usually between ten and forty.

"Independent" is the correct term for these masters, because they were not subject to the control of commune or church. They taught what they wished in the way they wished. An independent master was subject only to the ultimate authority of parents, who would withdraw their sons and stop paying the master if they disapproved of him and his teaching. He would then try to attract other pupils, or move to another town and open a new school. The independent master can be documented as early as the thirteenth century in Italy, and his origins probably go back further. Independent masters played a major educational role until the unified Italian state expanded public education in the second half of the nineteenth century, and can still be found today. Because neighborhood independent schools were far and away most numerous and available, it is nearly certain that Piero attended one.

Boys—or girls, if they were fortunate—began school at the age of six or seven. In the first year or so they learned to recognize the letters of the alphabet.[11] Then they learned syllables, such as "Ba be bi bo bu, Da de di do du, Ga ge gi go gu." Word and sentence recognition came later. The student did this with the aid of a hornbook or primer which contained the letters of the alphabet and prayers, such as the Our Father and the Hail Mary. The primer was written in Latin or Latin and Italian. Much of this learning was done orally: the pupil spoke aloud the letters and syllables in response to the teacher's prompting or when he recognized them in the hornbook. The student also began to learn to write in the first year or so, writing letters, syllables, and finally words. As soon as the student learned letters, syllables, and a few words at the age of about seven, the parents had to make the most important educational decision of the child's life: should the child attend a Latin or a vernacular school?

Latin schools had existed in medieval Italy for hundreds of years and would continue in the Renaissance and beyond. Medieval pre-university Latin schools taught Latin grammar and rhetoric with the aid of a series of Latin texts.[12] They began with the *Ars minor* of Donatus, the fourth-century Roman grammarian who taught Saint Jerome. Donatus' *Ars minor*, or another elementary Latin syntax manual that went under the name of Donatus, was the beginning of medieval Latin schooling. A number of elementary Latin readers followed, which taught grammar and good morality. These readers were mostly "manufactured" Latin texts written by medieval authors. That is, like a twentieth-century English "Dick and Jane" elementary reader, they were original texts written with the needs and limitations of young school children in mind. Medieval Latin primary and secondary schools also taught to a limited extent parts of some ancient Latin classical texts.

The humanists condemned most of the texts taught in medieval Latin schools as barbaric and uncultured. They offered as alternatives a new curriculum based almost exclusively on ancient classical texts, above all the poetry of Vergil and the letters of Cicero, especially his *Epistulae ad familiares*. The famous humanist pedagogues, Gasparino Barzizza (1360–1430), Guarino Guarini (1374–1460), and Vittorino da Feltre (1373/1378–1446/1447), developed Renaissance Latin schools in the first half of the fifteenth century. By about 1450, probably half or more of the Latin schools in Italy had adopted a humanistic curriculum. After mastering Italy, humanistic studies passed on to northern Europe in the sixteenth century. Latin schools teaching a classical curriculum trained Europe's future leaders and professional classes for hundreds of years. The story is well known and immensely significant for the history of European civilization.[13]

Sansepolcro had Latin teachers. The commune supported a Latin schoolmaster, while a few independent Latin teachers taught there at the time of Piero's youth.[14] Thus some boys in Sansepolcro attended Latin schools in the first third of the fifteenth century. When the humanist curriculum arrived in Sansepolcro, possibly in the middle of the fifteenth century, these pupils learned the Latin classics and how to write Ciceronian prose.

But late medieval and Renaissance Italy had an alternative school curriculum. Italy had primary and secondary schools that taught vernacular reading and writing, commercial mathematics, and accounting, instead of Latin grammar and literature. These schools taught the skills of commerce and work. Abbaco and vernacular literature schools[15] arose in the second half of the thirteenth century in response to the needs of the leading commercial society of Europe: Italian merchants needed schools to train their sons and future employees in commercial mathematics.

Commercial mathematics, called abbaco, came from the famous treatise entitled *Liber abbaci* (1202, revised 1228) of Leonardo Fibonacci (or Leonardo of Pisa, c. 1170–after 1240).[16] The son of a Pisan governmental official sent to direct the Pisan trading colony at Bougie (located in present-day Algeria), Leonardo studied Arab mathematics in North Africa and during business trips to Egypt, Syria, Greece, Sicily, and elsewhere. Upon his return to Pisa about 1200, Leonardo composed a series of Latin mathematical works that made him the most important western mathematician between Archimedes of the third century B.C. and

Newton of the seventeenth century. One of these works, his *Liber abbaci*, was an encyclopedia of practical mathematics adapted to the needs of merchants. The mathematical problems presented were overwhelmingly commercial ones: measuring and calculating the prices of bolts of cloth; money exchange problems; interest and discount problems; dividing the profits of a successful partnership; alligation exercises, that is, determining how much gold or silver to add or subtract to an existing metallic mixture so as to have the correct alloy with which to produce coins of a certain purity; and every sort of linear and solid measurement problems including those requiring a knowledge of plane and solid geometry. Abbaco used arithmetic, algorism (computing with numbers, especially decimals), algebra, and geometry, all based on the Hindu-Arabic numeral system, to solve these business-related mathematical problems.[17]

Schools and teachers of abbaco appeared within twenty-five years of Leonardo's death and possibly earlier. The first known reference to a "maestro d'abaco" appeared in a Bolognese document of 1265.[18] By the second half of the fourteenth century, vernacular abbaco schools were very common. They remained a major part of the educational landscape through the fifteenth and sixteenth centuries and beyond.[19]

Latin and vernacular abbaco schools were physically separate. One boy attended a neighborhood independent Latin school led by a master who taught about thirty boys in his home or rented quarters. The boy who lived next door might attend an independent vernacular literature and abbaco school led by a different master. The latter taught a different group of thirty boys in his home or rented room. In Venice in 1587–1588, for example, approximately 47 percent of schoolboys attended Latin schools, and 53 percent of schoolboys were enrolled in schools that taught vernacular reading and writing, abbaco, and accounting.[20]

The two curricula overlapped very little. Most of the vernacular literature and abbaco schools in late sixteenth-century Venice also taught the rudiments of Latin grammar, basically the contents of an elementary syntax manual. But these schools did not teach boys how to read the Latin classics. At the age of fourteen or fifteen, the schoolboy who attended a vernacular literature and abbaco school emerged with only the ability to recognize a few words and inflected forms in Latin, if he remembered that much. Latin schools did not cross the curricular boundary either. Only 5 percent of Venetian Latin schools taught abbaco as well as Latin grammar and literature at the end of the sixteenth century.[21] The two school curricula were quite separate. The same curricular separation was found elsewhere in Italy as well.[22]

The two curricula arose to meet distinct occupational needs of Italian society. Latin was the language of the university, the church, law, and the formal statutory aspects of government. All university lectures, assigned texts, disputations, and examinations were conducted in Latin. Church documents were written in Latin. Legal documents, such as notarized records of property transactions, were written in Latin. Formal governmental records, including official accounts of governmental discussions, were written in Latin, even when fifteenth-century city councillors orated in an Italian dialect. Hence boys who intended to become bishops, statesmen, physicians, lawyers, judges, administrators, or secretaries attended elementary and secondary Latin schools. In general, all those destined for leadership roles or professional careers attended Latin pre-university schools. Renaissance Latin schools ignored abbaco because it added nothing to the social status and career skills needed by their students.

By contrast, boys who would be assuming an apprenticeship or position in the commercial world attended abbaco and vernacular literature schools. Hence the son of a prominent merchant who would inherit the business attended a vernacular abbaco school. Boys whose parents expected them to find more modest posts in commerce and banking also attended abbaco and vernacular schools. More broadly, almost every boy who did not come from a privileged or professional family attended a vernacular abbaco school. This included the sons of artisans, if they were fortunate enough to attend school at all. Latin and vernacular abbaco schools were socially and occupationally separate.

Contemporaries expected that artisans wish-

ing to learn mathematical skills would attend abbaco schools. Sassolo da Prato (1416/1417–1449), pupil and biographer of Vittorino da Feltre, wrote in 1443 that many say that arithmetic should be left to artisans.[23] Although Sassolo noted that Vittorino rejected this view, it is clear that he was in the minority. And Vittorino only partly departed from the majority view. He had a strong interest in mathematics and had studied Euclid (probably the *Elements*) and possibly algebra when he attended the University of Padua. Vittorino then taught some mathematics in his famous humanistic Latin school at Mantua between 1423 and 1446/1447. The sparse available evidence mentions that Vittorino taught Euclid in his school as part of the quadrivium, but not abbaco. In other words, Vittorino probably taught Euclid within the context of a philosophical approach to mathematics, an approach typical of university mathematical study. There is no evidence that Vittorino learned or taught abbaco.[24] He was a Latin humanistic schoolmaster teaching the sons of princes.

Piero Goes to School

Did Piero attend a Latin school or a vernacular abbaco school? Because the Renaissance was a hierarchical age, parents and society assumed that most boys would follow in the occupational and social footsteps of their fathers. Residence, whether in urban metropolis or provincial hamlet, also played a role in determining school choice.

Future artists born outside the major urban centers to parents who were not part of the small class of social and civic leaders of Renaissance society normally attended vernacular abbaco schools. Donato Bramante (c. 1444–1514) was born poor in or near Urbino. Vasari wrote: "In his childhood, besides reading and writing, he gave much attention to abbaco." Then his father set him to painting in the hopes that he would earn some money.[25]

Leonardo da Vinci (1452–1519), the illegitimate son of a man who came from a region a few miles west of Florence, also studied abbaco and was a brilliant student. "Thus, in abbaco, he learned so much in a few months, that he constantly confused his teacher with the questions and problems that he raised," Vasari wrote. Vasari stressed both Leonardo's youthful brilliance and his instability. Leonardo made brilliant progress in whatever he turned his mind and hand to, but would as quickly drop a subject.[26] Vasari's accounts suggest that Bramante and Leonardo da Vinci studied vernacular reading, writing, and abbaco as schoolboys, but not Latin.

The early schooling of Filippo Brunelleschi (1377–1446), who was born in Florence, was different. Filippo's father, Ser Brunellesco Brunelleschi, was a notary who held an important and responsible position in the Florentine civil service. Filippo's great grandfather and great-great grandfather had been physicians. Filippo's mother was a Spini, an old and quite important Florentine family. Filippo's father acted on behalf of the Dieci della Balìa, a Florentine magistracy that oversaw military affairs. Ser Brunellesco often went abroad to Germany, France, Britain, and Flanders on behalf of the Republic of Florence in order to purchase arms, armor, and horses, or to hire mercenary soldiers.[27]

A boy of Filippo Brunelleschi's background learned Latin because his father would want him to follow in his and his family's footsteps. Brunelleschi's fifteenth-century biographer tells us that this is exactly what happened. Filippo was sent to school to learn reading, writing, and abbaco, and then to learn Latin: "At a tender age, Filippo learned reading and writing and abbaco . . . and also some Latin (*qualche lettera*), because his father was a notary, and perhaps thought to make him the same. At that time only a few besides those who expected to become a physician, notary, or priest studied, or were sent to study, Latin (*lettere*)."[28] However, because Filippo soon demonstrated a great love of drawing, his father sent him to become a goldsmith. Architecture followed.[29]

Bramante, Leonardo da Vinci, and Brunelleschi all became artists of great importance, but the first two were not sent to study Latin at an early age. The dissimilar elementary educations stemmed from the obvious differences in the professional positions of the fathers and the social status of the families. Finally, birthplace made a difference. Other things being equal, a boy born in the metropolis of Florence would be more likely to study Latin than Bramante, born in the

hills of Umbria, or Leonardo, born in the Tuscan countryside.

It seems almost certain that Piero received an early education in abbaco and vernacular literature. It was almost preordained that Piero would receive an education preparing him to follow in the footsteps of his father, a merchant in a provincial town. Vasari's comment supports the supposition that Piero attended an abbaco school: "In his youth Piero applied himself to mathematics."[30] The most likely place where Piero studied mathematics as a youth was in an abbaco school. The fact that the adult Piero wrote an abbaco treatise clinches the point.

To date historians have not been able to document the presence of an abbaco schoolmaster in Sansepolcro at the time of Piero's youth.[31] But this does not mean that Sansepolcro lacked one or more abbaco teachers. Abbaco schoolmasters are considerably more difficult to locate in archival records than Latin teachers, because most abbaco masters were independent teachers. The commune did not hire them and took no official notice of them unless a master ran afoul of the law. Abbaco teachers seldom became visible in tax records, because their incomes were low. Latin teachers often appeared in archival records as the authors of, or witnesses to, Latin notarial documents dealing with a variety of matters.[32] Abbaco teachers did not compose or witness notarial records because they normally lacked the requisite Latin.

Although archival evidence is lacking to document the presence of most abbaco teachers, they certainly taught in provincial commercial centers. Indeed, Tuscany produced many abbaco teachers who fanned out across the peninsula to teach elsewhere.[33] And Luca Pacioli, a famous mathematician of his day, was born in Sansepolcro c. 1445.[34] It is safe to assume that one or more abbaco masters taught in Sansepolcro during Piero's youth.

The Curriculum of Vernacular Abbaco Schools

A boy such as Piero attended an independent abbaco school in his neighborhood. There in a single room, a teacher, who was almost always a layman, taught abbaco, vernacular reading and writing, and sometimes accounting to about thirty boys.

The mathematical content of abbaco instruction is found in a large and important corpus of professional literature. Late medieval and Renaissance abbaco teachers wrote numerous treatises in which they posed and solved a variety of mathematical problems. Warren Van Egmond has catalogued 288 extant Italian abbaco manuscripts written between c. 1290 and 1600, plus 153 printed editions of abbaco treatises published before 1600.[35] These manuscripts demonstrate that abbaco schools closely followed the lead of Leonardo Fibonacci. Even though Fibonacci wrote in Latin, practically all abbaco manuscripts were written in Italian because the vernacular was the language of business, and the schools also taught vernacular literature.

In a historical development whose details are unknown, abbaco masters at some point added new subjects beyond abbaco. They taught double-entry bookkeeping and, above all, vernacular reading. That is, they taught boys how to read a series of secular and religious vernacular books and how to write in Italian. For example, a fifteenth-century contract obliged an abbaco teacher in Volterra to do the following in addition to teaching abbaco: "You must teach accounting and writing to all the boys who come to your school. (You have) the additional obligation to teach reading to those who do not wish to study Latin but wish to learn to read vernacular books and written letters."[36] Thus fifteenth-century abbaco schools taught vernacular texts as well as abbaco.

No list of the vernacular texts taught in fifteenth-century vernacular reading and abbaco schools has come to light.[37] The only known list of the texts taught in vernacular schools comes from late sixteenth-century Venice, the byproduct of a teacher survey.[38] It is likely that sixteenth-century schools taught the same texts as taught in the fifteenth century for several reasons. First, many of the elementary vernacular schoolroom texts had been written in the fourteenth century. Since they were still taught in the late sixteenth century, they must have been part of the fifteenth-century curriculum. The elementary school curriculum is notoriously resistant to change and was even more recalcitrant in centuries past.

Second, these texts were the works of adult popular culture. Since neither town council nor pedagogical theorist told vernacular schoolmasters what to teach, the masters taught the books that teachers and parents owned and loved. Indeed, parents sometimes sent children to school carrying the book or two owned by the household. Or the teacher brought his own copy to school in the pre-print age. A wave of popularity swept certain titles into the classroom, and the dike of tradition kept them there.[39] Most of the books offered a combination of didacticism and human interest.

The beginning reader was the *Fior di virtù*.[40] Written between 1300 and 1323 by an unknown author, this book is one of the most interesting medieval books of virtues and vices. The book contained about forty short chapters of about five hundred words, each devoted to a single virtue or vice. Every chapter contained three main parts: an animal legend, a series of maxims of conduct, and a story with human subjects, all illustrating the dangers of a vice or the rewards of a virtue. Some of the human stories presented examples of heroic Christian virtue; others recommended worldly-wise social conduct. The text carefully avoided doctrine, theology, and praise of the religious life. Tight organization, vivid stories, and clear, simple prose made the book popular.[41]

Another text commonly used was the *Epistole e Evangeli che si leggono tutto l'anno alla messa* (Epistles and Gospels that are read the whole year at mass). These books or lectionaries contained the canonical selections from scripture, that is, the two pericopes (extracts) to be read daily at mass, the first drawn from the Epistles, the second from the Gospels. The pericopes included well-known sermons, parables, and scenes from the life of Christ, plus important passages from Paul's letters. Often the epistle and gospel pericopes were thematically related.[42]

Students in vernacular schools read various saints' lives. The texts were often listed generically in such terms as "vite dei santi" or "vite dei diversi santi," making precise identifications impossible. But two identifiable and famous collections of saints' lives were used as school texts. Some teachers taught *Le vite dei Santi Padri*. This was a collection of lives of the desert fathers of Egypt, composed in Greek by Saint Athanasius (295–373) and translated into Latin in the fourth century. Additional saints' lives were appended to the collection in future centuries. Then the Pisan Dominican friar Domenico Cavalca (c. 1270–1342) and anonymous collaborators from his order freely translated and rewrote the lives into Italian in the fourteenth century.[43]

Some teachers taught a vernacular version of the *Legenda Aurea* (composed 1260–1267) by the Dominican Jacopo da Varazze (Jacobus de Voragine, c. 1230–1298), who spent most of his career in Genoa. Translated into Italian as *Leggendario dei santi* in the middle of the fourteenth century, these historically unreliable lives and legends tried to foster devotion toward God and the saints by means of stories skillfully adapted to an unlearned readership. Piero della Francesca may have first encountered the story of the Holy Cross as a schoolboy reading Jacopo da Varazze's work in the classroom.[44]

The vernacular schools also taught the ever-popular chivalric romances.[45] They did not build character nor lead men to God, but gave pleasure through exciting stories of knights and ladies, adventures and battles. Chivalric romances appeared in the curriculum because readers loved them. They must have come as welcome relief to children after the relentless moralizing of the *Fior di virtù* and saints' lives. Piero della Francesca more than likely read these or very similar books in the vernacular literature and abbaco school that he attended in Sansepolcro in the 1420s.

Vasari wrote that at the age of fifteen it was determined that Piero would become a painter.[46] Vasari's words seem to mean that Piero began his apprenticeship as a painter at that age. Indeed, it is likely that Piero was an apprentice to the local painter Antonio di Giovanni d'Anghiari for an indefinite period before 1431. Piero then served as Antonio d'Anghiari's paid assistant, a stage beyond apprenticeship, for at least five projects between 1432 and 1438.[47]

If Piero left school at the age of fifteen to begin his apprenticeship, he followed a well-trodden path. Boys attending abbaco and vernacular literature schools might leave at any age because no regulation required a student

to spend a minimum number of years in school. Boys normally abandoned the schoolroom between the ages of twelve and fifteen in order to become apprentices to a merchant or artisan. If Piero began school at six or seven and left at fifteen, he had eight or nine years of schooling, a generous span of years for a person of his background. Since instruction cost money, parents halted a boy's schooling when he could begin a career. Thus Piero left school with a knowledge of abbaco and a few texts from late medieval vernacular literature.

The Adult Piero

The adult Piero was a profoundly thoughtful painter and one of the ablest mathematicians of his century. He obviously learned a great deal more mathematics as an adult than he had known as a child. He knew well the mathematics of Euclid and Archimedes. Did he acquire as an adult the Latin enabling him to study ancient Greek mathematical texts in Latin translation? The evidence supports both a negative and a positive answer.

That Piero wrote his mathematical treatises in Italian argues that he could not write Latin prose. Piero wrote the *Trattato d'abaco* in Italian. He also wrote *De prospectiva pingendi* in Italian; his fellow townsman Matteo Cioni da Borgo Sansepolcro then translated it into Latin. It is also likely that Piero wrote the *Libellus de quinque corporibus regularibus* in Italian and that someone, possibly Cioni, translated it into Latin.[48] Had he been able, Piero more than likely would have written all his treatises in Latin, the prestigious and universal language of learning.

Instead, Piero wrote the *Trattato d'abaco* in a simple and inelegant Italian. This is the tacit judgment of a contemporary. About 1493 an unknown person revised Piero's Italian as he prepared a second manuscript version of the *Trattato d'abaco*. The unknown editor rewrote passages to clarify the meaning. He revised the language to make it read more smoothly and tried to add the syntactical rigor missing in the original.[49]

Modern scholars who have examined the autograph *Trattato d'abaco* concur that Piero wrote a simple and unimpressive Italian prose. Margaret Daly Davis judges Piero's Italian to have been "simple, at times even elementary."[50] Marshall Clagett describes Piero's Italian prose as unclear.[51] Warren Van Egmond appraises Piero's literary abilities as "mediocre at best."[52] Since Piero's Italian prose style was inelegant and simple, he probably did not spend enough time in school to acquire a fluent Italian literary prose style.

In addition, if Piero had learned to write Latin well, his Italian would have implied as much. Renaissance Italian prose often betrays an extensive training in classical Latin, especially a good knowledge of Cicero, the model for prose style in humanistic schools. Some Renaissance Italians were so steeped in classical Latin that they wrote a convoluted Italian prose which mimicked Latin sentence structure, periodization, and rhetorical flourishes, all to the detriment of a good vernacular style. Piero's Italian did not do this. The simple Italian prose of Piero's mathematical treatises confirms a lack of classical Latin.

Although Piero's Italian skills have not impressed scholars, his mathematical skills have. While noting Piero's occasional fumbles, historians of mathematics agree that he was an accomplished mathematician. Piero was "one of the foremost mathematicians of his period," writes Van Egmond. His *Trattato d'abaco* was "one of the more important algebraic works of the fifteenth century."[53] Davis notes the high quality of Piero's mathematics in the *Trattato d'abaco* and the *Libellus de quinque corporibus regularibus*.[54]

Historians of mathematics who have analyzed Piero's three treatises are convinced that he knew all fifteen books of Euclid's *Elements* and had some knowledge of Archimedes as well.[55] Did he read these Greek mathematicians in Latin or Italian translations? The answer to this question depends on the availability of these texts in Latin or Italian, an area where much research remains to be done. Euclid's *Elements* were available in Latin translation in the fifteenth century, but not in Italian translation until the sixteenth century, so far as is known.[56] Piero may have known Euclid directly through medieval Latin translations or through a medieval Latin intermediate text.[57]

But Piero may also have learned a good deal of Euclidian mathematics through an Italian translation of Leonardo Fibonacci,

who knew and used all fifteen books of the *Elements*. While he wrote his *Liber abbaci* in Latin, Fibonacci's works were available in Italian translations in the fourteenth and fifteenth centuries.[58] Piero knew Leonardo Fibonacci's works well.[59] In addition, the many abbaco vernacular manuscripts also repeated some Euclidian material.[60] Thus Piero may have learned his Euclid through vernacular versions of Fibonacci and/or other abbaco manuscripts.

Piero also had some knowledge of the works of Archimedes. As Clagett writes, "Piero's early geometrical work . . . reveals essentially a knowledge of the medieval Archimedes (and particularly a knowledge of the Archimedean sections of Leonardo Fibonacci's *Practica geometrie*)."[61] Piero probably also read additional medieval mathematical texts which transmitted Archimedes' mathematics. Like Fibonacci's works, some of these were available in Italian translation.[62] Thus Piero may have learned his Archimedes from Italian texts.

There is one exception to the preceding statement. Clagett also argues that Piero closely followed one particular Latin manuscript of Archimedes for a small section of his last mathematical work, *Libellus de quinque corporibus regularibus*.[63] Unless someone prepared a translation that has not survived, or orally translated material from this manuscript as Piero wrote down the Italian, Piero had to have read it in Latin. Since the *Libellus de quinque corporibus regularibus* was probably written in the late 1480s, Piero may have learned enough Latin to read Archimedes in a Latin translation by the end of his long life. It is certainly possible that the highly intelligent and strongly motivated Piero della Francesca learned some Latin on his own initiative as an adult.

The Florentine Giannozzo Manetti (1396–1459) is a contemporary example. His father sent Manetti to school to learn vernacular reading, writing, and abbaco. He then removed Manetti from school when he was ten and put him to work in a merchant shop or bank. After a few months, Manetti took charge of the accounts of the cash box and then became the bookkeeper of the firm, a post that he held for several years. At the age of twenty-five, however, Manetti abandoned his accounting career in order to learn Latin. Allowing himself only five hours of sleep a night, he learned to read Vergil, Terence, Cicero, and other Latin authors, and then passed on to Greek and Hebrew. He became skilled enough in Greek to translate Aristotle into Latin, and in Hebrew to study the Hebrew Old Testament.[64] Indeed, Manetti became the most learned of all the fifteenth-century Florentine humanists, and the only one to master Hebrew.

The contradictory evidence bars a definite answer to the questions, did Piero study ancient Greek mathematical authors in Italian or in Latin? Did he rely on the Italian he learned as a schoolboy, or did the adult Piero learn enough Latin to read mathematical treatises with their special vocabulary and nonrhetorical style?

Possibly Piero did both. He may have initially approached the rich world of ancient Greek geometry through the vernacular abbaco treatises and the works of Leonardo Fibonacci. This learning enabled him to write the *Trattato d'abaco*. Wanting to go further, Piero may have learned enough Latin, without mastering classical literary Latin, to be able to read medieval mathematical texts with their specialized vocabulary. We can only speculate as to when, how, and, possibly, from whom Piero learned some Latin. Piero's additional knowledge of ancient mathematics and his own development as a mathematician then could have enabled him to write his more sophisticated later treatise, *Libellus de quinque corporibus regularibus*. But it is not likely that Piero learned enough Latin to be able to write that work in Latin.

Piero's Handwriting

There is one final piece of evidence bearing on Piero's education to consider. The autograph manuscript of Piero's *Trattato d'abaco* in the Biblioteca Laurenziana in Florence is written in humanist roman script. This is also sometimes called "chancery formal" or "humanistic bookhand."[65] Fifteenth-century humanists invented humanist roman script. Dissatisfied with medieval gothic handwriting, Poggio Bracciolini created humanist roman script in 1402 and 1403. He based it on Carolingian minuscule, which he and other early humanists thought was an ancient Roman script.[66] Humanist roman script had

neatly spaced, upright, and rounded letters; it was the ancestor of roman typeface. Later in the century, Latin schools taught humanist roman script plus humanist cursive script, after the latter was invented in the 1420s.

By contrast, Italian merchants used merchant or mercantile script, especially in their account books. Hence fourteenth- and fifteenth-century schoolboys studying in abbaco and vernacular literature schools learned to write merchant script so that they could read and write the script of the merchant world. They continued to learn and use merchant script in the sixteenth century.[67] Indeed, the majority of abbaco manuscripts were written in merchant script, which is further evidence of the link between merchant script and abbaco school.[68] Given these links, it might be argued that, since Piero used humanist roman script rather than merchant script to write out his *Trattato d'abaco*, he must have attended a Latin school.

The argument does not succeed for a chronological reason. Humanist roman script and humanist cursive script did not become standard until chanceries adopted them in the second half of the fifteenth century, long after Piero's schooldays were over.[69] It is very unlikely that Latin schools in provincial Sansepolcro taught the humanist scripts in the 1420s when Piero was a boy.

Piero probably learned merchant script in school, but then switched to humanist roman script as an adult. The artist in him may have found merchant script's wavering and exaggerated letters, some of which rise or fall considerably above and below the line, inelegant and unattractive. By contrast, the neat, elegant, concise, and regular letters of humanist roman script could have appealed to him on aesthetic grounds. So he may have decided to learn it. Learning to write a new script without the benefit of school instruction would be difficult for most people, but not for Piero. An artist with Piero's highly developed eye-hand coordination could easily learn to write a new script.

Conclusion

His father's occupation and social position probably determined that Piero della Francesca attended an abbaco and vernacular literature school, perhaps only for a few years. The boy Piero probably received the same schooling as did thousands of other Italians of his background, but it was a surprisingly rich and diverse education. The adult Piero may have learned enough Latin to enable him to read Latin mathematical texts with their specialized vocabulary. The key seems to be that Piero continued to learn throughout his life. And his learning worked in him. One has the impression that Piero retained everything—the saints' legends read in school, the mathematics of abbaco school, his creative explorations into ancient geometry—and that all his learning enriched his painting. Harnessed to consummate technical skills and his life experiences, Piero's schooling helped produce the profoundly moving and original paintings that inspire admiration today.

NOTES

I wish to thank James Banker for answering my questions. I am also grateful to Marilyn Aronberg Lavin and Marcella Grendler for their many suggestions and careful reading of this paper.

1. The birthdate is based on two pieces of information: Vasari's statement that Piero began his apprenticeship as a painter at the age of fifteen (see note 46 below) and the secure knowledge that Piero, after his apprenticeship, worked as a paid assistant to Antonio d'Anghiari in Sansepolcro between 1432 and 1438. Thus he was probably a youthful apprentice before 1431. See James R. Banker, "Piero della Francesca as Assistant to Antonio d'Anghiari in the 1430s: Some Unpublished Documents," *Burlington Magazine* 135 (1993), 17. See below for further discussion about the age that a boy left school and began an apprenticeship.

2. These figures come from James R. Banker, *Death in the Community: Memorialization and Confraternities in an Italian Commune in the Late Middle Ages* (Athens, Ga., 1988), 33–35.

3. Banker 1988, 38.

4. See Iris Origo, *The Merchant of Prato: Francesco di Marco Datini* (London, 1963).

5. Eugenio Battisti, *Piero della Francesca*, 2 vols. (Milan, 1971), 1:30–32, 2:218–220.

6. See the schooling and literacy statistics for late sixteenth-century Venice in Paul F. Grendler, *Schooling in Renaissance Italy: Literacy and Learning 1300–1600* (Baltimore, 1989), 43–47. Historians sometimes cite the famous numbers of Giovanni Villani (d. 1348) as evidence for a much higher schooling and literacy rate for Florence at this time and, by extension, Italy as a whole during the Renaissance. Villani wrote that 9,550 to 11,800 Florentine boys and girls attended formal schools in Florence in 1338. If Villani were correct, a simple calculation based on the known population of Florence at the time, and the knowledge that those who attended school were overwhelmingly boys, would show that Florence in 1338 had a male schooling rate of 67–83 percent. That figure would have been higher than Italy or any other European nation would reach for centuries. Villani's figures are surely wrong for this and other reasons. By contrast, Florence in 1480 had a male schooling rate similar to that of Venice in 1587–1588. See Grendler 1989, 71–78, for further discussion.

7. This and the following two paragraphs summarize Grendler 1989, chap. 1.

8. Grendler 1989, 6–11.

9. This is the theme of Jo Ann Hoeppner Moran, *The Growth of English Schooling, 1340–1548: Learning, Literacy, and Laicization in Pre-Reformation York Diocese* (Princeton, 1985).

10. Church schools will reappear in Italy in the late sixteenth century in the form of schools run by the new religious orders of the Catholic Reformation, such as the Jesuits and Piarists. But that is another story; see Grendler 1989, 331–399.

11. See Grendler 1989, chap. 6.

12. See Grendler 1989, 111–116, for a brief list and description of the texts taught in medieval Latin schools. See also Paul F. Gehl, *A Moral Art: Grammar, Society, and Culture in Trecento Florence* (Ithaca, N.Y., 1993).

13. There is an enormous bibliography on these developments. See the analysis of the curriculum of Renaissance Latin schools in Grendler 1989, chaps. 5 and 7–9.

14. James Banker informs me that the commune paid a Latin teacher at least on one occasion. In addition, Battisti found three teachers who taught at Sansepolcro during the youth of Piero della Francesca. The first was Maestro Antonio da San Severino who taught there in 1426; see Battisti 1971, 1:30. A certain Antonio Salimbeni da San Severino was the communal Latin teacher of Arezzo from 6 October 1435 to 5 October 1438, at a salary of 50 florins per annum. This may be the same Antonio da San Severino who taught at Sansepolcro in 1426; hence he was a Latin teacher. See Robert Black, "Humanism and Education in Renaissance Arezzo," *I Tatti Studies* 2 (1987), 226. Short contracts and frequent moves were characteristic of the teaching profession in the Renaissance. Battisti found two other teachers: Maestro Agnolo di Clemente da Novilara (or Novellara) in 1428, and Maestro Lucha da Vinegia in 1430. While it is not known for certain, it is likely that they were also Latin teachers; see Battisti 1971, 1:30.

15. These schools are often called simply "abbaco schools." But the more correct term is "abbaco, bookkeeping, and vernacular literature schools." For simplicity's sake, the term "vernacular abbaco schools" will be preferred.

16. Kurt Vogel, "Fibonacci, Leonardo," *Dictionary of Scientific Biography* 4 (New York, 1971), 604–613, with additional bibliography.

17. For the mathematics and typical problems taught through abbaco, see Warren Van Egmond, "The Commercial Revolution and the Beginnings of Western Mathematics in Renaissance Florence, 1300–1500," (Ph.D. diss., Indiana University, 1976), chaps. 5–6, 228–346; and his *Practical Mathematics in the Italian Renaissance: A Catalog of Italian Abbacus Manuscripts and Printed Books to 1600* (Florence, 1981), 15–33. See also Frank J. Swetz, *Capitalism and Arithmetic: The New Math of the 15th Century including the Full Text of the 'Treviso Arithmetic' of 1478*, trans. David Eugene Smith (La Salle, Ill., 1987). Van Egmond and Swetz list much additional bibliography, such as Gino Arrighi's studies and editions of abbaco texts.

18. Guido Zaccagnini, "L'insegnamento privato a Bologna e altrove nei secoli XIII° e XVI°," *Atti e Memorie della Reale Deputazione di storia patria per le provincie di Romagna*, series 4, 14 (1924), 32–33.

19. Van Egmond 1976, 72–139, 348–411; and Grendler 1989, 5, 22–23, 48–53, 72–77, 308–309.

20. See Grendler 1989, 47–51.

21. Grendler 1989, 50.

22. Florence separated Latin from abbaco schooling a little differently. A Florentine boy might spend several years in a Latin school, then devote two years between the ages of eleven and fifteen to studying only abbaco with a different master, and then return to an advanced Latin school. This is what Niccolò Machiavelli (born 1469) did. A Florentine schoolboy might also begin an apprenticeship after his intensive abbaco schooling; see Grendler 1989, 74–77. However, since this schooling pattern has not been found outside of Florence, not even in Tuscany, it is assumed that Sansepolcro schools followed the common pattern of separate curricular streams extending over several years.

23. "Arithmeticam opficibus relinquendam dicens," from Sassolo's biography, *De Victorini Feltrensis vita* (written 1443–1444), in *Il pensiero pedagogico dell'umanesimo*, ed. Eugenio Garin (Florence, 1958), 510; same sentiments on 526.

24. See the biographies written by Sassolo da Prato and Francesco da Castiglione, *Vita de Victorini Feltrensis* (written c. 1469), in Garin 1958, 510, 513, 526, 528, 536; and William H. Woodward, *Vittorino da Feltre and Other Humanist Educators* (Cambridge, 1897; repr. New York, 1963), 7–8, 42–43.

25. "e nella sua fanciullezza, oltre il leggere e lo scrivere si esercitò grandemente nello abbaco. Ma il padre, che aveva bisogno che e' guadagnasse, vedendo che egli si dilettava molto del disegno, lo indirizzò, ancora fanciulletto, all'arte della pittura," Giorgio Vasari, *Le vite de' più eccellenti pittori, scultori ed architettori scritte da Giorgio Vasari pittore aretino*, with notes and commentary by Gaetano Milanesi, 9 vols. (Florence, 1878–1885), 4:146–147.

26. "e nella erudizione e principj delle lettere arebbe fatto profitto grande, se egli non fusse stato tanto vario ed instabile. Perciocchè egli si mise a imparare molte cose; e incominciate, poi l'abbandonava. Ecco, nell'abbaco, egli in pochi mesi ch'e'v'attese, fece tanto acquisto, che movendo di continuo dubbj e difficultà al maestro che gl'insegnava, bene spesso lo confedeva," Vasari 1878–1885, 4:18.

The policy adopted here on the question of the accuracy of the accounts of the early lives and schooling by Vasari and other Renaissance biographers is to accept them as truthful unless modern scholars have demonstrated that they are wrong or the information contradicts common sense or general knowledge of the period.

27. This information comes from the late fifteenth-century biography of Brunelleschi attributed to Antonio Manetti, *Vita di Filippo Brunelleschi preceduta da la novella del Grasso*, ed. Domenico de Robertis, with introduction and notes by Giuliano Tanturli (Milan, 1976), 49–51. Manetti (1423–1497), a Florentine, apparently wrote this life in the 1480s. See also Antonio di Tuccio Manetti, *The Life of Brunelleschi*, introduction, notes, and critical text by Howard Saalman, English translation by Catherine Enggass (University Park, Pa., 1970).

28. "Nella sua tenera età, Filippo apparò a leggere e l'abaco, come s'usa per gli uomini da bene e per la maggiore parte fare a Firenze, e così qualche lettera, perché 'l padre era notaio, e forse fe' pensiero di fargli fare quel medesimo; perché, a chi non s'aspettava d'essere o dottore o notaio o sacerdote, pochi erano quelli in quel tempo che si dessono o fussono dati alle lettere;" Manetti 1976, 52. The editor's note indicates that "qualche lettera" meant a knowledge of Latin, acquired after elementary instruction in vernacular reading, writing, and abbaco. (The English translation is my own; Manetti 1970, 38–39, presents a slightly different Italian text and English translation.)

29. Manetti 1976, 52–53.

30. "Attese Pietro nella sua giovanezza alle mathematiche;" Vasari 1878–1885, 2:490. For an English version, see Giorgio Vasari, *The Lives of the Artists: A Selection Translated by George Bull* (Harmondsworth, 1965), 192.

31. James Banker informs me that he has not found any abbaco teachers in Sansepolcro.

32. The impressive list of references to Venetian teachers between 1287 and 1500 compiled by Bertanza and Dalla Santa is based almost exclusively on notarial records. Latin teachers often appear as witnesses, while abbaco teachers very seldom appear. See Enrico Bertanza and Giuseppe Dalla Santa, *Documenti per la storia della cultura in Venezia*, vol. 1: *Maestri, scuole e scolari in Venezia fino al 1500* (Venice, 1907).

33. An examination of the "Index of Authors, Copyists, and Cited Authorities" in Van Egmond 1981, 355–368, underlines the importance of Tuscan abbaco author-teachers. In the sixteenth century, abbachists from Venice and the Veneto may have supplanted Tuscans as leaders in the field.

34. However, there is no evidence to support Vasari's statement that Pacioli was a mathematical pupil of Piero della Francesca. See Marshall Clagett, *Archimedes in the Middle Ages*, vol. 3: *The Fate of the Medieval Archimedes 1300–1565*, part 3: *The Medieval Archimedes in the Renaissance, 1450–1565* (Philadelphia, 1978), 416; S. A. Jayawardene, "The 'Trattato d'abaco' of Piero della Francesca," in *Cultural Aspects of the Italian Renaissance: Essays in Honour of Paul Oskar Kristeller*, ed. Cecil H. Clough (Manchester, 1976), 230.

35. Van Egmond 1981. Of course, an unknown number of manuscripts and printed editions have disappeared.

36. "Dovete insegnare a far di conto e scrivere a tutti li fanciulli che verranno alla vostra scuola. Con carico ancora d'insegnare leggere a quei non vorranno attendere a grammatica e vorranno esercitarsi in legger libri volgari a lettere in penna;" quoted in Mario Battisti, *Il pubblico insegnamento in Volterra dal secolo XIV al secolo XVIII* (Volterra, 1919), 29, 45.

37. No curricular directives of any sort for vernacular literature and abbaco schools have been discovered. Since society did not intend these schools to

train future leaders, humanistic pedagogical theorists and communal councils did not feel that it was necessary to tell teachers what they should teach. Indeed, the instructions in the Volterra contract were unusually specific.

38. In the spring of 1587, the Venetian government ordered all teachers in the city to make a profession of their Catholic faith, a requirement imposed by Pope Pius IV in his bull *In sacrosancta beati Petri* of 13 November 1564. The profession of faith was often ignored, but this time it was enforced. Hence, between 30 April 1587 and 27 May 1588, 258 Venetian teachers appeared before a representative of the patriarch to swear that they were Catholics. In the course of their appearances, they answered questions about themselves and their schools; they almost always told the patriarch's representative which texts they taught. The surviving documents in the Archivio della Curia Patriarcale di Venezia offer a uniquely informative picture of Renaissance education. While the papal bull was enforced elsewhere in Italy, nowhere else did the action yield such useful surviving documentation. Grendler 1989 makes extensive use of this material.

39. For expansion and evidence on this point, see Grendler 1989, 275–278. In addition, the late medieval vernacular texts used in schools (*Fior di virtù*, Voragine's *Golden Legend*, and so on) appeared repeatedly in contemporary book lists. For numerous book lists from the fourteenth, fifteenth, and sixteenth centuries, see Christian Bec, *Les livres des florentins (1413–1608)* (Florence, 1984). The vernacular texts used in the classroom appear repeatedly in these lists. Unfortunately, Bec reproduces only inventory entries; he does not identify the titles. Finally, the survival of numerous fourteenth- and fifteenth-century manuscript copies of these texts offers further evidence of their cultural importance.

40. The following discussion is based on Grendler 1989, 275–299.

41. There is no critical edition. See *Fior di virtù historiato*, colophon, Florence, Compagnia del Drago, 1498; photographic reprint, Florence, 1949. This edition has numerous woodcuts. See also *The Florentine Fior di Virtù of 1491. Translated into English by Nicholas Fersin with Facsimiles of All of the Original Wood Cuts*, introduction by Lessing J. Rosenwald (Washington, D.C., 1953). The most important study is Carlo Frati, "Ricerche sul 'Fiore di virtù,'" *Studi di filologia romanza* 6 (1983), 247–447.

42. See Grendler 1989, 280–281. Although a number of manuscripts exist, I know of no studies of the vernacular *Epistole e Evangeli che si leggono tutto l'anno alla messa*. For a study of the illustrations in some Greek and Latin manuscript lectionaries, see Kurt Weitzmann, "The Narrative and Liturgical Gospel Illustrations," in Weitzmann, *Studies in Classical and Byzantine Manuscript Illumination*, ed. Herbert L. Kessler, introduction by Hugo Buchthal (Chicago, 1971), 247–270.

43. Domenico Cavalca, *Le vite dei Santi Padri*, 2 vols. (Milan, 1915). For Cavalca's life, see Carlo Delcorno, "Cavalca, Domenico," *Dizionario biografico degli italiani* 22 (Rome, 1979), 577–586. Delcorno is preparing a modern critical edition of the work; see Carlo Delcorno, "Per l'edizione delle 'Vite dei Santi Padri,'" *Lettere italiane* 29 (1977), 265–289; 30 (1978), 47–84. It is well known that artists have depicted episodes from *Le vite dei Santi Padri*. See, for example, Marilyn Aronberg Lavin, "Giovannino Battista, a Study of Renaissance Religious Symbolism," *Art Bulletin* 37 (1955), 85–101; and "Giovannino Battista: A Supplement," *Art Bulletin* 32 (1961), 319–326.

44. The edition used is Jacobus de Voragine, *Leggenda Aurea*, ed. Arrigo Levasti, 3 vols. (Florence, 1924–1926); see 2:589–604 and 3:1144–1156 for the Holy Cross legend. For an English version of the legend, see *The Golden Legend of Jacobus de Voragine*, translated and adapted from the Latin by Granger Ryan and Helmut Ripperger (New York, 1941, repr. New York, 1969), 269–276, 543–550. A modern study is Sherry L. Reames, *The Legenda Aurea: A Reexamination of Its Paradoxical History* (Madison, Wisc., 1985). Two recent studies of the artistic influence of the Holy Cross legend are Rab Hatfield, "The Tree of Life and the Holy Cross: Franciscan Spirituality in the Trecento and the Quattrocento," in *Christianity and the Renaissance: Image and Religious Imagination in the Quattrocento*, ed. Timothy Verdon and John Henderson (Syracuse, N.Y., 1990), 132–160; and Marilyn Aronberg Lavin, *The Place of Narrative: Mural Decoration in Italian Churches, 431–1600* (Chicago, 1990), chaps. 4 and 6. Hatfield, Lavin, and others point out that Piero took liberties with the story as found in the *Legenda Aurea*.

45. Paul F. Grendler, "Chivalric Romances in the Italian Renaissance," *Studies in Medieval and Renaissance History* 10 (1988), 57–102, with additional bibliography; and Grendler 1989, 289–299.

46. "ed ancora che di anni quindici fusse indiritto a essere pittore," Vasari 1878–1885, 2:490.

47. See the new documents uncovered by Banker 1993, 16–21.

48. Margaret Daly Davis, *Piero della Francesca's Mathematical Treatises: The "Trattato d'abaco" and "Libellus de quinque corporibus regularibus"* (Ravenna, 1977), 54, note 8; Clagett 1978, 390.

49. Warren Van Egmond, "A Second Manuscript of Piero della Francesca's 'Trattato d'abaco,'" *Manuscripta* 24 (1980), 155–163. See also the detailed description of the manuscript (Florence, Biblioteca Nazionale Centrale, Conventi Soppressi A. 6. 2606), in Van Egmond 1981, 98–99. A watermark dates it as c. 1493.

50. Davis 1977, 117.

51. Clagett 1978, 391.

52. Van Egmond 1980, 162.

53. Van Egmond 1976, 406.

54. See Davis 1977, 21–63, for analysis of the works. Two other discussions of the *Trattato d'abaco* do not offer judgments on the quality of Piero's mathematical abilities: Piero della Francesca, *Trattato d'abaco: Dal Codice Asburnhamiano 280 (359*–291*) della Biblioteca Medicea Laurenziana di Firenze*, ed. Gino Arrighi (Pisa, 1970), 13–24; and Jayawardene, in Clough 1976, 229–243. For a brief discussion of some of the algebra employed in the *Trattato d'abaco*, see Gino Arrighi, "Note di algebra di Piero della Francesca," *Physis* 9 (1967), 421–424.

55. Davis 1977, 21–63; Clagett 1978, 383–415. Arrighi (1970, 16) notes that the *Trattato d'abaco* has ten references to Euclid, one to Archimedes, and two to Ptolemy.

56. On the history of medieval Latin translations of Euclid's *Elements*, see John Murdoch, "Euclid: Transmission of the Elements," in *Dictionary of Scientific Biography* 14 (New York, 1987), 437–459. Niccolò Tartaglia published the first Italian translation of the *Elements* in 1541; see *Mechanics in Sixteenth-Century Italy: Selections from Tartaglia, Benedetti, Guido Ubaldo, & Galileo*, translated and annotated by Stillman Drake and I. E. Drabkin (Madison, Wisc., 1969), 21. Van Egmond (1981, 169) lists a 1539 manuscript of an Italian translation of Book 1 done by "Constantio bolognese."

57. Davis' comment after analysis of part 2 of the geometry section of Piero's *Trattato d'abaco* merits repeating: "In this section Piero's relationship to Euclid becomes evident in such references in his text as 'commo per la penultima del primo de Euclide se demostra.' Similar references, however, abound in Fibonacci, and we may not exclude a priori the possibility of an indirect transmission of Euclidean geometry via Fibonacci. Nonetheless, Piero's first-hand knowledge of the works of Euclid can be demonstrated by a close reading of his text." She then argues for Piero's direct reliance on propositions 13 to 18 of book 13 of Euclid's *Elements*. See Davis 1977, 38–40, quotation page 38.

58. Van Egmond (1981) lists vernacular translations of much of Fibonacci's works from the fourteenth and the first half of the fifteenth century: Florence, Biblioteca Nazionale Centrale, Palatina 577; Florence, Biblioteca Riccardiana, MSS. 2186 and 2252/I; Vatican City, Urbinatus latinus 291. This last manuscript is a fourteenth-century Italian translation of Leonardo's Latin works found in Vaticanus latinus 4606. Urbinatus latinus 291 includes an Italian translation of Fibonacci's *Practica geometriae* which, in turn, used Hero, the *Agrimensores*, Euclid, and

Archimedes. See Vogel 1971, 609. For descriptions of the manuscripts, see Van Egmond 1981, 126–127, 147–148, 149–150, 215–217, 220–221. See also Leonardo Fibonacci, *La pratica di geometria: Volgarizzata da Cristofano di Gherardo di Dino cittadino pisano dal Codice 2186 della Biblioteca Riccardiana di Firenze*, ed. with introduction by Gino Arrighi (Pisa, 1966). This translation of 1442 considerably shortened Fibonacci's text. Of course, there may have been additional vernacular translations of Fibonacci's works that have disappeared.

59. See Davis 1977, 21–63, especially 35–36; and Jayawardene, in Clough 1976.

60. Van Egmond (1981) lists 102 vernacular abbaco manuscripts dated c. 1290 through c. 1450, plus another 94 vernacular abbaco manuscripts dated 1452 through 1492. Investigating the depth and quality of the knowledge of Euclid in the abbaco manuscripts would be a very time-consuming task and one beyond the capacity of the present writer.

61. Clagett 1978, 389.

62. Clagett 1978, 385–386, especially note 7.

63. Clagett 1978, 389–394.

64. Vespasiano da Bisticci (1421–1498), "Commentario della vita di Messer Giannozzo Manetti," in Vespasiano da Bisticci, *Vite di uomini illustri del secolo XV*, ed. Ludovico Frati, 3 vols. (Bologna, 1892–1893), 2:84–85. This passage is reprinted in Garin 1958, 297. On Manetti's humanistic writings, see Charles Trinkaus, *In Our Image and Likeness: Humanity and Divinity in Italian Humanist Thought*, 2 vols. (Chicago, 1970), 1:230–258, 2:573–601.

65. See the detailed description of the manuscript in Van Egmond 1981, 84. Van Egmond calls the script "a neat humanistic bookhand." See the photographs of some pages of the manuscript in Arrighi 1970 and Davis 1977, illustrations 17–19.

66. Berthold L. Ullman, *The Origin and Development of Humanistic Script* (Rome, 1960), is the standard account, which can be supplemented by exhibition catalogues of humanistic manuscripts.

67. See Grendler 1989, 323–329, with illustrations.

68. Van Egmond 1981, 14.

69. See John F. D'Amico, *Renaissance Humanism in Papal Rome: Humanists and Churchmen on the Eve of the Reformation* (Baltimore, 1983), 30, for the Roman chancery; and Robert Black, *Benedetto Accolti and the Florentine Renaissance* (Cambridge, 1985), 155–157, for the Florentine chancery.

J. V. FIELD
University of London

A Mathematician's Art

Piero della Francesca is a figure of importance not only for the history of art but also for the history of science. The mathematics of the fifteenth century has been studied much less intensively than its art, but it is nonetheless clear that the period is notable for the increased use of mathematics in the crafts. Together with this, we have an increased availability of elementary instruction in mathematics, through the abacus schools set up to provide a practical education for prospective merchants and prospective members of craft guilds.[1] This practical tradition led to important developments within learned mathematics through the rise of algebra as an independent discipline, in the sixteenth century. Algebra then joined as an equal partner with geometry in the *Geometrie* (Leiden, 1637) of René Descartes (1596–1650). This union was to prove immensely fruitful in connection with the later development of the infinitesimal calculus of Newton (1642–1727) and Leibniz (1646–1716). In geometry, the study of perspective, which from the mid-sixteenth century onward began to attract the attention of learned mathematicians such as Federico Commandino (1509–1575) and Giovanni Battista Benedetti (1530–1590), eventually led to the invention of a new kind of geometry—now called "modern" or "projective" geometry—in the *Brouillon project d'une atteinte aux evenemens des rencontres du cone avec un plan* (Paris, 1639) of Girard Desargues (1591–1661).[2] Changes within mathematics associated with the practical tradition can also be seen as affecting the development of the new relationship between mathematics and natural philosophy that played such an important part in the rise of modern science in the sixteenth and seventeenth centuries.[3]

There is a sense in which the new use of mathematics in natural philosophy in the later sixteenth and early seventeenth centuries can be seen as a "mathematization" of man's picture of the world.[4] However, the further claim that the Renaissance re-invention of perspective played a crucial part in this process by introducing or initiating a "mathematization of space" seems to me to be misguided.[5] One very important objection to the claim is that the authors on whose behalf the claim is made did not actually have a notion of space as an independent entity.

The idea that geometry is "the science of space" comes with the work of Blaise Pascal (1623–1662) and concerns the infinite space of the geometry of Desargues, introduced in the work on conics to which we have already referred, published in 1639. In this space, all lines are infinite, so that "the line AB" means the infinite straight line that passes through the points A and B. To Piero della Francesca and his contemporaries, as indeed to Euclid and his, "the line AB" means the straight line from the point A to

177

1. Piero della Francesca, drawing of a cuboctahedron, diameter 5.8 cm

From Piero della Francesca, *Trattato d'abaco*, Biblioteca Medicea-Laurenziana, Florence, Codice Ashburnhamiano 280 (359*), folio 108 recto

the point B.[6] This finite concept of the line fits in well with the Aristotelian conception of space that was universal among natural philosophers of Piero's time. For Aristotle, space is extension, measured by body. For the geometer, concerned with abstract entities, the measure is a line of given magnitude, but the metaphysical basis is clearly the same. Space accordingly has no independent existence, and as it is defined by measurement we never need to think about a distance, say, that is "immeasurably large" or "infinite." Philosophers did, of course, discuss the infinite, but mathematicians, whose professional writings were generally in a non-discursive style that did not require one to explain omissions, simply preferred to steer clear of infinity.

Of the "many" mathematical treatises that Vasari tells us Piero wrote, three are now known. All are available in modern printed editions. The titles by which they are known may not conform to those given them by Piero, and the dates of composition of all three are uncertain. In fact, the situa-

tion is rather like that for Piero's paintings. All three treatises belong in some degree to the "abachista" tradition in which Piero almost certainly received his earliest training as a mathematician.[7] In fact, one of the treatises, called *Trattato d'abaco*, though clearly not written for use in a school, is closely similar to surviving texts that we know were used as a basis for teaching in abacus schools.[8] Piero's *Trattato* is written in Italian, or rather in Tuscan. Some of the problems from the *Trattato* appear in a neater or more developed form in the *Libellus de quinque corporibus regularibus*, which survives in a single Latin copy, though Piero may have written it in the vernacular.[9] It thus seems that the *Libellus* was written after the *Trattato*. The third surviving treatise by Piero, apparently written in the vernacular but known by the Latin title *De prospectiva pingendi*, is the earliest known work on the mathematics of perspective. It is with this work that we shall largely be concerned, since it is the one which relates most closely and obviously to Piero's activ-

ity as a painter. However, we shall begin with a brief discussion of the nature and contents of the *Trattato* and the *Libellus* since it is clear that *De prospectiva pingendi* must be seen in the context of these other works.

The *Trattato d'abaco*

As Gino Arrighi, the modern editor of Piero's *Trattato*, has argued, and as other scholars have since abundantly confirmed, Piero's treatise conforms in large measure with the conventions of schoolbooks.[10] There is very little discursive text, and instruction proceeds through a series of worked examples, apparently graded in order of difficulty.

We begin with arithmetic—of which algebra was, at the time, regarded as an offshoot. A simple example from near the beginning of the treatise will show the style.

There is a fish that weighs 60 pounds,[11] the head weighs ⅖ of the body and the tail weighs ⅓ of the head. I ask how much the body weighs.[12]

In the twentieth century, a pupil would probably be told to treat this problem algebraically, starting off by setting the weight of the body of the fish equal to x. Piero, however, merely uses numbers—though later more elaborate problems do involve an explicit "unknown" called "la cosa" (literally "the thing").[13] For the fish, the solution begins

Do thus; say that the body weighs 30 pounds, ⅗ of 30 is 18, which is the head, the tail weighs ⅓ of the head, which is 6. Adding together 30 and 18 and 6 makes 54; and you want 60, which you have [but] less six, . . .

There follows the application of methods used in earlier examples, involving a certain amount of multiplication, division, subtraction, and addition, until we end up with

So the body weighs 33⅓, the head weighs 20, the tail weighs 6⅔, which added together make 60, as I said the fish weighed.

The fish may seem to be on the large side—though perhaps it was a sea fish—but the problem is in principle a practical one, and one whose structure is similar to that of other practical problems of interest to tradesmen and their customers. In this it resembles many other problems found in "abacus books" from the thirteenth century onward.

An important difference between Piero's *Trattato* and standard abacus books is that Piero's work contains many more geometrical problems than was usual. It is, of course, hardly a surprise that a mathematician who was also a painter should show more than the conventional degree of interest in geometry, but Piero's geometrical problems do not in fact show any immediate connection with his concerns as a painter. For instance, unless this is another as yet unremarked example of his "plagiarism," it was not Piero but Luca Pacioli (c. 1445–1514) who was to write a treatise on the mathematical properties of the Golden Section.[14] Most of Piero's problems are conventional. Again, a single relatively simple example can be used to show the style. This time, the problem is proposed in abstract terms, though still in numerical form.

2. Drawing of an octagon in perspective. The "perfect" shape is shown in the lower part of the diagram and the "degraded" (perspective) one in the upper part
From Piero della Francesca, *De prospectiva pingendi*, Book 1, Proposition 29, Biblioteca Palatina, Parma, MS no. 576, folio 16 recto

There is a triangle ABC in which the side AB is 14, BC 15, AC 13; in which I want to put the 2 largest circles that are possible. I ask what will be their diameter.[15]

This is not a problem that is solved in Euclid's *Elements*, but it is clearly to be seen as a more complicated variant of the construction given in *Elements*, Book 4, Proposition 4, "In a given triangle to inscribe a circle."[16] On his previous page, Piero has, in fact, already solved a simple special case of this problem, in numerical form:

There is a triangle ABC, which along each side is 10 bracci, I want to put in it the largest circle that will fit in. I ask what will be its diameter.[17]

and has then gone on to solve a general case, again in numerical form:

The diameter of such a circle can be found in another way. So let the triangle ABC have unequal sides, and let the side AB be 15, and BC 14 and AC 13. Now you need to square. . . .[18]

This tendency to divide up Euclid's general cases into special ones, and then to add more elaborate examples, is entirely typical of the abacus book tradition. So too is Piero's 13, 14, 15 triangle. This triangle has several simple numerical properties: for instance, its height is 12 (above the base 14) and the radius of the incircle (the circle Piero proposed to find) is 4.

All the geometrical problems in Piero's *Trattato* are given in numerical form, and many, like the ones just cited, are clearly related to elementary problems from the Euclidean tradition. Moreover, most of the conventional problems concerning finding the heights of triangles, finding their areas, dividing areas—triangular or rectangular—in various ratios, and so on, are found in Piero's *Libellus de quinque corporibus regularibus* as well as in the *Trattato*. Thus the *Libellus* also has close links with the abacus school type of mathematics.

However, both the *Trattato* and the *Libellus* contain problems which are not known from any earlier text and appear to be original to Piero, though he makes no such claim on their behalf. These problems concern some of the so-called "Archimedean polyhedra." These solids are, in modern terms, convex uniform polyhedra. That is, their faces, which are regular polygons, are completely visible on the outside of the solid

and are arranged in the same way around each vertex of the solid. Thirteen such solids are known, and all of them are described by Papous (fourth century A.D.) as having been discovered by Archimedes (c. 287–212 B.C.), hence their name. Pappus' descriptions of the solids are, however, minimal: he merely lists the number and type of faces of each solid. Thus the solid now called a "cuboctahedron" is described as having fourteen faces, six of them square and eight triangular.[19] Piero's descriptions of the six Archimedean polyhedra he discusses[20] are in terms that in principle allow the reader to visualize the solid, and accompanying illustrations show the solid inside a sphere. In fact, Piero's verbal description includes the sphere, so it is clear that he has added to Pappus' descriptions by recognizing the equivalence of the vertices of the solid and thus noticing that it can be inscribed in a sphere. Piero is accordingly, and rightly, credited with having re-discovered the six solids in question. The easiest of these six solids to visualize is probably the cuboctahedron (mentioned above), since Piero's description starts from a shape with which everyone is familiar, namely the cube:

There is a spherical body, whose diameter is 8 bracci; I want to put inside it a figure with fourteen faces, 6 square and 8 triangular, with equal sides. I ask how big each side will be.

This kind of figure is cut out from the cube, because that has 6 faces and 8 corners; which, cutting off its 8 corners, makes 14 faces; like this. You have the cube ABCDEFGH, divide each side into equal parts: AB in the point I, and CD in the point L, BD in the point K, AC in the point M,[21]

As can be seen, Piero's line of thought is rapidly submerged (for most twentieth-century readers, at least) in a welter of detailed instructions for carrying out the construction. This is a style we shall meet again in Piero's treatise on perspective, where, as in the *Trattato*, the reader is called "tu" and addressed mainly in the imperative. In both the *Trattato* and the perspective treatise, "tu" is clearly expected to draw diagrams as he goes along, but Piero does not supply a figure for the final state.[22] One of the figures showing the cuboctahedron is reproduced in figure 1. This figure shows the solid with letters on its vertices. Piero's other figure of

3. Drawing of a hexagonal
well-head in perspective
From Piero della Francesca, *De
prospectiva pingendi*, Book 2,
Proposition 6, Biblioteca Palatina,
Parma, MS no. 576, folio 22 recto

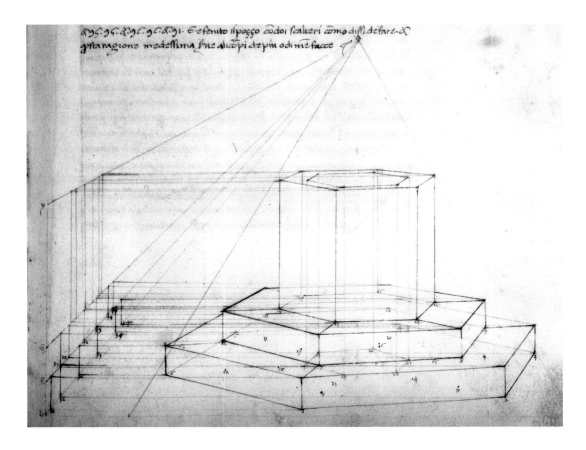

the cuboctahedron is not lettered, and the circle passing through the vertices is much easier to see. Although the solid seems to be shown in perspective, and the pattern of faces round each vertex can be seen with perfect clarity, the circle round the outside suggests some other pictorial convention. The circle is to indicate that the vertices of the solid lie on a sphere. However, if one visualizes the actual shape of the solid (as the inner part of the diagram invites one to do), it becomes clear that the vertices through which this surrounding circle passes do not all lie in the same plane (the odd one out is K, the vertex at about two o'clock) and they therefore cannot lie on a circle. Other diagrams in this manuscript of the *Trattato*, for instance those of the truncated tetrahedron on the previous page, also show clear departures from "naturalistic," that is, perspective, drawing conventions.[23]

In fact, the status of the illustrations to the part of the *Trattato* concerned with polyhedra, and the corresponding part of the *Libellus*, is not entirely clear. The text does, as already noted, give the reader detailed instructions for constructing the solids, but

these refer to the actual shape of the figure in space (formed by cutting the corners off a cube, for instance) rather than drawing an illustration in two dimensions. In this, as we shall see, the instructions in the *Trattato* and the *Libellus* contrast sharply with most of those in Piero's treatise on perspective. It seems likely that the illustrations of the polyhedra are intended as aids to visualization, rather in the manner of the illustrations found in modern mathematical texts. In this case, Piero presumably expects his readers to recognize and accept the conventions that are employed, and it is a matter of interest that, on the whole, he apparently does not seem inclined to regard naturalistic perspective pictures as his best means of communication.

In this respect Piero's drawings are very unlike those done later, as illustrations for Pacioli's *De divina proportione* (Venice, 1509), by Leonardo da Vinci. Nonetheless, a detailed comparison between Leonardo's drawings and the various versions of Piero's would probably not be very instructive, since it is already clear that drawing conventions for this kind of mathematical diagram

were not notably rigid at the time. The difference between Leonardo and Piero may well be explained by differences in their education and in their temperaments. Leonardo makes everything he draws real and particular (so that his drawings of the polyhedra look as if they were made from actual models), whereas Piero is clearly intent on showing abstract mathematical form.

The *Libellus de quinque corporibus regularibus*

Most of what has been said of the style of the *Trattato d'abaco* is also true of the *Libellus de quinque corporibus regularibus*. Though the latter survives only in a single Latin copy, its style is that of vernacular works. Again, as in the *Trattato*, what we are given is essentially a series of worked numerical examples. However, the *Libellus* is novel in that all its problems are geometrical, even though their being posed in numerical terms means that their solutions involve large quantities of arithmetic. Most of the problems in the first two parts of the *Libellus* seem to be directly copied or slightly adapted from those in the *Trattato*.[24] The second part consists of problems concerning the five regular polyhedra, taken individually. These problems are essentially adapted versions of the results in the last book of Euclid's *Elements*, Book 13 (to which references are given). The third part of Piero's *Libellus* deals with problems derived from the book he knew as Euclid's Book 15. From the sixteenth century onward it became increasingly widely known that this book, and the preceding one, Book 14, were Late Antique additions to the *Elements*, but both would have been found in the versions of Euclid that Piero is likely to have known, and they appear later in many printed editions of the *Elements*. Book 15, and the third part of Piero's *Libellus*, deal with problems that relate one regular polyhedron to another, for instance by inscribing one solid inside another by constructing the inner solid as having certain vertices in common with the outer one. The difference between Piero's treatment and that in *Elements* 15 is that Piero, while giving references to the propositions in *Elements* 15, poses the problems in numerical form.

The problems are again posed in numerical form in the fourth and final part of Piero's treatise, which concerns what he calls "irregular bodies." These include four Archimedean solids not described in the *Trattato*.[25] Then comes the truncated tetrahedron, already mentioned in the *Trattato*.[26] There is no mention of the cuboctahedron. As in the *Trattato*, a diagram is supplied for each proposition, apparently as an aid to visualization, and employing the range of pictorial conventions we have already encountered among the illustrations to the *Trattato*.[27]

After dealing with the truncated tetrahedron, the remainder of the *Libellus* becomes a series of apparently more or less unconnected propositions that have the air of being tacked on as an afterthought. One proposition, repeated from the *Trattato*, is a very strikingly practical solution to an apparently realistic problem, namely that of finding the volume of a completely irregular shape, such as a statue of a human or animal figure. Piero instructs the reader to construct a wooden tube of square cross-section, using four stout planks, taking care to see that the corners are well sealed, then filling it with water . . . and so on.[28] This is the last paragraph but one of Piero's treatise. One may perhaps be permitted to wonder whether the many historians who have called the *Libellus* "Euclidean" (presumably on account of its being entirely concerned with geometry) have actually read right to the end of the work. Piero's final proposition concerns the abacists' familiar 13, 14, 15 triangle. For all its emphasis on geometry, and its apparently surviving only in Latin, the *Libellus*, like the *Trattato*, very clearly has strong connections with the world of practical mathematics.

The Perspective Treatise: *De prospectiva pingendi*

The introduction to the *Libellus* tells us that the work was intended by Piero as a companion piece to his treatise on perspective. The works were, it seems, shelved next to one another in the library at Urbino.[29] This raises various questions concerning the intended, and actual, readership of the works—questions to which we shall return. It may also be taken as an indication that

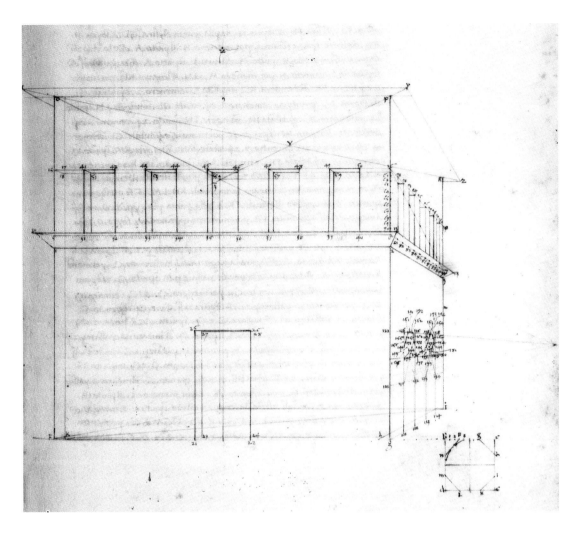

the original version of the *Libellus* was in Italian.[30] There can be little doubt that the perspective treatise was written in the vernacular, though all known manuscripts of it, vernacular as well as Latin, have the Latin title *De prospectiva pingendi*. As we shall see, like the *Libellus*—which not only draws on the *Elements* but also gives references to it—*De prospectiva pingendi* similarly shows some concern to establish a relation with the learned mathematical tradition. It thus seems possible that the Latin title is actually Piero's own choice.[31]

De prospectiva pingendi gives every appearance of being conceived as an instructional text. As in the *Trattato d'abaco* the reader is called "tu" and addressed mainly in the imperative. In fact, a very large proportion of the text of *De prospectiva pingendi* consists of immensely detailed drawing instructions. What Piero has written is a workshop manual for teaching an apprentice

to draw in perspective, and the model for the style of presentation, through a series of worked examples, is clearly also that of the abacus books. Thus, although as far as we know, Piero's treatise on perspective was the first of its kind, it is not lacking in antecedents. Its descendants were legion. Almost every treatise on perspective addressed to painters follows the series of worked examples in the first two books of Piero's work.[32]

In one obvious respect, however, *De prospectiva pingendi* differs from both the *Trattato* and the *Libellus*: its problems are not posed in numerical terms. All the same, a few propositions do end with a brief run-through of a numerical example of the particular problem that has just been treated. The explanation for this more purely geometrical appearance of the perspective treatise is prosaic: the problems proposed are drawing problems, so the "solution" is a drawing and the treatment of the problem is

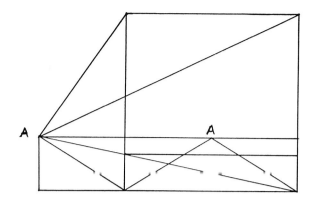

accordingly geometrical rather than numerical. Piero's style of exposition should thus be seen largely as a matter of practicalities rather than an attempt to link *De prospectiva pingendi* with the learned mathematical tradition to which pure geometry belonged. However, as we shall see below, there are in fact many indications that he did wish his work to be seen as having a place in a learned context, namely as a legitimate extension of the well established "mixed science" of *perspectiva* proper.

In Piero's time, *perspectiva* was the complete science of vision, dealing not only with the nature and properties of light but also with the method of functioning of the eye and the sense of vision. There was a long tradition of treating such matters in a partly mathematical way, so Piero's almost exclusively mathematical discussion of what came to be called "artificial" or "painters' perspective" (the latter being, it seems, Piero's preference) was entirely in accord with the methods used in the established part of the science.[33]

Each of the three books of *De prospectiva pingendi* has a discursive introduction. The introduction to the first book begins by situating perspective within painting.

*Painting has three principal parts, which we say are drawing (*disegno*), proportion (commensuratio*), and coloring (*colorare*). . . . Of the three parts I intend to deal only with proportion, which we call perspective, mixing in with it some parts of drawing, because without this perspective cannot be shown in action; coloring we shall leave out, and we shall deal with that part which can be shown by means of lines, angles, and proportions, speaking of points, lines, surfaces, and bodies.*[34]

These are the very first lines of Piero's introduction, so there can be no doubt that he is consciously setting out to write a treatise concerned with only one part of the painter's work. It thus seems inappropriate to assess Piero's treatise as if it were to a significant extent conceived as a response to Alberti's Latin *De pictura* (1435) or its vernacular version *Della pittura* (1436). The scope of the works is entirely different. Alberti, writing initially in Latin, is addressing himself to patrons, or at least to courtiers who wish to find something intelligent to say when confronted with a prince's latest acquisition. Piero, who (as we have already noted) calls his reader by the familiar "tu," is writing for fellow practitioners and making the specifically mathematical contribution that he is well recognized as competent to make.[35]

The main text of Book 1 of *De prospectiva pingendi* begins with a series of propositions relating to natural vision, for instance that if two objects are of the same size then the one nearer the eye appears larger than the other.[36] For some of these propositions, Piero gives appropriate references to the corresponding propositions in Euclid's *Optics*, though it is not possible to decide whether these references are to Euclid's original work or to the recension by Theon of Alexandria

5. Drawing of a horizontal square in perspective
Copy of a diagram illustrating Piero della Francesca, *De prospectiva pingendi*, Book 1, Proposition 13, with most of the lettering omitted

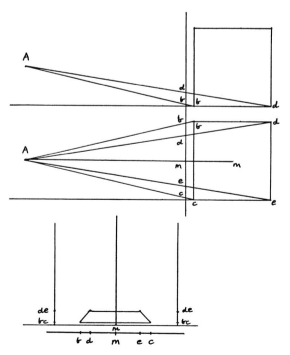

6. Drawing of a horizontal square in perspective
Copy of a set of diagrams illustrating Piero della Francesca, *De prospectiva pingendi*, Book 3, Proposition 1, with some lettering omitted

(fourth century A.D.). Both texts were widely distributed, in Latin, in Piero's time, and parts of them were also available in medieval works on optics, such as John Pecham's *Perspectiva communis*, which Piero seems to have known.[37] There are also some mathematical preliminaries, for instance the theorem that if a set of concurrent lines divides any given line in a particular series of proportions then it will divide any other parallel line that cuts the set in the same series of proportions.[38] Piero gives references to the relevant theorems in Euclid's *Elements*.[39] Propositions directly relevant to perspective construction, and not to be found in Piero's ancient or medieval sources, begin at section twelve of Book 1. The following proposition, 1.13, deals with the problem of constructing the perspective image of a horizontal square lying with one edge along the ground line of the picture (that is, along the line of intersection of the picture plane and the ground). In a style with which the persistent reader will become familiar in all later propositions of *De prospectiva pingendi*, Piero's solution to the problem, which involves a proof that the construction is mathematically correct, consists almost entirely of drawing instructions, delivered in the imperative. However, it is not explained why the particular proportionalities Piero proves have been established actually prove that the construction is mathematically correct. Furthermore, Piero's proof of this crucial result is, given the prolixity of the drawing instructions, disconcertingly concise.

As we have already seen from our examination of Piero's *Trattato d'abaco*, the drawing conventions used in his time are noticeably different from those that prevail in the twentieth century. This fact should hardly surprise an art historian, but it makes the interpretation of the drawing instructions and proof in 1.13 a far more difficult matter than some have supposed. In fact, there has even been a claim that Piero's proof of his construction is mathematically incorrect.[40] On closer scrutiny, this surprising claim turns out to be unjustified: Piero's proof is perfectly correct. All the same, it must be admitted that Piero's curious use of the same letters to designate two different points (for three separate pairs of points) in the same diagram makes some of his argument

difficult to follow—though the ambiguity it introduces in fact allows the proof to be shorter.[41] This may have been regarded as an elegance at the time, but the apprentice painter would surely have experienced something of the twentieth-century historian's difficulty in working through a line of reasoning concerning two pairs of similar triangles at the same time. The contrast with the prolixity elsewhere, and the generally elementary nature of the mathematics found in *De prospectiva pingendi*, strongly suggest that the proof in 1.13 was put in because Piero, rightly, recognized the importance of the result and decided it was appropriate to supply a proof, even if the majority of his readers would have to take it on trust. In fact, this is one of the propositions in which Piero suggests some numerical values by way of supplement to the geometrical reasoning; and there are several other propositions where, as here, one may reasonably suppose that the apprentice merely checked the correctness of the result by drawing an accurate diagram.[42]

Having constructed the perspective image of a horizontal square, Piero goes on to divide it into smaller squares, to produce a simple *pavimento* like that considered by Alberti. First, in 1.14, he constructs the orthogonals (the lines which are the images of lines which run perpendicular to the picture plane), using the theorem in 1.8, about concurrent lines dividing all parallel lines crossing them in the same proportions, to which we have already referred. This is the first appearance in Piero's work of what Alberti called the "centric point" of the perspective scheme. Piero gives it no name, and continues to designate it by the letter A, as in the earlier part of his work (where it appeared merely as the meeting point of two lines). In this next proposition, 1.15, Piero obtains the images of the transversals (the lines which are the images of lines parallel to the picture plane) by drawing the diagonal of the square and then putting in lines parallel to the ground line through its points of intersection with the orthogonals. That is, unlike Alberti, he does not repeat the perspective construction for each transversal. Piero's construction is thus rather easier than Alberti's to carry out in practice, since it involves fewer lines going beyond the edge

of the picture field.[43] Dividing orthogonals and transversals in more complicated proportions allows Piero to go on to construct the images of *pavimenti* with more complicated patterns of tiles. There then follow regular polygons, shown as if drawn on the same horizontal plane used for the *pavimento*. Piero deals with the most general case, in which none of the sides of the polygon is parallel to the ground line (see fig. 2), employing the convention of showing the "perfect" shape (that is, the real shape in space) in the lower part of the diagram, oriented so that it shares a ground line with its "degraded" version (that is, the perspective image) in the upper part. This makes for a neat diagram, and an economy of lettering, but may make it a little difficult for the twentieth-century reader to actually visualize what is going on, rather than merely following it as mathematics. The same drawing convention is found in almost all subsequent treatises on perspective.

Book I ends with a proposition that is not a construction problem but a theorem. It concerns the assertion that this part of *perspectiva* is not a true science because its practice can lead to lines near the edge of the picture being shown as longer, in the picture, than they actually are in reality. That is, the "degraded" line comes out longer than the "perfect" one. Luckily the English word "foreshortening" agrees with the Italian "scorcio" in showing up the paradoxical nature of such an outcome. It is, however, from a twentieth-century viewpoint, entirely arbitrary to regard such an outcome as unacceptable and, as Piero and his contemporaries appear to have considered, sufficient to prove that painters' perspective was not "a true science" (*vera scientia*). Matters are further confused by the fact that Piero's argument is not purely mathematical, but depends on the angular

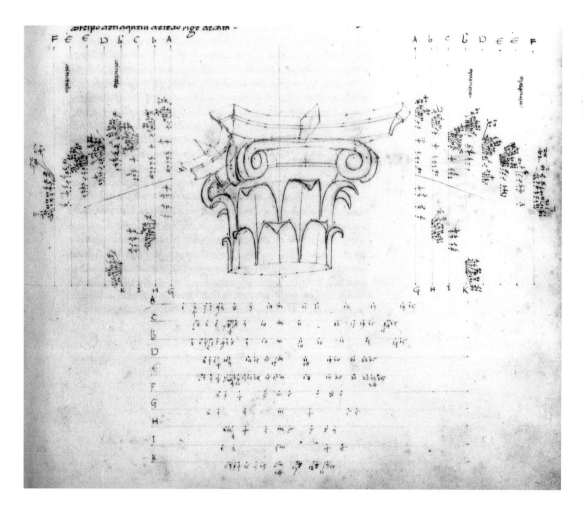

7. Drawing of a column capital in perspective, third stage only, showing rulers for height and width and finished drawing
From Piero della Francesca, *De prospectiva pingendi*, Book 3, Proposition 7, Biblioteca Palatina, Parma, MS no. 576, folio 57 recto

width of the visual field of the human eye. Following Pecham, Piero supposes this to be a right angle. Though closer inspection shows the proof is incorrect, the theorem would almost certainly appear to be true if checked by means of dividers in a diagram of reasonable size, and the actual rule which Piero proposes for choosing the viewing distance does in fact ensure that the degraded line will not come out longer than the perfect one. What we seem to have is a proof that will pass muster with readers of a practical rather than a theoretical bent—and we may note in passing that it passed muster with Daniele Barbaro (1513–1570), who printed it in his *Pratica della perspettiva* (Venice, 1568, 1569)—coupled with a practical rule that is mathematically correct. The disjunction between proof and rule suggests that Piero was at least uneasy about the proof. What is clear, however, is that he feels the necessity to establish that his form of *perspectiva* is a "true science" and is proposing it as an extension of *perspectiva* proper.[44] A rather similar proposition occurs at the very end of Piero's second book (2.12), providing a proof that if a colonnade is shown running parallel to the picture plane, the columns near the edges of the picture will not appear wider than those near the center. This time, the proof is best described as approximate. Its lack of rigor consists merely (in modern terms) of ignoring some inconvenient sines and cosines. The theorem itself is true.

For the painter, the two theorems at the ends of *De prospectiva pingendi* Books 1 and 2 concern the construction of pictures, since they fix the angle the completed picture is to make at the eye of the ideal observer, whose position must be decided before the perspective construction can be carried out. However, both propositions are anomalous within Piero's text, first in actually being theorems rather than construction problems and secondly in the way they return to *perspectiva* proper, drawing lines linking the eye of the observer to the things that are seen. Piero might have omitted both theorems without detriment to the practical usefulness of his text, provided he had included the unexplained, but adequate, rule for avoiding unacceptably long lines mentioned in 1.30. Thus the inclusion of these theorems must be seen as following on from the references to natural vision in the preliminary propositions in Book 1 and as an indication of Piero's intention to establish painters' perspective as a legitimate extension of the accepted optical science of his day. It seems that for Piero these theorems, and the whole of painters' perspective, are part of the same scientific discipline that tells him how to render the reflection of the background hills and figures in the still waters of the Jordan seen round Christ's feet in the *Baptism*, and the slender white highlights that run down the crystal staff of the crozier of *Saint Augustine*.[45]

De prospectiva pingendi Book 2 begins with a short introductory paragraph that tells one a solid has three dimensions (namely length, width, and height), lists a few examples, and says it is things such as these with which Book 2 will be concerned. For the modern reader, as possibly for the fifteenth-century apprentice, this passage chiefly serves to introduce the technical terms which will be used in the main body of the text. The last lines of the introduction indicate that the connection of this work with that of the previous book is that some of the plane figures shown in Book 1 will now become the bases of solid figures. This is exactly what happens. In mathematical terms, Piero constructs prisms. For instance, the square becomes a cube, seen in various orientations and then transformed into a house (complete with such details as the thickness of the walls being visible in the door and window openings; see fig. 4). More complicated polygons yield, among other things, the hexagonal plinth and body of a well-head (fig. 3), and the many-sided shaft of a fluted column. It is presumably because he has dealt with the column and another architectural element (a cross vault) that Piero then, at the end of Book 2, discusses the problem of showing a colonnade parallel to the picture plane. The problem is, as the diagram itself makes clear, essentially a two-dimensional one, and therefore belongs mathematically with the problems considered in Book 1. As a practical matter, however, it belongs in Book 2.

The *pavimento* problems in Book 1 and the problems relating to simple solids in Book 2 are certainly realistic ones for the apprentice painter. Forms corresponding more or less closely to those treated by Piero

can be found in the work of many fifteenth-century painters, and Piero's problems duly reappear, sometimes in simplified form, in the elementary perspective treatises printed in the following century. Since the solid forms are so simple, detailed comparison with anything found in Piero's own work is not likely to be very informative. For instance the diagrammatic house, shown in figure 4, looks like the houses on the right in the *Flagellation* and in the scene of the *Proving of the True Cross* from the fresco cycle at Arezzo, and like houses in a large number of other Italian pictures of roughly similar date. To understand Piero's work, as mathematician and painter, it is probably more useful to notice the relation of the house (fig. 4) to the cube from which it has been derived: the outline of the cube is still clearly visible in Piero's drawing. In any case, it is clear that as far as the end of Book 2 Piero's subject matter was close to the concerns of many other painters, of his own and succeeding generations.

Piero himself seems to have been aware that things were otherwise with *De prospectiva pingendi* Book 3, for he provides the book with an elaborate introduction, considerably longer than that to Book 1, which begins by explaining the great importance of perspective for the painter. The first few lines of the introduction have the defensive tone that we have already encountered in Piero's proof that perspective is a "true science" (in 1.30).

Many painters are against perspective (biasimano la prospectiva) *because they do not understand the power of the lines and the angles to which it gives rise: with which every contour and lineament* (lineamento) *is portrayed. Therefore it seems to me that I ought to show how necessary this science is to painting.*[46]

The remainder of the paragraph is essentially concerned with the optical truthfulness obtainable only through perspective. Piero ends by repeating that perspective is a true science, working "through the power of lines" (that is, by the use of mathematics). Implicit in this defense is Piero's belief that the painter's business is accurate representation, in accordance with what is known about vision, that is, the results obtained by the established science of *perspectiva*. He is also assuming, or asserting, a continuity between this science and the mathematical tech-

niques used in his treatise. In fact, as we shall see, the technique used in Book 3 differs from that used in the previous books, and is, in fact, closer to the mathematical methods familiar from *perspectiva* proper.

Following what we might call Piero's "scientific" defense of perspective there comes the humanist historical-rhetorical one: a list of the greatest painters of Antiquity, taken from Vitruvius, though possibly not directly.[47] All these painters are asserted to have followed the rules of perspective. Piero exhorts his contemporaries to do likewise, says it is for this purpose he has written his treatise, and (here he turns the rhetorical volume down to the level more usual for treatises) has divided it into three books, "as I said in the first." He goes on:

In the first I demonstrated the degrading of plane surfaces of various kinds; in the second I have demonstrated the degrading of square bodies (corpi quadri), *and those with more faces, placed perpendicularly on the plane.*[48]

Piero's summary of the first two books has reduced the matter to geometrical rather than specifically representational essentials, and he writes in equally abstract terms of his final book:

But since now in this third book I intend to treat of degrading bodies enclosed by different surfaces and differently placed, because having to treat of more difficult bodies, I shall take a different approach and another way of degrading them, which I did not use in my earlier demonstrations; but its effects will be the same, and what one does is what the other does.[49]

The equivalence of the new method to the previous one is, of course, an important matter for the mathematician, since the previous method has been shown to be mathematically correct. Piero displays his awareness of this by repeating the degradation of some plane figures, including that of the horizontal square, performed in 1.13, using the new method. Even a rapid glance at the accompanying diagrams, which have been redrawn in figures 5 and 6, omitting most of the lettering, shows something of the difference between the methods. In Book 1, the degraded square was constructed in a single drawing. In Book 3 we begin with two drawings, one (at the top) showing a vertical section

(though with the square shown as if folded up into it), the next showing a ground plan. Both these diagrams show sight lines from A to the corners of the square. We are told that these are constructed using a nail driven into the point A and a string to make the line, or using a needle and a very thin silk thread, or a piece of hair from the tail of a horse. Presumably the string was used for large-scale drawings and the finer materials for smaller ones. There follow instructions for using paper and wooden rulers to transfer the positions of the intersections of these lines of sight with the vertical line just to the left of the square (this line represents the picture plane) to the vertical and horizontal edges of a third diagram, shown below and to the left of the first two, in which the degraded square is then constructed.

Part of the differences between the diagrams in figures 5 and 6 is due to the fact that in 3.1 (fig. 6) the nearest side of the square lies a little back from the ground line of the picture, whereas it lay along this line in 1.13 (fig. 5). However, the important difference is that in Book 3 we are clearly in the world of the surveyor, taking sightings, combining plan with section. As becomes clear in later examples, Piero chooses important points of the original "perfect" shape and finds where lines joining them to the eye will cut the picture plane. Each of these points of intersection is a point of the "degraded" object. One then joins them up, with a curved line if necessary, to obtain a complete drawing showing the object correctly degraded.

This ray-tracing method of Piero's presumably seemed to him not to stand in need of proof. He simply tells the reader that A is to be the eye, and proceeds to deliver drawing instructions in, as we have seen, the most practical of terms. There is, nonetheless, no specific reference to suggest that the drawing is being made directly onto a wall or panel as a preliminary to painting.[50] The problems of Book 3 are, however, entirely practical in the sense that they concern objects found in Piero's paintings, and in those of many of his contemporaries. He deals with a *torculo* (his name for a *mazzochio*) (3.4), a cube balanced on one corner and with none of its edges parallel to the picture plane (3.8), the molded base of a col-

umn (3.6), and two forms of column capital (3.7) (see fig. 7). The first column capital has Ionic volutes and is a slightly less ornate version of the capital of the column to which Christ is attached in the *Flagellation*; the second, best described as "composite," is a similarly simpler version of those of the four columns of the judgment hall in the same picture. This simpler form is found in the *Story of the True Cross*, in the scenes of the Annunciation and of Solomon receiving the Queen of Sheba.

After column capitals, Piero turns to the human head. For the column capital, one plan, composed of several superposed sections, and one side view had sufficed. For the "more difficult" shape of the human head we are given a side view and a front view plus two series of superposed sections, each with four components (see fig. 8). Sixteen points have been taken round each section, and appear in corresponding positions on the side and front views. The group of drawings shown in figure 8 is the second set of illustrations to 3.8. The first had shown the same head but without the numbering. Subsequent figures show lines of sight at an angle to the sections and side views and then a head seen slightly from below, much like the head of the man holding the miracle-working Cross in the Proving scene. Piero then uses the same head again, taking different sight lines, to obtain a view of it from below and slightly to one side. Though the features appear to be different, the problem is clearly the same as that which would need to be solved to make a correct drawing for the head of the second soldier from our left in the *Resurrection* fresco.

After the heads, we have a quarter-dome divided into caissons, and two pieces proposed as *trompe l'oeil*: a goblet (*rinfrescatoio*) that will appear to stand up from the table on which it is painted, and a ring (the kind from which a lamp is suspended) which will appear to hang down from the vault on which it is painted. Vasari tells us that Piero did actually make a trick painting of a goblet of this kind.

Drawing the trick goblet and the ring is actually quite easy (though making them look real enough to deceive the eye would require skills in other parts of painting). Drawing most of the other things in Book 3 is

decidedly laborious. Piero's instructions cover folio page after folio page, swarming with numbers and mind-numbingly repetitive. The tasks are clearly ready-made for the electronic computers that will be invented nearly five centuries later. For a human mind to follow such instructions requires a degree of skill at visualizing form in space that is almost certainly beyond the common, even among painters. We may guess as much from the fact that almost nothing of what we find in Book 3 reappears in the later perspective treatises that make so much use of the two earlier books of Piero's work. Most of these later treatises replace Book 3 with some chapters showing the use of instruments designed to make correct perspective drawings by mechanical means.

Mathematics and Painting

The *intonaco* of the Proving scene in the *Story of the True Cross* carries incised lines delineating the contours of architectural elements, including all the verticals, and outlining each surface of the Cross. *Spolvero* marks outline all the heads, usually also marking some of the features, as well as all the drawing of figures' hands, and the naked torso and arms of the young man who is coming back to life. A similar use of incisions and *spolvero* is found in the other scenes on the same wall and the adjoining end wall.[51] Photographs suggest that *spolvero* marks are present in corresponding parts of all the scenes of the fresco cycle. *Spolvero* marks do not appear to be present in most of the drapery, though it is possible that in some passages they are merely hidden by the relatively dark color of the paint, for instance in the heavy pink-purple cloak of the figure on the far right in the Proving scene. This figure is of great compositional importance, and *spolvero* marks are visible in the drapery of a comparably important figure, namely along the sinuous lower edge of the tunic of the figure in white (a color contrary to Alberti's prescription) standing with his head turned away from us close to the left side of the Exaltation scene.

This evidence for the use of cartoons implies a large amount of preparatory work and, almost certainly, some layout lines on the underlying rough plaster.[52] The careful planning is matched by the execution. There are some graceless passages, particularly in large draperies, but the cleaning in progress in 1992 was showing that the paint handling has the same delicacy that one finds in Piero's panel pictures. Some of this, for instance the very subtle modeling and coloring of faces, might be visible to a viewer on the floor of the church, in the sense that it would enhance the effect of solidity and reality of the figures. However, much would undoubtedly be lost. The patterns of corrugated roof tiles, and details such as the small pincer-like implements displayed for sale outside one of the shops facing onto the main street in the city on the hill, are surely far too small for Piero to suppose that they would be visible from the floor of the church.

As one might expect, given the extensive evidence for the use of cartoons, Piero's *intonaco* shows no lines that seem likely to relate to a perspective construction. There are no equivalents to the "snapped" orthogonals one finds in, for example, Masaccio's *Trinity* fresco.[53] These snapped lines are, as it were, a relict of Masaccio's perspective scheme. Piero has left no such direct clues.

The fact that Piero seems to have relied entirely on cartoons to transfer his design to the wall may, however, be taken, rather more tentatively, as evidence of another kind. Piero must surely have known what many of his contemporaries seem to have known about perspective pictures, namely that to create an adequate space for the *historia* it was enough to use a few highly readable elements, such as regularly-shaped buildings. Indeed, Piero's subtle use of the crosses in the *Story of the True Cross* shows him employing their well-known shape in exactly this way—for instance to define the shape of the group of people kneeling round the bier in the Proving scene. Moreover, in both the middle registers, that is for the pictures combining the scene of the Queen of Sheba's recognizing the wood of the Cross and that of her reception by Solomon, and the picture combining the scene of the Finding of the Crosses and the Proving scene, Piero follows the example of Masaccio's *Tribute Money* by using architecture to create depth on one side of the picture and showing the other in the more gently structured form of landscape. It seems clear, from

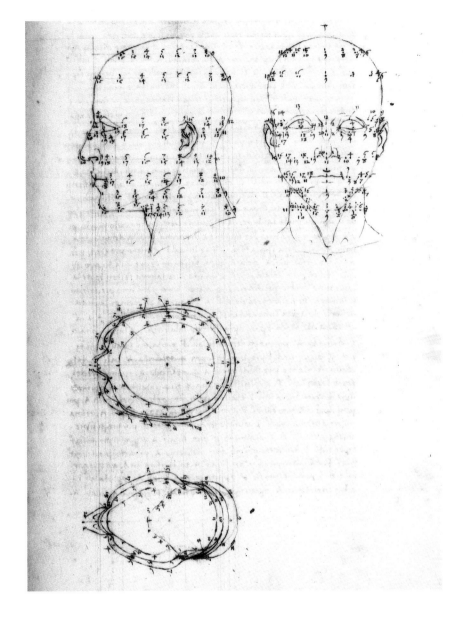

8. Drawing of a human head
in perspective, first stage
only, with points numbered
From Piero della Francesca, *De
prospectiva pingendi*, Book 3,
Proposition 8, Biblioteca Palatina,
Parma, MS no. 576, folio 64 recto

a much lesser extent in the left background of the London *Nativity*, does Piero seem to have used aerial perspective to help give distance in his landscapes. Since aerial perspective depends on color changes, it is specifically excluded from *De prospectiva pingendi*, but all the other means which Piero, like most of his contemporaries, relies upon to convey depth and distance, are dealt with in mathematical terms in the first two books of Piero's treatise. Yet on the wall in San Francesco the rectilinear objects and the "more difficult" ones that correspond to examples from the third book of *De prospectiva pingendi*, are (it seems) equally treated by means of cartoons. This does not, of course, prove that the cartoons for the column bases, the column capitals, the heads and hands of every figure, were drawn by using the point by point perspective construction Piero describes in his treatise. On the other hand, it is difficult to doubt that some mathematical construction went into the drawing of the rectilineal elements, whose perspective is extremely convincing.

If Piero has done preliminary drawings for the buildings and the crosses, using perspective constructions or making copies after drawings done using such constructions, as described in Books 1 and 2, then why should he not have used the methods of Book 3 to make cartoons in equally accurate perspective for, say, the heads? The apparent equality of treatment in the use of cartoons would seem to argue for some mathematical equality in the origins of the cartoons. One winces, however, at the thought of how laborious it would have been. We are all Vasari's children in admiring *sprezzatura*. It is perhaps hard to accept that in Piero its realm was so very limited. It may, however, be worth investigating what explanatory power this otherwise rather unpalatable hypothesis may have.

First, let us remind ourselves that the hypothesis is made less unpalatable by the fact that Piero was a very good mathematician. He wrote his mathematical treatises because he wanted to write them. Moreover, *De prospectiva pingendi* was a new kind of work, which Piero must surely have felt well qualified to write. In fact, some of the features that make it rather hard to read are the result of a mathematical form of *sprezzatura*. The elegance of concision in proofs,

these and from a number of other examples in the panel paintings, that Piero recognized the preeminent importance of relatively simple straight-edged objects in conveying a sense of three-dimensionality. More basic still, of course, are simple occultation and the relative sizes of well-known objects, so that the effect of distance in landscape can be achieved by a subtle deployment of trees (as in Masaccio's *Tribute Money* and Piero's *Baptism of Christ*) or by small portraits in recognizable cities (Borgo San Sepolcro in the background to the *Baptism*, Arezzo as Jerusalem in the background to the *Finding of the Crosses*).

Only in the Montefeltro portraits, and to

notably in 1.13 (see above), and the elegance of treating only the general case for the orientation of the solids in Book 2, as well as of the intricate, though still diagrammatic, shapes of the "more difficult" bodies in Book 3, all make the work more difficult for the reader, and suggest Piero was partly addressing himself to fellow mathematicians. Such features make it less surprising that Piero apparently took the trouble to cooperate in the making of a Latin translation of the work.

As his rediscovery of the Archimedean polyhedra shows, Piero was very good at geometry, in three dimensions as well as in two. There is, of course, no problem in seeing a corresponding skill at work in his paintings, all of which function extremely well as compositions in space as well as in the plane. That is to say that they are readable, correct in pictorial terms as Piero's mathematics is correct in mathematical terms. Now, merely getting the mathematical part of the perspective correct (or trying very hard to do so) does not achieve this effect, as witness almost any picture by Piero's slightly older contemporary Paolo Uccello (1397–1475). Vasari implies that the defect of Uccello's pictures is to contain too much mathematics. I should like to float the suggestion that they contain too little. More mathematics might give the control of composition in space that we find in Piero—and indeed in many painters who were not known as expert mathematicians. My point here is, to adapt Alexander Pope, that in the use of mathematical perspective it is a medium amount of knowledge that is a dangerous thing.[54]

Piero's control in regard to composition in space is an interesting component of his paintings because the need for it was something new that went with the use of naturalistic perspective. Control of composition in the plane was part of the stock-in-trade of any painter. There is, however, one characteristic of Piero's composition in the plane which seems to tell us something about his attitude to spatial composition, and this may lead back to his mathematics: namely his repeated tendency to let forms run into one another on the plane when they do not do so in space. Being most familiar with the three Piero paintings in London, my exemplar for

this is the white-on-white whereby, in the panel from the now-dismembered Augustinian altarpiece, Saint Michael's wing is almost lost, on our left, against the white marble of the balustrade, whose molding moreover mimics the patterning of the feathers. The other wing vanishes against the marble on Saint Michael's other side, behind the severed head of the dragon. In a rather similar way, the shadowed side of Saint Michael's right leg has almost the same color as the brownish marble behind it. There are similar passages in the London *Nativity*: the Child's left hand contrasts only very weakly with the color of the angel's foot behind it, the cream-colored lining of the Virgin's cloak, shown as the cloak is folded to go under the Child, is almost the same color as its background, thus slightly separating the two figures that the cloak itself unites, and the line and color of the neck of the lute of the angel on the left blend into the color and shape of the horn of the ox behind it. None of these non-contrasts jars in the sense of snatching at one's attention. There are, however, enough of them to suggest that they are connected with Piero's undoubted skill at balancing composition in three dimensions with composition in two. He is prepared to risk something of his spatial illusion to assure coherence of the composition in the plane. This implies a considerable degree of self-confidence, something which should not be overlooked merely because the self-confidence is so clearly justified.

The *Flagellation* provides a slightly different example of Piero's risk taking. The mathematical structure of the picture is visible to a degree that has allowed the perspective scheme to be reconstructed in detail.[55] Perhaps because of some non-contrast effects and the brilliant color Piero has used, when turning from the picture to the ground plan I tend to find the space startlingly deep. There is, however, no doubt about the reconstruction, and the difference between the instinctive, and entirely confident, reading of the space by the viewer and its reconstruction by mathematical means presumably tells one something about optical illusions. It is, in any case, the confidence of the viewer's reading that is important, because it turns out that this has to resist a non-natural use of lighting.[56] Since the casting of shadows is

a powerful clue in reading what we see in spatial terms, as Piero undoubtedly knew, this invisible non-natural light source in principle endangers the reading of the composition as a whole.[57] Perhaps the inclusion of the miraculous light may partly explain why Piero gave this particular picture such a strong perspectival structure in mathematical terms; or perhaps the reasoning should go the other way, to suggest that the choice of a visibly non-natural miracle as the subject gave additional point to mathematically correct illusionism. Whichever way it goes, Piero seems to have been taking a risk which made his confidence in his mathematical skill an important part of the way he chose to design his picture.

The same could be true of the fresco of the *Resurrection*, but the case is less clear-cut because the perspective of the picture, expressed in measurable mathematical terms, is non-existent, and a little exercise of optics-assisted common sense shows that we are seeing the soldiers from below (as we in fact see the picture) while we are seeing Christ's left foot from slightly above, and the rest of Him apparently more or less straight on. Piero seems to have arranged for each part to look so convincing that the human visual system flatly refuses to acknowledge contradictions, except perhaps to the extent of agreeing that Christ seems at once solid and weightless (an impression that is, of course, theologically sound in the circumstances). If Piero has done this without using the mathematical techniques of *De prospectiva pingendi* then he has produced one of his most characteristic pictures, and one of the most imposing pictures of all time, while not using one of his most characteristic skills. Perhaps this is so, but I think one can come up with a more interesting view of Piero if one does not believe it. At the very least, one thereby makes an honest man of him, for the text of Book 3 of *De prospectiva pingendi* certainly presents itself as practical. As we have seen, it has references to using nails, string, and other practical means to construct "rulers" to be made of wood or paper.[58] Moreover, the examples treated include things found in Piero's pictures, and the fact that drawings are provided is surely meant to imply that Piero did himself use the techniques he illustrates.

Craft and Science

In its style, Piero's mathematics is essentially that of the abacus school tradition, and as such is entirely in keeping with his activity as a craftsman. What makes him interesting, as a craftsman mathematician, is that he is clearly striving to establish links between this kind of mathematics and the learned mathematics of Euclid and, more importantly for our present purposes, to show painters' perspective as a legitimate extension of an established branch of natural philosophy.

The affiliations of Piero's work with the learned tradition find concrete expression in the preservation of his treatises in Latin versions as well as vernacular ones.[59] This is the earliest example I know of the process of interaction between craft and learned mathematics that was to prove so important in the sixteenth century. It would be very rash to claim Piero as a moving spirit in the process, but his attitude is an interesting indication of the way the intellectual wind was blowing.

Piero's perception of painters' perspective as an extension of the learned science of *perspectiva* may well have been shared by some of his contemporaries,[60] but it did not prove to be of lasting historical significance—not least because of the changes that took place in natural philosophy in the following century, converting the unified science of *perspectiva* into a rather more fragmented science of optics. However, Piero's perception of perspective construction as a legitimate extension of an established partly mathematical science was certainly important for his own work, and (as we have seen) it seems to have played a part in determining the structure and content of *De prospectiva pingendi*. For a twentieth-century reader, the repetitious drawing instructions seem to lower the intellectual tone of Piero's treatise, but they were no doubt appropriate for its intended primary readership, and they cannot disguise the essentially orderly nature of the treatise. Since Piero's methods are mathematical, and *perspectiva* was called a "science" (because it was mathematical), we do his thought no violence in calling it scientific. Piero is proposing a science of representation, at least as far as draftsmanship is concerned.

Piero's paintings, irrespective of their medium, seem to continue this scientific attitude. Even Vasari, who was not the most sympathetic observer of fifteenth-century

painting, admired the way Piero managed to render the reflections from the armor in the Battle of the Ponte Milvio in the *Story of the True Cross*. While Piero's style cannot of course be likened to Photorealism, his concern for optical accuracy seems to have been at least as scientific as that of his younger contemporary Leonardo da Vinci.

If, then, we may take the mathematical exposition of *De prospectiva pingendi* as a true reflection of Piero's working methods, the treatise may perhaps prove useful in the study of Piero's paintings. First, it seems unlikely that the particular examples Piero chose to use in his treatise were selected specifically for the treatise rather than because they had already been used, or were about to be used, in Piero's pictures. This applies particularly to the "difficult" objects of Book 3, where the perspective construction was clearly an elaborate matter. In any case, it seems reasonable to suppose that Piero would have wished the treatise to stand at least partly as a memorial to his pictures as well as to his skill as a mathematician. The illustrations to *De prospectiva pingendi* thus probably reflect preliminary drawings made for Piero's pictures, though we do not know whether any of the illustrations in surviving copies of the treatise were actually by Piero, and there is, of course, no guarantee that the corresponding paintings are still extant. The treatise should thus be seen as making at most a rather modest addition to our knowledge of Piero's painted oeuvre.

Secondly, if the examples in *De prospectiva pingendi* relate to actual constructions Piero carried out for elements in his pictures, they may make a contribution toward providing dates for the pictures. Here again, the situation is clearly not simple: we have no specific dates regarding the composition of the perspective treatise. We do, however, know that it antedates the *Libellus de quinque corporibus regularibus* or, at least, the Latin copy that has come down to us. It thus seems likely that the perspective treatise was finished before Piero gave up painting (if he did give up painting). One suggestion for a picture that may have been designed after the treatise was completed is the Montefeltro altarpiece. The coffered vault, with its rosettes, is clearly a more purely "classical" version of the vault in Masaccio's *Trinity*

fresco, a painting one may surely suppose Piero to have admired. The ideal viewing distance for Piero's picture is so long that the spacing of the curved ribs in the picture plane is very nearly even. However, merely using a ruler on an approximately quarto reproduction of the picture shows that the spacing is not exactly even, so Piero has presumably carried out a construction of some kind. The problem would seem to be a much simpler version of the one of the coffered quarter dome that is treated in *De prospectiva pingendi* 3.9.[61] Perhaps Piero thought the problem of the barrel vault too simple to be worth including, but it is not in fact such a very simple one—as can be seen from the diverse solutions proposed for it in the literature on the *Trinity* fresco. On the whole, it seems more likely that the absence of the barrel vault from the treatise is an indication that the work was written before the Montefeltro altarpiece was designed.[62]

Finally, I should like to suggest, much more tentatively, that Piero actually made extensive use of mathematics in all his paintings, though usually in a way that does not allow us to reconstruct his procedures.[63] I have already suggested that mathematics was used in this way in the *Resurrection* fresco. For this, the mathematics concerned would involve elaborate constructions like those in the final book of *De prospectiva pingendi*. Much simpler mathematical procedures would suffice in, say, the *Baptism*, where the calculations would need to have been made only to obtain a scientifically correct relation between the sizes of repeated elements such as human figures, and the nature of the reflections in the water. If Piero did actually carry out calculations for elements like these in all his pictures, that might explain the "stillness" that is so characteristic of his work. What I am suggesting, with due consciousness of following on from Berenson, is that the uniformity Piero has imposed, treating repeated pictorial elements as modules, makes his pictures very easily readable in spatial terms. The sense of unambiguous reading, due to the mathematical correctness and the uniformity or simple interrelation of sizes, gives the pictures their characteristic "stillness." This is to see Piero's painting as being, like his technical treatises, examples of a mathematician's art.

In the century following Piero's death art, mathematics, and natural philosophy were all to develop in ways that made Piero's work look thoroughly out of date. Moreover, the twentieth-century taste for abstraction has been kinder to Piero's pictures than to his artisan style of mathematics. Historians of mathematics, like historians of art, prefer to study works which they find attractive, so it is Piero's mathematics that has been neglected. The present essay is part of an attempt to redress the balance. Piero is an important figure, and the fact that he paints as he does provides insights into his mind and character of a kind usually denied to the historian of mathematics. Moreover, the range of his activities shows us something of the intellectual habits that prevailed before the important changes brought about by the shifting in position of disciplinary boundaries in philosophical and mathematical culture of the century following Piero's death. Piero's art epitomizes the representational conventions that gave us the Renaissance style in art. Its intellectual and social framework is a reminder of what was swept away in the developments that led to the rise of modern science.

NOTES

1. See Paul Grendler's article in this volume.

2. This story is not yet a standard component of histories of mathematics. A sketch and further references are given in J. V. Field and Jeremy J. Gray, *The Geometrical Work of Girard Desargues* (New York, 1987); see also J. V. Field, "Linear Perspective and the Projective Geometry of Girard Desargues," *Nuncius* 2.2 (1987), 3–40.

3. This period is now known to historians of science as the Scientific Revolution, a name derived from the title of A. Rupert Hall, *The Scientific Revolution* (London, 1954). The degree of felicitousness of this name has been the subject of much discussion. For recent summaries see David C. Lindberg, "Introduction," in *Reappraisals of the Scientific Revolution*, ed. David C. Lindberg and Robert S. Westman (Cambridge, 1990); and J. V. Field and Frank A.J.L. James, "Introduction," in *Renaissance and Revolution: Humanists, Craftsmen and Natural Philosophers in Early Modern Europe*, ed. J. V. Field and Frank A.J.L. James (Cambridge, 1993).

4. See Lindberg and Westman 1990; Field and James 1993.

5. Such a claim is made, for instance, in Samuel Y. Edgerton, *The Renaissance Rediscovery of Linear Perspective* (New York, 1975).

6. In modern terms this would be called "the line segment AB."

7. On Piero's education see Paul Grendler's article in this volume.

8. See the introduction in the modern edition of Piero's *Trattato:* Piero della Francesca, *Trattato d'abaco: Dal Codice Ashburnhamiano 280 (359* .291*) della Biblioteca Medicea Laurenziana di Firenze*, ed. Gino Arrighi (Pisa, 1970). Since a facsimile edition of the manuscript (Cod. Ashb.) is in preparation, all further references to the *Trattato* will include the manuscript folio numbers as given in Arrighi's edition.

9. Printed in Piero della Francesca, "L'Opera 'De corporibus regularibus' di Pietro dei Franceschi detto della Francesca, usurpata da Fra' Luca Pacioli," ed. G. Mancini, *Memorie della Reale Accademia dei Lincei*, series 5, 14.8B (1916), 441–580.

10. See Piero, ed. Arrighi 1970.

11. A Tuscan pound, which contained 12 ounces, weighed less than the modern Imperial pound (of 16 ounces): about 340 grams as against about 454 grams. That is, the Tuscan ounce is about equal to the modern one. See H. J. von Alberti, *Mass und Gewicht* (Berlin, 1957), 415.

12. Piero, ed. Arrighi 1970, 64; Cod. Ashb., fol. 17r. The word I have translated "body" is *busto*. In view of the proportions of the weights, a better translation might be "middle cut."

13. This use of *cosa* for the unknown eventually earned algebra the Latin name *cossa*.

14. Luca Pacioli, *De divina proportione* (Venice, 1509). There seems to be no evidence that Pacioli

was Piero's pupil in a formal sense, though he certainly knew Piero's work and made use of it in his own publications. However, before we join Vasari in his complaint about Pacioli's plagiarism, it is as well to reflect that almost all the arithmetical or algebraic problems in Piero's *Trattato* have been identified as derived from earlier sources, see S. A. Jaywardene, "The *Trattato d'abaco* of Piero della Francesca," in *Cultural Aspects of the Italian Renaissance: Essays in Honour of Paul Oskar Kristeller*, ed. Cecil H. Clough (Manchester, 1976), 229–243, and Margaret Daly Davis, *Piero della Francesca's Mathematical Treatises: The "Trattato d'abaco" and "Libellus de quinque corporibus regularibus"* (Ravenna, 1977).

15. Piero, ed. Arrighi 1970, 202; Cod. Ashb., fol. 95r.

16. Euclid, *The Thirteen Books of Euclid's Elements*, ed. and trans. Thomas L. Heath (Cambridge, 1908), 2:85.

17. Piero, ed. Arrighi 1970, 200; Cod. Ashb., fol. 94v.

18. Piero, ed. Arrighi 1970, 201; Cod. Ashb., fol. 94v.

19. The name cuboctahedron, and the modern names for all the other Archimedean polyhedra, are due to Johannes Kepler (1571–1630), who described and illustrated all thirteen of the solids in his *Harmonices mundi libri V* (Linz, 1619); Book 2; English translation *Johannes Kepler. Five Books of the Harmony of the World*, trans. Eric J. Aiton, Alistair M. Duncan, and J. V. Field, in *Transactions of the American Philosophical Society* (in press).

20. Two are discussed in the *Trattato* and four more in the *Libellus*; see below.

21. Piero, ed. Arrighi 1970, 231–232; Cod. Ashb., fol. 108r.

22. My phrasing is not meant to imply any particular authorship for the diagrams supplied in any extant manuscripts. It is, however, to be presumed that these are derived from originals drawn by Piero himself or drawn under his supervision.

23. Piero, ed. Arrighi 1970, 231; Cod. Ashb., fol. 107v.

24. See Davis 1977, 121–123.

25. In order of appearance, these are the truncated icosahedron (twenty hexagonal faces, twelve pentagonal), the truncated dodecahedron (twenty triangles, twelve decagons), the truncated octahedron (six squares, eight hexagons), and the truncated cube (six octagons, eight triangles). See Piero, ed. Mancini 1916, Tractatus 4, sections 2 to 5 inclusive, 559–564, and Pacioli 1509, second part, fols. 20v–22v.

26. Piero, ed. Mancini 1916, Tract. 4, sect. 6, 564; Pacioli 1509, second part, fol. 22v.

27. The illustrations to the Italian version of the *Libellus* in Pacioli 1509 are not exactly the same as those Mancini records as present in the single known manuscript of the *Libellus*. Pacioli's illustrations are, however, similar in style to those of the *Trattato*. It thus seems possible that Pacioli worked from a copy of the *Libellus* different from the one that has come down to us in Vatican codex Urbinatus latinus 632.

28. Piero, ed. Arrighi 1970, 234; Piero, ed. Mancini 1916, 578.

29. See Piero, ed. Mancini 1916, and Davis 1977.

30. The Italian version of the *Libellus* published by Pacioli as the second part of his *De divina proportione* (without ascription to Piero) may, in this case, be Piero's original rather than a translation of the Latin text preserved in the Vatican codex Urbinatus latinus 632.

31. We may note that Pacioli seems to have made this kind of choice in regard to *De divina proportione*, which, like Piero's *Libellus*, contains numerous references to Euclid.

32. *De prospectiva pingendi* was not printed in the Renaissance, but large parts of it were reproduced, with due acknowledgment to the original author, in Daniele Barbaro, *La Pratica della perspettiva* (Venice, 1569). See Thomas Frangenberg, "Piero in the Cinquecento," paper presented to a conference in Arezzo in October 1992 and to be published in the Proceedings (ed. Marisa Dalai Emiliani); see also Martin Kemp's article in this volume.

33. This point is worth emphasizing, from the point of view of the history of science, because this quiet extension of the use of mathematics in what came to be called optics—a quiet extension which has its analogues in other areas—forms a little-noticed contrast with the much-discussed extension of the use of mathematical methods in areas such as mechanics in the sixteenth century, notably in the works of Giovanni Battista Benedetti and Galileo Galilei (1564–1642).

34. Piero della Francesca, *De prospectiva pingendi*, ed. Giusta Nicco Fasola (Florence, 1942; repr. Florence, 1984), 63–64.

35. My reference here is to the initial intended readership of the works in the fifteenth century. In the mid-sixteenth century, Barbaro 1569, published in Venice and drawing heavily on Piero's *De prospectiva pingendi*, may well be seen as supplying a relatively learned mathematical supplement not only to Barbaro's editions of Vitruvius (1556, 1567) but also to the new vernacular version of Alberti's *De pictura*, translated by Cosimo Bartoli and published in Alberti's *Opuscoli morali* (Venice, 1568).

36. Piero, ed. Nicco Fasola 1984, book 1, proposition 4, 67.

37. See J. V. Field, "Piero della Francesca's Treatment of Edge Distortion," *Journal of the Warburg and Courtauld Institutes* 49 (1986), 66–99 and pl. 21c. Pecham's work, probably written between 1277 and 1279, was the most widely read optical text of Piero's time. In the sixteenth century it was gradually displaced by the more mathematical treatise of Witelo, Pecham's near contemporary, which is important historically for transmitting the optical work of Ibn al-Haytham (A.D. 965–1039), who is usually known in the West as Alhazen; see David C. Lindberg, *John Pecham and the Science of Optics* (Madison, Wisc., 1970) and David C. Lindberg, *Theories of Vision from al-Kindi to Kepler* (Chicago, 1976; repr. 1981).

38. Piero, ed. Fasola 1984, 1.8, 70.

39. For the proposition just mentioned, the reference is to *Elements* 6, proposition 21.

40. See James Elkins, "Piero della Francesca and the Renaissance Proof of Linear Perspective," *Art Bulletin* 69 (1987), 220–230.

41. See J. V. Field, "Piero della Francesca as a Practical Mathematician," paper presented to a conference in Arezzo in October 1992 and to be published in the Proceedings (ed. Marisa Dalai Emiliani).

42. The most notable example of this is in 1.30; see below.

43. In fact these second and third stages of Piero's construction of the image of the *pavimento* resemble the corresponding stages of what is known as the "distance point construction," and recall Alberti's reference to the use of the diagonal as a method of checking a construction carried out according to the method he has just described. Both of these reminiscences may point to an earlier workshop rule. Its possible form is discussed in Appendix 1 to J. V. Field, Roberto Lunardi, and Thomas B. Settle, "The Perspective Scheme of Masaccio's *Trinity* Fresco," *Nuncius* 4.2 (1988), 31–118.

44. Piero's proof and its scientific background are discussed in more detail in Field 1986.

45. These examples were chosen as being in principle calculable. For further details see Marilyn Aronberg Lavin, *Piero della Francesca's "Baptism of Christ"* (New Haven, Conn., 1981) and Martin J. Kemp, "New Light on Old Theories: Piero's Studies of the Transmission of Light," paper presented to a conference in Arezzo in October 1992 and to be published in the Proceedings (ed. Marisa Dalai Emiliani), and John Shearman's article in this volume. Reflection from curved surfaces can easily lead to rather intractable mathematical problems, some of which are dealt with by Alhazen (see note 37 above). It seems likely that observation played the greatest part in Piero's northern minimalist rendering of Saint Augustine's crozier, and of the glitter of the jewels on the armor of Saint Michael (from the same altarpiece).

46. Piero, ed. Nicco Fasola 1984, 128, Parma MS 1576, fol. 32r, British Library MS Add. 10, 366, fol. 37r.

47. Vitruvius does not mention Apelles, but with this exception Piero's list agrees closely, in its nonclassical orthography, with that given in the *editio princeps* of Vitruvius (Rome, 1486), and is therefore presumably to be found in the manuscript tradition. However, a similar list is also given in possible indirect sources, such as Ghiberti's *Commentaria*. Apelles is mentioned by Pliny, and in Filippo Villani's *De origine civitatis Florentiae et eiusdem famosis civibus* (1381–1382); see Michael Baxandall, *Giotto and the Orators* (London, 1986), first ed. 1971, 146 for Villani's Latin text. Apelles is discussed at length by Alberti in *De pictura*. The spelling of the artists' names in the Latin copy of *De prospectiva pingendi* in the British Library (MS Add. 10, 366) is the same as in the Italian version (Parma MS 1576), printed in Piero, ed. Nicco Fasola 1984.

48. Piero, ed. Nicco Fasola 1984, 129; Parma fol. 32v; BL fol. 37r.

49. As previous note.

50. If the reference to the use of a nail and string suggests large-scale drawing, it may still be for a paper cartoon; see below.

51. The *Finding of the Crosses*, the *Battle of Heraclius and Chosroes*, the *Exaltation of the Cross*, the *Removal of the Jew from the Well*, and the *Annunciation*.

52. Unfortunately, the history of restoration work in San Francesco over the centuries has been such that it is unlikely that the rough plaster under Piero's frescoes could be studied without destroying the pictures themselves.

53. See Field, Lunardi, and Settle 1988. It is most unlikely that these lines in the *Trinity* fresco are part of an actual construction carried out on the wall, for it is impossible to see how it could have been continued to yield the other lines required in the composition.

54. It is perhaps interesting that the artist Vasari quotes as particularly critical of Uccello's work should be Donatello (1386–1466) who, as a sculptor, certainly did have the strong spatial sense that Uccello seems to have lacked. In Donatello's reliefs, mathematics, in the form of perspective construction, seems always to have been thoroughly subordinated to theatricality, and with such success that to consider "errors" in the mathematics would clearly be entirely misguided; see John White, "Developments in Renaissance Perspective II," *Journal of the Warburg and Courtauld Institutes* 14 (1951), 42–69.

55. Rudolf Wittkower and B.A.R. Carter, "The Perspective of Piero della Francesca's 'Flagellation,'" *Journal of the Warburg and Courtauld Institutes* 16 (1953), 292–302.

56. For the *Flagellation* as a whole, and this non-natural light in particular, see Marilyn Aronberg Lavin, *Piero della Francesca: The Flagellation of Christ* (New York, 1972; Chicago, 1990).

57. The miraculous light streaming from the cross held by the angel in Constantine's Dream in the *Story of the True Cross* is much more easily read and is therefore less likely to be disruptive.

58. Piero, ed. Nicco Fasola, 3.1, first two paragraphs, 130; Parma fol. 32v; BL fol. 37r.

59. I am here allowing Pacioli's Italian version of the *Libellus* to stand in for Piero's original, with which it may be identical; see above.

60. See, for example, the discussion of the figure of "Perspectiva" in L. D. Ettlinger, "Pollaiuolo's Tomb of Pope Sixtus IV," *Journal of the Warburg and Courtauld Institutes* 16 (1953), 239–274.

61. Piero, ed. Nicco Fasola 1984, 3.9, 202–209; Parma fols. 77r–81v; BL fols. 96v–102r.

62. I should, however, strongly resist the suggestion that the absence of a cross indicates that the perspective treatise antedates the Arezzo fresco cycle. The cross is a simple case of a right prism and thus a trivial extension of the treatment of the cube in book 2.

63. It should be noted that the problem of extracting the mathematics from pictures is much like that of extracting sunbeams from cucumbers, see Jonathan Swift, *Gulliver's Travels* (London, 1726), part 3, "A Voyage to Laputa . . . ," chap. 5, describing the great academy of Lagado. Swift's satirical notion was picked up by W. S. Gilbert and used in the major-general's song in *The Pirates of Penzance*. (I am grateful to Marie Boas Hall for the latter part of this reference.)

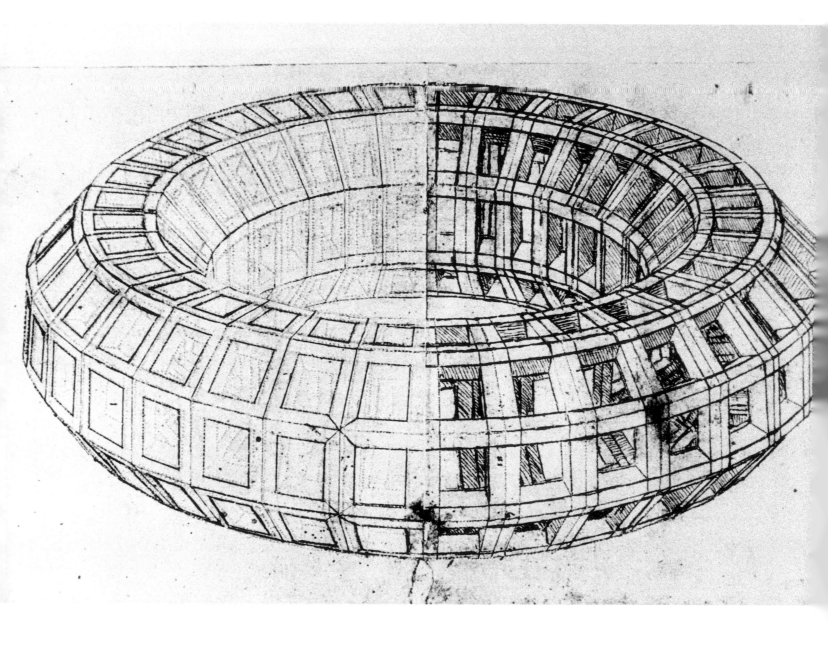

MARTIN KEMP
University of St. Andrews

Piero and the Idiots: The Early Fortuna of His Theories of Perspective

1. Leonardo da Vinci,
*Perspective Study of an
Annulus*, c. 1494, pen
and ink
Biblioteca Ambrosiana, Milan,
263va

Considered collectively, early Renaissance treatises on painting and sculpture comprise an odd and heterogeneous literary genre. The treatises may, with little exaggeration, be characterized as representing a new set of visual, intellectual, and professional aspirations in need of an effective format in which they could be expressed and in search of an identifiable audience. Each of the main surviving bodies of artists' writings—by Cennino Cennini, Leon Battista Alberti, Lorenzo Ghiberti, and Leonardo da Vinci—may be considered more as an individualistic response to differently perceived needs rather than as belonging to a coherent series or even as contributing to a debate framed in consistent terms.

Cennino's *Il libro dell'arte* represents a not unambitious attempt to marry some rather unresolved ideas about the cerebral principles of painting to an outline of the discipline of painting in terms of professional skills.[1] It is clearly addressed in great part to aspiring artists, but the evidence of manuscript survival hardly suggests a wide circulation in the workshops or any other forum. Alberti, by contrast, composed a humanist's didactic tract, on the lines of Cicero, Seneca, Lucian, and, most especially, Quintilian, and it seems to have thrived best in court schools and libraries.[2] Ghiberti's *Commentaries* open as a Plinian history of ancient and modern art, but his subsequent autobiography does not follow any obvious

precedent, and his addendum of a collage of texts from medieval optical science takes it decisively outside any humanist pattern.[3] Ghiberti's compilation has proved to be a more fruitful source of inspiration for modern historians than it ever provided for its contemporary audience, if indeed it enjoyed much of an audience at all. Leonardo's intentions in his unrealized treatise on painting, as far as they can be reconstructed, appear to have embraced almost every possibility, from windy humanist debates on the relative status of the arts to obsessively detailed observations of the behavior of light in nature. At different times, Leonardo appears to be addressing different audiences in different tones of voice. It was only in academic circles during the later sixteenth and seventeenth centuries that Francesco Melzi's edited version of Leonardo's notes found a substantial audience, and even then their impact would hardly have been as Leonardo expected.[4] As far as can be judged, lost treatises, such as those reputed to have been written by Vincenzo Foppa, Bramantino, and Giovanni Fontana, would have done little to unify the genre.[5]

The lack of standard format, terms of reference, and recognizable audience stands in contrast to books of ingenious machines, such as those by Mariano Taccola and Francesco di Giorgio and those apparently planned by Leonardo, which were located in an established European tradition.[6] Authors

writing on architecture could look to Vitruvius for form and content, as the books by Alberti, Filarete, and Francesco di Giorgio did to varying degrees. Although the workshops provided a ready readership for copies of drawings of machines and of architectural forms (particularly details of ancient monuments), the designated recipients of the set-piece treatises in the era of manuscripts, and even to some extent in the era of the early printed book, were actual or intended patrons of the engineers or architects. There has been a tendency to view such manuscripts as how-to-do-it manuals, but they may be more fairly described as I-can-do-it testimonials to their authors' abilities.

In this respect at least, the majority of the artists' treatises fit into this pattern of anticipated use. If they reached the point of finished manuscripts, they almost certainly were aimed at someone of status, first and foremost, and only at the workshops in a secondary way. Perhaps Cennino's *Libro* represents an exception, but even in this instance we cannot be sure that its primary destination was the regular apprentice. Alberti's *De pictura* ostensibly provides instructions (of a kind) for the aspiring artist, but as a set-piece didactic composition in the humanist manner, its primary readership was more likely to have been envisaged as young aristocrats who were studying Cicero, Lucian, and Quintilian than the artisan-apprentices in a traditional *bottegha*. The Italian version obviously attempts to reach a different and less highly educated audience, but the target group can be best identified as a small elite of intellectually alert and upwardly mobile artists of the kind mentioned in the preface. The aims and address of Ghiberti's and Leonardo's compilations are so uncertain and internally inconsistent that we would be unwise to posit clearly conceived audiences in either case, but the general sense that emerges is that neither was speaking for most of the time to unlettered tyros.

Where does Piero's *De prospectiva pingendi* stand with respect to these remarks? We should note immediately that the destination of one of the highly finished copies was the library of Federigo da Montefeltro at Urbino, where, as Piero himself specified, it was to be joined by a manuscript of his *De quinque corporibus regularibus*.[7] As a trea-

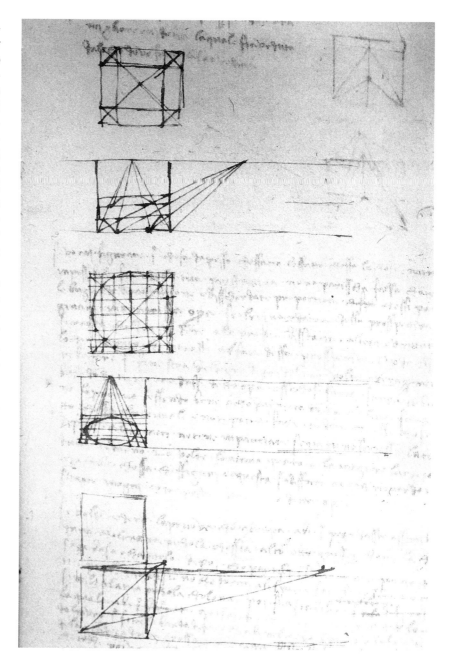

2. Leonardo da Vinci, *Studies in the Foreshortening of Geometrical Figures*, c. 1490, pen and ink Institut de France, Paris, (MS A 40r)

tise concerned with perspective and heavily imbued with Euclidean principles, it may seem plausible to align it with book 1 and part of book 2 of *De pictura*. However, the treatises by Alberti and Piero are quite different in tone and address. Alberti presents the basic elements of the perspective construction in terms of rudimentary geometry and optics, giving one universal exemplar, which is then set economically within a classicizing literary vehicle. He does not tell the artist how to tackle all the varieties of perspectival construction that might be

required in practice, and he studiously avoids long-winded passages of technical instruction, preferring to parade a series of knowingly elegant references to antiquity. Piero, by contrast, presents few humanist grace notes. The only conspicuous exception is the brief discussion of ancient *trattatisti* at the start of book 3, long after any humanist dilettanti are likely to have given up.[8] For the most part his text is unrelievedly concerned with the geometrical drafting of the configurations, moving in step-by-step fashion through each construction, almost literally guiding the reader's hand as the constructions are pedantically laid out, point by point and line by line.

Does this condensed, geometrical quality mean that *De prospectiva pingendi* can be recognized as a work of pure geometry? Is it a kind of painter's version of Euclid, who is heavily cited by Piero? The answer is definitely no, because Piero is almost exclusively concerned with the bread-and-butter operation of the constructions and very little with axioms, general cases, and proofs. Indeed, his main "proof" has proved to be highly problematic—at least in the form in which it is presented—as will become apparent. How different his tone is from Euclid's can be judged from his first account of how to achieve the full plane projection of a geometrical plan, in which he recommends his reader to trace the rays using a "thread of the finest silk" or a "hair from the tail of a horse."[9] Nor can Piero's treatise be aligned with the tradition of optical science, to which Ghiberti's third book aspires to belong, since it states few optical principles and pays virtually no attention to the operation of light rays with respect to the eye. In reality, the overall tone of *De prospectiva pingendi* is closer to the practical geometry of the abacus books than to a work of high mathematics or philosophical optics.[10]

The tone and address of *De prospectiva pingendi* do suggest that Piero had made a series of explicit or implicit assumptions about its readership. These assumptions were that:

(a) the reader required practical instruction in the procedures of perspectival construction on the basis of little, if any, existing knowledge;

(b) he or she possessed both the incentive and motivation to undertake an extensive

series of long-winded exercises;

(c) on the basis of (a) and (b), the author is primarily speaking to young artists who have the ambition to master the meticulous skills of Piero himself;

(d) the person undertaking the exercises was expected to be familiar with and reasonably practiced in accurate drawing in fine lines with a straightedge and basic geometrical instruments;

(e) the reader was not necessarily expected to be familiar with abstract geometry, though a background in the rudiments of abacus-book operations would be helpful;

(f) the person undertaking the more complex constructions required a notable combination of patience and high level of spatial visualization if the procedures were not to break down. (It is worth noting that the draftsmen of the existing manuscripts sometimes lost their way in such a way that the lines, labeling, and text are not always properly coordinated.)

Although a number of these assumptions are not unreasonable in themselves, taken collectively they set a series of requirements that few apprentice artists were likely to meet. Indeed, there is little evidence that the general run of aspiring painters, even those who became major masters, would have been inclined to tackle the full obstacle course set by Piero. Of the painters in his immediate orbit, Luca Signorelli is the most notable exception, at least on the evidence of one of his drawings for a tilted head.[11] The written and drawn evidence relating to the procedures of those Lombard masters who were reputed to be specialists in the spatial "transformation" of forms, such as Vincenzo Foppa and Bramantino, is too slight to permit a precise comparison with Piero, but it is at least likely that they would have shared his emphasis upon geometrical probity. However, it appears that even his most geometrically minded contemporaries fell short of Piero's unyielding insistence upon the full spatial plotting of most architectural structures and of a significant portion of the figural components, not only in terms of pedagogic exercises for the tyro but also in the pictorial practice of the mature master. Close technical scrutiny of his panels and frescoes is increasingly revealing the very high degree to which foreshortened forms were preplanned

and accurately transferred to the finished works, even where the details in question were too high, too far away, or too small to register for all but the twentieth-century viewer, equipped with scaffolding and the full panoply of modern equipment. Clearly for Piero, "getting it right" was an ethical imperative that overruled the more pragmatic considerations of simply making a functional image for the Renaissance observer.

The evidence of manuscript survival, which must be treated with caution, suggests that *De prospectiva pingendi* did not enjoy widespread success as an instructional manual for young artists, but that it did achieve a modest diffusion in its Latin form in humanist libraries.[12] Perhaps its greatest problem in either context is that it is extremely tedious to read. The instructions are routine and repetitious—join this point to that point—and the same kind of operation is undertaken again and again, increasing in complexity but with little variation in kind. Like other supremely talented obsessives, Piero seems to have little instinctive feel for what ordinary mortals might tolerate and accomplish.

The apparently crippling disjunction between Piero's expectations and his intended audience might lead us to anticipate that *De prospectiva pingendi* would have followed Ghiberti's *Commentaries* and the bulk of Leonardo's writings into relative obscurity in the years immediately following their deaths. However, his ideas entered the public forum in a rather unexpected manner. Indeed, I think it is fair to claim that *De prospectiva pingendi* exercised a more pronounced impact upon the books that were to be printed in the sixteenth century than any other quattrocento treatise on painting, and I would be inclined to include Alberti's *De pictura* in this estimate. Its position was not altogether unlike that of Brook Taylor's treatise in eighteenth-century Britain. Taylor's austere treatise, distinctly unfriendly toward the practically minded painter, provided a superb base on which the authors of more pragmatic books could build.[13] Although Taylor's compact treatment of perspective was more geometrically succinct and mathematically oriented than Piero's instructional book, they both provided accurate and methodical points of reference on which

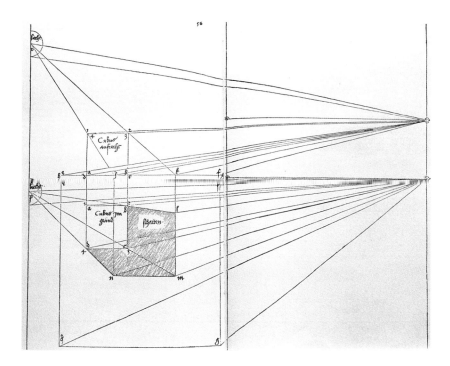

3. Albrecht Dürer, *Perspective of a Cube with Projected Shadows Underweysung der Messung* (Nuremberg, 1538), 95

authors with different priorities could draw. What happened was that Piero's perspectival procedures made a substantial impact because they were utilized by a few highly influential authors. This point serves to remind us that level of impact might be at least as important in the long term as breath of immediate diffusion.

To a greater or lesser degree, Piero's methods provided the foundation for two of the most highly regarded books on "visual geometry" in the sixteenth century, Albrecht Dürer's *Underweysung der Messung* (available in both vernacular and Latin editions) and *La pratica della perspettiva* by the Venetian patrician, patron, and editor of Vitruvius, Daniele Barbaro.[14] Before looking in some detail at the way in which they adopted and adapted the Italian painter's ideas, I can hardly avoid looking briefly at Piero's possible impact on Leonardo, who, with Dürer, presents the best evidence of interest in Piero's theories among the small elite of artist-theoreticians in the generation that grew to maturity in the very last years of Piero's life.

Some slight sketches by Leonardo show that he was acquainted with the method used by Piero for the systematic transformation of a form, most particularly a human head, by parallel projection.[15] Piero is not the only

potential source for Leonardo's knowledge, but, given our lack of information about the techniques of Foppa and the other Lombards, the transmission of Piero's method to Leonardo (probably via Luca Pacioli) is the most credible hypothesis. Leonardo also worked meticulous variations on Piero-like themes, most notably the kind of *torculi*, *mazzocchi*, or *annuli* (fig. 1) that were becoming favorite set pieces of the specialists in perspective. Piero's specific method, relying upon the full projection from plan and elevation, appears to have differed from that of Uccello (and probably those of the *intarsia* designers).[16] There is some evidence that Leonardo worked from plans, although the surviving examples relate to some kind of parallel projection rather than one-point perspective.[17] Perhaps most suggestive of Piero's impact are Leonardo's exposition of some simple projective procedures in MS A in the Institut de France (fig. 2), using geometrical plans of a kind which are very similar to those his predecessor used near the start of his treatise.[18] Interestingly, MS A dates from the early 1490s, before the arrival of Pacioli in Milan in 1496, and, if Leonardo's source was indeed Piero, some other line of transmission must be supposed.

Any reflections of Piero in Leonardo's work were ultimately of less consequence for the widespread broadcasting of his ideas than their adoption by Dürer. The German artist gained knowledge of what we may call the two signal techniques of Piero: the parallel

transformation of the human head, which featured prominently in Dürer's *Vier Bücher*, and the plan-and-elevation method for the projection of any given form on to an intersection, which appeared toward the end of his treatise on measurement (fig. 3). The most compelling evidence that Dürer had direct access to Piero's theories occurs in his definition of the five "conditions" of perspective. As noted by Erwin Panofsky in 1915, but largely overlooked in the subsequent literature, a note in Dürer's MS Sloane 5230 in the British Museum outlines the basic conditions in very similar terms to Piero:

Perspective [perspectiva] is a Latin word meaning seeing through [durchsehung] . . . The first is the eye that sees things. The second is the object that is seen. The third is the distance between them. The fourth is that everything is seen through lines that are straight. The fifth is the intersection [teillung] between the object and the agent of sight.[19]

This is a paraphrase of the five conditions established by Piero near the start of *De prospectiva pingendi*:

The first is sight, that is to say the eye. The second is the form of the seen object. The third is the distance from the eye to the seen object. The fourth is the lines which depart from the outer contour of the object and go to the eye. The fifth is the intersection [termine] which is between the eye and the seen object and on which it is intended to locate the objects.[20]

There is no shortage of possibilities for the opening up of lines of transmission between Piero and Dürer, but two are especially promising. One centers on the arrival of Galeazzo da San Severino in Nuremberg after the fall of the Sforza regime in Milan in 1499. Galeazzo was the dedicatee of the prime version of Pacioli's *De divina proportione*, and his contacts with Willibald Pirkheimer and his circle may have been responsible for firing Dürer's ambition to master the Piero-Pacioli techniques of spatial geometry.[21] Perhaps even more promising is Dürer's own proposed visit to Bologna in 1506 to learn the secrets of *perspectiva* (he specifically uses the Latin term).[22] Whomever he met in Bologna, it was someone conversant with Piero and Pacioli (and

4. Daniele Barbaro,
*Demonstration of the
Geometry of Perspectival
Foreshortening*
La pratica della prospettiva
(Venice, 1569), 31

probably also with Leonardo), and might just have been Pacioli himself.

Piero was not the only source for Dürer's ideas, some of which seem peculiar to the German theorist, including the surprising if relatively inconsequential error in what he calls his "shorter way."[23] However, Dürer's wholly accurate demonstration of the plan-and-elevation method ensured that any serious theorist in the succeeding generations had to take account of the method that Piero was the first to codify in written form and of which he was probably the actual inventor. What is particularly important is that Dürer's writings achieved a high status beyond the ranks of the practicing artists, attracting the admiration of professional mathematicians, such as Federigo Commandino, as well as becoming standard points of reference in the theory of art.[24]

Dürer provides an obvious and acknowledged source for the printed book on perspective that Daniele Barbaro published in 1569, not least with respect to the illustrations of perspective machines pillaged directly from the treatise on measurement, and some transformed heads drawn from the books on human proportions.[25] But Barbaro's use of the German artist pales into insignificance beside his sustained and direct exploitation of Piero's *De prospectiva pingendi* as the foundation for many of the procedures in his standard perspective constructions. Not only did Barbaro rely on Piero's techniques, and follow the general order of Piero's exposition, but he also took over a number of his predecessor's diagrams and texts without significant modification. Yet in his *proemio*, he was scathing about the nature of Piero's writings. Having lamented the loss of the books of the ancient artists, Daniele stresses that we now have to make do with modern writings that merely retail some elementary *pratiche*, which are devoid of system and provide no proper foundation in the underlying principles. Even looking at "painters of our time" who are "otherwise celebrated and of great name," he sees only a *semplice pratica* rather than true understanding. By contrast, Barbaro emphasizes *ragione, precetti, regole, principi,* and *fondamenti*. Thus in the first of his nine books, "si ordineranno i principi, & fondamenti della Prospettiva, & quelle cose, che bisogna sapere, o presup-

pore, che si venghi all'operare."[26] The successive books then work in an orderly manner through the nature of plans (the Vitruvian method of *ichnographia*) and their foreshortening, the raising of solids (or

5. Daniele Barbaro, *Square Foreshortened from a Lateral Viewpoint*
La pratica della prospettiva (Venice, 1569), 32

6. Daniele Barbaro, *Foreshortening of a Rectangular Plan*
La pratica della prospettiva (Venice, 1569), 35

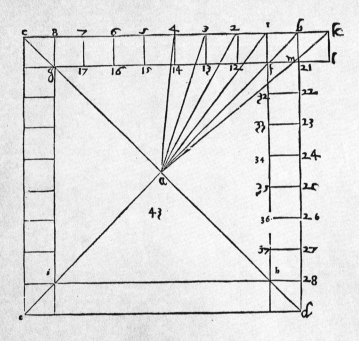

COME SI RISPONDA A QVELLI, I QVALI NEL PARTIRE
il piano a braccia, uiene loro maggiore lo ſcorcio, che il
perfetto. Cap. VIII.

IETRO dal borgo S. Sepulchro, ilquale hà laſciato alcune coſe di Perſpettiua,
dalquale hò preſo alcune delle ſoprapoſte deſcrittioni, dice queſte formali pa-
parole. Per leuare uia lo errore d'alcuni, i quali non ſono periti nella Perſpet-
tiua, & dicono, che molte ſiate per diuidere il piano a braccia, uiene loro mag
giore lo ſcorcio, che il perfetto: Dico che la ſeguente dimoſtratione potrà loro
leuare l'occaſione di errare. Facciaſi adunque uno quadrato, che ſia bcde.
di dentro del quale ſene faccia uno altro, i cui lati ſiano egualmente diſtanti dai lati del pri
mo: & ſia fghi. è tirerai le diagonali, lequali ſi taglieranno nel punto a. & paſſeranno per

li anguli del quadrato fghi. Diuiderai poſcia la ſoperficie trai due quadrati in parti egua
i con i numeri di ſopra. 1. 2. 3. 4. 5. 6. 7. 8. all'incontro de i quali ſeranno nel quadra-
o di dentro, i numeri 17. 16. 15. 14. 13. 12. & da uno angulo la lettera g. & dall'altro la let
tera

7. Daniele Barbaro,
*Demonstration of the Error
That Arises with a Viewing
Angle in Excess of 90°*
La pratica della prospettiva
(Venice, 1569), 36

prisms) over the plans, the depiction of architecture and practice of scenography, the secrets of illusionism, the projection of spheres as relevant to cosmography, the geometry of light and shade, the proportions of the human figure with a view to foreshortening, and perspective machines.

The setting of Piero's *De prospectiva pingendi* beside Daniele's *Pratica* highlights the extent to which Piero provides only the most laconic explanations of the basic principles and terms of reference, and tends not to define systematically the nature of such fundamental concepts as plan and elevation. Rather, he prefers to plunge rapidly into the actual operations and drawn exercises. By contrast, Barbaro's treatise goes through the expected opening moves of any humanist treatise on a *scientia media*, a practical discipline in which abstract principles are systemically translated into actual procedures. It was the artist's failure to use what Barbaro considered to be the proper expository manner in which to address an intelligent reader and the absence of a suitably learned tone of voice that explain Barbaro's stricture that "Piero and others" pandered to "the idiots."[27] By "idiots," Barbaro meant those who are of such simple understanding that they only want to operate a routine set of practical procedures without requiring a full understanding of the basis of the relevant science. The "wise idiot"—the shrewd and skeptical master of practical knowledge, as opposed to the myopically bookish philosopher—could be paraded in Renaissance writing as an admirable figure, but Barbaro's "idiots," viewed from the standpoint of a lettered patrician, were anything but wise.[28] They required the kind of insistent handholding and blow-by-blow instructions that Piero provided in such pedantic measure.

However, when we look at the actual demonstrations of perspective provided by Barbaro, he not only adopts many of Piero's diagrams but also follows essentially the same sequence in building up the reader's knowledge of the various kinds of operations. Thus, at the very start of book 1, he adopted five "conditions" for perspectival representation similar to those that Dürer had summarized from Piero.[29] Since Dürer's five conditions were not included in this form in his published works, Daniele is likely to have drawn directly upon Piero's outline. Also like Piero, Daniele founds his exposition on the proportional principles of similar triangles, while amplifying his own explanation by reference to a more elaborately mathematical demonstration of "pencils of lines" proportionately intersected by parallels.[30] He also considers the proportionality of asymmetrical figures, which lie outside Piero's concerns, and gives complex consideration to the appropriate viewing distances for a panel, in response to different locations for the viewer's eye.[31]

When in book 2 he comes to give the fundamental demonstration of the basis of the foreshortened square (fig. 4), he neatly regularizes the proof Piero had given in an awkward and somewhat confusing if essentially accurate form (fig. 5)—although in Barbaro's manuscript the demonstration was first laid out in a manner closer to Piero's original configuration.[32] Piero's explanation is not helped by the omission of supplementary lines in the surviving diagrams, nor by his repetition of the same letter in different places on the diagram. The asymmetry of the viewpoint A with respect to the line *fb* (which is to be projected as *de*) has also resulted in the misreading of Piero's intentions, though the asymmetry does serve to demonstrate the invariable length of the line in projection regardless of the position of the eye along a line parallel to the intersection. Barbaro's placing of the axis of the eye centrally with respect to the side of the square that serves as the intersection (thus effectively transforming the diagram into a simultaneous demonstration of the construction in plan and elevation), and his inclusion of all the supplementary lines, significantly clarify Piero's demonstration, at least as it appears in the surviving manuscripts. However, Barbaro's tidying up makes the mathematical generality of "Piero's proof" less apparent. When he also gives numerical values to the proportional distances and dimensions, such that 6:18 = 7:21 = *de*: *bc* (or 4:12), he is more like Piero than the master himself, since one of Piero's great concerns was to establish the nature of the arithmetical proportions inherent in geometrical constructions.[33]

Then, somewhat surprisingly for a humanist theorist, he follows this demonstration with an acknowledgment and diagrams of the kind of noncentral viewpoints that the painter may use in practice in particular circumstances—an acknowledgment that Alberti never openly provided, and that Piero only makes in passing, with a comment to the effect that the eye should not in any event pass outside the lateral boundaries of the picture. Dürer's demonstrations of both the full-scale procedure and "shorter way" use asymmetrical viewpoints (as in his master engraving of *Saint Jerome* in 1514), but he provides no discussion of its rationale, and in his shorter way the viewpoint

stands in an insecure relationship to the intersection.[34] Barbaro indicates that "things are better seen in perspective when the eye is located square on to the picture," but he recognizes that the eye may actually be placed "wherever we please," and even allows the axis of the eye to pass outside the lateral confines of the picture (fig. 5) in a way that Piero did not sanction.[35]

In his subsequent exploration of the geometry of the foreshortened plane, he again adopts some of Piero's explanations.

8. Daniele Barbaro,
Foreshortening by the "Plan and Elevation" Method
La pratica della prospettiva
(Venice, 1569), 118

One of the most notable cases is where he shows the foreshortening of an extended plan, five times longer than it is broad (fig. 6).[36] The second part of this demonstration, which shows how to determine a distance bl as equal in unforeshortened form to cb, given the distance of the eye at o, is also taken over from Piero, and provides the only evidence that Piero knew the so-called distance point construction—though his use of it only in this peculiar case suggests that he did not consider it adequate as a universal method for fully controlled projections of all kinds of form. Barbaro's accompanying text follows Piero closely, though the wording indicates that it is translated from one of the Latin texts rather than directly drawn from a vernacular version. There is a nice irony in a learned humanist translating back into the vernacular a section from the Latin version of text originally written in Italian for uneducated "idiots."

In the section that immediately follows, Daniele acknowledges that he has "taken some of the above descriptions" from "Pietro dal borgo S. Sepulchro," that is to say he has adopted Piero's *descrittioni*, for the purposes of illustrating his own *principi* and *fondamenti*.[37] This acknowledgment prefaces a substantial quotation from Piero (again apparently translated from the Latin) about the problem of the viewing angle with respect to an "error of perspective." The demonstration (fig. 7), which is true in such a limited sense as to be more or less invalid, purports to show that when the viewing angle is in excess of 90° the side of a square perpendicular to the picture plane or intersection will be longer in projection than its equivalent length lying along the intersection.[38] At the end of his extensive annexing of Piero's reasoning, given for the sake of "those who wish to follow practical matters of perspective (*praticare le cose della perspettiva*)," Daniele notes that he has elsewhere corrected Piero's supposition that "the circumference of the black portion of the eye [the pupil] is not such that it can embrace a right angle with its glance," a supposition that Piero had used to supplement his argument against the portrayal of wide-angle views.[39]

As he moves through the subsequent constructions, Daniele continues to follow Piero closely, though he supplements his predecessor's method for the raising of geometrical bodies on preforeshortened planes with two alternative techniques, for the sake of greater geometrical completeness.[40] It is characteristic of the different tone of his book that he prefaces these methods for the foreshortening of the regular and semi-regular solids by noting that "by these [bodies] Plato signified the elements, and heaven itself, and through the secret intelligence of their forms he rose to the highest realm of the speculation on things."[41] The essential character of Barbaro's address is maintained when he turns to the second major method of perspective, the three-stage procedure of point-by-point projection of any given form using plan, elevation, and intersection. He outlines the essential principles of Piero's method, again using some of the same diagrams (fig. 8), but he conspicuously avoids the tedious repetition of step-by-step instructions in each example in favor of abbreviated descriptions and succinct visual presentation of the results.

Inevitably when he comes to the projection of shadows in his seventh book, he has to look beyond Piero, who did not apparently write on shadows (although his paintings display a marked sense of optical rule in this as in all aspects of the transmission of light).[42] Here Barbaro relies substantially upon Dürer for technical demonstrations, while citing as a practical example the Rosa brothers' once famous ceiling decorations in Santa Maria dell'Orto.[43] In book 8, devoted to human proportions and transformation, he is also indebted to Dürer, but two of his diagrams (fig. 9) represent a rather crude annexing of Piero's demonstrations of a foreshortened head.[44] Daniele does not explain that Piero's results were obtained by the full procedure of plane projection, which involved the location of a series of nodal points designated by numbers onto an intersection with reference to a single eye point. Nor does he acknowledge that the method of parallel transformation he adopts from Dürer differs from one-point perspective, and that it is therefore inconsistent with Piero's diagrams.[45] He appears to be using Piero's radial "bands" or sections as guides in a rule-of-thumb technique for the tilting of a head. As translated by the cutter of the woodblock, Piero's elegant demonstration emerges in an

9. Daniele Barbaro,
*Foreshortening of the
Human Head*
La pratica della prospettiva
(Venice, 1569), 186

ugly and garbled form that would surely
have repelled the fastidious master.

What this necessarily compressed com-
parison of *De prospectiva pingendi* and *La
pratica della perspettiva* has shown is that
Barbaro was substantially indebted to Piero,
although he is speaking in a different tone of
voice to what was by now a well-established
audience, the growing band of educated book
buyers who appreciated humanist treatises
on a variety of "sciences" in the vernacular.
Although Barbaro criticizes, copies, trans-
lates, paraphrases, and occasionally traduces
Piero in a way that raises charges of plagia-
rism in our minds, I think he performed a
real service for the quattrocento painter by
representing some fairly indigestible demon-
strations in an amenable style with an effec-
tive literary vehicle that appealed over the
centuries to a surprisingly wide audience of
mathematicians, practitioners, and aficiona-
dos. In any event, charges of plagiarism—

such as those leveled against Luca Pacioli
for his adopting substantial parts of Piero's
Trattato d'abaco and *De quinque corporibus
regularibus*—can be judged more fairly
within the manuscript tradition, in which
transmission was by serial copying and com-
mentary, than in the light of modern
notions of intellectual property, which were
only just beginning to emerge in a coherent
form at this time.[46]

As a result of Barbaro's derivations, to an
even greater degree than those of Dürer,
Piero's lack of a realistic address to a wide
audience was effectively overcome. The very
scrupulousness and patience with which
Piero established his procedures and worked
through his examples provided his adapters
with a highly reliable set of technical re-
sources on which to draw—and with which
to draw. The consequence was that not only
was Piero one of the most influential geom-
eters of the century, largely through the

transmission of his ideas by Pacioli, but he also proved to be the most influential Italian theorist of perspective in the crucial period before the publication of Giacomo Barozzi da Vignola's *Le due regole* by Egnatio Danti in 1583, just over a hundred years after Piero's death.

NOTES

Thomas Frangenberg delivered a paper at the Arezzo congress in October 1992 on subsequent writers' knowledge of Piero's treatise, giving a wider range of later citations than is explored here. The purpose of the present paper is rather different from Frangenberg's. My aim is to explore how the main adaptations of Piero's ideas transmitted them to later generations and what the adaptations tell us about the nature of Piero's treatise itself.

1. Cennino Cennini, *Il libro dell'arte*, ed. Daniel V. Thompson (New Haven, Conn., 1932), and ed. Fernando Tempesti (Milan, 1984); trans. Thompson as *The Craftsman's Handbook* (New York, 1954). Thompson records only two fifteenth-century manuscripts.

2. Leon Battista Alberti, *On Painting*, ed. Martin Kemp, trans. Cecil Grayson (London-New York, 1991); and Michael Baxandall, *Giotto and the Orators: Humanist Observers of Painting in Italy and the Discovery of Pictorial Composition, 1350–1450* (Oxford, 1971), 127–129. Grayson noted twenty manuscripts of the Latin version and three of the Italian.

3. Lorenzo Ghiberti, *I commentarii*, ed. Ottavio Morisani (Naples, 1947). The text is known in just one imperfect manuscript. For the optical sources of the third commentary, see Klaus Bergholt, *Der dritte Kommentar Lorenzo Ghibertis* (Weinheim, 1988).

4. The story of the fortune of Leonardo's *Trattato* in terms of its reading and reception after the *editio princeps* of 1651 remains to be told, but for one incident see Martin Kemp, "'A Chaos of Intelligence': Leonardo's *Traité* and the Perspective Wars in the Académie Royale," in *Il se rendit en Italie: Études offertes à André Chastel*, ed. Pierre Rosenberg (Paris, 1987), 415–426.

5. For Foppa and Bramentino's lost treatises, see Giovanni Paolo Lomazzo, *Scritti d'arte*, ed. Roberto Ciardi, 2 vols. (Florence, 1973), 2:239–241, 257–258, and 273; for Fontana, see Eugenio Battisti and Giovanna Saccaro Battisti, *Le machine cifrale di Giovanni Fontana* (Florence, 1984), 18–24.

6. See *Prima de Leonardo*, ed. Paolo Galluzzi [exh. cat., Palazzo Publico, Siena] (Venice, 1991) for the tradition of manuscripts of machines.

7. Piero della Francesca, *De prospectiva pingendi*, ed. Giusta Nicco Fasola (Florence, 1942), 46, quoting the letter of dedication of *De quinque corporibus regularibus* to Guidobaldo; reprinted with introduction by Eugenio Battisti (Florence, 1984); and Margaret Daly Davis, *Piero della Francesca's Mathematical Treatises* (Ravenna, 1971), xiv and 20.

8. Piero, ed. Fasola 1984, 129.

9. Piero, ed. Fasola 1984, 30.

10. See J. V. Field's article in this volume.

11. C. Bambach Cappel, "On 'la testa proportionalmente degradata': Luca Signorelli, Leonardo and Piero della Francesca's *De prospectiva pingendi*,"

in *Florentine Drawing at the Time of Lorenzo the Magnificent*, ed. E. Cropper, Villa Spelman Colloqui 4 (Florence, 1994), 17–43.

12. The current tally of manuscripts is four Latin and two Italian. See Martin Kemp in *Circa 1492: Art in the Age of Exploration*, ed. Jay Levenson [exh. cat., National Gallery of Art] (Washington, 1991), no. 141.

13. Martin Kemp, *The Science of Art: Optical Themes in Western Art from Brunelleschi to Seurat*, rev. ed. (London-New Haven, Conn., 1992), 148–154.

14. Albrecht Dürer, *Underweysung der Messung* (Nuremberg, 1525); *Institutiones geometriae*, trans. Joachim Camerarius (Nuremberg, 1532); *Albrecht Dürer. The Painter's Handbook*, trans. Walter Strauss (New York, 1977); Daniele Barbaro, *La pratica della prospettiva* (Venice, 1569); also Barbaro's manuscript, *La pratica della perspettiva*, Venice, Biblioteca Marciana, codex Ital. Cl. IV, 39 (5446).

15. Windsor 12603v and 12605r; see Kim Veltman, *Studies on Leonardo da Vinci, I. Linear Perspective and the Visual Dimensions of Science and Art* (Berlin, 1986), 202–203.

16. Kemp 1991, nos. 139–140.

17. Milan, Biblioteca Ambrosiana, codex atlanticus, 261vb, 255va, 261va, 225vb; see Veltman 1986, figs. 331–334.

18. Paris, Institut de France, MS A 40r. Compare Piero's diagrams in *De prospectiva pingendi*, I, fig. 16, ed. Fasola 1984, pl. V, fig. xvi.

19. London, British Museum, MS Sloane 5230, 202; *Dürers Schriftlicher Nachlass*, ed. Hans Rupprich, 3 vols. (Berlin, 1956–1969), 2:373:

Item perspectiva ist ein latenisch wort, pedewtein durchsehung . . .
Recht vrsach funff ding zum gesicht
das erst ist das awg das do sicht
das ander ist der gegen würff der gesehen wirt
das trit ist dy weiten do zwischen
das fird alding sicht man durch gerad lini da sind
ely kürzesten lini
item das funft ist dy teillung von
ein ander der ding dy dur sichst.

See Erwin Panosfky, *Dürers Kunsttheorie vornehmlich in ihrem Verhältnis zur Kunsttheorie der Italiener* (Berlin, 1915), 43; and Strauss 1977, 27–28.

20. Piero, ed. Fasola 1984, 64, followed by an expanded listing with a short gloss on each condition:

La prima è il vedere, coié l'ochio;
seconda è la forma de la cosa veduta;
la terza è la distanza da l'ochio a la cosa veduta;
la quarta è le linee che se partano da l'estremità de la cosa e vanno a l'ochio;
la quinta è il termine che è intra l'ochio e la cosa veduta dove se intende ponere le cose.

21. Strauss 1977, 31.

22. For Dürer's letter to Pirkheimer announcing his intention to visit Bologna, see Rupprich 1956–1969, 1:58.

23. Kemp 1992, 59.

24. Frederigo Commandino cites Dürer in his *Ptolomaei planisphaerium. Jordani planisphaerium* (Venice, 1558), 58v.

25. For the background to Barbaro's treatise, see Margaret Daly Davis, "Carpaccio and the Perspective of Regular Bodies," in *La prospettiva Rinascimentale*, ed. Marisa Dalai Emiliani (Florence, 1980), 183–200. A summary of Barbaro's theories in the context of sixteenth-century perspective is provided by Kemp 1992, 76–78. A full study is needed of Barbaro's manuscripts in the Biblioteca Marciana, Venice (It., IV, 39 = 5446. "La pratica della prospettiva," and It., IV, 40 = 5447. "La pratica della perspettiva"). See the outline in C. Troti and A. Segatini, *Catalogo dei codici marciani italiani*, 2 vols. (Modena, 1911), 2:27–28; and *Archittetura e Utopia della Venezia del Cinquecento*, ed. A. della Valle [exh. cat., Palazzo Ducale] (Venice, 1980), nos. 179–180.

26. Barbaro 1569, 3.

27. Barbaro 1569, proemio.

28. The tradition of the "wise idiot" was largely initiated for the Renaissance by Nicholas of Cusa (Cusanus) in his *Idiota de mente, Idiota de sapientia,* and *Idiota de staticis experimentis.* The first edition of Cusanus' *Opera* was by Martin Flach (Strasbourg, 1488). For translations see *Unity and Reform: Selected Writings of Nicholas of Cusa*, ed. John Dolan (Notre Dame, Ind., 1962); and *Idiota de mente. The Layman: About Mind*, trans. Clyde Lee Miller (New York, 1979). See also Sandra Billington, *A Social History of the Fool* (Brighton, Sussex, 1984), 23–24.

29. Barbaro, 1569, 3: "l'ochio, che vede: il modo, col quale si vede: la cosa, che si vede; la distanza, dalla quale se vede: & il piano, sopra'l quale il Perspettivo ha da disegnare le cose, che si hanno a vedere." Compare above, notes 19 and 20.

30. Barbaro 1569, 13.

31. Barbaro 1569, 20–21.

32. Barbaro 1569, 31; compare Piero, ed. Fasola 1984, 76–77; and Barbaro's MS, codex Marc. It., IV, 39 (= 5446), 269r. I am grateful to Marino Zorzi for details of the Marciana MSS. For a convincing analysis of Piero's proof, see J. V. Field's article in this volume, correcting James Elkins, "Piero della Francesca and the Renaissance Proof of Linear Perspective," *Art Bulletin* 69 (1987), 220–230.

33. See his *Trattato d'abaco: Dal Codice Ashburnhamiano 280 . . . della Biblioteca Medicea Laurenziana di Firenze*, ed. Gino Arrighi (Pisa, 1970); and the *De quinque corporibus regularibus* as discussed by Davis 1977.

34. Kemp 1992, 59

35. Barbaro 1569, 32. Compare Piero, ed. Fasola 1984, 77.

36. Compare Piero, ed. Fasola 1984, fig. 1, 23, 86–87, pl. VII, fig. xxiii.

37. Barbaro 1569, 36.

38. Piero, ed. Fasola 1984, fig. 30, 96–99, pl. IX, fig. xxx. The problems with Piero's demonstration are analyzed by J. V. Field, "Piero della Francesca's Treatment of Edge Distortion," *Journal of the Warburg and Courtauld Institutes* 49 (1986), 66–90.

39. Barbaro 1569, 37.

40. Barbaro 1569, 43–44. Compare Piero, ed. Fasola 1984, figs. II, 2, 3, and 4, pls. XI, fig. xxxiv, and XII, figs. xxxiii and xxxv.

41. Barbaro 1569, 37. For the cosmological resonances of the Platonic solids, see Martin Kemp, "Geometrical Bodies as Exemplary Forms in Renaissance Space," *World Art: Themes of Unity in Diversity*, ed. Irving Lavin, 3 vols. (University Park, Pa.) 1:237–241; and J. V. Field, *Kepler's Geometrical Cosmology* (Chicago, 1988).

42. See Martin Kemp, "New Light on Old Theories: Piero's Studies of the Transmission of Light," to be published in the proceedings of the Convegno Internationale di Studi su Piero della Francesca, Arezzo, 1992; and John Shearman's article in this volume.

43. Barbaro 1569, 177. See Jurgen Schultz, *Venetian Painted Ceilings of the Renaissance* (Los Angeles, 1968), 95, no. 34; and Kemp 1992, 71.

44. Compare Piero, ed. Fasola 1984, fig. 79, pl. XLI, fig. lxxix.

45. Kemp 1992, 59 and 78.

46. For Pacioli's use of Piero's writings, see Davis 1977, 107. For notions of intellectual property in the Renaissance, see Pamela Long, "Invention, Authorship, 'Intellectual Property,' and the Origin of Patents: Notes toward a Conceptual History," *Technology and Culture* 32 (1991), 846–884.

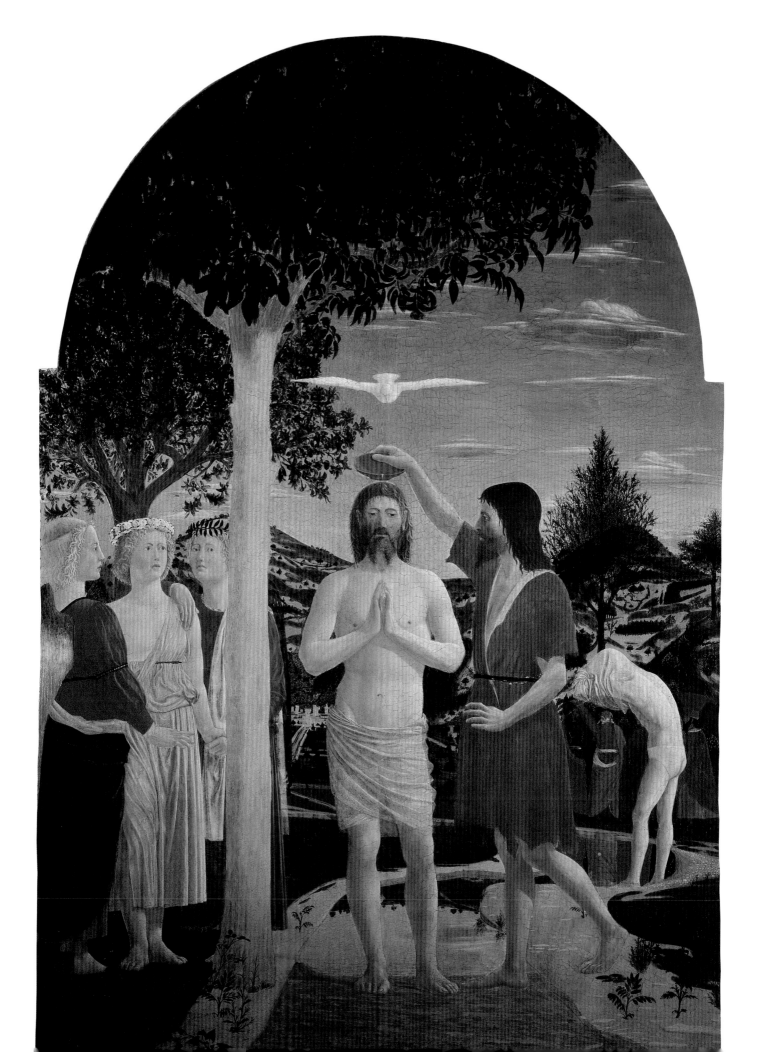

JOHN SHEARMAN
Harvard University

Refraction, and Reflection

The first part of this paper is the working up of an idea for interpreting Piero's *Baptism of Christ* that I suggested in lectures thirty-five years ago, and outlined in a footnote written in 1966.[1] It rested initially on basic schoolboy physics, namely, modern theory of reflection and refraction; and in its initial, too brief, published form it rested on some subsequent reading in the history of science, especially the works of Albert Lejeune and Graziella Federici Vescovini, which had been enough to persuade me that the idea was reasonable within the mentality of the mid-fifteenth century.[2] If I had explained myself fully then it would have saved a lot of trouble. But waiting until now has been beneficial in that I have been able to read newer work, above all by Bruce Eastwood, David Lindberg, and A. I. Sabra, which has sharpened the argument from Catoptrics;[3] and no less beneficially I started reading Umberto Eco on medieval aesthetics, who made me think again about the metaphysics of refraction, from which impulse is derived the second part of this interpretation.[4]

To begin again with the initial observation (figs. 1, 2): in the *Baptism*, in London, Piero's Christ stands on the bed of the River Jordan in about ten centimeters of water, and this we know to be the represented fact from the delicate but perfectly clear waterline that is traced round each of Christ's ankles, and John's right ankle too (a little less legibly). There is no ambiguity, and there

can be no arguing, about Piero's intention of representing the presence of transparent water over the river-bed at the point in space where Christ and the Baptist stand. And since from that point forward to the limits of vision the representation of the river-bed is in no way changed, the presence of a certain depth of water must also be presumed here, I think. I have found it empirically to follow that when these structural and spatial facts, including transparency, have been grasped, an observer generally finds that then, and only then, the structural integrity of the figure-group, with supporting ground- and river-levels, is complete.

I take it that the *Baptism* is a work of the early 1450s, since it seems, by its moderately greater technical control and somewhat more sophisticated descriptiveness, to follow soon upon Piero's *Saint Jerome* in Berlin, which is dated 1450. It is to the state of knowledge about the middle of the fifteenth century, then, that a final analysis of the optical phenomena represented will be referred. But the problem may be approached first in modern terms for a general understanding. A difficulty, or objection even, that then arises will be identified, one that may only be resolved by historicizing. Further, it will be shown that the difficulty according to modern optics would necessarily be produced if in fact the theory applied is that of the late Middle Ages, or, to put it the other way round, a representation that did not

1. Piero della Francesca,
Baptism of Christ, c. 1452,
tempera (and oil?) on panel
National Gallery, London

conflict with modern theory would be an anachronism in Piero's *Baptism*.

In crude terms, what Piero has described is a transition between two modes of vision. In the further stretches of water, from just behind the heels of the figure-group back to the double bend in the river, images are seen by reflection. Indeed, consideration of overlaps of reflected images, when compared with the overlaps in their prototypes seen by direct vision above, shows a high degree of understanding (but not, I think, of application) of the geometry of reflection. But from the lower limit of reflected sky forward the images seen in the water—the ankles and feet, the pebbles and mud—are seen by refraction, the prototypes themselves being seen, immersed in the transparent medium. The shift from reflection to refraction occurs at a certain angle, between the inclined line

of sight and a perpendicular drawn at the point of contact with the surface, that critical angle depending upon the densities of the transparent media above (in this case air) and below (in this case water); no exact calculation is possible, but Piero has got the critical angle about right. Modern optical theory treats the phenomena of reflection and refraction as separate, and in some degree susceptible of overlapping, so that in practice a gradual transition is seen from one to the other. What should not occur, and what seems unnatural to us, or in conflict with experience, is the abrupt transition, almost along a line, like a second horizon, on Piero's water. This abruptness has been adduced as an objection to the reading of reflection-and-refraction, and we must deal with it.[5] At the same time I am left uncertain as to what the objection is designed to

2. Piero della Francesca, *Baptism of Christ*, c. 1452 tempera (and oil?) on panel (detail) National Gallery, London

show or to disprove; but since its formulation ignores the undeniable waterline it seems to me incoherent or directed to avoiding a difficulty rather than confronting it. And if it cannot be denied that Christ's feet and the river-bed are seen through the water-surface, then it follows that we have a choice: either Piero has *observed* that, at a certain point or angle, modes of vision shift from reflection to seeing through the surface (and he misrepresents the transition), or he *knows* from optical theory that at a certain point vision must shift from reflection to refraction. If the second option is to be viable, even preferable, it must be shown that the theory at hand, unlike the one at hand to us, would produce the anomaly in question, the clean transition.

But first it must be asked if the whole hypothesis of our interpretation would be an anomaly, an isolated case in the fifteenth century. It would be as well to make clear at this point that the hypothesis brings into play only one half of a reflection-refraction (catoptric) system, that is, the shift in mode: seeing through the surface at smaller (more nearly vertical) incidence-angles, and seeing by reflection at greater (more nearly horizontal) angles. What is not in play, or not as yet, is the complementary experience or theory concerning the vertical displacement or relocation of the image, and its enlargement, when it is seen by transparency, by refraction. This half of the system we can find observed and apparently well understood in the representation of the glass carafe, half-filled with water, on the liminal step of Filippo Lippi's *Annunciation* of about 1438 in San Lorenzo (fig. 3).[6]

Filippo's carafe is of the kind that, from its throwing from a blob of molten glass, preserves a bulb rising internally from the base. This bulb, which is only partly under water, is seen twice. It is seen through the glass wall below the level of the water. Where the interface between the media of different densities (air-glass, glass-water) is approximately at right angles to the line of sight, at the upper limit of the bulb's image, refraction is negligible and displacement does not occur.[7] Where this interface, however, curves under, so as to produce increasing refraction in the lower part of the image, displacement and obvious enlargement do occur (which is clear when

the image of the bulb inside is related to the base outside, seen by direct vision). The bulb is seen a second time through the glass wall and then through the horizontal interface between air and water; the glass wall is again negligible in effect, but the water-surface produces an almost text-book case of refraction: it relocates vertically this part of the double image of the bulb and magnifies it (as we discover if we try to fit the upper image over the lower). It is a remarkably sophisticated visual demonstration of refraction-theory, yet as theory there is nothing here that has not been known in principle for four hundred years or more. It is in no way outside the scope of refraction-theory produced in Arabic science to explain the physiology of the eye. It is, on the other hand, a *unicum* in the history of painting, so far as I know. One expects to find something like it in Netherlandish painting, perhaps even before 1438, but while analogues and perhaps precedents may be found there for Filippo's description of glass and water as transparent materials, I have found no effects of refraction.

So: unless we can persuade ourselves that, in the *Baptism*, Piero has relocated and enlarged the immersed and refracted feet—and I do not think that we can—it seems from the comparison of his picture with Filippo's that we should be arguing that they are interested in, or perhaps informed about, two different and complementary aspects of the phenomenon of refraction. And it is significant, I think, that their interests seem to divide as Ghiberti's do. For in his third *Commentary* Ghiberti shows a quite unexpected wide reading in Arabic refraction-theory, and that of the West in the thirteenth and fourteenth centuries, if not, perhaps, a coherent exposition of them; yet his concern (so far as I can see) is the one Filippo needs, in the bending of rays, and the displacement and magnification of images, and I think he does not treat the transition from reflected to refracted images, nor what I shall call the ballistic model brought forward in his sources to understand it.[8] A source-analysis, even of the most impressionistic kind, of Ghiberti's book is rather unnerving, in that it makes it seem that practically the entire bibliography of Optics might be accessible to a curious artist in the first half of the fifteenth century.

Piero's interest in the transition between modes of vision may be given a context in a different way. His apparent description of the transition would follow, in fact, a remarkable one in the *Christ Walking on the Water* by Konrad Witz of 1444 in Geneva. In Witz's picture, at about the right angle of inclination of the line of sight, there is a *gradual* shift in the representation of the water, from reflection (above) to transparency (below), as Erwin Panofsky pointed out long ago.[9] It could certainly be said that Witz's description of the effect is more striking than Piero's for its conformity with what we may experience. But the very fact that his representation conforms to observation (and, incidentally, to modern theory) in its gradual transition suggests that he did not have a theoretical basis in medieval literature. Observation is applied to the illustrative problem, in that the intense focus on a property of water, on its physical reality, maximizes the miracle of Christ's walking on it. There is presumably this good reason for his studying the transparency of water, and that would explain an attention to mimetic description without parallel in his work.

A first approximation to a distinction between Witz's and Piero's understandings of the reflection-refraction phenomenon might be reached by analogy with a distinction to be found in the painting of pearls, which is more clearly an intellectual distinction. I have in mind a difference between the pearls of Jan van Eyck and those of Piero. Jan's pearls are famously successful in the mimetic-descriptive sense in a painting like the *Van der Paele Madonna*, and of course they are significantly earlier than any by Piero. Piero's are rather good too, and they are very probably to be understood as imitations on that level of Jan's, or perhaps, Rogier van der Weyden's, although under magnification they are not in fact technically similar, being much more freely painted, and I think they are perceptibly less pearl-like in lustre and texture. They are, however, more realistic in an important, behavioral sense. For if we watch what happens when a sequence of pearls by each artist passes from light into shadow, we see first that in Jan's case the distribution of lights remains the same, if diminished, whereas in Piero's case the lights shift, as

logically they should, to reflect new sources, including reflected light. The one artist sees with astonishing intensity, and invents a compelling equivalent in paint, the other (probably) imitates an imitation, but unquestionably *reasons* as he paints. Piero thinks spatially, holistically, and causally.

Fra Angelico, when painting the San Marco altarpiece a decade earlier, had already thought about the lighting of pearls in this way. But I should not like to propose a general rule, along these systemic lines, for dividing Netherlandish from Italian artists, and my example of the painted pearl is designed only to clarify for present purposes a difference between Jan, Rogier, and Witz on the one hand, and Angelico, Piero, and Filippo on the other. Any notion of national regimes is destroyed by looking at representations of the Baptism of Christ in later Italian painting, an interesting exercise for the rather obvious reason that a problem of representation necessarily arises—with the sculptors it amounts to a crisis of representation—where the integrity of the body must not be compromised by the essential, if partial, immersion. Transparency in the area of water around the feet of Christ becomes general in this culture around 1500, and mostly I think one wants to read these pictures as we read Witz's: a property of water is observed and faithfully described because narratively and symbolically the descent of Christ precisely into water is paramount. In Verrocchio's *Baptism*, for example, there seem to be complex observations of reflections overlaying transparency, which allows the rooting of Christ's feet on a firm and visible base, under water; there is no apparent distortion or displacement of the submerged parts, nor of rocks under water, and it would be hard to demonstrate that the representation is theoretically informed. The most puzzling case is perhaps no more than such controlled descriptive efficiency getting out of hand (fig. 4); it is in Francesco Zaganelli's *Baptism* of 1514 in London, where the overlapping of phenomena—the strongly reflected legs over a ghost of the immersed feet—does not suggest the light of reason, but rather a rhetorical *amplificatio* of something seen. At the very least it suggests Piero's wisdom pictorially, in making a clear division of reflection and

transparency, placing reflection only behind Christ's legs.

To return to the question about Piero's *Baptism* left unresolved so far: can it be shown that his description of an abrupt transition between two modes of vision in water is informed by a reading of the available optical theory? To answer this question it is necessary to give some impression of the sophistication of the theoretical tradition, and to define the perceived relationship there between reflection and refraction, but it is not necessary to pursue issues of causality or explanation. A good starting-point is the observation, reported already by Euclid and Seneca, that coins out of sight at the bottom of a deep vessel may be lifted into visibility by filling the vessel with water,

but they did not seek to explain it.[10] Ptolemy, on the other hand, who had an astonishing understanding of the principles in play, accounted essentially correctly for the vertical relocation of the image in this experiment, and demonstrated its simultaneous magnification, using mirror-theory in each case. He worked out different tables of deviation or bending of light-rays for the several interfaces between transparent media, air/water, air/glass, and water/glass; and he clearly understood the relationship between the different tables and the contrasting densities of each pair.[11] Ptolemy had a "ballistic" or "mechanical" model (to be explained below) for understanding reflection, but perhaps not for refraction; that might or might not have followed in the lost part of Book V

of his *Optics*, in a continuation of his discussion of refraction.[12] Ptolemy's greatest follower Alhazen, writing his *De aspectibus* and the *Optics* in Cairo around the year 1000, was able to apply a very complex understanding of even double refraction in three dimensions in graphic models to the analysis of ocular anatomy.[13] His knowledge of the optics of the eye was celebrated down to Newton and was retailed at length by, among others, Ghiberti. And here it may be remembered that Ghiberti had access to an Italian translation of Alhazen, which is the manuscript now in the Vatican Library.[14]

Alhazen used the analogy of an iron ball to clarify thinking about reflection and refraction; below a certain angle at which such a ball would strike a weak membrane it will slide or bounce off, and above that angle it will penetrate.[15] His alternative model was that of a sword, which will either be deflected off the surface of a solid or, at a steeper incident angle, will dig into it. These models were widely repeated in subsequent theoretical writings, eastern and western, for example, by Avicenna, Bacon, and Witelo. For most, however, it was explicitly not a causally explanatory model but a heuristic device, an analogy and no more. It was well enough understood that the phenomena did not hinge upon some skin or membrane between media of different densities, but upon the density-change itself at an interface. Nevertheless, the dominant model is conceptually cardinal in our argument, for it demonstrates the perceived continuity between the two modes of vision, and their apprehension as one unified phenomenon, subject to one body of theory. That position may in any case be argued on other grounds, from a commonality (sometimes a confusion) of terminology from mirror-theory, and from the subsuming of refraction under the title Catoptrics, which by etymological derivation concerns mirrors.[16] Furthermore the model allows for no gradual shift from one mode of vision to the other, but only a stark, either/or choice between the alternatives of reflection and penetration. There is said to be no significant revision in this matter in optical theory between the late thirteenth century and the fifteenth.[17]

Quod erat demonstrandum. It follows that if Piero was informed of Catoptrics in

4. Francesco Zaganelli, *The Baptism of Christ*, 1514, oil on panel (detail) National Gallery, London

the wider sense, by reading whatever was available to him, he would necessarily understand the transition between the two modes of vision represented in the water in his *Baptism* as an abrupt one, as a shift, along a horizon of inclination of the line of sight, directly from one to the other. Or, conversely: if what we see as anomalous in the *Baptism*—anomalous in that it does not conform to observable reality (as Konrad Witz's transition does)—if it conforms instead to available theory, then it is probable that he was so informed. At this point, however, recourse to the example of Piero's pearl suggests a likely complication, but a realistic one: that observed reality is not excluded from the process, but is imitated

under the ordering, sharpening, and rationalizing influence of a body of theory. And it is after all a fact that the anomaly that initiated this enquiry is not strictly a line between two modes of vision, not a line like that which divides water from river-bank, but a transition much more abrupt than experience suggests it ought to be. In the end the import of the anomaly may now be turned on its head: for what appeared to be an impediment to the initial hypothesis for interpreting Piero's transparent water is found to be a necessity, without which the hypothesis would be anachronistic. It remains a hypothesis, probable rather than proven. And that is what a reading of a painted surface must be, however that reading is contextualized and historicized. Conviction may perhaps grow from returning to a larger reading of the picture, for if the viewer is now persuaded of the probability that Piero was informed about catoptric theory, and that the river-bed is logically seen submerged under water, then the perception of a continuous if invisible water-surface, to the forward limits of vision, makes the construction of the figure-group work.

It was suggested above that the aspects of refraction-theory useful to Filippo Lippi—displacement and enlargement of the image—were not taken up by Piero, and the question may well be asked: why not? For he could not have read through one of the major texts of the optic tradition to the issue of reflection-refraction transition without encountering image-distortion. If the latter had been functional in Filippo's sophisticated, almost tangible fiction, was it perhaps dysfunctional in Piero's? That it might well have been so is suggested by the selective application of linear perspective, which lies in the same field of thought as Catoptrics, to images of Christ. That selectivity, or inhibition, is seen from the very beginning, in Masaccio's *Trinity*, where the laws of vision do not apply to the divine figures as they inexorably do to their physical context. And it is seen again, with the same effect, in Piero's *Resurrection* at Borgo Sansepolcro. It is as if exempting the Trinity group, or Christ alone, in this way was to say that these figures are too sacred to be subject to the distorting laws of this visible, imperfect, contingent world. The moralizing of Optics

in the thirteenth century, ultimately on platonic principles, would encourage precisely this sort of distinction between the godhead and the created, empirical world. At a more instinctive level it might also be felt, I think, that the comprehensive distortion of the refracted image of Christ's feet in the *Baptism* would seem bizarre, indecorous, and avoidable.

The argument thus turns toward content, and it bears reiterating that we should misrepresent later medieval texts on Optics if we did not notice that transmitted Greek-Arabic science is now very often framed in a metaphysical discourse, to the extent that the one cannot be excavated without regarding, or deliberately discarding, the other. From the thirteenth century onward—the creative figure here is Grosseteste, bishop of Lincoln—the laws of Optics had been moralized, even placed at the service of a cosmology.[18] Grosseteste's sources were partly platonic and partly patristic (which, in the case of Augustine, is almost the same thing); and so *perspectiva*, in his *De iride*, was shifted from natural philosophy to moral philosophy. Light is the First Principle, once more. While Plato had identified light as an emanation of the divine, Plotinus identified the Divine Being with light. Augustine and Pseudo-Dionysius praised God as the fount of light. Peckham thought that Augustine had said "God is light, not figuratively but properly." God is *Lux*, and sensible light (*lumen*) is degraded illumination. From this way of thinking is derived the magic of Catoptrics, described in nearly five hundred lines of the *Roman de la Rose* (18038–18518). The magic is a perfect allegory of man's relation to the divine.

Grosseteste's Christian cosmology is explained, then, in terms of light. In a later thirteenth-century tract once attributed to Witelo, *De intellegentiis*, it is reaffirmed that Light *is* God, and another, Bartolomeo da Bologna's *De luce*, in the Franciscan tradition of Grosseteste and Bonaventura, is a metaphysical commentary on biblical passages that compare the actions of God to those of light.[19] For Roger Bacon—and here it becomes apparent how this development has everything to do with the theology of Baptism—refraction of light is an analogue of the infusion of Grace to imperfect men.[20]

In this new phase, after the moralizing of Optics in the thirteenth century, the magic of the passage of light through transparent media becomes in poetry a figure of the divine mysteries for Hildegard and, notably, Dante (*Paradiso* ii.34–36).[21] Thus it can be that in both Piero's *Baptism* and Filippo's *Annunciation*, in different and complementary ways, the catoptric phenomenon may be such a figure again.

In Filippo's case, the liminally prominent glass carafe partly filled with water is not required in any literal representation of the Annunciation, nor does it have any structural or descriptive function, so it is almost inevitable that it be accounted for by a figurative interpretation. And that would not be unusual. But the problem is to define its subject. If it is *a carafe of water*, then it is probably a figure of the Virgin's purity, as is usually said. If, however, the subject is phenomenal, that is, *the passage of light refracted* through water, air, and glass, then it may on the contrary stand as a figure of the presence of the divine mysteries.[22] I believe that we have to think much more carefully than customarily we do about the difference between a static or object-based hermeneutics, on the one hand, and a kinetic or behavioral one on the other. It is the latter that is increasingly appropriate in Renaissance art.

With Piero the case is not so straightforward. The biblical texts that state that Christ was *in* the water were of great importance to the orthodox commentators, say Chrysostom, Augustine, or especially Jerome, who will explain that Christ's immersion sanctifies Baptism for all mankind.[23] Conse-

quently, earlier artists go sometimes to extravagant lengths to make the doctrinal point, as in the immersion represented in the mosaic at Daphni, about 1100, or the one by Andrea Pisano in his bronze doors of the 1330s. Thus an economical interpretation of Piero's treatment of his Jordan might say that, consistent with the doctrinal necessity of representing Christ in the river, he has used his awareness of the refraction-reflection shift to make, in spite of the water, a firm space-construction. He adjusted his angle of vision for maximum clarity. An equally economical interpretation (which I should prefer) might say that Piero has exploited what he knows of the combined behavior of light with water to stress the properties of water, and so the fact that Christ stands indeed in it. Such a minimalist reading is likely to collect support, these days, and it will pose as realist. And insofar as it does that, it must not pass without inspection. The refusal to interpret except reductively must be recognized as itself a choice, a position, agenda-driven. And in this case it is the less realistic position because the understanding of the visual phenomenon in play seems to be informed by theory, where it could not easily be found in the major western sources without a metaphysical or figurative gloss. If in his reading Piero found the science of Optics placed at the service of a Christian cosmology, then it is entirely reasonable to suggest that in his picture, too, the magic of the behavior of light is a figure of the mystery of the revelation of the Light of the World, or of the presence of the divine.

NOTES

1. John Shearman, "The Logic and Realism of Piero della Francesca," in *Festschrift Ulrich Middeldorf*, ed. Antje Kosegarten and Peter Tigler (Berlin, 1968), 184.

2. Albert Lejeune, "Recherches sur la catoptrique grècque d'après les sources antiques et médiévales," *Académie Royale de Belgique, Classe des Lettres, Mémoires* 52.2 (1957), and Graziella Federici Vescovini, *Studii sulla prospettiva medievale* (Turin, 1965).

3. Bruce S. Eastwood, "Grosseteste's 'Quantitative' Law of Refraction," *Journal of the History of Ideas* 28 (1967), 403; David C. Lindberg, "The Cause of Refraction in Medieval Optics," *British Journal for the History of Science* 4 (1968–1969), 23, and *Theories of Vision from Al-Kindi to Kepler* (Chicago, 1976); A. I. Sabra, *Theories of Light from Descartes to Newton* (Cambridge, 1981). In addition I have gratefully consulted Sabra on the argument of this paper.

4. Umberto Eco, *Art and Beauty in the Middle Ages* (New Haven, Conn., 1986), 44–50; Eco, *The Aesthetics of Thomas Aquinas* (Cambridge, Mass., 1988), 107; and Eco, *Interpretation and Overinterpretation* (Cambridge, 1992), 59.

5. Michael Baxandall, *Patterns of Intention: On the Historical Explanation of Pictures* (New Haven, Conn., 1985), 128, and Martin Kemp's review, in *Zeitschrift für Kunstgeschichte* 50 (1987), 138–140. My observation has also been noted and qualified by Marilyn Aronberg Lavin, *Piero della Francesca's Baptism of Christ* (New Haven, Conn., 1981), 39, 41, who believes that "Piero used his knowledge of optics to produce a dual impression: to suggest and, at the same time, to rationalize a miracle. While evidently ankle-deep in water, Christ and the Precursor appear to stand on dry ground." In her subsequent argument (notably page 51) she omits what had been "evident," and refers only to "the image of the halted water and the dry river bed."

6. This detail is well reproduced in Gloria Fossi, *Filippo Lippi* (Florence, 1989), fig. 18.

7. If the inner and outer surfaces of the glass are parallel or concentric, their refracting effects individually (as interfaces between media) will be in combination approximately self-canceling, in any case, save in extreme situations. In the case in question, then, the interface may be treated as one between air and water; the effect of the glass is chiefly to make an air-water interface vertical or inclined.

8. *Lorenzo Ghibertis Denkwürdigkeiten (I Commentari)*, ed. Julius von Schlosser, 2 vols. (Berlin, 1912), 1:55–233; it is characteristic, for example, that he relates (187) Euclid's experiment, the refracted image of the coins (see below), and (217) treats the apparently broken *bacchetta*.

9. Erwin Panofsky, "Artist, Scientist, Genius: Notes on the 'Renaissance-Dämmerung'" (1953), in Wallace K. Ferguson et al., *The Renaissance: Six Essays* (New York, 1962), 162.

10. Lejeune 1957, 152.

11. Lejeune 1957, 152–172.

12. Sabra 1981, 71.

13. Federici Vescovini 1965, 93; Lindberg 1976, 73, 83.

14. Vaticanus latinus 4595; Lindberg 1976, 265.

15. Lindberg 1976, 80.

16. Ghiberti, ed. Schlosser, 1912, 180–181; Federici Vescovini 1965, 93; Eastwood 1967, 406; Lindberg 1968–1969, 25.

17. I rely on Lindberg 1968–1969, 30. That there were small contributions is clear from Franco Alessio, "Questioni inedite di Ottica di Biagio Pelacani da Parma," *Rivista critica di storia della filosofia* 16 (1961), 79, 188.

18. Federici Vescovini 1965, 7–17; Lindberg 1976, 95–97; Eco 1986, 48–49.

19. Federici Vescovini 1965, 23–25.

20. Lindberg 1976, 99; compare note 23 below.

21. Giovanni Getto, "Poesía e teología nel *Paradiso di Dante*," in *Aspetti della Poesia di Dante* (Florence, 1947), 137–144; Eco 1986, 44.

22. A number of northern sources are applied to the problem of interpreting carafes in fifteenth-century Netherlandish painting by Brian Madigan, "Van Eyck's Illuminated Carafe," *Journal of the Warburg and Courtauld Institutes* 49 (1986), 227, with earlier references; I doubt whether the author should have mentioned refraction as faithfully rendered in such pictures.

23. The glosses of Chrysostom and Augustine are handily quoted in the *Catena Aurea*; Jerome's *Commentary on Saint Matthew* would probably be first choice for a gloss on the Gospel texts describing the Baptism: "Triplicem ob causam Salvator a Joanne accepit baptismum. Primum, ut . . . omnem justitiam et humilitatem Legis impleret. Secundum, ut baptismate suo Joannis baptisma comprobaret. Tertio, ut Jordanis aquas sanctificans, per descensionem columbae, Spiritus Sancti in lavacro credentium monstraret adventum." (*Patrologia Latina*, vol. 26).

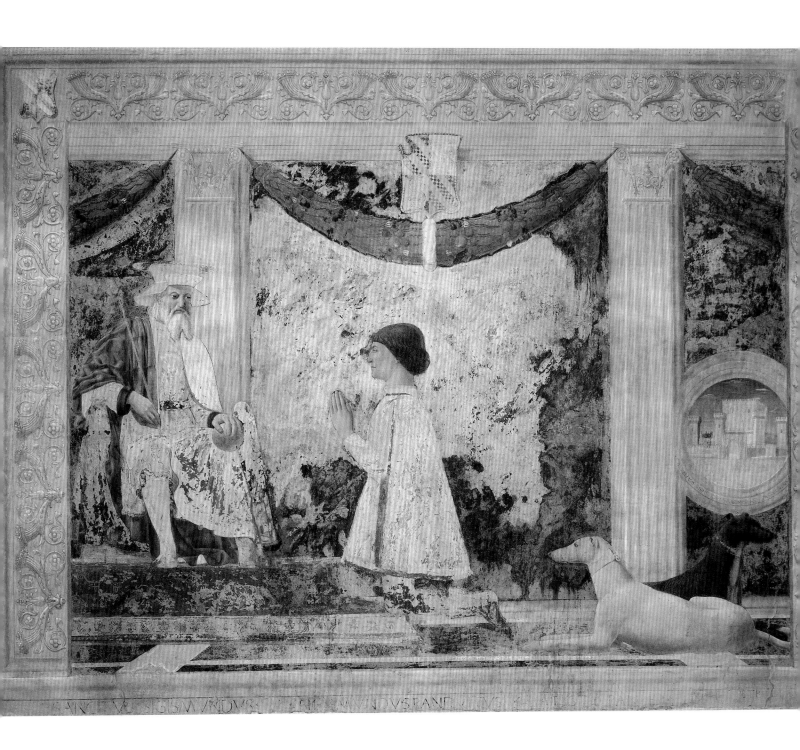

CHRISTINE SMITH
Syracuse University Program in Florence

Piero's Painted Architecture: Analysis of His Vocabulary

The question of the influence of Leon Battista Alberti on Piero's painted architecture is problematic for at least two reasons: one is uncertainty about the exact dates and nature of contact between the two artists; and a second is uncertainty about the dating of some of Piero's most Albertian-seeming paintings. To give just one example, if the *Flagellation* were to date in the 1440s or early to mid-1450s, influence of Alberti's Rucellai Chapel, designed in 1457, would have to be rejected.[1] A dating, instead, in the 1460s for the *Flagellation* would permit this comparison, but only if it is assumed (for it cannot be shown) that Piero was in Florence and saw Alberti's work, or at least met with him between 1457 and whenever he painted the *Flagellation*. The literature on Piero is full of suggestions about the relationship between these artists that may be right but are not certain. I propose to take the problem forward by taking a step back; from this perspective, the view will be unnaturally small, but clear. In order to clarify Piero's architectural sources, I applied an exclusionist or reductive method, considering only documented experiences. At first I thought this starting point would afford a more ample treatment of the problem and had no doubt that I would find plenty of Albertian connections. Instead of working from Alberti to the paintings, it seemed more prudent to begin with an analysis of the morphology of Piero's painted architecture, asking what it

owes to his documented visits to Florence, Rimini, Rome, and Urbino, as well as to his documented contacts with Alberti, both the person and the works. This approach resulted in a view that is admittedly narrow, since Piero's travels and acquaintances are not entirely known, and included documented and undocumented experiences that I am excluding. For instance, I did not examine the impact of architecture he might have seen in Arezzo, Sansepolcro, or Ancona because I was more interested in the ambients he shared with Alberti. Nor did I consider in detail all of his architectural settings, in some cases because these were too mutilated (the *Madonna del Parto*), but also because I wanted to focus on elements that are either repeated in a large number of paintings (framed marble panels) or that have been seen as pivotal for the definition of his architectural sources (fluted columns). Despite the limitations of my approach, the reduction of a large number of undocumented possibilities to a limited number of certainties produced a view of Piero's architecture so unlike what I found in the literature that I decided to present it to the scholarly community. In particular, by trying to account for some of Piero's morphology without referring to contacts that are assumed but undocumented, I saw some new connections that I think modify what can be said about Piero's architectural culture. What I am presenting, then, is not so

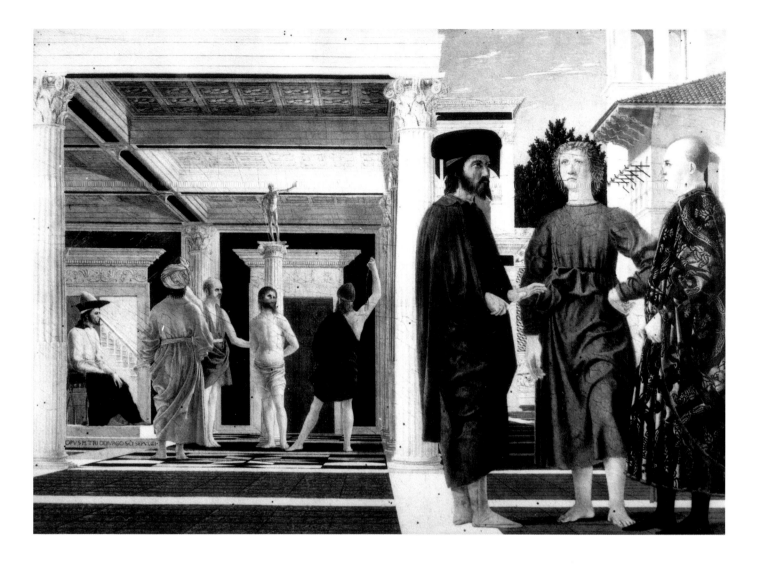

1. Piero della Francesca,
Flagellation of Christ,
c. 1458, tempera
Galleria Nazionale delle Marche,
Palazzo Ducale, Urbino

much an explanation of Piero's painted architecture as a methodological experiment: how does the problem of Piero's painted architecture, especially in relation to Albertian influence, look if we restrict the evidence to documented experiences?

Four hypotheses emerged from my research:

(1) The influence of Alberti, except in perspectival construction and perhaps proportion—neither of which I am considering—is problematic. We can be reasonably certain that they met in Florence in 1439, and, less surely, in Urbino around 1470; other direct contacts are less likely. While Piero seems to have known Alberti's treatise *Della pittura*, probably since 1439, I see no clear evidence in the morphology of his settings that he knew *De re aedificatoria*. Nor do I find evidence that he had firsthand experience of any of Alberti's buildings. My purpose is not

to argue that Piero's painted architecture is not Albertian, but only to point out the lack of conclusive positive evidence that it is.

(2) Piero's visit to Florence in 1439 was fundamental for his painted architecture, even though it had no immediate impact unless one accepts a date in the 1440s for the *Flagellation*.

(3) Specific relations between Piero's painted architecture and traditions of pictorial depiction often seem more compelling than those with architectural theory or practice.

(4) Piero's painted architecture seems to have unexpectedly close relations with sculptural techniques, and these require further investigation.

I will begin the discussion of Piero's painted architecture with his stay in Florence, documented in September 1439.[2] Piero must

have been impressed by the dome of the
cathedral, completed only three years ear-
lier. Alberti had praised it, drawing its sig-
nificance for the new art of Florence in his
letter to Brunelleschi which prefaces *Della
pittura*, a work of special interest for Piero.
Alberti himself was in Florence: at this
point he had never written on architecture,

3. Baptistery of Florence, pavement, thirteenth century
Photograph: Elizabeth Wicks

served as adviser for an architectural project, or designed a building.[3] In fact, he believed that "the architect . . . takes from the painter architraves, bases, capitals, columns, façades, and other similar things."[4] By 1439 the aged Brunelleschi's completed works, such as the Old Sacristy, and his works in progress, such as Santo Spirito, were establishing his new architectural vision as a kind of common practice in Florence. Masaccio had recognized the relevance of the new architectural vocabulary for painters fifteen years earlier in the *Trinity*, as had Donatello for sculptors in his niche for the Saint Louis of Toulouse; Ghiberti (in the East Baptistery doors) and Luca della Robbia (in the Cantoria) were working out versions parallel to, rather than derived from, Brunelleschi's classicism in the years just prior to Piero's visit.[5] What did Piero make of all this artistic activity?

Unless we accept a date in the 1440s for the *Flagellation* (fig. 1), I see no signs of the Florentine experience in Piero's work during the next decade or so in terms of painted architecture. The Berlin *Saint Jerome* has a landscape setting in which only a hut is shown; and while the London *Baptism* might be said to reveal an awareness of the landscape setting of Fra Angelico's *Deposition*, the settings of the *Misericordia Altarpiece* (or lack of them, rather) have no architectural elements at all. But let us suppose for a moment that the *Flagellation* does date in the 1440s.[6] We know that the essential concept of the setting—the flagellation taking place in an asymmetrically placed loggia—derives from a trecento pictorial tradition which Piero certainly knew, if only from a painting in his home town. As Marilyn Lavin observed, Piero retained many features of the trecento settings—the elaborate marble pavement, columns, and paneled ceiling—but also transformed his model or models, above all in terms of mathematical precision, but also in the more purely classicizing appearance of the loggia.[7] That the perspective owes much to Alberti's treatise on painting seems clear.[8] But what about the morphology?

By 1439, cable-fluted columns could be seen in Florence in the Baptistery interior and in Michelozzo's portal for the sacristy of Santa Trinita; fluted columns without cables are depicted in Ghiberti's *Flagellation* for

the north doors of the Baptistery. Of the fourteen columns in the Baptistery, only one is cable-fluted (fig. 2). Like Piero's, the column seems white and has a Corinthian Composite capital. It supports an entablature, stands before a marble-revetted wall, and rests on an elaborate opus sectile pavement into which is set a large disc of colored stone (fig. 3).[9] Every one of these features is repeated in Piero's *Flagellation*. Since the Baptistery was believed to have been an ancient temple to Mars, I would see this borrowing as Piero's positive response to his first experience of an intact classical structure.

The example of the Baptistery is of interest not only for what Piero adopted from it, but also for what he rejected. For example, precisely those elements that Brunelleschi

adopted—unfluted columns, the green and white coloring, the use of dark materials for the structural elements and light for the walls, the combination of arches on columns with fluted pilasters carrying an entablature, the cherub frieze—are those that Piero ignored. And what we see in Piero is what Brunelleschi excised from his version of classicism: the Florentine never used the fluted column, wall revetment, or inlaid floors. Piero's un-Brunelleschian preferences were shared by Michelozzo in the portal of the sacristy of Santa Trinita (the fluted column), and by Ghiberti for the *Flagellation* on the north doors of the Baptistery itself (the fluted columns with entablature)—both works before 1425. Whatever the date of Piero's *Flagellation*, it suggests his rejection of Brunelleschian classicism and therefore not only of the architectural idiom dominant in Florence at the time of his only documented visit to the city, but of the architect whom Alberti had singled out as representative of the new art.

It may be that Piero's choice of the fluted column was later reinforced by exposure to additional classical models: the fluted columns of the Arch of Augustus at Rimini, for example (which he surely saw in 1451), or of Santo Stefano Rotondo in Rome (where he is documented in 1459). And perhaps modern practice confirmed it, for example, the fluted columns by Maso di Bartolommeo in the portal of San Domenico in Urbino, of the early 1450s and surely known to Piero, rather than Alberti's at Rimini and Florence or Michelozzo's at Santissima Annunziata, which we cannot be sure he saw.[10] However, there is not much about most of these fifteenth-century sources not already present in the Baptistery; indeed, we might ask if the relation between many of these works is not exactly their common reference to the same authoritative classical model, since Alberti, Michelozzo, and Maso di Bartolommeo certainly knew the building.[11] In their works, and in Piero's *Flagellation*, the fluted column with trabeation appears as a quotation from a specific, prestigious classical source.

By suggesting the importance of the Florence Baptistery for Piero's painted architecture, I do not intend to support an early dating for the *Flagellation*. Indeed, its architectural setting would be an anomaly in the

4. Pantheon, Rome, detail of revetment, second century A.D. Alinari

context of his documented works of the 1440s. Moreover, Piero drew selectively from the Baptistery as a model. For example, whereas the Baptistery's revetment consists of closely fitted, unbordered white slabs and green geometric motifs, Piero's wall has large areas of richly colored stones bordered all around by white cornices. What, if not the Baptistery, is the source for Piero's depiction of marble paneling in the *Flagellation*? An answer to this question would also help to account for the marble revetment in *Sigismondo Malatesta before Saint Sigismund* in Rimini; the *Sant'Agostino Altarpiece*; *Saint Louis of Toulouse* and *San Giuliano* in Borgo Sansepolcro; the *Annunciation, Meeting of Solomon and the Queen of Sheba*, and *Proofing of the True Cross* in Arezzo; the *Madonna del Parto* in Monterchi; the *Annunciation* from the *Perugia Altarpiece*; the *Montefeltro Altarpiece*; and the *Williamstown Madonna*.

What Piero painted in the *Flagellation*—single slabs of colored marble surrounding doorways and extending from pavement to ceiling—is not possible in reality. Since real revetment slabs are, necessarily, of limited size, there is always a problem of how to conceal the seams between the pieces that

make up a wall. This aesthetic problem may be solved in various ways. In classical usage, at least in the examples still extant, rather small pieces of stone create patterns of contrasting colors and shapes; the joins are often acknowledged by inserted borders. This arrangement, for instance, is what we see at the Pantheon (fig. 4), and it is recommended by Alberti in *De re aedificatoria*.[12] Alternatively, the veining of the slabs can be matched (compaginated) as mirror images; seams are almost invisible in the resulting pattern. San Vitale in Ravenna (sixth century) is rightly famous for this kind of marble revetment, which is as expensive as it is rare, since it requires large slabs with beautiful veining and highly specialized workmen. Although compagination is usually thought to have been recommended by Alberti, that idea rests on a misinterpretation of his text.[13] Breaking up a field of solid color by the insertion of geometric motifs helps conceal the seams in the background by diverting the eye to pattern; this is what happens in the Baptistery of Florence (twelfth century). Alberti used this technique for his revetment at Santa Maria Novella and the Rucellai Chapel. It is, of course, possible to revet a wall without attempting to conceal

the joins: the entire lower part of the interior (up to gallery level) of San Marco in Venice is covered in this way. Since the slabs are not well-fitted one to another, seams interrupt the surface patterns created by the marbles and distract the eye. Although Alberti disapproved of this practice, Piero's revetment is an idealized version of this technique.[14] We will see, however, that Piero used painted and sculpted intermediaries, as well as more immediate sources in actual revetment.

Painters were unrestricted by the material limits of stone revetment: Masolino, painting in San Clemente in Rome, emended the revetment of the Pantheon by depicting large areas of unbroken color within white frames (fig. 5). Painters' versions of revetment can be studied in a fairly large number of fourteenth-century dados and in a smaller number of fictive wall revetments. Giotto's backgrounds for his virtues and vices in the Arena Chapel depict colored stones within light stone frames; the same combination can be seen in Taddeo Gaddi's dado in the Baroncelli Chapel in Santa Croce and in Agnolo Gaddi's dado in the cathedral of Prato. Larger-scale fictive revetments like that in the sacristy of Santa Croce follow the principles just described. These painted depic-

tions have no parallels in classical, medieval, or Byzantine wall revetment, which never use white (or light gray or cream-colored) marble frames around colored panels. Instead, they are evidence of painters' awareness of how colored marbles were applied by sculptors, that is, in panels of large but still manageable size, surrounded by white borders with simple profiles (often a cyma recta with a fascia). Bernardo Rossellino's Bruni Tomb of c. 1446 (fig. 6) may be the first Renaissance example of a technique that had been used for large-scale sculptural commissions such as altars, episcopal thrones, choir screens, baptismal fonts, pulpits, and tombs at least since the fifth century. The connection between Masolino's fresco and the sculptors' tradition is explicit since he uses their technique for the base of his pagan statue: his idealized depiction of the Pantheon's revetment applies the same technique to monumental architecture. This technique was not especially characteristic of tombs nor of Roman practice: we see it as early as the fifth century in the baptismal font of the Orthodox Baptistery in Ravenna and in locations as distant as the Cappella Palatina in Palermo, where it is used for the pulpit. It is used for tombs—for instance, for Enrico Scrovegni's tomb in the Arena Chapel

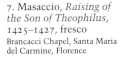

7. Masaccio, *Raising of the Son of Theophilus*, 1425–1427, fresco
Brancacci Chapel, Santa Maria del Carmine, Florence

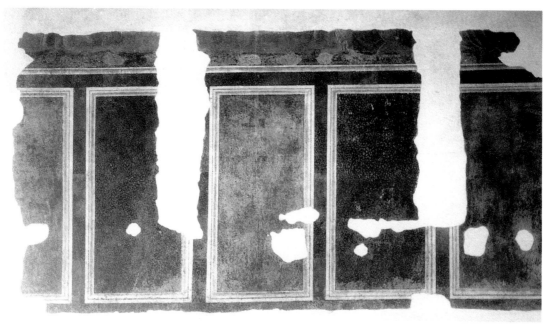

8. Alessio Baldovinetti?
dado from Sant'Egidio,
Florence, designed 1439,
executed c. 1460, fresco

9. Piero della Francesca,
*Sigismondo Malatesta
before Saint Sigismund*,
1451, fresco
Tempio Malatestiano, Rimini

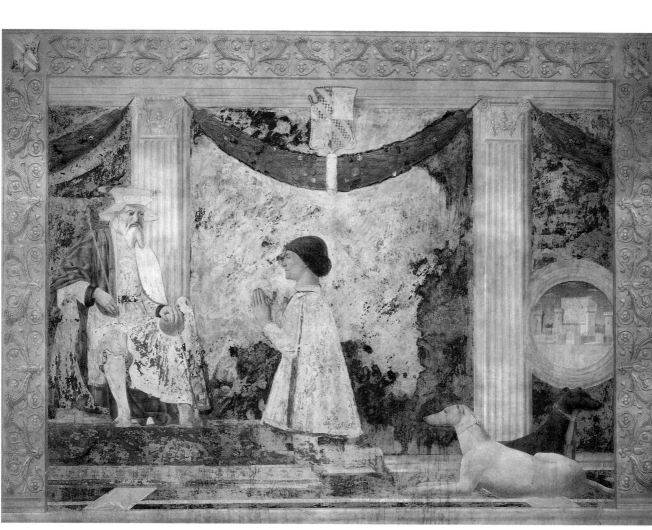

—but also for choir screens, as in a four-teenth-century example in the Baptistery of Pisa. This technique became popular in the mid-fifteenth century for the same kinds of objects, for instance, the episcopal throne in the Chapel of the Cardinal of Portugal and the altar of the Pazzi Chapel. In theory, the maker of wall revetment can also make an altar: both are marble workers (*marmorarii*) or stone workers (*lapidarii*). But if the skill is the same, the practices are in reality different. Makers of revetment do not usually work with large slabs and never with white borders, whereas makers of large-scale stone objects like tombs and altars do. The explanation for this difference between revetment and sculpture is beyond the scope of this investigation. What is clear, however, is that trecento and quattrocento painters almost always transposed a technique developed for sculptural objects onto their fictive wall planes as revetment rather than copied actual wall revetment techniques. Also, they consistently depicted white, gray, or beige borders such as are almost never seen in actual revetment. Two exceptions, both fifteenth-century, will be discussed below.

While the development of painted depictions of marble is still largely unstudied, it seems likely that Masaccio's background wall in the *Raising of the Son of Theophilus* (Brancacci Chapel) is an important landmark (fig. 7).[15] Here colored slabs, some imitating the color and markings of porphyry, are framed by the white borders used by sculptors. The importance of the wall, which until recently was assumed to have been added by Filippino Lippi, has never been properly appreciated. Now that the recent cleaning and study of the *giornate* have shown that this wall is by Masaccio,[16] we know that the colored marble backgrounds popular with mid-century Florentine artists like Castagno, Baldovinetti, and Benozzo Gozzoli developed from models painted in the 1420s, from Masaccio's work at the Brancacci Chapel and Masolino's at San Clemente in Rome. Piero would have had firsthand experience painting a fictive marble wall in Florence in 1439, if the painted dado at Sant'Egidio formed part of the original project; what we have now was probably executed by Baldovinetti around 1460 (fig. 8).[17] If he did not work on the dado in 1439, he

certainly saw Masaccio's paneled and framed wall in the Brancacci Chapel. The fictive marble walls in the Carmine and Sant'Egidio are innovative in their illusionism (the imitation of real marbles and real stone borders) and in their scale. Masaccio's wall is taller than the painted figures; the Sant'Egidio dado is as tall as a real person: in both, the painted marble panels are about the same size as the real marble panels in the Bruni Tomb. This leap, through increased scale, toward greater illusionism, is a fundamental premise for Piero's settings.

Although the Florentine experience was important for Piero's interest in fictive marble walls, his first use of this pictorial device occurred within the context of the reuse of ancient marbles at the Tempio Malatestiano project. A close look at the setting of his 1451 Rimini fresco will clarify its sources in contemporary revetment techniques. Within the frame of the fresco, moldings separate colored panels, probably representing dark green marble: fluted pilasters are attached to the vertical parts of these moldings (figs. 9, 10). The architectural setting has been interpreted in different ways, but never within the context of revetment technique.[18] In my view, the pilasters cannot be the front faces of square piers supporting an entablature since, in that case, the sides of the piers should be shown as converging rather than diverging. In fact, these are not piers receding into depth but moldings parallel to, rather than perpendicular to, the pilasters: they frame the colored panels on all four sides. This reading explains why the pilaster capitals continue up over the first two horizontal fascie of the "architrave": these two fascie are not the underside of an architrave shown in recession, but are parts of the continuous molding framing the fictive marble panels. What, then, do the capitals support? Nothing, since they are in front of the molding and "architrave." Piero did not depict the forward projection that should occur between the second and third fascie (counting from the bottom), which would correspond, architecturally, to the upper edge of the molding and the lowest part of the architrave. In other words, Piero has not depicted a weight/support system. There is other visual evidence for this reading. If the cornucopia frieze running at the top of the fresco

is part of an entablature behind the figures, why does it surround the fresco on three sides (cutting off the "architrave" which is supposed to support it), and why does it read as coinciding with the foreground plane at bottom left and right? Piero's lack of differentiation in the cornucopia border between the horizontal "frieze" and vertical "pilasters," obligatory within the classical understanding of a weight/support system, is a clue permitting us to identify his architectural sources: the "falling architrave" at Brunelleschi's Ospedale degli Innocenti and, ultimately, the attic of the Baptistery of Florence (fig. 11). At the Baptistery, as in Piero's fresco, a frame surrounds only three sides of a rectangular plane, enclosing a system of fluted pilasters and marble panels. As in the case of the *Flagellation* column, the model is Florentine and (to Piero) classical. The frieze serves as a kind of frame around the picture plane, through which we look.[19] Optically, then, it has a double reading: both as part of an entablature in the background and a frame in the foreground. Although these two readings exclude each other logically and architecturally, they work perfectly well pictorially, visually connecting the picture plane with the background.[20] Indeed, the entire so-called architectural setting is a painter's depiction of framing devices, intended to be read pictorially rather than tectonically.[21] Yet the setting has been said to be influenced, or even designed by, Alberti, even though it is hard to imagine that he could have disregarded the fundamental principle of weight/support just a year before presenting his treatise on architecture to Nicholas V.[22]

Piero's Rimini setting is not just a recollection and reworking of things seen twelve years earlier in Florence: there is a clear design relation between the setting of the fresco and the marble dado of the adjacent San Sigismondo Chapel, as Pier Giorgio Pasini first observed (fig. 12).[23] Scholars have been unsure about the nature of this relation: the fresco is dated 1451, whereas the chapel, worked on since October 1447, was consecrated on 1 May 1452. It has been suggested that the decision to have a real, rather than fictive, marble dado was connected to the choice of stone, rather than painted, decoration for the whole chapel; and that this deci-

sion was made sometime between 7 April 1449, when Sigismondo mentioned his intention to fresco the chapel in a letter to Giovanni de' Medici, and 1451, when work on the stone revetment for the chapel must have been in progress.[24] Uncertainty about the date of the dado design, following from uncertainty about when it was decided to carry out a painted rather than a sculptural scheme, has led some authors to believe that Matteo de' Pasti (architect in charge of the chapel

10. Piero della Francesca, *Sigismondo Malatesta before Saint Sigismund*, 1451, fresco (detail) Tempio Malatestiano, Rimini

11. Baptistery of Florence, attic, eleventh to twelfth century

12. San Sigismondo Chapel, dado, 1449
Tempio Malatestiano, Rimini; photograph: Elizabeth Wicks

project) copied Piero's fresco for the dado, or even that Piero designed the dado, thus dating the dado 1451 or later; others believe that the influence went the other way around.[25] I think I can show that the original project to fresco the chapel (May 1449) called for the stone dado, that the dado dates 1449, and that Piero therefore copied it for his fresco.[26] Rather than seeing the dado as part of the change to a sculptural scheme, I will argue that it was part of the first project, to fresco the chapel, but excluded from the second project which called for sculptural decoration.

As Corrado Ricci first recognized, the material for the dado—pavonazzetto and Proconnesian marble—must be the marbles that Sigismondo stole from Sant'Apollinare in Classe sometime before May 1449 and for which he indemnified the Venetian doge in August of the same year.[27] What he did not realize was that the design of the dado also comes from Ravenna since it closely copies that of the apse of San Vitale in Ravenna: paired pilasters and an entablature frame marble panels (fig. 13).[28] The common source for both dados is a series of second-century A.D. Roman reliefs (fig. 14), probably once a

frieze, with putti in front of pilasters and an entablature. These panels, now dispersed between Ravenna, Venice, and Milan, come from San Vitale, where they apparently served as a kind of guard wall at gallery level; at least since the sixteenth century, two of them have been in the presbytery of San Vitale.[29] Imagining the San Sigismondo Chapel frescoed and with a stone dado, rather than a painted one as is standard in fourteenth- and fifteenth-century Italian chapel decoration, enables one to identify its immediate formal source in fifth- and sixth-century decorative complexes in Ravenna. At San Vitale, the stone dado in the apse is surmounted by pictorial decoration, specifically, by the panels representing Justinian and Theodora on the lateral walls and by the enthroned Christ with saints in the apse.[30] Although at Ravenna this imagery is in mosaic, not fresco, it nonetheless furnishes a model for the combination of a stone dado on the lower part of the walls and pictorial decoration above. Since the marbles at Rimini certainly come from Ravenna, and the design of the dado surely imitates models at San Vitale, the original scheme for the San Sigismondo Chapel may have combined

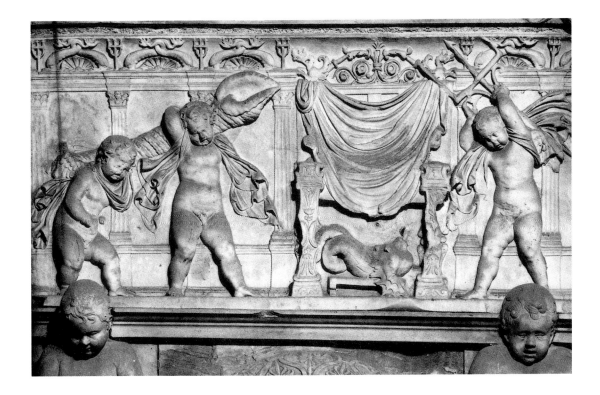

sculpture and monumental painting as at
that church. If the first scheme, of 1449,
included the stone dado, there is no reason
to date it together with the decision to deco-
rate the chapel with sculpture. This second
project, in fact, did not include a dado. In the
San Sigismondo Chapel, only the altar wall
has a dado; the two lateral walls are entirely
revetted from floor to ceiling with unframed
slabs in a kind of wallpaper effect (fig. 15).
Since the slabs were spoils, there are dispari-
ties in color and shape which Agostino di
Duccio concealed by sculpting them in low
relief. The unification of the wall plane that
could not be obtained through the color and
pattern of the materials was achieved
through the design of angels pulling back cur-
tains, originally painted blue and enhanced
with gold flowers.

This second project, which included the
stone altarpiece, also has a specific model,
the Mascoli Chapel in San Marco, Venice
(fig. 16). The importance of this chapel,
which was founded by Doge Francesco
Foscari in 1431 (1430 Venetian style), and
which has the first marble wall revetment of
the Renaissance, has not been appreciated.[31]
Here slabs of cipollino rosso (also known as
Carian, Iasos, or Africanone marble) flanking
the altar are so skillfully pieced (compagi-

nated) that they create the illusion of single patterned sheets running from floor to ceiling; simple light-colored borders frame their edges.[32] This approach to the wall—large, uniformly colored and patterned areas enclosed by sculptural, rather than architectural, frames—has no counterparts in classical or early medieval revetment; its immediate source is fourteenth-century revetment at San Marco and elsewhere in Venice. The wall revetment of the Mascoli Chapel, which has strong affinities with the revetment invented by sculptors and adopted by painters, has fifteenth-century parallels in Venice, Urbino, and Florence: this is the kind of revetment that Piero painted, first at Rimini, but then in Arezzo, and in the *Flagellation*. At the Mascoli Chapel, revetment covers all the vertical surfaces; the altarpiece is carved stone and the vault has mosaics. There is no dado, since the revetment serves to unify the altar wall as a colored and patterned background for sculpture.[33] The different approaches to revetment on the altar and lateral walls of the San Sigismondo Chapel correspond to two different conceptions of how the chapel should be decorated. The first, based on sixth-century Ravennate models and calling for the combination of a stone dado (the ultimate source for which was Roman) and frescoed walls, corresponds to the first project for the chapel. The second, comprising totally revetted walls, no dado, and a stone altarpiece, follows modern Venetian practice on the model of the Mascoli Chapel.

It can be shown that the materials for the dado, models for its design, workmen capable of making it, and advisers who would have recommended it were all available in Rimini by the summer of 1449. It can also be shown that these same advisers and workmen were all familiar with Venice and knew the Mascoli Chapel. However, the humanist advisers who might have preferred the first scheme, based on ancient usage, paid short visits to Rimini in the spring and summer of 1449, whereas the head of the project and his workmen, who may have had a greater affinity with recent decorative schemes, stayed on. Their opinion eventually prevailed. The influence of Filarete and Cyriacus of Ancona, both connoisseurs of marble revetment and both in Rimini in

1449, may have been decisive in choosing San Vitale as a model for the first scheme. Filarete is documented in Venice in 1449; his visit to Rimini occurred in the same year.[34] Filarete was impressed by the "Greek" marbles he had seen at San Marco and heard about in Hagia Sophia; marble revetment, usually in conjunction with mosaic decoration (and never with sculpture), is recommended throughout his treatise.[35] Ciriaco d'Ancona was surely in Rimini in June 1449, at which time he furnished the Greek inscription for the Tempio Malatestiano.[36] Ciriaco was something of an expert on ancient marbles; he had visited the underground quarries at Paros and had recorded the marble revetment of Hagia Sophia in drawings.[37] The drawings, probably made in Constantinople in 1444 or

16. Mascoli Chapel, San Marco, Venice, begun 1431 Böhm

1446–1447, formed part of the *Commentaria*, a copy of which he gave to Matteo de' Pasti while in Rimini.[38] These advisers understood marble revetment to be a distinguishing characteristic of all'antica buildings. Matteo de' Pasti, the man who took credit for the interior of the Tempio Malatestiano, is also first documented in Rimini in June 1449 (although it is supposed that he had been there since 1446); he had worked in Venice in 1441.[39] As for the workmen, Agostino di Duccio, who is first documented in Rimini in June 1449 as an "incisore lapidum," and is presumably the executing artist of the dado, had been in Venice since 1446.[40] Two

Venetian stone workers (*lapidarii*), Giovanni di Francesco and Pellegrino di Giacomo, are documented at the Tempio Malatestiano project during the summer of 1449.[41]

What about Alberti? The only evidence for Alberti's presence in Rimini before Piero painted his fresco, and before the San Sigismondo Chapel was consecrated, is the date of 1450 on Matteo de' Pasti's medal representing the Albertian project for the Tempio Malatestiano. Most scholars now agree that 1450 is not the date of the medal but rather of Sigismondo's vow to renovate the building and that the medal was probably struck about 1454.[42] As for Alberti's presence in Rimini, which is entirely undocumented, the best we can say is that he must have come to look over the site sometime before 1454, by which date we know that a model existed and construction was in progress.[43] The year 1449 is to be eliminated as a possible date for Alberti's visit if the second phase of the Tempio Malatestiano project was conceived in 1450: 1450, the date of the Jubilee, seems the least likely time for Alberti, as apostolic secretary, to have been away from Rome. Piero Scapecchi has argued, convincingly, I believe, that the renovation of the Tempio Malatestiano really got under way in 1453, and that this date is also that of Alberti's visit to Rimini.[44] Since the San Sigismondo Chapel was consecrated in 1452, the likelihood that Alberti participated in the design of its dado is small. Moreover, given the number of experts present in Rimini in 1449 who could have recommended, designed, and executed the dado, there is simply no reason to include Alberti. Although the project posed a question in which Alberti was interested—how ancient spoils could be reused—the solution was provided by nearby Ravennate models and a recently completed chapel in San Marco, Venice, rather than by his advice.

The doorway to the room in which Piero's fresco is located is also made of spoils and also probably by Agostino and his Venetian stone cutters (fig. 17). Here affinities with the fourteenth-century revetment at Saint Mark's in Venice are clear, especially with the entrance to the Baptistery (fig. 18).[45] Similarities are found in the way the doorway is surrounded by a framed border, within which the panels create a surface pat-

17. Doorway to the Cella delle Reliquie, 1450s
Tempio Malatestiano, Rimini; photograph: Elizabeth Wicks

tern, and the way precious materials are set off in roundels floating against the background of the wall. We see adaptations of this in Piero's fresco (the inset roundel) and in Alberti's façade at Rimini (precious stones set in frames against a neutral background).[46] Precedents could also be found in Venetian palace façades of the fourteenth and fifteenth centuries: the Palazzo Donà, Ca' Loredan, Palazzo Da Mosto, Palazzo Priuli, Palazzo Badoer, and the Ca' d'Oro. Above all, the treatment of the doorway at Venice and in Rimini is visually close to what Piero depicts on the back wall of the loggia in the *Flagellation* (fig. 1). What characterizes fourteenth- and fifteenth-century revetment in Venice is the application of large sheets of the same marble in a wallpaper effect—the approach adopted by painters in the same period and by Piero at Rimini, Arezzo, the *Louis of Toulouse* and *San Giuliano* at Sansepolcro, the *Williamstown Madonna*, and in the *Flagellation*.

What I am suggesting is that Piero's knowledge of pictorial conventions and sculptors' techniques, his contact with Agostino di Duccio and the Venetian stone workers, and above all his encounter with the problem of how ancient revetment materials could be displayed in a modern setting, account for his painted revetments. Further, what Piero paints has close parallels with actual wall revetment, above all in gothic and early Renaissance examples in Venice. I would add that whereas the Mascoli Chapel is the first instance known to me of light-colored stone borders being used to frame a wall of closely fitted marble slabs, the technique was also used for the tomb wall of the Chapel of the Cardinal of Portugal around 1460. The Renaissance revival of marble wall revetment, as seen in the Mascoli Chapel in Venice, the San Sigismondo Chapel in Rimini, and the Chapel of the Cardinal of Portugal in Florence, imitated the practice of sculptors and painters rather than the techniques used for classical and medieval walls. Piero's painted revetment is not only a further development of painterly practice; it also reflects the contemporary revision of revetment techniques.

That Alberti and Piero renewed their acquaintance in Rimini is unlikely. However, we do not need Alberti to understand Piero's

18. Entrance to the Baptistery, San Marco, Venice, fourteenth century
Photograph: Melissa Weese

setting. Indeed, comparison between the architectural membering of the chapel dado, where pilasters actually support the entablature, and the fresco's setting, where they do not, suggests that at this point in his career Piero's painted architecture was not structurally logical. By contrast, the settings in the *Flagellation*, in the *Annunciation* and *Meeting of Solomon and the Queen of Sheba* (fig. 19) at Arezzo, and in the *Resurrection* in Sansepolcro, *are* tectonic: the columns support loads, not only in the foreground but also when they are attached to the revetted background wall. The balustrade behind the standing saints in the lateral panels of the *Sant'Agostino Altarpiece* (fig. 20), commis-

sioned in 1454 but largely executed in the 1460s, is a corrected version of his Rimini setting, showing the pilasters and entablature on a plane in front of the moldings enclosing the marble panels exactly as it occurs in the dado of the San Sigismondo Chapel.[47] In Arezzo (but not at Rimini) Piero differentiated the frame around the revetment from the architectural setting of columns and entablature by color—white for the frames, light gray for the architecture—distinguishing the sculptors' parts from that of the architects. And in the *Resurrection* (but not at Rimini), the underside of the architrave, seen *di sotto in su*, is of a darker color than the front face. It might seem that these works represent a later phase in the evolution of Piero's architectural interest, or are even evidence that the setting of the *Flagellation* must be later than that at Rimini.[48] Yet in the *Montefeltro Altarpiece* (fig. 21), a late work, although two planes (marble panels and frames; pilasters and entablature) are distinguished in the foreground and middleground, in the apse proper there is no distinction in projection between these two systems. Although the underside of the architrave is in shadow in the foreground and middleground, this is omitted in the apse: the "architrave" becomes an extension of the frames around the marble panels. While Piero's settings certainly change, I do not think this is due to a progressively greater understanding of architectural structure or tectonic correctness.

Influence from Piero's stay in Rimini may be distinguished in the grand façade of the *Proofing of the True Cross* in Arezzo (fig. 22). Three elements distinguish the façade of what may be the Temple of Venus, originally on the site of the Holy Sepulcher, or perhaps a vision of Constantine's Golgotha basilica which replaced it:[49] (1) there is no distinction of roofing levels for nave and side aisles, hence the façade is a pure pedimented rectangle; (2) it is entirely revetted with colored marbles bordered with white frames; and (3) roundels inserted into the framed compartments introduce a striking geometric play against the rectilinear character of the revetted planes. Some of these qualities have been accounted for already, in terms of Piero's interest in colored marbles, but not all.

19. Piero della Francesca, *The Meeting of Solomon and the Queen of Sheba,* 1452–1466, fresco
San Francesco, Arezzo

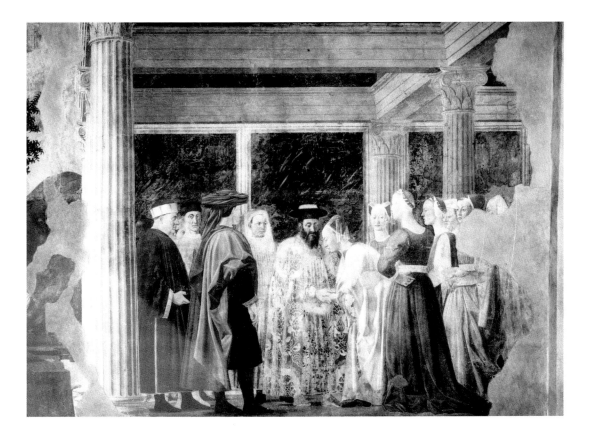

20. Piero della Francesca,
Archangel Michael, c. 1469,
oil and tempera
National Gallery, London

Marilyn Lavin, the first to suggest that the building might be an idealized version of a real structure, proposed a relation with the cathedral of Pienza.[50] But since the Pienza project was conceived after Pius II left Rome in 1459, developed by him while at Mantua with Alberti, and commissioned from Rossellino, who was in Florence, it is difficult to see how Piero would have known of it. However, some influence from one of Rossellino's sources for the design, the cathedral of Assisi (begun 1140, consecrated 1228), could be considered (fig. 23).[51] At Assisi we see the same flat, rectangular, pedimented block articulated into three vertical parts by slightly raised moldings and with three roundels disposed in a triangle. Since Lavin drew a connection between the scene at Arezzo and the story of Saint Francis telling brother Sylvester to drive out the demons from that city, this connection is also iconographically relevant.[52] But although Piero's interest in a rectangular, pedimented, church façade may reflect an early experience in Assisi, the depiction of such a form depended on more recent, reinforcing, encounters in Rimini.

The façade of San Francesco in Rimini, not yet the Tempio Malatestiano, which Piero saw in 1451, was a simple vertical rectangle terminating in a triangular pediment; it had a single large oculus (fig. 24).[53] The only structural, as opposed to ornamental, difference between the thirteenth-century façade of the Franciscan church in Rimini and the painted façade in the Franciscan church in Arezzo is that the former had only one portal, whereas the latter has three. There is, therefore, no need to relate Piero's frescoed church to either Roman monuments or Albertian projects.[54] Why did Piero use this Riminese model, and why did he transform it as he did? We need to remember that Piero himself had frescoed the façade of Sant'Agostino in Borgo Sansepolcro sometime after 1454, and that he had therefore thought about the way color and pattern should articulate a church façade.[55] But more important, it may be that the Arezzo fresco records a pre-Albertian project for the Rimini façade. Although this hypothesis cannot be proven, neither is it unsupported by evidence. Alberti's 1454 letter to Matteo de' Pasti includes a rather obscure passage about an oculus on the façade of the Tempio Malatestiano. In Scapecchi's reading, Alberti refers to the necessity of blocking up the original façade oculus, partly because it deviated by 50 centimeters from the new axis of the church.[56] But there is more. In the same letter, Alberti says that he is vehemently opposed to the use of oculi on church façades: "never in a praiseworthy building . . . will you find an oculus."[57] Ricci interpreted the strength of his condemnation to mean that Matteo de' Pasti wanted such an oculus and that Alberti was opposed to it.[58] But did Matteo want to include an oculus in Alberti's design, or was he defending an earlier design that he himself had made? We know something about the design principles at work at this project in 1449–1450: large panels of carefully fitted marble slabs were highly valued in both the San Sigismondo Chapel and the portal of the Cappella delle Reliquie. A project to veneer the whole façade, like that of San Marco, would not have been outside the technical capability or artistic experience of the work-

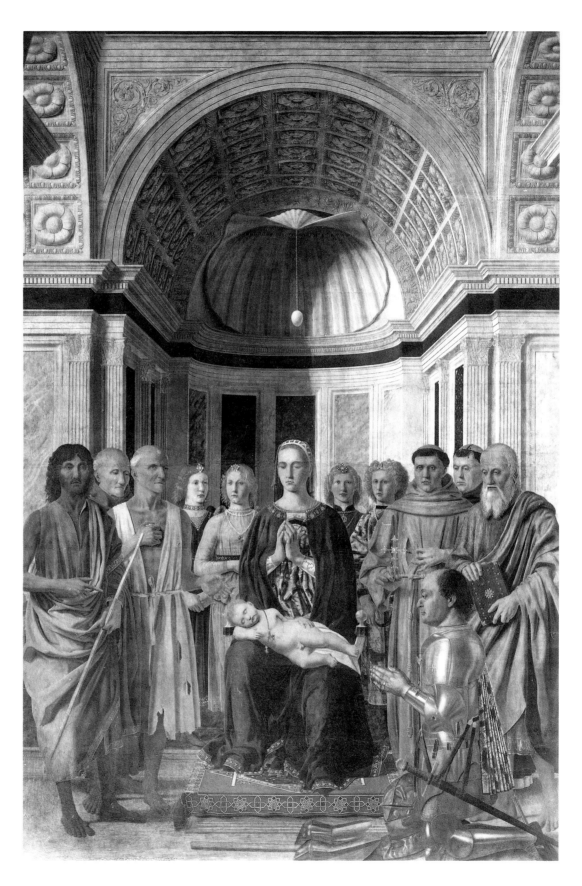

21. Piero della Francesca,
Montefeltro Altarpiece,
1472–1474, oil and tempera
Pinacoteca di Brera, Milan

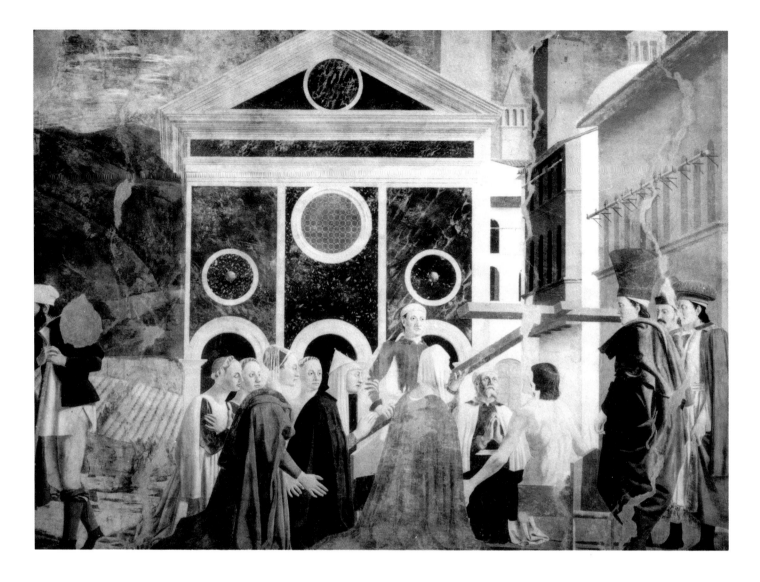

ers. The vertical strips in Piero's fresco correspond to the buttresses on the Rimini façade; the tondo of red marble in the pediment repeats that over the portal of the Cella delle Reliquie. That there is, once again, a Venetian connection between Piero's painted architecture and Venice is suggested by the two inset marble roundels of the Arezzo façade. Such roundels, embellished with metal bosses in relief as in Piero's fresco, are found on the left exterior flank of San Marco and were familiar to the craftsmen in Rimini. What I am suggesting is that before Alberti was associated with the Rimini project, Matteo de' Pasti had a design for the renovation of the façade which would have retained the thirteenth-century structure (rather than concealing it, as Alberti later did). This design had affinities with other

work being done in the church, not only in its focus on the display of colored marbles, reliance on Venetian models, acceptance of steep proportions, and planar character, but also in the introduction of classicizing elements—in the case of the façade, the creation of a pediment by adding cornices.[59]

On 12 April 1459, Piero was paid for frescoes in progress in Pius II's chambers in the Vatican; he probably left Rome in November of that year.[60] The pope had spent very little time in Rome since his coronation on 3 September 1458 and left Rome for about a year in January 1459. We do not know where Alberti was between the coronation in September and the pope's arrival in Mantua in the spring of 1459. He may have come to Rome as early as August 1458, but it is just as likely that he joined Pius in Florence in

22. Piero della Francesca, *Proofing of the True Cross*, 1452–1466, fresco (detail) San Francesco, Arezzo

on which Rome has a near monopoly: opus sectile pavements. Unless Piero visited Venice or Siena, the only non-Roman examples of this technique known to the painter were in Florence, above all that of the Baptistery. Is Piero's intarsia pavement in the *Flagellation* (fig. 25) related to any of these?

We know that many earlier representations of the subject included such pavements and that some of these included star shapes, as does Piero's.[62] Piero's pavement is especially close to that of a *Flagellation* in the Baptistery of Siena, a work of about 1453 from the circle of Vecchietta.[63] Domenico Veneziano's *Saint Lucy Altarpiece*, perhaps designed while Piero was with him in Florence, also has a star-patterned intarsia pavement (fig. 26).[64] But these comparisons make evident what is unique to the *Flagellation* pavement. Although only one square enclosing a disc is actually depicted, a sliver of another is visible at the far left, implying that the pavement was conceived as made up of four squares with discs, alternating with quadrants enclosing eight-pointed stars. Although the organization into quadrants has been read primarily as a perspective device, the decoration of alternating quadrants with discs is the key to Piero's formal source, Roman imperial pavements.[65]

In a number of Roman pavements made

23. San Rufino, Assisi,
1140–1228

24. San Francesco, Rimini, reconstruction drawing of thirteenth-century façade
After Franco Borsi, *Leon Battista Alberti* (Milan, 1976), fig. 136

April 1459. We know only that he was with the pope in Mantua, and therefore in Rome at the most for a few weeks in January during 1459. In other words, unless Piero began the Vatican frescoes before January 1459, that is, within three months of Pius' election, he certainly did not renew his acquaintance with Alberti in Rome. It may be that Piero did in fact arrive in Rome as early as November 1458; but since we do not know whether Alberti was in Rome, the whole encounter is hypothetical.[61] With or without Alberti, there was much in Rome for Piero to see. There is one kind of artistic product

between the second and fourth centuries A.D., colored stone discs at least 1.20 meters in diameter are set into square fields.[66] Most often, the decoration of the quadrants alternates: it is not uncommon for the fields to hold, alternately, circles and squares. Piero would have seen them in the Temple of Venus and Rome, the Curia Senatus, the Basilica of Junius Bassus, the Basilica of Maxentius and Constantine, and the Pantheon.[67] Although the Pantheon's pavement was relaid in 1873, it preserves its original design and some of its original materials (fig. 27).[68] The whole floor is divided into quadrants; discs are in alternate squares as in the *Flagellation*. Most of the imperial pavements favor warm tones of yellow, rose, purple, and green; Piero surrounds green (serpentine, porphyry, or verde antico) discs with rose spandrels.[69]

If the disc quadrants recall late imperial pavements like that of the Pantheon, Piero's star quadrants might reflect Roman Cosmatesque pavements of the twelfth and thirteenth centuries. Combinations of small opus sectile designs with large, reused pieces—often discs—are seen in Rome at medieval

25. Reconstruction of the pavement from Piero della Francesca's *Flagellation*
Drawing by Jane Zaloga

26. Reconstruction of the pavement from Domenico Veneziano's *Saint Lucy Altarpiece*, 1445, tempera
Galleria degli Uffizi, Florence; after Helmut Wohl, *The Paintings of Domenico Veneziano* (Oxford, 1980), fig. 15

churches like Santa Maria Antiqua, San Clemente, Santi Quattro Coronati, San Giorgio in Velabro, San Crisogono, and the San Zenone Chapel at Santa Prassede.[70] However, the discs are never set off in quadrants, and no Cosmatesque pavement used a bichrome white and red color scheme as Piero does. There is a striking resemblance between Piero's star pattern and the only fifteenth-century pavement in the cathedral of Florence (in the Saint Thomas Chapel) (fig. 28). Although the pavement is undocumented, it probably was made between 1435 and 1439, the years in which the tribune chapels first received altars and screens.[71] As far as I know, this unpublished work is the first Florentine opus sectile pavement of the Renaissance, and thus the immediate predecessor of the pavements in the chapel of the Medici Palace (1450s) and in the Chapel of the Cardinal of Portugal (c. 1460), both of which have evident Cosmatesque sources. Unlike these, the Duomo pavement is composed of small red, yellow, and black triangles forming star patterns against a white ground. The pattern, which is not set in quadrants like Piero's, is very close to that of the pavement of the *Saint Lucy Altarpiece*. But like Piero's pavement, there is an optical play in which both the dark and light designs form star shapes: Piero does not represent a dark star against a white ground, but a dark star within a white star, which is in turn enclosed by a dark star.

Not only the portico's pavement, but also that of the open piazza in the *Flagellation*, recall Florentine models. It is difficult for us to imagine today the visual impact of the Piazza della Signoria when it was paved in red brick quadrants framed with white stone borders.[72] Yet its influence, perhaps mediated by Brunelleschi's perspective view of the Piazza, can probably be identified in the pattern, color, and scale of the pavement outside the loggia in the *Flagellation*.[73] As with Piero's fictive revetment, his painted pavement has built counterparts in works of the mid-quattrocento, in this case the pavement of the originally open loggia on the corner of the Medici Palace on Via Larga. Thus, if he visited Florence after about 1460, both the marble wall and the pavement of the *Flagellation* could be seen as copying recently completed works there, and Piero's painted architecture could be seen as reflecting modern practice. However, since such a visit is undocumented, I am relating his setting to earlier models.

A final question about the pavement: does it owe anything to Alberti? Verga believed it to show the influence of a single sentence in VII.10 of *De re aedificatoria*: "I strongly approve of patterning the pavement with musical and geometrical lines and shapes, so that the mind may receive stimuli from every side."[74] He saw Piero's pavement as breaking with medieval tradition and, on Alberti's recommendation, introducing the new principle of centralization. But since classical, medieval, and Renaissance sources and parallels for Piero's pavement

27. Pantheon, Rome, second century A.D., pavement
Alinari

share its geometric and centralizing qualities, there does not seem to be a specific dependence on Alberti for these features. Moreover, the context of Alberti's comment in VII.10 is the decoration of temples; when he comes to private buildings (IX.4), after reviewing various kinds of decorated pavements, he concludes that Agrippa "was right to tile his floors in earthenware" and continues, "extravagance I detest."[75]

As we saw, it is unlikely that Alberti and Piero met in Rimini in 1451 or in Rome in 1459. But did they meet in Urbino, about 1470? We know that Alberti spent the autumn months of his last few years in Urbino (he died in 1472 in Rome); Piero is documented in Urbino in April 1469, and his activity there on commissions for Federico da Montefeltro is assumed.[76] Since Alberti came in the fall, he did not meet Piero in the spring of 1469. Their meeting, therefore, is hypothetical. Can we draw any connections between the settings of the *Montefeltro Altarpiece* or the *Senigallia Madonna*, both late works, and Alberti?

The church or audience hall represented in the *Montefeltro Altarpiece* has nave, or at least crossing, piers (their cornices barely visible at upper left and right), a crossing (presumably domed), and a coffered barrel vault before the apse (fig. 21).[77] The lower parts of the walls are articulated by framed marble panels separated by pilasters supporting an entablature, except in the hemicycle of the apse, where the tectonic elements are omitted. Undoubtedly, many of these features have parallels in Alberti's Sant'Andrea in Mantua, designed in 1470, as Clark observed.[78] However, if the commission for the altarpiece dates after July 1472, the year of Alberti's death, Piero would hardly have been able to consult the architect with this painting in mind. Only if Carlo Bertelli is right in dating the painting 1469–1472 is an Albertian connection convincing.[79] Some of the altarpiece's structural elements have close parallels with the cathedral of Urbino which, in 1474, Sixtus IV gave permission to rebuild. We know little about the new church which was designed by Francesco di Giorgio, begun before the duke's death in 1482, and which collapsed in 1789.[80] This little, however, tells us that Francesco's church, like the *Montefeltro Altarpiece*, had

28. Florence Cathedral, pavement from the Saint Thomas Chapel, c. 1435
Photograph: Elizabeth Wicks

nave piers with strongly projecting cornices, a domed crossing, and a barrel vault before the apse. But once again the dates pose difficulties. Francesco di Giorgio is first documented in Urbino on 8 November 1477, although he is thought to have come there earlier; since Piero is documented in Borgo Sansepolcro between 1474 and 1478,[81] at what date during the planning stage of the cathedral they would have met is problematic. If John Onians is right in suggesting that the new cathedral of Urbino owes much to Sant'Agostino in Rome, begun in 1479, the chronological gap between the commonly accepted date of 1472–1474/1475 for the *Montefeltro Altarpiece* and the design of the new cathedral is so great as to rule out any relation between the two.[82] The same chronological problems hinder a connection between the altarpiece and Francesco di Giorgio's designs for San Bernardino which, in any case, has little formal relation with the setting of the painting. Similarities between the *Montefeltro Altarpiece* and the Cappella del Perdono must also remain inconclusive since the date of the chapel has never been pinpointed any more closely than c. 1474–c. 1495; its designer is unknown.[83] Another current of scholarship has proposed relations, instead, between Piero's setting and Bramante, who was in Urbino 1469–1471.[84] Although there are no architectural works by Bramante from the 1470s, analo-

29. Piero della Francesca, *Senigallia Madonna*, 1478–1485, oil and tempera
Galleria Nazionale delle Marche, Palazzo Ducale, Urbino

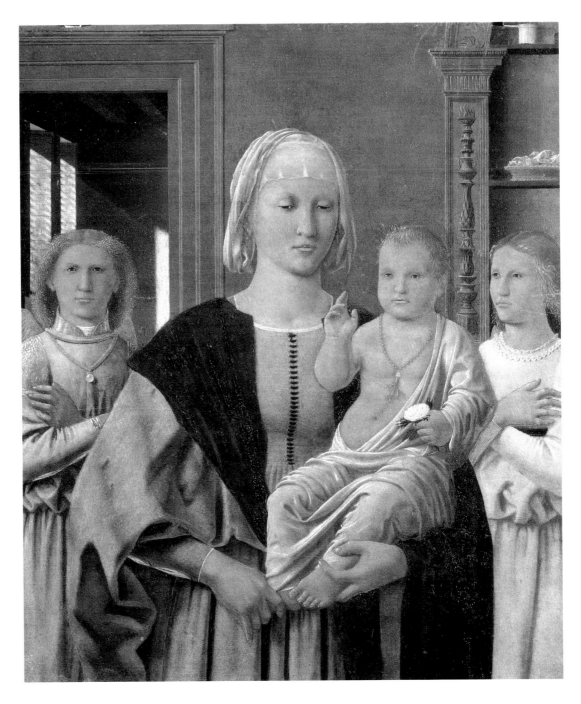

gies have been drawn between Piero's setting and the Prevedari print (1481). Relations have also been sought between Piero's painting and Federico's project for a mausoleum in the Ducal Palace at Urbino; with Luciano Laurana's loggia façade for the same palace; and with the architecture of Santa Maria Nuova at Orciaro di Pesaro, perhaps built in the 1480s by Baccio Pontelli.[85] Most of these suggestions would be more compelling if the date of the altarpiece were to be moved later

than that currently accepted by most critics. If the *Montefeltro Altarpiece* was painted between 1472 and 1474, any direct relationship with built works by Alberti, Francesco di Giorgio, Bramante, or Baccio Pontelli seems unlikely; influence from conversations or drawings is possible in the cases of Alberti and Bramante but not in the case of Francesco di Giorgio. What is most interesting about this discussion may be, instead, that plausible visual relations exist between

Piero's setting and designs by three or more different architects. Perhaps Piero's architectural vocabulary reflects the establishment in the 1470s–1480s of a common architectural usage different from the earlier quattrocento—piers rather than columns, vaults rather than timber roofs.

The gray setting of the *Senigallia Madonna* (generally dated in the 1470s) has been related to Flemish influence; we know that Federico owned a picture of a *stufa* by Van Eyck.[86] But unlike the walls in Flemish paintings, and unlike the similarly colored room in the predella of the *Misericordia Altarpiece*, Piero's color is descriptive of stone, as is clear from his sculpted door surround and the sculpted pilaster framing the niche (fig. 29).[87] That for some Italian painters in the Marche this color denoted stone is confirmed by Girolamo di Giovanni's 1463 *Madonna della Misericordia* for San Martino di Tedesco in Fiastra (fig. 30), which depicts an inscription incised in the stone.[88] It may be that Piero's setting is best understood within this local, painterly convention. But if Piero's setting has a referent in real stone, it can only be *pietra serena*, a material local to Florence.[89] Brunelleschi's preferred material for the carved elements of architecture, *pietra serena* was never used for wall revetment, although Donatello chose it for the architectural background of his *Annunciation* in Santa Croce, a work that Piero saw in 1439. Alberti, who always tried to work with local materials and techniques and who knew that *pietra serena* was not a material for wall revetment, could hardly have suggested it to Piero. Moreover, if the *Senigallia Madonna* was painted for the engagement of Federico's daughter (1474), her marriage (1478), or her arrival in Senigallia (1480), as scholars have thought, it dates some time after the death of Alberti.[90]

The gray stone depicted in the *Senigallia Madonna* brings into focus an aspect of Piero's artistic practice which I have called attention to in my analysis of other of his works and which, in closing, I would suggest as a general hypothesis: that he stored images in his mind over long periods, and that things seen many years earlier later proved relevant to the work at hand. Piero seems to have had a long and tenacious visual memory, and experiences that at first

had no impact on his work (his first quasi-architectural setting dates twelve years after the trip to Florence) later emerged with great clarity. In the cases of the Florence Baptistery column and the pavements of the Duomo and Piazza della Signoria, early visual experiences lay dormant for more than a decade before emerging, transformed, in Piero's work. In general, the relationship between what Piero saw and what he painted seems to have been neither immediate nor direct. We can see how his store of

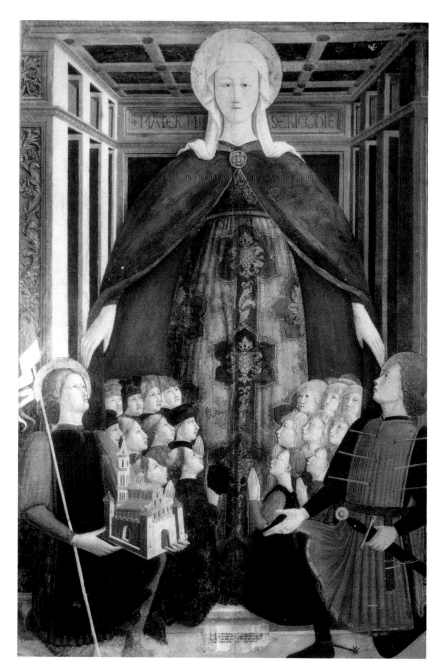

30. Girolamo di Giovanni, *Madonna della Misericordia*, 1463, painting on canvas
Pinacoteca civica, Camerino

visual experiences interacted: he interpreted the marble dado at Rimini in the light of his memory of other real and painted revetment, especially the attic of the Baptistery, Masaccio's wall in the Brancacci Chapel, and perhaps Domenico's dado at Sant'Egidio. For the church in the *Proofing of the True Cross*, his mental image of the project to renovate the façade of San Francesco in Rimini acquired added resonances from his own experience with façade decoration and old memories of the cathedral of Assisi. Other instances of the resurfacing of old memories have been noted in works that I have not considered here. Whereas Masaccio's perspectival demonstrations had no immediate repercussions in Piero's work, Helmut Wohl has—rightly, I believe—connected the long double colonnade in the *Annunciation* from the *Perugia Altarpiece* with a *desco da parto* by Masaccio.[91] That Piero's painting can be used to reconstruct a lost *Annunciation* by the same artist has long been recognized.[92] Yet the *Perugia Altarpiece* has almost always been dated in the 1460s or 1470s, twenty or thirty years after the Florentine visit. Creighton Gilbert, who saw the *Flagellation* as a perspectival demonstration, related it to Brunelleschi's lost panels, works that Piero would have seen ten, twenty, or even thirty years earlier in Florence.[93]

We have seen how in regard to three elements of Piero's painted architecture—the column, wall revetment, and pavements—he modified the painted tradition in the direction of a more authentic classicism

through direct contact with what he thought were classical models: the Baptistery of Florence, the spoils of Sant'Apollinare in Classe, and the Pantheon. The visit to Florence provided partial models for all three of these features, even though the paintings in which they appear were painted twelve or more years afterward: for the column, the Baptistery; for the revetment, the Sant'Egidio frescoes and Masaccio's wall; for the pavement, the Saint Thomas Chapel and the Piazza della Signoria. If the *Senigallia Madonna* depicts *pietra serena*, memories of Florence surfaced more than thirty years later. Piero's practice can be closely connected to that of sculptors (Michelozzo, Ghiberti, and Agostino di Duccio) and painters (Masolino, Domenico Veneziano, Castagno). But neither the column, revetment, nor pavement has a necessary connection with Alberti. Indeed, Piero did not embrace the architectural vocabulary of Brunelleschi after his trip to Florence, although Alberti had praised it in a work that otherwise did influence him; he did not depict the kind of revetment or pavement that Alberti recommended; he had but a limited allegiance to tectonic principles; and his church façade in the *Proofing of the True Cross* included a feature—the oculus that Alberti explicitly condemned. Even if they spent time together in Urbino—the old Alberti now the greatest authority on classical architecture and one of the foremost architects of the day—we do not find evidence of Albertian influence in Piero's painted architecture.

1. A date in the 1440s was first proposed in 1927 by Roberto Longhi, *Piero della Francesca* (Rome, 1927), 39–42, and has recently been reasserted by Ronald Lightbown, *Piero della Francesca* (Oxford-Milan, 1992), 24. Except for Lightbown, recent opinion has favored a date in the mid-fifties or later: Carlo Bertelli, *Piero della Francesca: La forza divina della pittura* (Milan, 1991), 115–125, and Maria Grazia Ciardi Dupré Dal Poggetto, "La *Flagellazione* di Urbino: Un'opera d'arte e la sua leggenda," in *Piero e Urbino, Piero e le corti rinascimentali*, ed. Paolo Dal Poggetto [exh. cat., Urbino, Palazzo Ducale and Oratorio di San Giovanni] (Venice, 1992), 115. For bibliography on the question, see Maria Cristina Castelli's catalogue entry in Dal Poggetto 1992.

Kenneth Clark seems to have been the first to argue that the setting of the *Flagellation* depends on Alberti's Rucellai Chapel; see his "Architectural Backgrounds in 15th Century Italian Painting II," *The Arts* 2 (1946–1947), 33–41. This connection is supported by Marilyn Aronberg Lavin, "Piero della Francesca's *Flagellation*: The Triumph of Christian Glory," *Art Bulletin* 50 (1968), 321–342, 324, and Lavin, *Piero della Francesca: The Flagellation* (London, 1972, 2d ed. 1981), 36. It was recently reiterated by Enrico Londei, "La scena della 'Flagellazione' di Piero della Francesca: La sua identificazione con un luogo di Urbino del Quattrocento," *Bollettino d'arte* 77 (1991), 29–66, n. 220.

2. Piero is mentioned in a payment of 7 September 1439 to Domenico Veneziano for work on the frescoes of Sant'Egidio. Domenico began the work in May of that year. When Piero, last documented in Borgo Sansepolcro in May 1438, joined him is not clear. Eugenio Battisti, *Piero della Francesca*, 2 vols. (Milan, 1971), 1:219.

3. Alberti was in Florence for the Council of Union since January 1439 and stayed until 1442. Franco Borsi, *Leon Battista Alberti* (Milan, 1975), 376.

4. Leon Battista Alberti, *On Painting*, trans. John Spencer (New Haven, Conn., 1966), 64.

5. A good survey of the artistic situation in Florence in 1439 in terms of what would have been of interest to Piero is Luciano Bellosi, *Una scuola per Piero: Luce, colore e prospettiva nella formazione fiorentina di Piero della Francesca* [exh. cat., Galleria degli Uffizi] (Venice, 1992), especially 18.

6. Lightbown 1992, 24.

7. Lavin 1972, 25–30, 34. Creighton Gilbert emphasized the importance of quattrocento Sienese models such as a predella from Sassetta's workshop in the Vatican; see Gilbert, "Piero della Francesca's Flagellation: The Figures in the Foreground," *Art Bulletin* 53 (1971), 41–51.

8. The classic study is Rudolf Wittkower and B. Carter, "The Perspective of Piero della Francesca's 'Flagellation,'" *Journal of the Warburg and Courtauld Institutes* 16 (1954), 292–302; but see also the analysis in Lavin 1972.

9. The disc in the Baptistery is red porphyry, whereas that in the painting is green, and perhaps intended as serpentine, verde antico, or green porphyry.

10. It is quite true that some of the details in the *Flagellation* are specifically related to the Urbino portal, which has the same doorway frieze and coffers (but no rosettes). This connection was especially urged by Ciardi Dupré Dal Poggetto (Dal Poggetto 1992, 115–116), who argued that Piero's painting can be understood in terms of Urbinate culture.

It is by no means certain that the façade of the Tempio Malatestiano was designed by 1451, when Piero was in Rimini. For further discussion of Alberti's activity in Rimini, see below.

The commission for the tabernacle at Santissima Annunziata dates 1444; a dedication plaque in the chapel gives the date 18 January 1452 (1453 common style).

Lightbown (1992, 56) emphasized the importance of the fluted columns and entablature of the Arca del Cavallo in Ferrara, finished before June 1451. Because the date of Piero's trip to Ferrara is uncertain, I am not considering possible contact there with Alberti. Piero also could have seen fluted columns at Matteo Nuti's library at San Francesco in Cesena, begun in 1447.

11. Overlooking the column in the Baptistery has resulted in distortions in the literature. Thus Ludwig von Heydenreich was misled, claiming that the fluted column is distinctively Albertian and that the only other example in Florence is at Santissima Annunziata; see his article "Die Cappella Rucellai von San Pancrazio in Florenz," *De Artibus opuscola XL: Essays in Honor of Erwin Panofsky*, ed. Millard Meiss (New York, 1961), 219–229. Clark (1946–1947, 35) identified the Composite Order, plain entablature, and marble inlays of the *Flagellation*—all elements present in the Baptistery—as "truly Albertian." His opinion was repeated by Ciardi Dupré Dal Poggetto as recently as 1983: *Urbino e Le Marche prima e dopo Raffaello*, ed. Maria Grazia Ciardi Dupré Dal Poggetto and Paolo Dal Poggetto (Florence, 1983), 60.

12. Leon Battista Alberti, *De re aedificatoria*, ed. Giovanni Orlandi (Milan, 1966), VI.10, 507: [in applying revetment] "maculae enim maculis et colores coloribus et talia talibus coaptanda sunt, ut alter alteri mutuo praestat gratiam." The plural forms used in the Latin suggest that Alberti means that different kinds of stones are to be arranged in harmonious contrast, and not matched in kind, as is implied in the English translation: "veining must join with veining, color with color, and so on, so that they each enhance one another." *Leon Battista Alberti. On the Art of Building in Ten Books*, trans. John Rykwert, Neil Leach, and Robert Tavernor (London, 1988), 178.

13. Alberti praises ancient revetment slabs which are joined along an undulating seam, a technique that cannot be used when the adjoining slabs are intended to be mirror images of each other. Instead of the word "compaginatione," the English equivalent of which we use today to mean "closely matched" or "set in mirror image," Alberti invents a Latin word to suggest the opposite—"expaginatione." Alberti 1966, VI.10, 506, 507.

14. At the end of his discussion of revetment, he

warns against using the same color or shape too frequently, or too much in the same place, and against leaving gaps between pieces. Alberti 1966, VI.10, 511.

15. The most thorough treatment of the problem so far is Roger Jones, "Mantegna and Materials," *I Tatti Studies: Essays in the Renaissance* 2 (1987), 71–90. But see George Didi-Hubermann, *Fra Angelico: Dissemblance et Figuration* (Paris, 1990). I thank Andrew Ladis for calling my attention to Masaccio's wall.

16. For the *giornate* see Umberto Baldini, *Masaccio* (Florence, 1990), 298–299.

17. For the dado, see Bellosi 1992, 77–79, with earlier bibliography.

18. A thorough analysis of the setting and the various ways it can be interpreted is in Marilyn Aronberg Lavin, "Piero della Francesca's Fresco of Sigismondo Pandolfo Malatesta before St. Sigismund," *Art Bulletin* 56 (1974), 345–374, especially 372.

19. Lavin 1974, 352. Lavin first realized that the frieze represents a frame and that it is not intended to be read as a post and lintel system.

20. Lightbown (1992, 92) observed how depth is negated by reading the proscenium together with the background and how this contradicts the recession set up by the pavement.

21. Lightbown's reading of the setting also emphasized its untectonic character (Lightbown 1992, 88).

22. Lavin 1974, 353; John Pope-Hennessy, "L'amico Piero," *Il Giornale dell'arte* 100 (1992), 52–67; Clark 1946–1947, 33. Only Lightbown (1992, 89) thought a connection with Alberti unconvincing.

23. Pier Giorgio Pasini, in *Sigismondo Pandolfo Malatesta e il suo tempo* (Rimini, 1974), 132.

24. Pasini suggested that the change of plan was due to the arrival of Matteo de' Pasti, Agostino di Duccio, and a small group of northern sculptors and, above all, to the presence of Alberti in 1450. Pier Giorgio Pasini, "Piero per Rimini," in Dal Poggetto 1992, 93.

25. Charles Mitchell, "An Early Christian Model for the Tempio Malatestiano," in *Festschrift für Hans Swarzenski* (Berlin 1973), 427–432; Pier Giorgio Pasini, "Piero della Francesca nel Tempio Malatestiano," in *Piero della Francesca a Rimini*, ed. Andrea Emiliani (Bologna, 1984), 103–119, 111; Pasini in Dal Poggetto 1992, 93–95. For earlier bibliography, see Lavin 1974, 353, note 31.

26. Pasini implied that the original project called for a stone dado and painted walls when he suggested that the dado (in his view, designed by Piero, and therefore dating 1451) might have already been installed when it was decided, largely on Alberti's recommendation, to decorate the chapel with sculpture. But he did not explore the models for these alternative schemes. See Pasini, in Dal Poggetto 1992, 93.

27. Corrado Ricci, *Il Tempio Malatestiano* (repr. Rimini, 1974), 210–212.

28. Since at San Vitale the dado has both paired pilasters (flanking the throne) and single pilasters, it relates both to the San Sigismondo Chapel dado and to Piero's fresco.

29. They were first published by Corrado Ricci, "Marmi ravennati erratici," *Ausonia* 4 (1909), 247–289, who saw the connection between them and the dado at San Vitale (259), but not with that at Rimini. See Giovanna Bermond Montanari, "L'impianto urbano e i monumenti," in *Storia di Ravenna. I. L'Evo Antico*, ed. Giancarlo Susini (Venice, 1990), 249–251.

30. I leave it to others to decide whether there are iconographic parallels between the apse scheme at San Vitale, showing royal donors and their patron saints in a court setting, and Piero's fresco. Lavin (1974, 361) already drew one connection between Piero's fresco and the apse mosaic; there may be more.

31. The chapel was founded by Doge Francesco Foscari, Bartolommeo Donato, and Leonardo Mocenigo as the Capella della Madonna. John Spencer, *Castagno and His Patrons* (Durham, 1992), 72; Michelangelo Muraro, "The Statutes of the Venetian Arti and the Mosaics of the Mascoli Chapel," *Art Bulletin* 43 (1961), 263–275.

32. While it is not always possible to identify marbles on the basis of their color and veining, Carian is distinctive enough in its blood-red color and large white waves to permit an identification. For Carian marble, see Gabriele Borghini, *Marmi antichi* (Rome, 1989), 237, and Raniero Gnoli, *Marmora romana* (Rome, 1971), 208. The stone appears elsewhere in San Marco and San Vitale in Ravenna, always in conjunction with Proconnesian marble, as at the Mascoli Chapel. There is no evidence that the quarries on Iasos were still open in the fifteenth century, raising the question of where the marble for the Mascoli Chapel came from. It seems likely that the materials were spoils, reworked for the Mascoli Chapel.

33. This scheme probably owes something to the reliefs inserted into revetment elsewhere in San Marco, and to the popularity of carved, rather than painted, altarpieces in fifteenth-century Venice (see, for instance, the altarpieces in the San Tarasio Chapel in San Zaccaria). But the direct model for the chapel is the Tomb of Saint Isidore, 1343–1354, in the Saint Isidore Chapel, San Marco, founded by Doge Andrea Dandalo.

34. Lavin (1974, 362, note 82) gives the dates of Filarete's visit in Rimini as February to 15 April 1449. John Spencer gives 1449; see his articles "The Dome of Sforzinda Cathedral," *Art Bulletin* 41 (1959), 328–330, and "Filarete and the Ca' del Duca," *Journal of the Society of Architectural Historians* 35 (1976), 219–222. However, Alessandro Rovetta did not feel that the visit could be pinpointed with greater precision than 1447–1451; see Rovetta, "Filarete e l'umanesimo greco a Milano: Viaggi, amicizie e maestri," *Arte lombarda* 66 (1983), 89–102, 95.

35. Antonio Averlino detto il Filarete, *Trattato di architettura*, ed. Anna Maria Finoli and Liliana Grassi (Milan, 1972), Book III, fols. 16r–17r; IX, fols. 64v and 66v; XIV, fol. 108r; XV, fol. 119v.

36. Ricci 1974, 44; Marilyn Aronberg Lavin, "The Antique Source for the Tempio Malatestiano's Greek Inscriptions," *Art Bulletin* 59 (1977), 421–422.

37. A. Dworakowska, *Quarries in Roman Provinces* (Warsaw, 1983), 1; Christine Smith, "Cyriacus of Ancona's Seven Drawings of Hagia Sophia," *Art Bulletin* 69 (1987), 16–32.

38. Edward Bodnar, *Cyriacus of Ancona and Athens* (Brussels, 1960), 65; Phyllis Lehmann, *Samothracian Reflections: Aspects of the Revival of the Antique* (Princeton, 1973), 22.

39. Ricci 1974, 38 and 104.

40. Ricci 1974, 104.

41. Ricci 1974, 106; Pasini in Dal Poggetto 1992, 89.

42. See my entry on the medal in the catalogue for the show "Renaissance Architecture," ed. Henry A. Millon and Vittorio Magnago Lampugnani, *The Renaissance from Brunelleschi to Michelangelo: The Representation of Architecture* (Milan, 1994), 458; Pier Giorgio Pasini, "Matteo de' Pasti: Problems of Style and Chronology," *Studies in the History of Art* 21 (1987), 143–159.

43. This seems clear from the letter to Matteo de' Pasti of that year. See Cecil Grayson, *An Autograph Letter from Leon Battista Alberti to Matteo de' Pasti, November 18, 1454* (New York, 1957).

44. Piero Scapecchi, "'Victoris imago': Problemi relativi al Tempio Malatestiano," *Arte cristiana* 714 (1986), 155–164.

45. Ricci (1974, 411) also noticed Venetian elements in this portal, in the border of alternating dentils and in its floral motifs.

46. Lavin (1974, 352) first noticed the relation between Piero's roundel and the oculus on the other side of the wall.

47. For the altarpiece, see Millard Meiss, "A Documented Altarpiece by Piero della Francesca," *Art Bulletin* 23 (1941), 53–68.

48. Dal Poggetto (1992, 115) recently dated the *Flagellation* to 1454–1455 precisely on the basis of similarities to the *Solomon and the Queen of Sheba* at Arezzo. But this date is too early to account for the pavement in the *Flagellation*, as we will see.

49. Marilyn Lavin, in *The Place of Narrative: Mural Decoration in Italian Churches, 431–1600* (Chicago, 1990) (344, note 110), suggested that it represented the future Golgotha basilica.

50. Lavin 1990, 344, note 110.

51. Brenda Preyer was the first to recognize San Rufino as Rossellino's source, in *Giovanni Rucellai e il suo Zibaldone*, 2 vols., ed. Alessandro Perosa (London, 1981), 2:193. Although a trip to Assisi is undocumented, Piero must have gone there. If, for instance, Piero studied with Domenico Veneziano in Perugia in 1438, as Bellosi has recently reasserted (1992, 98), Assisi would have been but a short distance away. And some elements in his paintings must be reminiscences of the frescoes there. The pavement and loggia of Pietro Lorenzetti's *Flagellation* in the lower church of San Francesco are related to Piero's version of this subject, as Lavin first observed (Lavin 1968, 322). I would add that the supernatural light playing on the coffered ceiling in the *Flagellation* must, at least formally, be connected with Lorenzetti's *Last Supper* in the same church. The loggialike, classicizing architecture of the *Last Supper* and the division of the scene into sacred and secular portions are also loosely comparable to Piero's *Flagellation*. Another memory of Assisi, intermingled with later impressions, is the cable-fluted columns and entablature of the Temple of Minerva in the main square of Assisi seen in the *Flagellation* and at Arezzo.

52. Lavin 1990, 185.

53. The thirteenth-century façade was partially uncovered during the post–World War II restoration of the Tempio Malatestiano. See G. Ravaioli, "La facciata romanica del S. Francesco di Rimini sotto i marmi albertiani," *Studi Romagnoli* 1 (1950), 291–294.

54. Lightbown (1992, 162), following Battisti (1971, 1:176 and 2: fig. 99), related the façade to a drawing of a Roman monument by Giuliano da Sangallo, although Lightbown intuited that Piero's façade was closer to the spirit of Italian Romanesque.

55. Lightbown 1992, 207.

56. Scapecchi 1986, 155.

57. Grayson 1957, 17.

58. Ricci 1974, 360.

59. It is outside the scope of this paper to investigate all the implications of this hypothesis: whether, for example, Matteo intended to open new doorways in the old façade; or whether two of Piero's arched openings are tomb niches. At the least, we can conclude that Piero's Arezzo façade represents a design approach diametrically opposed to that of Alberti's at Rimini, and that it boasts at least one feature—the oculus—which Alberti heartily condemned.

60. Battisti 1971, 1:224.

61. Lightbown 1992, 179.

62. The relation between Piero's pavement and those in Flemish works like Jan Van Eyck's *Virgin of Autun*, Rogier van der Weyden's *Annunciation*, and Dirk Bouts' *Last Supper* in Louvain, proposed by Corrado Verga, requires further investigation. Obviously, Piero did not know these specific works. But the comparison raises the question of why Flemish painters, whose native land has no tradition of opus sectile pavements, depict them in their paintings. Corrado Verga, "L'architettura nella 'Flagellazione' di Urbino," *Critica d'arte* 41 (1976), 1 (fasc. 145), 7–19; 2 (fasc. 147), 31–44; 3 (fasc. 148–149), 52–59; 4 (fasc. 150), 25–34; 1:19, n. 24.

63. Lavin (1972, 94, note 11) suggested that the settings in both works may depend on Castagno's lost fresco of the same subject in Santa Croce. However, the Sienese work and the *Flagellation* depict a kind of pavement hardly known in Italy outside of Rome, a city that Castagno is not known to have visited before 1453. We know that in March 1460 Vecchietta went to Rome; it is tempting to suppose that Piero was still there and that they met. Giorgio Vigni, *Lorenzo di Pietro detto il Vecchietta* (Florence, 1937),

65. Another point of contact might have been Matteo di Giovanni, who came from Borgo Sansepolcro but worked in Siena in the 1450s, if it is true, as Scapecchi thought, that he maintained contact with Piero. Piero Scapecchi, "'Tu celebras burgi iam cuncta per oppida nomen': Appunti per Piero della Francesca," *Arte cristiana* 72 (1984), 209–221.

64. The reconstruction of the pavement is in Helmut Wohl, *The Paintings of Domenico Veneziano* (Oxford, 1980), fig. 15. Wohl believed the *Saint Lucy Altarpiece* to be contemporary with, or slightly later than, the Sant'Egidio project, a view recently supported by Bellosi (1992, 98).

65. Wohl noted that Domenico's pavement does not have a gridiron pattern because it does not use the Albertian perspectival system, whereas Piero's painting does. Helmut Wohl, "Domenico Veneziano Studies" (Ph.D. diss., New York University, 1958), 61. Verga (1976, 32) suggested the pavements in late imperial villas as sources, but the Roman sources I am proposing are closer to Piero's pavement both formally and in terms of what we know Piero saw. I leave to those expert in perspective whether these are really circles and squares or, as Lightbown argued (1992, 59), ovals and rectangles.

66. Such pavements were especially popular under Trajan and Hadrian and again in the early fourth century. Federico Guidobaldi and Alessandra Guiglia Guidobaldi, *Pavimenti marmorei di Roma dal IV al IX secolo* (Vatican City, 1983), 50–54.

67. For these, see Guidobaldi and Guidobaldi 1983, 9, 29, and 41.

68. William MacDonald, *The Pantheon: Design, Meaning, and Progeny* (Cambridge, Mass., 1976), 35.

69. These pattern and color choices exclude the possibility of a relation between his pavement and that of ecclesiastical models such as Old Saint Peter's, which was not divided into quadrants, was mostly paved with white, and which had four red porphyry discs arranged in a cross in the nave. A relation with the pavement of the Lateran basilica, which may have had quadrants of colored marbles, is more problematic and would depend on the extent to which Martin V's replacement reused original materials. Guidobaldi and Guidobaldi 1983, 38, 54.

70. For the repertoire of geometric motifs, see the diagrams in Dorothy Glass, *Studies on Cosmatesque Pavements* (Oxford, 1980).

71. Giovanni Poggi, *Il Duomo di Firenze* (Berlin, 1909), parts 1–9, documents 1065–1075, 214–215. The only specific mention of this pavement is in a document of 18 December 1505, in which it is decided to complete the pavement in the Saint Thomas Chapel in the way it was begun (Poggi 1909, no. 1160, 231). The pavement is stylistically different from those designed by Il Cronaca in 1502 (docs. 1154, 1155, 229): it has small pieces of marble and a small, repetitive design; whereas the later pavements have larger and smaller pieces set in a large, nonrepetitive pattern. The wording of the 1505 document suggests that the original pavement of the 1430s was to be enlarged so as to fill the entire chapel (as it now does).

72. The pavement was made in 1330. It is depicted in an anonymous sixteenth-century painting of Piazza della Signoria in the Corsini collection in Florence. Giovanni Fanelli, *Firenze architettura e città* (Florence, 1973), 94.

73. There is no need to relate the pavement to the piazza at Pienza, which was of the same type as Florence, as did Verga (1976, 17).

74. Verga 1976, 32; Alberti 1988, 220.

75. Alberti 1988, 298.

76. For Alberti's presence in Urbino, see Borsi 1975, 193; for Piero see Ciardi Dupré Dal Poggetto and Dal Poggetto 1983, 56.

77. For the setting and the date, see Dal Poggetto 1992, 174–176.

78. Clark 1946–1947, 35.

79. Bertelli 1991, 130.

80. For the cathedral, see Pasquale Rotondi, "Ancora un'opera sconosciuta di Francesco di Giorgio in Urbino," *Commentari* 1 (1950), 89–91; Marilyn Aronberg Lavin, "Piero della Francesca's Montefeltro Altarpiece: A Pledge of Fidelity, *Art Bulletin* 51 (1969), 367–371; Londei 1991, 38; *Francesco di Giorgio architetto*, ed. Francesco Paolo Fiore and Manfredi Tafuri (Milan, 1993), 186–207.

81. Ciardi Dupré Dal Poggetto and Dal Poggetto 1983, 59; Lightbown 1992, 254.

82. John Onians, *Bearers of Meaning: The Classical Orders in Antiquity, the Middle Ages, and the Renaissance* (Princeton, 1988), 197, 201.

83. Pasquale Rotondi, *The Ducal Palace of Urbino* (London, 1969), 88, thought it dated before 1480, but there is no firm evidence for this.

84. Eugenio Battisti, "Piero and Pacioli ad Urbino," in *Studi bramanteschi* (Rome, 1974), 267–282; Guido Ugolini, *La Pala dei Montefeltro: Una Porta per il mausoleo dinastico di Federico* (Pesaro, 1985).

85. Ugolini 1985, 36–39, 32; Lightbown 1992, 250.

86. Dal Poggetto 1992, 190.

87. The predella was painted by Giuliano Amidei, as James Banker shows elsewhere in this volume.

88. For Girolamo's painting, see Dal Poggetto 1992, 294.

89. Lightbown (1992, 47) assumed it was *pietra serena*, not realizing that since this is not a revetment material, the identification raises questions about Piero's understanding of, or interest in, the stone depicted.

90. Lightbown 1992, 257; Dal Poggetto 1992, 190.

91. Wohl 1958, 66.

92. Wohl 1958, 66.

93. Creighton Gilbert, "On Subject and Not-Subject in Italian Renaissance Pictures," *Art Bulletin* 34 (1952), 202–216.

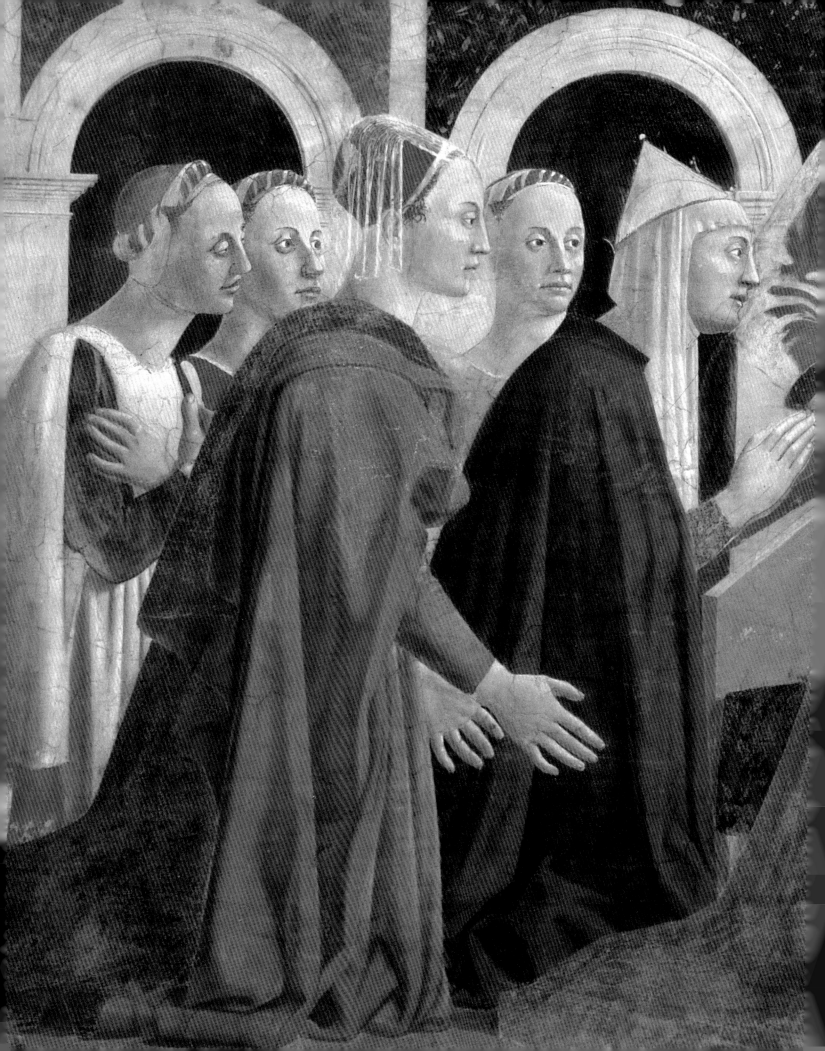

ALBERT BOIME
University of California, Los Angeles

Piero and the Two Cultures

P iero and his representations occupy a uniquely privileged terrain in the profession of art history. The enormous bibliography devoted to the painter since 1960 alone fills several pages of a computer printout, and, had Roberto Longhi lived until now, the burgeoning growth in the literature would have sorely tested his compulsive need to keep abreast of Piero's "fortuna storica." There is a steady stream of material about our obsession with Piero, but here I want to deal with the construction of Piero as an allegory of what recent writers such as Henri Zerner, Hans Belting, Norman Bryson, and Donald Preziosi have called the "crisis" in art history.[1] They stress the notion of an art-historical "doubt" about the identity and objects of art history's enterprise in relation to other disciplines and its secure role in an academic curriculum. Of course, such disciplinary self-doubt over objective validity and scientificity haunts all the practitioners in the humanities and the social sciences—can there ever be a political science, for example, when its self-definition collapses every time revolution breaks out?—but for art historians Piero represents a constitutive component of the peculiar insecurity of our scholarly domain.

Perhaps it is embedded in the very foundation of the craft: Vasari is so mesmerized by Piero's mathematical talents that he lauds them more than once, asserting at one point that in the sciences of geometry and

perspective "he was not inferior to any man of his own time, or perchance even to any man of any other time." Not bad for a painter, Vasari seems to be saying. And he concludes his account of this artist's life with the declaration that Piero's books have earned for him "the name of the best geometrician of his time."[2] Now if this is what matters for our noble ancestor Vasari—no mean geometer himself—in his transmission of Piero's glory to posterity, what might be expected of his devoted descendants?

An interesting article by Anthony Bertram, an author of a modest volume on Piero, in a 1951 issue of *The Studio*, entitled "Piero della Francesca and the Twentieth Century," uses as its springboard the monograph then recently published by Sir Kenneth Clark. Trying to account for the resurgent interest in the artist, Bertram speaks of a "world adrift" and the failure of the modern state to satisfy the spiritual needs of its citizenry. As he offered by way of explanation of the gaping spiritual void: "The Communists and the Financiers and their dupes, and all the other escapists, do not face this basic problem. They deny man." The source of Piero's appeal is that he provides the model of a solution for "that minority which is not satisfied to accept this status of ignorant animal existence." And Bertram continued:

Piero was a Christian, a mathematician and an artist. It is the balance in him, his integri-

Piero della Francesca,
Proofing of the Cross,
1452–1466, fresco (detail)
San Francesco, Arezzo;
photograph: Alinari

tas, his wholeness and his holiness, which make him so peculiarly attractive to us: a steady light above our dark turbulence, a certain star, knowing his own way with such assurance. It was a threefold way: the way of the spirit through faith; the way of the intelligence through mathematics; the way of the senses through art: not three ways, but one way. But it seems that for him the clearest expression of that way was through mathematics.[3]

Bertram's coded anti-Semitism and Cold War diatribe complements Sir Kenneth Clark's own introductory comments on the revolution of taste that shifted Piero from secondary status to the pinnacle of art-historical distinction. Their elitist concern with "wholeness" and "completeness"[4] at the outset of the Cold War era helps frame my discussion with what I believe to be a crucial document in our paper trail. At the height of the Cold War, C. P. Snow delivered his famous lecture on the dangers inherent in "The Two Cultures," addressing the vast communication gap separating the scientific and humanistic disciplines and rebuking the clichés. Snow reported in 1959 that nonscientists harbor the impression that scientists "are shallowly optimistic, unaware of man's condition." On the other hand, Snow confessed that his fellow scientists considered the humanists (he put it "literary intellectuals") "totally lacking in foresight, peculiarly unconcerned with their brother men, in a deep sense anti-intellectual, anxious to restrict both art and thought to the existential moment."

Snow then hurried to rebut the charges. He claimed that most of the scientists he knew deeply felt "that the individual condition of each of us is tragic. . . . Each of us is alone: sometimes we escape from solitariness, through love or affection or perhaps creative moments, but those triumphs of light are pools of light we make for ourselves while the edge of the road is black: each of us dies alone." Rather than exculpate the writers, however, he simply noted that it is unfair of scientists to judge them on the evidence of the period 1914–1950, when admittedly he could see a connection between some forms of early twentieth-century art "and the most imbecile expressions of anti-social feeling." He further

states that this perception explained "why some of us turned our backs on the art and tried to hack out a new or different way for ourselves."[5] (Of course, he omits, or forgets to mention, the scientists at Los Alamos or the ingenious inventors of poison gas.)

The scientist's illiteracy and the literati's ignorance of science prevent them from meeting on a common plane, with the result that the Two Cultures have nothing to say to each other. This isolation and mutual exclusiveness he considered a frightening prospect for the future of modern society. He even expressed disappointment that so little of twentieth-century science had found its way into twentieth-century art. Snow claimed that the cultural divide was not unrelated to the arrogance of younger scientists who felt they were "part of a culture on the rise while the other is in retreat,"[6] a feeling sustained by the economic guarantees unavailable to their counterparts in the humanities.

In retrospect, it would seem that there was nothing new in Snow's essay: the characterization of the two cultures was simplistic, and the polar types of scientist and literary intellectual he described resembled more the Hollywood stereotypes than actual people. But the timing was propitious, and the essay raised a storm of discussion and controversy around the world. Snow's polemic merged with the rhetoric enveloping the "Crisis of the Humanities" that became a recurrent theme from the 1960s on.[7] It was broadcast in the post-Sputnik era, when pandemonium and insecurity were rife among the Western elites. Snow concluded his Cambridge lecture with a warning that if the West failed to bridge the gap, "the Communist countries will in time," signaling the moral and practical failure of the West. Not surprisingly, Snow was violently attacked and defended by leaders of the Anglo-American intellectual elite, which in turn lent credibility to the debate. The essay went through numerous editions in the early 1960s and was translated into several languages including Hungarian, Polish, Japanese, French, and Italian.[8] It became the subject of major conferences held in England, America, France, and Italy.[9] The hated word became "specialization," and in the Italian debate the role models for the "one culture" were

Renaissance types like Leonardo, Galileo, Leibniz, Goethe, and Einstein.[10]

One writer who took a juste milieu position between Snow and his most outspoken opponent, F. R. Leavis, was Aldous Huxley.[11] Huxley, a sort of scientific mystic whose ambivalent position declares itself in *Brave New World*, claimed that neither science nor literature would "ever be adequate to the givenness of the world and of our experience," and that scientists and humanists should cheerfully accept this fact and continue to press on "into the ever-expanding regions of the unknown."[12] Fair enough, but what about the art historians and their need to carve out a space within this debate?

Creighton Gilbert's *Change in Piero della Francesca* was the fruit of studies made during the period 1958–1964, and he presented a draft of the material in 1959–1961, a period coinciding with the peak of the controversy surrounding the Two Cultures.[13] Gilbert starts out with an admission that his view derives in part from the reception of Piero in the contemporary period as an original most loved by contemporary artists. "His personal variation from the average of his time appeals to us, as resembling the twentieth-century variation from past culture." He classifies the peculiar quality of this variation under the label of "'formalism' in the sense of the opposite of Soviet realism." And he elaborated:

Piero della Francesca of course devoted himself to narrative . . . but we seem to feel that he discounted it in some important way. We say that his people are psychologically negative or neutral, with detached expressions. Movement is slowed to a procession, evoking a stability in the figures that transfers them from the organic to the architectural. While qualities of implication and association are thus being diluted, qualities of form are being emphasized: geometric shape, spatial order, and planes of luminous color.[14]

Gilbert proposes that the formalism has been overstated to the detriment of our capacity to recognize Piero's dynamic development. Nevertheless, he sees crisis, for example, in the Arezzo frescoes in discerning a transition from the style of the *Death of Adam* and *Dream of Constantine* to the *Sheba* and *Helena* scenes and from them to the luminous *Battles*. As he puts it, the conjunction of old and new techniques reveals the artist "at a moment of realization of changing values, whose quality of crisis is manifest in the explosiveness of both."[15]

In the end, Gilbert tries to give a more humane face to the familiar "geometric" qualities of Piero that he refers to in one place as "cold hauteur" but that even he experiences as "evocative." His perception of crisis in Piero's work corresponds to the global crisis of the Two Cultures and the crisis in art history as it attempts to open a politically neutral space within the Academy for itself in the Cold War era.

The year that Snow delivered his Rede Lecture I entered Columbia University's graduate program, and in the period 1960–1961 began research for a paper on Seurat and Piero della Francesca that I eventually delivered in a class taught by Charles de Tolnay. After archival research in Paris in the summer of 1962, the theme eventually became a master's thesis and was published as a note in the *Art Bulletin* of June 1965.[16] For an insecure graduate student trying to cope with the hallowed curriculum predominantly devoted to the Renaissance at Columbia while pursuing my own modernist proclivities, it represented the perfect compromise. I relished the confrontation between Seurat and Piero, as well as the act of analyzing their common "impressionistic" pictorial qualities and mathematical skills.

The debate of the Two Cultures must have crept into the periphery of my consciousness at the time, because I recall experiencing the pressure to bridge divided cultural gaps. The work on Piero and Seurat eventually took me into the heretofore prohibited realm of academic art and the École des Beaux-Arts, at a time when the concept of the avant-garde constituted the standard for mainstream critical judgment. Nevertheless, my work on the French academy paralleled the work of a generation of artists born around 1930 who were rethinking narrative and subject painting and the representation of the human body. In addition, even the older generation of abstract expressionists were beginning to embrace figurative and narrative elements even though it may not have appeared immediately obvious in their work. Imagine my surprise to learn that the month before my own article appeared,

Philip Guston published his article in *Art News* entitled "Piero della Francesca: The Impossibility of Painting."[17] The introduction to the article stated that Guston displayed postcard reproductions of the *Baptism* and *Flagellation* on his kitchen walls, and that for the previous eighteen months he had been working on the text "in order to formulate something of what they mean to him and to his crisis-bound vision of modern art." And he added: "One point to modern American painting is its radical challenge to all art dogma and corollary revitalization of the past in the light of present anxieties and achievements."

Not surprisingly, Guston began his piece with the statement that "A certain anxiety persists in the painting of Piero della Francesca." He then asks the existential question: "Where can everything be located, and in what condition can everything exist?" Guston struggles to eke out of the unyielding Piero some answer: "In the *Baptism of Christ*, we are suspended between the order we see and an apprehension that everything may again move. And yet not. It is an extreme point of the 'impossibility' of painting. Or its possibility. Its frustration. Its continuity."

Guston then singles out the distinguishing features of Piero's work: "He is so remote from other masters, without their 'completeness' of personality. A different fervor, grave and delicate, moves in the daylight of his pictures. Without our familiar passions, he is like a visitor to the earth, reflecting on distances, gravity and positions of essential forms." Piero is here seen as intergalactic spaceman landing on planet earth and seeing everything through multiple sets of fresh eyes. The objects of the *Baptism* are treated "without manner," and in the *Flagellation* there seems to be no structure or direction, enabling us to "move spatially everywhere, as in life." Indeed, it may not be a picture we see in this instance, "but the presence of a necessary and generous law." And Guston concludes on a note of existential doubt: "Is the *[Flagellation]* a vast precaution to avoid total immobility, a wisdom which can include the partial doubt of the final destiny of its forms? It may be this doubt which moves and locates everything." Compare this nebulous yet totalizing declaration with Lord Snow's anxiety

and despair over the apparent inability to establish a common culture: "It is leading us to interpret the past wrongly, to misjudge the present, and to deny our hopes of the future. It is making it difficult or impossible for us to take good action."[18] Hence for Guston, who used terms such as "anxiety" and "crisis" frequently, Piero holds out the "possibility" of reconciling the divide that Snow characterized as the Two Cultures.

Guston's daughter recalled her father praising Piero and Giorgio de Chirico because "They don't demand love. . . . They stand and hold you off."[19] Could it be that the anxiety Guston observed in Piero was the inner conflict he felt personally about loss of self-control? For here it is the cool, detached Piero, the cold, heartless father who answers to high modern taste. The demands on both artist and art historian as professional means a rejection of the recklessness, immoderation, and zeal for outgoing and effusive styles stamping the less privileged sectors of society. Impersonality and detachment signify power in the aristocratic world of high taste toward which artists and scholars, from the middle and lower middle social registers, gravitate. Paradoxically, Piero then becomes the favorite of the scholars for the very reason he withholds his love: he permits us to exercise personal self-restraint and construct a self-image of professional self-control—the codes of decorum and good taste.

Guston's family name was originally Goldstein. Did his name change signify his ambition to enter into that upper-class society whose taste marked out Piero as symbolic artist-in-residence? Take the case of Bernard Berenson, who subtitled his monograph on the Renaissance painter "The Ineloquent in Art," and proceeded to analyze the "fashionable taste" for Piero:

Piero della Francesca seems to have been opposed to the manifestation of feeling, and ready to go to any length to avoid it. He hesitated to represent the reaction which even an inanimate object would have when subjected to force, the rebound of a log, for instance, when struck by an axe. . . . one may venture to ask whether it is not precisely Piero's ineloquence, his unemotional, unfeeling figures, behaving as if nothing could touch them, in short his avoidance of inflation, which, in a

moment of exasperated passions like ours to-day, rests and calms and soothes the spectator and compels gratitude and worship.[20]

These comments may tell us more about Berenson's own rise from child of excitable Jewish immigrants to aesthetic arbiter and advisor to the stoic Boston brahmins than about Piero's art.

Indeed, he goes on in terms that would have been quite understandable to Aldous Huxley about the tawdry, *"over-expressive"* (italics Berenson's own), and sensational taste of modern culture that induces in us a craving "for the inexpressive, the ungrimac-ing, the ungesticulating; for freedom from posing and attitudinizing, to the extent of taking to inanimate King Log in preference to the over-animated King Stork." And he reflected on his own personal response to Piero's qualities:

After sixty years of living on terms of intimacy with every kind of work of art, from every clime and every period, I am tempted to con-clude that in the long run the most satisfac-tory creations are those which, like Piero's and Cézanne's, remain ineloquent, mute, with no urgent communication to make, and no thought of arousing us with look and gesture. If they express anything it is character, essence, rather than momentary feeling or purpose. They manifest potentiality rather than activity. It is enough that they exist in themselves.[21]

Berenson's very vocabulary betrays his aris-tocratic and conservative bias in his descrip-tion of the aloof, disciplined art of Piero della Francesca. The opposite of Piero is "over-expression" or "expressionism," that may be designated "as inflational, as over-loud, as over-emphatic. Its appeal is to the insensitive, the inattentive, who must be shouted at before they hear, hit in the eye before they will see, shaken and kicked before they feel. 'Expressionism' appeals to barbarians."[22]

Berenson's maturation at the turn of the century coincides with the emergence of modern modes in art and literature and the strenuous opposition to this modernism. His development suggests alignment with the opposition, articulated most eloquently in Max Nordau's electrifying critique enti-tled *Degeneration,* one of the most sensa-tional and influential documents of the

fin-de-siècle. Among other things, Nordau stressed the link between emotionalism and the work of the modern artists and writers whom he classified as "degenerate."[23] Nordau was a practicing physician who insisted on the scientific and rational ordering of ideas in opposition to the predominance of emo-tion in social and cultural life. It is also noteworthy that as the son of a rabbinical family he symbolically broke with his tradi-tion by changing his name from Südfeld (southern field) to Nordau (northern meadow). Thus his rejection of traits of "emotional-ity" and "excitability" in art as unprogres-sive is constitutive of class consciousness.

The essence of aristocratic "good taste" in the modern era is related to censorship of primitive emotion, taking the form in art-historical discourse of the rationalization of art as an intellectual process. What is cru-cial here is the conceptual pathway leading to the making of art rather than the mere "picturing" of something in it. Piero's works seem to lack moments of time or exact dia-logue or even logical spatial locations for his characters. Nothing climaxes, akin to mod-ernist art generally, and when this quality is allied with Piero's geometric compression, it is clearly profoundly satisfying to represen-tatives of high culture.

Sir Kenneth Clark's introduction to his monograph on Piero boastfully takes credit for his generation's elevation of Piero into an artist of the first rank. The "aesthetes" of the earlier period—who almost totally disre-garded Piero—could easily "have explained and deplored the frenzied and fitful charac-ter of modern painting, its lack of settled conviction and need for stronger stimuli." Indeed, "our discovery of the calm, majestic art of Piero della Francesca would have left them astonished and slightly jealous." The present generation—admirers of Cézanne, Seurat, and cubism—see their aspirations in the heroic geometries of a new classicism radiating order and solidity. Despite the caprices of taste change, Clark is confident that Piero's new pride of place is now fixed in perpetuity.[24] Beneath the rhetorical flour-ishes, one senses the social and class biases of Clark articulated in his preference for Piero.

Clark's flaunting of his monograph on Piero in the context of his identification

with the avant-garde—he even dedicated the work to Henry Moore—is a sign of his status as tastemaker. When he writes that visiting San Francesco in Arezzo is like "breathing the air of a more harmonious planet," he was following the lead of his predecessor at the Slade, Roger Fry, who compared Seurat's *Une Baignade* to Piero's "monumental and motionless groups" that project "a mood of utter withdrawal from all the ordinary as well as all the poetic implications of things into a region of pure and almost abstract harmony." Clark has no difficulty in comparing Piero's *Madonna della Misericordia* "to that of the finest Congo masks in the balance of convex and concave, the large domed projection of the forehead and the concentration of features hollowed out from the lower part of the oval." But Piero's sophisticated sense of form goes "beyond that of the negro carver. This head is in no way a mask. We never doubt that its formal consistency will continue all around." Piero and Cézanne restrict their palettes to a few colors to maintain control of the form, a sign of their intellectual superiority: "For in the hands of one who uses it creatively the word 'colour' means almost the reverse of its connotation in popular speech. There it means number, variety and contrast, the colours of the herbaceous border. . . . But colour used to reshape the world as part of a consistent philosophy must be restricted to those colours which are on easy terms with one another. Shouting will get them nowhere. It is only in quiet discourse together that a new truth may emerge." Here one senses the separation of Clark from the same mob that threatens his mentor and collaborator Berenson, the noisy vulgar crowd that associates "color" exclusively with brilliance and variety.[25] Thus the son of a thread manufacturer and the son of a scrap metal dealer share social assumptions that cannot be divorced from their taste for Piero.

I mentioned Aldous Huxley's participation in the debate over the Two Cultures; this same author had previously described Piero della Francesca's *Resurrection* as "the greatest picture in the world." Claiming some sort of British understatement as the hallmark of Piero, Huxley explained his reverence for the painter:

He is majestic without being at all strained, theatrical or hysterical—as Handel is majestic, not as Wagner. He achieves grandeur naturally with every gesture he makes, never consciously strains after it. Like Alberti, with whose architecture . . . his painting has certain affinities, Piero seems to have been inspired by what I may call the religion of Plutarch's Lives—*which is not Christianity, but a worship of what is admirable in man. Even his technically religious pictures are paeans in praise of human dignity. And he is everywhere intellectual. With the drama of life and religion he is very little concerned.*

The *Resurrection* he described as intensely dramatic: "Piero has made the simple triangular composition symbolic of the subject. . . . No geometrical arrangement could have been more simple or apt. But the being who rises before our eyes from the tomb is more like a Plutarchian hero than the Christ of conventional religion. . . . The whole figure is expressive of physical and intellectual power."[26] Huxley's repetition of two basic themes, Piero's disinterest in religion and his expression of intellectual power, anticipates the appeal of Piero to the modern liberal scholar caught between the Two Cultures.

John Pope-Hennessy confesses in *The Piero della Francesca Trail* that he first learned of Piero from reading Huxley's passages in *Along the Road*, and admits to his own cultlike worship of the master: "There comes a point in life when the artists one has known cease to be objects of research and become friends. The workings of their minds assume a taken-for-granted quality that transcends art-historical analysis." He then goes on to state why he chose Piero as the subject of his Neurath Lecture, and he states that the painter "is a reclusive, silent, rather taciturn friend," terms similar to those used by Snow to define the human condition. After summarizing the contribution of his predecessors to Piero scholarship, Pope-Hennessy insists that Piero remains a mystery whose personality and work still raise unanswered questions. Yet shortly thereafter he disputes the assertion that Borgo Sansepolcro was a sleepy country town and describes it as a "humanist center" that formed the focus of Piero's life and work. He cites a posthumous portrait there of Piero showing the artist standing beside a

table with volumes of Euclid and Archimedes, and bearing a Latin inscription that heralds Piero as "one who extended the bounds of painting, of arithmetic and of geometry." Pope-Hennessy reminds us that "a skeleton of theory underlies all his works," and that "his services were in continuous demand at the humanist courts in central Italy."[27]

This is a critical theme for Pope-Hennessy, who returns to the posthumous portrait and its theoretical implications after a sketchy account of Piero's major works. He recalls Vasari's passage that Piero started his career as a kind of "mathematical prodigy," and declares that his treatises on perspective and the five regular bodies "are milestones in the history of geometry and mathematics." Further, Piero's work on geometry "is infinitely more demanding" than that of the masters of the abacus who taught arithmetic, geometry, and algebra in behalf of mere mercantile activity. In fact, he knew Euclid well and even "understood biquadratic equations," and probably believed that the five regular bodies implied the cosmological significance outlined in Plato's *Timaeus*. Piero's mathematical knowledge is demonstrated in B.A.R. Carter's analysis of the design of the *Baptism of Christ*, for here, according to Pope-Hennessy, "we can abandon speculation and descend to fact." Thus to "the naked eye the result has a finality that is due not to the painter's imagination, but to his geometrical consistency." He reminds us also that it has been conclusively demonstrated that the *Madonna del Parto* is a dodecahedron and that the structure of the work that Pope-Hennessy identifies as *The Dream of Saint Jerome* "is also rigorously geometrical." This shows that in Piero "the linkage between art and science is closer and more purposeful than with any other artist."[28]

In this Spinozistic QED reduction, we see the desire of the art historian to push beyond imagination and speculation into something more tangible and mathematical. This yearning in turn prompts me to pose certain questions: what is the urge to hold Piero in the bonds of camaraderie, despite his taciturn traits, and stress his mathematical abilities? What's at stake here for the art historian? In the case of Pope-Hennessy and others, the notion of Piero as transcendental "friend" suggests the need for an object of

scholarly affection, perhaps pointing to the underlying insecurities of the art-historical profession. What he takes to be the "reclusive" and "taciturn" qualities of his "friend" may be understood as a metaphor for the solitariness of scholarly investigation and the inability of the object of this investigation to talk back. Like a pet animal or child's teddy bear, the object of the possessor's affection is always unconditionally there for him or her.

Italian historian Carlo Ginzburg, the relentless archival "detective," was impelled to step outside his field by the intriguing "enigma of Piero," a subject preeminently demanding of his investigative powers. He begins his trenchant study with the observation that "All in all, we have little certain knowledge of Piero's life; very few of his works can be dated. In such conditions, the researcher is in the position of a climber confronted by a particularly severe rock face, smooth and without anything to which a rope-holding peg might be attached." For Ginzburg the problems surrounding the scholarship on Piero make his case "of great methodological significance, quite apart from his artistic excellence."[29]

Pope-Hennessy's review of Ginzburg's book notes the projection of the author as "a detective in the mold of Sherlock Holmes, with an uncanny instinct for hidden clues."[30] But Pope-Hennessy rejects the parallel, thereby setting the stage for a negative critique of Ginzburg's book. He restates the question, "What is the enigma of Piero?" and adds that for "the past 75 years, Piero della Francesca has been one of the most admired Italian painters." He then tries to conclude with a peremptory dismissal of Ginzburg's speculative yet solidly grounded hypotheses, inadvertently betraying his own tenuous grasp on the sheer alpine height that is Piero:

If the paintings were restudied by a scholar who was skeptical of received opinion on every point, it might well transpire that Piero's development was less abnormal than is thought today, that he evolved like other artists, though with a stronger grasp of theory and a larger data bank of mathematics, and that the enigma (to return once more to Ginzburg's term) finally results not from his style, but from the blindness of the students by whom it has been analyzed.

Here, for all their seeming differences, Pope-Hennessy shows himself to be in agreement with his presumed adversary on the source of their fascination in Piero, with the former far more inclined to seize the mathematical break of that smooth rock face to gain the desired toehold.

Ginzburg's interpretation of the *Flagellation* depends for a solution on amplifying its political implications rather than seeking the devotional theme, relegating the New Testament event to a sort of background vignette and thereby secularizing it. Ginzburg's work, as does all modern Piero scholarship, starts from Longhi's seminal monograph, where the notion of "enigma" is anticipated in his discussion of the *Flagellation* as the "congiunzione misteriosa di matematica e di pittura."[31] Longhi, like Huxley and the rest of the moderns, also seems to have a stake in secularizing Piero, at one point asserting that the artist transformed the sacred narrative of the *Golden Legend* into "a sweeping epic of lay, profane life," replete with scenes of rustic life, regal ceremonies, glimpses of daily labor, legal customs, and modern tournaments.[32] Of course, Longhi vaunted Piero's appeal to modern painters such as Cézanne and Seurat, and it was in his 1942 edition of the monograph where I first learned of the copies of Piero at the École des Beaux-Arts. Indeed, the first edition was published by Valori Plastici, linking Longhi and Piero with the Italian metaphysical school and the Novecento movement.[33] Longhi's close friend Giorgio Morandi, whom he mentions in the later edition of the *Piero*, proudly displayed his copy on his studio worktable. Although Longhi was critical of Lionello Venturi's Skira publication on the master, he would have agreed with him that Piero, "of all Italian painters, is the one to whom our modern sensibility most readily responds."[34] Venturi's observation that in Piero's work "life goes imperturbably on as if time had never been; in it . . . life and death seem to merge into another sphere of existence transcending them both" is echoed in Eugenio Battisti's declaration: "In [Piero] tutto accade in un oggi che non ha né passato né futuro."[35] Although Battisti rails against the clichés associated with Piero, he comes up with one of his own—albeit with an original

twist—when he writes that dealing with Piero is akin to the author who wants to write the story of World War II based on *The Diary of Anne Frank*, that is, she is able to record "only that which has succeeded in filtering through a closed room."[36]

Scholars attuned primarily to Piero's mathematics, such as Gino Arrighi, Julian Lowell Coolidge, Margaret Daly Davis, and, more recently Angeli Janhsen, assert that Piero's dual interests were the products of a gifted mind that flourished during the Renaissance, when there existed a conscious attempt at a "union between the fine arts and the mathematical sciences of arithmetic and geometry." This notion is confirmed by Arthur K. Wheelock, Jr., who reminds us of the necessary involvement of the painters in the mathematical sciences in an effort to associate their discipline with the liberal arts.[37] Analogously, the fascination of modern art historians with Piero may consist in their need to remove their work from the realm of studio practice by identifying with the social sciences and physical sciences. In the case of Piero, painting becomes an intellectual operation. Carlo Bertelli lets slip that although Piero knew no Latin, "his exchanges with Florentine intellectuals must have been facilitated by his superior mathematical knowledge."[38] The study of the Renaissance is the starting point of the discipline, serving as the testing ground for the legitimacy of art history's claims. The parallel interest of modern artists in Piero further enhances art history's relationship with the master, by also valorizing its modernity. Piero then becomes the litmus test of the art historian's own intelligence and modern sensibility, all the while able to bask in the aura of Renaissance authority.

Something similar is going on in the semiotic reading of Piero, evident in the series of essays edited by Omar Calabrese, *Piero, teorico dell'arte*. Calabrese notes that what counts for him is that the painter's work does not manifest a simple "poetics" (what he would define as theory of style or practice of style), but articulates at one and the same time the technical, scientific, and philosophical conceptions that ground it. Whether as a writer of texts or a maker of images, Piero is in the fullest sense of the word a theoretician. The essays that follow, concerned with

his mathematics and narrative strategies, confirm that for these scholars Piero's mathematical interests provide them a golden opportunity to rehearse their own theoretical pursuits.[39]

Marilyn Aronberg Lavin's 1972 monograph on the *Flagellation* attests to a heightened awareness of the reasons for the interest in Piero's work: "With the waning of romantic attitudes and the critical acceptance of post-impressionism and cubism, it was soon drawing praise for the very qualities that had earlier been censured: its restrained expression, purity of color and, above all, the perfect equilibrium of its organization." Noting that the painting's rise to fame in the modern era coincided with the interest in abstract art, she declared that "the suppression of overt sentiment and apparent emphasis on formal values at the expense of the religious subject made it seem possible to find aesthetic fulfillment in the work without reference to its meaning."[40] She further projected back on to Renaissance spectators the modernist response to Piero, suggesting that "the factors that allow the twentieth-century viewer to read *The Flagellation* as 'non-objective' must, in its own time, have formed part of its meaning."[41] Although it would seem that she embarked on a contrary course in seeking "a coherent relationship between the organization of the composition and the subject matter," her meticulous analysis of the picture betrays a thorough preoccupation with its geometries including reconstructed floor plans, elevations, and axonometric views, and mathematical calculations that divide the work into discrete units. The mathematical pictorial space serves specific symbolic and expressive purposes, but conversely symbolic and expressive aims have to be served by mathematical space. Thus art for art's sake and art history for art history's sake are overcome through Piero's intercession.

Lavin's later work on the *Baptism of Christ* includes in an appendix the mathematical interpretation of the painting by Carter, engaging in a collaboration akin to his partnership with Rudolf Wittkower on the *Flagellation* in 1953. Lavin's preface opens with the *Baptism's* reconciliation of two opposing stylistic elements: its naturalism and its seemingly modern quality of for-mal abstraction. It was her recognition of this twofold aspect that stimulated her pursuit in understanding "the strangely evocative power of the image." Dissatisfied with what she termed the "incomplete" analyses of previous writers, she hoped to provide an analysis that would link the dichotomous features of the work in a coherent interpretation. But she also added a warning that her theme could "strain the credence of the less adventurous." Piero's "total vision" calls out of us a demand for "meaning beyond ordinary expectation." Finally, although Piero invented newly structured settings for his themes and articulated their contemporary significance, he retained and even reinforced the expressive values of the older, more hieratic forms. By so doing, he conveyed "a message neoteric in its universality, and universal in its availability to those who follow the language of its visual structure to its logical conclusion."[42] Here she implies, if I am not mistaken, Piero's capacity to speak across the generations and to diverse social and doctrinal beliefs as well as to bridge the Two Cultures.

Michael Baxandall's *Painting and Experience in Fifteenth-Century Italy* wishes to point out "that social history and art history are continuous, each offering necessary insights into the other."[43] Baxandall credits Piero with staging his compositions so as to manipulate the viewer, and this effort to read relationships in the groups enhances the experience for the viewer who is charged by the skills required to recognize their meaning. The viewer identifies with the spectator groups within the pictorial realm in such works as the *Baptism,* "active accessories to the event."[44] Baxandall, like Lavin, invests Piero with a psychological understanding of visual perception that stretches across the centuries.

Baxandall's interest in Piero's mathematical handbook for merchants, *Trattato d'abaco,* follows his view of the painter as a craftsperson more preoccupied with the accurate statement of an object's position than with the abstract beauty of outline. The coming together of painter and mercantile geometry attests to the shared skills necessary for analyzing forms and surveying quantities. In his treatise, Piero's example of gauging barrels derived from the practical

geometry he had been taught in the same secondary schools along with the apprentice merchants. This also meant that the painter's geometries could be understood and appreciated by the mercantile patrons who commissioned his art. Baxandall concludes with the speculation that paintings of the Renaissance offer "an insight into what it was like, intellectually and sensibly, to be a quattrocento person."[45] What he seems to be after is an object of investigation that offers the kind of measured practice that can be assessed in practical terms by the modern scholar. In this sense, Piero's gifts help us carve out a special niche for ourselves as art historians whose special training disentangles the significant meanings of his duality.

Bruce Cole's recent monograph on Piero is subtitled "Tradition and Innovation in Renaissance Art," using terminology familiar to scholars of modern culture. We learn that as late as a hundred years ago Piero was still a sort of local curiosity in his provincial hometown of Borgo Sansepolcro, and was suddenly rediscovered late in the nineteenth century. Artists of the period recognized in Piero's work values and ideals that they were trying to achieve, and his fame was crowned at the moment the new formalism emerged in Western culture. Piero's influence on artists has continually spread, and today postcard reproductions of Piero's work are conspicuously tacked on the walls of studios everywhere in the world.

Cole, although using a more conventional interpretive approach than Lavin, agrees with her in emphasizing Piero as one whose career demonstrates the tension between tradition and innovation. While retaining time-honored types and principles, Piero managed to articulate a highly original style. Finally, Cole aims to make understandable an artist "whose visions, universal in meaning, still have the power to move us profoundly half a millennium after their creation." He concludes his book on a note of confession: "Ultimately, every period admires the art of the past that most fully embodies its own values and aspirations. Piero's structured, luminous, and analytical art is in many ways a mirror of ourselves or what we wish to become."[46]

One piece of historical evidence that confirms this observation is the recent controversy over the restoration of the Sistine Chapel. The discovery that Michelangelo's colors were as intense as Matisse's and confirmed his influence on the mannerist movement overrode considerations of the quality of the restoration. Without entering into the specifics of the debate, it should be emphasized that some art historians were thrilled to see Michelangelo restored to a point where his work seemed "modern," as he emerged more fleshlike than ghostlike out of the past to vindicate their taste.[47] Is it possible that what drives art historians is the desire to justify the objects of their fascination in terms that satisfy the codes of cultural decorum in their own time while relying on the power of tradition to reinforce their authority?

Lord Snow, rethinking the Rede Lecture at Cambridge and the controversy it aroused four years later, concluded his "second look" with the following:

Changes in education are not going to produce miracles. The division of our culture is making us more obtuse than we need be: we can repair communications to some extent: but as I said before, we are not going to turn out men and women who understand as much of our world as Piero della Francesca did of his, or Pascal, or Goethe. With good fortune, however, we can educate a large proportion of our better minds so that they are not ignorant of imaginative experience, both in the arts and in science, of the remediable suffering of most of their fellow humans, and of the responsibilities which, once they are seen, cannot be denied.[48]

It is possible that our intense fixation on Piero lies at the heart of the discipline's conservatism. By maintaining the "mystery" of Piero until now, we have failed to understand the condition of his life and, by extension, that of our own. Have we not used his structures for projecting our own fears safely on to the past, deluding ourselves about our own modernity and avoiding meeting the conditions of our own social existence? In the end, the millions of those who live in the immediate presence of illness and premature death due to material deprivation combine with our own to make up the totality of the social condition. Perhaps by fully understanding our motivations in fixing on the peculiar nature of Piero it is possible to

gain an insight into what's at stake in the institutionalization of the profession.[49]

Lavin ends her book on the *Flagellation* on an intriguing note. Attempting to demonstrate how Piero's interweaving of contemporary history and mystical thematics influenced other artists, she calls attention to Joos van Ghent's *Communion of the Apostles* for the high altar of the church of Corpus Domini in Urbino in 1473–1474. Shown together with Federico da Montefeltro, Ottaviano Ubaldini, and two other members of the family is a Spanish Jew named Isaac who was in Urbino in the early 1470s as Persian ambassador. A convert to Catholicism, he is seen in the painting responding with profound emotion to the archetype of the Eucharistic mystery. Federico and Ottaviano sustain him with gestures of encouragement. He is the modern counterpart of Piero's Jew Lifted Out of the Well, exemplifying the Jew's conversion by the cross and his later career as a Christian. Here we may see Isaac as symbolic as well of the modern art historian, who seeks in Piero an object of study that can satisfy the demands of the personal and the political within the boundaries set by the dominant culture.[50]

NOTES

I want to acknowledge with gratitude the help of friends and colleagues who in one way or another contributed to the realization of this paper: Micaela Amato, Wayne Andersen, Carlo Ginzburg, Carl Goldstein, Marilyn Aronberg Lavin, and Alexander Waintrub.

1. Henri Zerner, "The Crisis in the Discipline," *Art Journal* 42 (1982), 279–325; Hans Belting, *The End of the History of Art?*, trans. Christopher Wood (Chicago and London, 1987), Donald Preziosi, *Rethinking Art History* (New Haven, Conn., 1989), 1–20. Bryson does not use the term "crisis," but it is implied in his preface to *Vision and Painting* which begins: "It is a sad fact: art history lags behind the study of the other arts." See Norman Bryson, *Vision and Painting: The Logic of the Gaze* (New Haven, Conn., 1983), xi–xiv.

2. Giorgio Vasari, *Lives of the Most Eminent Painters*, trans. Gaston Du C. De Vere, 10 vols. (London, 1912–1914), 3:18, 23.

3. Anthony Bertram, "Piero della Francesca and the Twentieth Century," *The Studio* 142 (1951), 120–123.

4. Kenneth Clark, *Piero della Francesca* (London, 1951), 11.

5. Charles Percey Snow, *The Two Cultures and the Scientific Revolution* (New York, 1959), 5–6.

6. Snow 1959, 19.

7. John Harold Plumb, ed., *Crisis in the Humanities* (Harmondsworth, 1964), 162.

8. *The Two Cultures: And a Second Look* (Cambridge, 1964), 54; *Les deux cultures* (Paris, 1968); *Le due culture* (Milan, 1964).

9. Armando Vitelli, *La cultura dimezzata* (Milan, 1965), 25. This gathers the papers of a number of scholars in two Italian congresses that met in Turin and Milan in 1964–1965.

10. Vitelli 1965, 100.

11. Aldous Huxley, *Literature and Science* (New York, 1963), 1.

12. Huxley 1963, 118.

13. Creighton Gilbert, *Change in Piero della Francesca* (Locust Valley, N.Y., 1968), vii.

14. Gilbert 1968, 1–2.

15. Gilbert 1968, 26.

16. Albert Boime, "Seurat and Piero della Francesca," *Art Bulletin* 47 (1965), 265–271.

17. Philip Guston, "Piero della Francesca: The Impossibility of Painting," *Art News* (May 1965), 38–39.

18. Snow 1964, 60.

19. Musa Mayer, *Night Studio: A Memoir of Philip Guston by His Daughter* (New York, 1988), 15.

20. Bernard Berenson, *Piero della Francesca, or the Ineloquent in Art* (New York, 1954) 3, 5–6.

21. Berenson 1954, 6–7.

22. Berenson 1954, 13.

23. Max Nordau, *Degeneration* (New York, 1968), 19. First published in 1892, the book went through several editions.

24. Clark 1951, 1.

25. Clark 1951, 11–12; Roger Fry, *Transformations* (New York, 1956), 253.

26. Aldous Huxley, *Along the Road* (New York, 1925), 181–190.

27. John Pope-Hennessy, *The Piero della Francesca Trail* (London, 1991), 7–8, 15, 17.

28. Pope-Hennessy 1991, 52–53.

29. Carlo Ginzburg, *The Enigma of Piero* (London, 1985), 7, 10.

30. John Pope-Hennessy, "The Mystery of a Master: *The Enigma of Piero* by Carlo Ginzburg," *New Republic* 194, no. 13 (March 31, 1986), 38–41.

31. Roberto Longhi, *Piero della Francesca*, in *Opere complete*, 14 vols. (Florence, 1956–1985), 3:25.

32. Longhi 1956–1985, 3:82.

33. See the recent catalogue devoted to Piero and the Novecento, and to Longhi's key role in this exchange: *Piero della Francesca e il Novecento*, ed. Maria Mimita Lamberti and Maurizio Fagiolo dell'Arco (Venice, 1991).

34. Lionello Venturi, *Piero della Francesca* (Lausanne, 1959), 5.

35. Eugenio Battisti, *Piero della Francesca*, 2 vols. (Milan, 1971), 1:11.

36. Battisti 1971, 28.

37. Julian Lowell Coolidge, *The Mathematics of Great Amateurs* (Oxford, 1990), 30–31; Margaret Daly Davis, *Piero della Francesca's Mathematical Treatises* (Ravenna, 1977), 2; Arthur K. Wheelock, Jr., *Perspective, Optics, and Delft Artists around 1650* (New York, 1977), 70–78; Angeli Janhsen, *Perspektivregeln und Bildgestaltung bei Piero della Francesca* (Munich, 1990), 9–35.

38. Carlo Bertelli, *Piero della Francesca* (New Haven, Conn., 1992), 12.

39. Omar Calabrese, ed., *Piero, teorico dell'arte* (Rome, 1985), 8.

40. Marilyn Aronberg Lavin, *Piero della Francesca: The Flagellation* (London, 1972), 12.

41. Lavin 1972, 13.

42. Marilyn Aronberg Lavin, *Piero della Francesca's Baptism of Christ* (New Haven, Conn., 1981), 85.

43. Michael Baxandall, *Painting and Experience in Fifteenth-Century Italy* (London, 1983), unpaginated preface.

44. Baxandall 1983, 75–76.

45. Baxandall 1983, 152.

46. Bruce Cole, *Piero della Francesca: Tradition and Innovation in Renaissance Art* (New York, 1991), xi–xii, 156.

47. See Charles Scribner III, "Michelangelo's Encore," *Art & Antiques* 8 (December 1991), 56, 60, 99.

48. Snow 1964, 100.

49. For a window on the different methodological approaches to Piero and their relation to historical change, see David Carrier, "Piero della Francesca and His Interpreters: Is There Progress in Art History?," *History and Theory: Studies in the Philosophy of History* 26 (1987), 150–165. Significantly, Carrier chose Piero as his test case for determining the "truth" of differing art-historical narratives.

50. For Piero's own anti-Jewish potential, see Joseph Hoffman, "Piero della Francesca's 'Flagellation': A Reading from Jewish History," *Zeitschrift für Kunstgeschichte* 44 (1981), 340–357. It is also noteworthy that the American poet Ezra Pound, a notorious anti-Semite, found in Piero the antagonist to the spirit of "usury." In the celebrated Usury Canto, number 45, Pound writes: "Duccio came not by usura nor Pier della Francesca." See Caterina Ricciardi, "Piero della Francesca nella poesia di Ezra Pound," in *Piero della Francesca nella cultura europea e americana*, ed. Attilio Brilli (Castello, 1993), 53–54; Alan Durant, Ezra Pound, *Identity in Crisis* (Sussex, 1981), 139–140.

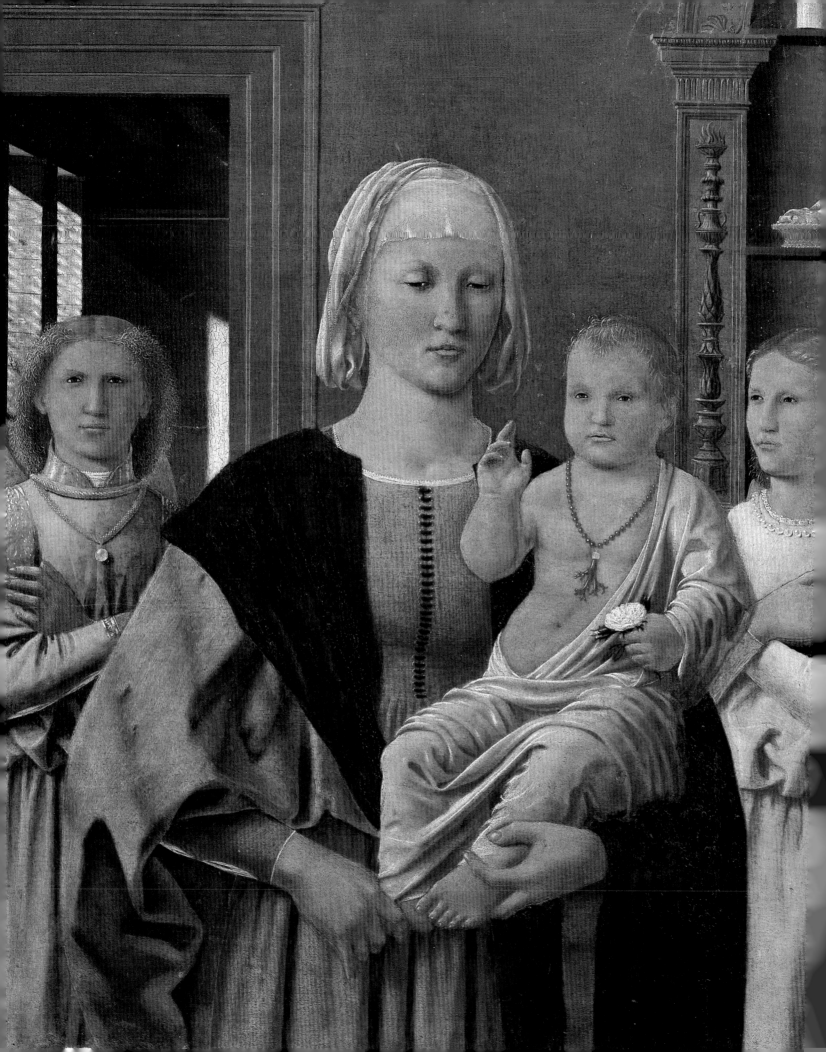

MICHAEL F. ZIMMERMANN
Zentralinstitut für Kunstgeschichte, Munich

Die "Erfindung" Pieros und seine Wahlverwandtschaft mit Seurat

Piero della Francesca n'est pas le contemporain d'Alberti — mais le mien.

Bernard-Henri Lévy[1]

1. Eine konservative Moderne, ihre Ahnen, ihre Väter

Piero della Francesca sei für Georges Seurat früh ein wichtiges Vorbild gewesen. Diese Annahme hat sich von einer intelligenten, kunstkritischen Pointe zur kunsthistorischen Lehrmeinung gewandelt. Die Geschichte dieses sehr produktiven Irrtums soll hier dargestellt werden. Dabei zeigt sich eine aufschlußreiche Verschränkung der Rezeption Pieros und der Seurats vor dem Hintergrund der frühen Moderne. Seurats Kunst scheint durchaus auch ohne die Annahme eines Einflusses durch Piero della Francesca verstehbar. Die These einer Beeinflussung ist entbehrlich, kaum zu belegen und, erwägt man sie im Kontext akademischer und naturalistischer Anregungen, nicht überzeugend. "Verwandte" wurden die Künstler erst in den zwanziger Jahren. Piero war damals seit wenigen Jahren neu entdeckt und zu einem erstrangigen Künstler erklärt worden. Seurat, den man bis zur Jahrhundertwende vor allem als Befreier der Farbe und Begründer einer verwissenschaftlichten Malweise gepriesen hatte, wurde mehr und mehr als konservativer Anarchist angesehen. Was man im Werk beider Künstler bewunderte, war die plastische Isolierung der Figuren und ein durchaus nicht archaischer, aber doch sehr reiner Rhythmus, der die Gestalten eint, auch wenn ihr Handlungsbezug untereinander nicht sehr eng ist. Die geringe Emphase im gestischen Kontakt zwischen den Figuren wertete man als Zeichen eines disziplinierten Verzichts auf Pathos zugunsten echter Emotion. Die eigenwillige Direktheit im Rückgriff auf mathematisch oder naturwissenschaftlich beeinflußte bildnerische Mittel sah man nicht mehr als Zeichen eines fast naiven Methodenglaubens, sondern als Bejahung der modernen Tendenzen der jeweils eigenen Zeit.

Voraussetzung für beide, sehr unterschiedliche Umwertungen war die Entwicklung einer modernen Art der Bilderzählung durch Künstler, die sich bemühten, in den verschiedenen Tendenzen der Avantgarde-Kunst Grundlagen eines klassischen Stils zu finden. Besonders in Paradiesesvisionen oder in Vorstellungen von einer ewigen Mediterrania als Wurzel der abendländischen Kultur kamen Strategien einer eigenwillig reduzierenden Bilderzählung zum Tragen. Auch deuteten Künstler wie Maurice Denis, Emile Bernard und Ardengo Soffici das Werk Paul Cézannes in diesem Sinne um. Sie schufen damit wesentliche Voraussetzungen für die epochale Neubewertung Piero della Francescas durch Roberto Longhi. Gegen Ende der Zwanziger Jahre wurden Piero und Seurat immer wie-

Piero della Francesca,
Madonna di Senigallia,
1478–1480, Öl auf Tafel
Galleria Nazionale delle Marche,
Urbino; Photo: Alinari

der als Vaterfiguren der eher konstruktiven Tendenzen moderner Kunst angerufen.

Von einer Verwandtschaft Seurats und Pieros spricht man im Verlauf der Zwanziger Jahre immer öfter. Erst später verdichten sich ästhetische Beobachtungen zur Behauptung eines Einflusses Pieros auf den jungen Seurat. Verfolgt man diese Debatte, hat man es nicht nur mit einem Lehrstück der Rezeptionsgeschichte zu tun, die aus einem "vielleicht" sehr schnell zu einem "es kann nur so gewesen sein" fand. Symptomatisch ist die erst nach und nach behauptete Verwandtschaft beider Künstler auch in einem anderen Sinne: Es zeigt sich hier exemplarisch, was die Moderne in die Künstler hineinprojizierte, die sie als Vaterfiguren aufbaute. Gerade eine konservative Moderne suchte mit ihren Vätern zugleich sich selbst. In der Zukunft findet der Glaube an das Machbare seine Berechtigung. Immer wieder enttäuscht oder skeptisch gegenüber hochtrabenden Fortschrittserwartungen kehrte die Kunst im 19. Jahrhundert periodisch zu vermeintlichen Ursprungszeiten zurück. Seit der frühen Moderne gilt diese Suche mehr als zuvor einer archaischen Ursprünglichkeit. In leidvoller Regression, in der Suche nach Geborgenheit auf einer vergangenen Entwicklungsstufe, sind Vaterfiguren nicht immer verklärte Idole. Man reibt sich an ihnen, um zu einer Identität zu finden, die auch die Spuren der Enttäuschung in sich aufnimmt. Es gibt einen Kreis von Künstlern, die unangefochten zu den Vätern der Moderne zählen. Gegenwärtig werden Joseph Beuys und Andy Warhol in diesen Rang erhoben. Doch Piero und Seurat sind neben Cézanne Vaterfiguren in einem anderen Sinne: Väter einer konservativen Moderne, die ihrer Ahnen eher bedurfte als wagemutige Begründer der Kunst einer neuen Gesellschaft unter den Kubisten und Futuristen.

Der Traum, Cézanne und Paul Gauguin seien die Vorläufer eines modernen und zugleich klassischen Kunstschaffens, hatte zuerst jungen Künstlern wie Emile Bernard und Maurice Denis geholfen, aus der Ortlosigkeit einer Bohème am Rande der Gesellschaft herauszufinden. Eine längere Zeit weihten sie sich und ihr Werk einem harmonischen Leben in mediterranen, plastischen Lichträumen. In einer Bildgestalt sollten die Landschaft und ihre Formen mit dem Rhythmus der Figuren und ihrer Gesten übereinstimmen. Die Zyklen des alltäglich Menschlichen sollten in den Bildern als Glück erscheinen—ein Idyll unter dem ewigen Gesetz des Wiederkehrenden.[2] Während Denis innige Häuslichkeit und ihre verdrängten Zwänge verklärte, gab auch Bernard sich bald mit einer mittelmäßigen Virtuosität bei der Anwendung Cézannescher Techniken zufrieden.[3]

Als sich der Kubismus durchsetzte, wurden Cézanne und Gauguin wie nie zuvor als Begründer der Moderne verehrt. Doch bewunderten Pablo Picasso (Abb. 1) und Georges Braque anderes als die ältere Generation: Die Verformungen und den Farb- und Formenrhythmus bei Cézanne werteten sie als Zeichen der Distanz zum Gegenstand—zur Landschaft oder zu den Äpfeln in einem Stilleben. Gerade nicht Einklang mit den umgebenden Räumen, sondern eine große Entfernung der Sinne von den Dingen schien Cézannes Werk nun auszudrücken.[4] Auch in Gauguin sah man sowohl den dumpfen Träumer, der um seine Welt ringt, ohne sie je zu erreichen, als auch den Visionär zeitloser Paradiese. In den schweren Farbräumen seiner Gemälde bewegen sich die Figuren mit dem Nachdruck ganzer Lebensanstrengung. Die Fauves steigerten Gauguins dunkle Farben zur Franchise ungebrochener Töne und lösten die bedrückten Rhythmen zu weitläufigen, die Menschen einenden Kurven. Aus der Versenkung frustrierten Sehnens befreite Henri Matisse das Zauberland Gauguins zum Wunschbild jugendlicher Erfüllung.[5]

Matisse, Braque und Picasso bewunderten also anderes an ihren Vaterfiguren als Bernard, Denis und jüngere Anhänger eines neuen, klassischen Stils. Der Generation der Kubisten ging es im Werk der Vorläufer um ein unfaßbar gewordenes, zugleich beschleunigtes und entfremdetes Leben. Die unmögliche Begegnung des Malers mit seinem Gegenüber, etwa im Porträt, erfuhren sie in Cézannes Bildnissen des Gärtners Vallier. Denis, Bernard und einigen der Fauves war das Glück als Ebenmaß unserer Wünsche mit der Natur noch vor- und darstellbar erschienen. Wo diese Vision nicht zur leeren Idylle gerät, ist sie mit dem Bild sehr disziplinierter, kontrollierter Menschen verbun-

1. Pablo Picasso, *Portrait de Gertrude Stein*, 1906, Öl auf Leinwand
Metropolitan Museum of Art, New York, Bequest of Gertrude Stein

den, die im Ebenmaß ihrer Begegnung zugleich den Einklang des Menschen mit den Wünschen an sich selbst und an seinesgleichen ausdrücken. In den Zwanziger Jahren sollte sich diese Tradition einer konservativen Moderne fortsetzen. Manche Bilder von Carlo Carrà oder Ardengo Soffici, von Fernand Léger, Robert Delaunay und dem klassisch gewordenen Picasso zeigen Glücksvisionen in einer Welt, die von den Ent-

täuschungen und Bedrohungen ihrer Zeit gezeichnet ist.[6] Zurücknahme der Emotion wie auch ein wenig erwartungsvoller Bezug der Figuren untereinander sprechen sich in reduzierter Sentimentalität und im Verzicht auf Emphase aus. In einer anderen Weise als Picassos *Demoiselles d'Avignon* zeugen einsame, nur durch ihren Formklang miteinander und mit der Natur verbundene Figuren von der Entfremdung aus bergenden Ge-

sellschaftsverhältnissen und vom Rückzug des Individuums in sich selbst—doch immer noch unter dem Blickwinkel möglichen Glücks.

Um 1910 wurden Historiker und Theoretiker der Kunst wie Roger Fry, Ardengo Soffici und Roberto Longhi von solchen Visionen und Debatten beeinflußt. Sie vertieften die Deutung der Kunst Cézannes und Gauguins als eines klassischen Neuanfangs. Seurat konnte in diese Ahnengalerie erst eingereiht werden, als die Rhythmen seiner Figuren in den Hauptwerken *Une baignade, à Asnières*, 1884 (National Gallery, London) und *Un dimanche après-midi à l'île de la Grande-Jatte*, 1886 (Art Institute of Chicago) (Abb. 16) in den Vordergrund traten—zugleich mit der Unergründlichkeit von Licht und Raum. Die Verbindung der Figuren allein durch den Rhythmus in Fläche und Tiefe—nicht durch gemeinsame Aktion—und der rätselhafte Ausklang in Lichträumen machten Seurat bald unzweifelhafter als Cézanne und Gauguin zum konservativen Modernen.

Während in der Kunstgeschichte die Malergeneration von Masaccio bis zu Gentile Bellini, Cosme Turra und Luca Signorelli neubewertet wurde, wandelten sich auch die Erwartungen an eine klassische Moderne.[7] Auf der Suche nach "primitiver" Ursprünglichkeit standen nun nicht mehr Byzanz, Giotto, Fra Angelico oder der frühe Raffael, nicht mehr die Meister des reinen Herzens im Mittelpunkt, sondern die gerade noch nicht klassischen Künstler. Hatte das 19. Jahrhundert Leonardo da Vinci oder Raffael nahezu auf eine Stufe mit den normgebenden Künstlern der griechischen Plastik von Phidias bis zu Praxiteles gestellt, so gerieten nun Künstler ins Blickfeld, in deren Werk Bilderzählung, Emotion der einzelnen Figuren und Dramatik wie Dekorum des Ambientes noch nicht zu vollendeter Einheit verschmolzen waren—obwohl das Individuum in seiner modernen Körperlichkeit schon präsent war. Piero della Francesca ist die bleibendste Entdeckung dieser Generation. Im Rückblick von Raffael her werteten noch Jakob Burckhardt oder Charles Blanc seine Erzählkunst als unvollkommen. Nun erschienen seine modern konstruierten Räume dem Auge als messendem, geschulten Sinn angepaßt: Es ruht auf den Gestalten inmitten einer Landschafts- und Stadträum-

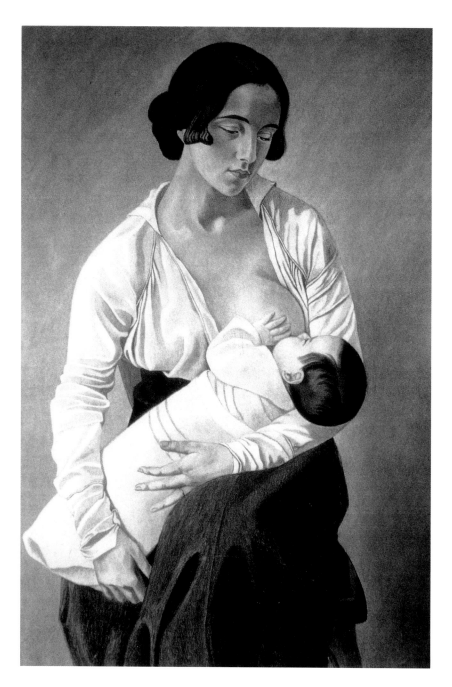

lichkeit, in der nur das verstehende Erleben zählt. Daß so viel Rationalität doch tiefere Emotionalität enthält als romantische Einfühlung, empfand man bei Piero wie bei Seurat deutlich—und doch rätselhaft.[8]

2. Piero vor Piero

Um beurteilen zu können, ob Seurat durch Piero beeinflußt wurde, muß die Rezeption Pieros bis zu Seurats Zeiten zurückverfolgt werden. Weiter unten soll eine verglei-

2. Gino Severini, *Maternità*, 1916, Öl auf Leinwand
Museo dell'Accademia etrusca, Cortona

3. Gino Severini,
Kopfstudien, aus *Du
Cubisme au Classicisme*
(Paris, 1921), Tafel 20

Fig. XX.

chende Darstellung der kunsthistorischen Auseinandersetzung mit Piero und Seurat die These eines Einflusses sozusagen zum Verschwinden bringen. Die Kunstkritik zu Seurat kann in diesem Rahmen natürlich nicht vorgestellt werden, zumal sich Parallelen im ästhetischen Urteil erst nach 1910 ergeben. Detailliert wird die Einflußthese erst am Ende des Artikels, als Teil der Rezeptionsgeschichte, dargelegt.

Das 19. Jahrhundert zählte Piero genausowenig zu den überragenden Künstlern wie vorherige Epochen. Während Giorgio Vasari ihn noch als Vorläufer der Hochrenaissance bewertet hatte, war seine Kunst den Akademietheoretikern bis ins 18. Jahrhundert kaum zugänglich. Vasari lobte einseitig den "miglior geometra che fusse ne tempi suoi" (1568), der durch Luca Pacioli um die "debita gloria sua" (1550) betrogen worden sei. Wenn er sein Verdienst vor allem darin sieht, daß er "redusse a facilità quasi tutte le difficultà delle cose geometriche" (1550), so wurde dieses Lob stereotyp noch von den Begründern der universitären Kunstgeschichte wiederholt, dabei aber durch Kritik ergänzt—ein erstes Zeichen wach-

sender Aufmerksamkeit.[9] In John Ruskins Gesamtwerk findet sich nur eine recht abfällige Zeile zu Piero, der, wie der vollständige Name sage, angeblich von seiner Mutter Francesca geschult worden sei; Burckhardt geht auf die Qualitäten des Lichts ein.[10]

Charles Blancs Urteil ist in diesem Zusammenhang entscheidend, da Seurat sich mit dessen *Grammaire des arts du dessin* nach seinem eigenen Zeugnis intensiv auseinandergesetzt hat. Sollte Seurat sich tatsächlich mit Piero befaßt haben, so wäre Blanc ohne Zweifel der Vermittler gewesen. Der Begründer der *Gazette des Beaux-Arts* wurde unter der Regierung von Adolphe Thiers Frankreichs Directeur des Beaux-Arts. Während seiner dreijährigen Amtszeit von 1871 bis 1873 war sein wichtigstes Projekt, im Palais de l'Industrie, dem Vorgängerbau der Ausstellungspaläste an den Champs-Elysées, ein Museum für Kopien von Meisterwerken der Weltkunst einzurichten. Es sollte die Sammlungen des Louvre in pädagogischer Hinsicht ergänzen. Zu den Kopien für das geplante Museum zählten auch zwei Arbeiten des Malers Charles Loyeux, der Pieros *Kreuzesprobe*

(Abb. 17) und die *Schlacht des Heraklius* in Öl nachschuf. Sie wurden am 12. Oktober 1871 bzw. am 20. Februar 1873 in Auftrag gegeben und bald darauf abgeliefert. Anfang 1874 gelangten sie in die Ecole des Beaux-Arts. Im Medium der Ölmalerei wirkt das Licht dumpf; die Figuren muten eher gehemmt als archaisch an; die Gesichter sind erstarrt—gerade dadurch, daß Loyeux durch etwas zu zeichnerische Konturen den Ausdruck ungeschickt verlebendigen wollte.[11] Blancs politisch konservativer Nachfolger, der in der kunsthistorischen Methode jedoch einer moderneren, weniger idealistischen Gesinnung anhing, Philippe de Chennevières, hielt das Musée des Copies nicht mehr für sinnvoll und brachte die bereits angefertigten Arbeiten anderswo unter. So gelangten die Kopien nach den Aretiner Fresken in die Kapelle der École des Beaux-Arts, wo Seurat sie wohl sah und sie hätte studieren können. Sie wurden jedoch sehr weit oben im Halbdunkel aufgehängt.

Warum Blanc den Künstler aus Sansepolcro in seinem Kopienmuseum vertreten wissen wollte, ist unbekannt. Doch stand erzählende, "öffentliche" Wandmalerei in seinem Projekt im Vordergrund, und in einem solchen Panorama erscheinen Pieros Aretiner Fresken als die eines Vorläufers der Hochrenaissance. Tatsächlich zeugt der Auftrag an Loyeux durchaus nicht von einer Neubewertung Pieros, wie man allzu bereitwillig angenommen hat. Ein Jahr vor der Konzeption des Kopienmuseums hebt Blanc den Maler aus Borgo Sansepolcro denn auch nur als Vorläufer, nicht aufgrund seiner eigenen Leistung hervor: "En somme, Piero della Francesca n'est, si l'on veut, qu'un précurseur, un ancêtre"[12] Man spürt die akademische Gesinnung dieses Anhängers des Primats der Zeichnung: "Trente ans environ avant Léonard de Vinci et le Pérugin, il introduisit dans la peinture la géométrie, la perspective, l'harmonie des proportions et des nombres. . . ."[13] Blanc zitiert Crowe und Cavalcaselles *New History of Painting in Italy*, worin Piero seine wenig gelungenen Inkarnatstöne und Physiognomien vorgeworfen werden.[14] Er lobt jedoch seine Verdienste um Proportion, Anatomie und Perspektive.[15] Doch entkräftet Blanc dadurch Crowes and Cavalcaselles Einschätzung keineswegs: "Il est d'autant plus

remarquable, le sentiment de grandeur qui caractérise les personnages de Piero della Francesca, que les choix des types et la recherche de la beauté n'y sont pour rien."[16]

Blanc verteidigte wissenschaftliche Prinzipien der Kunst und propagierte im Bereich des Helldunkel und der Farbe neue Kunst-Gesetze. Pieros Leistung hebt er vor allem vor diesem Hintergrund hervor: "Piero della Francesca n'avait trouvé que la vérité des ombres, il était réservé à Léonard d'en découvrir la poésie."[17] Blanc stellt auch klar, er habe die Kopien vor allem wegen des schlechten Erhaltungszustandes der Aretiner Fresken herstellen lassen. Der einflußreiche Akademietheoretiker hat das Studium von Pieros Werken jungen Künstlern gewiß nicht

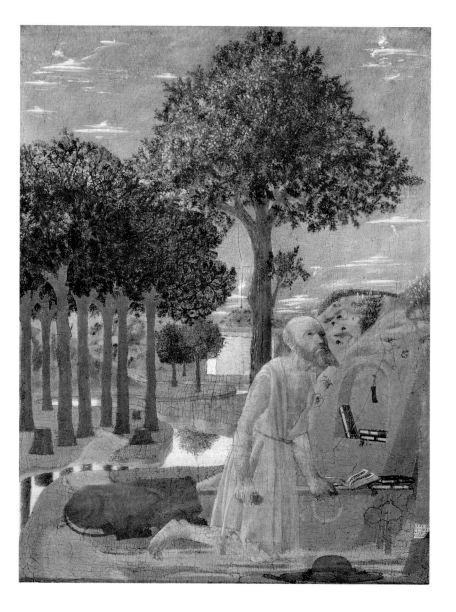

4. Piero della Francesca, *San Girolamo*, Öl auf Tafel Staatliche Museen, Berlin

5. Paul Cézanne, *La Route et l'étang*, c. 1880–1890, Öl auf Leinwand
Rijksmuseum Kröller-Müller, Otterloo

fie à la recherche du naturalisme la beauté des types ou de l'ordonnance, la poésie de l'invention, la force dramatique." Wenn der Kunsthistoriker Piero seinen Platz zuweist, so ähneln die Argumente der zeitgenössischer Naturalismus-Kritik: "dans sa passion pour la netteté et la précision, il oublie que la mission de l'artiste consiste à élever l'esprit autant qu'à satisfaire l'œil par la fidelité de la reproduction. De là les traits vulgaíres et choquants qui déparent bon nombre de ses compositions et qui obscurcissent trop souvent des beautés de premier ordre."[20]

Müntz' abschließendes Urteil ist noch zwiespältiger als das Blancs. Was später als hoheitsvoller Archaismus gefeiert wurde, erscheint diesem Bewunderer Raffaels als prosaische Naturkopie: "Si la passion et l'inspiration, si le culte de l'idéal lui ont manqué, en revanche sa peinture est profondément originale et attachante, grâce à l'absolue sincérité de ses observations et au charme qu'il a su donner à sa couleur. Mon regretté maître Charles Blanc ne s'est pas trompé lorsque, au moment de constituer le Musée des Copies, qu'on a pu voir un instant au Palais de l'Industrie, il a tenu à donner une place à Piero della Francesca au milieu de tant de peintres éminents."[21]

Um auf bedingungslose Verehrung für Piero zu treffen, müssen wir noch zwei Jahrzehnte warten. Über Pieros *Auferstehung* im Palazzo Municipale von Sansepolcro schreibt Adolfo Venturi 1911: "In quest'affresco le forme di Piero hanno tutta la pienezza, la plasticità, la grandiosità monumentale." Erst Venturi findet zum Grundton moderner Verehrung für Piero in seinem Lob der "semplicità arcaica unita alla piena cognizione dell'arte."[22]

3. "Moments of Spent Sensibility"—auf der Suche nach Pieros Größe

Der erste Aufsatz von Roberto Longhi über Piero dei Franceschi erschien 1914. Die Umwertung des "Vorläufers" Piero zu einem Künstler eigenen Rechts hatte Longhis Lehrer Adolfo Venturi vorbereitet. Doch erst Longhi bewirkte durch sein fortgesetztes Engagement, daß Pieros Werk dem Grundbestand abendländischer Kultur zugerechnet wird.[23] Longhi war dabei tief von seinen

besonders angeraten; keine der Errungenschaften Pieros fänden sich nicht in späterer Malerei in höherer Perfektion.[18]

Auch Eugène Müntz, der Bibliothekar der École des Beaux-Arts und einer der einflußreichsten Erforscher italienischer Kunst, findet nicht viele Worte über den "réaliste Toscan." Nur in der gemalten Architektur habe dieser der Antike nachgeeifert; alles andere, auch das Dekorum, bleibe in seiner Malerei zeitgebunden.[19] Der Vorwurf mittelalterlicher Formgesinnung hindert Müntz nicht, Piero wenige Jahre später zum Naturalisten zu erklären. "Observateur impeccable, sachant rendre avec une égale sûreté de main les moindres détails de la structure du corps humain et les jeux de lumière les plus fugitifs, l'artiste de Borgo San Sepolcro sacri-

Interessen für moderne Kunst angeregt. Im Jahre 1963 erinnerte er sich, Cézanne und Seurat hätten ihn bei der Neubewertung der plastischen Qualitäten von Seurats Werk geleitet: "La mia cultura moderna, assodatasi sugli anni attorno al 1910, si fondava, sono costretto a ripeterlo ancora una volta, non già sul momento cubistico, né, tanto meno, su quello, ancora da venire, della 'metafisica,' ma sul momento del post impressionismo ricostruttivo di Cézanne e di Seurat che, con la loro facoltà di sintesi tra la forma e il colore per via prospettica ('le tout mis en perspective' è già un detto che si può credere autentico di Cézanne), diedero entrambi il via non già alla confusione estetica degli ultimi cinquant'anni d'arte, ma almeno a una ricerca critica in grado di recuperare la storia di una grande idea poetica sorta nella prima metà del Quattrocento. Criticamente insomma, Piero è stato riscoperto da Cézanne e da Seurat (o da chi per loro) non già dal geniale rapsodo Picasso." Doch Longhis Erinnerung täuschte ihn in einem Punkt: Seurat war erst später in seinen Ideenkreis getreten.

Longhi war damals durch die Schriften des Kunstkritikers und Malers Ardengo Soffici über Cézanne und die Neo-Impressionisten beeinflußt. Soffici wollte dem Futurismus eine solide theoretische Grundlage verleihen.[24] In einem 1914 veröffentlichten Artikel über Boccionis Skulptur bekennt sich Longhi zu Sofficis Gedankenkreis: "Ho detto che la pittura per prima si è liberata dalla dissoluzione dell'impressionismo per procedere verso intenti che sono di natura strettamente plastica ... devo supporre nel lettore una conoscenza, forse pure sommaria, di questa chè storia di ieri, così come da poco l'abbiamo delineata Soffici ed io, senza per ora doverci smentire."[25]

Cézanne wurde von Soffici in einem Artikel vom Juni 1908 als Vorbild einer neuen Kunst mediterranen Gleichmaßes gepriesen. Das Vokabular der Gefühlswelt des Novecento begegnet uns bereits, wenn Soffici den inneren Abstand Cézannes vom Impressionismus beschreibt: "E quel che mancava ad essi, sentì di averlo proprio trovato dentro di sè e intorno a sé, per le solitudini delle pendici e delle spiaggie provenzali, inondate di sole o spazzate dai larghi venti del mediterraneo. Nelle ore so-

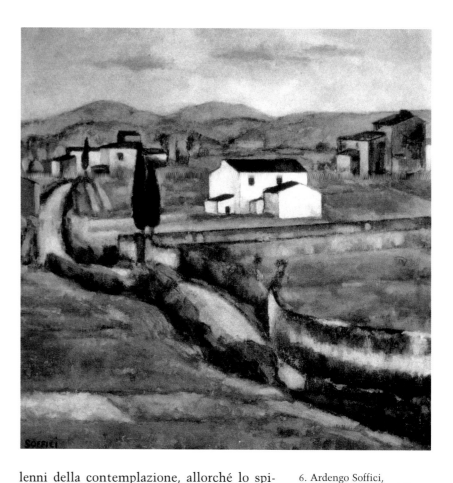

6. Ardengo Soffici, *Tramonto d'inverno (Al Concone)*, 1922, Öl auf Leinwand
Collezione Galleria Michaud, Firenze; Photo Archivio Soffici, Commune di Poggio a Caiano

lenni della contemplazione, allorché lo spirito dell'uomo s'apre come una foglia per ricevere le ondate di simpatia materna emananti della natura, egli sentiva montare lento ad avvolgerlo tutto, come un'atmosfera tranquilla, quel medesimo senso di religiosità semplice e grave che aveva impregnato in altri tempi la sua anima attonita di bambino. Tutto in simili momenti appariva chiaro e omogeneo alla sua mente: non più cozzi di opinioni diverse, non più impressioni frammentarie; ma una visione compatta, genuina e libera" Dann träumt Soffici schon 1908 von einer Kunst, die sowohl die Naturverbundenheit der Impressionisten als auch die Tradition des Tre- und des Quattrocento aufnehmen würde. Diese Synthese würde unzweifelhaft noch Größeres hervorbringen; sie solle das Werk italienischer Künstler sein. "Amante sviscerato del genio della nostra razza, io non son di quelli che aspettan la luce dal nord; credo anzi—e la storia mi conforta in questo—che la luce—la vera—sia sempre sorta e sia ancor per sorger di qui"[26]

Sofficis Sehnsucht nach einer schmerz-

7. Ardengo Soffici, *Strada*,
1925, Öl auf Leinwand
Civica Galleria d'Arte Moderna,
Milan

Cécile Puvis de Chavannes. Der später so bewunderte Cézanne galt Soffici nur als unvollkommener Vorläufer einer neuen Tendenz.[27] Doch zwei Jahre später—vermutlich unter dem Effekt der Cézanne-Retrospektive im Salon d'Automne vom Oktober 1907—sah Soffici in Cézanne das Vorbild einer neuen italienischen Kunst, die dennoch ihren eigenen nationalen Errungenschaften treu bleiben solle. Dem journalistischen Universalgelehrten Giovanni Papini schrieb er über Cézanne: "Senza contare che i pittori francesi sono da molto tempo i più grandi del mondo e qualche nome che ti dirò (come Gauguin e Cézanne—Denis ecc.—ma specialmente Cézanne) resterà gloriosamente e l'opera sua sarà come una base sulla quale i vigliacchi italiani dovrebbero costruire senza fine, perché in fondo l'opera di questi francesi ha solo il merito (enorme è vero) di pigliarci per il collo e tuffarci per forza nella freschezza delle cose naturali, semplicemente, profondamente come quella di Giotto e di Dante Dii eterni."[28] Vor dem Hintergrund der italienischen Kunstdiskussion war diese Aufwertung Cézannes durchaus eine bemerkenswerte Leistung. Der einflußreiche Kritiker Vittorio Pica hatte sich in einer 1908 erschienenen Monographie über den Impressionismus nur sehr beiläufig über Cézanne geäußert und dessen "bravura di lui nel dipingere, sia anche con qualche squilibrio formale, le frutta."[29]

Doch auch Soffici hat diese Sehnsucht nach einer italienischen Klassik auf der Grundlage des Impressionismus nicht als erster empfunden. Schon ein einflußreicher Begründer der italienischen Kritik zur ausländischen Moderne, Diego Martelli, hatte den Impressionismus mit Blick auf heilsame Wirkungen gedeutet, die er für die italienische Malerei haben würde. Freund der Macchiaioli und der Impressionisten, lobte Martelli neben anderen Primitiven wie Giotto und Paolo Uccello auch Piero della Francesca.[30] Im Jahre 1892 hielt er wahrscheinlich im *Circolo artistico fiorentino* einen Vortrag über Giotto, Fra Angelico, Masaccio, dann über Piero, schließlich über Benozzo Gozzoli, Sandro Botticelli und Domenico Ghirlandaio. Martellis Lob von Pieros Doppelporträts Federico da Montefeltres und seiner Frau Battista Sforza in den Uffizien ist durchaus durch die Freilicht-

haft innerlichen und doch harmonischen Kunst wurde nicht durch Cézannes Werk entzündet. Wie ein Text von 1904 zeigt, hat sie ihren Ursprung in einer bereits jugendlichen Verwirrung über die gegenwärtigen ästhetischen Tendenzen. Zunächst mochte er sich überhaupt nicht mit irgendeiner aktuellen künstlerischen Strömung identifizieren und träumte von einer ganz neuen Epoche. "Après la Grèce et l'Italie du Rinascimento c'est la troisième Beauté que nous poursuivons. Beauté profonde, méditative et intérieure. Beauté sans apparat, sans draperies. Muscles qui se plient pour seconder des mouvements psychiques, étoffes qui enveloppent des passions, paysages qui s'harmonisent avec les battements du cœur D'autres harmonies résonnent autour de nous; des harmonies douloureuses et crispées, ou sombrement et hermétiquement joyeuses qui ont besoin pour être saisies et communiées, d'autres instruments que la flûte primitive et d'autres matériaux que couleurs vives et lignes diligentes." Seine Heroen waren damals Arnold Boecklin, Giovanni Segantini und vor allem Pierre

8. Carlo Carrà, *Autunno in Toscana (Il Pagliaio)*, 1927, Öl auf Leinwand
Privatbesitz; Photo Massimo Carrà

malerei beeinflußt: "Ora questa potenza di mettere di contro alla luce una figura, di farne vedere tutti i dettagli, non forzando oltremodo né troppo caricando le tinte e nello stesso tempo facendola risaltare su un cielo immensamente chiaro, e in un paese chiarissimo, è opera precisamente di grande artista e di grande coloritore."[31]

Überhaupt treffen Martellis Bemerkungen über die Malerei vor der Hochrenaissance im Tonfall oft seine Kritik zu zeitgenössischen Künstlern. Eine sich gleichbleibende Natur fand er im Werk der Macchiaioli, und die sich zyklisch wiederholende, dabei plastisch-statische Landschaft im Werk der Macchiaioli zeugt in seinen Beschreibungen von Sehnsucht nach Bleibendem. Selbst in die flüchtigen Landschaftsausschnitte der Impressionisten, die in den siebziger Jahren noch vom modernen Vorstadtleben geprägt waren, deutete Martelli vor allem das Licht als konstantes Element hinein. Den Künstlern der Zukunft "veri e propri *Impressionisti*, . . .

l'alba dell'avvenire," wäre die Modernität nicht mehr das Hauptanliegen. "Tutta la grande pittura antica non è che luce, sempre e non invano cercata."[32]

In Sofficis Schriften findet sich der von Longhi 1963 genannte Hintergrund im Post-Impressionismus, durch den er zu seinem ersten Text über Piero inspiriert wurde. Wenn er den umbrischen Künstler zu einem Gründer nicht nur der Renaissance, sondern zu einem Katalysator für den italienischen Geist in der Kunst umdeutete, so folgte er damit einem von Soffici fünf Jahre zuvor entworfenen Programm (Abb. 4–7). Mit Vasaris Grundidee, die Renaissance sei vor allem ein Weg zur naturalistischen Wirklichkeitserfassung gewesen, ist diese Deutung nicht mehr zu vereinbaren. Longhi wirft Jakob Burckhardt vor, Vasari in diesem Punkt zu bereitwillig gefolgt zu sein. Stattdessen hebt er die das plastische Bildgeschehen vereinheitlichende Funktion etwa der Zentralperspektive hervor: "La corrente prospettica è stata . . .

condannata come tendenza, peggio che naturalistica, scientifica. Eppure non è così. Si può anzi dimostrare ch'essa è l'elemento più astrattamente idealistico che fosse fino allora apparso nell'arte." In einer revolutionären Analyse der Perspektive als Mittel bildnerischer Farb- und Formsynthese gelangt Longhi zu dem Schluß: "Come sensazione lirica questa resa prospettica doveva esaltare e raffinare le nostre intuizioni di chiarezza di rapporti spaziali armonicamente raggiati." Sprachgewaltig erfaßt Longhi den Dienst tiefenräumlicher Ordnung an der Farbe: "Il grande merito di Piero fu infine quello di comprendere che era necessario arginare il serpeggiamento funzionale entro inesorabili tubature prospettiche, perché, regolarmente irrigate, fiorissero ad un tempo le vaste praterie del colore." Liest man zwischen den Zeilen, so hat Piero nach Longhis Auffassung die neu verwendeten bildnerischen Sprachmittel nicht nur den Meistern der Hochrenaissance zur Verfügung gestellt: "Egli offriva a chi volesse svilupparlo per nuove attuazioni il risultato complesso del sintetismo prospettico di forma-colore." Longhis Analyse der in sich ruhenden Farbharmonie zeugt von der Kenntnis farbtheoretischer Debatten im Kreis der NeoImpressionisten.[33] "Da lui insomma la creazione del colorismo come armonia calda e solare di toni contrapposti e di gamma totale, espansi sulle vaste superfici di un riposo coloristico non più raggiunto." Da er seine bildnerische Sprache zur Vollendung entwickelt habe, konnte Piero seine eigene Zeit in vielfältiger Weise beeinflussen, ohne wirkliche Nachfolger zu haben. Pieros Mythos, wie er hier von Longhi konstruiert wird, ähnelt in dieser Hinsicht dem wenig später entstehenden Mythos Seurats: "Si dovrebbe realmente concludere, e sarebbe conclusione tragica, che lo stile di Piero dopo essere arrivato alla pura forma e al puro colore, si disperse assorbito nel sottosuolo di altre fondazioni deteriori."[34]

Die von Soffici erträumte Synthese mediterraner Tradition und formaler Errungenschaften der französischen Moderne bereicherte Longhi also vor allem um die Deutung der Perspektive als Mittel der Bildsynthese. Diese Idee konnte nur im Umkreis der Debatte um futuristische Versuche immer neuer Synthesen von zeitlich auseinanderliegenden, plastisch-dynamischen Erfahrungen aufkommen. Die formalistische Analyse brachte Longhi jedoch mit einer tieferen Deutung zusammen, die er Bernard Berenson verdankt.[35] Dieser hatte Piero schon 1909 vorsichtig und im unspektakulären Zusammenhang eines Buches über die mittelitalienische Malerei als überragenden Künstler beurteilt: "He is hardly inferior to Giotto and Masaccio in feeling for tactile values; in communicating values of force, he is the rival of Donatello; he was perhaps the first to use effects of light for their direct tonic or subduing and soothing qualities; and finally, judged as an illustrator, it may be questioned whether another painter has ever presented a world more complete and convincing, has ever had an ideal more majestic, or even endowed things with more heroic significance." Von den üblichen Kritiken nimmt Berenson vor allem die an der mangelnden Bilderzählung nicht mehr auf. Zwar schränkt auch er sein Lob noch ein: "Now and again such as are always on the outlook for their favorite type of beauty, will receive shocks from certain of Piero's men and women. Others still may find him too impersonal, too impassive." Die Vorteile des unpersönlichen Charakters der Figuren lägen darin, daß der Betrachter nicht mehr abgelenkt werde von anderen künstlerischen Werten und ohne die Brechung durch Emotionen eine "wahrere" Szene präsentiert bekomme (Abb. 1). Doch dann kommt Berenson zum Kern: Er erlebt die Figuren bei Piero als mit höheren seelischen Kräften ausgestattet. "As ardently as we love those beings who react to things by the measure and in the quality that we ourselves react to them, so, in other moods, in moments of spent sensibility, we no less eagerly love those other beings or objects which, though we endow them with a splendid and kindred personality, yet do not react at all to things that almost overpower us. Taking it for granted that they are no less sensitive than we are, and seeing that they are not moved at all where perhaps we should be overwhelmed, we ascribe to them the calm and majesty of heroes; and as we more than half become the things we admire, we also, for a moment too brief, are heroes." Die Gestalten Pieros sind plötzlich mit übermenschlichem Gleichmut begnadet.

Über die "other moods," die "moments of spent sensibility," denkt Berenson nicht weiter nach, und so fällt ihm nicht auf, daß der bewunderte Heroismus in seiner Beschreibung gerade die Verdrängung des Gefühls, sein Scheitern, seine Enttäuschung spiegelt.[36]

Longhi bringt solche Ideen mit einer weitverzweigten formalen Analyse zusammen, die scheinbar im Vordergrund stehen sollte. Sein Lehrer an der scuola di perfezionamento in Rom, Adolfo Venturi, faßt acht Jahre nach dem Erscheinen von Longhis spektakulärem Artikel die Ideen seines Schülers zusammen: "La composizione, dove le forme sono architettonicamente coordinate secondo un sistema di piani convergenti a un centro prospettico, porta con sè la possibilità di un accostamento di colori in larghe regolari zone, ignota al colorismo gotico per il sopravvento dell'arabesco lineare, ignota alla corrente fiorentina masaccesca per il sopravvento del chiaroscuro, e più tardi, alla corrente che deriva da Andrea del Castagno per lo sviluppo della linea energica, a danno del colore. L'architettura rigorosa dello spazio porta con sè l'astratta regolarità della forma, l'assorbimento dei singoli tipi in un tipo unico, l'arresto del movimento e della vita, il supremo equilibrio del gesto Ne deriva, alle composizioni e alle figure di Piero, una semplicità schematica, divinamente arcaica La figura umana, abbarbicata al suolo dai suoi larghi piedistalli, come gli alberi dalle loro radici, vive silenziosa nel grande silenzio del paese, dove l'acqua non scorre, le ombre non si muovono, l'aria torrida ferma il respiro delle cose." Mittelmeerisch ist diese Vision, wie die Cézannes, durch den Licht- und Formenrhythmus, schließlich durch die "tonalità generale creata dalla diffusa luce meridiana, che smorza ogni urto e conduce a un accordo calmo di colore, come l'architettura spaziale alla regolarità cristallina dello stampo entro cui si modellan le forme."[37]

4. Piero und Seurat in Italien

Unter allen italienischen Künstlern versuchte niemand so vehement wie Gino Severini eine Neo-Renaissance in der Malerei.[38] In einem Stil, dem ein genaues Verständnis der Perspektive der menschlichen Figur zugrundelag, malte er im Jahre 1916 die klassischen Themen der Intimität: Auf ein Porträt seiner Frau Jeanne Fort (*Jeanne*, 1916, Rom, Privatbesitz) folgte eine Darstellung mit ihrem Sohn, eine säkularisierte Madonna (*Maternità*, 1916) (Abb. 2). Die Melancholie in Jeannes Zügen zeugt in dieser gewollt zeitlosen Darstellung nur durch Verdrängung von den schrecklichen Kriegsereignissen: Severini zog sich zurück auf Mutterschaft, Werden und Vergehen. Kaum ein Jahr zuvor hatte er in futuristischen Gemälden die französische und italienische Kriegführung verherrlicht.[39]

Fünf Jahre später versuchte Severini, seinen neuen, auf perspektivisch-geometrischer Konstruktion beruhenden Stil als Versuch einer neuen Renaissance zu rechtfertigen (Abb. 3). Er ging damit auf einen ebenso moralischen wie stilistischen Verfall der Malerei seiner Zeit ein. Der Verfall wissenschaftlicher Grundlagen der Malerei wird zum Symbol für einen ethischen Verlust. "Les causes peuvent se résumer en quelques mots: Les artistes de notre époque ne savent pas se servir du compas, du rapporteur et des nombres. Depuis la Renaissance Italienne, les lois constructives sont graduellement rentrées dans l'oubli. En France le dernier peintre qui les a héritées des Italiens et consciencieusement appliquées, est Poussin. Après lui on se sert de quelques règles générales, mais de plus en plus on s'éloigne de la conception de l'esprit et on se rapproche de la nature ou, pour être précis, de l'aspect extérieur de la nature. On confond la Vie et l'Art, on devient d'une habilité monstrueuse, on cherche à susciter l'admiration par la *surprise* et non par la pure beauté des formes de l'esprit."[40] Wissenschaft in der Malerei wird nicht mehr, wie in der Tradition des Neo-Impressionismus und des Futurismus, als stets wieder in Frage gestellter Erfahrungsschatz und Fortschrittsgarant verstanden, sondern als Rückhalt ewiger Seinsgesetze: "L'Art ce n'est que la Science humanisée L'art doit se développer à côté de la Science; ces deux manifestations humaines sont inséparables l'une de l'autre, et toutes les deux du principe unique et religieux qui est le commencement du Tout."[41]

Severini kehrt zurück zu einem Idealismus, der die Kunst in überzeitlichem, auch naturkundlich vermitteltem Wissen zu begründen trachtet. Mit einer Auffassung

9. Georges Seurat, *Maisons*,
c. 1881/1882, Conté Kreide
Metropolitan Museum of Art, New
York, Bequest of Walter C. Baker

Cézannes als mediterranem Klassiker war dies nicht mehr zu vereinen. Daher wandte Severini sich von Cézanne ab und begründete damit eine im folgenden Jahrzehnt einflußreiche Tendenz. Ohne Seurat zu erwähnen, bereitete er einer konservativen Bewunderung des pointillistischen Künstlers dennoch den Weg. In seinem Luca Pacioli und damit auch Piero verpflichteten Buch sah Severini die Mathematik als Weg zu einer klassischen Reform in der Kunst. "J'ai cru comme tout le monde à la 'tendance classique' de Cézanne; mais maintenant que je vois clair dans l'origine sensorielle de ses 'intentions,' je ne puis plus croire à un homme qui veut faire 'du Poussin sur nature', qui veut 'redevenir classique par la nature, c'est-à-dire par la sensation.'"[42]

Während Soffici bereits Cézannes Werk (Abb. 5) als das Ende einer im Impressionismus kulminierenden Auflösungstendenz galt, setzt sich für Severini dieser Mangel an bildnerischer Synthese bis in den Kubismus hinein fort. "Je crois sincèrement que le cubisme . . . tout en étant . . . à la base du mouvement du nouveau classicisme qui se prépare, est néanmoins encore aujourd'hui à la dernière étape de l'impressionnisme."[43] Eine neue Beherrschung der Natur in der Kunst stand für eine gewandelte Lebenseinstellung, in der Geistigkeit wieder die Herrschaft über die geschichtlichen Verhältnisse übernehmen sollte. Die Kehrtwende eines Künstlers, dessen Bilder der Vorkriegsjahre die Massen auf Pariser Boulevards und in öffentlichen Tanzbars gefeiert hatten, kann deutlicher nicht ausfallen.[44] Immer wieder vertritt stilistische Strenge für den konservativ gewordenen Severini auch soziale Ordnung: "si nous savons faire mutuellement le sacrifice de notre orgueil, nous pouvons préparer par notre art une société bien meilleure que celle où nous vivons."[45]

Wie Longhi hebt auch Severini Seurat als Vorbild dieses Wertewandels erst im nachhinein, in seiner im Jahre 1946 erschienenen Autobiographie, hervor: "Secondo me, era stato Seurat, prima e meglio degli altri, a stabilire un equilibrio tra soggetto, compo-

sizione, e tecnica." Zwar interessierte sich Severini schon 1906 bei seiner Ankunft in Paris für Seurats Werk. Wie sein römischer Lehrer Giacomo Balla schätzte er den pointillistischen Maler aber vor allem als Begründer der divisionistischen Technik. Tatsächlich lehnte sich Severini damals viel enger an französische Techniken der Farbzerlegung an als irgendeiner seiner Freunde, wie etwa Umberto Boccioni, die kurze Zeit darauf zum Futurismus gelangten. "Fui un po' meravigliato, arrivando a Parigi, di constatare che Seurat non aveva, nel giudizio dei pittori, il posto che meritava; essi preferivano Cézanne, il quale ebbe, anche lui, intenzioni di ordine compositivo e di mestiere, ma cercava l'esempio nel passato." Eine erst in den zwanziger Jahren gewonnene Interpretation Seurats im Sinne einer modernen, archaischen Klassik überlagert in Severinis Tagebüchern seine ursprüngliche Einschätzung des Begründers wissenschaftlicher Malerei. Im zweiten Teil seiner Autobiographie, der ebenfalls zwischen 1943 und 1946 verfaßt wurde, berichtet Severini von einem Streit mit Bernard über Seurat. Bernard wollte den Pointillisten nicht neben Cézanne und van Gogh als Begründer eines modernen Klassizismus gelten lassen. Severini bekennt: "Per mio conto io prendevo sempre come punto di partenza il neo-impressionismo e Seurat come maestro; per me l'idea di classicità, oltre che da Cézanne, era rappresentata brillantemente da Seurat e continuava a lavorare in quel senso, intendevo cioè portare nella linea e nella forma lo spirito scientifico che i neo-impressionisti avevano portato nel colore."[46]

Severinis Wende zu einem "lateinischen" Klassizismus ist nur ein besonders hervortretendes Zeugnis einer Rückwendung zu romanischen Kulturwerten, die viele—vor allem ausländische—Künstler im Paris der Kriegsjahre vollzogen. Der allzu theoretisch begründete Kubismus wurde, wie Kenneth Silver beispielhaft gezeigt hat, von vielen als Zeugnis germanischen Kulturimports mißverstanden. In der erneuten Besinnung auf klassische Werte, mit denen sich das französische Kulturempfinden seit jeher besonders identifiziert hatte, spricht sich jedoch nur selten politischer Opportunismus aus. Kenneth Silver hat die sozialpsychologischen Motive der Kehrtwende vor dem

10. Carlo Carrà, *L'attesa*, 1926, Öl auf Leinwand Privatbesitz; Photo Massimo Carrà

Hintergrund der privaten Lebenssituation von Malern wie Picasso oder Matisse, Robert Delaunay, Albert Gleizes oder Jean Metzinger, Juan Gris oder Severini nachvollziehbar gemacht oder in einer Reihe aussagekräftiger Werke verfolgt.[47] Die konservative Verdrängung sozialer und politischer Unterschiede zugunsten der alle einenden Verteidigung entsprach der Stimmung der Künstler. Die jüngeren, männlichen Ausländer fühlten sich zudem genötigt, ihre Existenz in einer Nation zu rechtfertigen, in der alle Gleichaltrigen Soldaten waren. Nach dem Krieg wurde die Fiktion der politisch geeinten Nation für das Ziel des Wiederaufbaus weiterbemüht. Das politische Klima war bis 1926 konservativ. Angesichts sich vertiefender sozialer Mißstände wurde die Vorstellung vorwaltender Einigkeit mehr und mehr zur Ideologie.

In Italien vollzog sich während des Krieges eine in mancher Hinsicht analoge Entwicklung in der Kunst wie in ihrem politischen Hintergrund. (Es wäre lohnend, sie kunsthistorisch unter dem Aspekt der Kriegserfahrung im Vergleich zu Frankreich zu untersuchen.) Die ideologischen Erschüt-

terungen auf der von Kriegshetze, erschöpftem Liberalismus und überzogener Hoffnung auf Kriegsgewinne geprägten Apenninenhalbinsel waren ohne Zweifel noch radikaler; auch die Künstler vollzogen grundsätzlichere Kehrtwendungen. Das Spektrum vom kampfeslustigen Irredentismus oder Futurismus zu tiefer Abkehr von der aktuellen Welt war während und nach dem Krieg noch weiter gespannt. Sehnsüchte nach einer zugleich modernen, triumphierenden und statisch konservativen Gesellschaft äußerten sich in zahlreichen Varianten, die man nicht unterschiedslos einer unterschwellig zum Faschismus führenden Weltsicht zuordnen darf.

In den Schriften Carlo Carràs kam die Bewunderung für Piero und andere "Primitive" mit der für Seurat zusammen. Sein Werk ist der gültigste Ausdruck einer konservativen, bewußt archaisierenden Kunst in Italien (Abb. 8, 10). Vor ihrem Hintergrund erschienen sowohl Piero als auch der nur gelegentlich mit Interesse betrachtete Seurat in einem anderen Licht.[48] Carràs Beurteilung Pieros in der Chronologie seiner Schriften ist aufschlußreich. Doch erst im Zusammenhang mit seinem Werk wird eine immer noch wirksame Betrachtung Pieros erlebbar. Im Jahre 1921 verlangte Carrà, junge Künstler sollten sich vom Naturalismus und Sensualismus des 16. Jahrhunderts befreien, um zu den Werten früherer Kunst zurückzufinden: "Perciò più che alla pittura secentesca o settecentesca, meglio è, a parer nostro, richiamarli a Giotto, a Pier della Francesca e magari a Simon Martini."[49]

Auch Soffici erschien eine Synthese der Erfahrungen der Avantgarde mit klassischen Werten bald nur in einer reduzierten Kunstsprache möglich (Abb. 6, 7). Stilisierung erscheint als der Preis, um den sich die Massengesellschaft und ihre Pluralität verdrängen lassen. Ende der zwanziger Jahre deutete Soffici die futuristische Bewegung und Carràs *pittura metafisica* als bloße Vorbereitungszeit. Der Malerfreund habe sich damals nur auf bestimmte Formwerte konzentriert, die ewigen Leidenschaften der Kunst aber vernachlässigt. "C'era poi quella rinunzia al semplice incanto della natura visibile, ai chiari spettacoli del mondo fenomenale, alla serena dolcezza o alla fiera tragicità di tutte quelle cose che hanno sempre blandito o agitato la fantasia umana e che gli uomini amano veder fissate e perpetuate sinteticamente col magistero di uno stile geniale." Nun gehe es Carrà um "insegnamenti futuristici fusi con quelli tradizionali nel crogiuolo del suo spirito volto all'assoluto plastico." Die Rückkehr zu einer Realität, deren Elemente "limpidissimi nella loro schematicità" seien, habe erst die Rückwendung auf die eigene Tradition ermöglicht.[50]

Carrà und Soffici, herausragend "fra i rarissimi eredi di una tradizione nazionale," wurden 1930 in einem der gemeinsamen Leistung gewidmeten Buch unter faschistischen Vorzeichen gewürdigt. Vor dem Hintergrund einer politischen Kulturdebatte kämpft der Verfasser zugleich gegen einen kleinbürgerlichen Regionalismus, der im Namen faschistischer Kultur auftrete, wie gegen Tendenzen, einen akademischen, nationalen Einheitsgeschmack auf Raffael zu begründen. Mit anmaßender Emotionalität erklärt er die Frage zur Gefühlsangelegenheit. "Soltanto pochi uomini, eredi di una tradizione che sopravvive all'indolenza ed alla viltà delle plebi, foggiano una coscienza italiana che trionferà con la Rivoluzione Fascista, nello stesso solco del Risorgimento." Die Elite definiert sich und ihren Stil selbst; ohne Argumente setzt sie ihre Moral, die "generosità degli uomini di azione" gegen die "rettorica degli avvocati Con questi concetti, accanto a Carrà e a Soffici, riprendiamo a un secolo dalla prima rivoluzione moderna, la polemica dei giovani per l'arte europea in Italia."[51]

Carrà und Soffici nahmen spätestens seit Mitte der zwanziger Jahre einen wichtigen Platz in der Kulturdebatte um den Faschismus ein.[52] Sie wandten sich gegen eine staatliche Agitationskunst im Sinne des *Secondo Futurismo*, aber auch gegen reaktionäre, die Moderne überspringende Tendenzen. Statt neo-römischer Triumphe wünschten sie eine freie, regionale Kultur, die dem traditionellen toskanischen Elitebewußtsein entgegenkam. Zweifellos waren sie und ihr Werk sehr früh im Sinne des Faschismus wirksam. Doch nach Ende des terroristischen *squadrismo* gehörten sie wohl eher auf die Seite des intellektuellen, auf konservativen Ausgleich bedachten Faschismus des parlamentarisch taktieren-

11. Paul Cézanne, *Les petites maisons à Auvers*, c. 1873–1874, Öl auf Leinwand
Fogg Art Museum, Harvard University Art Museums, Bequest of Annie Swan Coburn

den "pacificatore" Mussolini. Auch Lionello Venturi, Erforscher des "gusto dei primitivi," hing damals dem Faschismus an; 1925 unterschrieb er das "manifesto degli intellettuali fascisti."[53] Wenige Wochen nachdem Mussolini im Oktober 1922 nach einem geschickten Wechselspiel von Drohung eines Wiederauflebens des Bandenterrors und dem Angebot zu dessen bürgerlicher Befriedung zum Premierminister ernannt worden war, schrieb Carrà dem Freund nach Poggio a Caiano: "Passando alla situazione politica, ti dirò che qui a Milano circolava, nei giorni della preformazione del ministero Mussolini, il tuo nome come probabile Sottosecretario alle belle arti. Io, ci ho creduto un poco, e ne provai una certa delusione quando vidi che tu non eri nella lista del nuovo ministero." Am 7. Juli 1925 schreibt Soffici Carrà aus Anlaß des Ankaufs zweier Werke des Freundes durch Mussolini: "Sarebbe ottima cosa che sbarazzandosi sempre più di tutti i cretini che gli gravitano futuristicamente o passatisticamente intorno, da Tato a Brasini, egli desse ogni tanto prova di certo gusto artistico, anche, ché non gli farebbe male neanche da un punto di

vista politico."[54] Zweifellos hatten Soffici und Carrà zu vielen ihrer Ansichten vor 1921–1922 gefunden, der Zeit des frühen faschistischen Terrors.[55] Wenn sich der antiintellektuelle Zug ihres Werkes hernach akzentuierte, so mag man das durchaus als Einschwenken auf ein bestimmtes faschistisches Kulturverständnis sehen. Die Rhetorik konservativer, faschistischer Künstler aus dem Kreis um die Gruppe "Novecento" war jedoch dem Gedankenkreis nichtfaschistischer Kritiker oft verwandt.

Carrà hatte im Jahre 1927 Longhis Buch über Piero della Francesca mit wärmstem Enthusiasmus begrüßt. Vergessen waren Polemiken des Jahres 1920, als der Künstler den Kunsthistoriker einer übertriebenen Rationalisierung der Kunst bezichtigt hatte. "Ma dove Piero raggiunge il massimo delle sue potenze pittoriche è nel famoso *Sogno di Costantino* definito dal nostro critico la pittura forse più inaspettata di ogni tempo italiano: 'Un'opera dove il fiabesco notturnale del gotico collima col classicismo del Rembrandt, e, persino, con la pesatura pulviscolare del Seurat.'"[56]

In einem 1945 veröffentlichten Text

besteht Carrà auf der Bedeutung Pieros für die Anfänge der *pittura metafisica*. Nicht eine kränkliche Neigung zu eigensinniger Mystik habe ihn in diesen schweren Kriegszeiten geleitet. Vielmehr habe er nach Harmonie zwischen Geist und Wahrnehmung gesucht. "A due grandi artisti del passato, Paolo Uccello e Piero della Francesca, io mi riferivo spesso negli scritti che andavo pubblicando, portandoli quali numi tutelari della nuova arte. La ricerca di un vero poetico e vero metafisico voleva per me significare però indirizzare l'arte a una particolare facoltà tutta attuale e moderna che tenesse conto del giusto rapporto fra realtà e intelletto, rapporto che fu sempre con modi diversi essenziale nella pittura italiana delle buone epoche."[57]

Longhi unterstützte Carràs Vorstellungen und zögerte nicht, auch öffentlich dazu zu stehen. Im Jahre 1945 erschien eine populäre Monographie über Carrà aus seiner Feder. Darin zieht er den Freund gegenüber seinem Rivalen Giorgio de Chirico vor—wegen des italienischen Charakters seiner Kunst: "Destinato a servire le ragioni proprie della pittura, e assai più convinto che non il de Chirico della portata spirituale insita nelle forme italiane, egli ci presentava in questi anni una serie di acrostici sibillini, che trovano tuttavia in sé stessi la forza della soluzione. Si può narrare un quadro di de Chirico; ma in Carrà la favola, meglio che dalle intitolazioni ambigue, si spreme proprio dagli incastri dei colori fulgidi e torvi, dall'infeltrirsi magico degl'impasti, dai duri incontri degli spazî segmentati entro le comerelle primitive."[58] Seurat, Piero, Cézanne sind Longhis Bezugspunkte, um die malerische Poesie seines Freundes zu erfassen. "E . . . il nome di Seurat che, dopo quello di Cézanne, riaffiora con più insistenza a proposito del nostro pittore. . . . In effetto, al pari di Cézanne e di Seurat, anche Carrà . . . è un 'solidificatore dell'impressionismo,' un dominatore del vecchio 'motivo,' un ricostruttore del linguaggio pittorico mentre Seurat dopo aver calibrato e rettificato

12. Paul Cézanne, *Maison en Provence*, c. 1885, Öl auf Leinwand
Indianapolis Museum of Art, Gift of Mrs. James W. Fesler in memory of Daniel W. and Elizabeth C. Marmon

13. Georges Seurat,
*L'Hospice et le phare,
Honfleur,* 1886,
Öl auf Leinwand
National Gallery of Art,
Washington, Collection of
Mr. and Mrs. Paul Mellon

volumi e spazi come un Piero rinato, l'imbotta poi di polvere da sparo versicolore, di cruschello 'divisionistico,' di grana litografica, e cade, sia pur da grande, in un esanime scientismo; Carrà s'apre una strada diversa e rifiutandosi di riassumere quei precedenti come sufficienza di tecnica sistematica, li riscopre poeticamente come brani, giunture ed accenti da comporre in un canto che ha da trovare il suo tono in una inclinazione dell'animo."[59]

Diese Äußerungen sind Meilensteine auf einem künstlerischen Weg, der in Carràs Briefwechsel mit Ardengo Soffici detailliert über die Jahre verfolgt werden kann. Immer wieder ist von den "Primitiven," von der Tradition, aber auch von Cézanne, den Impressionisten und den Kubisten die Rede. In Carràs Werk hat die skizzierte gedankliche Entwicklung tiefe Spuren hinterlassen. Magisch wirkt sein Werk auch nach der metaphysischen Phase durch die Rückführung der Welt auf Bilder, die einem elementaren, gedanklichen Konzept von Häu-

sern, Bäumen, Booten oder Menschen zu entsprechen scheinen (Abb. 10, 14). Wie Cézanne betont Carrà die orthogonale Bildgestalt. Doch wird die Bildgeometrie nicht, wie bei Cézanne, als vorgegebenes Ordnungsschema spürbar, dem die beobachtete Welt mühsam und subtil anverwandelt wird (Abb. 11, 12). Auch die Farben arrangieren sich nicht, wie bei Cézanne, in subtilen Kontrasten, deren Plastizität sich das Auge erst durch das Eindringen in Farb- und Lichtgefüge erschließt. Zwar zwingt Carrà wie Cézanne die Form in einen orthogonalen Rhythmus. Er vereinfacht sie jedoch soweit, daß die Reduzierung der Gestalt auf ein einfaches, geometrisches Formverständnis als abgeschlossen erscheint, die Anverwandlung der Natur an vorgegebene Farb- und Form-Kategorien, also nicht als dynamischer Prozeß erfahren wird. Auch präsentieren sich die Farbfelder als pastoses, festes Flächengefüge. Die Zweidimensionalität der Leinwand wird durch eine Art von Parallelperspektive betont, bei der auch die

denen die Erscheinung der Dinge in einer Art kindlicher Vorstellung nur ihren Begriff einlösen (Abb. 13). Dabei vereinsamen die Dinge durch ihr beziehungsloses Nebeneinander—und durch die Abwesenheit des Menschen, deren Ambiente sie üblicherweise formen.

Carrà übernimmt vieles von dieser Gestaltung in seinen dörflichen Ambientes. Doch verleiht er der stets bewohnten Landschaft eine archaische Gestalt, als ob sie eine uralte mediterrane Kultur von jeher so gewollt und gestaltet hätte. Trotz dieser wärmeren, konservativen Sehnsucht spüren wir bei Carrà die Entfremdung von Begriff und Anschauung, gerade weil seine Bilder unser anschauliches Wissen mit der einfachen Geste einer Regression unterschreiten. Fremd sind auch diese Lebensräume: Warum umfangen sie uns nicht wie selbstverständlich? Sie scheinen doch das Wenige, was wir brauchen, bereitzuhalten. Die Reduzierung der täglichen Lebenswelt auf archaische Dinge objektiviert den Lebensbedarf, der durch diese Dinge gedeckt wird. Sie fordert zugleich zu einer konsumfeindlichen Bescheidung der Subsistenzbedürfnisse auf das von jeher Notwendige auf. Die Überflutung an Anreizen durch die industrielle Warenwelt verdrängt Carrà in rätselhaft-kindlicher Regression.

Bei Piero della Francesca hatte Longhi vor allem die Zentralperspektive als Medium bildnerischer Synthese hervorgehoben. Wenn nun Carrà und andere Künstler, die sich gerade von der traditionellen Tiefenräumlichkeit abkehrten, Piero bewunderten, so galt ihre Verehrung vor allem der Klarheit der Bildauffassung. Nicht die Perspektive übernimmt Carrà, sondern die Einfachheit der Wirklichkeitserfassung gemäß einem einmal akzeptierten System. Eine naive Direktheit der Übersetzung von konzeptuell Gewußtem in Sichtbarkeit hatte das 19. Jahrhundert in Pieros Werk gesehen und es daraufhin abgewertet. Die moderne Kunstgeschichte hat gerade die Raffinesse seiner Perspektivkonstruktionen herausgestellt, die den ikonologischen Gehalt oft unerwartet unterstreichen. Carrà scheint in Pieros Werk immer noch die im 19. Jahrhundert kritisierte, unmittelbare Sichtbarmachung von Gewußtem zu beobachten, nur bewertet er sie positiv.

14. Carlo Carrà, *Il pino sul mare*, 1921, Öl auf Leinwand
Photo Massimo Carrà

in die Tiefe fluchtenden Linien sozusagen in die Bildfläche hineingezwungen werden, um das orthogonale Gefüge nicht zu unterbrechen. Wenn diese Strategie des Bildaufbaus im Gegensatz zu Pieros Perspektivik steht, wie sie Venturi und Longhi lobten, so finden sich im Werk Seurats bemerkenswerte Parallelen (Abb. 13, 14). Die Einfachheit der Komposition, die ihren Rhythmus wie selbstverständlich vom rahmenden Bildgeviert bezieht, und das Zusammentreffen schwerer und doch zarter Farben mit einer fast naiven Konzeptualisierung landschaftlicher Volumina scheinen weniger bekannten Meisterwerken des frühen Seurat verpflichtet. Doch auch unter den späteren Landschaften Seurats finden sich Werke, bei

5. "Nous aspirons à une rigueur grave" —Seurat als verspäteter Vater einer klassischen Moderne

Konservative Sehnsüchte der Jahrhundertwende bereiteten auch in Frankreich den Weg für neoklassische Tendenzen. Um Seurats späte Aufnahme in den Kreis der "Väter" der Moderne verständlich zu machen, müssen vorher Grundzüge der Debatte um Cézanne und Gauguin umrissen werden. In einer sich allmählich herausbildenden, konservativen Epocheninterpretation begegnet man auch Piero della Francesca.

Vorreiter einer Cézanne-Interpretation im Sinne einer neuen, klassischen Kunst waren die Symbolisten der 1890er Jahre, besonders Emile Bernard und Maurice Denis. Die Suche nach allgemeinen Kunstgesetzen stand bei ihrer Deutung des Malers aus Aix-en-Provence im Vordergrund; nur gelegentlich gaben sie zu erkennen, daß es ihnen auch um emotionale Werte französischer Klassik ging.[60]

Seurat hatte versucht, ästhetische Normen durch jüngste Entdeckungen zur Physiologie der Sinnesorgane und des Nervensystems zu begründen.[61] Gauguin und seine Freunde wollten die Gesetze der Kunst nicht so genau fassen wie die Neo-Impressionisten um Seurat und Signac. Doch auch sie glaubten an Zusammenhänge zwischen Linien und Farben, die immer wieder die gleichen ästhetischen Wirkungen hervorriefen. Die Dichter von Charles Baudelaire bis Arthur Rimbaud hatten von geheimen Analogien zwischen der Wirkung von musikalischen und optischen Harmonien und von rätselhaften *correspondences* aller Sinne gesprochen. Dieser Glaube wurde von Gauguin wiederbelebt und nur wenig genauer gefaßt. Er berief sich unter anderem auf das Vorbild byzantinischer Madonnen.

Die Suche nach künstlerischen Gesetzmäßigkeiten ist als Reaktion auf die Auflösung aller Normen durch den Impressionismus verständlich. Manet und seine Freunde, vor allem Emile Zola, hatten gehofft, daß das Individuum, das sich von allen Vorurteilen befreie, in voller Aufrichtigkeit eine Vision erringen könne, die sich die Gesellschaft hernach zu eigen mache.[62] Erst die Jünger Gauguins und Seurats hofften auf Gesetze der Harmonie, die endlich eine soziale Kunstpraxis und eine höhere Eingän-gigkeit und Wirksamkeit der Kunst ermöglichen sollten. Richard Shiff hat diese Gesetze allzu voreilig als genau das dargestellt, wonach die Impressionisten gesucht hätten.[63] Tatsächlich bedeutet die Sehnsucht nach überzeitlichen Werten der Kunst eine oft konservative Kehrtwendung zu einer meditativen Form von Malerei.

Ein frühes, rätselhaftes Beispiel für die Legitimierung ewiggültiger Kompositionsgesetze zeugt von dieser Sehnsucht. In der Zeit um den Winter 1885–1886 zirkulierte in der Pariser Avantgarde in mehreren Versionen ein Text, der angeblich aus dem Altpersischen übersetzt worden war, offensichtlich aber in der Auseinandersetzung mit Gemälden wie Puvis de Chavannes' *Enthauptung Johannis des Täufers*, 1869 (Barber Institute of Fine Arts, Birmingham) entstand. Der Magier Wehli-Zunbul-Zadé berichtet darin über ein Gemälde zu einer Exekution: "Quand Oumra a représenté le supplice d'Okraï il n'a point levé le sabre du bourreau, prêté au Klakhan un geste de menace et tordu dans les convulsions la mère du patient. Le sultan, assis sur son trône, plisse sur son front la ride de la colère: le bourreau debout regarde Okraï comme une proie qui lui inspire pitié, la mère appuyée sur un pilier témoigne de sa douleur sans espoir par l'affaissement de ses forces et de son corps. Ainsi une heure se passe-t-elle sans fatigue davant cette scène plus tragique dans son calme que si la première minute passée l'attitude impossible à garder eût fait sourire de dédain."[64] In dieser Rücknahme des Selbstausdrucks der Figuren äußert sich unterschwellig auch eine Selbstdisziplinierung der Künstler und ihres Publikums. Gerade die statuarische Isolierung der Figuren sollte später an Piero della Francesca gerühmt werden, nachdem man vorher seine Bilderzählungen getadelt hatte.

Die Rücknahme emotionaler Ansprüche in seltsam reduzierten, melancholischen Idyllen scheint ein Grundzug moderner Klassik. Symbolistische Texte über Cézanne sind davon geprägt. Gleichklang in einem Leben nach scheinbar ewigmenschlichen Zyklen erscheint kaum je als unbeschwert. Das hieratische Arrangement der Flächen und der durch die Brechung der Farben gebändigte Farbklang erscheinen bei Cézanne als Bedingung des Ebenmaßes. Archaische

Ruhe ist damit Spur des Verzichts. Für Emile Bernard war Cézanne auf der Suche nach universellen Gesetzen des Schönen in der wahrnehmbaren Welt. Analog hatte Bernard sich 1895 in "De l'Art naïf à l'art savant" schon über Giotto geäußert. Naiv wurde für Bernard, so Richard Shiff, gleichbedeutend mit "savant." Die Tradition, die Wissenschaft des Weisen in der Malerei, habe für Bernard zudem die Autorität göttlicher Inspiration. Die Gesetze würden zwar in der Natur gefunden, ermöglichten hernach aber eine absolute, überzeitliche Logik der Kunst. Ein Kritiker wie Théophile Thoré hatte die Tradition profaner noch lediglich als Gesamtschatz der Naturwiedergabe durch frühere Meister gesehen.[65]

Seurat war für Bernard und Maurice Denis noch keinesfalls der Kronzeuge einer neuen, klassischen Ästhetik. Wenn Seurat über die pointillistische Schule hinaus keinen tieferen Einfluß auf die Generation der nachfolgenden Künstler ausüben konnte, so führt Denis das auf den Charakter seiner Kunst zurück. Sogar van Gogh gesteht er noch im Jahre 1909 eine höhere Bedeutung für eine klassische Kunst zu. Zwar gibt er zu: "Seurat fut le premier qui essaya de substituer à l'improvisation, plus ou moins fantaisiste, d'après la nature, une méthode de travail réfléchi. Il chercha à mettre de l'ordre, à créer la nouvelle doctrine que tout le monde attendait. Il eut le mérite de tenter la réglementation de l'impressionnisme. La hâte avec laquelle il tirait des conclusions techniques ou esthétiques de certains théories de Chevreul ou de Charles Henry, ou de ses propres tentatives, a fait de son œuvre, trop tôt, hélas! interrompue, une expérience tronquée Van Gogh et Gauguin résument avec éclat cette époque de confusion et de renaissance. A côté de l'impressionnisme scientifique de Seurat, ils représentent la barbarie, la révolution et la fièvre—et finalement la sagesse."[66] Denis stellt neo-klassische Elemente im synthetischen Form- und Farbaufbau der Bilder van Goghs und Gauguins heraus. Dabei gesteht er diesen Künstlern neben Cézanne eine Vorreiterrolle zu.

Die Kunstkritik um den Kubismus gelangte keineswegs zu einer allgemeinen Neubewertung Seurats in diesem Kanon nachimpressionistischer Kunst. Sie nimmt zwar die Vorstellung auf, Cézanne habe gegenüber der reinen Augenkunst des Impressionismus das geistige Element der Wahrnehmung wieder in den Vordergrund gestellt. Insofern ist etwa die Argumentation von Gleizes und Metzinger in ihrem berühmten Buch *Du Cubisme* Vorstellungen der Symbolisten-Generation verpflichtet.[67] Die impressionistische Formfreiheit lesen Gleizes und Metzinger jedoch nicht als Symptome eines Werteverlustes. Wenn sie Cézanne als Neubegründer einer intellektuellen Konzeption vom plastischen Objekt herausstellen, fehlt dabei die konservative Komponente der Sehnsucht nach neuer Ordnung.[68]

In diesem kubistischen Malermanifest stellen die Verfasser Seurat nicht nur als den Erfinder des Pointillismus dar, sondern der ganzen Entwicklung zur befreiten Farbmalerei des Fauvismus. In einer pedantischen Diskussion der Vorteile optischer Mischung deklarieren sie es indessen als Fehler, die Erdfarben aus der Malerei verbannt zu haben.[69] Nach ihrer Auffassung richtet sich die Qualität des Kubismus nahezu gegen Seurat und den Neo-Impressionismus: "C'est alors que les Cubistes enseignèrent une nouvelle façon d'imaginer la lumière. Selon eux, éclairer c'est révéler; colorer c'est spécifier le mode de révélation. Ils appellent lumineux ce qui frappe l'esprit et obscur ce dans quoi l'esprit est obligé de pénétrer."[70] Apollinaires unbefangene Beurteilung Seurats wirkt demgegenüber vorteilhafter, klassische Tendenzen sieht er nur verhalten: "Aucun peintre ne me fait songer à Molière comme Seurat, au Molière du *Bourgeois gentilhomme*, qui est un ballet plein de grâce, de lyrisme et de bon sens. Et des toiles comme le *Cirque* ou le *Chahut* sont aussi des ballets pleins de grâce, de lyrisme et de bon sens."[71]

Erst als die szientistische Legitimation der pointillistischen Technik nicht mehr für bare Münze genommen, als die Aufforderung zur Verwissenschaftlichung von Kunst nicht mehr ernstgenommen wurde, bahnte sich eine neue Bewertung Seurats an. Es ist kein Zufall, daß wir in einem Buch über Seurats Zeichnungen früh auf eine neue Rhetorik stoßen, die später die Parallelisierung von Seurat mit Piero della Francesca ermöglichen sollte. Die ordnungsstiftende Funktion der rationalen Kunstmittel Seurats

stellt Lucie Cousturier 1914 in den Vordergrund. Es geht ihr mehr um eine Ordnung als um deren Verwurzelung in Naturgesetzen. Die Wirksamkeit von Kontrasten, die auf analogen Abstufungen von Helligkeit und Linie beruhen, führt sie nicht mehr allein auf die physiologische Organisation des Auges, sondern vor allem auf ihre intellektuelle, ja humanistische Überzeugungskraft zurück.[72]

André Salmon schlägt um 1920 in seinen Bemerkungen über Seurat nur einen geringfügig anderen Tonfall als Apollinaire an. Auch für ihn ist Seurat gerade in seiner Naivität charmant. Doch zugleich paßt der Begründer des Pointillismus nun in den Mythos des einsamen Künstler-Heroen, der hinter der pittoresken Oberfläche des Alltäglichen Geheimes und zugleich Dauerhaftes verwirklicht. Zuvor hatte Salmon den Einfluß des *Chahut* und des *Cirque* auf die Futuristen herausgestellt: "Par la tendre rigueur de son architecture, Seurat atteint à quelque chose qui est au-delà du pittoresque: un surpittoresque dont l'essence est en deçà de la notation anecdotique, cette notation anecdotique que prolonge innocemment l'impressionnisme dans l'illusion sympathique de la réduire."[73]

Salmon steht am Anfang einer Neubewertung Seurats in Frankreich. Die neoklassischen Tendenzen der zwanziger Jahre waren bei Künstlern wie Picasso oder Juan Gris von einer oft unterschwelligen Melancholie getragen. Bei Picasso wurden die bürgerlichen Aspirationen des Künstlers nach einem langen Durchsetzungskampf in der künstlerischen Bohème durchaus bewußt in ästhetische Sehnsüchte umgemünzt. Brüche in der künstlerischen Sprache, Kunst-Zitate, die sich mit rigoros Zeitgenössischem reiben, schließlich die immer präsente, alle vorher erreichte Stilstufen zugleich zitierende und kommentierende Handschrift des Künstlers machen sein Werk zum aufregendsten Erzeugnis der neoklassischen Umbesinnung gegen Ende des Kriegsjahrzehnts. Kenneth Silver hat die Neubewertung Seurats im Frankreich der zwanziger Jahre zuerst analysiert. Sie stand weniger im Zusammenhang mit den bekannten neoklassischen Tendenzen ehemaliger Kubisten als mit Bemühungen um eine neue Regelkunst. Die Puristen Amédée Ozenfant

und Edouard Jeanneret, der spätere Architekt Le Corbusier, sowie der Künstler André Lhote und einige Anhänger der konstruktivistischen Gruppe Cercle et Carré wie Jean Hélion stehen im Hintergrund einer neuen Zuwendung zu Seurat als künstlerischem Gesetzgeber.[74] Perspektivische Figurenrhythmen, Kompositionsaufbauten nach dem goldenen Schnitt geraten nun in den Mittelpunkt des Interesses. Wie bei Le Corbusier der Mensch, später auf die ideale Form des Modulor gebracht, einer umgebenden Stadtarchitektur den Rhythmus abgibt, so strahlt der Formklang der Figuren auch bei Seurat in die luftige Kulturlandschaft aus. Die Wiederaufnahme des akademischen Primats des Menschen, als Ebenbild Gottes das perfekteste Geschöpf, bereitet auch einer Neubewertung Seurats den Weg: "Il y a une hiérarchie dans les arts: l'art décoratif est au bas, la figure humaine au sommet," schreiben die Puristen 1918 in ihrer ersten Programmschrift.[75] Die Natur öffnet sich dem städtischen Ambiente, dieses strahlt umgekehrt in den großen Landschafts- und Himmelsraum aus. Die Eroberung von Erde und Luft durch die industriellen Verkehrsmittel und die großstädtische Vermassung werden durch diese moderne Variante französischer Klassik akzeptiert; ein rationaler Lebensrhythmus holt das aus den Fugen geratene Großstadtleben wieder ein. Im Stilleben zeigt sich das durch die Darstellung auch industriell produzierter Gegenstände in einem Stil, bei dem es nur auf "gereimte" Formen ankommt (Abb. 15). Bei Seurat erscheinen die Menschen zwar voneinander isoliert, aber diese Isolierung hat nun das Bedrohliche verloren. In ihrer Programmschrift von 1918 münzen Ozenfant und Jeanneret die Erfahrung der Entfremdung zu kollektivem Machtempfinden um: "L'ouvrier qui n'a exécuté qu' une pièce détachée saisit alors l'intérêt de son labeur; les machines couvrant le sol des usines lui font percevoir la puissance, la clarté et le rendent solidaire d'une œuvre de perfection à laquelle son simple esprit n'aurait osé aspirer. Cette fierté collective remplace l'antique esprit de l'artisan en l'élevant à des idées plus générales." Ähnlich strebten die Puristen auch eine weniger individuelle Kunst an, die sich mit der kollektiven Schöpferkraft der industriellen

15. Amédée Ozenfant,
Maroc, 1919, Öl auf
Leinwand
Hôtel Monte Verità, Ascona

binden sich in dieser eminent französischen Variante konservativer Moderne. Das neue Paradies ist rigoros modern und wird planvoll angestrebt; rückwärtsgewandte Idyllen, die, wie die Bilder der Novecento-Maler, auch von den Merkmalen des Verlustes geprägt sind, haben in dieser Vision keinen Platz.[77]

In der konkreten ästhetischen Bewertung äußerte sich die Vereinnahmung Seurats vor allem darin, daß man ihn zum Ahnherren des Kubismus hochstilisierte und diesen wiederum zur Vorbereitungsphase einer öffentlichen, bevorzugt architektonisch gebundenen Wandmalerei umdeutete. Die Disziplin des Flächenarrangements wurde zum Merkmal gesellschaftlicher Rationalität; der Individualismus des 19. Jahrhunderts stand nun für ordnungsfeindliche, beängstigende Vermassung. André Lhote rühmte Seurat 1922 im Geist dieses *retour à l'ordre*: "Au moment où Sisley et Monet cultivaient les plus dangereux paradoxes picturaux et côtoyaient le gouffre de l'évanescent, Seurat, sans rien perdre de la sensibilité impressionniste, sans renoncer à son sens des modulations et surtout sans opérer un retour vers l'art des musées, trouve, d'un seul coup, des formes aussi dépouillées, aussi épurées que celles des primitifs." "Primitiv" steht in dieser Tradition stets für eine kollektive, gesellschaftliche Ordnung, die sich im Flächenrhythmus sakraler und dadurch öffentlicher Kunst ausgedrückt hatte. Statt Seurat nun unmittelbar für den fortschrittlich-rationalen Klassizismus zu vereinnahmen, erklärt Lhote ihn zum Vorläufer des Kubismus, den er zugleich mit Seurats Werk in seinem Sinne umdeutet: "Plus un tableau est grand, plus il doit se rapprocher comme aspect de la fresque primitive, dont il est une réduction; or la fresque ne souffre qu'une profondeur suggérée. Cette profondeur relative, plus propre à satisfaire l'esprit que les pieds du touriste, devint la plus tenace préoccupation de Cézanne, de Renoir, de Seurat. Ils l'obtinrent tous trois en imprimant à la lumière un constant retour sur elle-même. Mais où Renoir obtient ce battement du clair-obscur sur le plan vertical par ondes sphériques, par superpositions de globes inégaux, Cézanne et Seurat l'obtiennent par une oscillation partant de la ligne, élément régulateur, et

Gesellschaft solidarisch weiß: "Assez de jeux. Nous aspirons à une rigueur grave."[76]

Die Menschenmasse auf der Grande-Jatte (Abb. 16) ist durch einen gemeinsamen Formtakt geeint, der sie zudem mit der umgebenden Stadträumlichkeit verbindet. Hinter dieser Lesart steht großstädtischer Optimismus. Seurats Zeitgenossen haben die Hauptwerke des Künstlers als durchaus bedrückender, zwiespältiger empfunden. Moderne Technik, ästhetisch vereint zum Formklang moderner Architektur, macht die Großstadt nun zur endlosen Weltbühne eines rationalen Lebensgefühls. Ängste vor der Unüberschaubarkeit einer sinnlos gewordenen Masse und vor Vereinzelung werden durch den Verstand gebändigt. Im rationalen Gesamtgefüge einer modernen Klassik wird dem Individuum sein Platz zugewiesen; die Ortlosigkeit wird durch Bejahung der Mobilität, deren Preis sie ist, kompensiert. Seurat wird zum Heros einer Modernität, die ihn selbst tatsächlich beängstigt hatte. Eine Parallelisierung mit Piero oder anderen Renaissance-Künstlern wie vorzugsweise Leonardo da Vinci ergibt sich nur vor dem Hintergrund wissenschaftlicher Kunstgesetze. Sie wird zugleich als Bejahung auf technischem Fortschritt beruhender, gesellschaftlicher Entwicklungen gedeutet. Fortschrittsoptimismus, Rationalität und Klassik ver-

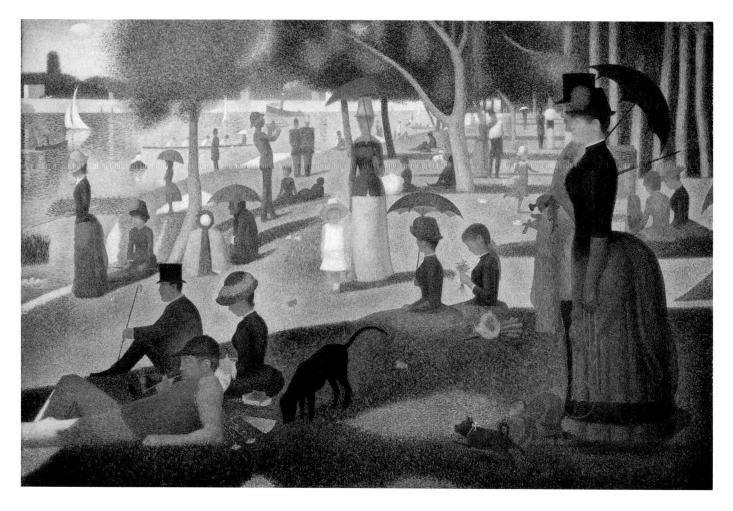

aboutissant à une espèce d'escalier dont la dernière marche reviendrait au niveau de la première. Par l'établissement de ces subtiles déclivités, de ces dégradés réguliers, par le chevauchement de ces arrêtes brillantes du haut en bas de la toile, qu'elles ferment complètement, Seurat arrive ainsi à maintenir son tableau fidèle à la muraille qu'il recouvrira. Il habille, en quelque sorte, le mur nu, avec son tableau; mais, au lieu de le plaquer, inerte, contre son support, comme le ferait un décorateur linéaire, il le laisse doucement flotter, il lui imprime un mouvement vivant et mesuré. Le cubisme naissant fut en partie constitué par l'amplification du mécanisme plastique dont je viens de tenter la difficile démonstration Dans les premières recherches de Picasso et de Braque, on remarquera les mêmes singularités, avec cette différence que les lignes, points de départ des dégradés, au lieu de faire le tour des objets, le brisent par endroits, comme le fait la lumière, pour l'œil qui sait en

percevoir les subtils contours." Wenn Picasso und Braque, als Lhote dies schrieb, diese bildnerischen Techniken bereits aufgegeben hatten, so gewinnt seine Darstellung dadurch nur an Wert.[78]

Die gleichzeitige Berufung auf Seurat und Renoir wird typisch für die Puristen und ihr Umfeld. Poussin wie Puget machten zusammen die französische Tradition aus. Heiterkeit wie auch Formendisziplin sollten auch in der Gestaltung des modernen Frankreich obwalten. Das steht hinter Amédée Ozenfants Bewertung von 1927: "Nous aimions dans Seurat le sec de la grande tradition française depuis toujours, et cette lucidité, cette politesse des choses vraiment grandes, cette peau bien grenée qui recouvre les riches tissus profonds. On ne vous dit pas que nous n'aimons *que cela*; nous aimons aussi le direct de Renoir: Quelle émotion devant ces deux femmes couchées du Luxembourg, sa dernière œuvre!"[79] Ästhetische Disziplin ist in dieser Perspektive

16. Georges Seurat, *Dimanche après-midi à l'île de la Grande-Jatte*, 1884, Öl auf Leinwand
Art Institute of Chicago, Helen Birch Bartlett Memorial Collection

Vorbedingung modernen Glücks. Den Verzicht auf emotional differenzierten Selbstausdruck und Spontaneität rechtfertigen letztlich nicht die zugleich propagierten Gesetze der Kunst, sondern Gleichklang, der aus Ordnung erwächst. Vor diesem Hintergrund werden Seurat und Cézanne für Claude Roger-Marx zu Komplizen. "Ce qui est remarquable chez Seurat, c'est non d'avoir fait choix de tel ou tel procédé, mais d'avoir senti si vivement qu'il fallait s'imposer des contraintes. Il prétend ignorer l'impressionnisme. Ce n'est pas contre une école déterminée qu'il réagit, mais contre ce manque de discipline dont toute la peinture du XIXe siècle aurait souffert; c'est l'idée de 'hasard' et 'd'improvisation' qu'il chasse."[80]

6. Roger Fry und die Mythen moderner Kunstgeschichte

Roger Fry, ein englischer Kunstkritiker, der mit Recht zu den Begründern der Kunstgeschichtsschreibung des 20. Jahrhunderts gezählt wird, führte die Entwicklung eines Epochenmodells zur modernen Kunst einen entscheidenden Schritt weiter. Wie Ardengo Soffici war Roger Fry einer der wirksamsten Propagatoren moderner französischer Kunst in seinem Land. Und wie Soffici beeinflußte er die Kunst seiner Zeit. Doch wirkten seine Schriften aus dem Kriegsjahrzehnt stärker als die des Italieners auf Frankreich zurück. Nachdem der Kritiker Seurats Werk zunächst gar nicht beachtet hatte, verglich er ihn 1926 als einer der ersten mit Piero und gelangte zu einer Würdigung, aufgrund derer Seurat seither den Begründern der modernen Kunst zugerechnet wird.

Die erste Ausstellung neuer französischer Kunst, die Fry ausgerichtet hatte, wurde im November 1910 in den Londoner Grafton Galleries unter dem Titel *Manet and the Post-Impressionists* eröffnet. Cézanne, van Gogh und Gauguin waren gut vertreten. Von Seurat fanden sich nur zwei Seestücke.[81] In seiner zweiten, der post-impressionistischen Bewegung gewidmeten Ausstellung, die 1912 am selben Ort stattfand, wurde Seurat nahezu übergangen.[82] Erst Ende der zwanziger Jahre befaßte sich Fry eingehender mit Seurat.

Bis heute einflußreich ist besonders seine Einführung des Begriffs Post-Impressionis-

mus. Zwar faßte Fry damit die Maler zusammen, die den Impressionismus in den achtziger Jahren durch stärker stilisierende oder subjektivere Ausdruckskunst überwanden, vor allem van Gogh, Gauguin, Seurat und Cézanne. Jedoch wurde der Begriff besonders mit Blick auf den Provençalen geprägt.[83] Anders als Maurice Denis hält Fry es nicht für möglich, gleichzeitig spontan expressiv und klassisch zu gestalten; für ihn müssen diese Stadien aufeinander folgen. Cézanne erst gebe der spontanen Imitation der Natur im Impressionismus einen geistigen Sinn. Im Katalog der zweiten Ausstellung beschreibt Fry den klassischen Grundzug der Kunst, die er in einer etwas konstruierten post-impressionistischen Bewegung zusammenfaßt, ohne Seurat auch nur zu erwähnen. Vor allem von Picasso und Matisse ist die Rede—und natürlich von dem "originator of the whole idea, Cézanne."[84] Klassisch wird für Fry nahezu gleichbedeutend mit formalistischen Kunstwerten. Diese hatte er anfänglich in Anlehnung an psychologistische Vorstellungen über "Gesetze" der Ästhetik entwickelt, wenn er etwa verlangte, die ideale Augenhöhe solle über der Mittellinie des Gemäldes ausbalanciert werden, um Einheit im Bild zu gewährleisten. Später fand er die Gesetze reiner Kunst nur noch im Gemälde —nicht mehr in experimenteller Psychologie; Cézanne sei wie alle klassischen Künstler instinktiv darauf gekommen. Romantische Kunst hänge von Assoziationen, mithin vom praktischen Leben ab. "Classical art, on the other hand, records a positive and disinterestedly passionate state of mind. It communicates a new and otherwise unattainable experience. Its effect, therefore, is likely to increase with familiarity It is because of this classic concentration of feeling (which by no means implies abandonment) that the French merit our serious attention. It is this that makes their art so difficult on a first approach but gives it its lasting hold on the imagination."[85] Für Fry ist Cézanne gerade deshalb der größte aller Post-Impressionisten: Zu der neuen Rationalität sei er unbewußt, ohne vorzeigbare Methode gelangt. Es ist klar, daß für Seurat in dieser Perspektive zunächst kein Platz bleibt.

In einem 1919 erschienenen Text über Kunst und Wissenschaft erwähnt Fry den

Namen Seurats nicht einmal. Als wollte er seinen eigenen, früheren Interessen für psychologistische Tendenzen widersprechen, urteilt er skeptisch über den Wert naturwissenschaftlicher Anregungen für die Kunst, die dem ästhetischen Vergnügen immer fremd blieben.[86] Erst 1928 zeigte Fry vertieftes Interesse für Seurats Werk. Zweifellos war er dabei von der Umwertung in Frankreich und Italien beeinflußt. Doch dementierte er seine ursprünglichen Ansichten nicht. Wenn er über die Vernachlässigung des Pointillisten spricht, so scheint er erneut die Gründe seines anfänglichen Desinteresses zusammenzufassen: "It is due partly to the special character of Seurat's genius, partly to the accident that, just when he might have emerged, Cézanne, himself long overdue, occupied the field to the exclusion of every rival. But now that Cézanne's contribution has gradually been assimilated by the artistic consciousness of our day, it is evident that, if we set aside Renoir and Degas, whose work had long been accepted, the other outstanding figure of later nineteenth-century art ist that of Seurat. Nonetheless he will, I think, always make rather a limited appeal. There was in his personality the strangest combination of an extreme sensibility and a devouring intellectual passion. He had, indeed, what is perhaps a good thing for an artist, more intellect than judgment His pictures are alive, indeed, but not with the life of nature. He will paint air and almost nothing but air filled with light, but there is no breath in his air. If his designs live and breathe it is by the tension of the imaginative concentration which they reveal and impel us to share. Seurat is of the lineage of Poussin, and is as austerely aloof and detached as he. Seurat's ambition was as vast as his disinterestedness was complete."[87]

Seurats Une Baignade, Asnières, 1883/1884 (National Gallery, London) veranlaßte Fry schließlich, den Pariser Maler mit Piero zu vergleichen: "The effect is neither of lyric beauty, nor of banal or ironic realism. Seurat's aim lies behind and deeper than all such attitudes to the scene. It would be hard to find any word uncolored enough to describe the mood this evokes. It is like that which comes to us from some of Piero della Francesca's monumental and motionless groups. It is a mood of utter withdrawal from all the ordinary as well as all the poetic implications of things into a region of pure and almost abstract harmony in spite of the rigor of its harmony, this picture retains also something of its quality of immediacy, of a thing that was actually seen and seized on by the imagination in a single ecstatic moment With him the balance between sensibility and doctrine was a delicate one." Der Vergleich mit Piero hilft Fry, Seurats Werk in vollem Umfang zu akzeptieren. "Seurat's artistic personality was compounded of qualities which are usually supposed to be opposed and incompatible. On the one hand, his extreme and delicate sensibility, on the other a passion for logical abstraction and an almost mathematical precision of mind." Der Wert naturwissenschaftlicher Einflüsse kann nun vor allem darin gesehen werden, daß sie die Neukonstruktion eines autonomen, künstlerischen Systems sozusagen auf der tabula rasa ermöglichten.[88]

Wenige Jahre nach Frys Buch von 1926 galt Seurat weithin als einer der Gründerväter der modernen Kunst. Zwei verschiedene Zeugnisse für die Etablierung eines Topos kunsthistorischer Erzählung sollen dazu angeführt werden. In der Einschätzung des konservativen Robert Rey erscheint Seurat—ähnlich wie bei den Puristen und André Lhote—als Kronzeuge einer Gesetzeskunst.[89] Alfred Barr, Gründungsdirektor des Museum of Modern Art in New York, machte sich nicht zum Partisanen klassischer Gesetzeskunst. Für ihn wurde Seurat neben Cézanne zum Begründer einer konstruktiven Tendenz in der Moderne, neben der eine expressive sich unabhängig entwickelte. Beide ließ Alfred Barr gelten. Doch in einer Zeit, als die Abstraktion sich anschickte, zur Kunstsprache der "freien Welt" zu werden, kam der konstruktiven Tendenz sozusagen mehr öffentliches Gewicht zu—ganz in der Tradition eines forensischen Klassizismus. "At the risk of grave oversimplification the impulse toward abstract art during the past fifty years may be divided historically into two main currents, both of which emerged from impressionism. The first and more important current finds its sources in the art and theories of Cézanne and Seurat, passes through

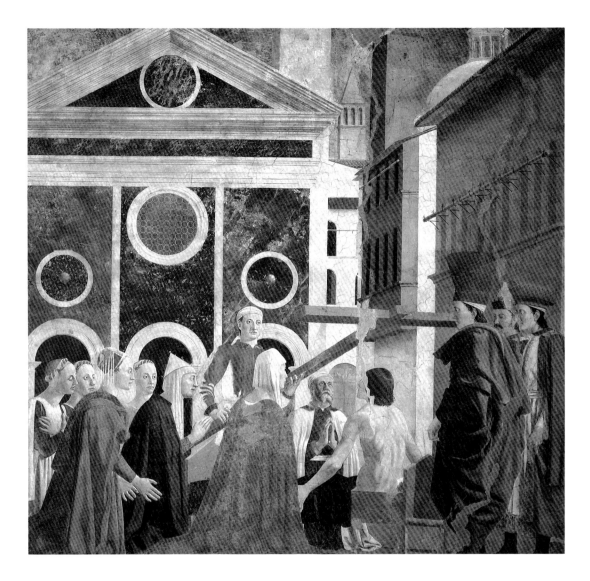

the widening stream of cubism and finds its delta in the various geometrical and constructivist movements which developed in Russia and Holland during the War and have since spread throughout the world. This current may be described as intellectual, structural, architectonic, geometrical, rectilinear and classical in austerity and dependence upon logic and calculation."[90]

7. Piero und Seurat: "quasi certezza"

Longhi betrachtete 1950 die stilistischen Quellen von Seurats *Baignade à Asnières* und *Dimanche après-midi à l'île de la Grande-Jatte* vor dem Hintergrund akademischer Tendenzen der frühen 1880er Jahre. Vor allem der Einfluß Puvis de Chavannes' schade der Leistung jüngerer

Künstler. "Primitivere" Quellen hätten auch ursprünglichere Leistungen gefördert. Nach Longhis Auffassung war Seurat nur der bekannteste Vertreter einer Künstlergeneration, die Inspiration an "primitivistischen" Quellen suchte, bevor die Avantgarde der darauffolgenden Generation sich afrikanischer Plastik zuwandte. Zunächst fordert Longhi dazu auf, die Geistesverwandtschaft von Seurat und Piero vor der Zeichnung eines sitzenden Mädchens, einer Studie für die *Grande-Jatte*, nachzuvollziehen. Diese Zeichnung war auch frei von dem von Longhi stets belächelten Pointillismus: "La elementarità di soluzione formale non s'impaccia qui, come nei dipinti definitivi, di 'mélange optique' e di ricerche fotocromatiche: è solo la diversa densità del bianco e nero, la diversa precipitazione della luce

che serve a ricreare la materia; emergenone una forma severa come in un basalte egiziano o come da uno 'spolvero' di Piero della Francesca. Fine ultimo di Seurat, quello, dunque, di una gravità formale suprema e, per più vie, di 'antico' aspetto." Noch ähnelt der Tonfall Longhis ästhetisch begründeter Argumentation der zwanziger Jahre. Doch dann rechtfertigt er den Vergleich durch den Hinweis auf Loyeux' Kopien in der Kapelle der École des Beaux-Arts, indem er zugleich jede skeptische Beurteilung eines Einflusses abtut: "Ma, per venire a Seurat e alla sua disperata serietà di ricerca, l'aggancio col precedente di Puvis, già complicato con un impoverimento di classicismo Poussiniano, si sente poco portante. . . . Proprio in quegli anni il direttore dell'accademia, Charles Blanc, aveva fatto eseguire dal pittore Loyeux e porre nella Chapelle de l'École des Beaux-Arts alcune copie degli affreschi di Piero ad Arezzo. Sarebbe futile stinarsi a credere che Seurat non le abbia vedute, studiate, e, soprattutto, intese. Questa, per me, quasi certezza à già espressa nella seconda edizione del mio 'Piero della Francesca' (allestita nel 1942 e, per la guerra, apparsa nel 1946) dov'è detto precisamente: 'Verrebbe così a indicarsi una fonte molto più solenne che non sia Puvis de Chavannes per il 'neo-impressionnismo' et per il 'sintetismo.' Non ne scapiterebbe il genio di Seurat, ma la mediocre Oceania di Gauguin, rischierebbe, com'era da aspettarsi, di ridiventare un avallaccio di ritorno dal contado aretino.'" Der polemische Tonfall akzentuiert sich gerade zu der Zeit, da die Debatte aus der künstlerisch relevanten Kunstkritik in die universitäre Kunstgeschichte überwechselt. Longhi läßt nicht unerwähnt, daß Kenneth Clark in seinem 1949 erschienenen Buch *Landscape into Art* der Annahme einer Verbindung zwischen Seurat und Piero zugestimmt hatte. Immer noch stellt er den jungen Pointillisten als Vertreter einer klassischen Tradition heraus, hofft aber nun nicht mehr auf die Gründung einer neuen Tendenz. "E rimane che, fra le molte rievocazioni culturali del primitivismo, care alla pittura francese nell'ultimo ventennio del secolo scorso, quella di Seurat è certamente la più penetrante, sia per la scellezza dell'antico richiamo, sia per la suprema intelligenzia di chi ce l'ha ripro-

posto in forma nuova e personalissima."[91]

In Frankreich hat der kunsthistorische Gedanke, Seurat sei—vermittelt durch Loyeux' Kopien—von Piero beeinflußt worden, eine kürzere Geschichte als in Italien. André Chastel hat ihn, gewiß angeregt durch seinen Lehrer Roberto Longhi, in derart bestechender Weise formuliert, daß jedem Zweifel für lange Zeit der Boden entzogen wurde. Sein anderer Lehrer Henri Focillon war offenbar bereits damit vertraut, daß man Seurat und Piero für verwandt hielt. Doch bewußt hatte sich Focillon für andere Vergleiche entschieden. Am Ende eines Buches über Piero erklärt er den umbrischen Maler 1952 zu einem Geistesgenossen Jean Fouquets. Die Begegnung mit dem französischen Genie läßt so etwas wie eine sozialistische Variante der von Soffici und wohl auch von Longhi beschworenen Latinität entstehen. "Leur humanisme est bien plus large que celui du lettré. L'homme-type, pour Piero et pour Fouquet, c'est l'artisan, l'homme qui prend sa peine, aux membres forts, capable de soulever de lourds fardeaux. Tous deux glorifient un être solide dont le geste a une belle économie."[92] In den zwanziger Jahren war Focillon offenbar von Frys Vorstellungen über die Klassik in Seurats Werk beeinflußt. Die übersensible Delikatheit, die Focillon damals in Seurats Werk sah, paßt nicht in das eben skizzierte Bild der soliden Menschentypen klassischer Primitivität. "Nous sommes à l'opposé de 'l'impression' pure, dans le domaine d'un irréalisme féérique qui conserve intact le prestige du plus délicat des songes, tout l'esprit et toute la sensibilité de la chose vue, mais qui ne laisse rien au hasard ou au caprice. On le sent, cet art n'est pas la suite de l'impressionnisme, mais, né de lui, l'expression d'une esthétique contraire."[93]

Erst André Chastel sollte neben Piero nicht Fouquet, sondern Seurat stellen. Er sah in Seurat einen Künstler, der sich dem Hauptstrom der Malerei seiner Zeit eigensinnig entgegenstellte: "La grande revendication de la peinture moderne est celle de la liberté d'invention et de réalisation: voici un peintre qui semble renoncer d'un coup à tous ces bénéfices et se complaît à enchaîner la spontanéité jusque dans ses moindres mouvements." Um der Last der Konventionen auszuweichen, hätte Seurat auf die

Naturgesetze zurückgegriffen; durch prakti-
sches Experiment habe er einen neuen Stil
geschaffen. Dieses Vorgehen ist für Chastel
vergleichbar mit dem Leonardos. Doch für
die fühlbaren, sichtbaren Strategien der
Herrschaft über das Sujet sieht Chastel eher
in der Malerei Paolo Uccellos oder Piero
della Francescas ein Pendant. "*L'art-science.*
On dirait que pour échapper définitivement
à la tradition classique, le novateur doit
repasser par la situation qui l'a engendrée.
L'art-science culmine dans la volonté
obstinée de Léonard qui, pour condenser
dans le tableau les effets souverains de la
nature, s'engage dans les calculs inter-
minables de l'optique et de la théorie des
couleurs. Le *Trattato* incomplet et com-
pliqué de Léonard fut d'ailleurs l'objet d'une
lecture attentive de Seurat. Il n'y en a pas
tellement d'esprits préoccupés du 'système.'
Pour eux, les pratiques non vérifiées par
l'analyse ne sont pas plus valables que les
trouvailles d'intuition. On part de l'hypothèse
que le tableau se comporte comme un
morceau de nature; on y reportera les données
de certains processús du monde physique en
s'arrangeant pour élever le tout au maxi-
mum d'intensité par le contrôle des formes.
Telle est l'attitude des novateurs du
Quattrocento et telle est celle de Seurat.
Ainsi peut s'expliquer le 'primitivisme' de
Seurat, l'analogie si frappante avec les
ordonnances d'Uccello et de Piero della
Francesca—seules références que l'on puisse
trouver dans toute l'histoire de la peinture,
pour éclairer sa manière. C'est le même
espace articulé en bandes parallèles et en
échelonnements, la même lumière claire,
verticale et diffuse, multipliant irisations et
ourlets ou au contraire les jeux fantasques
de l'éclairage artificiel, le même pivotement
lent des figures et jusqu'à la même attention
pour les couvre-chefs plantés sur les têtes."
Die Autonomie des Bildes wie des künst-
lerischen Ausdrucks wird solcherart durch
bloße Methode erreicht—aber eines metho-
dischen Geistes, dessen Verallgemeinerung
jedenfalls im Prinzip universelle Ordnung
hervorbringen könnte. "L'ordre fondamental
du tableau ne fait qu'expliquer l'ordre caché
des choses, mais au prix d'une réforme fon-
damentale. . . . L'organisation rigoureuse du
tableau implique la conception d'une struc-
ture universelle." Seurat und Piero scheinen
mehr als andere Künstler aus sich selbst und
aus dem naturwissenschaftlichen Weltver-
ständnis ihrer Zeit zu schöpfen. Statt von
Vorgängern beeinflußt zu werden und deren
Bilder, deren Träume zu modifizieren,
nehmen sie die Welt auseinander und bauen
sie wieder zusammen. Für Chastel ist ihre
Kunst dadurch etwas unmittelbarer zu Gott
als das Werk anderer Künstler. Eigentlich
sollte durch diesen Gedanken die Vor-
stellung eines Einflusses Pieros auf Seurat
erledigt sein. "Le génie de Seurat fait un peu
penser au diamant qui ne peut être rayé que
par lui-même."[94]

ANMERKUNGEN

Für Anregungen und Informationen danke ich
Marilyn Aronberg Lavin sowie Albert Boime, Robert
L. Herbert, Christine Kupper, Thomas Lersch, Avra-
ham Ronen und Willibald Sauerländer.

1. Bernard-Henri Lévy, *Piero della Francesca* (Paris,
1992), 44–45; 165. Vgl. auch Martin Warnke, "Vor-
wort," in Carlo Ginzburg, *Erkundungen über Piero.
Piero della Francesca, ein Maler der frühen Renais-
sance,* Übers. Karl F. Hauber (Berlin, 1981), 7–14.

2. Jean-Paul Bouillon, *Maurice Denis* (Genève, 1993),
vgl. bes. 97–125.

3. Henri Perruchot, "Emile Bernard et Cézanne,"
in *Arts et livres de Provence,* 1972, 81, 3–6; Jean-
Jacques Luthi, *Emile Bernard en Orient et chez Paul
Cézanne (1893–1904)* (Paris s. d., c. 1979); Jean-Jacques
Luthi, *Emile Bernard. Catalogue raisonné de l'œuvre
peint* (Paris, 1982); Mary Anne Stevens et al., *Emile
Bernard, 1868–1941. Ein Wegbereiter der Moderne*
[exh. cat., Städtische Kunsthalle Mannheim und
Rijksmuseum Vincent van Gogh] (Zwolle, 1990).

4. Zum Cézanne-Verständnis Picassos und Braques:
William Rubin, "Cézannisme and the Paintings of
Cubism," in W. Rubin, ed., *Cézanne: The Late Work*
[exh. cat., Museum of Modern Art] (New York, 1977),
151–202; Alvin Martin, "Georges Braque and the
Origins of the Language of Synthetic Cubism," in
Isabelle Monod-Fontaine with E. A. Carmean, Jr.,
ed., *Braque: The Papiers Collés* [exh. cat., National
Gallery of Art] (Washington, 1982), 61–85; Mark
Roskill, *The Interpretation of Cubism* (Philadelphia,
1985), 70–77; William Rubin, *Picasso and Braque.
Pioneering Cubism* [exh. cat., Museum of Modern
Art] (New York, Boston, 1989); William Rubin, Kirk
Varnedoe, Lynn Zelevansky, ed., *Picasso and Braque.
A Symposium* (New York, 1992).

5. Zu Gauguin: Richard Brettell et al., ed., *The Art
of Paul Gauguin* [exh. cat., National Gallery of Art,
Washington; Art Institute of Chicago; Grand Palais,
Paris] (Washington, 1988). Zu Paradieses-Visionen
im 19. Jh. und bei den Fauves: Werner Hofmann,
Das irdische Paradies. Kunst im 19. Jahrhundert
(München, 1960); John Elderfield, *The "Wild Beasts."
Fauvism and Its Affinities* [exh. cat., Museum of
Modern Art, New York; Museum of Modern Art,
San Francisco] (New York, 1976); Pierre Schneider,
Matisse (Paris, 1984); Isabelle Monod-Fontaine,
Matisse: Le rêve, ou les belles endormies (Paris,
1989); Margaret Weth, "Engendering Imaginary
Modernism: Henri Matisse's 'Bonheur de Vivre,'
in *Genders,* Nr. 9 (Herbst 1990), 49–74; John Elder-
field et al., *Henri Matisse. A Retrospective* [exh.
cat., Museum of Modern Art] (New York, 1992).

6. Kenneth E. Silver, *Esprit de Corps. The Art of
the Parisian Avant-Garde and the First World War,
1914–1925* (Princeton, 1989).

7. Adolfo Venturi, *Storia dell'arte italiana* (Milano,
1901–1940), vol. 5, *La pittura del trecento e le sue
origini* (1907), vol. 6, *La pittura del quattrocento,*
Teilbände 1–4 (1911–1915); Bernard Berenson, *The
Central Italian Painters of the Renaissance,* 2. ed.
(New York, 1909), 68–75; Adolfo Venturi, *Luca
Signorelli* (Firenze, 1922); Lionello Venturi, *Il gusto
dei primitivi* (Bologna, 1926); *Edizione delle opere
complete di Roberto Longhi,* vol. 1, *Scritti giovanili,
1912–1922* (Firenze, 1956), vol. 3, *Piero della Fran-
cesca (1927. Con aggiunte fino al 1962)* (Firenze,
1963), vol. 8, *Fatti di Masolino e Massaccio e altri
Studi sul Quattrocento. 1910–1967* (Firenze, 1975);
Bernard Berenson, *Piero della Francesca o dell'arte
non eloquente* (Firenze, 1950); Giovanni Previtali,
La fortuna dei primitivi dal Vasari ai neoclassici
(Torino, 1964); August Buck, ed., *Il Rinascimento
nell'Ottocento in Italia e Germania* (Bologna, 1989);
August Buck, ed., *Renaissance und Renaissancismus
von Jacob Burckhardt bis Thomas Mann* (Tübingen,
1990).

8. Maria Mimita Lamberti und Maurizio Fagiolo
dell'Arco, ed., *Piero della Francesca e il novecento.
Prospettiva, spazio, luce, geometria, pittura murale,
tonalismo 1920/1938* [exh. cat., Museo Civico, Sala
delle Pietre, Sansepolcro] (Venezia, 1991).

9. Giorgio Vasari, *Le vite . . . Nell'edizione per i tipi
di Lorenzo Torrentino, Firenze, 1550,* ed. Luciano
Bellosi und Aldo Rossi (Torino, 1986), 337–343;
Giorgio Vasari, *Le Vite . . . (Firenze, 1568),* ed. Paolo
della Pergola, Luigi Grassi und Giovanni Previtali.
Textrevision von Aldo Rossi (Mailand, 1962–1966),
vol. 2, 1962, 375–384.

10. Johann David Passavant, *Ansichten über die
bildenden Künste und Darstellung des Ganges der-
selben in Toscana. Zur Bestimmung des Gesichts-
punktes, aus welchem die neudeutsche Malerschule
zu betrachten ist* (Heidelberg, 1820); Friedrich von
Rumohr, *Italienische Forschungen* (Berlin, 1827–
1831), vol. 2, 40 (ed. Julius von Schlosser) (Frankfurt,
1920), 433, 517. Rumohr spricht im Zusammenhang
der Aretiner Fresken von "dem schwächlichen Geist,
welcher darin sich ausspricht." "Diese Gemälde sind
mit Fertigkeit gemalt, doch sehr maniert." Zu Piero:
"ein Name, auf welchen Alles paßt, weil mit dem
selben gegenwärtig keine Vorstellung zu verbinden
ist; den selbst Vasari sichtlich mehr aus Patriotismus
begünstigt." Stendhal, *Histoire de la peinture en
Italie* (Paris, 1868); Jakob Burckhardt, *Der Cicerone.
Eine Anleitung zum Genuss der Kunstwerke Italiens,*
ed. Wilhelm von Bode und C. von Fabriczy (Leipzig,
1910), 721–723; John Ruskin, *Fors Clavigera. Letters
to the Workmen and Labourers of Great Britain.
1871–1873* (London, 1907), 373; vol. 27 of Edward
Tyas Cook and Alexander Wedderburn, ed., *The Works
of John Ruskin* (London, 1903–1912); Heinrich Wölff-
lin, *Die klassische Kunst. Eine Einführung in die
italienische Renaissance,* 7. ed. (München, 1924).
Wölfflin braucht Piero nicht, um die klassische Er-
füllungskunst gegen die formal und auch emotional
befangenere des Quattrocento abzusetzen. Biblio-
graphie zu Piero-Literatur: Eugenio Battisti, *Piero
della Francesca* (Milan, 1971), vol. 2, 259–310.

11. Pierre Vaisse, "Charles Blanc und das 'Musée des
Copies,' in *Zeitschrift für Kunstgeschichte,* 39, 1976,
54–66; Pierre Vaisse, *La Troisième République et ses*

peintres: Recherches sur les rapports des pouvoirs
publics et de la peinture en France de 1870 à 1914
(Thèse pour l'obtention du doctorat d'Etat, Univer-
sité de Paris-Sorbonne, 1980), 78–80, 162–164, 328–
332; Stefan Germer, Historizität und Autonomie.
Studien zu Wandbildern im Frankreich des 19. Jahr-
hunderts: Ingres, Chassériau, Chenavard und Puvis
de Chavannes (Hildesheim, Zürich, 1988), 96–114
(zur Wandmalerei als Staatskunst); Michael F. Zim-
mermann, Seurat. Sein Werk und die kunsttheoreti-
sche Debatte seiner Zeit (Antwerpen, 1991), 28–41
(zu Charles Blanc); Patricia Mainardi, The End of the
Salon. Art and the State in the Early Third Republic
(Cambridge, 1993), 15, 40–46, 58; Piero della Fran-
cesca e il novecento, Hrsg. Maria Mimita Lamberti
und Maurizio Fagiolo dell'Arco [exh. cat., Museo
Civico, Sansepolcro] (Venezia, 1991), 193.

12. Charles Blanc, Histoire des peintres de toutes
les écoles. Ecole ombrienne et romaine (Paris, 1870),
17–25: Piero della Francesca.

13. Blanc 1870, 1.

14. Joseph Archer Crowe and Giovanni Battista
Cavalcaselle, Geschichte der italienischen Malerei
(Leipzig, 1869–1872), vol. 4, 1. Hälfte, Umbrische
und sienesische Schule des XV. Jahrhunderts (1871).
Äußern sich die Autoren hier noch sehr einschrän-
kend, fast abfällig zu Piero, so hat sich ihre Einschät-
zung bald gewandelt. Vgl. Crowe, Cavalcaselle, A
New History of Painting in Italy, ed. Edward Hutton
(London, New York, 1908), 1–24.

15. Blanc 1870, 4.

16. Blanc 1870, 6.

17. Charles Blanc, Histoire de la Renaissance en
Italie, vol. 2 (Paris, 1894), 97, 101.

18. Blanc 1894, 106.

19. Eugène Müntz, Les précurseurs de la Renais-
sance (Paris, 1882), 100.

20. Eugène Müntz, Histoire de l'art pendant la
Renaissance, vol. 1: Italie. Les Primitifs (Paris, 1889),
627–633.

21. Müntz 1889, 632–633.

22. Adolfo Venturi, Storia dell'arte italiana. VII.
La Pittura del Quattrocento, Parte I (Milano, 1911),
432–486. Vgl. Sergio Samek Ludovici, Storici, teorici
e critici delle arti figurative (1800–1940) (Roma,
1942), 360–373.

23. Vgl. Lodovici 1942, 206–207; Giovanni Previtali,
ed., L'arte di scrivere sull'arte. Roberto Longhi nella
cultura del nostro tempo (Roma, 1982); Paragone,
XLII, Nuova Serie Nr. 30 (501), November 1991,
Dedicato a Roberto Longhi.

24. Carlo Carrà, Soffici. Editions de "Valori Plastici"
(Roma, 1922); Ardengo Soffici, Opere, vol. 1–7
(Firenze, 1959–1968) (a cura dell'autore); Giuseppe
Raimondi und Luigi Cavallo, Ardengo Soffici, con
la collaborazione della galleria Michaud (Firenze,
1967); Ardengo Soffici. L'artista e lo scrittore nella
cultura del 900. Atti del convegno di studi, Villa

Medicea, Poggio a Caiano, 7.–8. giugno 1975
(Firenze, 1976); Carlo Carrà, Ardengo Soffici, Lettere
1913/1929, ed. Massimo Carrà und Vittorio Fagone
(Milano, 1983); Luigi Cavallo, Soffici immagini e
documenti (1879–1964), mit Indices zu den Opere
Sofficis (1959–1968) von Oretta Nicolini (Firenze,
1986); M. Biondi, ed., Ardengo Soffici: un bilancio
critico. Atti del convegno, Gabinetto Vieusseux,
Firenze, 16.–17. ottobre 1987 (Firenze, 1990); L.
Corsetti und R. Gradi, Rassegna bibliografica su
Ardengo Soffici (1985–1991) (Poggio a Caiano, 1991);
Luigi Cavallo, ed. Ardengo Soffici [exh. cat., Palazzo
della Permanente, Milano] (Milano, 1992).

25. Roberto Longhi, "La scultura futurista di
Boccioni," Libreria della "Voce" (Firenze, 1914).

26. Ardengo Soffici, "L'Impressionismo e la pittura
italiana," 1909, in Opere, vol. 1, 1959, 3–29.

27. Ardengo Soffici, "Le Salon d'Automne. Consi-
dérations," in L'Europe artiste, vol. 1, s. n., Octobre-
Novembre 1904, 333–339, in Mario Richter, La
formazione francese di Ardengo Soffici, 1900–1914
(Milano, 1969), 290–296.

28. Brief Sofficis an Papini, wahrscheinlich Juni
1906, erstmals in Richter 1969, 78–79.

29. Vittorio Pica, Gl'Impressionisti Francesi
(Bergamo, 1908), 201.

30. Alessandro Marabottini und V. Quercioli, Diego
Martelli. Corrispondenza inedita (Roma, 1978);
Piero Dini, Diego Martelli e gli Impressionisti
(Firenze, 1979).

31. Diego Martelli, "La pittura del Quattrocento a
Firenze," in Diego Martelli, Scritti d'Arte di Diego
Martelli, ed. Antonio Boschetto (Firenze, 1952),
162–179.

32. Diego Martelli, "Gli Impressionisti" (Vortrag
1879 im Circolo filologico di Livorno. Erstmals 1880
in Pisa gedruckt), in Scritti d'Arte di Diego Martelli,
1952, 98–110, 106, 108.

33. Vermittelt etwa durch Paul Signac, De Dela-
croix au Néo-Impressionnisme (1898 in La Revue
Blanche), ed. Françoise Cachin (Paris, 1964, 1987),
oder durch futuristische Schriften über den com-
plementarismo congenito.

34. Roberto Longhi, "Piero dei Franceschi e lo
sviluppo della pittura veneziana," in L'Arte, 1914,
198–221, 241–256.

35. Fiora Bellini, "Una passione giovanile di Roberto
Longhi: Bernard Berenson," in Giovanni Previtali,
ed., L'Arte di scrivere sull'arte. Roberto Longhi nella
cultura del nostro tempo (Roma, 1982), 9–26.

36. Berenson 1909.

37. Adolfo Venturi, Piero della Francesca (Firenze,
1922), 65–67.

38. Gino Severini, Du cubisme au classicisme.
Esthétique du compas et du nombre, 4ème éd. (Paris,
1931); Gino Severini, Dal cubismo al classicismo e
altri saggi sulla divina proporzione e sul numero

d'oro, ed. Piero Pacini (Firenze, 1972); Joan M. Lucach, "Severini's Writings and Paintings 1916–1917 and His Exhibition in New York City," in *Critica d'arte*, 21, 1974, 138, 59–80; Maurizio Fagiolo dell'Arco, Ester Coen and Gina Severini, *Gino Severini. "Entre les deux guerres." 1919/1939* [exh. cat., Galleria Giulia, Roma] (Pomezia, 1980); Maurizio Fagiolo dell'Arco and Daniela Fonti, *Gino Severini* (Milano, 1982); Gino Severini, *La vita di un pittore*, Vorwort von Filiberto Menna (Milano, 1983); Gino Severini, *Ecrits sur l'art* (Paris, 1987); Marisa Vescovo, ed. *Gino Severini. Dal 1916 al 1936* [exh. cat., Palazzo Cuttica, Alessandria] (Torino, 1987); Daniela Fonti, *Gino Severini. Catalogo ragionato* (Milano, 1988).

39. Silver 1989, 85–86, 151–154.

40. Gino Severini, *Du Cubisme au Classicisme: Esthétique du compas et du nombre* (Paris, 1921), 13–14.

41. Severini 1921, 16–17.

42. Severini 1921, 19–20.

43. Severini 1921, 20–21.

44. Severini 1921, 120–121.

45. Severini 1921, 122.

46. Gino Severini, *La vita di un pittore*, 1983, 237.

47. Silver 1989. Diese Studie ist Ken Silvers Buch in jeder Hinsicht verpflichtet.

48. Massimo Carrà, *Carrà. Tutta l'opera pittorica*, vol. 1–3 (Milano, 1967–1968); Piero Bigongiari, *L'opera completa di Carrà. Dal futurismo alla metafisica e al realismo mistico 1910–1930* (Milano, 1970); Massimo Carrà, ed. *Carlo Carrà. Tutti gli scritti* (Milano, 1978); Paolo Fossati, "Carrà—Longhi 1920. Una definizione di critica d'arte," in *Paragone*, 36, 1985, 419–423, 286–296; *Carlo Carrà—Retrospektive* [exh. cat., Staatliche Kunsthalle Baden-Baden] (Mailand, 1987); Maurizio Fagiolo dell'Arco, ed., *Carlo Carrà. Il primitivismo 1915–1919* [exh. cat., Chiesa di Bartolomeo, Venezia] (Milano, 1988); Claudio Pizzorussi, "I neo-tradizionalisti," in *L'Idea di Firenze*, 1989, 259–266.

49. Carlo Carrà, "Il Seicento e la critica italiana," in *Valori Plastici*, Nr. 4, 1921, 223. Carrà zitiert in diesem Text einen eigenen, zwei Jahre zuvor verfaßten Artikel.

50. Ardengo Soffici, "Carlo Carrà," *Arte Moderna Italiana*, Nr. 11 (Milano, 1928), 8–9.

51. Pietro Maria Bardi, *Carrà e Soffici* (Milano, 1930), 9–11, 45–46.

52. Zum historischen Hintergrund: Renzo de Felice, *Fascismo e Partiti Politici Italiani 1921–1923* (Bologna, 1966); Clark 1984, 203–285.

53. Zur Kunstpolitik und zur Kunst während des Faschismus: Philip V. Cannistaro, *La fabbrica del consenso* (Roma–Bari, 1975); Annette Malochet, "Novecento. Point d'ordre?" in *Le Retour à l'ordre dans les arts plastiques et l'architecture 1919–1925. Actes du second colloque d'histoire de l'art con-* temporaine tenu au Musée d'Art et d'Industrie de Saint-Etienne, 1974 (Paris, 1975), 203–208; Fanette Roche-Pézard, "Valori Plastici 1918–1921: Ordre Plastique, Ordre Moral, Ordre Politique," in *Le Retour à l'ordre*, 1975, 225–240; Susanne von Falkenhausen, *Der Zweite Futurismus und die Kunstpolitik des Faschismus in Italien von 1922–1943* (Frankfurt am Main, 1979), besonders 78–98; Paolo Fossati, "Pittura e scultura fra le due guerre," in *Storia dell'arte italiana*, vol. 7, *Il Novecento* (Torino, 1982), 175–259.

54. Carlo Carrà, Ardengo Soffici, *Lettere 1913/1929* (1983), 157, 162–163.

55. Der Tonfall der Briefe Carràs und Soffici ändert sich seit c. 1920 kaum. Vgl. Carrà, Soffici 1983, 139, 148.

56. Carlo Carrà, "Piero della Francesca," in *L'Ambrosiano*, 5. September 1927, 382.

57. Carlo Carrà, "Fatti e dibattiti per il rinnovamento della pittura," in *Il rinnovamento delle arti in Italia* (Milano, August 1945), 581.

58. Roberto Longhi, *Carrà* (Milano, 1945), 10.

59. Longhi 1945, 15.

60. Richard Shiff, *Cézanne and the End of Impressionism* (Chicago, 1984), 44–51.

61. Zimmermann 1991, 279–321.

62. Anita Brookner, *The Genius of the Future. Studies in French Art Criticism: Diderot, Stendhal, Baudelaire, Zola, the Brothers Goncourt, Huysmans* (London, 1971); Jean-Paul Bouillon, Nicole Dubreuil-Blondin, Antoinette Ehrard, Constance Naubert-Riser, *La Promenade du critique influent. Anthologie de la critique d'art en France 1850–1900* (Paris, 1990); Michael F. Zimmermann, ""Il faut tout le temps rester le maître et faire ce qui amuse." Zum Stand der Debatte um Manet," in *Edouard Manet. Augenblicke der Geschichte* [exh. cat., Kunsthalle Mannheim] (München, 1992), 132–148.

63. Shiff 1984, 52.

64. Robert L. Herbert, "Le "papier de Gauguin," in Françoise Cachin und Robert L. Herbert, ed., *Seurat* [exh. cat., Réunion des Musées Nationaux, Paris; Metropolitan Museum of Art, New York] (Paris, 1992), 447–448.

65. Shiff 1984, 127–129.

66. Maurice Denis, "De Gauguin et de van Gogh au Classicisme," in *L'Occident*, Mai 1909.

67. Albert Gleizes, Jean Metzinger, *Du Cubisme* (Paris, 1912), 40.

68. Gleizes, Metzinger 1912, 41.

69. Gleizes, Metzinger 1912, 54–57.

70. Gleizes, Metzinger 1912, 57.

71. Guillaume Apollinaire, *Les peintres cubistes* (Paris, 1913).

72. Lucie Cousturier, "Les dessins de Seurat," in *L'Art Décoratif*, Paris, March 1914.

73. André Salmon, *La révélation de Seurat* (Paris, 1921).

74. Le retour à l'ordre 1975; Charles–Edouard Jean-
neret, Juan Gris und Amédée Ozenfant, *Après le
Cubisme* (Paris, 1919, reprint Turin, 1975). Zu Ozen-
fant: Amédée Ozenfant, *Mémoires 1886–1962* (Paris,
1968); John Golding, *Ozenfant* (New York, 1973);
Susan L. Ball, *Ozenfant and Purism. The Evolution
of Style, 1915–1930* (Ann Arbor, Mich., 1981); Fran-
çoise Ducroz, "Ozenfant et l'esthétique puriste: une
géométrie de l'objet," in *Cahiers du Musée National
d'Art Moderne*, 1983, 268–283. Zu Le Corbusier:
Paul Venable Turner, *The Education of Le Corbusier*
(New York und London, 1977), 136–195; besonders
144–155 (zu *Après le Cubisme*); *Le Corbusier. Pittore
e scultore* [exh. cat., Museo Correr, Venezia] (Milano,
1986); Reyner Banham, "*La Maison des hommes* and
La Misère des villes: Le Corbusier and the Architec-
ture of Mass Housing," in H. Allen Brooks, ed., *Le
Corbusier* (Princeton, 1987), 107–116; Stanislaus
von Moos, ed., *L'Esprit Nouveau. Le Corbusier et
l'industrie 1920–1925* [exh. cat., Museum für Gestal-
tung, Zürich; Bauhaus-Archiv, Berlin; Les Musées
de la ville de Strasbourg; Centre culturel Suisse,
Paris] (Berlin, 1987) (vgl. den Aufsatz von Françoise
Ducroz, "Le Purisme et les compromis d'une 'pein-
ture moderne,'" 66–79); Paul Venable Turner, *La for-
mation de Le Corbusier. Idéalisme et mouvement
moderne* (Paris, 1987); Marina Causa Picone, "Auto-
nomia e dipendenza di Le Corbusier pittore," in
Scritti di storia dell'arte in onore di Raffaele Causa
(Napoli, 1988), 439–451. Zu Hélion: René Micha,
Hélion (Paris, 1979). Zu Lhote: André Lhote, *Georges
Seurat* (Roma, 1922); André Lhote, *Ecrits sur la pein-
ture* (Paris, 1946); Nathalie Reymond, "Le rappel à
l'ordre d'André Lhote," in *Le retour à l'ordre 1975*,
209–224; *André Lhote. Rétrospective 1907–1962.
Peintures, aquarelles, dessins*, préface de Bernard
Dorival [exh. cat., Artcurial] (Paris, 1981); André Lhote,
Alain Fournier und Jacques Rivière, *La peinture,
le cœur et l'esprit. Correspondance inédite (1907–
1924)*, ed. Alain Rivière et al. (Bordeaux, 1986).

75. Ozenfant, Jeanneret, *Après le Cubisme* (Paris,
1918), 59.

76. Ozenfant, Jeanneret 1918, 26.

77. Zur Neubewertung Seurats in den zwanziger
Jahren vgl. Silver 1989, 336–339.

78. Lhote 1922.

79. Amédée Ozenfant, "Seurat," in *Cahiers d'Art*, 1926.

80. Claude Roger-Marx, "Georges Seurat," in
Gazette des Beaux-Arts, Dezember 1927, 311–318.

81. Jacqueline V. Falkenheim, *Roger Fry and the
Beginnings of Formalist Art Criticism* (Ann Arbor,
Mich., 1980), 15–17.

82. Falkenheim 1980, 101.

83. Shiff 1984, Kap. 10, 143–152.

84. Roger Fry, *The French Post-Impressionists.
Preface to the Catalogue of the Second Post-impres-
sionist Exhibition* [exh. cat., Grafton Galleries]
(London, 1912), 158.

85. Fry 1912, 159.

86. Roger Fry, "Art and Science," in *Athenaeum*,
1919; wieder in Roger Fry, *Vision and Design*
(London, 1920), 52–55.

87. Roger Fry, *Transformations. Critical and
Speculative Essays on Art* (London, 1926), 188–196;
"Seurat," 188, 190.

88. Fry 1926, 191, 196.

89. Robert Rey, *La peinture française à la fin du XIXe
siècle: La renaissance du sentiment classique. Degas–
Renoir–Gauguin–Cézanne–Seurat* (Paris, 1931).

90. Alfred Barr, *Cubism and Abstract Art.*
Metropolitan Museum of Art (New York, 1936).

91. Roberto Longhi, "Un disegno per 'La Grande
Jatte' e la cultura formale di Seurat," in *Paragone*,
1950, 40–43.

92. Henri Focillon, *Piero della Francesca* (Paris, 1952).

93. Henri Focillon, "Le Salon de 1926," in *Gazette
des Beaux-Arts*, 1926.

94. André Chastel, *Tout l'œuvre peint de Seurat*
(Paris, 1973), 5, 7, 8. Vor Chastel vertrat Albert
Boime die These eines Einflusses Pieros auf Cézanne.
Vgl. dessen: "Seurat and Piero della Francesca," in
Art Bulletin, 1965, 265–271. Boime vertritt diese
Auffassung nicht mehr.

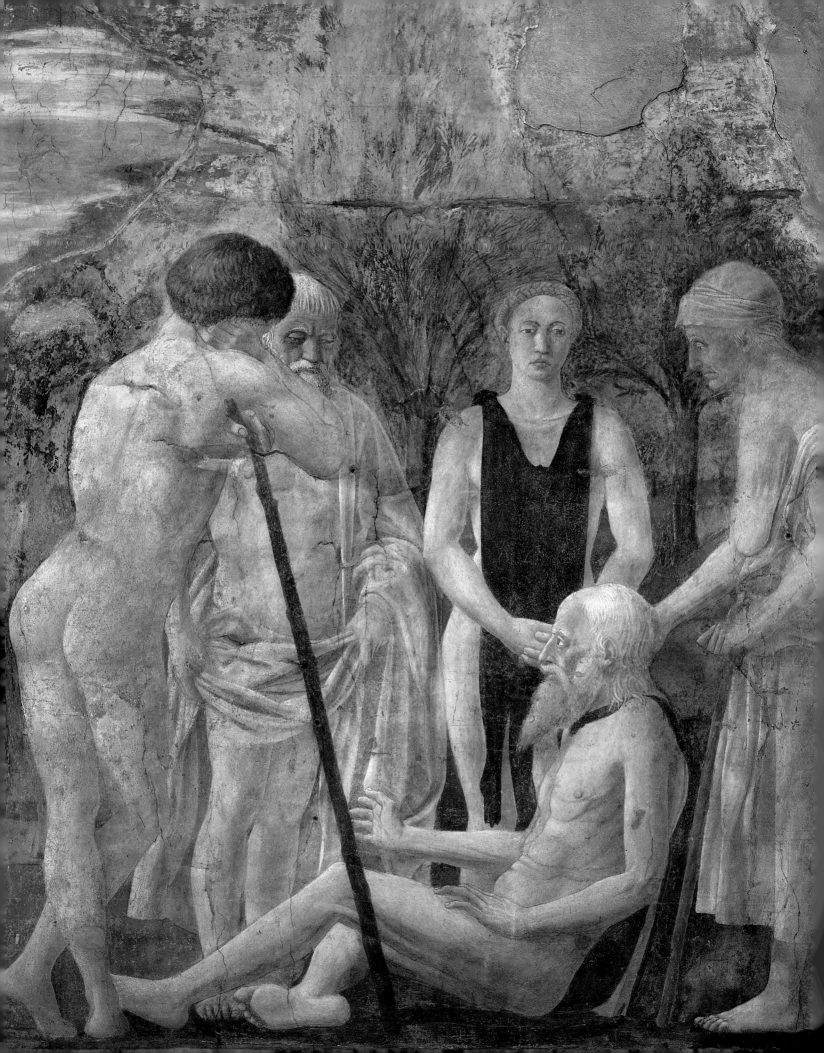

ROSALIND E. KRAUSS
Columbia University

The Grid, the True Cross, the Abstract Structure

I n 1923 Léon Rosenthal presented the work of Piero della Francesca to the readers of *L'Amour de l'art* in a move that Bernard Berenson would later condescend to describe as typical of those "painters, and critics who suck paint-brushes, as well as the culture-snobs who hang upon the critic's lips," all of whom were busy at the time, he said, seeking "a justification from the past for their worship of Cézanne."[1] Of course, by the early 1920s, the worship of Cézanne had already undergone several transformations, and the context Rosenthal himself was addressing was the one the purist painters Amédée Ozenfant and Édouard Jeanneret had already christened *Après le cubisme*: a post-cubist practice most fully represented by the work of Fernand Léger and most insistently theorized in the magazine *L'Esprit Nouveau*, particularly through the voice of Le Corbusier.[2]

"It's because I've recognized in Piero's work special affinities with the best painters of our time that I want to call your attention to him," Rosenthal begins, explaining that "what Piero shares with contemporary painters is the need for rhythm, synthesis, construction."[3] But after talking about Piero's stripping away of extraneous detail to assimilate his personages to the universalizing geometry of what appears to be a set of

Platonic solids, Rosenthal turns to another characterization of Piero that was in fact more important to the artistic clientele he was addressing. This had to do with the analysis of the surface of Piero's paintings into a rhythmic network of modular grids.

Citing the characterization given by a contemporary art historian, Rosenthal speaks of the way the works "are rigorously organized by means of a schema of line that constitutes their armature or webbing." Turning to the Arezzo frescoes and particularly to the section representing the death of Adam, he tells his readers that they can easily analyze for themselves the linear network in whose grip they are unconsciously held fast:

Take a ruler and you will see a contour initiating a straight line that is prolonged with great exactitude by a neighboring figure. Thus, the leg of Adam and the forearm of Eve; the right arm of the young man leaning on a stick and the right forearm of the young man facing outward; the tree in front of Eve and the left arm of Adam . . . And: by an even more refined harmonic, the intersections of lines are not drawn in a chance and empirical manner. Most of the angles systematically have the same aperture. In the Death of Adam the 135 degree angle repeats almost constantly. That this is intentional and not fortuitous, I can furnish an obvious proof. The line of Eve's chest forms the typical angle with the lower line of her right forearm, but the arm not being cylindrical, the angle formed with the upper line of this forearm is too obtuse. In

Piero della Francesca,
Death of Adam, 1452–1466,
fresco (detail)
San Francesco, Arezzo;
photograph: Alinari

For Louis Marin

order to narrow this separation, Piero has drawn an undulation in the earth just behind her that reestablishes the rhythm. . . . The Death of Adam is a symphony in 135 degrees with harmonies of 110 degree angles.[4]

Twenty-five years later, as the painter André Lhote looked back on this period, he was led to cite Rosenthal and his evocation of the golden section. Under the same image of the dying of Adam, he quotes the sentence about the symphony of the 135° angle, which he introduces with: "In the heroic days of cubism, three painters were especially invoked: Ingres for his deformations derived from those of the Egyptians, and Uccello and Piero for their regulating lines based on divine proportions."[5]

Lhote's use of the term "regulating lines" when speaking about Piero's linear network betrays, of course, his earlier commitments to purism, for which two notions—the plastic invariant and the *tracé régulateur*—were fundamental. Although Le Corbusier had described the regulating lines early on in his famous article by that name in *L'Esprit Nouveau*, in relation to the analysis of building façades, Lhote explains the basic relationship the regulating lines have to the three-dimensional lattice constructed by means of central point perspective.[6] "The invention of perspective," he says, "is connected to that of the regulating lines, which are to the picture what the architectural 'module' is to the construction of temples and palaces." Because if the perspectival lattice orders and regulates the spatial array according to a fixed unit of measure, it does so in a way that nonetheless depends on a successive reading as the eye penetrates layer after layer of fictive depth. It is the genius of the regulating lines, Lhote argues, to transform this depth into pure surface, to turn successiveness into synchrony. It is through their repetition across the single, planar surface of the pictorial field that the ultimate goal of art can be achieved, which, he claims with Ozenfant and Le Corbusier before him, is unity.[7]

The distillation of the perspective lattice into the planar web of the regulating lines is a merely fancier, more technical way of saying what in the popular imagination has been the self-appointed task of modernist art, as the fullness and extension of illusion-istic space was contracted onto the zero degree of depth of the painting's flat surface. Indeed, nothing seemed to represent this contraction to flatness more ruthlessly and completely than the grid, whose own paper-thin two-dimensionality seemed to describe nothing so perfectly as the material facts of that surface itself. As in one practice after another—from the analytic cubism of Picasso, to the neoplasticism of Mondrian or the purism of Léger, to the *Cercle et Carré* pictures of Herbin, or the Black Mountain work of Albers—the grid cast and recast its net over the pictorial event always to redefine it in the terms of the planar surface, modernist art seemed to have been endowed with its most telling paradigm. And, if the grid is the name of this paradigm, then somehow standing behind it, legitimating it from the depths of the past, was Piero della Francesca—or at least this is how it seemed to a particular sensibility for which the names Le Corbusier, Léger, and Lhote are only three of a vast number of possibilities.

But their reading of Piero, represented by the passage from Rosenthal's essay, seems of course tremendously limited in the light of a very different way of theorizing the activity of the grid in Piero. It is to this competing theorization that I intend to turn in order to be able to examine modernist assumptions about the grid in the light of *it*.

The theorization I have in mind is structuralist, and it was put forward by Louis Marin in 1985, although such a reading is consistent with the work Marin had been doing on painting for the fifteen previous years.[8] This is most particularly so since Marin was tremendously focused on the question of deictics, that is, the condition that pictures have (but written texts do not) of being physically present to their viewers. This is a presence that central point perspective not only articulates but insists upon, since the trajectory set up by the viewing- and vanishing-point axis is a form of pointing, as though the picture were taking aim at the viewer in a mode of address that has to be defined as "here" and "now" and directed to the onlooker as "you." What interested Marin in this deictic (or, in the terms of Emile Benveniste, this discursive mode) was its seeming incompatibility with storytelling which was, after all, the major

preoccupation of those Renaissance and baroque artists for whom history painting, or narrative, was the highest form of their medium.[9] Taking a structuralist view of the matter, Marin agreed with Benveniste that historical narrative implies another modality altogether from that of spoken discourse, one in which all direct (or deictic) forms of address—you, here, now—are suppressed in favor of an impersonal, indirect form that speaks of its characters in the third person only—he, she, they—and from the safe and objective vantage point of the past. Therefore Marin came to the phenomenon of history painting or of narrative cycles as to a great paradox, an intellectual puzzle he was continually astonished by, and all the more so as he looked at instance after instance of the different and extraordinary feats of art through which this paradox was resolved.

Thus when faced with the great narrative of the Arezzo frescoes, Marin began with the curious fact that the deictic connection is itself narrativized in the story the frescoes celebrate, since the fact of being there in a particular place and at a particular time, namely, the Bacci Chapel on the third of May, places the viewer of the frescoes in a liturgical relation to an event that is itself depicted in the frescoes—Saint Helena's finding of the True Cross—but an event that is simultaneously a finding and a refinding and thus a present that is also a past. This is to say that to be witness to this event is simultaneously to be flipped back into historical time, since the cross itself, discovered "today," had already been discovered not once but four times previously, and thus wore its past somehow within it and perhaps at right angles to the deictic axis that connects one to its finding in the present.

This figure of the *right angle* is not summoned randomly here. Indeed, Marin considered the lateral progression of writing, ignoring as it does the presence of the viewer and closing its space along the surface of the page, as transecting the trajectory of vision piercing across it into depth. It was this right angle of reading versus viewing that formed the basis, for example, of the analysis he made of Poussin's *Et in Arcadia Ego* with its sliding of the deictics of perspective under the transversal parade of the inscription on the tomb in order to mask the immediacy of address in the present and to convert it into an utterance that can only come from the past.[10]

But if the figure of the right angle has to be synthesized in the case of Poussin from the transection of writing's axis with that of vision, it comes ready-made so to speak in the instance of Piero, since the cross itself is the most absolute emblem of two intersecting directions. Thus a cross that is present which is simultaneously a cross that is past can already be seen to carry this potential for two opposing temporal vectors in the very weft of its simplest physical description. Thus the cross is simultaneously a figure (a cross) and a schema (a crossed axis); the first the object in space, the second what could be said to be a thought about that object, or the means in which that object is displaced—propelled from the spatial into the temporal: the cross one finds in the present that has already been discovered four times. The crossed axis as the structural operator of history or the conversion of present into past is thus for Marin not so much the object of the story—the True Cross—as it is its subject, a modality of consciousness of it.

There is a further axial relationship to which a structuralist is particularly sensitive, namely, the relation between what is often articulated as the horizontal plane of syntax—as the sentence unravels one word after another—and the vertical stacking of alternatives or substitutions for each term in the horizontal chain. *Syntagm*, or the sequential unrolling of the sentence or telling of the narrative, is thus contrasted with and indeed intersected by *paradigm*, which implies the symbolical levels of the tale.

That the story of the cross involves a syntagmatic chain, as in the course of its history before the Passion it undergoes its fourfold transformations from tree of knowledge to branch to tree to beam to bridge, only finally to be fashioned as the cross of the crucifixion, already prefigures, of course, the sense in which the cross itself is invested with paradigmatic values that transcode it into cosmological and allegorical levels of meaning. For Saint Augustine had explained that the axes of the cross map the four dimensions of the world: height, width, breadth, and depth—the latter being the space beneath

the surface of the earth into which the cross had originally been driven. And further, because each of these physical dimensions is determined by the Passion—marking either the attachment of Christ's body to the cross or the cross' own attachment to the ground—each is metaphorically elaborated by Saint Augustine: the cross beam where Jesus' hands were stands for the good works accomplished through Christ; the place of the body is equivalent to the love of Jesus; the site of the head opens onto belief in heavenly bliss; and the securing to the ground symbolizes the duty of not profaning the sacraments. It is on this symbolic level as well that the cross is secured as pure sign, rising so to speak above its merely objective role in a narrative or syntagm to operate beyond space or time in the perpetual present of the efficacy of belief as trace or relic invested with symbolic power.

Now the story of the True Cross is in a certain sense the story as well of a point of view, one that can cut through the extraordinary physical transformations of the object to perform an act of recognition which restructures the narrative of change and of time into the symbolic force of the cross' meaning, its true transformative power which operates for the believer in an eternal "now." Within the perspective system there is, obviously, a pole specifically reserved for a point of view; and this pole, occupied by the crystalline lens of the viewer's eye, is itself designated by Piero as cruciform in nature. Which is to say that if the perspectival lattice that maps geometrical space is able to connect to the visual apparatus of the beholder *truly*, it is because that apparatus—human vision—is also constructed by means of a grid: as the nerves that carry visual impulses cross at right angles through the center of the eye. The truth of vision, set in place by this structural mirroring of nerve connections and visual rays, already serves as the basis, we could say, for vision's access to the truth marked out here as one of recognition. Once again, then, there is an axial crossing operated less by an object in space than by a subject who by assuming a point of view performs the switch from syntagm to paradigm, from spatial object to miraculous relic, from figure to sign.

For Marin, the genius of the Arezzo frescoes is that Piero brings all these axes into coordination with one another, all these crossings—the present and the past; the sequence and the symbol; the object in space and the viewer's position on it—all these right angles which themselves intersect. For each right angle is simultaneously an object to be operated on and a subject or structural operator that performs these operations. And it is important to insist that the fact that Piero instantiates these operations within the frescoes makes the structuring network or matrix of relationships no less abstract.

Two examples of the instantiation will suffice. The Sheba and Solomon fresco involves a single visual field occupied by temporally distinct though sequentially connected parts of the narrative: Sheba on her way to visit Solomon, refusing to cross the bridge thrown over a stream leading to his palace since she recognizes in its timber the sacred meaning of the wood, venerates it instead, and then, having entered the scene from left to right, she must, in order to come before Solomon, which she does from right to left, go around the stream, tracing in her own movements the trajectory—syntagmatic and spatial—of the cross. Yet the possibility of her recognition is also enacted by the transformative structure which itself is the operator of the meaning to vision in the here and now. Thus Piero manipulates the perspective to produce the extreme spatial recession of the colonnade of Solomon's palace such that we experience its façade as having contracted to a single column, becoming thus a vertical strikingly set at right angles to the transversal beam of the "bridge" at Sheba's feet. Separated temporally, the two scenes nevertheless fuse spatially and metaphorically to configure a cross and thus both to enact the polymorphic transformations of the holy wood while inside Solomon's palace (as it was explained: "The tree of the cross is neither long nor short, neither wide nor high because it is simultaneously long, short, wide, and high") and to register the point of view from which these transformations gain their symbolic force.

The second example involves the scene of the finding and proofing of the cross, where on the syntagmatic or narrative axis the powers of the True Cross perform the resus-

citation of a dead man, even while spatially the dimensions of the cross—height, width, breadth, and depth—are reinforced by the placement of the figures grouped around it, dimensions that are in turn given their expanded allegorical meaning as, for instance, the retinue of Saint Helena kneeling at the point where the vertical of the cross touches the ground are in fact shown to be observing the sacraments. But the subjective dimension of the story, transforming the cross from an actual object into a sign and thus displacing it from the site of its effects in the historical past into the deictics of its activity in the present, the liturgical "now," operates along a visual axis, and that is once again the achievement of a conflation between a perspectivally wrought point of view and a recognized icon or sign. As Marin himself writes:

Better yet—and in this, the narrative, its model, and its structure become co-terminous with the representation, with its formal model and with its theory of perspective structure— we note that the transversal bar of the cross operates in the plane of representation as the "view finder," the sight line, of the eye of the man in profile with the conical hat, a line tangent to the two blind oculi decorating the façade of the Renaissance church, in order to lodge itself exactly at the crossing *of the left- most cross, standing in the narrative sequence that precedes the one the spectator is now viewing, as if, inattentive to the present (and represented) miracle that proves its reality, the person in profile—the spectator's on-stage representative—saw in it, retrospectively (in the field of the story but presently and imme- diately in the field of narration), by means of this "view finder" from theoretical perspec- tive, the religious truth that the depicted object offers him via the transversal bar of the cross.*[11]

That such a reading moves far beyond the merely surface or decorative intuition of the grid offered by Rosenthal and taken up by the *tracés régulateurs* goes, it seems to me, without saying. But I would also like to stress that the direction it goes is no less abstract for the fact that it ties together a sense of spatial three-dimensionality and temporal distention with the explosive fact of a here and now. Indeed, it is the structure through which all such dimensions are related and transcoded that is itself abstract.

This means that the modernist grid itself, in order to be seen in its fully abstract condi- tion, must, I think, be submitted to a similar order of structural analysis. To do this I will need to leave the specific historical moment with which I began, in which the purists were celebrating Piero's grids, and to address a far more singular and persistent practice of the grid as that can be discovered in the art of the 1960s. I will thus talk briefly about the case of Agnes Martin, who worked with the grid unceasingly over the course of three decades in a format that never varied—can- vases measuring exactly six by six feet—and in materials that likewise remained con- stant—canvases covered with either pig- mented or plain gesso, scored or articulated by penciled lines, sometimes in graphite, sometimes in colored leads.

Within the current state of critical dis- course, two interpretive positions have con- verged on Martin's work, producing a reading that purports to be definitive about its meaning even while being itself highly symptomatic of the belief system that per- vades contemporary criticism. These posi- tions are first, that the grid defines the objective conditions of the canvas—mainly by redoubling its infrastructural weave; and second, that at the point where the grid has become so fine as to dissolve into a kind of atmospheric haze, as in Agnes Martin's work, the points on the surface start to ges- ture toward a sense of the infinite and the painting takes on a reference to the sublime. That this sublime is further interpreted as crypto-landscape is also a dominant strain in the set of received ideas that circulate around the work, beginning with the kind of associations Robert Rosenblum made between the abstract expressionists and nineteenth-century landscape painting, and continuing to the analyses of Lawrence Alloway or Carter Ratcliff on the specific subject of Agnes Martin in terms of what come to be known as the "abstract sub- lime." As Alloway wrote, Martin's work invites an analogy to nature both "by infer- ence from her imagery and by judging her titles," to which end he cited names such as *Falling Blue, Orange Grove, The Islands,* or *Night Sea.* And obviously in the context of a structuralist assessment of the grid as a true operator of abstractness, I want to claim that

it is no accident that the notion that the grid is a property of the objective surface and the idea that the grid can be used to depict landscape—no matter how diffused or covertly—somehow go hand in hand. For both of these positions are equally referential. So that the "abstract sublime" consideration of Martin's art implies that *atmosphere* or *light* are a given of the paintings, which, like a certain kind of landscape subject—clouds, sea, fields—can simply be observed from any vantage one might take on them. In this reading, the landscape subject, no matter how reduced or abstracted, simply defines the work, is an objective attribute of it, like the color blue, or red.

Within modernism, however, the grid can no more be said simply to signify the objective character of the picture surface than Piero's cross can be thought merely to represent a historically located, physical thing. Rather, like the cross' capacity to function, as well, as the subject of the system of transformation, the modernist grid also has—and this very forcefully—the capacity to body forth the subjective nature of the matrix that receives it. Whether the grid is prefigured in the all-over network of pointillist dots that represent the sensations of light hitting the retina, or whether it is given the character of a lattice through which light passes to penetrate a darkened room—in a kind of representation of spiritual illumination—the grid occupies a subjective rather than an objective pole, and it is in this sense that it becomes the perfect vehicle for the mapping of opticality or what came to be called "vision as such." The grid's structure as pure simultaneity, erasing everything sequential even as it pressed out the last vestiges of shadow or tactility, made it in this sense the treasured emblem of the visual. For the grid to operate as a structure, it must put into play both these aspects—subjective and objective—in an interconnection that approaches Piero's operations of the True Cross.

It could be said that the overwhelming experience of Agnes Martin's paintings is a registration of what I have been calling the purely visual that one feels welling before one in the barely colored cloud that seems to fill the space between oneself and the surface of one of her works. But the close-up view of that surface provides a very different sense of the canvas from this diffused one of "atmosphere." There one is engaged in the work's facture and drawing, in the details of its materiality in all their sparse precision: the irregular weave of the linen, the thickness and uniformity of the gesso, the touch in the application of the penciled lines. In the one careful phenomenological reading of Martin's work, written in the early 1970s by Kasha Linville, this close-up reading is elaborated:

Sometimes her line is sharp, as in an early painting, Flowers in the Wind, *1963. Sometimes its own shadow softens it—that is, it is drawn once beneath the pigment or gesso and then redrawn on top, as in* The Beach. *Most often, her line respects the canvas grain, skimming its surface without filling the low places in the fabric so it becomes almost a dotted or broken line at close range. Sometimes she uses pairs of lines that dematerialize as rapidly as the lighter-drawn single ones. As you move back from a canvas like* Mountain II, *1966, the pairs become single, gray horizontals and then begin to disappear.*[12]

It is this "moving back" from the matrix of the grids of Martin's paintings that creates a second "moment" in their viewing. For here is where the ambiguities of illusion take over from the earlier materiality of a surface redoubled by the weave of the grids; and it is at this place that the paintings go atmospheric. But then, as one steps back even further, the painting closes down entirely, and it becomes completely opaque.

That opaqueness of what is now a third "moment," produced by a distanced, more objective vantage on the work, brackets the atmospheric interval of the middle view. Wall-like and impenetrable, this vantage now disperses the earlier "atmosphere;" and this final result is, as Linville remarks, "to make her paintings impermeable, immovable as stone."

The "atmospheric" is, then, not an objective property of a work by Martin, but rather an integer of a system, one dependent upon the physical displacement of the viewer through space, one in which the hazy is explicitly contrasted to the opaque, the open to the closed, the luminous to the tactile. Which is to say that the three distances that organize the experience make it clear that

/atmosphere/ is an effect set within a structure in which an opposite effect is also at work, and that it both defines and is defined by that opposite.[13] The three distances, that is, transform the experience from an intuition into a system, and convert *atmosphere* from a signified (the content of an image) into a signifier—/atmosphere/—the open member of a differential series: wall/mist; weave/cloud; closed/open; form/formless.

It is Hubert Damisch's book *Théorie du /nuage/*—with the /cloud/ of its title bracketed explicitly as signifier rather than signified—that helps us grasp the structuralist position with regard to this notion of /atmosphere/ as the integer of a differential system. For the cloud, he points out, enters the earliest demonstration of perspective—that of Brunelleschi—precisely as the surfaceless, immeasurable, and thus undepictable element that can only be reflected within the system from the sky above it by being captured on that area of the painting executed in silver leaf which thus acts as a mirror. "The process to which Brunelleschi had recourse for 'showing' the sky," Damisch writes,

this way of mirroring that he inserted into the pictorial field like a piece of marquetry and onto which the sky and its clouds were captured, this mirror is thus much more than a subterfuge. It has the value of an epistemological emblem . . . to the extent that it reveals the limitations of the perspective code, for which the demonstration furnishes the complete theory. It makes perspective appear as a structure of exclusions, whose coherence is founded on a series of refusals that nonetheless must make a place, as the background onto which it is printed, for the very thing it excludes from its order.[14]

It is in this sense that painting understands its scientific aspirations—toward measurement, toward exact knowledge—as always being limited or conditioned by the unformed, which is unknowable and unrepresentable. And if the /architectural/ came to symbolize the reach of the artist's "knowledge," the /cloud/ operated as the lack in the center of that knowledge, the outside that joins the inside in order to constitute it as an inside.

Thus before being a thematic element—functioning in the moral and allegorical sphere as a registration of miraculous vision,

or of ascension, or as the opening onto divine space; or in the psychological sphere as an index of desire, fantasy, hallucination; or, for that matter, before being a visual integer, the image of vaporousness, instability, movement—the /cloud/ is a differential marker in a semiological system. This can be seen, for example, in the extent to which cloud elements are interchangeable within the repertory of religious imagery. "The fact that an object can thus be substituted for another in the economy of the sacred visual text," Damisch writes, "this fact is instructive: the /cloud/ has no meaning that can be properly assigned to it; it has no other value than that which comes to it from those serial relations of opposition and substitution that it entertains with the other elements of the system."[15]

Meaning, according to this argument, is then a function of a system that underpins and produces it, a system—/cloud/ versus /built, definable space/—with its own autonomy, that of painting, which precedes the specifics of either theme or image.

In insisting on the autonomy of system, the structuralist art historians are aware of course of the battle they are opening with the contextualist historians who accuse them of engaging in a kind of formalism that is itself nothing but the blinkered product of ideological construction. Yet much art has been produced within this ideology and in relation to a conception of autonomy; and the rush to move beyond the circumscribed aesthetic sphere to the *hors texte*, the context, the legitimating "real" text, often produces superficial readings, as in the case of leaching out Agnes Martin's painting into the concealed landscapes of the "abstract sublime."

It is, in fact, in an effort to open a more resonant sense of meaning that the structuralists both hold on to a concept of autonomy and are interested in the founding texts of the discipline of art history itself in which autonomy and structure work together. Indeed, it is there that one can find a position that sets up, along with Damisch's /cloud/, a model for Agnes Martin's three distances. For if Alois Riegl insisted on the entirely internal or autonomous evolution of the art of antiquity, fending off all hypotheses about the putative effect of ex-

ternal factors on art's development—whether material, or mimetic, or historical—to posit instead a sweep that continues without gap or deflection from the most ancient civilizations of the Near East through Byzantium, he arrives at an experience of late Roman art that has a particular relevance for our analysis.

Mapping a progression that arises from the desire, externalized via art, to grasp things in the most objective way possible, untainted, that is, by the merely happenstance and contingent vantage point of the viewing subject, he demonstrates the "dialectic" that drives this evolution. Because, in acknowledging the object in terms of almost any level of sculptural relief (that is, in promoting an experience of its tactility), shadow is necessarily admitted into the confines of the object—shadow which, marking the position of the spectator relative to the object, is the very index of subjectivity. "The art of antiquity," Riegl wrote,

which sought as much as possible to enclose the figures in objective, tactile borders, accordingly was bound from the very beginning to include a subjective, optical element; this, however, gave rise to a contradiction, the resolution of which was to pose a problem. Every attempt to solve this problem led in turn to a new problem, which was handed down to the next period, and one might well say that the entire art history of the ancient world consists of a developmental chain made up of such problems and their solutions.[16]

If the Greeks had begun with a haptic objectivism, Roman art could only be called an optical objectivism, one that produced an extreme, almost paradoxical moment of this opticalism, carried out in the service of the object. For when the relief plane itself becomes the "object" whose unity must be preserved, this leads, in examples Riegl drew on from late Roman decorative arts, to the construction of the object itself in terms of a kind of moiré effect, with a constant oscillation between figure and ground depending—and here is where this begins to get interesting for Agnes Martin—on where the viewer happens to be standing. Writing that now "the ground is the interface," Riegl describes the fully optical play of this phenomenon once what had formerly been background emerges as *object*: "The rela-tionship of the bronze buckle alters with each movement of its wearer; what was just now the light-side can become at the next moment shadow-side."[17]

Since this figure/ground fluctuation varies with the stance of the viewer, one might argue that the object, now fully dependent upon its perceiver, has become entirely subjectivized. And indeed, although Riegl argues that this development ultimately gave rise to the subjective as a newly autonomous problem for the history of art, one that would fulfill itself in the efforts, for example, of seventeenth-century Dutch portraitists to portray something as nonobjective as states of attention, he does not read this late Roman moment as itself subjective. Rather, he wants to argue, with this optical glitter organized into the very fabric of the object, it is the subject-viewer who has been fractured, having now been deprived of the security of a unitary vantage. This is still the *Kunstwollen* of objectivism at work, he argues, but in the highest throes of its dialectical development. The filigrees of late Roman relief, far from being a regression to a more ancient or barbaric linearism, are instead the sublation of this aesthetic problem.[18]

Agnes Martin's persistent claim to be a classical artist—along with the full complement of Egyptians, Greeks, and Copts who make up Riegl's objectivist *Kunstwollen*—has been in the main disbelieved by her interpreters.[19] How can her interest in formlessness, it is argued, be reconciled with such a claim, given classicism's complete commitment to form? When Martin observes, approvingly, "You wouldn't think of form by the ocean," or when she says that her work is about "merging, about formlessness, breaking down form," this is thought to underwrite the idea that she has transcended classicism for a newly ardent and romantic attitude toward the sublime.

Yet let us take Martin at her word and allow her her affiliations to a classicism that, in Riegl's terms, would commit her to an objectivist vision, no matter how optically fractured, and to a place within a development internal to the system of art, a system within which the visual signifier /cloud/ has a foundational role to play.

This objectivism, unfolding within the twentieth century, would itself have to be

seamed into the fully subjectivist project that was put in place following the Renaissance, a Cartesian project that has only intensified steadily into the present. Except that at the beginning of the century, modernist painting opened up what we could call an "*objectivist* opticality" (and here I am inverting Riegl's "optical objectivism" of the late Roman filigree to fit the new circumstances). This means that within an ever growing dependence of the work on the phenomenology of seeing (and thus on the subject), modernism set out on an attempt to discover—at the level of pure abstraction—the objective conditions, or the logical grounds of possibility, for the purely subjective phenomenon of vision itself.

It is in this context that the grid achieves its historical importance: as the transformer that moved painting from the subjective experience of the *empirical* field—what it means to see things—to the internal grounds of what could be called subjectivity as such, subjectivity now construed as a logic—that is, what it means to see anything at all. Its efficiency in this regard arises from the way the grid not only displays perfectly the conditions of what has been called the *visual*—what I pointed to before as the simultaneity of vision's grasp of its field dissolving the spatial (tactile) separation of figure *against* ground into the continuous immediacy of a purely optical spread—but also repeats the original, antique terms of a desire for extreme clarity. Like the Egyptian relief, the grid both enforces a shadowless linearity and is projected as though seen from no vantage at all. At least this is so in what could be called the classical period of the modernist grid, for which Mondrian would stand as the prime figure.

Let us say further that this attempt to grasp the logical conditions of vision was, like the dialectic of the ancient drive toward the utterly independent object, continually forced to include its opposite. For as the grid came to coincide more and more closely with its material surface and to begin actually to depict the warp and weft of its canvas support, this supposed "logic of vision" became infected by the tactile. Two of the possible outcomes of this tactilization of what I have been calling an "objectivist opticality" are: (1) to materialize the grid lines themselves, as when Ellsworth Kelly constructs the network of *Colors for a Large Wall* out of sixty-four separate canvases (nonetheless retaining the optical or the indefinite in the form of chance);[20] or (2) to make the optical a function of the tactile (kinesthetic) field of its viewer, that is to say, the succession of those viewing distances the observer might assume. This latter is the case with Agnes Martin. And in her work it also remains clear that the optical, here marked as /cloud/, emerges within a system defined by being bracketed by its two materialist and tactile counterterms: the fabric of the grid in the near position and the wall-like stele of the impassive, perfectly square panel in the distant view. It is this closed system, taken as a whole, which preserves—like the moiré belt buckle—the drive toward the "objective," which is to say the fundamental classicism of its *Kunstwollen.*

Many other such analyses of different examples of the modernist grid are possible.[21] But the fact that cannot be stressed too strongly is that for us to take seriously the aspirations toward abstraction that the grid encodes and, as Louis Marin has shown, has to a certain extent always encoded, we need to grasp it as a structure and not a referent, as the operator of a system and not as the object of depiction. Piero's True Cross does, indeed, stand behind the modernist grid, authorizing it, I would say; but not in the sense that Léon Rosenthal or André Lhote could have understood.

1. Bernard Berenson, *Piero della Francesca, or the Ineloquent in Art* (London, 1954), 1–2.

2. Amédée Ozenfant and Édouard Jeanneret, *Après le cubisme* (Paris, 1918).

3. Léon Rosenthal, "Piero della Francesca et notre temps," *L'Amour de l'art* (December 1923), 767.

4. Rosenthal 1923, 770–771.

5. André Lhote, *Traité de la figure* (Paris, 1950), 180.

6. Le Corbusier, "Les tracés régulateurs," *L'Esprit Nouveau* 5 (n.d.), 563–572.

7. Lhote 1950, 17.

8. Louis Marin, "La théorie narrative et Piero peintre d'histoire," in *Piero: Teorico dell'arte*, ed. Omar Calabrese (Rome, 1985), 55–84.

9. Benveniste's distinction between *discourse* and *narrative* (or historical writing) is made in Emile Benveniste, *Problems in General Linguistics* (Miami, 1971), 205–222.

10. This leads Marin, then, to dispute Erwin Panofsky's assertion about the "correct" meaning of the phrase *et in arcadia ego* as "there in Arcadia I am also" by answering that this grammar of the present tense has been submitted to the operations that clearly transpose it into the past of its elegiac reading: "I also lived in Arcady." See Louis Marin, "Toward a Theory of Reading in the Visual Arts: Poussin's *The Arcadian Shepherds*," in *The Reader in the Text*, ed. Susan R. Suleiman (Princeton, 1980).

11. Marin 1985, 76. Another version of my summary of Marin's argument appears in Rosalind Krauss, "The LeWitt Matrix," *Sol LeWitt—Structures 1962–1993, Museum of Modern Art, Oxford, 24 January–28 March 1993* (Oxford, 1993), 28–30.

12. Kasha Linville, "Agnes Martin: An Appreciation," *Artforum* 9 (June 1971), 73.

13. In the formal notation of semiological analysis, the placement of a word between slashes indicates that it is being considered in its function as *signifier*—in terms, that is, of its condition within a differential, oppositional system—and thus bracketed off from its "content" or *signified*.

14. Hubert Damisch, *Théorie du /nuage/* (Paris, 1972), 170–171.

15. Damisch 1972, 89.

16. Alois Riegl, "Late Roman or Oriental?" in *Readings in German Art History*, ed. Gert Schiff (New York, 1988), 181–182.

17. Quoted in Barbara Harlow, "Riegl's Image of the Late Roman Art Industry," *Glyph* 3 (1978), 127.

18. Thus Riegl (1988, 187) writes: "The screw of time has seemingly turned all the way back to its old position, yet in reality it has ended up one full turn higher."

19. Martin often repeats that she sees herself joined to an ancient tradition of classicists—"Coptic, Egyptian, Greek, Chinese"—a tradition she defines as something that turns its back on nature, saying, "Classicism forsakes the nature pattern." *Agnes Martin: Writings/Schriften*, ed. Dieter Schwarz (Winterthur, 1992), 15.

20. For an important analysis of Kelly's recourse to chance, see Yve-Alain Bois, "Kelly in France: Anti-Composition in Its Many Guises," in *Ellsworth Kelly: The Years in France: 1948–1954* [exh. cat., National Gallery of Art] (Washington, 1992), 24–27.

21. This one has been adapted from my essay, "The /Cloud/," in *Agnes Martin* [exh. cat., Whitney Museum of American Art] (New York, 1992).

MARILYN ARONBERG LAVIN and KIRK D. ALEXANDER
Princeton University

Appendix
The *Piero Project*

The *Piero Project* is a computer simulation of Piero della Francesca's fresco cycle of the True Cross in the apse (Cappella Maggiore) of San Francesco in Arezzo (1452–1466). In a demonstration of the project in Washington, the frescoes were shown in high-resolution, full-color digitized images set in their three-dimensional architectural ambient through which the spectator's line of sight moves at a natural rate of speed.[1] The project is a collaborative research effort involving an art historian, a graphics specialist, a graphics programmer, and, in its later phases, a relational database expert. This team is in the process of creating the first operative computer facility for research and teaching in the history of art using exclusively digitized material with moving images. Under the joint sponsorship of Princeton University's Department of Art and Archaeology and the Interactive Computer Graphics Laboratory (ICGL),[2] the project began as a test for a then newly developed Silicon Graphics VGX IRIS workstation and its capacity to simulate the view of a spectator moving about in three-dimensional space. The goal was to investigate what this specialized equipment could offer the study and analysis of large-scale works of art in their spatial context that traditional still photography and 35 mm slides cannot.

The project came into being just at the completion of a study of the narrative arrangements in Italian fresco cycles, sometimes numbering as many as twenty or thirty scenes in a sequence, for which a computer database of nearly 250 examples was created.[3] While my work was still in progress, I realized that traditional photographs and diagrams were not adequate to illustrate my topic; general views would give a notion of the ambients but overlook the particulars: photographs taken from scaffolding would show individual scenes and details, but lose the context and the overall conceptual planning.[4] I wanted clear details and good color, but above all I sought a way to retain context and show the progressive movement of the narratives. In my search for alternative methods, I ventured into the Interactive Computer Graphics Laboratory. Kirk Alexander, manager of the laboratory, had majored in art history as an undergraduate and later studied architecture before specializing in computer graphics. Although he was fully aware of the need for a new approach, he could offer little help; the laboratory at that time had no equipment that could accomplish the desired tasks, and he advised me to publish my book with traditional means.

Several years later (after the book was published) the ICGL acquired a powerful new workstation. The full potential of the machine was not known at the time, and the laboratory was looking for projects with which to try its facilities. Recalling the problems I had earlier posed, Alexander contacted me to inquire if the issues we had discussed still had currency. Declaring the

predicament to be of much more than occasional value, I responded with a strong affirmative, and our cooperative venture was launched. We were joined by Kevin Perry, a skilled mathematician and computer programmer, who provided most of the solutions to the technical problems as they arose. The Princeton University Computing and Information Technology (CIT) administration agreed to lend the necessary computer time and staff to get started. Our first step was the decision to focus on a single work of art. Because of my interest in its narrative disposition, we chose Piero's Arezzo cycle. Considering Piero's scientific interests, creating a digitized version of his major work, displayed with a new electronic technique that involved mathematics and geometry, seemed eminently appropriate. There were, furthermore, intrinsic reasons why the cycle was an apt subject for analysis.

Like many fifteenth-century rectangular apses where fresco cycles were painted, the Arezzo chapel is quite tall, approximately forty-five feet to the height of the groin vault. The walls are divided into three tiers, each nearly twelve feet high, over a dado, or base, of almost nine feet. Thus all the tiers of narrative frescoes are above the spectator's head. Notwithstanding this physical fact, Piero designed all the figure compositions from the point of view of a spectator standing on the same level as the figures on each tier. Thus, in theory, to see the paintings correctly, a viewer would have to stand at three different levels, in midair. One may question this arrangement until it is pointed out that several of Piero's contemporaries also made what seem to be equally arbitrary decisions for their own cycles. Fra Filippo Lippi, for example, in the Cathedral of Prato, designed the viewing station for his fresco cycle (the *Lives of Saint John the Baptist and Saint Stephen*, 1452–1464) with the perspective on the lower tier more or less perpendicular to a viewer who stands just above the floor of the apse; on the second tier, the perspective is oblique, as though responding to the spectator's upward glance. On the third tier at the top of the wall, the perspective is still more stilted, almost *di sotto in sù*. Fra Filippo thus exaggerated the increase in foreshortening as the eye moves up the

1. Diagram of the narrative disposition of Piero della Francesca's cycle of the True Cross, San Francesco, Arezzo
Drawing: Susanne Philippson Curčić

wall. Andrea Mantegna, on the other hand, in the Ovetari chapel in Padua (the *Lives of Saint James and Saint Christopher*, 1450–1457), made an even more radical design. He lifted the spectator above the lunette looking down on the scenes; lowered him to a position floating opposite the middle tier looking directly into it; and, finally, dropped him to the floor of the chapel looking up from below at the bottom tier.[5] Clearly there was no "right" way to sight a fresco cycle, and the aim of all three artists was to create spaces and perspectives that amplified their subjects. One artist decided the worshiper should gaze heavenward; one changed the

angle of vision on all three tiers; and one, Piero, gave the worshiper the same line of sight, always on an equal footing with the religious characters, but in a new position for each new chapter in the story.

Within his ideal scheme, Piero painted the individual forms in a technique that is precise, meticulous, and detailed, not only inviting but demanding close observation. Textures are differentiated; forms are delicately modeled and lit; complicated poses are carefully worked out with pounced edges or incised contours. As a result, when one stands on the floor of the chapel, it is very hard—not to say frustrating—to discern the refinements.

Attempting to follow the narrative is equally difficult, since the story, which is set in ten major narrative fields, moves across the architectural surfaces in a quite irregular manner. The plot does not begin where one might expect, that is, on the left wall at the top. It starts in the right lunette where it reads "backward," from right to left. The sequence reverses direction on the second tier, after which it begins a series of jumps: from the right wall to the altar wall; from the altar wall back to the right wall; back to the opposite side of the altar wall; over to the left end of the middle tier of the left wall; down to the bottom tier; and finally up to the left lunette where the story comes to a close (fig. 1). The sinuosity of this pattern is augmented by the fact that the individual episodes are unframed, and the spatial fields seem to interpenetrate at the corners. Although when standing on the chapel floor one can experience the overwhelming vigor of the strongly modeled figures, one gets little sense of the narrative progression.[6] The task can be overwhelming, as well as rather hard on the muscles of the neck!

It is well to remember that expectations of viewing works of art in the Renaissance, particularly during Mass, were not the same as studying the history of art in the twentieth century. The Cappella Maggiore in San Francesco is, first of all, the sanctuary that houses the high altar of a friary church that also served a parish. The altar itself was originally flush against the back wall of the apse, under the window. The "monks' choir" would have projected out into the nave, and there surely was a choir screen

(*tramezzo*, or *ponte*) across the opening of the apse that further blocked the view.[7] Thus what the ordinary fifteenth-century parishioners saw was the huge painted Crucifix hanging under the triumphal arch, with the frescoes, high on the walls of the apse, as a backdrop.

In creating the cycle, the artist would naturally have had to comply with the religious needs of the proprietors of the church, the Franciscans in this case, and with the particular requirements of the patrons, the Bacci family. His special expertise would have been in the realm of design, and this is the aspect of the cycle upon which modern visual analysis focuses. The heart of the *Piero Project* is the search for improved methods of seeing the frescoes, both as a whole in their physical context and up close in detail on every level. The ultimate purpose of the endeavor, however, is to achieve greater understanding of the way in which the design of the cycle enriches its meaning as a work of art in its physical setting and in its larger historical framework.

Technically, the project started with a perspective drawing in the computer. The rendering of the rather simple rectangular chapel appeared as a transparent structure, or "wire-frame," enclosing the illusion of a realm known as "virtual space." The procedure, called "modeling," was accomplished with AutoCAD, a computer-aided drawing application. After filling in the virtual walls, photographs of the separate tiers of the frescoes were scanned and then transferred by the computer (with a process known as texture mapping) onto their proper positions in the chapel. The result was a three-dimensional digital construction of the entire chapel with its mural decoration seen in correct perspective.[8] Up to this point, we had done what many different kinds of computer systems can do. The next step, however, was unique. With a custom program created by the Princeton technical team, the machine was able to move the spectator's line of sight around in the virtual space. Within four months, we had digitized (scanned and saved in files) all the elements of the cycle, and were able to move freely (if somewhat jerkily) throughout the chapel: up, down, sideways, turning, returning, entering into details and

backing out again, to observe the paintings from an infinite variety of angles. Even though our preliminary images were fairly mediocre, it was immediately apparent that we had a new and very effective tool for viewing works of art, one that would change the way we see, use, and relate to surrogate images. The team created what we called a "video sketch"—a videotape copy of what was in the computer—which we showed at the 1991 meeting of the College Art Association of America. The enthusiasm of the response from the professional community encouraged us to press on.

By the end of the first calendar year, the equipment had been greatly reduced in price and greatly improved by a "tool kit" (named Inventor) that did automatically most of the things our programmer had painstakingly accomplished on his own. Although these advances meant that we had to start again, we did so at a much higher level of refinement. We now obtained superior images of the cycle and set to work again.[9] As the project evolved, our interests came quite naturally to focus on a number of points.

1. Movement

One of the greatest assets of the workstation with the Inventor software is the ability to emulate human movement. The IRIS redraws images rapidly at different sizes, producing the effect of coming closer or moving farther away, and thereby changing the spectator's position of viewing. The redrawing takes place at such a rapid pace (approximately sixty times a second) that one cannot perceive the changes, and the result is apparently smooth movement (in computer terminology, this is called "realtime"). The change of viewpoint can be produced with the traditional "mouse," which creates movement in two dimensions over the surface of the screen, or with a spherical object, a "space-ball," which creates movement in three dimensions through the represented space. The process of moving the image by hand is known as "interactivity," with the implication that commands given by the user generate instantaneous response by the system.

The demonstration in Washington started with a few moments that imitate one's experience in the church. Entering at the façade through the door at the left, we "walked" diagonally down the nave toward the east end. Once in the apse, we turned on lights (with a special menu). The model of an average-height man was called up to give scale to the structure. The point of view then was turned upward toward the top of the side walls, and swung around from side to side, as one might move one's head when standing in the chapel. In so doing, the difficulties of the oblique view were illustrated. (It is important to point out that during all such movement, the images are continuously generated in correct perspective.) At this point, the demonstration turned from what is possible in the church under ordinary circumstances to what can be done only with the aid of a computer.

Activating the space-ball, the line of sight was made to rise through space to the height of the lunettes where, for the first time and with great facility, we attained one of Piero's ideal viewing positions. Not even Piero at work could have seen his frescoes in this manner. The structure of the scaffolding he used is unknown, but two forms seem the most plausible. One form is scaffolding that filled the chapel completely (as was done in the 1961–1963 cleaning campaign); in this case, the painting would have proceeded horizontally, so to speak, one level at a time on all three walls, moving down from top to bottom (because of dripping paint). The other possible form is scaffolding that covered only one wall at a time (as is the case with the preservation campaign currently being carried out by the Soprintendenza ai BAAAS di Arezzo); in this case, the painting was carried out by completing one wall from top to bottom, and then moving the scaffold to work on another. In either instance, Piero would never have had a chance to see his work from this level without at least part of the scaffold structure blocking his view. With the computer, by contrast, the viewing station can be suspended in the middle of the space. The spectator can then, so to speak, turn the point of view back and forth across all three walls, float about, arrive at any level, and meanwhile have the entire painted surface remain in his or her field of vision. Retaining the context of each scene is, in fact, one of the most important assets of this technique. In providing a visual range that

Rotx Roty Zoom 62.0 Dolly

2. Hard copy printout of workstation computer image of Piero della Francesca's cycle of the True Cross, prepared for "windowed" details, geometric study, and "chained travel."

with which the scanning process is carried out. During the scanning, the image is broken into a number of illuminated cells called pixels (picture elements); the more pixels per unit square area, the higher the resolution. In this context, however, it should be remembered that Piero's frescoes are in deplorable condition, having suffered severe losses in color intensity. A new photographic campaign, impossible in any case because of the conservation work in progress, sadly would only document their deterioration.[11] For this project, therefore, we turned to the best color slides and transparencies already available. After scanning transparencies in a flat-bed scanner proved unsatisfactory for various reasons, we made 35 mm slides from the transparencies and scanned them in a slide scanner with much greater success. The digitized images were then preserved in the workstation, and retained in a relatively high level of quality.

The next step was texture mapping, or situating scanned images of all the separate tiers of frescoes at their proper locations on the walls of the computer model of the chapel. In this way, we produced the three-dimensional image through which the line of sight can be moved at will.

Early models of the IRIS workstation (the VGX) could not move images in high resolution. In any given journey, the crispness dissolved and the movement proceeded with visible jerkiness. Only when the movement came to rest could the machine refresh the screen, or "re-paint" the images, once more in high resolution. By the time of the demonstration, however, this problem had been solved (through a more advanced version of the workstation called the "Reality Engine"). Using the same software, the images now retained high resolution during flight, while moving freely around the three-dimensional space, with no shift of focus upon coming to a halt. This technical advance was very important for the quality of the visual experience.

far surpasses traditional reproductive media, the program helps to reveal new juxtapositions and relationships. In so doing, it will serve to stimulate new observations, and ultimately make us ask new questions and lead us to ask them in new ways (fig. 2).[10]

2. Resolution and Quality

Achieving high resolution, or clarity of the image in the computer, is by now no longer a problem. Scanned images stored in the computer can be as crisp in form and faithful in color as the best photographs. The quality of a digitized image depends on the quality of the prototype (an "original," a photograph, a transparency, or a slide), the quality of the scanner, and the precision

3. Details, Comparisons, Hard Copy

Once the images are texture-mapped into place, the line of sight can be made to rove across the entire space. Pauses can be effected for prolonged observation whenever

desired. At any chosen place on the surface, one can "pick" with a mouse click and open a window on a particular area. Within this area, it is possible to "pan" about and see details with great clarity. A number of lighting effects can be called up, either as a generalized illumination or as spot lighting to single out the specific detail. Auxiliary images can also be embedded under the texture-mapped surface and called up for inspection in other windows, superimposed on the primary image. These added scans can be details of surface elements at higher resolution. They can be material that is really under the surface, such as preparatory techniques (underdrawings, incisions, pouncing, *giornate* joins), or changes (*pentimenti*). Or they can be images from outside the primary visual database, ancillary material for use in making comparisons. The embedded images are brought up to the surface again by clicking the mouse button. They can be placed on the screen so that they appear side by side, as in a traditional slide comparison. Images can be flipped or reversed, cut out, or superimposed, if that is what the analysis indicates. The size of the images can be scaled in proper proportion, and they can be placed on the screen in such a way that the general context on the wall remains visible.

Any of the images that appear on the screen—general views, details, corners, juxtapositions, angle shots—can be printed out as glossy hard copy in full color or black and white.

4. Geometric Study

Another tool offered by the workstation is the generation of geometric diagrams both in two dimensions, on the surface of the picture plane, or in three dimensions, defining solid geometrical relationships. By overlaying painted forms with lines and the representation of planes, relationships of distant parts of the composition can be emphasized and analyzed with alacrity. Because of the ease and speed of such procedures, one is encouraged to test such ideas and perceptions. Mistakes and false starts are easily removed and successes can be preserved and saved in separate files for future use or printing out.

5. Chained Travel

The internal working of the computer's tool kit recognizes the identity and orientation of wall surfaces. By clicking the mouse button on any of the walls of the model, the computer will take the line of sight to a position that views that wall head on. For example, if we are stationed up in the air, facing the second tier on the right wall, and we wish to see the lowest tier on the left wall to make a comparison, a click of the mouse button will make the complicated move, swinging us around and down in one continuous motion. This automatic maneuver would allow analysis to continue without the distraction of interactive manipulation.

To prearrange a series of such moves around the chapel, with pauses at preordained locations, Kevin Perry devised a method for chaining the travel. Visible markers (combining a cone, indicating a position in space, and an arrow, indicating the direction of movement) enable the line of sight to move to a chosen position. It is possible to program a series of moves in advance, evoke a menu that removes the markers from sight, initiate the travel, and then be quite free to concentrate on extended study and discussion while the computer does the rest. Whether moving the viewing position by hand interactively or using chained travel, the result is vastly superior to anything that could be achieved with slides.

6. Future of the Program

In the fall of 1992, the team was awarded a two-year grant by the United States Department of Education, Fund for the Improvement of Post-Secondary Education (FIPSE), to prepare a seminar on Piero della Francesca for advanced undergraduate and graduate students, using all electronic material instead of slides. In the spring of 1994, the seminar was held in the classroom of the Interactive Computer Graphics Laboratory at Princeton University, where twenty workstations are available to students. Since the Washington demonstration, all of Piero's works have been scanned along with much comparative visual material. Peter Vince developed a user interface for Oracle software to create a relational database combin-

ing text and images. The database contains standard catalogue information for all the works of art involved, and links every image to all the historical ideas, iconography, personalities, and contexts to be discussed in the course. The textual material and the images appear on the screen together, and both are browsable together or separately. The seminar explored the usefulness (and pitfalls) of this approach for teaching and research.[12]

7. Notes on the Technical Aspects of the Demonstration

The demonstration equipment included:[13]

HARDWARE

Display Workstation
Silicon Graphics "Crimson Reality Engine" Workstation

1 gigabyte permanent storage (hard disk, 1,000 megabytes or 1,000 x 1 million characters)

128 megabytes Random Access Memory (RAM)

32 bits of color per pixel plus separate alpha channel and 4 megabytes of realtime texture memory

12 graphics co-processors (additional computer hardware for performing graphics operations)

CPU: 100 megaHertz MIPS R4000 RISC Processor with Floating Point Co-processor

Projection System
A special feature of the Washington demonstration was the use of two Sony HDTV Projectors. These machines project an image that is 1536 x 1033 pixels in resolution to a size of 9 x 16 ft. on the screen in the auditorium. Because the Reality Engine computer supports this format directly, we were able to project the largest and clearest electronic image that could be shown with current technology.

Development Hardware
All of the development for the *Piero Project* was carried out on a Silicon Graphics 220 VGX workstation at Princeton University. This machine contains 96 megabytes of RAM, ½ gigabyte of hard disk space, 32 bits of color per pixel, plus 512 kilobytes of texture memory. The CPU is a 25 megaHertz

MIPS R3000 RISC Processor with a Floating Point Co-processor.

Silicon Graphics now makes two lines of desktop workstations, both of which are fully capable of running the software that has been demonstrated, although at a slower rate of speed. Realtime walk-throughs would not be possible on these machines, but model-building and full three-dimensional displays, complete with all the art images, are feasible even on the least expensive machines.

SpaceBall
This special motion control device is made by SpaceBall Technologies, Inc. and resold by Silicon Graphics. It consists of a palm-sized sphere mounted on a small pedestal. Twisting and turning, pulling and pushing of the sphere cause the expected corresponding motion of a viewer through a three-dimensional scene.

Scanning Equipment
Howtek flat-bed scanner

Nikon LS-3510AF slide scanner

The process known as scanning consists of running a sensor over the slide or image and breaking it up into a number of tiny color cells known as pixels (picture elements). Factors taken into consideration in this process are color matching, light intensity, scale of originals, and camera resolution.

SOFTWARE

The software listed below comprises the special instructions for creating the three-dimensional views, the image transformations, and the three-dimensional models shown in the demonstration. Most of the programs were developed by commercial software vendors, but the technical staff of the *Piero Project* wrote the special customizations.

AutoCAD®
A Computer Aided Design (CAD) program by AutoDesk that is used to build three-dimensional architectural models. This program runs on many kinds of computers, including the Silicon Graphics workstations, IBM PC compatibles, and the Apple Macintosh.

Inventor®
A tool kit developed by Silicon Graphics which enables others to develop three-dimensional programs for special purposes.

Inventor provided the foundation for all the three-dimensional viewing software shown in the demonstration.

Princeton enhancements
The extensions to Inventor developed at Princeton made possible the "art-history specific" behavior that was demonstrated. Among other things, this behavior consisted of multiple resolution textures and image detail display

Adobe Photoshop®
An image manipulation program used in the *Piero Project*. Our slide scanner was controlled using Photoshop. Several special effects images were created with this package.

Technical Glossary

bit: the smallest measure of computer memory or storage; generally refers to ⅛ of one character

bytes: characters of memory/space: (RAM or disk)
kilobytes = 1,024 bytes of memory/space
megabytes = 1,024 kilobytes
gigabytes = 1,024 megabytes

HDTV: High-Definition Television

ICGL: The Interactive Computer Graphics Laboratory, Princeton University; responsible for developing the software used in the *Piero Project*

interactive: descriptive of interactions with a computer: an action or control by a user that receives immediate response by the computer

IRIS: original name for workstations developed by Silicon Graphics; acronym for Interactive Raster Imaging System

markers: a term coined for the *Piero Project* to denote geometric elements inserted into a scene for the purpose of representing a predetermined viewing position. A mouse click on a marker directs the computer to alter the apparent viewing position of the viewer to the represented location

menu: a control area (*see* window) which presents a series of choices that may be selected by a computer user

paint/re-paint: jargon term for the process of displaying or refreshing an image on a computer screen to simulate motion. The image must be changed or "re-painted" faster than the human eye can detect discrete transitions to produce smooth motion

pixel: one element of a grid or matrix of color cells into which an image is divided so that it can be represented numerically in a computer. The term pixel refers to picture-element

RAM: Random Access Memory. RAM is the active, temporary computer memory, as opposed to the permanent disk storage

realtime: the rate of response by a computer that appears to be instantaneous. When applied to "motion" on a computer screen, the term implies continuous smooth motion that seems natural or "real"

scanning: the process of making a slide or photograph understandable to a computer. The image is "scanned" by an electronic eye which converts light and color values from the image into numbers for the computer

software, application, program: packages of instructions for computers without which they cannot function

spot light, point light: simulated lighting effects. A spot light emanates from a single location and spreads out only in one specific direction; a point light also emanates from a single location but spreads out in all directions

textures: images stored in a computer that appear to be glued to the surface of a geometric object, such as a wall

texture mapping: the process of attaching (mapping) textures (images) to geometry. In the *Piero Project* demonstration, all the mural images were texture mapped to the virtual surfaces representing the walls of the chapel

texture memory: special computer memory for storing images that will be transformed continuously by the computer as a viewer moves about a composition

window, box: rectangular subsections of a computer screen devoted to different purposes. A window may contain text, graphics, or control menus

wire-frame: a simplified representation of a geometric object stored in a computer. Because of its simplicity, a wire-frame can be drawn by the computer much faster than a "solid" or "filled" model

NOTES

1. In conjunction with the symposium *Monarca della Pittura*, the demonstration was performed in December 1992 in the small auditorium of the East Wing of the National Gallery of Art, Washington, on a Silicon Graphics "Crimson Reality Engine" workstation, one of the most sophisticated computer graphics workstations then available. The machine used for the demonstration was generously lent by the Silicon Graphics Company for the occasion. The electronic images were displayed on the monitor and, through two Sony high-definition television (HDTV) projectors, on a 9 x 16 ft. high-resolution screen. Technical information pertinent to the project is given in the last section of this paper.

2. The ICGL is under the direction of Computing and Information Technology. Along with Lavin and Alexander, the team is made up of Kevin Perry and Peter Vince.

3. Using the program Statistics Analysis Systems (SAS), stored on the Princeton University mainframe. The analysis brought forth new material that resulted in *The Place of Narrative: Mural Painting in Italian Churches 431–1600 A.D.* (Chicago, 1990) by Marilyn Aronberg Lavin.

4. Still photographs have other characteristics that limit their usefulness for art-historical purposes. Both long views and close-ups are frozen in time and limited in shape by the very nature of the still camera. In reproductions, relative scale is often ignored, with small parts frequently appearing as large as or larger than the total object. Finally, fresco scene close-ups are often framed in a way that makes them look like panel paintings.

5. See Lavin 1990, 153–167.

6. See Lavin 1990, 167–194, for discussion of the disposition of the cycle and its effects.

7. The tomb of the Bacci family, patrons of the frescoes, was in this *tramezzo*.

8. It is important to remember that no general view of the chapel was used. The illusion is created from flat photographs assembled by the computer program.

9. We leased 8 x 10 in. transparencies owned by Scala, Florence, probably made soon after the cleaning of the 1960s. The company has two sets: one is too yellow; the other is too blue. We chose the yellow set, which seemed somewhat closer to the original. The parts of the ensemble that have never been adequately photographed, such as the painted cornices between the tiers and the whole dado area, were generated by the computer from the few details that show in other photographs.

10. I have set out some preliminary results of viewing the frescoes in the computer in my article in this volume and in my book on Piero's cycle, *Piero della Francesca: San Francesco, Arezzo* (New York, 1994). The new observations resulting from vistas into the corners of the tiers were afforded by the program where juxtapositions and relationships rarely photographed can easily be seen.

11. *Un progetto per Piero della Francesca: Indagini diagostico, conoscitive per la conservatione della Leggenda della croce e della Madonna del Parto*, ed. Giuseppe Centauro and Monica Maffioli (Florence, 1989). The current campaign, which is primarily one of preservation and will continue for several more years, has not yet produced new photographs available to the public.

12. When the team feels that the *Piero Project* has been developed to its most useful level, we intend to make the custom program available to the academic public. At this time, the program is suitable for use only on Silicon Graphics hardware.

13. See the Technical Glossary for an explanation of terms used in this section.

Contributors

Kirk D. Alexander manages the Interactive Computer Graphics Laboratory (ICGL) at Princeton University. He earned his undergraduate degree in art history at Princeton, as well as his master's degree in civil engineering. At the ICGL, he has worked on the development of computer graphics for university-level education. His publications include an analysis of the structure of Bourges Cathedral in the *Journal of the Society of Architectural Historians* and articles on electronic visualization.

Daniel Arasse is professor at the École des Hautes Études en Sciences Sociales, Centre d'Histoire et Théorie de l'Art, Paris. His current research concerns the mnemonic and rhetorical structures of Italian pictorial representation in the fourteenth and fifteenth centuries. He has written extensively on the history and theory of European painting. Recent publications include *Le détail: Pour une histoire rapprochée de la peinture* and *L'ambition de Vermeer*, which was translated into English as *Vermeer: Faith in Painting.*

James R. Banker teaches Italian Renaissance and early modern European history at North Carolina State University. In 1988 he published *Death in the Community: Memorialization and Confraternities in an Italian Commune in the Late Middle Ages* on religious life in Borgo Sansepolcro. He has maintained a scholarly interest in the Tuscan town and recently completed several studies on Piero della Francesca from previously unknown documents. Banker is preparing a book on "The Culture of Borgo Sansepolcro in the Time of Piero della Francesca," which explores the relationship between the painter and his local setting.

Albert Boime is professor of art history at the University of California, Los Angeles. He has published widely in nineteenth-century art and is currently working on the third volume of his *Social History of Modern Art.* Boime's most recent work is *Art and the French Commune* (forthcoming).

Maurizio Calvesi, professor of art history at the University of Rome, "La Sapienza," is editor-in-chief of *Art e Dossier.* Specializing in Italian Renaissance and baroque art, he has written on Piero della Francesca, Albrecht Dürer, Caravaggio, and the patronage of popes Sixtus IV, Sixtus V, and Innocent X. He is also active in the field of twentieth-century Italian art, with publications on Giorgio de Chirico, Carlo Carrà, Umberto Boccioni, Marino Marini, F. T. Marinetti, and the futurists.

Michael Curschmann directs the Program in Medieval Studies at Princeton University, where he is professor of Germanic languages and literatures. His research and teaching span German literature to 1600, Old Norse literature, and various interdisciplinary topics such as oral versus literate culture, literature and music, and literature and the visual arts.

J. V. Field is a Leverhulme Research Fellow in the department of the history of art, Birkbeck College, University of London.

Jack Freiberg, assistant professor of art history at the Florida State University, received his doctorate from New York University and has been a fellow of the American Academy in Rome and a Samuel H. Kress Foundation Fellow at the Bibliotheca Hertziana. His research and publications have focused on Italian Renaissance and baroque art and architecture. He is the author of *The Lateran in 1600: Christian Concord in Counter-Reformation Rome* (1995).

Marc Fumaroli is professor of rhetoric and sixteenth- and seventeenth-century European society at the Collège de France, Paris. He is president of the scientific advisory council of the Bibliothèque Nationale and Chevalier of the Légion d'honneur. His most recent books include *Eroi et oratori* (1990), *L'État culturel* (1991), *Le Genre des genres littéraires français* (1992), and *L'École du silence* (1994).

Paul F. Grendler was educated at Oberlin College and the University of Wisconsin. Since 1964, he has taught at the University of Toronto, where he is professor of history. Grendler is the author of five books, including *Schooling in Renaissance Italy: Literacy and Learning, 1300–1600* (1989) and *Books and Schools in the Italian Renaissance* (1995). He has also written articles on a variety of Renaissance topics, and is working on a history of Italian Renaissance universities, 1400–600.

Martin Kemp studied natural sciences and art history at Cambridge University and at the Courtauld Institute, University of London. He is the author of *Leonardo da Vinci: The Marvellous Works of Nature and Man* (1981, winner of the Mitchell Prize), and *The Science of Art: Optical Themes in Western Art from Brunelleschi to Seurat* (1990). He is presently doing research on issues in scientific representation and writing a book on anatomical, physiognomic, and natural themes in art from the Renaissance to the nineteenth century. After teaching at the University of St. Andrews, Scotland, in 1995 he will become professor in art history at the University of Oxford.

Rosalind E. Krauss is professor of art history at Columbia University and cofounder and editor of *October* magazine. Her books include *The Optical Unconscious, The Originality of the Avant-Garde and Other Modernist Myths*, and *Passages in Modern Sculpture*.

Marilyn Aronberg Lavin has taught at Princeton and Yale universities and the University of Maryland. Among her books are *Seventeenth-Century Barberini Documents and Inventories of Art* (1975, winner of the Charles Rufus Morey award for distinguished scholarship) and *The Place of Narrative: Mural Decoration in Italian Churches, 431–1600 A.D.* (1990). In addition to articles on Piero della Francesca, she has written four books on the artist, one of which, *The Baptism of Christ* (1981), was presented for the Christian Gauss seminar in criticism, Princeton. She is a member of the advisory board of the Art History Information Program, J. Paul Getty Trust.

Bert W. Meijer is director of the Istituto Universitario Olandese di Storia dell'Arte in Florence and professor of art history at Utrecht University. His research includes painting and drawing of both Italian and northern Renaissance and the baroque, and in particular their reciprocal relations. He is a curator of the exhibition *Fiamminghi a Roma 1508–1608*, to be held in 1995 in Brussels and Rome.

Stephen G. Nichols, professor of French at the Johns Hopkins University, specializes in Old French and Old Occitan literature in their relations with art and history. He is the author of *Romanesque Signs: Early Medieval Narrative and Iconography* (1983, 1985). Recent projects include *The New Medievalism* (1991), *The New Philology* (1990), *Commentary as Cultural Artifact* (1992), *Medievalism and the Modernist Temper* (1995), and *The Whole Book: Cultural Perspectives on the Medieval Miscellany* (1995).

John Shearman taught at the Courtauld Institute, University of London, from 1957 to 1979 and served as deputy director from 1971 to 1977. Following several years at Princeton University, in 1987 he went to Harvard where he was appointed University Professor. Among his works are *The Landscape Drawings of Nicolas Poussin* (with Anthony Blunt, 1963), *Andrea del Sarto* (1965), *Mannerism* (1967), *Raphael's Cartoons* (1972),

The Early Italian Pictures in the Collection of Her Majesty the Queen (1983), and the Andrew W. Mellon Lectures in the Fine Arts, *Only Connect ... Art and the Spectator in the Italian Renaissance* (1992).

Christine Smith is chair of the department of art history at the Syracuse University Program in Florence. Her most recent publications on Alberti and fifteenth-century culture include *Architecture in the Culture of Early Humanism: Ethics, Aesthetics, and Eloquence 1400–1460* (1992), "The Winged Eye: Leon Battista Alberti and the Visualization of the Past, Present, and Future," in *The Renaissance from Brunelleschi to Michelangelo: The Representation of Architecture*, ed. Henry A. Millon and Vittorio Lampugnani (1994), and "Leon Battista Alberti e l'ornamento: Rivestimenti parietali e pavimentazioni," in *Leon Battista Alberti*, ed. J. Rykwert and A. Engel (1994).

Michael F. Zimmermann is assistant director at the Zentralinstitut für Kunstgeschichte in Munich and elected secretary of the Association of German Art Historians. After studying art history, philosophy, and history in Cologne, Rome, and Paris, he became assistant professor at the Freie Universität in Berlin, then at the German Institute for the History of Art in Florence. In 1991 his monumental monograph on Georges Seurat was published.

Studies in the History of Art
Published by the National Gallery of Art, Washington

This series includes: Studies in the History of Art, collected papers on objects in the Gallery's collections and other art-historical studies (formerly *Report and Studies in the History of Art*); Monograph Series I, a catalogue of stained glass in the United States; Monograph Series II, on conservation topics; and Symposium Papers (formerly Symposium Series), the proceedings of symposia sponsored by the Center for Advanced Study in the Visual Arts at the National Gallery of Art.

[1] *Report and Studies in the History of Art,* 1967

[2] *Report and Studies in the History of Art,* 1968

[3] *Report and Studies in the History of Art,* 1969 [In 1970 the National Gallery of Art's annual report became a separate publication.]

[4] *Studies in the History of Art,* 1972

[5] *Studies in the History of Art,* 1973 [The first five volumes are unnumbered.]

6 *Studies in the History of Art,* 1974

7 *Studies in the History of Art,* 1975

8 *Studies in the History of Art,* 1978

9 *Studies in the History of Art,* 1980

10 *Macedonia and Greece in Late Classical and Early Hellenistic Times,* edited by Beryl Barr-Sharrar and Eugene N. Borza. Symposium Series I, 1982

11 *Figures of Thought: El Greco as Interpreter of History, Tradition, and Ideas,* edited by Jonathan Brown, 1982

12 *Studies in the History of Art,* 1982

13 *El Greco: Italy and Spain,* edited by Jonathan Brown and José Manuel Pita Andrade. Symposium Series II, 1984

14 *Claude Lorrain, 1600–1682: A Symposium,* edited by Pamela Askew. Symposium Series III, 1984

15 *Stained Glass before 1700 in American Collections: New England and New York (Corpus Vitrearum Checklist I),* compiled by Madeline H. Caviness et al. Monograph Series I, 1985

16 *Pictorial Narrative in Antiquity and the Middle Ages,* edited by Herbert L. Kessler and Marianna Shreve Simpson. Symposium Series IV, 1985

17 *Raphael before Rome,* edited by James Beck. Symposium Series V, 1986

18 *Studies in the History of Art,* 1985

19 *James McNeill Whistler: A Reexamination,* edited by Ruth E. Fine. Symposium Papers VI, 1987

20 *Retaining the Original: Multiple Originals, Copies, and Reproductions.* Symposium Papers VII, 1989

21 *Italian Medals,* edited by J. Graham Pollard. Symposium Papers VIII, 1987

22 *Italian Plaquettes,* edited by Alison Luchs. Symposium Papers IX, 1989

23 *Stained Glass before 1700 in American Collections: Mid-Atlantic and Southeastern Seaboard States (Corpus Vitrearum Checklist II),* compiled by Madeline H. Caviness et al. Monograph Series I, 1987

24 *Studies in the History of Art,* 1990

25 *The Fashioning and Functioning of the British Country House,* edited by Gervase Jackson-Stops et al. Symposium Papers X, 1989

26 *Winslow Homer,* edited by Nicolai Cikovsky, Jr. Symposium Papers XI, 1990

27 *Cultural Differentiation and Cultural Identity in the Visual Arts,* edited by Susan J. Barnes and Walter S. Melion. Symposium Papers XII, 1989

28 *Stained Glass before 1700 in American Collections: Midwestern and Western States (Corpus Vitrearum Checklist III),* compiled by Madeline H. Caviness et al. Monograph Series I, 1989

29 *Nationalism in the Visual Arts,* edited by Richard A. Etlin. Symposium Papers XIII, 1991

30 *The Mall in Washington, 1791–1991,* edited by Richard Longstreth. Symposium Papers XIV, 1991

31 *Urban Form and Meaning in South Asia: The Shaping of Cities from Prehistoric to Precolonial Times,* edited by Howard Spodek and Doris Meth Srinivasan. Symposium Papers XV, 1993

* Forthcoming